P9-DGJ-729

CHALK

MELVILLE HOUSE

BROOKLYN
LONDON

C

THE ART AND ERASURE OF

H

CY TWOMBLY

A

JOSHUA RIVKIN

L

K

Chalk
Copyright © 2018 by Joshua Rivkin

First Melville House Printing: October 2018

Melville House Publishing Suite 2000
 46 John Street and 16/18 Woodford Rd.
 Brooklyn, NY 11201 London E7 0HA

mhpbooks.com
@melvillehouse

Book design by Richard Oriolo

Library of Congress Cataloging-in-Publication Data

Names: Rivkin, Joshua, author.
Title: Chalk : the art and erasure of Cy Twombly / Joshua Rivkin.
Description: Brooklyn : Melville House, 2018. | Includes bibliographical
 references and index.
Identifiers: LCCN 2018034338 (print) | LCCN 2018034705 (ebook) | ISBN
 9781612197197 (reflow able) | ISBN 9781612197180 (hardback)
Subjects: LCSH: Twombly, Cy, 1928-2011. | Artists--United States--Biography.
 | BISAC: BIOGRAPHY & AUTOBIOGRAPHY / Artists, Architects, Photographers. |
 ART / History / Contemporary (1945-). | BIOGRAPHY & AUTOBIOGRAPHY / Rich &
 Famous.
Classification: LCC N6537.T96 (ebook) | LCC N6537.T96 R58 2018 (print) | DDC
 700.92 [B] --dc23
LC record available at https://lccn.loc.gov/2018034338

ISBN: 978-1-61219-718-0
ISBN: 978-1-61219-719-7 (eBook)

Printed in the United States of America

10 9 8 7 6 5 4 3 2 1

FOR ERIN & ESME

What I consume with pleasure is absence.

—ROLAND BARTHES

CONTENTS

PART THREE

PART FOUR

IN THE BLACK

THE SURFACE OF LAKE EDEN is black glass under the press of winter stars. The snow, stopped for now, hangs onto the branches of the pine trees. A young man, Robert Rauschenberg, is alone in the icy water. He hears in the distance the breaking of branches, the hurry of feet through the woods to the lake's edge. His mind, like the sky, is black.

With a single flashlight, the men on the shoreline scan for the shape of arms or a head above water. They call. They wait. They too are shivering. Another young man, Cy Twombly, his friend and fellow student, his lover too, wades out in the cold water and calls him back to dry land. The dark water around Twombly's waist is ice and fire both. "I can't catch my breath," he gasps, surprise and worry, not to the others even,

but to himself. He's about to give up, about to turn back. The men with the flashlight think of their own bodies slipping below the water were they to swim out to the young men in trouble, two of them now.

And then Rauschenberg turns back, begins to move towards shore. Twombly calls out to him, This way, this way, warmth and affection in the southern drawl of his voice. He continues to speak his friend's name: Bob, this way. They find each other in the water. This way, he says again, softer now, calmer, his speech slow and careful. Cy guides Bob as they move through and out of the lake, black water, slick mud.

Swallowed up by their shivering is their usual talk, easy and joyous, of their art, their ambitions, their plans to travel beyond the small towns of their youth. Any talk about the consequences of what they're doing, Rauschenberg's wife and child at home in New York, the hurry and foolishness of desire, that is gone too.

They move inside and gather themselves back to warmth; Bob strips down before the fire, while Cy hunches over an electric burner. The moment passes between them and the few others that stood with them at the edge of the lake. A shared spark, a cold terror, a silence. The other students, artists and writers, continue their conversations as if nothing extraordinary has just happened.

▌

The story of this almost drowning comes to us in letters between Robert Creeley and Charles Olson.

"Crazy part, that, it all passed into the silences of history," Olson writes to his friend and fellow poet, "on the surface, just as though he had gone for a swim and had come out with no help."[1]

After the two young men emerged from the water, Olson, who had recently started running the college at Black Mountain in North Carolina, questioned them about what had just occurred. Without his inquiries—and the letter relaying the incident, this "tale of the lake & the boy"—"no one except those involved would have known the event had happened at all."[2]

One is reminded of the crapshoot of memory and history, the endless list of accidents avoided—fires that didn't start, cleaning crews that

missed a box, moths that bit their tongues, wars that stayed home—that allowed these letters, *any* letters, to come down to us in the present, those stray and few gems of Sapphic verse or shards of papyrus that say *this happened.*

"[H]e is in the black, just now," Olson writes of Rauschenberg in another letter to Creeley, "his marriage smashing, probably over the affair with Twombly, his contract with the gallery not renewed, and—I'd also bet as an added hidden factor—the terrible pressure on him of the clear genius of this lad, Twombly, the success of his year and the total defeat of Bob's."[3] "In the black," he writes, as if the young artist's life were a thundercloud or a balance sheet or a painted-over canvas.

"I noticed a few nights ago Twombly's concern for this boy," he writes, "when we were all talking in the study building entrance and Rauschenberg was sitting too carelessly on the railings over the well's edge—that sort of attention, and warning one takes as feminine, guarding the beloved."[4] More than simply capturing the trouble caused by their affair or the near drowning or the uneven state of their young careers, Olson's letters capture the clear affection of Twombly for Rauschenberg, and the older poet's dim view of what he describes as "these sexually marginal girls & boys." I'm struck by the tenderness between the two, the groundwork not just for their short affair but a lifelong friendship.

"It was not so felt now," Olson writes, "simply, that he, as all of us, had this danger in our minds . . ."[5] The danger is not simply the way Rauschenberg sat "carelessly" on the railing, but, I like to think, a larger worry about the consequences of their affair: the "smashing" of his marriage to the artist Susan Weil who had recently given birth to their son, Christopher. His falling in love with Twombly was certainly part of the reason.

Desire is not simple or safe. In life and in art, desire is the complication. A decade after their time at Black Mountain, Twombly would be the one with a wife and child, just beginning a relationship with another man, much younger, Nicola Del Roscio. In time, Nicola would become Twombly's closest friend and partner, eventually the man responsible for managing all of Twombly's affairs, including the foundation set up after the artist's death.[6] But when they first met, Nicola was a college student, sixteen years his junior, living across the street from Twombly's Rome

apartment, about the same age as those young men in the water back at Black Mountain.

Twombly's marriage, unlike Rauschenberg's, never dissolved. Twombly and his wife, Tatiana Franchetti, remained together and close friends: divided lives under the same roof. Complex arrangements of love and domesticity span all the way from that winter night until the end of his life.

<center>▮</center>

The ghosted memory of those two young men in the water, one saving the other, returns, perhaps, in the wave-like undulation of Twombly's chalkboard paintings or the fire-swept sea of the *Lepanto* series. Not in any direct way—and certainly not for every viewer—but it echoes, that night, *This way, this way.*

I can't help but think of his paintings named for Hero and Leander, canvases of lush, impasto pinks and whites. Leander, who nightly swims across the Hellespont to his beloved Hero, drowns. Hero in her sorrow, throws herself into the water to join his fate. That old story: two young lovers, star-crossed, perish together rather than live apart. Twombly named multiple paintings after doomed pairs who have lost each other, or are just about to: Orpheus and Eurydice, Narcissus and Echo, Acis and Galatea, Achilles and Patroclus.

In *Achilles Mourning the Death of Patroclus* 1962, two cloudbursts chase each other across the canvas, one a deep crimson, the other a lighter red, almost pink, washed out with white. If one is rage, the other is absence. The red is the red of blood and violence. Of loss. Storms of paint touch and drift apart like those boys in the lake. The very title of the painting is handwritten below the shapes, and then crossed out by the same anxious hand.[7]

Grief over the lost beloved—caught in the gerund *mourning*—is ongoing in the painting of Achilles and Patroclus, a passage of loss, an emotional drama of trying to hold onto what slips away. Not the past-tense myth of history books, this is an event as alive and emotional now as it was thousands of years ago.

And yet, to describe Twombly's abstract paintings, or to look at

reproductions, tiny postage stamps a poor proxy for his floor-to-ceiling canvases, is to miss why they capture the imagination. "A Twombly looks," writes one critic, "the way thinking sometimes feels."[8] And that is Twombly's gift, the bewildering slipstream between thinking and feeling—a gift I've spent years trying to understand.

My own obsession with Cy Twombly's work started a decade ago at the Menil Collection in Houston. My job, as a teacher for a writers-in-the-schools program, was to lead students through the museum, including the Cy Twombly Gallery. At first, I didn't know what to make of the work, or how to talk to students about those passionate splashes of color or the curves of white chalk looping through the darkness. It all seemed too much. Or too little. Over time, though, I began to recognize something extraordinary and personal in the swirling vortex of his massive masterpiece *Untitled* (*Say Goodbye, Catullus, to the Shores of Asia Minor*) 1994. It's selfish, perhaps, to think that a work of art speaks to any one of us. But in the right moment it can voice what we can't say, or don't yet know.

I adored the scale of this painting, its three panels, the size of a small airplane, floor to ceiling, wall to wall, filling the room completely. Its explosive rush of colors—the yellow of fresh egg yolks, and the warm purple of a healing bruise, fire reds and candy pastels of blue and pink and white rising up only to descend into a chaotic central mass, like a hornet hive, before trailing off in dark marks at the far left of the canvas. Black lines, like primitive boats with crosshatched oars, open into a shimmering sea of white.

As a poet, I was drawn, too, to the lines of Rilke's poems scrawled and erased over the canvas. I recognized in the poetic passages that Twombly inscribed on the canvas a shared faith in the power and wonder of the word. "Surrendering to Twombly's best art entails an odd transaction," claims another writer, "confessing fundamental bewilderment in return for being granted a flare of exaltation."[9] I admit it, I surrendered.

And yet, when I went to find out more about the man who made these works I was confronted by the absence.

Twombly never wrote or spoke about that cold night in the lake, the rescue or the aftermath, though that's not surprising given how little Twombly said publicly. Famously reclusive, he published just one essay in 1957 and appeared in a handful of magazine profiles, mostly in the early 1990s. There are only two published interviews with him, both short and done near the end of his life, one from 2000 and the other from 2007. How he felt about what happened or how the event would later enter his work has to be read between the lines, in the omissions and absences that fill the record of Twombly's life, in an offhand anecdote found in a newspaper article, an archived letter, a painting named after drowned lovers.

The problem and pleasure of writing about any artist is that the life and the art always overlap, are always in conversation. No neat divide. No way to write about one without the other. Life and art are never separate conversations. It's easy to read—and overread—the biographical in Twombly's art. He practically dares you.

Looking back, it is possible to see the continuous narratives and themes of Twombly's art and life in that singular, almost mythic, event one winter night at Black Mountain. As in all myths, the threads of meaning unravel over time. And so we stitch back new meanings in the present. Achilles and Patroclus become Twombly and Rauschenberg become Hero and Leander. This is the genius of Twombly. And the hazard.

Twombly, who died in 2011, is not here to correct, clarify, or contradict this or any other story from the past. And so we are left only with versions of the past that are as numerous as they are overlapping, woven together from fragments and silences.

"Everything revolved around Olson," Twombly said almost forty years after his two summers and one winter at Black Mountain College:[10]

> That summer . . . was stimulus. They were into
> D. H. Lawrence. I never went to Olson's classes. There was
> a whole interesting group around—more than the painting
> group. Then the second summer I just visited. There was

Franz Kline, who I liked very much. He did a very beautiful painting there. Then Motherwell came back—he saw me in the beginning and he saw me at the end. And he wrote me one of the nicest testimonials.[11]

The names of the famous, Lawrence, Kline, Olson, Cage, Motherwell, fill out the memory of that time, give it weight and lineage, but also obscure it.

What perhaps matters most in his narrative is that ellipsis, that break between "That summer" and "was stimulus." That moment of suspension in Twombly's description of Black Mountain, as marked by the ellipsis, holds everything and nothing: all that is forgotten or erased, all the narratives that reshape our perspective of an artist, all the stories waiting to be told. Is Twombly pausing to find the right word? Or are there simply no right words to capture that time?

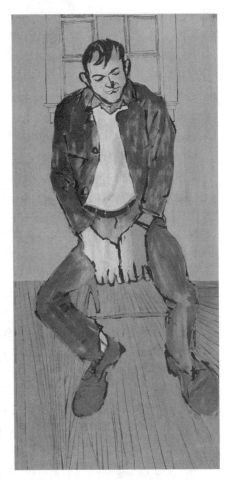

Fielding Dawson, *Cy Twombly at Black Mountain*, 1951

Fellow Black Mountain classmate Fielding Dawson retells a very different anecdote: "Bob and Cy posed for a couple of drawing classes. Nude. The model didn't show up. They rose from their drawing boards, walked to the front, and began to strip."[12] A story that defies credulity. Twombly never seems unclothed. Always a cloak or pose, always a stance away, almost never unguarded, and so it's hard to picture him like a hermit crab without its shell, there for the seeing and the taking. In the portrait of the artist done by Dawson in 1951 at Black Mountain, Twombly is fully clothed in heavy work pants and shirt, his hands enormous and roughly sketched.

In his lifetime, Twombly kept "perpetual guard over his biogra-

phy."[13] From his low public profile to his choice of editors for the catalogues of his work—first Heiner Bastian and Yvon Lambert, and then Nicola Del Roscio—to his coy responses to questions in interviews about his process, Twombly sought to control the interpretations about his life and work.

Art critic Rosalind Krauss wrote of Bastian (a statement that could be equally true for Del Roscio), "Bastian is, after all, Twombly's chosen mouthpiece, having published on his work since the early '70s and having been consigned the task of gathering together the entire oeuvre. Bastian's word is the voice of the artist passed along to us, as though by ventriloquy."[14] Since his death, it is the Cy Twombly Foundation that continues to keep guard, with Del Roscio as its president, offering or denying access to images and information, attempting to manage which narratives are considered worth telling.

Part of the official record, the letters between Olson and Creeley are, surprisingly, included in *Writings on Cy Twombly*, a collection of essays and reviews published in Twombly's lifetime and edited by Del Roscio. Surprising because Twombly's sexuality isn't elided in these letters as it tended to be during his life and elsewhere in the record. "[The] first overt reference to the open secret," as one critic writes, her own observation submerged in a footnote.[15] Maybe it is possible to acknowledge the affair of Twombly and Rauschenberg because it happened in their youth. Maybe the story can be included as it's almost possible to miss the nature of their relationship. Maybe the story can be included because Twombly is the hero of that night. Or maybe that one bright phrase—"the clear genius of the lad"—makes it worth retelling. It begs the question though, What facts are left out? What stories are *not* included?

PART ONE

1

EDWIN PARKER

EDWIN PARKER "CY" TWOMBLY, JR., was born in Lexington, Virginia, on April 25, 1928.

The threads of his adult life, his art and identities, real and claimed, mythic and true—artist, southerner, exile—can be found in the hills and mountains and streams of the place where he grew up and returned to in his later years. The facts of his childhood are scarce, bits and pieces of a personal history scattered in interviews and decade-after recollections of the friends still living and willing to talk. The shape of this time, indeed any time in Twombly's life, is created as much by what's missing as what's known.

Lexington, Virginia, ringed by the rolling hills and farmland of

Rockbridge County and the Blue Ridge Mountains, sits at the southern basin of the Shenandoah Valley. Deeply southern, both Robert E. Lee and Stonewall Jackson are buried there. Lexington is a company town: the Virginia Military Institute (VMI) and Washington and Lee University offer up each year a crop of clean-cut novices. On the small-town streets of boutiques and galleries, what a tourist brochure might describe as quaint, VMI students parade in their dress whites like flocks of doves and Washington and Lee students wander in mixed packs, the late American empire dress of fraternity students, jeans and baseball caps and sweatshirts.

The photographer Sally Mann, a close friend of Twombly and fellow Lexington native, wrote, "The experience of growing up here is timeless and universal in certain ways: Cy's childhood experiences were remarkably similar to my own, despite the two dozen years that separated us. Like most southern white children of a certain economic and social class, we were both reared by black women who we adored."[1]

Lula Bell Watts, later Lula Bell Mills, started working for the Twombly family when she was just thirteen and would remain connected to Cy for her entire life. Lula offered him "imperishable and bounteous love," or so Mann imagines.[2] When Watts's church was badly damaged in a fire, Twombly, by then famous and rich, paid for a new roof. She died in 2005, six years before Twombly. Watts, like most of the people who might speak of his youth, his parents, his older sister Ann, his childhood friends, are all gone or refuse to talk. About their relationship, or the relationship of Twombly to any members of his family, one can only speculate.[3]

In the end though, more than the people of his youth, it was the place itself that was formative. Lexington, Twombly said, "is not one of the most exciting landscapes in the world, but it's one of the most beautiful."[4]

Despite a peripatetic life, homes in Rome and Gaeta and Bassano, long stints in New York City, travels in the Middle East and Asia, Lexington remained a fixed point on the map of his travels. When he returned to his birthplace as an older man, living part of the year in town, one of his daily rituals was to be driven for several hours though the countryside, past the creeks and dirt roads, the broken fences and the broken

down cars, the family farms and the doublewides and country houses, all of it cast in the lush green shadows of old growth trees and hills.

■

This southern world of traditional ways and manners, of history and heritage—at least for "a certain economic and social class"—was an essential part of Twombly's self-conception and very way of being in the world. It became part of his public persona, an affect, it seems, even more pronounced in later life.

"It's very funny, but when I grew up you always had to say, 'Yes, Ma'am' and 'Yes, Sir.' And you were never to talk about yourself. Once I said to my mother: 'You would be happy if I just kept well-dressed and good manners,' and she said: 'What else is there?'"[5] He told this story in 2007 as one reason why he didn't, for most of his lifetime, feel the need to speak publicly about himself or his work, reluctance as modesty, proof of unpretentiousness.

Twombly never lost his southern drawl even after living in Italy for decades. He spoke in "slow, careful phrases . . . followed by and sometimes interrupted by long pauses."[6] His almost daily uniform as an older man—white linen pants, starched Brooks Brothers shirts, often with suspenders—had a distinctly southern flair, a country gentleman out for his afternoon constitutional. He cut an elegant, distant figure leading some to describe his aristocratic or gentlemanly air. "When he moved to Italy, I think he was recovering that aristocracy that he always felt by nature," Rauschenberg observed. "I couldn't forget that he couldn't forget it."[7]

To be in Lexington is be continually reminded of both history and war—the living culture and ceremony, the pageantry and performance. When Stonewall Jackson's body was returned to be buried in Lexington he was met by weeping crowds. A large statue of the Confederate general leaning on his sword looks out over the graveyard that bears his name, the graveyard where Twombly's parents are both buried. At the base of the large stone pedestal on which Jackson stands, visitors leave flowers and small Confederate flags.

One doesn't have to look very hard to see those graveyards and

battlefields of the Civil War, and the more present-tense reminders of military culture of Lexington, in Twombly's visual vocabulary. Battles, heroes, tombs, violence, and monuments—from his take on the Trojan war in *Fifty Days at Iliam* to the battle of Lepanto to his sculptures after Thermopylae.

"In Twombly's youth," writes one critic, "when local sons and daughters of Confederate soldiers still retained memories of Mananas they had learned at the knee, this association among historical myth, cultural grace and arms would have been especially pervasive."[8] The critic continues: "It might seem to have little direct bearing on art, but on an imagination later fired by Troy and Thermopylae, it left its imprint." One might look even closer to home: his father, Edwin Parker, was drafted into the military during WWI and the artist himself served, unhappily and briefly, as a cryptographer in the army.

If one can see Twombly's obsession with war in the geography of his youth, one can see too his first love of boats and the sea. "When I grew up, in summer with my parents we were always in Massachusetts, and I was always by the sea. You know, sometimes little boys love cars, but I had a particular passion for boats."[9] From his early works with pea pod–shaped hulls the size of a quarter to the Celtic boats and crafts of dazzling hues that cover entire walls, those boats became, years after, essential to his art and imagination. Later in life he would restore a house in Gaeta on Italy's Mediterranean coast, a harbor city of bright sails and enormous military ships.

Never just one thing. Never one desire or one place. Never one past. Twombly described his southern upbringing in contrast to his parents' New England roots and its influence on his life and work: "My parents were from New England. One from near Boston, the other from Mount Desert Island."[10] Twombly placed himself between the two places, informed by each landscape, each sensibility. As one profile of Twombly puts it, "Cy's parents came from old-line New England families—as a boy, he used to visit his grandparents in Bar Harbor, Boston, and Palm Beach—and a sense of that old American aristocracy is never far from the surface of his laconic, laid-back personality."[11] Again and again in the story of Twombly's life, place becomes character.

There is a swimming pool on the campus of Washington and Lee University in Lexington that bears the name of Cy Twombly. The Cy Twombly Pool is named for the artist's father, who for many years was a coach, golf and swimming at first, then later football, baseball, and basketball.[12] In time, he would become the school's athletic director, a position of importance in a small town. The older Cy was "an amazing athlete, could still do a back flip even in his fifties."[13] By contrast, his son "showed no enthusiasm for organized athletics" and preferred the solitude of making art.[14] As Twombly joked, "He always wanted me to be a left-handed pitcher."[15] The artist was not left-handed, a joke that betrays, in a quick glimmer, something of their uneasy relationship.

Before Twombly Sr. took a coaching job at Washington and Lee in the fall of 1921, he played one summer of professional baseball. In the 1921 season, Edwin Parker "Cy" Twombly, then age twenty-four, played seven games for the Chicago White Sox, a righty pitcher with a speciality curveball. In the four games he pitched, he allowed 21 runs for an unimpressive 5.86 ERA. He went up to bat ten times. He never made it on-base and struck out four times. I'm not sure when he picked up the nickname Cy after the hall-of-fame baseball player Denton True "Cyclone" Young, a name that hardly seems accurate for his brief, inauspicious career in the major leagues.[16]

Each time the younger Cy signed a painting CY TWOMBLY or CY he was in fact writing the name of his father. He was writing down a nickname of a nickname. How many half-moon Cs and divided Ys until it separated from its first meaning, until it became, finally, and fully his own?

One sees, in the name of Twombly's own son, Cyrus Alessandro Twombly, the echo of his father and grandfather's nicknames. In one very early painting, an oil portrait of a young girl, heavy paint like a middle-period Picasso and featured in the literary magazine *Shenandoah* in the summer of 1950, the artist is listed as "E.P. Twombly Jr." It is as if the young painter was trying to reject his hand-me-down nickname; he was as a boy Cy Jr. or, simply, Junior. In time, he made the name his own, signing it again and again, his handwriting so distinctive, and essential, to his process as a painter.

Once, at a dinner party, Twombly, by then a famous artist, was asked for directions and so wrote out a little map for a friend, who interrupted him partway through to say that, oh yes, he knew after all how to get there. The half-written map in Twombly's handwriting was left on the table. When the artist was out of sight the guests at the table quickly tried to grab the scrap, "like Wagnerian harpies out of the rafters."[17]

The critic Alice Spawls points out that while this would have happened for any famous artist, "the idea of a Twombly napkin has a sort of genius to it: so many of his surfaces, painted white or bare material, are repositories of scribbles, dribbles and smears, scrawled with lists and doodles and diagrams, written on then crossed out or rubbed out leaving only messy traces."[18] The mark—doodle, diagram, trace—is his genius, but so, too, is the name—his name, written again and again: Edwin Parker, Cy Jr., Cy Twombly, Twombly, CT, Cy.

▌

Tall, dark, and very outstanding—Cy is really one of the boys. He's the only one of our class to have gained state-wide recognition (with his educated brush). Unlike may of us, he's often seen with some weighty volume on a deep subject . . .[19]

So begins the short yearbook entry for EDWIN PARKER TWOMBLY Jr. "Cy," part of the 1946 class of Lexington High. The pages of the yearbook teem with witty profiles and club photos, last wills, advertisements, military service pages, a blur of all-white faces in black-and-white. Cy's there in the last row of the "Library Club" photograph, a head taller than those around him, this bookish young man, who played no sports and wasn't involved in much, at least by the yearbook tally.

Ironically, given his love of antiquity and the Roman world, he was part of the Le Cercle Francais, and not the Latin Club, the groups' photos above and below on the same page. By Twombly's account, his sister, Ann, studied both Latin and Greek for a number of years, as did their father, who "would joke with the artist's sister in Latin."[20] Of his own education in Classics or languages, he said little.

Weighty books and a language he'd never use as an adult—is this where he became, or started to become, the man and artist he'd be? Or should we look to the accounts of his boyhood published years later? Reminiscences told from the golden light of old age and fame: "I grew up with a lot of friends who were children of people at the colleges . . . We were always riding bikes or taking our ducks to the creek. I had lots of pets. I once traded a watch for a white mouse."[21] In the same 1994 article, his former nanny, Lula Bell Mills, in her seventies then, recalls his sly sense of humor: "He used to push us [his sister and me] into Anderson's Creek or set a booby trap for me when I walked in the house by dumping sand and water on my head." She added: "Mischievous in a nice way."

We add them up, these moments—Edwin Parker in French Club, Cy learning to smoke as an Eagle Scout, the book-loving jokester—and what happens isn't some magical transformation or equation, his life opened like an umbrella, but a slow unwinding. Revelation is a process, more tide than wave.

A book reviewer recently knocked a biography of the architect Louis Kahn for not devoting enough ink to the early years of the subject, the big question of a biography to his mind being how does an extraordinary life emerge from ordinary beginnings. "[Wendy] Lesser's biography has a flaw," the reviewer writes,

> and it's not insignificant. She races through the eight years
> Kahn spent in high school and college in eight pages. There's
> little exact detail. These are the years most biographers linger
> on, extracting all the juices, because they're when an unusual
> life begins to diverge from the mundane ones that surround it.
> They're when a personality is forged.[22]

What answers of self can be found on a tree-lined street in a quiet middle-class Lexington neighborhood, in the unremarkable slope of green lawn or shutter-framed windows of the single-family house on Edmondson Avenue where Twombly grew up? According to the woman who bought the house when his mother died, the concrete basement

walls were covered with the young Cy's scribbled drawings, his future work foreshadowed.

"Why we become who we become, or do as we do, or are born with a facility or something when others are not," writes the artist Tacita Dean, "remains for the most part, unknown to us. We cannot guess what incident or influence arranged our lives or ambitions in the way that it did, or whether in fact it was something deeper. And most mysterious of all is why artists become artists, and why they become the artists they are."[23] Of that mystery, we get glimpses—pieces of the puzzle—but never, thankfully, its solution.

An extraordinary life is that not simply because of where it starts, but how it unfolds, that impossible algorithm of chance and luck and determination. "Biography," as one Twombly scholar notes, "does not fully satisfy, however."[24] This, dear reader, is not a biography. This is something, I hope, stranger and more personal.

But still, we start here, those first dreams and early wants, hoping for some fragment of truth that unlocks the end from the beginning.

▌

In all the stories of his youth becoming an artist is fated. If you believe Twombly's versions of things, he so wonderfully copied Picasso's sleeping Marie-Thérèse Walter from the cover of Jean Cassou's book on the artist, his mother arranged for him to study with Pierre Daura.[25] Daura, a Spanish-born painter, arrived in Virginia in the summer of 1939 by the unhappy collision of war and history. His avant-garde chops, formed by decades in Paris, offered Cy, in addition to the practical skills of drafting or color, an expanded worldview, a sensibility. For four years, starting when he was twelve, Twombly studied painting and modern European art with Daura who had found a teaching position at nearby Randolph-Macon College. "I used to spend weekends with Daura and his wife, painting and looking at art books," Twombly said of his early artistic education. They offered, against his "solitary" youth, the company of adults who understood him and the possibility of a world outside of Lexington: a first window to Europe and the art

world, to the life that he might someday have. "The Dauras became," as Twombly put it, "a kind of family."[26]

Unlike Rauschenberg, who grew up in the small town of Port Arthur, Texas, with just a single public library, Lexington, a university town and all that orbited around it—secondhand bookstores with texts on art, for example—offered the young Twombly a world where literature and poetry, history and art, mattered.[27] By his own account, beginning around age twelve or so, he would spend hours alone in these bookshops and libraries, reading and learning.

Twombly's talent was recognized and encouraged by his mother. Beyond paying for lessons with Daura, whose guidance and friendship sustained him far beyond the artistic instruction, for his sixteenth birthday she bought him a Sears, Roebuck arts kit and *A Primer of Modern Art* by Sheldon Cheney, a book that offers lessons in periods of modern art: Impressionism, Cubism, Expressionism; "I cannot do better," Cheney writes, "in trying to help you to an understanding of modernism, than to point out the devastating effect the realistic movement had on the arts."[28] It was instruction the young artist took to heart.

After high school, Twombly spent a year at a college preparatory boarding school, the Darlington School in Rome, Georgia, and a summer with an aunt in Ogunquit, Maine where he painted "abstract seascapes" alongside the colony of artists there. There's a tantalizing, unnerving portrait of a young Cy—leather vest, bare arms, brooding expression—done by Channing Hare, "the crown prince of society portrait artists." Hare, who "identified more with the summer society life than with the art colony," owned a small antiques business in Ogunquit and was an active part of the town's gay community. The portrait leans against the walls of Nicola Del Roscio's Rome apartment in a 1998 photograph, just below a fresco of Zeus and Venus.[29] The history of its making is almost impossible to reconstruct. At the same time, I can't help but line it up with a sepia photograph of Twombly painting *en plein air* in Ogunquit in the summer of 1947, a nineteenth-century painter, with box easel and umbrella and brimmed straw hat, remaking the waves. The contrasts between these portraits of the young

artist are striking—boss Cupid's errand boy in one, aristocratic gentleman in the other.

In the fall of 1947, Twombly started his formal artistic education at the Museum School in Boston, a decision influenced by the fact that Twombly could live rent-free in the caretaker's apartment of his grandfather's house.[30] Writing to Daura about his first year of art school in Boston, Twombly describes his frustration with the traditional teachers and students who only praise perfectly executed pictures. The students, by his account, have no understanding of what makes great or modern art, and even less ambition. Twombly laments the school is "a factory for precise anatomy drawings void of any self-expression." More important to the young artist than technique or perfection was "self-expression."[31]

He didn't last long in Boston. He returned to Lexington in 1949 to enroll in the newly started art program at Washington and Lee. The path of Twombly's early education as an artist—from Lexington to Boston to Lexington—was filled with stops and starts, with disappointments about teachers and methods of education, but there was little doubt, at least to Twombly, about his future as an artist. He wrote to Daura of his desire to paint all summer in Virginia, a place where he thrived as an artist—without school and with the freedom to paint from morning to late at night as he wished, copying from the masters when he ran out of his own ideas.

He left Lexington after only one year, to continue his studies at the Art Students League in New York City and then Black Mountain. Twombly's teacher at Washington and Lee, Marion Junkin, in a prophetic letter of recommendation for the young artist wrote, "I feel that he will develop into a poet in paint and that it will be a strong poetry as he is not easily changed from his purpose."[32] It's all there: Twombly's lyric style, painter as poet in the writers that fill his canvases, and even more, his stubborn certainty about the direction of his life.

In a letter from 1951 from Black Mountain, Olson wrote to Creeley, "Anyhow, the pleasure, of talking to a boy as open & sure as this Twombly, abt *line*, just the goddamned wonderful pleasure of *form*, when one can talk to another who has the feeling for it—and christ,

who has?"[33] Twombly, "open & sure," possessed an understanding, "a feeling," beyond his years, something unteachable and rare.

It seems now inevitable too that he would leave the country. Twombly recalled that after he moved to Italy his mother said, "'Oh, but you always wanted to live in Europe.'"[34] The same anecdote is told in a slightly different form, a game of telephone, words transformed across the line, in an essay by critic Laura Cherubini: "Nicola Del Roscio recalls having heard Twombly's mother telling a story about how Cy, as a small child, would always repeat: 'When I grow up I'll go to Rome!'"[35]

2

THE STEPS

CY TWOMBLY STANDS BEFORE THE enormous stone hand of an emperor. Rome. September 1952. The broken apart statue of Constantine was once lofted hundreds of feet off the ground. A god in the body of a man. And then, in its pieces, it returned to earth where one could see the precision of the sculpture's details: rough fingernails, striated creases of skin on the fingers, a palm riven with age. The stone hand, with its index finger pointing to the sky, shows one direction for the mind to travel. Towards greater things, forces more powerful than even an emperor. And yet these hands are also the hands of desire. They take. They want.

Rauschenberg, behind the lens, captures the young artist in rapt attention; Cy's angular face in profile and faraway expression, as always

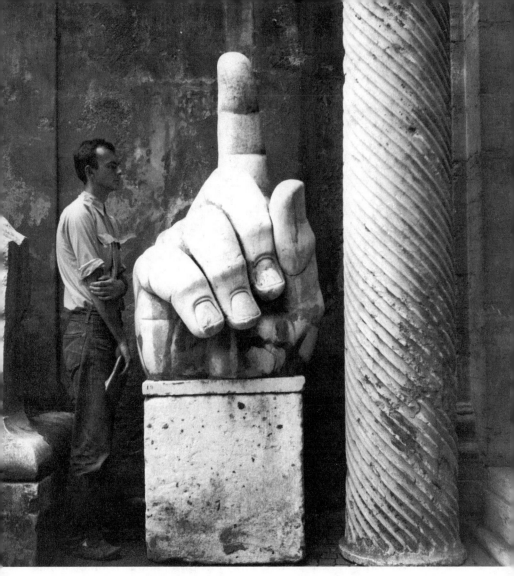

Robert Rauschenberg / *Cy + Relics, Rome,* **1952**

in these early photographs, reveals so little of his emotions or thoughts. He wears the same dark jeans and workman's shirt, sleeves rolled up, as in the other photographs taken by Rauschenberg on the nearby stairs of an ancient church. In his right hand, a notebook. His left hand reaches across his chest to hold his opposite elbow.

Whose decision was it, I wonder, to make the hands the focus? It's hard to believe this was an accident. Usually we give credit to the photographer. The one who says, put your hand across your body, yes,

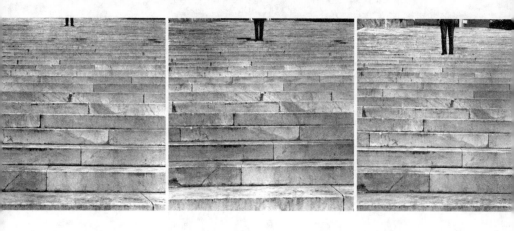

like that. Lower your face. Don't smile. No, really, don't smile. But in this case, I suspect both men were involved in any decisions about the picture, how to frame it, how to shape the subject, and how these pictures might be seen. No one is smiling.

Maker, the picture seems to say. Artist. The living hand of life and the stone hand of death, the hands of earthly making and the hand of authority, the hand of the present and the hand of history.

They've come to look. To learn. A slow boat from the United States to Italy, first Palermo and Naples, and now Rome. They are in love, or something like it, the man taking the photograph and the man in the photo. We see, in part, what Rauschenberg admired in Twombly, beyond his artistic talent—"[his]self-confident eccentricity and his tall, aristocratic good looks."[1]

After meeting in New York City at the Art Students League in 1951, Rauschenberg encouraged Twombly to follow him to Black Mountain. Now, their roles reversed. Rauschenberg, his marriage completely over, "shaken and depressed," followed Twombly to Europe.[2] Twombly's grant from the Virginia Museum of Fine Arts of $1,800, paid out in installments of $150 a month, was, for a time, enough for the two men to live and travel.

"Erotic charge" is how one critic describes the other pictures taken that same day, Cy on the steps of a fourteenth-century church, Basilica di Santa Maria in Aracoeli. Cy advances down the sunbleached and suncracked stairs, a "striptease" almost, as his crotch comes closer, and closer.[3] One by one, they come into focus, the hair on his arm, the wrist-

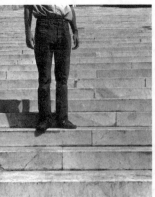

**Robert Rauschenberg /
Cy + Roman Steps
I–V, 1952**

watch turned inward, each charged detail, immediate, and yes, erotic.

The five photographs, called *Cy + Roman Steps I–V* 1952, as well as the one of Cy with the hand of Constantine, *Cy + Relics, Rome,* 1952, were not printed until over forty years after they were taken. Without them these days would be lost. And in many ways this is the subject of the photographs: the silences of history, the mute stone and the speechless gaze. What we learn most about Rauschenberg and Twombly's first days in Rome from these pictures though is this: the body was never far from their minds.[4]

▮

"Rome is everybody's memory, as it was a hundred or a thousand years ago," writes Eleanor Clark in her book of essays and travel journals, *Rome and a Villa,* "the thing now is to find a way into it. You could start anywhere, it doesn't really matter, you will see so little anyway."[5] It doesn't matter what landmark or historic site, which hill or temple or church, you begin with. They all are fine and equal starting points.

The entrance to Rome is no longer a matter of geography.
It is a place secret, sensuous, oblique, a poem and to be
known as a poem; a vast untidiness peopled with characters
and symbols so profound they join the imagery of your
own dreams, whose grandeur also is of dreams, never of
statements or avenues; from which the hurrying determined

mind takes nothing but its own agenda, while the fearful logic and synthesis that were there escape like a lion from a zoo.[6]

We look. We're lost. The entryway into the "poem" of the city is not unlike the entrance into some of Twombly's paintings—a "vast untidiness," a grand wildness.

I love Clark's description, though in my own early days of living in Rome, following the trace of Twombly around the city, I was like a man looking for his keys, circling around the same known geography, the same city streets in the hope I'd find something lost and meaningful. The photographs of Cy on the steps are a piece of the puzzle. But like a story passed down from years before, they've been altered. The contact sheet for the photographs taken on the steps show that Cy is closest to the camera in the first frame. With each subsequent photo, he moves up the steps. When the photographs were printed and named and displayed, though, the progression is coming towards us, so that Cy starts at the top and approaches the camera: this is the striptease, the revelation. And so, if this is a piece of the puzzle, then it's one that has been edited, shaped, made into art. To reverse the progression so that Cy goes towards the camera is to suggest their intimacy. The body as arrival.

Of those first days in Rome in the fall of 1952, Rauschenberg's photographs are not the only record. There are also a few letters, six to be precise, sent by Twombly to Leslie Cheek, director of the Virginia Museum of Fine Arts (VMFA), the organization that offered Twombly the fellowship that made this trip possible. Twombly writes,

I finally arrived in Roma and have a large room in a pensione overlooking the Piazza di Spagna a block from the via Margutta where most of the important contemporary Italian painters and sculptors have studios. I got off the boat in Palermo, Sicily, in hopes of seeing the many Greek ruins throughout Sicily and the Arab-Norman buildings located in Palermo—but instead of staying a mo. [sic] I stayed three days unable to cope with a city of 300,000 in dire poverty & not able to speak, I was overcharged, and sobbed continually—it was a fantastic experience.[7]

What else can we say about the first starts, the overwhelming, wondrous world? "It was a fantastic experience." Twombly was twenty-four. The farthest from home he'd been at that point was to Key West and Cuba with Rauschenberg the previous spring. How easy to forget those first great fires, first great floods.

"In the first two days I've been here I've walked miles so excited to see everything at once," writes Twombly, "but find I will have to plan more. I'm very anxious to start work myself and just bought materials. I will work each morning in my room then site see [sic] in the afternoon, and reading up the night before the history of the Church, ruins, palace & etc. which I will go to the next day."[8]

Far from the taciturn artist of later years who claims to paint only when the mood strikes, the wide-eyed writer of these letters shows no indifference to the labor required to gather up a body of knowledge or make a great work of art. The writer of these letters betrays his youth, his hunger.

▌

Seeing the photographs from Rome, I'm reminded of the lesser-known ones of Twombly taken by Rauschenberg on a Staten Island beach the year before. In one photo from 1951, a rarely printed image, the camera looks down at a man's torso; it's Twombly's chest, though he's unnamed. The head is missing, like an anticipated echo of the photo on the stairs, another body dismembered by the camera, just a mossy patch of chest hair and a trail of hair descending to just above the waistline. The dark seduction of it. The hands—always in these photos the hands—rest on the thighs, a little frame of sex. In another photo taken the same day on the beach, like a key that unlocks the faceless one, Twombly is the object of desire, his arms behind his head in the shape of wings. A metal trashcan, almost beautiful, sculptural, rises from the sand between Cy's body and the waterline, like a reminder of the real world. The picture is of the body, of bright sunlight, of pleasure.[9]

"Beauty," goes a line from a poem by Dan Chiasson, "can't be gainsaid no matter how sarcastic we are."[10]

Rauschenberg's black-and-white photographs from Rome, beyond

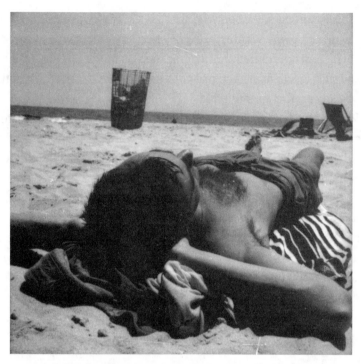

Robert Rauschenberg / *Staten Island Beach (II)*, ca 1951

the ones of Cy and the relics, or Cy on the steps, or the one of Cy in their Rome apartment, some kind of musical instrument in his hand, capture the markets of the streets. A flower stall in front of a church, a man selling eyeglasses on the sidewalk, a sign—*Occhialeria*, hung on the cement wall—and in the flea markets, broken and time-worn objects, bike wheels chained and dirty work boots, the portrait of a large woman. These photographs resemble, close-up and blurred, Twombly's own Polaroid experiments taken at the yard sales around Lexington decades later.[11]

"It was good and interesting for about two weeks," said Rauschenberg about their first weeks in Rome:

> Then Cy started collecting antiques. He still collects great antiques. He discovered a little flea market, not the flea market outside of town, but one in a little Piazza del something or other. Anyway, the farmers would bring in Etruscan things

and occasionally a marble bust. He just went crazy. He kept his half of the money and started spending mine on antiques. I ended up being furious and hating him, but also needing to do something to make money to live on.[12]

Cy the finder, the collector, the gatherer of impractical old things, at least in Rauschenberg's version. "He's worse than a collector," remembered Gian Enzo Sperone, an Italian art dealer who represented Twombly in the 1970s. "One day he'll see a Greek helmet in the Corinthian style and not sleep for three days. Often though he would pay for these objects by trades. He's afraid that if he uses money, his hand will get dry. Most people call him snobbish, but he's like a monk."[13]

His collecting habit started young. A boy of five or so, he'd follow behind his father's two sisters through junk shops as they picked up this or that, dusting off a china tea set or haggling over the price of a seascape watercolor. The young artist-to-be would eye the objects that he admired, and a brief impassioned phase would follow—stamps gave way to cards which in time were replaced with tin soldiers. At the houses of his friends and relatives, he'd often stand around, eyeing one thing or another, until they offered it to him.[14]

It didn't end in youth, the searching through dusty flea markets and yard sales, filling his houses with old antiques. I too love that feeling of walking through the markets, not simply for the visual pleasure of the displays of objects, but for the very tactile sensations that come with being there: to test the weight of the sculpture, to turn over the pocket watch, to slide your arms through the sleeves of another man's jacket.

▌

After a month and a half in Rome, Rauschenberg, out of money, took a job with Atlas Construction in Casablanca. Their rift didn't last long. Twombly followed Rauschenberg to Morocco, though there are no extant letters or telegrams between them, so what called the men back together, I cannot say. Twombly returns as subject in Rauschenberg's North African photographs: crouching under a tree in one and in another sitting naked in an oasis pool somewhere in the desert.[15]

Before they left for Europe, Twombly claimed that Willem de Kooning said to him, "Are you going to Tangiers? Look up Paul Bowles."[16] How much to believe this recollection fifty years after? By Rauschenberg's account, the southern turn to North Africa was the consequence of Twombly's indulgent spending of the "last of our 'joint' investment on a Roman emperor."[17]

The two did eventually meet up with Bowles in Tangiers. The writer gave Twombly a letter to deliver to Truman Capote who was in Rome, frantically working on the script for the film *Beat the Devil.* "I ran into him outside American Express at the Piazza di Spagna and gave it to him," said Twombly of the letter for Capote. "We walked to his car—he had a little Volkswagen. Bob was there too. The car wouldn't run, and Bob fixed it."[18] Everyone was there, or had just left.

Everyone came to Rome then.

And why not. Rome offered freedoms that couldn't be found elsewhere. "First we have the two American homosexuals who have every reason to be pleased at finding themselves in Rome," wrote John Cheever in his journal in 1957. "Here they are not the talk of the landlady; rough boys do not whistle at them as they go down the street, nor do respectable householders look on them with loathing and scorn."[19] In Rome, Cheever observed, "no one cares."

Rome, as described by Cheever, perhaps too generously or naïvely, recalls a similar protected space: Black Mountain. For Rauschenberg and Twombly, among others, "the college provided the respite—a physical space, a cover, or a stopover—needed to depart anew."[20] Twombly's early Franz Kline-esque paintings done at Black Mountain in 1951, bold dark strokes and zoomorphic forms, betray in their very titles—*Attacking Image, Slaughter, Riot*—a challenge, almost violent, to the conventions of art.

Beyond its artistic or creative freedom, Black Mountain offered "these sexually marginal girls & boys" something even rarer in 1950s America. Looking back at his time at Black Mountain, one writer describes the "hotbed of communists and homosexuals" this way: "Perhaps, I found a safe place—a rare enclave in America of that time—for my own queer self."[21]

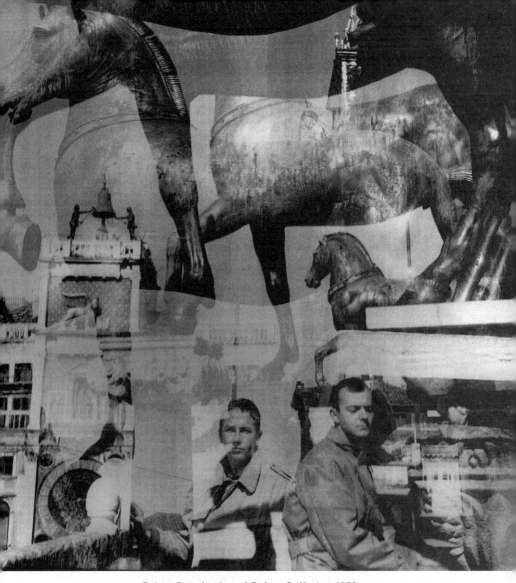

Robert Rauschenberg / *Bob* + *Cy*, Venice, 1952

Sometimes all we can know for certain of a life is a single day. A bright September afternoon in the middle of a century, a day to wander through a beautiful ancient city, a day to capture how hands are both the instruments of making and the objects of desire.

My plan was to find a stranger on the steps to take my picture, as I

stood in for, and became, by proxy, Cy. This path and habit of pilgrims the world over. To go where something great happened and stand there and imagine the angels of history whispering our names.

Halfway up, I looked down to the tourists and nuns and strangers climbing towards the church, pausing to take in the view. For that is what the images suggest, too, not just the ascension but the stopping, and the turning around to look back out. Each step another vista, another landscape.

Though writing this now, I realize the image I was re-creating *wasn't* the one of Cy and the steps. There's another photo from their time in Italy, a picture of Rauschenberg and Twombly in Venice. At first, that photo seems like a mistake: a double exposure, an overlap of frames as the two men are collided together, the statue of Bartolomeo Colleoni astride his horse in Piazza San Marco and the whole city of churches and bells, piazzas and watery slips, like a dream, are part of the image. But it's not random, not, as I once thought, accidental. This is Rauschenberg's careful manipulation, putting them together in the eternal present of being young and handsome and traveling.

"Why does the writing make us chase the writer?" asks Julian Barnes in *Flaubert's Parrot*.[22] "Why can't we leave well enough alone? Why aren't the books enough?" Simply replace "writer" with "artist," replace "we" with my name. That desire—chase, follow, obsess—is as inexplicable as why some paintings, why some lives, in their depths and contradictions, captivate us, enter our blood. I am made and undone by this obsession.

I climbed those steps because it wasn't enough. It wasn't enough to read the letters or the catalogues or essays that describe this trip. I needed to walk up those seven-hundred-year-old steps of the basilica, I needed to stand where he stood and look out to apartment windows with white sheets drying on their lines, like a thousand ships sailing out to sea.

3

MOSAIC

WALKING DOWN THE NARROW COBBLESTONE streets around Piazza Farnese and Campo de' Fiori, or farther down Corso Vittorio Emanuele II past Chiesa Nuova, or through Piazza Navona, I couldn't *not* try to see the city through his eyes, his mind gathering up the forms and colors of the city: the washed out yellow of an arriving night sky, the carvings in the narthex of Santa Maria in Trastevere, the endless graffiti—cocks, love notes, political slogans—on the sidewalks and walls, on bridges and iron grates shuttering the cafés at night—as ever-present now as when he first walked these streets. During my seven months living in Rome, Twombly was like a radio playing in another room, there and background, hum and echo.

One rainy afternoon, at the Capitoline Museums, one of the two museums we know he visited that first trip to Rome—the other being the Museo Nazionale Preistorico Etnografico Luigi Pigorini, known as the Pigorini, where Twombly sketched a series of designs and shapes and patterns from tribal objects, collectively described as "North African Sketchbook"—I stood before the giant hand and head of Constantine, the split-apart emperor.[1] Proof of impermanence. Forgetfulness. The larger than life hand is, paradoxically, a reminder of our small mortal lives. What we imagine as permanent—the statue of an emperor the size of a hundred-year-old tree, ourselves in our immortal twenties— breaks. It breaks apart and cannot be put back together.

It was—and is—both limit and permission, the absence of a diary or any other records of where he went, what he saw, what he touched. I imagined him walking through the Vatican or strolling through San Luigi dei Francesi to see the three paintings from the life of St. Matthew by Caravaggio. For lack of any better itinerary, I read my own loves back to him: the ruins of the Forum, Bernini's sculptures, Caravaggio's boys.

In the end, it wasn't the dismembered body of an emperor that I loved at the Capitoline Museums or that made me think of Twombly, but the beautiful and strange mosaic by Sosos of three doves, one drinking from a cantharus and the other two perched on the rim of the water bath, sunning themselves. Shadows of their bodies reflected in the water, so unreal as to become lifelike again. There's another mosaic by Sosos that reminds me even more of Twombly's early work: the mosaic of the unswept room.

This mosaic, a copy of a lost original, once the dining room floor of a palace, contains in colorful tesserae the remains of a meal, images of luxury and refuse bounded together: bone and carcass, husk and crumb, a mouse and its shadow double, twin flairs of a cherry, a pink spiny conch, an urchin's empty armor, and a pea pod. Left in that copy, the original artist's name: "Heraclitus made this."[2]

The pea pod. A shape so familiar in Twombly's work one art historian wrote almost an entire essay on its recurrence: charm and fetish, motif to be followed from canvas to canvas like a cipher for an unbreakable code. This is what I love about Twombly's work. The chase of it.

"One must desire the ultimate essence even if it is 'contaminated,'" Twombly wrote in 1957, in a short essay for the Italian art journal *L'Esperienza moderna*, the first and last time he wrote publicly about his own art.[3] What's more contaminated than that which has fallen to the floor? Cast aside and half-consumed, the discarded is picked up and turned into art in the mosaic, as in Twombly's work. Narrative in the mosaic of the unswept floor is implied by what's leftover. After the decadent celebration held in honor of an emperor's victory or an all-night symposium of poets, all that is left is a mouse gnawing on a hazelnut.

The word mosaic perhaps comes from the Greek *mousa*, or muse. How appropriate to think of the mosaic as Twombly's muse, one form of ancient art that spoke to him, suggesting a way forward through the past. He is, as one critic describes him, "a poet of belatedness," his work "a medium for fugitive traces of other lostness: Mediterranean aches, Roman poetries."[4]

To think of the mosaic as part of these "fugitive traces" is to find a whole world of correspondences to Twombly's art. "His paintings," as one writer observes, "claim the rooms they inhabit"[5] So, too, the mosaic. More striking than these connections is the way in which Twombly gathers debris into his work: the debris of history, the debris of quoted poems, the debris of the body, the debris of the mind. When I look at the unswept floor this is what I see, too—the remains of the meal as what is normally hidden away, discarded, moved out of sight. Here it is highlighted, shadowed, made into something wondrous and strange.

One can see the patterning of the mosaic echoed in the later work as well. Simple shapes in a mosaic—a heart, a vine, a diamond—repeat like the endless loops in Twombly's blackboard paintings.

"I've just returned from digging a Roman bath with the Director of the Museum here," Twombly wrote in a letter from Tangier to Leslie Cheek at the Virginia Museum of Fine Arts. "Northern Africa is covered with

wonderful Roman cities and in this part they are just beginning in the last yr. to excavate."[6]

I like to imagine Twombly helping uncover the great number of mosaics in Roman North Africa, the tattered edges of an empire, preserved by the dry climate and absence of large cities. His hands digging down, taking away layer after layer of dirt, to see the patterns emerging below the surface. Twombly, the amateur archaeologist, the hungry excavator, stripping away the top layers of the fugitive past. (This to me, too, is one of the powers of his work: there's always a below, some unreachable distance that calls to us: keep looking.)

The "unswept room" was dug up from its first home, the dining room floor of a Roman villa on the Aventine Hill, and installed in the Lateran Apostolic Palace before being moved in the 1960s to its current home in the Vatican Museum.[7] Did Twombly visit there when he first arrived?[8] Or was his vision secondhand—pictures in books about Roman art or descriptions in ancient texts? Perhaps he read an account of the unswept floor in Pliny the Elder's *Natural History*, a work he'd use decades later in a series of lithographs, collages of phallic mushrooms and Italian trees and red swirls of ink.

We cannot know. "It is very difficult to talk about an artist," said poet Octavio Paz about Cy Twombly, "always we are talking about another way of trying to understand a secret."[9] The secret life of making, I think he means, is not just the color as it moves from brush or hand to surface, but how an idea travels across the surfaces of a mind. The secret life of hours spent looking. These most secret hours of a life.

▌

Here's what we do know.

When Twombly returned to the United States in the spring of 1953, dividing his time between New York City and Lexington, it wasn't Rome on his mind but Morocco. He had traveled across Italy—places and sights he'd dreamed of for so long—but what he brought back, besides some Roman busts and Etruscan terra-cotta figures and Iberian bronzes, were the marks and signs, as he witnessed them, of North

Africa. He ended up there by accident, following Rauschenberg, but it affected him in deep and powerful ways.

One can feel the energy in his work from this era, done in New York City, a digging in and a digging down: layers of thick paint, white almost yellow, a timeworn shade, and the rough black of spikes and glyphs carved into the wet paint.[10] One critic describes these paintings as "a symphony of dirty whites and creams variously laid on in thick impasto and roughly gouged away, thin scratches worrying the edge of forms, marked up and marked into, and, notably, half of them titled after Moroccan towns: *Tiznit*, *Volubilis*, and *Quarzazat*."[11] In all of these, *La-La* to *Tiznit* to *Volubilis*, he has excavated the surfaces with the wrong end of a brush or a sharp spike, as if searching for the ruin or mosaic below.

In one of these Morocco Paintings, *Untitled* 1953, three massive phallic shapes rise up on a ground of dirty beige; these transformed landscapes, ancient ovens still used in Morocco, great earth sculptures, communal and raised, or perhaps the outlines of a village's roofs. These are not literal landscapes but places abstracted into feeling. "Cy Twombly's paintings are landscapes of this foreign and yet familiar terrain," writes John Berger. "Some of them appear to be laid out under a blinding noon sun, others have been found by touch at night."[12]

In a way, his new works weren't so different from paintings he'd done at Black Mountain and Lexington in 1951 and 1952—*MIN-OE* or *Zyxig*, both from '51, or *Solon I* and *Solon II*, from '52—with their deep black and blue tangents, expressive and moody like ancient figures or symbols. "Even the things Twombly made in a frenzy the night before also looked somehow as if they had been around forever," writes one critic of these forms, works that "conjur[e] the zoomorphic forms of ancient Iranian metalwork—or an illuminated shape reflected in water at night."[13] Twombly's paintings, in the years before and after this first trip to Europe and North Africa show not a radical break, but refinement. His months away amplified and clarified the feeling, and visual language, that was already there.[14]

That summer of 1953, working in Rauschenberg's Fulton Street studio, the sounds and heat of New York City everywhere, Twombly returned to these places, a retracing and uncovering. "Generally speak-

ing my work has evolved out of the interest in symbols abstracted," Twombly wrote in an unsuccessful application for another fellowship, "but never the less humanistic; formal as most arts in their archaic and classic stages, and a deeply aesthetic sence [sic] of eroded or ancient surfaces of time."[15] He could've been writing of the surfaces in these new works—ancient, eroded, and finally, felt. These paintings, based on his sketches and memory, were like souvenirs—objects that record and exceed the places they name, digging down into experience and finding memory and desire.[16]

His show in the fall of 1953 at Eleanor Ward's Stable Gallery, alongside Rauschenberg's "fetish" sculptures and White Paintings, was hardly the welcome to the New York City art scene the artist might have hoped for. "Everyone was so hostile, with the exception of a few artists," Ward remembered. "One well known critic was so horrified he came out on the street literally clutching his forehead, and then fled down the block . . ."[17]

Savage reviews and not a single painting sold. Here is James Fitzsimmons's 1953 review in *Arts & Architecture*, another critique that points to the artist's very conscious refusal of technique:

> Twombly's recent paintings are based on drawings made in North Africa, but there is nothing specifically African about them. Large, streaked expanses of white with straggling black lines scrawled across them, they resemble graffiti, or the drawings of pre-kindergarten children. The contours of the white area enclosed by line suggest rows of tottering, crudely fashioned spikes or totems. Presumably the feeling-content of this art is ugliness: shrillness, conflict, cruelty. There is something that resembles a crown of thorns. Fine. The artist is clearly a sensitive man and this is what he finds in the world. Does he have to express it clumsily?[18]

The answer to that last question is yes. The rough unfinished edges were no accident but a careful performance, a stance against perfection. The paintings, wrote Stuart Preston in a review of the show, "lack, to my way of seeing, even the first elements of discipline in color, design

or draftsmanship, to read any intelligible or communicable meaning into them is quite impossible. The best thing to be said is that they apparently render the artists sensations convincingly."[19]

None of the reviews at the time mention the basement of Ward's gallery, a room the two artists cleaned out together in the summer of '53. The basement's single source of light, a grate on the ceiling, gave that converted room "a sort of underwater feeling," an ideal space in their minds to show Rauschenberg's fetish sculptures. "Those boys worked like galley slaves," said Ward of their weeks-long efforts to clear "dozens and dozens of loads of junk that had to be carted away, debris that was two or three feet thick on the floor."[20] They whitewashed every surface, top to bottom, like one of Rauschenberg's White Paintings that would be shown upstairs. This excavation now seems a kind of bookend on their months away, a last joint venture and moment of collaboration, a joyous digging down together.

4

THAT SIDE OF THE LINE

"IT IS DIFFICULT," TWOMBLY WROTE of his eight months in Europe and North Africa, "to begin to tell of the many, many things I saw and experienced—not only in the art and history but of human poetry and dimensions in the fleeting moment and flux. I will always be able to find energy and excitement to work with from these times. I see clearer and even more the things I left. It's been like one enormous awakening of finding many wonderful rooms in a house that you never knew existed."[1]

It wouldn't last—this sense of possibility, his awestruck entrance to that house with vast unknown rooms, windows opened out to art and history and poetry.

In November 1953, Twombly was drafted into the army and sent for basic training at Camp Gordon in Augusta, Georgia. Unlike his father, Twombly never had any interest or aptitude for physical endeavors or organized activities, and the experience of basic training with its obstacle courses, chin-ups, rifle practice, marching formations, would have been awful, all the more so in the bright knowledge of the world he'd left behind.

It's ironic to read of the artist's later love for the weekly VMI cadet dress parade in Lexington when he returned to his hometown in the last decades of the century. In his older age Twombly loved the military pageantry, often taking visitors to see the young men in their sharp white pants and gray coatees march and salute and fix bayonets while drums and trumpets beat the practice songs of war.

After basic, Twombly was assigned to Washington, DC, as a cryptographer. "I was a little too vague for that," he said of his time codebreaking, a typical downplaying of his own emotional or psychological state of being.[2] His words themselves a kind of cipher. A waiting code. "His time in the military was above all a period of unbearable pressure," writes critic Richard Leeman. "Having refused transfer to other camps, Twombly was put under psychiatric observation and released from the service in August 1954."[3]

Twombly told a story that during his short stint at Walter Reed Hospital in DC under psychiatric evaluation, he was selected along with another patient to be interviewed by a visiting panel of psychiatrists. Among the questions they asked was "What do you think of van Gogh's last painting?"

"As if I would know the last painting of van Gogh," Twombly recalled years after. He was discharged for anxiety.[4]

That's not the story, of course—pressure and observation and discharge—usually told about Twombly's military service and cryptography training. Instead the story most often told of this time, coming from his days in basic training, is one of transformation, breakthrough, discovery: Twombly on leave from basic, rented a motel room off a highway in rural Georgia and drew in the dark.

Picture the dark room. Picture the artist pacing, trying to figure out a way out of his own head. Out of his own knowing and certainty. How to escape the mind—and the hand, too—their stubborn insistence on order. It is summer in Augusta, the air heavy with honeysuckle and thunderstorm, and the kind of heat that begins before the sun rises, and never lets up.

The neon sign of the highway motel room flashes as cars speed past. He closes the blinds and the room is pitch black. It's dark, if not quite enough. He finds a shirt and covers his head. He gives himself a series of tasks. Draw a perfect circle. Draw a tree. Now the face of your mother's mother. Twombly drawing in the dark, the dark drawing back.

No, he is not drawing a circle or a chair or a bird taking flight from a cypress tree. His hand follows the path of its motion. Drawing over drawing over drawing, like the Surrealists before him who tested the bounds of automatic writing to find the movement below the conscious mind.

The lines become muscle memory. Like a runner. It's a memory that translates itself in the quality of ecstasy one finds in his work, that rush of energy and expansion. This trick of artistic control that makes his lines seem effortless: the illusion of ease. So much practice to make something look unpracticed. So much work to follow the mystery of unconscious motion, to trust that one will arrive, not at perfection but maybe something closer to ecstatic vision, true experience.

This is Twombly's mythos, the artist in the dark, letting his hand trace without the pressure of the eye: "On weekends in Augusta, he rents a hotel room to produce drawings at night in the dark to obliterate any graphically expert routine. These drawings form the basis of his first one-man show at the Stable Gallery in 1955, as well as the new direction of his work from then on."[5]

Alone, the hero on his quest for self-knowledge, for wisdom, for the mysterious secrets at the heart of things. It's a sentiment echoed in other accounts of Twombly's practice: "Twombly has always been a loner. Unlike most successful artists these days, he has no studio assistants and wants nobody around when he's working."[6]

Robert Rauschenberg once compared his working relationship with Jasper Johns and Cy Twombly:

[Johns] and I were each other's first serious critics. Actually, he was the first painter I ever shared ideas with, or had discussions with about painting. No, not the first, Cy Twombly was the first. But Cy and I were not critical. I did my work and he did his. Cy's direction was always so personal that you could only discuss it after the fact. But Jasper and I literally traded ideas. He would say, 'I've got a terrific idea for you,' and then I'd have to find one for him. Ours were two very different sensibilities, and being so close to each other's work kept any incident of similarity from occurring.[7]

If the direction of Twombly's art is as "personal" as Rauschenberg describes it, there's a thin line between personal and private, between merely guarded and utterly inaccessible. This, too, is what I admire about Twombly: his headstrong faith in his own direction as an artist.

Though Twombly and Rauschenberg worked separately, one of Cy's crayon drawings from 1954 is embedded in *Rebus*, one of Rauschenberg's combines, or assemblages, inventive combinations of painting and sculpture. It is possible, too, to see in Rauschenberg's combine *Bed* 1955, a little Twomblyesque drawing on the pillow, a cutout dream of his former lover, a reminder of that not so distant "erotic charge."[8]

An ongoing conversation, a world of echoes. To think of Rauschenberg's *Bed* is to see, in a new light, the rare photographs taken by Twombly in 1951 in New York City, each called *Bed*; crumpled sheets like topographical maps. One can feel the heat where the body, or bodies had been. In another of Twombly's photographs, also called *Bed*, taken in New York City in 1957, a single bed, the covers pulled back just to one side, and the bust of a god or emperor hung on the wall above like an omen.[9]

When he was discharged from the army in 1954, Twombly rented a small apartment in New York City on William Street, a block and a half from Rauschenberg's studio loft on Fulton Street. Even before moving to New York, Twombly would come up from Washington, DC, to work in Rauschenberg's studio; in addition to sculptures and paintings that reflected his ongoing fascination with North Africa, Twombly continued to explore the kind of wild, abstract, and spontaneous drawings he practiced in that Georgia hotel room. "These are loose, gawky glyphs of spiky, unidentifiable flora or fauna," writes one critic of Twombly's drawings done in Rauschenberg's borrowed studio. "Their manner suggests both the guilelessness of small children and the insolence of graffitists."[10] In other words, defying order.

It was in this studio on Fulton street that Twombly painted *Panorama* 1955. A series of frenetic white marks—cipher, chalkboard, star chart—on a ground of gray-black, *Panorama* is one of his most remarkable pictures. In one way, this is the first blackboard painting, the style for which Twombly would become most famous, all those whorls of white loops in vertical rows. Unlike those later works, trompe l'oeil transformations where wax crayon appears as chalk, in this painting, he actually used chalk.

Panorama, shown at the Stable Gallery in January 1957, was not displayed publicly again for more than two decades.

"I remember there was a disparaging review of him but they had an illustration of his blackboard painting. I remember cutting it out and I put it on my own personal dictionary at home, my little precious dictionary," the art dealer Ivan Karp said in an interview. "And that was my prime illustration of what art was supposed to be. I thought that was the most important object of abstract art in the world."[11] I love the story of that clipping, magic carried-over from the canvas to the page of the review in *ARTnews* and saved in this private, precious library.

The review, which describes the "utter nihilism" of Twombly's paintings, "white pigment on a black surface," asks this question: "How much farther can the sub-conscious release take one? It seems a painful autobiography."[12] The answer, dear reader, is much further and deeper.

Often what in Twombly's art looks like a departure—his turn to large-scale monochrome paintings, the blackboards, in the late 1960s and '70s—is in fact a return. But this is no classroom chalkboard or lesson in handwriting; the mark-making in *Panorama* is completely different from those later pictures; "all over scratchy, tangled, staccato scribbles" is how art critic and curator David Sylvester describes the manic picture, a work that resembles those later ones mainly in its size and ambition, its monochrome palate, its motion.

Panorama, most likely completed in 1954, is all the more noteworthy for being one of six or eight similar large-scale paintings done in Rauschenberg's Fulton Street studio, and the only one not destroyed. Twombly's photographs are the only documentation of these lost works.[13]

We don't know why these canvases were destroyed, just one or two years after they were made. Perhaps it was the "very bad canvas"—a cheap drop cloth—Twombly used. Perhaps it had something to do with the start of Rauschenberg's romantic relationship with Jasper Johns and the moving of his studio in the late fall of 1954 from Fulton Street down to the Pearl Street building where Johns lived. (It's hard not to read Rauschenberg's description of trading ideas with Johns and not imagine Twombly, excluded from their inside talk, jealous and apart.) Perhaps Twombly decided the work just wasn't good enough. Perhaps they were painted over in a rage. Or maybe it was better to have just the photographs, a fragmented piece of a puzzle, another myth. Hardly the only question from that time.

▌

In an interview with curator Nicholas Serota, one of the two published interviews with the artist, the other being a highly edited conversation with David Sylvester, Twombly described "two or three great moments" in his over-six-decade career: finishing *Say Goodbye*, the period of *Poems to the Sea*, sculptures constructed in Jupiter Island on the Florida coast, the "lobster" reds in *Lepanto*, and "a series of drawings I never saw again."[14]

An unusually detailed note in the first catalogue raisonné of drawings describes the drawings in question, made in New York City in 1955:

"The artist intended to make one work in an album out of the works from Cat. Rais. no. 65 to no. 97. On the occasion of his trip to Europe, he left them in the custody of a friend in New York. Later, when the artist asked for them back, they were denied. They appeared on the market for sale and in several museums as individual works and gifts." One hears in the note Twombly's protest. One hears his loss.

I became obsessed with those drawings. The immediacy. The confidence. The sense that something essential about line and freedom was being discovered. In those twenty-three pencil drawings one sees Twombly's whole artistic career, condensed, compressed, presaged in the all-over lines.[15]

The art wasn't enough, though. I wanted the story of those drawings. I wanted to know who owned them and why they weren't returned. I was still foolish enough to think that if I looked hard enough, asked the correct questions, I might find the right answers.

▌

The "friend" who didn't return the drawings isn't named explicitly but it wasn't hard to figure it out. The first owner for each of the drawings is the same: John Bedenkapp.

A modernist architect, Bedenkapp worked at several high-profile firms, including Philip Johnson's, before setting up his own office in New York City. In the 1970s, he helped design an exhibit at the National Gallery of Art in Washington, DC. An obituary in the *East Hampton Star* describes his death in 1983 after "a long illness," code it seems for complications from AIDS.[16] All of this leads nowhere. Twombly's name doesn't appear.

John Bedenkapp, his name misspelled in the first catalogue raisonné of paintings as Biedenkapp, also owned the painting *Desert of Love* 1959, an enormous painting of scattered marks and whirls that was "destroyed in the late sixties, approximately in 1969." All that's left is a black-and-white photograph of the painting in which the words EGYPT and DEAR and WING and VENUS appear. The title is perhaps based on Francois Mauriac's 1949 novel *The Desert of Love* about a love triangle. Is it simply a coincidence that the book, *Egypt: Painted and Described* by

R. Talbot Kelly (1906), was donated to the NYU library in Bedenkapp's memory, his handwritten name a few pages after the frontispiece: *In Memory of John Bedenkapp 1983*? There's no record of who donated it— or why this book. One riddle hides another.

After months of trying to track down any living family or colleagues, of trying to connect Bedenkapp to Twombly, I gave up. Searching for the story of those drawings is not unlike the process of writing about Twombly in general: fragments without narrative, puzzles without answer. So many uncertainties and dead ends. So many questions and small failures. An education in frustration.[17]

▌

Charles Olson was once asked by a visitor what he taught at Black Mountain. "You might say that I teach posture," he replied, an answer one might have expected from Twombly about his own teaching.[18]

For several semesters, from the winter of 1955 until the spring of 1956, Twombly taught art at Southern Seminary and Junior College, a two-year women's college in Buena Vista, Virginia, near Lexington. Again, Twombly returned to the familiar landscape. It's hard to imagine Twombly standing before a classroom of female college students, describing traditional ideas about form and line, not for lack of skill, but for the forced suffering of foolish rules and petty bureaucracy that often accompanies education.

"If someone presented something to him that didn't move him, he made no effort to pretend that it did. He was like an island that requires an invitation, rarely offered, to visit," wrote Alec Wilkinson about the artist.[19] Later in his life, Twombly agreed to help teach a philosophy class at Washington and Lee. He came one day and claimed that he was so annoyed by the student questions he never returned.[20] The older Twombly could walk away from what the young man felt compelled to do.

The education Twombly valued is to be found in the pages of the books he loved at the time, Proust, Mann, Verlaine, Dostoyevsky, and Plutarch's *The Life of Alexander the Great*, and in the places he experienced, the world as seen through his own eyes. "In New York I lived in galleries," Twombly said in an interview about his days at the Art

Students League, "I hardly ever went to school. I got that side of the line before."[21]

"That side of the line" is precisely what Twombly hoped he could erase in the dark, what his painting *Academy* 1955 attempts to break down. *Academy*, along with *The Geeks*, *Criticism*, and *Free Wheeler*—all done in New York in the mid-fifties, cryptic marks, illegible symbols, and half-formed letters inscribed into beige house paint—would become a kind of template for the work he continued when he returned to Rome in 1957.

In *Academy*, letters rise off the surface: A and T and O and K. A linear motion, from left to right makes it appear that the words are in rows, a hint at order within the chaos. I love, too, how the marks Twombly has made are at once frantically nervous and patiently sure. The poet and critic Frank O'Hara captures the animal physicality and intensity of these early works, the canvas scratched and clawed, lined and riveted: "A bird seems to have passed through the impasto with cream-colored screams and bitter claw-marks."[22]

Like a bad kid carving into a desk or page, Twombly has written, unmistakably at the bottom of the painting, F U C K. And yet, letters disappear as fast as they appear. We think we can read a word, but it vanishes into a stray mark. Twombly's handwriting is his art, one that slips like mercury from word into nothing, an unreadable message traced into the surface.

I return to the letters Twombly wrote to Daura from the Museum School in Boston, those "academic" teachers in Boston who only had praise for "perfect made drawings."[23] The title in that light is perhaps ironic, a reference to what would be considered a painting by those in the academy. Then again, at least according the artist, these titles— *Academy*, *The Geeks*, *Criticism*, *Free Wheeler*—were selected by himself and Johns and Rauschenberg by chance. "We were going to show the work and we made a list and gave the titles to different paintings."[24] Notice that he doesn't say the titles were completely random, just that the titles followed the works.

With pencil and pastel and lead Twombly drew into white house paint—as much drawing as painting—layers dried and relined; "the canvas was a field for mark-making that shouted and whispered, surged and

slowed, swirled and skittered."[25] It is both a work of "untutored rawness" and careful application of the layers.

"For Twombly, too," writes Ann Temkin, "the process of making and unmaking went hand in hand."[26] Pencil erases pencil, overwriting, over-drawing, overtaking. Decades after *Academy*, Twombly would say, "I use paint as an eraser. If I don't like something, I just paint it out."[27]

I think of Rauschenberg's *Erased de Kooning*, perhaps the most famous erasure of the twentieth century. But Twombly is not like his friend erasing de Kooning's drawing.

"He really made me suffer," Rauschenberg said of de Kooning's process to find the right drawing to give the younger artist. "I want to give you one I'll miss," the older artist said, eventually settling on one that would be difficult to erase, "charcoal, lead, everything." To erase the master's work was an act of rebellion, a "murder" made public.[28]

Twombly, like Rauschenberg, also loved "the rude parodic squawk in the temple of art," though their methods diverge: Twombly erases away the surface by building it up, a process of accretion and layering and crossing out, pencil or paint, not unlike how a city wall accumulates—like graffiti over posters over graffiti over brick, over and over—or for that matter, a life.

5

PROOF OF LIFE

CY DREAMED OF ROME. HE dreamed of return, of dissolving the tether of his lonely life, the tedious need for work, and the disappointments of desire. He dreamed the dream of starting over, a new city, a new tongue, a new self: the dream of an untroubled life.

He wanted to travel, not just to the places he had already visited, but all the rooms still unseen. "[M]y work thirsts for their contact," he wrote in a fellowship application in 1955, thinking of all the cities and sites yet to be visited: Luxor, Thebes, Karnak, Istanbul, Persepolis.[1] Despite his passion, and glowing letters of recommendation, this, and the previous application to the Virginia Museum of Fine Arts, were unsuccessful.

In a letter to Betty Stokes, a friend from Lexington who had recently

moved to Rome, Twombly praises the greatness of that eternal city, its grandeur, its limitless possibilities, all the things his life at that moment teaching in Virginia wasn't. "I ain't got nobody," he writes, "Bully Boy Rauschenberg just lives his austere and unyielding life and you are off and gone. I'm here soul-less. You just better love Rome up."[2] In his loneliness and isolation—alone in Virginia while Rauschenberg and Johns made work together in New York—he imagined Betty's happy life.

In the years between his first trip to Rome and his return four years later, there's a striking contrast between his productivity as an artist and his seeming unhappiness. Twombly's crises of confidence are not about his own artistic talent and vision, but about where and how to live, and though he doesn't say it explicitly, who to love.

Cy met Elizabeth Stokes, who everyone called Betty, in Lexington in the summer of 1952 when her father, a military officer, was temporarily put in command of the VMI. At different times, they were both students of Pierre Daura. They "got on like hot cakes" discussing art and aesthetics, their friendship continuing in New York City.[3] They were kids who found each other: a shared sensibility, cynical and funny, kindred spirits who imagined lives of travel and new experiences, a great world beyond the confines of small-town life. And though not uncommon—think Truman Capote and Harper Lee, think Patti Smith and Robert Mapplethorpe—it's something remarkable to find those people early in life, and keep them—a stroke of good luck and good timing.

For four decades Betty and Cy remained close friends. Without her, the story of Twombly and Italy would be completely different.

In many ways they lived parallel lives—both Americans who married into wealthy, aristocratic Italian families and stayed. Betty went to Rome for a modeling job where she met and married Alvise di Robilant. Both Cy and Betty were immersed in the life of Rome and Italy, but always lived apart from it—physically, in their late-life hilltop houses, and culturally.

Rome was, in the 1950s and '60s, to them, heaven on earth. The time before political troubles and protests, the time before tourists crowded street corners like bewildered sheep.

"A whole other world from what it is now," Twombly said in 2000. "It's not the same city. In a sense, the life is totally different. It had more

space, you could see it and you could enjoy it. Now you just plough through just trying to get to where you're trying to go with the least stress. It's wall to wall. If I went to Rome now, I wouldn't spend two days. But when I went I was in paradise."[4]

Paradise. The years after the war, the years of poverty and rebuilding and renewal, the years when two Americans, young and good-looking, could stroll barefoot through Piazza del Popolo and join the tables of the Italian artists—Giosetta Fioroni, Mario Schifano, Franco Angeli, and others—who gathered at Caffè Rosati.

That description of the good life of Rome—fewer people, cheap as dirt—is echoed in almost every conversation about the years when Twombly arrived. Romantic and hopeful, and like all good love stories, only partially true.

I

What is our proof of life? A photograph? A letter? A conversation fifty years later?

If you looked for Betty's name in the biographical notes of the most recent catalogue raisonné of drawings, you'd be disappointed. Her name is missing, by accident or intent, I don't know.

The entry for 1957 reads: "In February he leaves New York to spend time in Italy at suggestion of Italian painter Toti Scialoja. He also works on drawings in Grottaferrata for two months."

Was it Toti Scialoja who suggested he return to Rome? Perhaps. But in his interview with Serota, when asked if he intended to stay in Italy when he arrived in 1957, he said, "No, I came to see Betty di Robilant, a friend from Virginia who had got married and was having a child."[5]

In one idealized vision of Twombly's Roman life, that return was no holiday but a lifelong pledge. Not quite.

"I don't know how long he was planning to stay," Betty said in her only public interview, a short conversation at the end of the lot essay for the sale of a sculpture Twombly first made for her wedding anniversary. "He stayed with us in Grottaferrata, there was an extra room and he lived with us for a short time. We had fun, he'd go up every afternoon and get ice creams and so on. We were like brother and sister really."[6]

Twombly, even as he made his life in Rome, looked to return to the United States. The gallery scene in Italy, to his mind, was "nil" and, he claimed, "There is very little chance of my selling here."[7]

"If anyone is looking for a teacher next winter write to me," Twombly wrote to his gallerist Eleanor Ward. In April 1957, and again in March and October of 1958, Twombly asked that she keep her ears open for any teaching jobs in the United States.

"I hope I can get that job next year," Twombly wrote in October 1958 of a teaching gig at UC Berkeley held the previous term by Conrad Marca-Relli. "Then I would come back to Europe for a few more years."[8]

❙

When Cy returned to Rome in 1957, Betty was his password. It was through Betty and Alvise that Twombly would be introduced to the Italian art world, to the people who would help and protect him—Plinio De Martiis who ran Galleria La Tartaruga in Rome, Giorgio Franchetti, perhaps his biggest supporters in those early years, and Tatiana Franchetti, his future wife.

"He set up a studio," Betty remembered, "and he did paintings in that place with us. I don't remember all of them but one of them I know was called *Blue Room*, and then we introduced him to the Franchettis and Plinio De Martiis and he moved into Rome, but we all had a very interesting life in Rome together."

It's hard to read the biographical entry in the most recent catalogues and not think that Betty's name has been whitewashed from the story of Twombly's life and art: her importance, her influence, her very presence elided.

The process of erasure has been going on for years, a slow moving glacier. In Heiner Bastian's 1978 selection of one hundred paintings from 1952 to 1976, Twombly's *Blue Room* is dedicated "To Betty di Robilant." Not just her first name, but her complete name.[9] This dedication, once part of the title, is missing from later catalogues. In the *Catalogue Raisonné of Paintings Vol. 1*, published in 1992, it is simply *Blue Room*. The catalogue describes the painting as being completed in Rome, though Betty remembers it being done at Grottaferrata.

If the omission of her name in *Blue Room* might be read as an accident or mistake, the absence of her name in other places is harder to ignore. Take *Scent of Madness* 1986, watercolor flowers by Twombly over top of prints made by Betty. It is both an overwriting and a collaboration.

Until the fall of 2016, the website for the Cy Twombly Foundation listed the work as "SCENT OF MADNESS, 1986, Watercolour on paper over a print by Betty di Robilant." And yet, in the catalogue raisonné of drawings, the official accounting, edited by Del Roscio, there is no mention of Betty's print that sits below each of Twombly's ten watercolor flowers.

A catalogue raisonné aims to include everything, every painting or drawing an artist ever completed with as much detail as possible: the first owners and all the hands who possessed the drawings and paintings for a time as well as the exhibition history and reference history. Minute details—"There are traces of acrylic on the verso of each piece" or "Paper with the watermark BFK Rives FRANCE"—fill its pages.

A field guide for the obsessed. A concrete, printed record; not perfection but the promise of an attempted totality, even including works that have been destroyed or lost or painted over. Amid the facts are tantalizing suggestions of story, the secret histories of the objects to be deciphered and names to be remembered.

"I read every word like I was following a mystery novel," John Waters writes of the first catalogue raisonné of paintings. I, too, know that feeling, tracing the clues written between the lines—places or owners, notes added or missing.[10]

Beyond its usefulness to academics or the fanatical, its primary purpose is to separate the real from the fake—this "reasoned" sorting of what is and isn't an artist's work. Often produced by an artist's foundation, the only ones with enough resources or interest for this Herculean gathering and identifying and sorting. "Artist foundations have come to serve as the art market's rating agencies," writes James Panero, "with catalogues raisonnés providing triple-A stamp of approval."[11] Their decisions of authentication can have significant financial consequences for the foundations and their assets, often based on an artist's work. Even as it purports to be simply factual, the last official word, the editing of a catalogue raisonné can have far-reaching consequences and

not simply financial. At stake too is the biographical. These catalogues shape narratives. They create context. They tell a story.

One of the first major works Twombly made on his return to Italy in the early winter of 1957, *Blue Room* is often mentioned in the same breath as his other Roman paintings—*Sunset, Olympia,* and *Arcadia,* each with a bright cream surface, the result of a new paint he found in Italy, cementino. It is, as one critic writes, "like eating an orange flan; the effect is simple, yet you know it took skill to make."[12] This new paint was nearly impossible to roll without cracking, a problem for the artist in sending work back to the United States.

Twombly painted these in a studio across from the Colosseum—his first full-time studio in Rome—a continual sight line to the ancient past, the great walls of stone in beautiful, stalled ruin. Subtle and elegant gradients of shade and textures that are "utterly immune to reproduction," these paintings, with streaks of red and yellow colored pencils, with lines that resemble letters, feel deeply personal.[13]

"Dearest Eleanor," he wrote to his gallerist when he had just arrived in Rome. "This is a pale day. The Palatine and Colloseum [*sic*] are in a blue silver vapour."[14] That blue, that silver, that vapor—I see them too on these canvases. Surfaces radiant like weathered walls. In a letter just over a decade after their making, Twombly perfectly describes these early Rome paintings as "tender open canvases."[15] And he's right, there's something both tender and open about these works, a lightness that pulses and breathes from within.

▮

Who can blame Betty for the defensiveness of her response, an argument for her place in the story, when an interviewer tells her about a photograph of Twombly and de Kooning and Afro, an image that for him represents the energy and pleasure of the time period in Rome.

"Well, I knew Afro, and I knew Burri, because I had met him when he had a show at Eleanor Ward's gallery," said Betty. "I remember Burri let me stay in his studio when I arrived, and I stayed there for a week or so. I met Afro through Plinio I think and de Kooning came out much later with Pollock's girlfriend Ruth but that was around 1960 at a time

when I was very ill after my second son was born so I wasn't going out so much at that time but there was a lot going on."[16]

The interviewer didn't mention the artists Burri or Pollock, or the gallerists Ward and Plinio. Betty makes a case for herself, for her part in art world comings and goings. She stakes her claims of intimacy—staying in Burri's studio or the then girlfriend of Pollock—and, at the same time, suggests why she is absent from the pictures.

I'm reminded of Twombly's description of his time at Black Mountain College, "And then I don't know which summer it was, the first or the second . . . Bob was working with Cage and other things. I was always doing my own things. I always wondered why there are books, with photographs of all the artists of that period, and I was only in one! I thought: where was I? But I never was there. I was somewhere else."

▌

"I'll be the old lady at the train station wearing a leopard-print scarf," Betty said on the phone when I finally talked to her in the spring of 2014. "You can spend the night if you like."

After months of coffee dates in Rome with two of her three sons, one a sculptor, the other a writer—and much to their surprise—she invited me to her house in Porto Ercole, a small town on the coast, a couple of hours north of Rome.

Betty, leopard-print scarf as promised, greeted me on the platform of the train. She moved slowly, in part because of her bad cough—bronchitis, she said. Though her face had changed shape in the fifty years since the sepia photograph taken by Twombly in 1957, a young woman looking thoughtfully out of a window, her eyes were just as striking.

We drove across the causeway from Orbetello to Porto Ercole, a handprint of land surrounded almost completely by the Tyrrhenian Sea. In our small talk of family and places lived, we realized we had both spent time in a small town on the eastern shore of Maryland, another place surrounded by water and set apart from the hurried rhythms of urban life.

We ascended the narrow switchbacks to her hilltop house, a square of glass and white stucco, modest yet elegant, surrounding a small courtyard of lemon trees, a garden designed by Cy. From her lawn one can look across the water to the old Spanish fort that still guards the entryway into the bay. The day seemed full of possibility, the sun shimmered, gold and glass, across the waves.

6

THE SWING

AT BETTY'S HOUSE, SUN-FILLED ROOMS of art and books, we started with the photos. From their shelves in her art studio, Betty took down album after album for us to look at together. Heavy oversized things, the year embossed in gold on the spine, the albums were filled with curated happier times, and like all records of the past, they are incomplete. Images of family picnics at Grottaferatta, group shots on the island Procida when Twombly had just arrived, baby pictures of her three boys, vacations on Greek islands, candids and portraits, all the modest hours that would be lost if not for these images.

Betty pointed out the people in the photos—Tatiana, her brother Giorgio, and Alvise, Betty's late husband—then, in later albums, her

boys and Alessandro, as they stood together on a beach or leaned back in their chairs at dinner.

Cy's face I knew by heart. His bird nose and hard jawline. In many of the photographs, he is unguarded, often smiling. To be a well-known artist in the second half of the twentieth century is to have been caught, by choice or by accident, again and again: sometimes publicly, glossy profile pictures in glossy magazines, or more often, candid ones taken by family or fellow artists, hundreds of images tucked away in darkness, far from view, in the drawers of lovers or friends. In Betty's albums, page after page of photographs blurred into one long afternoon. Children off with nannies, meals prepared by other hands, and the concerns of work far from their minds.

Betty's stories were like that too. The days at Grottaferrata when Cy worked in the studio, always alone, until it was time to take the children for ice cream. The day they made plaster casts in the sand at Staten Island. The times Twombly worked in the studio at Porto Ercole in the '80s on drawings, mostly flowers.

Don DeLillo's essay "That Day in Rome—Movies and Memory" begins with seeing a movie star in a lavender blouse and long boots on the streets of Rome. "That was twenty-five years ago, or longer, one of those occasions whose precise point in time has collapsed into other memories of the same place."[1] All the times that Cy came up to Porto Ercole, all those early days when they were all young and just married, have collapsed in Betty's retelling. Her stories, like private films, cannot be translated back from time into speech.

What is clear is that for a time Betty was essential to Twombly. And Twombly was essential to Betty. Their lives intertwined, first by shared places and then by the binds that keep friendships going in the years after that first thrill of recognition. In Lexington and later New York, they talked of what their lives could and might be. When Twombly was in the army, Betty was a listening ear for his unhappiness; in Italy, she introduced him to her influential friends. For a time, from the early 1950s through the late 1980s, he trusted her—one of the very few in his lifetime—to give him feedback on his art. Their lives were bound by history and language and family.

Over the years though he relied less and less on Betty, others taking

the place of friend and critic and confidant. They saw less and less of each other. First, this drift apart, and then, a falling out.

How, she wanted to know, could a friend she loved and trusted simply stop speaking to her?

▋

Betty keeps each letter, each scrap of paper Cy touched, in a locked drawer.

The ephemera, collected over a lifetime—a note about going into town, a realistic sketch of one of her sons, a comic dirty drawing of a man's nose as a penis becoming erect, the kind of drawing done to make the other person laugh—reveal less about Twombly as an artist and more about how much they cared for each other, his magnetic personality, his sharp wit, their affection.

There was great ceremony, pride, and guardedness in how she showed me the letter he sent when he found out she was getting married to Alvise. In April 1956, he writes, in all caps, how "terribly HAPPY" he is for her, his handwriting hurried and off-kilter, falling off the edge of the page. He claims to be overjoyed for her but also saddened by her decision to marry. His hyperbolic prose, praising Betty's loveliness, matches her account about his reaction when she returned to New York City after her wedding.

"Cy stood in the doorway crying. He said to me, 'I always thought we were going to get married.'"[2]

The activity of remembering makes remembering possible. Recover, we command. Recover, we plead. Certain memories sharpen with age. They brighten in relief to all that is forgotten.

For several hours, we toured the rooms of the past—his affectionate letters full of inside jokes, photographs of them together from several decades, his drawings. Betty's house—her life—is not an archive. It is not a library. I wished I could've read each letter slowly, methodically, and on my own time. I wished that she let me take the photographs home to study. They all passed through my hands so briefly.

"Bric-a-brac, relics, memorabilia, items around which has congregated an aura of light of the most personal depth and value," describes

one biographer of Keats about his effects after death. "But what if that value becomes, on its own, not just personal but universal? Who owns that memory then?"[3]

"Maybe my children will want to write a book," Betty said when she locked the letters away. Desire and reluctance, claim and refusal.

Betty decided it was time for a break. She drove fast down the hill into town, each curve of the road familiar. "Everything in Italy has an hour," Betty said as we looked for a place to get a coffee, "and this is the ice cream hour."

As we walked through the square, past a display of old cars, Betty pointed out one similar to Tatiana's Alfa Romeo. In an uncrowded cafe, a few *cornetti* from the morning still under glass, Betty and I talked about the Twombly pieces we love. When Twombly's blackboard paintings came up she broke into a little song about cursive—*the hand is connected to the body*—a tune she learned in elementary school, a glee in her voice at this old memory still present.

I asked Betty about the relationship of Nicola and Cy and Tatiana. Did Cy ever talk about it?

The answer was no. Cy didn't talk about those things and Betty never asked.

"It makes it sound like I didn't know him. We were intimate," she said, a little defensive. "We just talked about what's for dinner. Not really about art or sexuality."

Is this the certain course of all relationships as they evolve from youth, those early intensities and connections made by recognition—*I thought I was alone but you're here too*—are displaced into routine and familiarity, into the closeness of everyday life: cooking meals together, washing dishes before bed, watching the children play in the garden?

The last time Betty saw Cy was at the opening for his 1994 MoMA retrospective.

In the atrium of the museum, Cy came over and said hello. He took slow steps towards her. An older man by then, his large, rangy body moved unhurried through the crowd of art-world elite. He kissed her on the cheek and that was it. They never, as far as Betty remembers, saw each other again. No great blow up, no single fight or argument ended their friendship. No confrontation. Instead, in Betty's telling, Cy simply fell away from her life.

"Why do you think the friendship ended?" I asked again.

She said she didn't know. Perhaps, she had heard, it was because she—or one of her sons—sold one of his sculptures. For their tenth wedding anniversary in 1966, Twombly gifted Betty and Alvise a sculpture he called *In Time the Wind Will Come and Destroy My Lemons*. It was a piece, in Betty's words to me, with "a light in it." I first took what she said as figurative—like the sculpture in Rilke's "Archaic Torso of Apollo" suffused from within by illumination. Later, when I went back and read her description of its "bowler-hat shaped form . . . oval-type shape as forms the base of the sculpture as it is now, only turned upside-down and with this light-bulb fitting in it," I realized she had been literal: "A light in it."

Fourteen years later, in 1980 Twombly asked for it back to rework it. The revised sculpture, two vertical extensions of plaster, one thick and the other thin, like a bow and string, was a fragile thing of rising and falling. With Twombly's permission four bronze casts were made: one for her and one for each of her three sons. "Where's mine?" Twombly asked, and a fifth bronze of the plaster original was made for the artist.

For Betty—or a member of her family—to sell a work might have been to the artist, a betrayal. Was that why Twombly stopped speaking to Betty? Twombly was very protective of his work even after it was out of his hands, concerned that it was going to the right collector or the right museum.[4] But it's more complicated than that.

"I like to hoard," Twombly said in an interview when asked about his sculptures—small scale, portable, and easily assembled alone. "I really liked having them around."[5] They were kept close, not out of avarice or pride, but for the pleasure they offered. Works to live with.

Twombly's sculptural practice was "extremely personal for him,

almost private."[6] And so, I like to imagine that despite their distance, Twombly thought of Betty in the winter of 1992 when he returned, five decades later, to the technique of pouring wet plaster into molds dug out of beach sand. A summer day on Staten Island in 1954 with Betty repeated decades later on Jupiter Island, Florida. The returns of Twombly's art aren't just about image or story, not just the same lines from poems he'd scrawl on canvas for decades, but methods and practices. The returns are personal.[7]

Earlier that day, Betty brought up what I knew but did not mention: the murder of her ex-husband.

In January of 1996, Alvise di Robilant was brutally killed in his Florence apartment, bludgeoned with a candelabra while playing Bach on the piano. Alvise and Betty had split up years before the murder but were still on good terms.

"While famous for his female conquests, the count reportedly began a homosexual love affair shortly before he was killed," as one account describes the murder.[8] Like something from a Patricia Highsmith novel, rumors abounded at the time of his death, shaking the art world and Italian society. Di Robilant, after all, had been a managing director of Sotheby's, Italy, as well as a noted collector and member of the aristocratic elite. Gossip continues still about the unsolved case; recent speculation suggests that he was killed by a serial killer targeting older homosexual men.

Much of this I learned later. That day, at Betty's house, she mentioned the death of her husband as proof of how Twombly had changed. After the murder, Twombly's son, Alessandro, called Betty to express his condolences. Cy never called or wrote.

"There goes another one," said a mutual friend of Betty and Twombly when he heard of Twombly's falling out with David Whitney, the collector and critic.

Twombly changed. Or was changed. It depends who you ask. More than one person described to me running into Twombly and Nicola

Cy, Grottaferrata, 1957, Photo: Elizabeth Stokes

on the street in Rome and within a few minutes, Nicola, looking at his watch, would remind Cy of some appointment or event, hustling him off quickly.

After their last meeting in 1994 Betty wrote Cy two letters asking for an explanation for his silence. She never received a reply from him or any acknowledgment of her attempt to repair the relationship. Sometimes, silence is its own reply.

"Friendships based on food are rarely stable," writes one poet, a friend, now lost, and I think of how one could substitute "art" for "food." Or maybe just delete a couple of words: Friendships are rarely stable. There's too much motion, within and and around us. Lovers come and go. Houses and countries, too. We change. They change. Too much time. Too many shadows.

The next morning as we sat down for breakfast, Betty said that we'd had enough Twombly. Her cough was worse than the day before. She held up bottles of medication to the morning light, unsure which to take.

"We've had enough Twombly," Betty repeated as she stood in the kitchen making coffee. The little *moka* whistled on the stove. We tried to talk of other things—her grandchildren visiting her up here, my life and family in Rome—but the conversation veered back to him. It couldn't not. There was too much at stake in this conversation for her, to right the wrongs of the past and resolve what had been left undone. There's too much history.

Affection and anger. This was Betty's bind. On the one hand she wanted to claim Twombly as her lifelong friend. To show me the photographs of their youth, the ones she took of the artist at Grottaferrata in 1957, Cy the serious young emperor, a sheet bunched over his shoulder like a toga, taken on the same day as his photographs of her, these portraits of play and intimacy.

On the other hand, there was the falling out.

The day before, when we returned from our tour of Porto Ercole, we pulled back into the driveway of her house. Betty stayed in her seat, seatbelt across her body, the car turned off. She looked out of the car window and said, "I'm not mad but hurt." Her hurt comes, I think, from a place of deep affection. Hurt that she's spoken of so rarely and never to a writer. It's the kind of hurt that collects inside the body. We sat in the car for another long minute. I had no answers for Betty, no certain explanations.

"I'm not mad but hurt," she repeated. Then, like a quick summer storm, a flash of anger. "Son of bitch," she said and slammed the car door closed.

More than anger was her disappointment. There was nothing cathartic in rereading old letters or dusting off old photos. What she wanted I couldn't offer: clarity or explanation or reconciliation. I couldn't explain

the end of their relationship. I couldn't offer closure or forgiveness. There will never be a chance to repair the friendship with Cy. Never a moment in which explanations or recriminations will end in shared stories of the good days.

Betty got up from the kitchen table and brought back a book, a green hardback, worn by use. *The Limits of Art*, edited by Hamilton Cairns, is an assemblage of passages from the great and lesser-known scholars and poets and critics of Western civilization. This book, she explained, was one that she and Twombly both loved, and returned to together, reading passages aloud, marking pages.

The book, like the tender photos of their early years, was totem and charm, talisman and spell. I leafed through the pages and put it down on the table where, for the rest of breakfast, it sat between us.

Betty wanted to stop talking. But she couldn't. I understood this experience all too well. All the materials of Twombly's life—letters and photos and drawings—and those less tangible pieces, the blue hours, the days overlooking the sea, the memories that defy a precise point in time—were there, just waiting to be said, to be claimed, to be understood, and they were, always, just out of reach.

∎

There's a photograph of Cy and Betty I thought of that morning, and think of still. An image I wanted to freeze. A threshold. A caesura. I wanted to nail it down in my memory before the next page covered it in darkness: Betty sitting on Twombly's lap on a swing while Alvise, her late husband, stands on the swing behind them looking down and smiling. They are all so young.

The swing hangs down from the branch of an enormous tree. The grand lawn of Villa Marlia, cast in the black and white of the old print, extends behind them. It's 1957. Young and laughing, the three of them move towards the camera in the upward arc of the swing. Motion and stillness, a stopgap against the slippages of memory and the damages of time.

This photo is part of the catalogue of days that have become a sin-

Alvise, Betty, Cy, and Graziella Pecci-Blunt, Villa Marlia, 1957

gle one of light and pleasure. It stands in for all that Betty cannot or does not say.

The swing goes back and forth, cutting through the air. The exact day is missing. The exact moment that Cy sat down and called Betty over, then Alvise followed, stepping onto the back of the swing and pushing off with his feet, sending them forward and then calling to another friend to take their picture who catches them at that point of perfect suspension, before they return.

7

FRANCHETTI

"EVERYONE FELL IN LOVE WITH him," recalled the Italian artist Giosetta Fioroni about Twombly's arrival in Rome in the late 1950s. We sat together in her cavernous Trastevere studio, the rooms filled with six decades of her own luminous paintings and drawings. A bowl of cherries, deep red, almost black, sat on the table between us.

"The whole Franchetti family—Tatiana, Giorgio, and the brother [Mario]—they all adored him, wanted to help and support him."[1]

Giosetta and Cy shared an artistic affinity, though it was with Tatiana that she had a stronger connection. Tatiana, who was not beautiful, at least not conventionally, who was "strange" and *"sportiva"* (athletic),

who loved skiing and old cars, who painted realistic portraits, mostly of children, captured people's attentions with an admixture of innocence and mystery, openness and charm.

Ordinary Italians recognize the Franchetti name. *Ricco come Franchetti*, goes an expression still said in the northern region of Reggio Emilia. Rich as Franchetti; a hundred-year empire of trade and banking and transportation. Their fortunes "reached their apogee in 1858 when Baron Raimondo Franchetti—who could ride from Venice to Tuscany without leaving his property—married Sara Louise Rothschild, heiress to the Frankfurt branch of the famous banking family, thereby becoming off-the-chart rich."[2] In the years after, the branches of the family tree have continued to be filled out with the famous and well-named, though like all dynastic lines, especially those filled with impractical heirs collecting art and climbing mountains, among other wild pursuits, what lingers longer than money is fame.

What the Franchettis offered to Twombly wasn't just access to the contemporary Italian art world but space and time and money. They made possible his first work spaces in Italy—his studio by the Colosseum, their house on Via Appia Antica, and their castle (they are after all the kind of people who own castles) in the Dolomites, Castel Gardena. They offered him a family. They offered him a myth to inhabit; "a bohemian aristocrat," describes one critic, "the young Twombly might have been a model for a character in a novel by E. M. Forster or Somerset Maugham—a kind that was no longer being written . . . slippery figure, not quite of our time yet not of any other."[3]

Another writer is less generous about the Franchetti family— "thorough snobs"—and their "collecting" of Twombly. "Though arrogant like the rest of their newly aristocratic family, they [Tatiana and Giorgio] had the grace to recognize the extraordinary splendor of the young, elegant American traveller they caught."[4] Twombly was willing to be "caught," at least for a time.

Just as Betty's name is missing from the biographical notes in the recent catalogue raisonnés of the drawings, edited by Del Roscio, there is no mention of Giorgio or Mario Franchetti. The sentence, "Meets Giorgio and Tatiana Franchetti," part of the biographical notes of

the *Catalogue Raisonné of Paintings Vol. 5*, edited by Heiner Bastian, is omitted in the drawing catalogues. Tatia's name appears once: "1959: Returns to the United States in early spring. He marries Luisa Tatiana Franchetti in New York on 20 April."

∎

"Dear friend and patron Illustrious Signore Barone Giorgio Franchetti," begins a joking note from Twombly to Giorgio that leaves to his "big brother" all the paintings done in Rome. Twombly writes that his friendship and "generous financial assistance . . . made the last two years in their half-ass way, seem slightly possible."[5] The 1958 letter is a playful promissory and thank you for the debts—friendship, money, connections—he couldn't repay.

When Giorgio first saw Twombly's art, he immediately recognized the genius at work; he said that he thought that Cy "managed to put down unconscious mind."[6] He later described that when he saw Twombly's scribbles for the first time, "che ricevetti come una scossa elettrica." *I received an electrical shock.*[7] A partner in Galleria La Tartaruga with Plinio De Martiis—the same gallery of Giosetta Fioroni—Giorgio offered Twombly access to the center of contemporary art in Rome.

"Plinio was a genuine deus ex machina," Giosetta remembered, "a unique figure. He fueled a 'neurotic frenzy' of exchanges, discussions, passions, events and debates that were, however, transformed into a vital amount of work. I saw a whole gallery of 'originals' pass by at the Tartaruga, some more authentic than others but all of them interesting."[8]

Galleria La Tartaruga—"the turtle" in Italian—offered a meeting place and home for many Italian artists, including Twombly, whose first solo show at the gallery opened in May 1958. Twombly was on the periphery, part but not part. Present but absent, not unlike those photos from his summer at Black Mountain in which his face does not appear. Many years later the artist Brice Marden described the "voyeuristic aspect" of Twombly, "he would kind of sit back and watch everything that was going on."[9] He *was* there, taking it in, with careful attention—at a distance.

Twombly's letters to Giorgio offer, in fragments, a vision of

Twombly's artistic process, his struggles and his constant concerns about money and success. Of the letters that survive, the best ones are the five from 1959, when Twombly was back in New York City trying to establish his name. On Giorgio's advice Twombly left the "Dragon Lady," his nickname for Eleanor Ward, and her Stable Gallery for Leo Castelli's gallery. Even as he complains about the depressing nature of the gallery business, Twombly is keenly aware of how much others are selling their work for. In one letter to Giorgio from 1959, Twombly describes his terrible distress and misery at dealing with the whole business of art.[10] The world, too much with him.

At the same time, it was a period of incredible productivity. Twombly describes working happily in New York, quickly finishing five large paintings. Full of energy and surprise, these early letters offer a vision of Twombly's optimism for the future and his return to Italy: "I feel very strong and stay close to my work, and reading many books. And come spring I tell myself I will slip through the Pillars of Hercules and I will be home once again ushered in by dolphins."[11] Home is no longer Lexington or New York City but Rome.

▌

"Letters are the great fixative of experience," writes Janet Malcolm. "Time erodes feeling. Time creates indifference. Letters prove to us that we once cared. They are the fossils of feeling. This is why biographers prize them so: they are biography's only conduit to unmediated experience."[12]

She's right; these "fossils of feeling" capture what time erodes, what memory rewrites. Even letters can't be read without a gimlet eye. Careful performance or exposure of our rag-and-bone self, the truth of who we are or what we want—stay or go, love or don't—is always elusive, a best guess, even sometimes for ourselves. Consistency is for fools and saints.

Go back to Twombly's claim that Motherwell "wrote one of the nicest testimonials" for his first solo show, at The Seven Stairs Gallery in Chicago.[13] Here's how Olson describes that same "testimonial" at the time to Creeley: "I so like this lad, and Motherwell (who has pushed

him, arranged a NY show opening for him next week) has just made a blurb for him . . . which is such nonsense that Twombly himself (he is a cool one) when I sd I didn't believe M wrote it, knew instantly what I was talking abt it."[14] The distance from "nonsense" to "nicest" is measured in decades.

Twombly is not a great letter writer. His letters, to Giorgio and Betty or David Whitney, don't burn with grand statements about the life of the mind or meditations on art or making. A man of nicknames to start, affectionate and telling—Dixie for his mother, Bully Boy for Rauschenberg, Betty Boop for Betty—and some less flattering, Goon Baby for Alessandro, Crazy George for Giorgio. There's wit to be sure but there's also business to be done. And yet, beyond the daily affairs and endless travel plans and news of art world friends, there are occasional flashes of his razor sharp mind and wry sense of humor, fleeting moments where we see the man as one writer described him, "a rare juxtaposition of the fantastic and the homespun, Lewis Carroll and Mark Twain."[15]

"I am two steps out of the world," he writes to Giorgio from New York. Very shortly, he tells Giorgio, he will begin painting on "acres" of new, untouched canvas.[16] "Two steps out of the world," a beautiful description of that terribly lonesome and lovely feeling of being apart from the motion around us. A description of want and hunger. Twombly in New York in 1959 was not unlike Twombly throughout his life, a man happiest when making work.

His feeling of being out of step comes through even in his joking to Giorgio. "Euclid," he writes to Giorgio, one of his pet names for his brother-in-law, "I'm going to ditch this so called difficult painting and get a smart DeKooningesque style, make lots of money and buy a model A Ford, paint it kitchen green (apple green) with gold plated bumpers chintz drapes in the windows and bud vases just full of Neapolitan wax lilies."[17] The letter goes on to describe bringing the car to Rome and dressing two Russian drivers in faux fur earmuffs to take them on day trips out of the city. Behind the inside jokes is a real want and anxiety about his "so called difficult painting."

Many years later, asked about fame and reputation, Twombly

remarked, "It's something I don't think about. If it happens, it happens, but don't bother me with it. I couldn't care less."[18]

Is this the only reaction to being unpopular that makes sense? To claim, like Emily Dickinson in a letter that, "If Fame belonged to me, I could not escape her . . . My Barefoot-Rank is better—."[19] Can indifference silence your critics and turn them into believers? It's hard now to remember, before multi-million dollar auctions, before a Foundation with a claimed billion in assets, Twombly struggled for recognition.

His late-life nonchalance about being under appreciated—"I couldn't care less"—is part of his own mythology. His move to Castelli's gallery was, in part, about increasing his profile, his sales, his name.

Two steps out of the world, but trying to walk towards it.

▌

When I arrived at Gaia Franchetti's house in Rome, a photo shoot was underway in the courtyard garden, a tablecloth the star of the show. Gaia runs a business that deals in textiles from India and Italy, and on the table sat flatware with gold trim and delicate pastel pastries. Lanterns illuminated a table set for no one. The photographer and Gaia tried to catch the blue-hour light, that fleeting time between evening and dark, more sense than color, like waking up from long sleep to find the world stranger and wilder.

Gaia, the second wife of Giorgio, lives in a beautiful rambling house in Trastevere, the walls filled with her late husband's collection of contemporary work. Tatiana Franchetti's *Ritratto di Giorgio Franchetti* hangs on a wall opposite Twombly's own *Portrait of Giorgio Franchetti* 1967.

Before meeting Twombly, Tatia painted portraits. In one story I can't confirm, Tatiana painted portraits of all the Kennedy children including a picture of John F. Kennedy while he was staying in a hospital in New York City. Tatiana's portrait of Giorgio captures her brother's self-possessed air and incisive gaze, his eyes narrow and intense. The portrait bears a striking resemblance to her son, Alessandro Twombly, something about the lean of his shoulder and the wild flare of eyebrows. The image is painterly, realistic but not photographic, gestural but not flashy.

Twombly's portrait of Giorgio Franchetti contains no human figure. Instead, a large vertical, rectangular shape, with an oval around it, dominates the top of the canvas. A window instead of a man. A body ghosted by form. His living name—Giorgio Franchetti—handwritten by Twombly in blue, is what one sees most clearly in the painting.

Twombly is not often thought of as an artist of the portrait, yet at various points in his career he called paintings "portraits"—of his friends and patrons and dealers, of famous emperors and poets, and a few of himself, distinguished as much by the name on the canvas as any representational shape or fidelity to a photographic reality. Mainly done in Rome in 1967, and mostly of husband and wife pairs, their names handwritten: Paul Getty and his wife Talitha, Giorgio and Ann Franchetti, and George and Ann D'Almeida, and Alvise di Robilant; it is as if he were a Renaissance artist paying tribute to his wealthy and powerful patrons. These works attempt to catch the essence of their subjects, not through precision but motion. It's as if Twombly tries to solve the paradox of portraiture: "the target is always a moving one."[20]

Two of Twombly's earliest paintings were portraits, one a self-portrait from 1947 in ink and gouache, and the other of a friend, the face of a young man in thick blues and beiges and greens, a heavy-handed Picasso imitation, not quite realistic but still very much a face.

His later portraits are acts of love and affection. In *Portrait of Yvon Lambert* 1975, a blue vertical line running down the middle of the tall and narrow canvas turns at an angle about two-thirds of the way down like a reversed L. "Yvon," Twombly joked in 2008 to his dealer, "you were skinny then."

"He portrayed me behind the glass door of my gallery," Lambert recalled of the artist's explanation of the painting's secret meaning, "waiting for a possible collector to pass by: it was a lovely metaphor for a period when making money from sales was not the primary motivation!"[21]

In addition to portraits of his patrons and friends, Twombly titled at least four paintings from 1962 *Portrait*, and three from 1963 either *Autoritratto* or *Ritratto D' Artista*. In one of Twombly's "portraits" of this time, a rectangular box, hand-drawn, is filled corner to corner with a large X. It is as if they are pictures of the idea of portraits and not of a particular individual. As another critic wrote, a statement true of so much of the

artist's work: "Rather than paint a subject, Twombly paints the subject of painting—the moment of the idea."[22]

In *Portrait of a Young Man* 1962, a triangular shaped swirl of pencil and oil dominates the center of the picture, not unlike his later renderings of Achilles in the shape of an A. Next to the central shape, the "young man" is a straight line, plumb line, or height. Or maybe it's not a portrait of a young man at all. "In Twombly's titles, we must not look for any induction of analogy," writes Roland Barthes. "If the canvas is called *The Italians*, do not look for the Italians anywhere except, precisely, in their name."[23] There's nothing straightforward about Twombly's lines or words. There is nothing sure in the name.

I stood before the two portraits in Gaia's house, one by Cy and the other by Tatia, seeing not the difference but their similarities. Each of the paintings of Giorgio attempts to catch the man, not the angle of his nose or the arch of his eye, but the unfathomable mystery of him. "The picture," claimed Lucian Freud, "in order to move us must never merely remind us of life but must acquire a life of its own, precisely in order to *reflect* life."[24] Radically different in approach, the two portraits are part of the same conversation, the same thinking through, the same struggle—which is my struggle, indeed the struggle of every artist—of how to give a portrait "a life of its own."

8

TATIA

CY AND TATIA FIRST MARRIED at City Hall in New York City on April 20, 1959. Another ceremony took place at a church in Rome on July 8, 1959. This second wedding, unrecorded in any book about the artist, was captured in intimate photographs by Camilla McGrath, a close friend of Tatia.

"In marrying Tatiana Franchetti," writes Valentine (Nick) Lawford, the artist gained, through her family, entrance to an "international, intelligent, liberal, upper-bourgeois Europe." From Tatiana's great-grandmother, who had tea with Liszt, to her art collecting and Oxford-educated grandfather, her family was filled with eccentric, independent, and well-connected relations: "Mrs. Twombly's Bavarian-

born grandmother, the sister-in-law of the painter Lenbach, lived in state at Bellosguardo near Florence where she ruled the local German colony with a rod of iron."[1]

"Roman Classic Surprise," Lawford's admiring, name-dropping 1966 *Vogue* profile of the pair accompanied photographer Horst P. Horst's striking images of their Rome palazzo on Via Monserrato. In it Lawford describes Tatia's father, Carlo Franchetti, "noted Anglophile, airman and sportsman," as "a talented draftsman and a man of famous charm: a talent and charm which his daughter has inherited in full measure."[2] The Franchettis had money and power and freedom. They went alpine climbing and downhill skiing and spelunking. When she was five, Tatia explored caves with her father. It's a striking contrast to Twombly's own childhood—his refusal of sports, his melancholy, his middle-class background.

Tatiana's last name, and all it implies, reveals and obscures what's so captivating about her, in and of herself. She was brilliant. She was shy. She was mysterious. She captured people's attention with her innocence and openness and generosity. "Her manner is extraordinarily gentle," writes Lawford.

TOP: **Tatiana, Rome 1959,**
Photo: Camilla McGrath
BOTTOM: **Cy, Tatiana, and Stefano Franchetti, Rome 1959,**
Photo: Camilla McGrath

"She is unsurprisable, unshockable, and ever ready to laugh. Like a reed in La Fontaine's fable, she may often have to bend, but it is inconceivable that she should ever be broken."[3]

Her strength, as in that fable of the Oak and the Reed, comes from her easygoing nature, her flexibility and grace.

In a way, the woman described by her friends isn't that far off from Twombly, or at least Twombly's presentation of himself. Off in her own world, a private universe where animals and plants were as interesting as people, where the conventions for a woman of her class and country held for her no interest.

To write about Tatiana is to encounter similar problems as writing about Twombly, though it's perhaps even more difficult. She died in 2010, a year before him. The only portrait I've seen of hers is the one she painted of Giorgio. She gave no interviews. There are no museums with archives of her letters. No biographies. No catalogues. No dissertations. Instead I have had to rely mostly on the scant written accounts of her and her family, and the memories of the people who knew her. What is clear is that Tatiana Franchetti would never be defined by the roles assigned to her by the world into which she was born: sister, wife, mother.

She was, as one friend put, "like air, hard to catch."

In a tongue-in-cheek letter back to Rome, Twombly announces that Shirley—one of his pet names for Tatiana—was pregnant. He tries to make light of the situation but the news must have been unnerving—changing their plans and their lives. To Giorgio, Twombly wrote, "I bet that kills you the idea of getting us back there after you thought you had gotten rid of us for at least a year."[4]

They spent their honeymoon in Cuba and Mexico before returning to Rome. There's a photo taken by Tatia of Cy in Cuba. He sits alone at a two-person table, a simple tablecloth, a decorative pattern of grape leaves curl over the edge. A tank top reveals his thin and tan arms. One feels the heat, the hot air and bright sun. No smile, he glares at the camera, one hand on the empty glass and the other around the back of the chair. The table is set but there is no food; the place across from him untouched, glass overturned, chair empty. Her photograph isn't a casual snapshot, but a careful and thoughtful composition, the white

light through the drawn shade, the curve of Cy's arm like pattern on the tablecloth, the empty tables and chair in the foreground that fill the frame.

Not every painting or photograph is a metaphor. A work of art exists in and of itself and without reference. At the same time, there is a story in and around this moment, a subtext like a pulse. They were in a place where the camera could've been handed to the waitress or the cook, where they could've sat across from each other and smiled. Held hands across the table. Not a conventional honeymoon; not a conventional marriage.

In some of Horst's photos, Tatiana sits in the driver's seat of her 1928 Alfa Romeo. Twombly, on the far side of the car, stands in leather trench coat. Her love of old cars is well known. Sometimes with Cy, and sometimes on her own, she participated in road rallies across the continent. A window into her passions as much as it is a window into the differences between them.

To join the Franchetti clan was to become part of their world. In one letter to a friend in Rome, Twombly cast himself as an illegitimate child in their family. He belonged and he didn't; Twombly, always the insider and the outsider, the exile and the citizen, the guest and the resident.

After hearing Twombly's gossipy stories about the odd habits and poor choices of the Franchettis—an overblown opera about Christopher Columbus by an uncle, marriages to famous actors—Edmund White wrote, "Twombly loves to talk about the Franchettis, whose history obsesses him. Sometimes he is mildly contemptuous of them, but one senses that the contempt is proof of his privileged access to the people he admires so much."[5]

Isabella Ducrot, a visual artist in her seventies, lives in an apartment on the fourth floor of the Palazzo Doria Pamphilj. The palazzo's first two floors are a museum, one of the best in Rome: Velázquez's portrait of Innocent X, the jewel of the collection. To enter Isabella's apartment is to slip into the Rome of other centuries. Twombly was my password to these great rooms. Enormous Italian baroque paintings collected by

her husband ("for years no one wanted them") and Indian art and modern abstract canvases fill the walls. Unlike Twombly, she doesn't have her own art on the walls—old tapestries and textiles, painted, collaged, undone and remade.

Isabella and her husband, Vicky—a Sicilian, as more than one person told me, the regional bias of Italy never far away—organized the trips that Cy and Tatia and Nicola and Alessandro went on, sometimes just Cy and Tatiana, sometimes husband, wife and "Del Roscio" as Isabella refers to Nicola, and sometimes all of them together. A family.

From their first trips to Tunisia in the 1960s to later expeditions to Iran and Syria, India and Afghanistan and Greece, Isabella got to know all of them, a friend to both Cy and Tatia.

One might mistake Isabella for an ex-ballerina. She is tall and moves with an easy grace: the way her hand pushed back a bit of her silver hair or how she pointed to a picture in an old photo album, one of Cy sitting on the floor of a Tunisian hut, his face half-turned away. "He hated having his picture taken," she told me when I visited her in Rome. The same spotlight-shyness seems true of Tatiana, absent too from most of Isabella's pictures.[6]

Before their trips, Tatiana would study the maps of their destinations. From above on the airplane she could always describe what was below, naming places and geological landmarks, just one example of her original, brilliant way of seeing the world. "A real artist in the way she lived and looked at things. An extraordinary person," said Isabella, a description that might apply to her as well.

She told me a story about a time they were traveling in Uzbekistan. The group came across a field of blue flowers. Tatiana started digging up a few bulbs to take home. The others in their group followed her lead. "She despised them," Isabella said. "She said to the others digging, 'Will you leave some for Alessandro?'"

Tatia did only what pleased her, never following the lead of others. At the same time it's a story that, unintentionally, shows a less flattering side of Tatiana; one can see why some who knew her might call her "arrogant" or "snobbish."

Isabella remembered too how Tatiana, pulling up bulbs to take home for her own garden, described this field: "the roof of the world is

full of blue irises." Strange and luminous, it's the kind of description that one might find in one of Twombly's canvases, a line from a borrowed poem.

▌

After they married, Tatiana stopped showing her portraits.

"One strike against Cy is that she gave up painting," said Milton Gendel, an American who like Cy and Betty came to Rome as a young man and never left.[7] Tatiana put his work before hers, a one-artist family. Instead of painting, she had other interests, other passions: gardening, walking, traveling.

A friend to the wealthy and well-named, Gendel is famous, in a minor-key sort of way, in certain Roman circles. Before Tatia met Cy, he was friends with the Franchetti siblings, spending time with them at their house on Via Appia Antica. These were the days when the *centro* was considered unfashionable and everyone wanted to live outside the city. Days when, if you had a car, as he did, you were very popular. "I could drive to Via Corso to the bank, park, and jump in the car again," he told me.

But Tatia didn't stop painting completely, she only stopped taking commissions for her work. She painted occasionally, but only for herself. Alessandro found a bunch of her paintings behind a cabinet after she died.

Tatiana, like her husband, was a collector. She gathered objects from her travels: little portraits of the natural world. In her studio, a space between the floors in their palazzo and reached by ladder, she "kept her apothecary jars, brimful of dried insects, shells, snails and other nature finds."[8]

And what she collected most and for longest was roses, cuttings gathered from her adventures. Old roses—Alba, Gallica, Damask, Moss, Rugosa—like any artifact of the past, mosaic or kylix, offer a link to the ancient world. The living past, transplanted from soil to soil, or grafted, or merged, so that it might have another life in another garden. One imagines Alexander the Great collecting cuttings and planting them across his empire. The rose, like a story, any story worth telling,

is bloom and decay, rank and lovely. It is a history and a future in one.

A 1991 profile in *Vogue* of Twombly describes Tatiana's love of roses, a small window into their complex relationship. The reporter writes, "He travels all the time, sometimes with his wife, Tatiana, who nevertheless leads a highly independent life of her own, and whose hobby is collecting old rosebushes—she was on a rose hunt in Turkistan at the time of our visit to Gaeta. (Their 34-year-old son, Alessandro, who is also a painter, collects iris tubers.)"[9]

To see Tatiana in the story of Twombly's life and art we have to read between the lines. I don't know which is more suggestive, the phrase "highly independent life" or the absence of Nicola's name from the article.

▌

"Tatia had very good reds. And I used them," Twombly said in a conversation about the baroque *Triumph of Galatea* 1961.[10]

It's a rare moment where Twombly acknowledges Tatiana's artistic background. A rare moment when he mentions his wife. A moment when they seem like collaborators in the life they shared. A moment like the letter to Giorgio in 1959 in which Cy writes that it was Tatia's kindness that held him together.

She was, at least at the start of their relationship, in admiration of Twombly. She dedicated herself to him and his work. She tolerated what many wives or husbands would not have allowed. At the same time, "Tatiana was not the kind to organize exhibitions or go to openings," Gaia Franchetti told me the night of the photo shoot in her garden. "She would've hated going to parties, being an artist's wife." She then added, "Wild."[11]

Tatiana's influence on Twombly is hard to describe exactly. Practically speaking, she had money and connections. She made the purchase of their Rome palazzo possible. She made Twombly's life as an artist, free from the obligations of daily work, possible.

But her influence goes beyond that. I want to see, in his own interest in portraits, her influence too. Cy trusted her opinion about his work.

She offered the perspective of an artist, an exchange of equals. In an uncanny repetition of what many people have said about Twombly, Tatia had a "good eye." Her "taste," claims Hamish Bowles, "is legendary."[12]

Bowles gives the credit for that first beautiful interior in Rome to Tatia, not Cy. This is not his vision—Roman busts and Pop Art, gold-gilded chairs and a fur draped over their bed, empty rooms "bare-windowed and picked down to the bone . . . as a tree in winter or a shell on a beach"—but hers, or as likely a shared one, a collaborative venture in the spaces they inhabited together.[13] "Those pages," Bowles writes, "proved an epiphany for a whole generation of tastemakers."

Decades later, the magazine *Nest* reprinted photos from the *Vogue* shoot, a celebration of Twombly's genius as a maker and arranger of spare interior spaces: "You are looking at the birth of a new style of interior decoration. The rooms belong to Virginia-born painter, Cy Twombly, who having moved for good to Rome in 1959, took up residence with his wife and child in a seventeenth-century palazzo." Tatiana isn't credited—or even named.

∎

In a set of drawings dedicated to Tatia, *Untitled (to Lola)* 1961, Twombly borrows lines from Rilke's *Letters to a Young Poet*: "The Sadness that / Cast a Shadow / Across her / heart." Lola, like Stella or Shirley or Little Star, was one of his endearing nicknames for Tatiana.

Twombly often made many versions of the same drawing, obsessive returns with only minor changes or differences. The phrase from Rilke is sometimes "over her heart" and sometimes "across her heart." Should we read that line as a gloss on Tatia's moods or Twombly's? What is the shadow? Does it cover "over" her heart, or pass across it? What did she think of these drawings?

The questions only continue: What do we make of a painting titled *Untitled (Scenes from an Ideal Marriage)* 1986, perhaps an ironic reference to Ingmar Bergman's *Scenes from a Marriage* and the domestic narratives of affair and divorce, fight and reconciliation? Knowing of Tatiana's love of roses, are we supposed to see the marriage of Cy and

Tatiana in the 1988 sculpture of a black rose emerging from a stone set upon a velvet-lined box, a little plaque engraved with the phrase, *That Which I Should Have Done, I Did Not Do?* The black flower, like a terrible apology, like a swipe at romantic convention, like bad news.

"I hate roses," Twombly once said in an interview. "Don't you? It's all right if you can hide them in a cutting garden, but I think a rose garden is the height of ick."[14] The conversation, from 1994, is a little more than a decade before Twombly painted his enormous Rose Paintings, now permanently installed at the Brandhorst Museum in Munich, a room like a rose garden. Twombly's acerbic view of the roses is deeply ironic given his own obsessive canvases. It's hard not to read his claims in light of Tatiana's lifelong love of roses, and her own rose garden planted from the cuttings she gathered from around the world.

Twombly once told a story about visiting Joseph Cornell at his house in Utopia Parkway, Queens. Cornell's mother took him out to the side of the house where some tulips had been planted in a tiny strip of dirt. She spent too long, a couple of hours by his account, talking about a couple of lowly tulips. Decades later, Twombly would make a series of photographs, close up and out of focus, of tulips; these photos, gathered together for a show in Munich, and later published as the book *Tulips: Fifteen Photographs*.

What little Twombly said—or wrote—is not law. It is not certainty. Read the biographical, but beware. This is the true warning inscribed in each of the poetic lines Twombly borrows, lines that resist certainty, that can be read as ironic or sincere, sometimes at once—over her heart, or across it, scenes from an imperfect marriage, or scenes from an ideal one.

There is always a mystery, a concealment, at the heart of Twombly's work and life. And yet we still try to put it down, repeat the lines, retell the stories. "I realize that this background (or what gives me the illusion of being a background) is something I could never produce," writes Barthes about his own failed attempts to redraw the works in his own hand. "I don't even know how it is done."[15]

Mystery is power.

"Tatia knew very well how not to hurt yourself," explained Gaia. "So too with Giorgio, a strong control of self. They were zero neurotic and encouraging, enjoying life." It is hard not to think of the contrast between Gaia's descriptions of the Franchetti siblings and Twombly's anxious personality. "Cy was a person with a strong, oversensitive nervous system," Nicola claims in an essay. "[O]r shall I call it depression?"[16]

Perhaps for Twombly this was part of the attraction. Tatia, and the Franchetti brothers, offered him a perspective on the world that was far from his own. I like to think they offered, in daily practice, an image of the person he wanted to be.

But the interior life of a couple is like a house with its blinds pulled down, at best a shadow play of shifting forms. Thinking about Tatiana and Twombly, their lives together, I go back to Eavan Boland's poem "Quarantine." The poem is a caution against thinking we can know too much about history or love. Boland writes of a couple, a man and woman, during the Irish famine who went walking from the workhouse in search of food, and who died, and were found, frozen, her feet against his chest. The heat of his body was his last "gift." The poem ends with warning and this "merciless inventory": "And what there is between a man and woman. / And in which darkness it can best be proved."[17] By time and need, trust and fear, all those invisible threads of dependence and desire, what it is between partners—husbands and wives and lovers—is from the outside a mystery.

POEMS TO THE SEA

AFTER RETURNING TO ITALY FROM their honeymoon, Cy and Tatiana spent July and August of 1959 in Sperlonga, a picturesque fishing village down the coast from Rome with a view of the blue Tyrrhenian Sea. It was clear now that Twombly would remain in Italy, at least for the foreseeable future. When he returned to New York earlier that spring, he could've easily stayed in the United States. He was unmarried. There was no child on the way. When they returned to Italy, he was, and was not, the same man.

"This was 1959. Tatia was there—she was expecting Alexander. It was a Saracen village. No tourists there—they had just opened up the road. It was just a white town," Twombly said about that time and the

making of *Poems to the Sea*, a series of twenty-four drawings completed in a single day.[1]

In the interview, Twombly doesn't say that he had been going to Sperlonga since his return to Rome in 1957. He spent several weeks at Giosetta Fioroni's apartment in Sperlonga around this time.[2] All the rooms of her flat were free but he slept on the balcony, only a sleeping bag, a lamp, and the open sky above him. Giosetta described too that one day, they saw a "blond, beautiful Canadian boy" running on the beach. Everyday after, at noon, Twombly and the blond jogger would "run away together." It was not love.

Giosetta told me that story without thinking of what it would mean or who would care about something that occurred so many years ago. It wasn't a story told to embarrass, it just happened. It is impossible to confirm the details of that time. The blond runner, like Twombly's desire to sleep on the balcony, were more vivid to her than the year, 1957 or '58, she couldn't quite recall.

To retell the story is to risk salaciousness but I do because it's another story about Twombly's sexuality that doesn't fit neatly into his later depiction of himself: a newlywed in an isolated village making art, the young expectant father—all the markers of his new, straight life in Italy.

▌

In the months before my daughter was born, my wife and I lived on the far edge of Cape Cod in a tourist town empty for the winter season. I walked to the beach each morning and looked out over the water of the bay. I thought of that blue line across the drawings of *Poems to the Sea*. The line shifts slightly in each drawing, a divide between sea and sky, between above and below, between past and present.

I was struck at the time between the parallel of our lives and that of Twombly and Tatiana, a reverse mirror: our constant view of the cold ocean, a child on the way, the dominant color not white, but gray. The gray of winter, the gray silence of the off-season when tourists disappear and T-shirt shops hang handwritten signs in the window: *Thanks for a great season see you in May.* The gray was the color of the waves, the sky, even the birds were flits of puffed slate against the sky.

The more time I spent with the *Poems to the Sea*—reproductions, as always, fail to capture the energy of his lines—the crossed-out lists, the doodles and curls, the approximations of wave or wind, the Xs and triangles, the numbers—the more I understood them.

My understanding of them wasn't rational. Instead, I let myself experience them without trying to impose a narrative—*A man looking at the sea* or *A father thinking about his future son*. I tried to pay attention to the way in which each erratic mark or erasure shows the hand in flights of reason and imagination, tension and release.

"Each line is now the actual experience with its own innate history," writes Twombly in that sole essay from 1957. "It does not illustrate—it is the sensation of its own realization."[3] Said another way, Twombly's pictures never seem far from their making. An immediacy even after the ink or paint dries.

Influenced by his reading of French symbolist poet Stéphane Mallarmé, or so he claimed, the irregular squares of *Poems to the Sea* are dense accretions, a lattice of illegible calligraphy. Twombly's work, here and always, swerves from playful to meditative to literary, as if this range is proof of a brave and restless mind.

Just as in later drawings, *Letters of Resignation* or the screen print *8 Odi di Orazio* (8 Odes of Horace) 1968, for example, the suite of *Poems to the Sea* invokes the literary. But "invokes" isn't the right word. To collapse the very definition between a drawing and a poem, to ask if the boundary between them is more fluid, more uncertain, than we often think—this is Twombly's ambition.

The drawings—the "poems"—are composed "to" the sea: ode or elegy, plea or offering. Is each one of the drawings a poem? Is each mark a poem? Perhaps they are what the mind looks like in the process of making a poem, a pentimento of thought. Or, are they X-rays of a finished poem's bones and organs? Below ordered lines and neat stanzas, a poem miswritten, erased, revised. Then again, maybe these are poems in the sense that a poem is as much about what's unsaid as what's said, the white space of "eloquent, deliberate silence."[4]

Cy, 1959, Photo: Camilla McGrath

In Sperlonga, below the hillside houses, sun-bleached buildings like stacks of dirty sugar cubes, blue umbrellas bloom across a curve of sandy shoreline. The air tastes of salt. The color white is everywhere: in the whitewashed buildings, in the hurricanes of seagulls picking at the tideline, in the sky on bright days, even the water.

"Whiteness," Twombly wrote, "can be the classic state of the intellect, or a neo-romantic area of remembrance—or as the symbolic whiteness of Mallarmé."[6] It is the "symbolic whiteness of Mallarmé" that Twombly claims for *Poems to the Sea*. If white is a color of purity or creation or intellect, a whiteness that consumes as it covers, then it is also the color of erasure. Scattershot marks of white paint in *Poems to the Sea* cover, hide, layer. The snow that blankets the fields. The fog that hides the sea.

I'm reminded of a story Isabella told me about a time she was in Syria with Twombly. Inside of a temple in Aleppo, a temple that has probably been destroyed, Cy said to her, "White always works." He was speaking as one artist to another, a shared secret about his process of thinking.

"I felt a disillusion at this," said Isabella. "Way too easy a way to solve an aesthetic problem."[7] Maybe white "works" for Twombly because its range of references is so wide. White of another consciousness, white of intellect, white of remembrance. "White paint," he said, "is my marble."[8]

Maybe white "works" because what he describes as "white" is never that. In his sculptures and paintings, white is never the white of new dice or sheets hanging between apartment buildings, but something washed out. A surface that was white, once, long ago. White before the salt-heavy winds and the scorching sun. White before graffiti and piss and all the other human ways of saying, *this is mine* or *I was here*. White, then not, and then all the attempts after that to whitewash it back. Whitewashed is not the same as symbolic whiteness. The white he loves, and returns to, is grittier, dirtier, wilder, and contradictory.

Whiteness, and all it symbolizes, was a lifelong obsession for Twombly. Not the cold classical order of things, but the white of the burned-out past: the calcified, the layered, the almost lost. The white isn't perfect but lived-in. It's how to look up close at a bone is to see flecks of black and gray. Sperlonga might seem, from a distance of space or time "just a white town," but wandering through the narrow passageways, touching the walls, it is anything but.[9]

One of the wonders of Twombly's art is how much it changed, and at the same time how it stayed steadfast to certain ideas or images. "My ideas at a time are maybe too singular," he wrote to Leo Castelli in August of 1959, an acknowledgment that when something inter-

ests him—a landscape, a myth, a color—he doesn't let it go.[10] From the drawings in the suite of *Poems to the Sea* to the multiple versions of one drawing—the hundreds of times he made an A for Achilles—to his returns to the same myths—Leda and the Swan or Narcissus—he is an artist of obsession.

On taking the train down the Italian coast, from Rome to his later home in Gaeta, just over the hills from Sperlonga, Twombly said,

> The sea is white three quarters of the time, just white—early morning. Only in the fall does it get blue, because the haze is gone. The Mediterranean, at least—the Atlantic is brown—is always just white, white, white. And then, even when the sun comes up, it becomes a lighter white. Only in the fall is the Mediterranean this beautiful blue colour, as in Greece. Not because I paint it white; I'd have painted it white even if it wasn't, but I'm always happy that I might have. It's something that has other consciousness behind it.[11]

White, in the words of Twombly, "has other consciousness behind it." It is ever present and inevitable.

When I first read that description of the train traveling down the coast to Gaeta, the artist watching the waves crest, I misread "I'd have painted it white even if it wasn't" as "I'd have painted it light even if it wasn't." For as much as Twombly's work depends on whiteness, negative space, and erasure, his works inhabit and project light. To explain why he was "enraptured" by a Twombly painting, one critic comes to the conclusion that it was because "Light appears to have become a substance."[12]

▮

Poems to the Sea sold for 21 million dollars at auction in 2014, far exceeding the estimated sales price of 6–8 million. It's ironic to read of Twombly's anxious letters at the time of their making, and his concerns about prices—higher at the time in Europe than New York. More than his worries about money, there is an uncertainty, a despair about the state of his new work. After initially showing at Leo Castelli's new

gallery as part of a group exhibition in 1958, plans were made for a solo show.

In another letter to Castelli in August of 1959, Twombly wrote that despite the appearance of being difficult or uncooperative, the truth was that he had produced "nothing." He promises to have everything ready by the spring. This long summer away, in Sperlonga with Tatia, when he made *Poems to the Sea*, produced, in his words, "nothing." The drawings weren't shown until almost six years later.

"I was relieved to get your letter," Castelli wrote back later that month, "and at the same time a little disturbed. I don't know whether you are quite aware of the fact that this is your first show in New York after four years . . . therefore, we cannot afford to compromise for the sake of my or your convenience. I am willing to postpone it for a month or two, but I feel that I must have your best work available to show here."[13] Castelli asks that he send "the four new paintings and the revised black one."

A back and forth exchange with frustration on both sides. Castelli wanted Twombly to finish the paintings he promised. Twombly worked at his own pace and desired to get the works right. This was, finally, more important than a single show. Almost three weeks later, in September 1959, Twombly wrote a Western Union telegram back to Castelli: "Everything up in the air and working hopeless will have to postpone show until another year terribly sorry, cy."[14]

Tension between Twombly and Castelli continued for years. In one letter from 1961, in an often frustrated tone, the artist wanted to know what was happening with his paintings, for his dealer to be "more considerate concerning the sale of pictures."[15] Twombly was hungry, not just for sales, but for information about the business of selling the works.

In another incident, in May of 1962, Twombly refused to be part of a drawing show at Castelli's gallery. Ileana Sonnabend, Castelli's wife and partner, tried to convince Twombly of his "mistake." At her apartment in Rome they argued over his refusal and tone in response to Castelli's invitation.

"Bitch," he called her and Sonnabend threw him, and Tatia, out of her apartment.

"I did not question the substance of your letter," Sonnabend wrote

to Twombly the next day, "but the wisdom of it in its form . . . As for your outburst and Tatia's, I do expect an apology."[16]

"You probably don't realize," she continued, "as I have while I was there, the importance of Leo's gallery right now, and how good it is to be in it."

Sonnabend saw what Twombly, living in Europe, couldn't have known about the state of the New York art world and the market he was anxious to be a part of.

▌

"Everything up in the air," I read and think of how hard it is to wait. How hard it is to feel great changes coming. The ecstatic rush of finishing twenty-four drawings in a single day, the mind hurried by ideas, the quick euphoria, and then the reverse, worries and anxieties that send the next days into shadow and paralyze the mind and the hand.

In drawing XXIV of *Poems to the Sea*, Twombly has drawn a question mark inside a square at the left side of the picture. I love that mark. A little frame around all of the uncertainties—set apart and held up and contained. That mark like a buoy in a turbulent sea.[5]

I think too of Tatiana. "Everything up in the air," Cy writes about his art, that doubt about direction and his worries about success. But everything for her too was changing and changed. Not only her life, but her very body.

I remember my wife's body, those days on Cape Cod, when heavy darkness settled over the bay in late afternoon, the globe of her belly and how, hand on skin, I felt the kicks and punches from within their sheltered walls. This new life, strange and unknowable, terrifying and thrilling, distant and close at once, a horizon line about to change.

THE AGE OF ALEXANDER

"MY LIFE HAS BECOME HOPELESSLY and grandly spoiled. I am now the owner of a beautifully long grey eyed blonde son named Cyrus Alexander and an enormous 17th C. Palace near Piazza Farnese," Twombly wrote to Castelli shortly after his son's birth on December 18, 1959.[1] The son's first name, Cyrus, echoes his father's and grandfather's nicknames, though Alessandro, like his father, doesn't go by his first given name. He goes by the Italian for Alexander, Alessandro.

Against the excitement of Twombly's letter, his pride for his new son and home, the surprising shape of his Italian life, is the anxiety one senses in his painting *The Age of Alexander* 1959. A title borrowed from Plutarch, Alexander is both Alexander the Great, the Macedonian king

who stomped his way across Asia Minor, and Alexander the small, the infant. This is his age, his kingdom and domain.

Like *Poems to the Sea*, the painting was created in a single day. Rome, New Year's Eve, 1959. The cusp of one year to the next, one decade to the next. "To paint involves a certain crisis," Twombly writes in that 1957 essay, "or at least a crucial moment of sensation or release." For hours, as streets filled with people celebrating the new year, Twombly painted and drew, filling the white void of canvas with uncertainty and promise. New life, new age.

Literary and historical and personal, *The Age of Alexander* is a massive work, over 9 feet x 16 feet, full of white space between the "delicate notational episodes and graphic outbursts."[2] You can't take it as a whole. You have to see it in parts—fragments, textures, shapes, signatures. It's both wild abandon and careful mark. A space that's both, paradoxically, full and empty.

The painting, with its little ideograms, its words in pencil, some drawn into smears of wet white paint, forces one to get up close and then pull away. Critic Brooks Adams, comparing the piece to the famous Alexander Mosaic in title and subject, writes of the painting's "deployment of graphic 'troops' and the occurrence of pictorial skirmishes between paint and pencil suggest a huge battle painting."[3] The battles of the painting are both public and private, ancient and present-tense.

"Why should these things, when put together, add up to an art that you ache for but cannot fully hold on to nor understand how it does as it does?" asks the artist Tacita Dean of Twombly's art. "I don't know of another visual artist who can achieve this, although writers sometimes do."[4] Just as a good poem might be said to occupy more space than its words, Twombly's parts and pieces, the fragments of his making add up to more than a sum of their parts. His canvases gather and build, multiply, progress.

▌

When you enter the Cy Twombly Gallery at The Menil Collection in Houston *The Age of Alexander* hangs in the room immediately to the left. For years, I always turned right. *The Age of Alexander* never called me.

Until it did. Now I can't help but see how intensely personal it is, how the painting is an act of struggle and questioning. Maybe it's that we're partially blind to the world until it concerns us, a selfish need to see ourselves reflected and named, for our questions to be voiced. Maybe this is a painting for fathers, a mostly illegible manual of instruction for fears and worries and wonders.

The words inscribed in Twombly's hand on the enormous canvas— *1959 into (1960), Sad flight, Floods, (Kill) (What)?, What wing can be held, Whiskey Anymore?*—doubt and ask: what now, what else. The question mark, like that single boxed question in *Poems to the Sea*, is not used often by Twombly. His borrowed phrases and lines are usually statements—"I have known the NAKEDNESS of my scattered Dreams" or "Honor to those who in their lives are committed and guard their Thermopylae" or "The blissful clouds of summer-indolence"—by which Twombly arrives at his perpetual themes: time and mortality, desire and secrets, pleasure and consequence, melancholy, nostalgia, and occasionally, hope. Questions without answers are essential to the ecstatic wonder of *The Age of Alexander.*

Twombly's work resists an easy reading. There's always some intention that stays submerged, guarded from interpretation: a personal dictionary in a strange, lost language. "Something always seems left out," writes one critic, "blurred, made invisible, but only just barely, so even this invisible something that should hide is intentionally visible."[5] As true for the work as the man. There and not there. Said and unsaid. Even still there's a feeling that is hard to put into words, "an art that you ache for but cannot fully hold on to nor understand." Yes, it's a painting in which his son Alexander is named explicitly. But the sources of Twombly's work overlap and radiate. The Alexander Mosaic. Alexander the Great. Mallarmé and Sappho. Rome.

The signs in *The Age of Alexander*, the word WING, or the phrase *What wing can be held*, all caps, can be read as markers of freedom and escape, of transience. But in the context of his other work, the wing, as word or sign, becomes more private. Like the pea-pod charm or windows or boats, wings are one part of Twombly's personal lexicon, particularly in works from the early 1960s: *School of Fontainebleau* 1960 asks "how to hold a wing" and the drawing *Study for the School of Athens* includes a

Sappho passage "the bright air / trembling at the heart to the pulse of countless / fluttering wingbeats."

The list goes on: the wings aflutter and chaotic in Twombly's many versions and variations on the myth of Leda and the Swan, the mysterious destroyed painting *Desert of Love* with the word WING clearly written on the canvas, or *Herodiade* 1960, with its Mallarmé quote from his poem of the same name, "abolished, and her frightful wings in the tears / of the pool, abolished, that mirror her alarms." The last word is mostly illegible; in one critical essay on the painting, the word is transcribed as "dreams." How in Twombly's hand, one word can become another, and even scholars who spend hours looking mistake dreams for alarms, mistake one meaning for another.[6]

I met Alessandro in Rome for the first time in the spring of 2014. A quiet restaurant near the Spanish Steps, white tablecloths and waiters in starched black aprons, past the death-room of Keats enshrined in velvet and ether, past the shop windows glimmering with Prada handbags and Bulgari diamonds. The pension where Twombly and Rauschenberg first stayed is a block away. The ghosts of the past collide with the commerce of the present, a tidy tagline for the state of modern Rome.

Tables of lawyers and bankers and businessmen on their lunch hour talked in low voices. As I looked across the table, I tried to see his father's face, and in certain moments I did. An artist like his father, most of Alessandro's paintings are of large flowers—bright pinks and oranges and reds. They resemble his father's late works with their florescent petals and stems, their huge gestures. And like his father, he works in sculpture too, forms that evoke bulbous reefs or wasp hives. Did the father borrow from his son or did the son borrow from his father? It's a question I can't answer, though I've heard both versions.

Alessandro shares with Cy a far-off look, a sense that more is thought than revealed. What Alessandro knows about his father and what he's willing to say are not the same. Talking to Alessandro is what I imagine interviewing Cy would be like: questions are unanswered and answers digress away from the self.

When Alessandro talked about his farm of hazelnut trees and olive groves, a gentleman's estate an hour outside of Rome, his eyes brightened. Hazelnuts, he told me, can only be grown in certain volcanic soils. He's a man of small facts, little gems of knowing, though he carries himself in a way that is modest and unassuming.

A friend in Rome described him as shy, but that's not the word that comes to mind. Restrained, perhaps. Shadowed. "He doesn't say much," his wife told a reporter with "masterly understatement."[7] There's something unassuming about his manners, and yet he ordered the waitstaff with the confidence of a man who wants what he wants. He is not someone who looks at the prices on a menu.

On the one hand, Alessandro sees his father clearly. Of his restlessness, his moves, Rome to Bassano in Teverina, Gaeta to Lexington, Cy wanted to "create a new world" in each of these places.[8] The utopia of new beginnings. No place is home. No place is not home.

"I don't want to get in my father's head," Alessandro said when I asked if he knew why Cy stopped talking to Betty Stokes.

Curiosity doesn't drive Alessandro, though not because he isn't thoughtful. Perhaps the fame of his father makes asking these questions unimportant. Perhaps these are questions that he stopped asking years ago. It's not that Alessandro isn't being honest or is evading the truth, it's more like he has built a wall around the pains of his youth, the difficulty of being born into a world where you, as a child, don't quite fit.

I recently met a young writer, the son of a very famous novelist, who carried in his handshake the jittery anticipation that you'd ask about his last name, or that you already knew and had judged him the lesser writer. Every artist, I think, feels belated, that he or she has come late and must live in the shadow of the past. To be the child of a great artist is a particular kind of burden and privilege.

Just as Cy Twombly would always be his father's son, Little Cy or Cy Junior to the older folks in Lexington, Alessandro can never not be the only child of Cy Twombly. When he is described as a painter—as in "Alessandro, who is also a painter, collects iris tubers"—the word "also" or "too" is almost always present.

I think of the story Twombly told Dodie Kazanjian in her 1994 pro-

file of the artist. At lunch, while children dashed around the tables of the restaurant, Twombly said "ruefully": "'Alessandro was such a good child . . . If you sent him out to play, he'd send back a note saying, 'I'm in the garden.'"[9] I'm unsure how to read the writer's judgment of this story as being told "ruefully." I can't help but think of Twombly's own father, his lifelong athleticism and love of sports, and his son, who wanted nothing more than to be an artist. What kind of son did Twombly wish for? What kind of father did Alessandro want?

Shortly before Alessandro was born, Cy and Tatiana bought a palazzo in Rome. Or, to be more precise, with Tatiana's money, they bought their new home on a narrow cobblestone street in the *centro*, near Piazza Farnesse and Campo de' Fiori. These were the rough days of protests and prostitutes and petty crime, this undesirable, dangerous part of town, all ruins and rage.

For many years the vast, drafty rooms of the apartment on Via Monserrato were his primary studio in Rome, and later storage for the works he couldn't—or wouldn't—sell. Though he kept a studio just around the corner in Piazza del Biscione for five years, and later would work out of his home in Bassano and then Lexington, Via Monserrato was a central place for Twombly, a constant in his restless life.

Palazzo in Italian can mean palace or simply building or apartment. Reports sent stateside by friends and family suggested Twombly lived in a palace, a place of lavish wealth. I'm not sure how much Twombly did to correct this impression.

The home Alessandro described to me, however, seems far from a palace. Heated by coal in the 1960s and then kerosene, the apartment, cold and drafty, was divided into two parts: one where Alessandro lived with his mother; and the other, where Twombly lived and worked, his spartan and private life. Separate wings and divided spaces, a physical metaphor for their lives—one roof, different homes.

"He didn't like comfort," Alessandro said. For a time, he told me, Cy only had a single electrical outlet by his bed for reading and used a flashlight for the rest of his wing. He demanded his private space. He

covered his part of the apartment in upholstery to block the sound from the restaurant just below, a little fortress of solitude amidst the noise of Rome, the noise of domestic life.

How far from the luxurious images in Horst's 1966 *Vogue* shoot: Cy's bright paintings and the marble busts of dead emperors, antique furniture and the whitewashed interior, stripped bare: a picture of luxury and wealth.

Or so I remembered. Alessandro forced me to look again, more carefully at the images. In one photograph, from Horst's archived roles of film, reprinted years after in the interior design magazine *Nest*, Cy lurks in the corner, a room of white, blue, and red floor tiles, a cape over his body, a black leather day bed (white pillow, crumpled sheet) is the only piece of furniture in the room. The hexagonal tiles are not pure colors but washed out, scratched up. The wall too is marked and dirty.

A layer of age, of dust and silt. "No blade of grass, no sign of neighborhood," writes Auden of Achilles' shield, "Nothing to eat and nowhere to sit down."[10] This wasn't a world of comfort. Not a toy or children's book in sight.

▌

There is a picture of Alessandro as a young boy taken by his father. Again, photographs, documents of Twombly's life, often staged, preserve what might otherwise have been lost. The boy, seven or eight, dressed all in white, sits on a simple wood chair, one knee up and the other down. Barefoot, a mop of hair, his expression is at once innocent and knowing, cherubic and bored. Beside the boy, a doric column with the bust of a Roman emperor—Marcus Aurelius, perhaps—the ancient face in profile and shadow.

The black-and-white photo, formal, stylized, staged, offers a study in contrasts: shadow and light, living and dead, past and present, cold marble and live skin. And yet, even as the perspective of the photograph, down a darkened hallway, creates a distance, there's something intimate and revealing about this image. We see the son through his father's eyes. We see too, I think, the artist making a kind of mirror: Cy is everywhere. This is the true subject of the photograph. There in the

face of the patriarch towering over the boy. There in the choice of the boy's white clothes and the white background. There in the signature that courses across the bottom of the photo like a wave.

The subject matter of Twombly's paintings is Twombly himself, or so claimed the artist Richard Serra: "Is the subject matter the content of the painting? Or is the subject matter Twombly? In Twombly's paintings it seems to me that the subject matter is Twombly himself, and the content of the painting, you can't decipher."[11] Every painting a self-portrait, not of the surface, the face in the mirror, but a reflection of that wilderness inside.

By contrast is the bright and joyous photo of Alessandro taken by Horst and published in *Vogue* in 1966. Six-year-old Alessandro is dressed in a military uniform, a red jacket with epaulets, white military pants, a Knights of Malta hat. A sword raised in one hand, as if rushing into some small battle, and in the other hand a leash connected an enormous black dog. Both the boy and the dog look off to someone or something we can't see.

Alessandro looks happy, as if smiling and speaking at once. Next to him, an empty chair, gold arms with ornate carvings and wings. ("A Louis XV writing table tends to please the modern eye only if it has been demystified by a glass of field flowers and some silver-framed snapshots, as in a Horst photograph for *Vogue*," wrote Joan Didion, in a review of the Getty Museum, as if thinking of these Twombly images.)[12] Behind the chair and the boy and the "silver grey Neapolitan mastiff couchant on an Aubuson rug" is Twombly's own work, the *Triumph of Galatea*, pink impasto swirls, paint layered so thick it seems to be falling off the surface. The enormous painting extends beyond the photograph's edges. To be the child of an artist is to have your parent's work like an ocean behind you.

The photograph by Horst seems to echo (rhyme? suggest? flirt with?) Velázquez's *Las Meninas*. In Velázquez's painting, the subject of the courtly drama might be the artist at his canvas, the little girl in the yellow dress with her handmaids around her, the large dog who patiently endures a young boy's foot on his back, the dwarf, the mysterious man on the stairs, or perhaps it is the king and queen, their reflections in the mirror on the back wall of the room. The king and

queen, standing where we, the viewer, would stand to see the painting. The very subject becomes the act of looking, and the confusion of what is real, what is dream, what represents what in this strange order of things. And just as the Velázquez painting calls attention to the stage and the staged, the photograph of Alessandro by Horst is a mannered set piece in the narrative of Twombly's family life, an elaborate device of transparency and concealment.

▌

Twombly's life before the birth of Alessandro wasn't very different from his life after Alessandro. He traveled. He painted. With the exception of *The Age of Alexander*, Twombly's art doesn't shift in a radical way related to being a father.

"He was fully immersed into art and being an artist," Alessandro said to me that day in Rome. Before father or husband, before son or brother, he was first an artist. He understood what he needed to do as an artist. To guard his time, not simply for making work, but to stare off into the unknown, to see new places, to live selfishly and for oneself. What artist hasn't wished to undo all the bounds that hold them steady to the earth?

"He was so unpleasant with his children that they're still discussing him," Twombly

Alessandro, Via di Monserrato, Rome 1966,
Photo: Horst P. Horst

said to Edmund White about Picasso, "I suppose that's the way to make sure you're remembered. Nice dads are quickly forgotten."[13] Twombly was neither the terrible father that Picasso was with his children, nor was he the forgotten "nice dad" either.

To say that Twombly was present in only a very small way isn't news. And yet, to read the biographical details of these early years is to wonder: Where was Alessandro? Take 1962, described in the biographical notes of the catalogue raisonné this way: "In January and February he takes a sailing trip down the Nile as far as Wadi Halfa in the Sudan. He spends the summer sailing in the Dodecanse Islands of Samos, Patmos and Rhodes in Greece and visits the towns of Ephesos and Didim along the coast of Turkey."[14] It's hard to imagine a two-year-old aboard these boats or wandering through Roman ruins.

In a letter to Betty sent from Rauschenberg's home on Captiva Island in the fall of 1968, Twombly writes, "I love my freedom of not having other people's patterns crossing over and under mine."[15] The patterns of children and the habits of Twombly's artistic making do not align. The fundamental want of most artists is not money or fame but space and time.

"We have a very formal relationship," Twombly told White when asked about Alessandro's art. "I wouldn't know about that . . . He went to an English-language school in Switzerland, and lives part time in New York, so his English is impeccable, but even so he's 120 percent Italian and a true Franchetti."[16]

▌

Waiters cleared our plates and then with a small silver tool and graceful motion, scraped the crumbs from the empty table. Alessandro promised, at some point, to take me on a tour of Upper Lazio to see Twombly's country house and studio in Bassano and the other sights, Villa Lanta and the Gardens of Bomarzo. It was hard to know at the time if he was being genuine or just polite.

That day in Rome I didn't tell Alessandro the story told to me by one of Twombly's friends in Lexington, a story that suggested Twombly, at least in older age, regretted his absence. One night the artist came over

for dinner and after they sat together on the front porch of the house as lightning bugs flashed under a canopy of sycamores. The host's small child, three or four years old, came out to the porch to say goodnight to all. The father gathered his son in his arms and took him upstairs, his bedroom just above the porch, and tucked him into bed. When he returned to his drink and their conversation, Twombly pointed up to the boy's bedroom and said, of his own son, of Alessandro, "I don't know where he slept."

11

VIA MONSERRATO

WHEN CY AND TATIA FIRST lived in their ancient palazzo on one of the labyrinthine streets of the capital, people still dumped their chamber pots from second-floor windows. Shit, literally, falling from the sky. Their narrow cobbled lane, filled too with the droppings of horses trundling carts of fruit and pots and eggs, men and boys walking alongside calling up to women hanging laundry from open windows. A world in pace and rhythm that might have seemed to the young artist like the pantomime performance of another century and not the bright, postwar middle of the twentieth century.

Even now, decades later, to think of Rome as a modern city is to be mistaken. Or at least not totally true. Rome is a city perpetually of

the past. Or, really, if you look closely enough, a city of pasts—recent, distant, ancient. Even as one passes men and women dressed in the standard issue of modern life, smartphones, sharp gray suits, leather briefcases, one is struck by how the city feels moored to some unnameable, unreachable ago. The ago of emperors and gods. The ago of streetlights lit by hand or communal water taps.

Take the ruins. Neither completely destroyed nor rebuilt. Temples and palaces linger in half-taken-away decay, stripped by weather or theft, like featherless birds, weirder and more savage. Archaeological sites, with their gangs of feral cats, resemble more closely vacant lots than great treasures of antiquity. The point is not preservation. The Colosseum is not re-marbled or rebuilt. The sawtooth edges of its slow deterioration left raw and jagged, a reminder of all that cannot be experienced in the present. And all that can.

For any trace of Twombly that might still exist in Rome I walked that narrow street of Via Monserrato often, listening for the ring of Tatia's bicycle, her giant white dog lumbering along beside her, or Cy playing the piano in those grand cavernous rooms, his canvases nailed to the wall.

The other points of the map of Twombly's first years in Rome—his studio by the Colosseum or the second studio in Piazza del Biscione—are harder to find. Not true about Via Monserrato, owned now by Alessandro. The number is still there. Twombly, after reading Richard Ellmann's biography of James Joyce, searched Rome for the house where the writer first lived. He found the address in the book and went to see it, not far from the Plaza di Spanga and the Spanish Steps. He wished there had been a plaque outside the door, something that said *Here*.[1]

There's no marker on Twombly's door. The tiny piazza beside their palazzo, the church around the corner, are more or less unchanged, as are the small storefronts, galleries, and workshops that lead back down to Campo de' Fiori, at the other end of their street.

Mazes inside mazes, all of which arrive, often it seems by a strange magic of a deranged geography, at piazzas: Navona, Campo de' Fiori, di Santa Maria, and on and on. There you are, lost, wandering, in the cool shade of a side street of the *centro*, a street like his, and suddenly (*Ad un tratto!*) the walls vanish and the familiar sound of water falling from fountains returns, as the square, with its patch of sky, arrives, breathless.

To change our space, our evening light or daily walls, our air or acoustics, is to change our work. The high ceilings and large walls of Via Monserrato allowed the artist to unroll the canvas into new longer, taller, grander shapes. His Rome paintings from 1960—*Crimes of Passion II*, *Garden of Sudden Delight (To Hieronymus Bosch)*, *Sahara*, to name just a few—are vast, creamy surfaces filled with scattershot marks, "distributed like so much flotsam, a welter of sexual imagery: heart shaped cunts and heart-shaped butts. Pink cocks. Empty holes. Waves, numbers, and words."[2] Not a single one of his pictures from the early '60s are perfect squares. He could, as was his process, tack the stretched canvas directly to the wall, or lay out drawing papers on the floor.

That same expansiveness was made possible in the studio Twombly rented in Piazza del Biscione, just down the street from Via Monserrato, an alley off Campo de' Fiori. Twombly first rented the space in 1961 and for five years it was his primary studio, the place where he painted his best works of the early '60s, the place where he developed his new visual style. An expansiveness of space that led to an expansiveness of mind.

"The inimitable art of Twombly consists of having imposed the Mediterranean effect," Barthes writes of Twombly's early work, "while starting from materials (scratches, smudges, smears, little color, no academic forms) which have no analogy with the great Mediterranean radiance."[3] That was the starting point, an elusive radiance infusing his canvases from the late '50s, from *Blue Room* or *Olympia* to the drawings of *Poems to the Sea*. In those years, after his first trip to Italy and North Africa, Twombly absorbed and then enacted that Mediterranean effect, a quality of light and feeling, an ethereal sensation of standing on a centuries-old footbridge over the Tiber as the sun descends and the domes turn from straw-yellow to inky blue.

Something shifts. Now, rather than writing into the wet paint, pencil, or wax crayon, the paint piles up at the surface, mounds of color squeezed directly from the tube onto the canvas. "The red-complexioned fields," writes Christopher Knight of some of these early 1960s paintings, "give to the torrential flow of marks an impression of

human or animal evisceration . . . The marks comprise an expansive lexicon of handprints, tracings, big sweeps of the arm, furious doodles, languid meanders, bored inscriptions, anxious erasures and more."[4]

Ornamented, ironic, literary, these baroque dances of erotic and bodily images are unmistakable in their smears of vivid color and unsubtle sexuality: *The Italians, Empire of Flora, The Second Part of the Return from Parnassus, Bay of Naples, Untitled* 1961, *School of Athens*. In these works, all from 1961, the themes—sex, transformation, desire, birth and death, assassination, violence, war—all circle and overlap. These works share a palette as Nick Lawford observes in that 1966 *Vogue* profile: "zinc white, Naples yellow, *rouge anglais clair*, deep Cadmium red, rose-madder, purple—and for some of his latest pictures, merely a blue or two, and *terre verte*."[5]

Each piece records Twombly's love affair with a place and its culture. The scattershot calligraphic marks of black and gray on white surfaces of the untitled Lexington Pictures of 1959 or the carved-into-surface graffiti of *Academy* and *Free Wheeler* or the (by contrast) restraint of those first Rome paintings like *The Age of Alexander*, gave way to an embrace of color and composition, different methods of making, his hands smeared in paint. A new man. A new vocabulary.

His new style is also a sign of luxury. This isn't cheap house paint or *cementino* of those earlier canvases. He now has the "good reds" borrowed from Tatia's kit. There's nothing sparse or spare about these lush oil paints. Nothing that says poor, struggling artist. Instead, decadence. Instead, a sense that more is better, that nothing—not flesh, not shit, not blood—should be left out.

❚

In August of 1961, while most Romans tried to escape from the intolerably humid air and the smell of garbage rotting in the blazing sun, Twombly stayed in the apartment on Via Monserrato and worked. The oil paints liquefying as he tried to apply them. His sweat part of the canvas. And when I think about those paintings, I imagine not the light of that August sun but the dim and cavernous interiors of their palazzo.

Luminous, restless, and sexually charged, Twombly's five *Ferra-*

gosto 1961 paintings are cartoonish and serious, anxious and wild, layered and dirty, a sequence that mirrors his state of mind and his home of Rome.

This is not the glamorous aura of antiquity. Earthy browns collide with the hues of flesh and bone. Francesco Clemente, describing Twombly's imagination, offers this quote he attributes to Italo Calvino, "Ancient Greece was not what the Germans made us believe. Ancient Greece smelled of monkeys, and it was a place filled with monkeys and goats."[6] Clemente reminds us of the stubborn truth: the ancient world wasn't all beautiful marble columns and nymphs dancing to pan-flutes but a shit-filled river, a mountain of broken trash, a world of brutal, short lives.

"I was completely crazy, out of my mind with heat in this town," said Twombly about the painting of the *Ferragosto* series.[7] And it shows. The five paintings build from an abstract and swirling palate of browns and blacks to a bacchanal of fleshy pinks and reds. The fifth of the series is a wild, frenetic, and all-over canvas. Hot. The weather reflected in the canvas. The canvas reflecting the body's making and remaking. Making is always a physical act. That giving up and giving over, the body in struggle and possibility and engagement.

Within the abstract streaks of color, some by brush and others by Twombly's own fingers and hands, are the unmistakable images of cocks and asses and breasts. Comic and hurried, they look like the dirty pictures on the walls of an elementary school bathroom.

"Vivid, even festive, these large works look like the aftermath of a bull's tormented passage through a pastry shop," goes one description of the paintings.[8] One scholar describes the paintings as "a physical and sexual encounter enveloped by the materiality of the paint."[9]

Twombly, who also recalled being "fraught" while working, said of the paintings: "It really gets heavy because paint is a certain thing. I don't have a dislike for it, but those paintings, for instance were done in August in terrific heat in Rome. All my things, every one of them, show a certain agitation."[10]

Ferragosto, the word from the Latin, *Feriae Augusti*, or Augustus' rest, essentially an end-of-harvest tradition updated by the emperor and then, years after, by the Fascists, marks a season of going away: a

slow train out of Rome, a blue umbrella, a chance to see the sea and forget, for a few days, the poverty or routine of daily life. I imagine Tatiana and Alessandro, far from Cy in Rome, sitting on a sea-breezed beach or at the Franchetti castle in the Dolomites where even in summer you can see your breath at night.

In that intense heat, Twombly painting and smoking, reading and pacing. In the dim and quiet rooms of Via Monserrato, colors bold enough to break the dark open. Then, as now, on summer days, the window blinds stay closed. Wood or metal shutters cooling apartments by day. The sun, its breakneck burn and fire, kept out. In the evenings, the blinds raised and the windows thrown open to the cooler air. A cycle of opening and closing. Of darkness and a different kind of darkness.

"Thick"; "Florid"; "Smear"; "Rapid"; "Urgent"; "Orgy"—all words later critics use to describe these pieces in which the paint, a palette of reds and pinks, beiges and browns, blues and yellows, earthy, physical, swirl together. In some ways these pictures return to the sexual shapes and heavy paint of the North African–inspired work of the mid-fifties such as *Tiznit* or *Volubilis*. But the color and the methods feel entirely new for Twombly.

To squeeze the paint directly from the tube is to embrace a haphazardness, the chance of the action as the paint falls and must be either left or spread out. To squeeze the paint is a kind of play, a child's rebellious action and refusal to follow the rules. It's another form of unlearning that marks Twombly's great style—a continuation of that *gauche* hand drawing in the dark of the hotel room in Georgia. The metaphor of the oil tube is embarrassingly obvious, and yet it fits with the imagery of this period too. Erotic innuendo becomes erotic directness.

Again, his hands. I watch in my mind as they press into wet paint, the cool, smooth texture. "Twombly guides his smudges," Barthes writes, "drags them along as if he used his fingers; his body is therefore right there, contiguous with the canvas, not through a projection but, so to speak, through a touch which always remains light: the color is never crushed."[11] Again Barthes is Twombly's most perceptive and generous

reader, seeing Twombly's tactile relationship with paint and surface not as a violence but an act of harmony, his own skin "right there."

Twombly, like the cave painters of prehistory, turns his body into brush. No difference between body and canvas, between the self making the mark and the mark itself. Some of our signs are divine. Others are reminders of our humanness.

"Yet if one remembers the first, the basic, purpose of painting," writes Berger, "is to conjure up the presence of something which is not there, it is not surprising that what is usually conjured up are bodies. It is their presence which we need in our collective or individual solitude to console, strengthen, encourage or inspire us. Painting keeps our eyes company. And company usually involves bodies."[12]

This is the truth Twombly never forgets. The weight of his body, hand or finger, makes contact first with the canvas and then the viewer. "Massive accumulations of erotic paint in various primordial shapes," is how Rauschenberg describes lost early works *Torahs* and *Chandeliers* done by Twombly at the Art Students League in New York.[13] The past, as always, prologue.

In an interview, Twombly offers the example from Jung of a small child in the bathroom to show the "infantile thing" of painting and paint: "The child is in the bathroom and the father gets very anxious. So he goes to the door and says 'What are you making?' and she says 'Four horses and a carriage.' She was making a sculpture. Because children have that."[14] They have *that*: the vocabulary of the body, in play and wonder, feeling the slipperiness of matter between the fingers and the tactile pleasure of pressing, smearing, shaping, creating.

12

TRANSFIXED

"IN FACT, MANY VISITORS ARE so charmed by the still regal city," goes an article in *GQ* from 1962, "by its remarkable ruins, great monuments, by the smiling inhabitants and their generous hospitality, that they have no desire to look behind the facades."[1]

The facades of Rome are still maddeningly beautiful, cut stone and pillaged obelisks with their ascending hieroglyphs. The article, a guide for the unseen eternal city by Melton Davis continues:

Beguiled by guided tours and travel folders, they think they've caught the essence of the city. Yet only by a kind of depth perception can Rome be seen in its true framework. It's not

easy, mainly because there are many Romes. The new city, strikingly modern, apparently gay, confusingly glossy; papal Rome, with its baroque ornate facades; medieval Rome, a teeming maze of crooked streets with colorful little squares suspended in time; and imperial Rome, Byron's "marble wilderness" of statues, columns, ruins.[2]

So many Romes. Always another city inside the ones we inhabit, little nesting dolls of a place, endless and luminous. And yet, there is really just one. The Rome that exists in the mind, neither city nor site nor space, but something wild and uncontainable, that speculative city we try to hold but can't, we try to see but miss, we try to still into whatever form—poem, map, painting, sculpture—we hope will explain what we can't quite say. No Rome but Rome.

The two versions of *Blue Ridge Mountains Transfixed by a Roman Piazza* 1962 gesture to Twombly's homes, present and past, and his love affair with his new geography. They say, these paintings: This is my life. One critic described these "singularly personal and nostalgic works" as a take on Poussin's *A Roman Road*, the edges of the ancient road vanishing in the distant perspective.[3] The autobiographical collides against the history of art. The history of art collides against the personal.

In Twombly's paintings, the mountains of Virginia, swirling formations of white and brown paint, as if scraped with fingernails, are divided by the schematic penciled grid of a piazza. And yet, unlike the "real" piazzas of Rome, this one is empty.

Is Twombly, man and artist, meant to be the mountains, "transfixed" by the classical lines, the ordered splendor, flat, level, walkable? Transfixed, its double meaning, is both the enraptured pause of wonder or terror, and the piercing, as in *a field mouse is transfixed by the curved talons of an owl*. Transfixed, the American by the Italian, the natural by the man-made, the past cutting across the present like a runway.

And in those handwritten words, BLUE RIDGE MOUNTAINS TRANSFIXED by A ROMAN PIAZZA, the lowercase "by," another reading of the painting, as if the "Roman piazza" is the author of a work called "blue ridge mountains transfixed." The painting is not a dialogue between these two places but a kind of calling back to the past from

the present. An artist and his work. In this sense, Twombly isn't the mountain, not the boy from Lexington driving through the hills with his parents, but that Roman piazza looking back on the Virginia landscape that was once his, now transfixed in the past.

▌

String tied around the finger. Ghosted limb. Twombly's Roman paintings of the early 1960s do not try to capture the experience of the past, but how that past is felt in the present. A new home. A new style.

"I'm influenced by everything I see—a painting but also a rush of sky," Twombly said. "The more character you have, the more influence you can take on."[4]

Three things to notice. First, Twombly's power of sight includes not just art but the natural world. Second, that "rush of sky" is not the stillness of a cloud or the empty blue openness but motion. Third, Twombly claims that there is some relationship between "character" and the taking on of influence. Vision and originality, goes his bold claim, makes being influenced possible.

What test do we have for such an assertion? His art, perhaps, as it hunts and gathers in the galleries of antiquity.

"I would have liked to be Poussin, if I'd had a choice, in another time," Twombly once said, a quote often repeated without the qualifications that follow. "I had a Poussin period in my head. I did *Woodland Glade* and it was a kind of romantic English thing rather than Poussin. It was just a homage. Just someone I had respect for. I had different crushes on different artists."[5]

We can see these "crushes" shift over time, but in the early 1960s he wears his artistic debts and influences on his sleeve: *To Sappho* 1959, *Untitled (To Vivaldi)* 1960, *School of Athens* 1964, *School of Fontainebleau* 1960, *Woodland Glade (to Poussin)* 1960, *To Leonardo* 1960, *Garden of Sudden Delight to Hieronymus Bosch* 1960, *Hyperion (To Keats)* 1962. Twombly doesn't try to throw off the world he was born into, but hold it as close as one can. These are not *after* but *to*. To. To. To. Love letters from one artist to another.

Woodland Glade, like *Blue Ridge Mountains Transfixed by a Roman*

Piazza, returns, through Poussin, to Twombly's first landscape. Placed at the foot of his bed, as it appears in one of the outtakes from Horst's shoot, each morning he woke up in several different landscapes at once—Lexington, Rome—and in the sightline of his "crush."[6]

This is one of Twombly's gifts—to know how to borrow. As T. J. Clark astutely notes, "No artist was more aware of—more honest about—his belatedness."[7] One response to that feeling of coming after, that anxiety of "belatedness," is to claim what you can. In one of his prints, *Natural History, Part I, No. I* 1974, you can see the edge of Francesco Melzi's *Leda and the Swan (After Leonardo)*, a copy of Leonardo da Vinci's destroyed masterpiece peaking through at the edges. Twombly's overlaid drawing, a penciled bird's neck, half-covers the cut-out reproduction of the painting, the wing of the bird visible.

Or consider the detail of a black top hat from Degas's *A Cotton Office in New Orleans* 1873 that found its way into the final canvas of the ten-part *Coronation of Sesostris* 2000. Reminiscent of Franz Kline's deep and long obsidian marks—and Twombly's own early works—the black detail cuts across the canvas like a bottle of ink broken against the white ground. As one critic puts it, "What, Twombly seems to be asking, are images, words, poems, treasured works of art, *for*, if not to be put to our own different uses?"[8]

Twombly takes what he wants, a striking image, and leaves the rest. As if that were possible. When that black hat enters, like a broken bit of a cloud floating through an open window, so too does the subject of Degas's painting—cotton and labor and the exchange of commodities. Twombly's painting erases all that the cotton and the exchange symbolize: a history of violence and racial oppression.[9] His genius is also his blind spot.

The intersection of originality and theft, these works—often just in their titles—suggest how Twombly roams through myth and art history. Magpie. Collector. Thief. Twombly is the great imperialist in the empire of imperialism. His crushes—on artists and writers—ripple through his art. In Rome, source material is everywhere. In the display cases of museums, on the graffiti-marked walls of apartment buildings, in the hurry of train stations where the cars arrive off-schedule, in lovers

arguing at intersections, in great epics, in the shit falling from the sky. High and low. Past and present.

There's a tension in Twombly's art between his mythological or literary or historical allusions and the willful obliteration or submerging of technical skill.[10] Twombly knew that while we read with our minds, as Nabokov said, "the seat of artistic delight is between our shoulder blades."[11]

▌

"A friend once mused," writes curator and critic Kirk Varnedoe, "that Twombly's ideal abode might be 'in a palace,' then paused and added, 'but in a bad neighborhood.'"[12] One might imagine Twombly's Biscione studio as that kind of palace. Set above the squalor of his surroundings, the paintings, at least by their titles, became more explicitly literary, more explicitly in response to other artists.

Twombly's *Triumph of Galatea* name checks Raphael's famous fresco at the Villa Farnesina in Rome, Poussin's rendering of the same myth, Ovid's retelling of the love triangle of Galatea, Acis, and the Cyclops, the sculptor Pygmalion's animated statue brought to life, and countless other artistic renderings.[13] In all the versions, desire is the center of the story. Flesh taken. Flesh touched. Flesh changed.

In Ovid's version, Galatea's suitor Acis is killed by a boulder thrown by his rival, Cyclops. The young lover's crushed body transforms into a river: "Red blood came tricking from the mass, and faded / And turned the color of a torrent swollen / By the spring rains . . ."[14] A story of change inside a story of violence inside a story about desire.

In the most famous painted versions, we see Galatea, water nymph, in her beauty, or the two lovers Acis and Galatea embracing, the threat of the brutish Cyclops nearby or simply erased. No one shows the moment of death or the sorrow. What part of the story does Twombly retell in his *Triumph of Galatea*? Which moment does he capture in the smears and globs of paint, the shades of brown and pink, tans and whites, the layers of hand and brush that seem to be thrown onto the surface in an act of worried haste?

The painting, writes one reviewer, "of course" refers to another Galatea story, that of the sculptor Pygmalion who fell in love with a statue named Galatea.[15] Transformed from marble to life by the act of a goddess, this myth has launched a thousand takes and versions. *Of course*—but nothing with Twombly is that set or certain in the matrix of so many texts, so many allusions and possibilities, each with their gravity.

One reference leads to another, switchback and rabbit hole; in Goethe's *Italian Journey*, for example, a book well known to Twombly, the second diary entry for Rome on November 1, 1786, describes Goethe's arrival in the city of his dreams, a place known through images made by others, paintings and etchings and models. "Whenever I walk," he writes, "I come upon familiar objects in an unfamiliar world; everything is just as I imagined it, yet everything is new." In that same entry, he writes, "When Pygmalion's Galatea, whom he had fashioned exactly after his dreams, endowing her with as much reality and existence as an artist can, finally came up to him and said: 'Here I am,' how different was the living woman from the sculpted stone."[16] Is this the "triumph" of Galatea, that breaking apart of whatever vision we have in our head?

Twombly's embrace of history and myth and literature in his work had been there from the start. "At Black Mountain College everyone was always rebelling," remembered the artist Dorothea Rockburne, "both in their lives and in their work, and it struck me at the time that it was only Cy and I who were not rebelling against the history of art." Rockburne was, for a time, a co-conspirator of artistic play with Bob and Cy in those lush, endlessly romantic days on Lake Eden, part of their secret club, attempting to photograph a spirit in their haunted house, or playing Ophelia in a scene from *Hamlet* rewritten by the artists. Of her friendship with Cy, she writes, "We both shared a love for ancient history, ancient art, and the poet Rilke. (It was impossible to come out of Black Mountain College and not love Rilke.)"[17]

The rebellion of Twombly's work—and it is indeed a rebellion—isn't about looking away from the past but staring at it long enough that it might, like that statue of mute marble, breathe with new life.

"We can say of Twombly's work—as praise—that we don't know where it comes from," writes the playwright Edward Albee, "that its sources exist solely in the mind of the artist and that comparisons tell us nothing."[18]

I once disagreed. We can point to the possible sources, revealed in their titles, in their methods, in their very life and breath, and say look, here is the start. But now, I'm not so sure. Consider *Triumph of Galatea*, completed in the late spring or summer of 1961 in Rome, a painting that started, as many of Twombly's works, as an obsessive series of drawings. In Focene, a small fishing town to the west of Rome, Twombly worked in April and May of 1961. Alone or with others, I don't know. We have only the record of the drawings, eighteen done over the course of two months, eleven of which are titled "Triumph of Galatea," "Study for Triumph of Galatea," or "Study for Triumph of Love." The earliest title for the April 1961 drawings—"The Triumph of Love"—was replaced by the introduction of the myth.

To look for the finished painting in these earlier studies and sketches is an exercise in frustration. The same can be said too of the biography. Rome changed the man. I want to read a newfound openness, some transformation in vision and self. The work changes because the man changes. (Or is it the other way?) In the not-so-subtle shifts of paint and method, of subject and matter, there is some proof, some reflection of what's happening below the surface in the handprints and myths, stories of transformation.

Everything changed. No longer the wandering artist but the resident with a fixed address and a fixed life. The pleasure of settling down, of making new work, of learning the city's secrets. In time he knew which buildings were plastered with the yellow-ochre of old Rome and the newer, false shades of difference. He knew the frescos hidden in the naves of small, out-of-the-way churches or how to enter secret, symmetrical courtyards of ancient palazzos.

And yet there is a kind of consistency in Twombly's character, stretching from city to city, from year to year, that is magnified, made more extreme in those Roman days. Rather than opening up, becoming

freer, it is as if Twombly becomes more himself. More anxious. More private. More restless.

Sometimes in Roman museums I wanted to touch the marble thighs of sculptures to feel the cool press of stone. These still bodies, so present and available and faraway. Twombly, I imagined, in these same quiet rooms, his hand wanting to fall along Antinous' chiseled spine or grazing Diana's left ankle, as if his fingers could turn the marble either tame, or more wild. He would leave the museum, emerge into the mercilessly bright Roman sun, his hands full of the absence, and return to his studio to touch his own canvases into life.

13

UNMADE BEDS

THE MUSEUMS CLOSE AT NIGHT. Historical sites lock their gates. Galleries shutter and the black dogs of desire and possibility prowl the streets.

The route from his studio to his palazzo passes through Campo de' Fiori, the old flower market. Under the hooded statue of Giordano Bruno, a grim and towering figure, heretic philosopher set ablaze at the stake during the Inquisition, gleaming rows of stolen cameras and watches are for sale. The young, in their bravado and careless desire, drink and smoke, pair off and go home. The evening pink light slips into something darker, a purple-bruise, a crow belly. Twombly moves through the square, object of attention and the one scanning the faces and bodies of the men and women leaning against the base of the

statue. Imagine the artist, always looking, observing. His heart in his chest and his blood under skin, alive and burning in the conflicted hum of need.

Even now, if you stand in Campo de' Fiori and close your eyes, you can hear some echo of the past, the riots of conversations at cafés, arguments on street corners, kids wilding through the streets in mischievous packs. The young, hungry as fire, tight shirts and pants, still lurk and lean, these figures of desire, waiting. The evening blooms with the clink and laugh of the *aperitivo* hour.

This is the soundtrack Twombly painted to, the city life that entered his night windows. This is the soundtrack—sex and violence, flesh and marble—of those paintings of the early 1960s. How far he'd come from his boyhood bedroom in Lexington, an occasional car sliding past his window or close-clipped lawns of crickets showering the darkness.

There are no photographs of those hours. No letters by Cy describing cruising or being cruised. Instead, there are, as always, fragments and implications, the suggestive words of others and the images Twombly left like breadcrumbs.

When the *Vogue* article was first published in November 1966, Twombly wrote to David Whitney that even though they didn't select his favorite photos, he thought the article was very good: "We look pretty tacky with all the costumeynees. I look plain alcoholically decadent."[1] Even as Horst's images create a perception of Twombly's domestic splendor, his son at play, rooms of ancient busts and modern art, Lawford's accompanying text suggests a very different reality.

"The whole floor is now used exclusively by artists," writes Lawford of Twombly's Biscione studio, "who come and go like transients in a doss house, borrow one-another's cigarettes and painting materials and permanently unmade beds. Twombly spends whole days and nights there, rarely emerging to eat, working himself into a fury of creativity during which he sometimes completes four or five smaller pictures in twenty-four hours."[2]

The coming and going of artists. The unmade bed. Whole days and

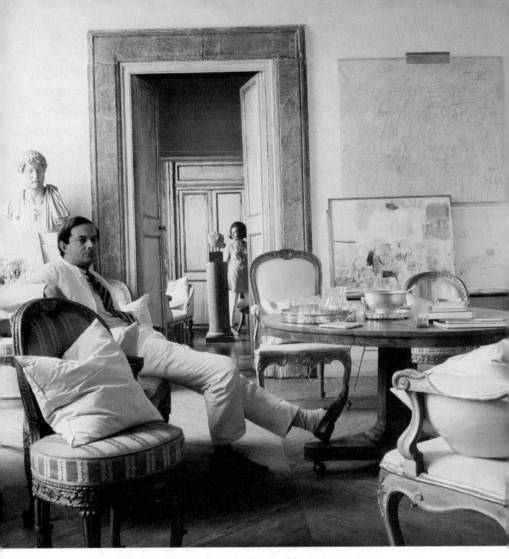

Cy and Tatiana, Via di Monserrato, Rome, 1966, Photo: Horst P. Horst

nights. The subtext isn't hard to read. "[Lawford] tacitly underscored what was louche about Twombly," writes Pierre Alexandre de Looz in his essay on the history of that photo shoot. "Twombly whipping a canvas red with a rope, Twombly speaking softly and plaintively, Twombly out all night, all day in bed with the wife away. Naturally, these clues opened a speculative window onto the artist's personality, and conjured a specter over his most intimate relationships, not least of which was to his work."[3]

To picture the artist walking home, after days away, is to imagine his body, his long limbs and his eyes intense, as if he was scanning the horizon from a ship's crow's nest. I think of Giosetta Fioroni's description of Twombly walking through another piazza: "Twombly would walk around Piazza del Popolo barefoot; he was aware of owning the scene and took to it naturally. He knew everybody. He was absolutely beautiful and I was in love with him."[4] The self-possessed awareness, a studied indifference, a knowledge that to move through the world is to be seen.

"His strangeness is not merely sartorial," writes Lawford in the *Vogue* piece, "Beak-nosed as a Quattrocento portrait, tall and tending to stoop, with dark eyes that even at their liveliest have a shielded, inward look, he hovers like a shy but unmistakable eagle above the peacocks."[5] A sharp description to be sure but I wish there was a video of those days, some captured frames of Twombly moving in his studio or on the streets of Rome.

In the famous Hans Namuth video of Pollock, there's a moment at the beginning where he changes from his shoes into boots splattered with paint. The canvas, in progress, on the ground at his feet. These gestures of preparation, shaking out his boot, these little mirrors of his work, the shoe's toes streaked and crisscrossed like one of his own canvases, cigarette dangling from his lips, his sloped shoulders, add up to something more than technique or the preserved image of him working. His body moving. The man, alive on film, not ideal or finished as a painting in a museum, but in the middle of the business of living.[6]

Twombly would never have allowed someone to capture him at work. He wasn't that kind of artist. He wasn't that kind of man. And yet, by purpose or accident, the images in *Vogue* betrayed him: as one critic observed years after, "Twombly had not simply flared the finger of continental privilege by landing in *Vogue*; he let his whole hand go limp."[7]

If we can't follow Twombly through the streets of Rome or across the screen decades after, we can turn to his paintings, works so full of sex

that to write about myths from Ovid is to miss the bright neon sign flashing: here, here.

Not coy. Not metaphor. There are breasts and cocks and asses and vaginas. Body parts in various states of arousal and dismemberment. "An overeducated bibliophiliac suddenly—graphically, nearly obscenely speaking in tongues," writes the critic Roberta Smith of Twombly's torrent of sexual imagery.[8]

Sometimes I think this is as close as Twombly comes to confession. To admit his own body. His own wants and desires. As Olson wrote of Melville, his secret as an artist is "the presentation of ambiguity by the event direct."[9] In a way that's Twombly's power as well, at least when it comes to sex. There's so much of it, one can almost miss it.

No, not miss it, not exactly. Pretend that what one sees are the domes of Moroccan ovens or the bulbous fronds of a tropical plant. "But paintings like *Leda and the Swan*, *Bay of Naples*, and *Triumph of Galatea*, are really ejaculations as activity and sexual analogy as creation," said Brice Marden. "And I don't mind that at all. I mean, if Picasso's got his Minotaur, bravo, and Twombly does it in spades, particularly between 1961 and 1967. There are in the exhibition about six paintings like that, that are really full of cocks and come, tits and shit, in the best sense of the word. And no one talks about it."[10]

The question though is why? Why is it not discussed? Or when it is, why is it turned into suggestion, a description of his "subjective, erotic signs," as one encyclopedia entry on Twombly obscurely suggests?[11] "Certainly no painter has ever made such a point of the male orgasm," writes Mark Stevens in a review. "Critics are hilariously skittish—me, too—about the really rank, leaky, semen-stained character of some pictures. The sensual musing is much easier to write about."[12]

It seems strange, in part, since this provocative vocabulary of sex makes his work of the 1960s so surprising and revelatory. I'm reminded of Giorgio Franchetti's early response to Twombly, "He managed to put down unconscious mind." It is a mind of the body, dark and strange and sexual.

But these are not realistic, anatomical forms. No one would be turned on by the comic cocks in *Triumph* or the exaggerated breasts in *Birth*

of Venus. Even in these over-the-top caricatures, torpedo phalluses like something one might find graffitied on a wall along the Tiber, Twombly holds something back. It's as if the only way he could make art about sex was as a phenomenon distant from his own body, something to be seen in its risible and foolish anatomical absurdity. Sex is not sanitized or erased but made so absurd in its fleshy pinks and reds as to be separated from the man who made it.

I

"My whole energy will work, and instruments and things will have a very definite male thrust," Twombly said in an interview to describe, in part, his obsession with the figure of Achilles and his process of creation. The artist describes the "phallic aggression" of the Greek hero as rendered in his 1978 version of *Vengeance of Achilles,* part of his sequence *Fifty Days at Iliam.*

"The male thing is the phallus, and what way to describe the symbol for a man than the phallus, no?"[13] How serious, and full of rage and anger, is Twombly's rendering of Achilles as a cock: that spear, that barrel of a gun, "like a rocket" or missile. In the painting, circles of black swirl and turn below the phallic dart, red at its tip. The handwritten words on the painting trail away, the word *Vengeance* large and visible in the foreground, while the words *of Achilles,* almost disappear. His name—and human self—recedes as the violence begins. I'm not sure which I dislike more, the almost puerile phrase "the male thing" or the idea that the symbol for a man is a phallus. The brush as phallus, the phallus as projectile: it feels too reductive, too easy, too evasive of how, in Twombly's images, sex and violence are not apart but connected.

When I think of Twombly and sex, it is not the *Vengeance of Achilles* from 1978 that comes to mind, but the obsessive drawings with the same title more than a decade before. In the many versions of *Vengeance of Achilles* 1962, one feels the suppressed energy in the shape Twombly makes and makes again, a triangle with a red peak, like a building with its roof on fire. Masses of scribbles, a hurried line bursting at the edge: An A. A volcano. I imagine his hand as it first draws in pencil the two sides of the triangle and then the sharp line that bisects near the top.

He fills the empty pyramid with a swirl of energetic lines, black below and red above, that bleed out over the edge. This figure, for me, seems closest to getting at the sexual energy one finds in Twombly's works. The container cannot hold those lines.

What changes in the multiple versions is not this singular shape, that pyramid alight at its top, but the size of the paper. Sometimes they are large sheets for drawing and other times, small squares no bigger than a piece of toast.

Twombly is nothing if not obsessive. In a 1959 letter to Castelli, Twombly claims to like the "obsessive austerity of the idea rather than variation."[14] He can't get that figure out of his head. Out of his hand. But then again, why would he want to. He's found another shape and sign to make his own.

There is no sex in his images of birth or transformation—*The Birth of Venus* 1962, 1963, *Diana Passing* 1962, *Venus Anadyomene* 1962, *Venre Franchetti* 1963—not exactly. "His paintings on the theme of Venus explore symbolic images of physicality, passion, seduction and carnal yearning," writes Bastian about these pictures.[15] But whose carnal yearning is being explored? Is it the desire of Venus? Or is it the man making the picture? In the figures he uses to represent the female body, breasts, like loaves of bread or half-hearts, Twombly again dismembers the body. In one version of *The Birth of Venus*, his variations on the iconic, half-naked goddess on a scallop rising from the sea, he layers a hundred breasts like petals of blooming flower, a bouquet.

Unreality is Twombly's trade when it comes to sex. There's no intercourse, no seduction, no revelation or pleasure. These are body parts without bodies. This is what makes the pictures, almost as much as the sexual images themselves, resemble graffiti. On the wall of a bathroom stall, below the hearts and the telephone numbers and the bad puns, the crudely rendered cocks have no faces. No arms or torso. This is sex without the full, human, lived presence of another.

Twombly's sexual images, like the innuendo in the *Vogue* article, those unmade beds and nightly absences from home, hide and reveal,

give then take away. To say that one can read Twombly's own wants or anxieties from these pictures is a mistake. That doesn't mean his obsessions don't matter. It doesn't mean that one can't look at the bright years, 1960 to '63, Twombly still immersing himself in Rome, traveling some—down the Nile in Egypt and over to Greek or Italian islands for a summer holiday—but really living his daily life in the narrows of the cobblestone, and wonder why it's here and now that Twombly's visual vocabulary is so tied up with the sexual body. In her short essay on a series of drawings done on the island of Capri in 1960, novelist Rachel Kushner tracks how the "round energy whorl" in *Dawn (See Naples and Die)* 1960, "looks like a rotary phone in one glimpse. A flower in another. Or more like a vagina surrounded by hairy numbers, which seem pulled into centrifugal motion by spinning or magnetism."[16] Phone to flower to vagina, we arrive, always at the body.

In the years after, graphic sexual markings, explicit and unmistakable, diminish but do not disappear. In the winter of 1968, visiting Rauschenberg at his compound on Captiva Island, just off Florida's Gulf Coast, Twombly would return to these sexual images. With postcard-size cutouts from Leonardo da Vinci's notebooks—little yellow fragments of history and magic, with their sure and inevitable lines—Twombly again makes sex into something unreal and comic. The drawing/collage *Untitled* 1968—Buona FUoRTuna (White Horse), written on the back—is basically a series of dick jokes: a reproduction of a horse drawing by Leonardo, with crude sketches by Twombly of erect human and horse penises on the white paper below. Measured lengths and girths. The picture, owned by Rauschenberg, is both serious and ridiculous at once, an inside joke between friends and a dig at tradition.

But the drawing/collage that I keep going back to, as if it might hold some clue for these earlier pictures, is Twombly's study of Leonardo da Vinci's anatomical cross-section of a man and a woman engaged in intercourse. As if a response or gloss on Leonardo's drawing of the mechanics of heterosexual sex, Twombly has penciled two meshing gears, their teeth intertwined like those bodies, beside the reproduction. In a large drawing below that, Twombly isolates just the male anatomy from Leonardo's copulation. From its tip, a cascade of lines

stream down the length of the page. A fountain. A chandelier. Exaggerated, to be sure, the picture isn't as comic or one-note as the one of the horse/man penis comparison. The word "reject" is scrawled beside the image. Testicle-like forms border this central ejaculation and appear, like teardrops, at the bottom of the page. The artist has transformed Leonardo's image of coupling into something quite different. This is not about a bringing together—artist and viewer or lover and lover—but an activity done solo. The self doesn't reproduce new life, but itself. Twombly's mind, erotic daydreams and fantasies, wanders through the world alone. There's no one else there.

14

DISCOURSES

ANOTHER NEW YEAR'S EVE IN Rome, 1963 to 1964, riot and blur as children and adults fill the streets. The buzz then burst of Roman candles. Smoke and sulphur cloud the air around the city. Revelers call out to each other, sounds carry from Campo de' Fiori to Via Monserrato. All those lovely shadows, red and silver, cast around the narrow streets as Twombly watches the sky above his city, a neon orchestra. Drawings in silver frames around his room. The *Commodus* paintings tacked to the wall of his studio.

The paintings are done and ready to be sent back to the United States. Difficult pieces to be sure, big, serious, ambitious paintings. "I am really terribly happy over them + think you will be pleased by them,"

Twombly writes to Leo Castelli of *Nine Discourses on Commodus* 1963. Earlier tensions with Castelli have been replaced with appreciation and enthusiasm. "Thank you so much for giving the check on the Commodo. I lost my head for it, but it inspired this series so maybe it is good to loose [*sic*] my head + gain a new."[1]

This moment will come to seem like another life, a brief impossible spell. Twombly and Tatia and Alessandro together in Rome, the artist thriving in his studio and hopeful for his return to the New York art scene. Maybe it is because I know what's ahead that I begin to feel anxious. It's so hard to see our own lives in their lived momentum but here, in this lighthouse, this late-night palace, this distance, I can look out to the trouble that's on its way.

▮

If in Rome one is never far from a masterpiece, one is also never far from a grave. The blood-soaked floor of the Colosseum arena. The graves of the poets. The site where Julius Caesar was assassinated, almost visible from Twombly's studio in an early-nineteenth-century building constructed on the site of the long destroyed Theater of Pompey.

The paintings that make up the *Nine Discourses on Commodus*, completed in December of 1963 and shown in the spring of '64 at the Castelli Gallery, are a meditation on violence. Or at least that is the popular reading of them: Twombly looking back to the history of Aurelius Commodus, Roman emperor and madman, a sequence of feeling and action and narrative. "Conflict, opposition, and tension dominate the paintings' composition," writes Nicholas Cullinan. "Two whorls of matter hold the central focus of each piece, ranging in mood from serene, cloudlike structures to bleeding wounds and culminating in a fiery apotheosis in the final panel."[2] The paintings, like a saint's life, builds towards a bloody end.

As a dramatic subject for a painting, one could do worse than Emperor Commodus' madness and violence. Murder for sport, "defiling every part of his body in dealings with persons of either sex," debauchery, habits of consumption, gambling, and on and on. "It is claimed that he often mixed human excrement with the most expensive foods, and

he did not refrain from tasting them, mocking the rest of the company."[3] And I haven't even mentioned his love of being a gladiator, often competing in the arena as the claimed descendant of Hercules, or his violent end, poison and strangulation. Sex and violence. Shit and madness.

As always, Twombly's paintings refuse literal narrative in favor of the feeling of their making. The group—its historical allusion and bold color, its seriality and ambition—is a good reminder of just how much Twombly's art had continued to evolve in the years since returning to Italy. At the same time, in theme and subject the new pictures are not exactly a departure. He had been, for the last year, working through multiple drawings and images of (or at least references to) historical violence: assassinations, murders, the bloody affairs of ancient states. *Ides of March* 1962, *Death of Giuliano de Medici* 1962, *Catullus* 1962, *Pompey* 1962, and so on. In these pictures of violent ends, Twombly's subject matter reflects the real world.

The Commodus pictures were completed in the month following the assassination of John F. Kennedy, December 1963, and in the "curiously funereal atmosphere [that] pervaded the early 1960s."[4] Threat and danger of the world, from the Cuban Missile Crisis to the escalating conflict in Vietnam, is perhaps reflected and foreshadowed in this and the other titles. Even as they announce the painter's historical obsessions, Twombly wasn't interested in history but the violence of it.

▮

Another painting about the body. The textured surface of those nine canvases, invisible in photo reproductions, "scabs of congealed impasto," recall the body of the man.[5]

Over six feet tall and four feet across, to see the canvases in a single row in a room at a museum is to be further reminded of the bodily presence, not just of the paintings but of the man making them. One can feel the tension in the paintings' two central forms, the "whorls of matter," sometimes like white clouds and sometimes like violent red tornadoes, bound to a grid and bound to each other. There's a push and pull within each of the nine paintings and across the series. Sometimes

they seem like figures dancing. Other times those two figures seem like a single mind, split apart like a pomegranate.

Discourse, "from the verb *discurrere*, from *dis-* 'away' + *currere* 'to run.'" Perhaps the running away or fleeing is of Commodus, from himself, his disturbed mind. I can't help but think of Francis Bacon's paintings of figures in unimaginable pain, their faces distorted and blurred; one face becomes many as he captures the myriad, dividing states of agony and worry, hope and desire, madness and loss.

Or maybe we can see Twombly's own internal divisions of love and sex, certainty and risk, anxiety and safety. The figure of the painting is not a stand-in or example for questions about power or the state. Twombly's concerns are more intimate, more personal. The true subject of the painting is control. The desire for it. The dream of it. But our lives are not grids but waves. We are imperfect clouds.

▌

"Cy Twombly is an American gone to the bad," claims one writer, "—a decadent exile who chose to live among the mouldering palaces and antiquities of Europe. A man who is dirty-minded, and history-minded. Somehow, the two go together for this genius of rot."[6] The "decadent exile" is the man in the Horst photos, leaning on a divan, dressed as a dandy in all white, making baroque paintings—and calling them "discourses"—about dead emperors.

Twombly would have never described himself as an exile or expatriate. He would have waived that off as foolishness. Never mind what he might have wanted. Plenty of others, writers and critics, have used those labels for him. "Twombly was an expatriate," as the artist Sandro Chia put it, "but he spoke about Europe the way Hemingway spoke about Paris or Spain. Out of sorts but still at home."[7]

Exile isn't one thing; it isn't as simple as an emperor banishing you to the Black Sea or a forced flight from a brutal regime. "For some writers exile means leaving the family home," writes Roberto Bolaño, "for others, leaving the childhood town or city; for others, more radically, growing up."[8] Some exiles, Bolaño says, experience a lifetime of it,

for others it's over in a day: "Bartleby, who prefers not to, is an absolute exile, an alien on planet Earth. Melville, who was always leaving, didn't experience—or wasn't adversely affected by—the chilliness of the word *exile*." Twombly's exile is closer to Bartleby's, that reluctant clerk, refusing to live in the ways that were asked or expected of him.

The Commodus paintings are but one example of this. "They attracted scathing reviews," writes Cullinan, "which tellingly focused on Twombly's absence from the New York art scene, implying his abandonment of the United States and carrying the distinctly chauvinistic subtext that these paintings had been imported from 'old Europe.'"[9] Absence and abandonment, the works arrived like a bird singing off-key.

Twombly didn't attend the opening of the show in March of 1964. If he had, I'm sure he would've objected to the way the pictures were displayed, not in a single row as they are today in a famous museum, but out of order. The progression from one painting to the next matters in these sequences. This is the discourse that means narration. There is a building, an escalation not unlike the motions of sex or hunger or rage.

"Twombly has not shown for some time," starts Donald Judd's takedown of the show, "and this adds to the fiasco. In each of these paintings there are a couple of swirls of red paint mixed with a little yellow and white placed high on a medium gray surface. There are a few drips and splatters and an occasional pencil line. There isn't anything to these paintings."[10] The short review goes on to describe that the best thing at the show is the advertising poster, which shows one of Twombly's earlier paintings "scribbles on white ground." At least in those works, goes Judd, Twombly had something in mind.

Judd's review featured a small black-and-white image of Part IV with the title of the work misspelled as *Diccourses on Commodus*. Salt in the wound. The reproduction erases the subtly of the pictures, the tension between order and abandon—the grid, the straight lines, the light gray ground, the red fingerprints, the smears of white and brown, the heavy paint and the cool surface.

I like to think that Judd's reaction, "there isn't anything to these paintings," is knowing in its own way: there isn't *any one thing* to these

paintings. In their energetic explosions of paint, thrown and smeared and pressed across a plane of gray, and their textured marks of crayon and pencil that grid or guide or divide, the sequence of nine canvases attempts to capture the tension between control and rage, between containment and dissolution.

▌

Imagine yourself as a critic seeing Twombly's works from this time, the Commodus Paintings or *School of Athens* or any of the hundreds of drawings from the early '60s.

In his "expansive lexicon" there's too much to see. Too much to experience, impossible all at once, and when you start trying to break apart the little shivers of thought, little campaigns of color or form—the hurry of an X, the smear of brown paint, the penciled heart, the cartoonish breast—the whole disappears.

"The work of art as a field of details," is how Philip Fisher describes *Il Parnasso*, a Twombly painting from 1964. "We see," Fisher writes, "a line, a dab of paint, a splash, a spatter, a scribble, a scratch, a mark. Each is a kind of gesture and each gesture is in essence a thrill, a vibration, a shudder or rapid pulse. These are records of energy, vital bursts, a mimesis of pleasure." It is a work that "demands immersion and a patience willing to invest time in looking at it, or nothing at all."[11]

In a way it is like listening to a piece of music: you move through in time, hearing one note or phrase, then gliding or tumbling to the next. Or, perhaps the better analogy, the one that Twombly himself might have preferred, is to the poem. A poem refuses paraphrase. The paintings too can't be summed up in their fractured pieces or frenetic composition, their refusal to play by the rules. A list of all the figures, signs, symbols and marks, misses the whole. It misses the desire one feels for these paintings, something that happens not despite the parts, but because of them.

"A day or two after you see the Twombly show, what you may recall is all the careful looking that you did, rather than anything that you actually saw."[12] The critic who wrote that meant that as a kind

of disparagement, when in fact it is one of Twombly's gifts. To offer an experience of looking, really looking. You walk away with an idea instead of an image, a feeling that refuses to let go.

I

Failure or letdown. Disappointment or grief. There was no triumphant return to the New York art scene. *Nine Discourses on Commodus* returned, ungraciously, to Italy. Unsold in New York by Castelli, Twombly sold them to Claudio Cavazza, the founder of the Sigma-Tau pharmaceutical company.

For many years they hung in one of the hallways of Cavazza's house on Piazza Campitelli in Rome, these works of violence and rage, in a single line, sharing a wall with other paintings, a passageway from room to room. It's strange to think of those paintings only visible in the home of a single, wealthy collector. A work that centers on a single powerful man coming apart, madness, destruction, death, remained more or less unseen, alone. Even today very few of Twombly's paintings call Italy home. And of those, even fewer are on display to the public.

Some days, the paintings might have only been appreciated by a young woman sweeping the dusty hallways of the palace, or a lost delivery boy with his basket of fresh fruit and vegetables. When Claudio and his wife Lorena split, the works were sold and shipped out of Italy, eventually landing at the Guggenheim Bilbao.[13] Now, you can pay your 13 euros and walk into the curves of Gehry's titanium dream to see the paintings together. They look good on their single wall. The paintings suffuse the room with a silver-gray halo.

The story of the paintings is also a story of a marriage. Another slipshod boundary between the private life of a couple and the public life of these works. When, after no small feat of internet sleuthing, I got in touch with Lorena, I asked her to tell me more about the works, where they were hung, how she or Claudio felt about them or Cy. She was confused. What good, she asked, is it to know these things? What was "worthwhile" about knowing their place in the palazzo they called home?

Context, I wanted to say, matters. And transforms. From room to

room to room, these stations of Commodus, carried across the ocean and then back, matter to our sense of the works as objects that can change, that can shift in their rooms, that can change us. The pictures hung in Twombly's studio and the ones displayed at Castelli's gallery and the ones now in Bilbao are not the same. All true.

But mostly, I wanted her to say they were loved.

PART TWO

15

WINDOWS

1964. FROM THE WINDOW OF his apartment in Rome, Nicola Del Roscio could look into Cy Twombly's palazzo on Via Monserrato.[1]

Cy drawing. Cy opening the windows to let in the cool spring air. Alessandro racing around the empty rooms, a new kite under his arm. Cy gone for long stretches of the day and night. Tatiana laughing with famous guests. By accident and intent, we notice our neighbors, our days and theirs intertwine and diverge.

Across Rome, even now, these rituals of windows opening and closing, as people raise their blinds in the evening or stretch outside to hang wet clothes to dry. We catch sight of the world. And when

those windows were open Nicola could, I imagine, hear Italian cut with English, the inflected tones of domestic life, kindnesses, fights, laughter, those echoes carrying across the street's narrow divide.

How hard it is to see in the moment when our lives are undone. The spool of thread unraveled. The stone in the pond. The beat of a wing. Only looking back do we see the shape of the arc, that bright day in spring, when a young man, just a kid, really, reading at his desk, exam papers spread before him, first watched a man cross the panes of the window and then disappear into the vast rooms.

▍

From here until the end, Nicola is part of this story.

"Cy's partner, lover, critic, administrator, and helper," as noted art critic Arthur Danto writes of him. Nicola is always there, beside or behind Cy, though if you were to look in any of the catalogues or interviews or books published in the artist's lifetime, you probably wouldn't see him. Unless you knew to look. He is elusive shadow and invisible hand.

"Nicola del Roscio is Twombly's closest associate in the studio (although Twombly does not refer to him as an assistant)," Claire Daigle claimed in her 2004 doctoral thesis on Twombly and Roland Barthes. More recent articles and books on the artist describe Nicola as Twombly's "close collaborator," a progression that puts him on equal footing as the artist, working alongside, together, and not simply a paid assistant or casual friend.[2]

Whatever word, or euphemism, you prefer—"friend" or "partner," "lover" or "close companion," "archivist" or "editor," "assistant" or "executor"—Nicola is the person closest to Twombly, living or dead. He is the official gatekeeper. Editor of *Cy Twombly Drawings: Catalogue Raisonné Vols. 1–8* as well as the doorstop anthology *Writings on Cy Twombly*, Nicola is the president of the Cy Twombly Foundation and the Fondazione Nicola Del Roscio, a foundation that controls the rights to Twombly's photographs.

In an *Artists Documentation Program* video recorded at the Menil in 2000, Twombly, Nicola, and Carol Mancusi-Ungaro, the former chief

conservator at the Menil and friend of the artist, walk together around the Cy Twombly Gallery. We never see any of the faces. We just listen. Mancusi-Ungaro asks questions of the artist and describes the restoration or cleaning of pieces. Twombly's voice, his soft timbre and southern drawl, often fades away as he's talking.

When Twombly first agreed to the interview he didn't realize it would be filmed. "The whole thing was a disaster," Mancusi-Ungaro remembered. He "just blew up" and refused to be on camera. Years later, only after he overheard her describing how future conservators would mistake the dirt he mixed into paint as an accident, something to be corrected or removed, did he agree to be on camera—or at least partially.[3] Once we see his torso, just his waist, really, as he crosses in front of the camera. The camera stays positioned on the works as they discuss Twombly's process of layering paint.

Nicola is there too, with Carol and Cy, walking along, filling in dates, the name of the Belgian linen on which *The Age of Alexander* is painted—utrecht—asking a question or saying something inaudible. In the transcript of the video, so many moments where his words, mumbled or said only in partial range of the microphones, can't be deciphered: *NDR: _____ [word inaudible]* or *NDR: _____ [phrase inaudible]*. We never see his face.

"You—find me—in fragments," Ezra Pound said to Donald Hall in their 1960 interview in Rome.[4] That is where we find Cy. That, too, is where we find Nicola. They are men of fragments left behind, stories held in the care of others, voices preserved like imprints in cement.

At one moment in the video, we hear Carol correct Cy; the woman who took off her clothes to dance naked in the gallery, so inspired by the paintings, a moment of ecstatic abandon before his lush later works, didn't dance in the room of pink paintings but in front of the big one, *Say Goodbye*.

Nicola asks, betraying the foreignness of his English, "Was she handsome?"

As if beauty is an explanation that answers and not its own kind of riddle, its own strange, impossible question.

"At times I would hear from the apartment someone playing the piano in spurts," Nicola writes in a short, untitled essay that opens the third volume of the catalogue raisonné of the drawings. "A blond child would run by quickly, passing in a split second by the window or at other times a very tall American passed through on a bicycle."[5]

In Twombly's room, drawings in silver frames filled the entire wall, from ground to ceiling. "It was an astonishing revelation," writes Del Roscio, "a tree of life, a puzzle of scattered ideas, sedimentation of psychological experiences, memories narrated using colors, fragments of figures, numbers, lines of poetry, graffiti, stripped down symbols that invited me to recompose the scene in my own mind."

What Nicola recalls is not the countless small marks or scribbled forms, not the sex of these billowing loops, breasts or heart-like asses, not the violence of Twombly's inscriptions, but the way these works transform the viewer. Tree, puzzle, fragment—how much, reader, can you see of those works? Not much I suppose, but then again, this is often what happens when looking at Twombly's drawings, "works that at first can seem to be nothing but details," as one critic writes.[6]

A 2015 *New York Times* profile of Nicola, immodestly titled "Cultivating Genius," characterizes their first meeting this way: "Del Roscio was a 20-year-old university student in Rome restoring and selling old apartments on the side when he met Twombly, or at least first glimpsed him, in 1964 . . . A few months later, a mutual friend introduced Del Roscio, who describes himself at the time as 'undisciplined, anarchic' to Twombly, who appreciated the young man's ability to recognize painters' styles after only a brief exposure to their work."[7]

Nicola tells the writer, "'I had a good eye . . . It increased me in his estimation. He wouldn't give you his friendship just like that.'"[8] He's right. Twombly had discerning tastes when it came to other people. He suffered few fools. But that doesn't mean he was immune to the thrall and excitement that comes from attention, particularly the attention of an attractive young man. "The most handsome man I'd ever met," one mutual friend told me about Nicola. "A good eye," perhaps, but Nicola, when he was younger was, simply put, beautiful.

By the *Times* profile, when Nicola met Twombly, in addition to being a student at an unnamed university in Rome, he also restored and sold apartments: "Twombly gave him his first job in art, cutting a canvas, before asking him to frame a painting for a client." Of the details in the *Times* article—that he for a time was "dealing in museum-quality antique frames," for example—I've found no second source.

Both Nicola's piece about his first meeting with Twombly, and the *Times* profile told to a sympathetic writer, are vague and gauzy—interesting, erudite people talking, Twombly slipping into another room to play phrases on the piano, and the blond child who entertained the sophisticated guests with his "innocent beauty and happiness."

What's perhaps most notable about Nicola's own impressionistic, romanticized etching of his first meeting isn't what he says, but what he leaves out. He leaves out the age difference, sixteen years or so. He leaves out Tatiana. He leaves out the romantic nature of their relationship, either at the time or later. What remains is the thrill: "When I left the house," Nicola writes, "I was in turmoil and excitement having found an entirely new aspect of life."[9]

▌

To imagine Nicola looking from one window to another is to return to one of Horst's photographs, an image only published in 2003 in *Nest*: Twombly leaning out of his apartment's window, his face visible through one part of the window's glass. Unlike the pictures selected to be published in *Vogue* in 1966, in this one, Twombly wears jeans and a blue sweater, causally dressed, a down-to-earth artist and not the dandy in his white suit. It is as if he's looking down to a friend on the street below, arranging an afternoon coffee date or complaining about the government. This common sight, the ongoing and daily conversations between people on the street and people at their windows. This, I imagine, is how Twombly first saw Nicola, a stranger on the street below.

On a side table beside the artist, framed photographs of Twombly as a younger man, leaning back against a stone wall in a city, maybe Rome. Twombly at thirty-six and Twombly at twenty-three.

"Unless *Nest* is deceiving itself, the photo on the table comes from a series Rauschenberg took of Twombly during their [1952] visit."[10] The story—the ex-lover's photos, the past refusing to be past—is hard to resist.

Except, it's not true. The photograph on the side table was taken by Tatiana. It's reprinted as the frontispiece in *Catalogue Raisonné of Paintings Vol. III 1966–1971*. How hard, once we have a good narrative, to break from it.

These little windows of his days. These little windows of seeing into spaces we can only imagine. In one of the two 1962 versions of *Leda and the Swan*, above the chaotic center of crayon and pencil, cartoonish phalluses and hearts and breasts emerging from the violent scrum, a narrative of sexual violence implied by the title, hangs a window, watching and fateful. The other version from that same year— and sold at auction in May 2017 for 52 million dollars—has at its center a smear of red, a bloody handprint, perhaps a sign of the rape at the center of the myth.[11]

Six times between 1960 and 1963 Twombly would title a painting after this myth, and in all but the first, that little window appears above the action. In each, the rectangular window, crude and quick and imperfect, fixes the viewer's eye and body. We are, by this sign, this recognizable perspective, grounded. It's not, I think, a sign of order above the chaos—the rectangle is too roughly made—but instead a figure for our incomplete human view. We are implicated by our looking.

I'm not alone in noticing the windows in Twombly's work, an allusion to Renaissance art or a view on "an interior reality," as some critics suggest.[12] I think of Twombly's windows differently. It feels personal. This is not the window that leads out to an afterlife away from the painting, nor is it a view to the interior. The window is the reminder of possibility. To open or shut. To let in the breeze or keep the house silent. To witness or to look away. No sign in his work is ever one thing. Each has its own weight and history, its own reading and import, private or shifting as a memory.

Cy, Via di Monserrato, Rome, 1966, Photo: Horst P. Horst

Following the terrible reviews for the Commodus show—unsold work and the rejection of his new aesthetic—the artist sought new, temporary places to work, the beginning of his lifelong move away from Rome. Twombly spent the spring of 1964 in Greece and the late summer months at Castel Gardena, the Franchetti castle at the foot of the Dolomites, working on drawings.

"One day I was looking out of this window," Twombly said, "and a cloud came by and it broke apart on the tower. A small piece of it came in my window and floated across the room."[13]

I love this story, this place, apart from the world, of close and touchable wonders. Nicola retells this same incident in the introduction to the seventh volume of the catalogue raisonné of drawings, published five years after the artist's death. In his account, Cy calls down to Nicola in the courtyard of the castle to hurry up to the studio to see this bizarre meteorological event, the clouds entering one side of the room and passing to the other, "like a sausage or puffs of cigarettes [sic] smoke. He used to laugh and laugh about the episode and used it in his work."[14]

In Twombly's version he is alone. The moment is more transcendent than humorous. Which version to prefer, or trust—the solitary artist alone in his tower, or a moment shared between them.

"Used it in his work," according to Nicola, though what part of the story, what image of windows and castles and clouds and towers, is unclear. Twombly is no illustrator. No easy mark. Nicola is perhaps thinking of the drawings done at Castel Gardena in July and August of 1964, *The Tower*, written at the bottom of one drawing as five windows gather above the swirl of circles and Xs. Or, is Nicola thinking of the paintings done later that year while Twombly lived in Munich making work for the show, "Notes from the Tower/The Artist in the Northern Climate." On one of those paintings, *Untitled* 1964, Twombly has written *The Tower Incident*.[15]

In so many of the drawings and paintings from that Munich show, cool and spare, windows rise above. I imagine Twombly in that tower, all those windows, all these ways of looking out on the world—or looking within. Unlike *Leda and the Swan*, with its single and singular fixed window, in these later works, *Untitled* 1964, for example, a series of four to five rectangular forms hang above the field of action, a semi-circle of windows, like a chorus, above the pencil and wax crayon marks. A visual representation, perhaps, of just how many ways there are to see any moment or incident. A reminder of how much perspective matters.

The world enters. Our windows go both ways. Twombly can escape

to an island in Greece or a tower in the Alps or a studio in a cold country, but as Virginia Woolf so beautifully puts it, as if describing a fragment of sky entering the room, "What happens is, as usual, that I'm going to write about the soul, & life breaks in."[16]

Twombly would, eight years later, paint over the works done in Munich. In *Untitled* 1972, palimpsests of enormous windows, ghosted under washes of paint, hover in the upper left quadrant of the picture. The earlier version of the painting is submerged under the "hazy atmosphere," an "overt cancellation of his own, albeit recent, past."[17] An act of frustration or refusal. In bloodred Twombly has scrawled *How Long Must You Go?* Like words said from one lover to another. Like versions of departure and goodbye.

In another of these revisions, *Untitled* 1972, an intense layering of white and blue and gray with flashes of red—think a sea before a storm—painted over for reasons that are unclear, Twombly has written the phrase, *The secrets that fade will never be the same.* Again we have more questions than answers. To whom is that question asked? Who is speaking those words? If there's a literary source for these provocative inscriptions, these "grudgingly divulge[d] text fragments," I have yet to find them.[18] These words become, like those windows, gestures at once private and public, shifting and stable. Every painting, too, is a cipher, some more than others.

▌

At the 1969 Spoleto Festival in Italy, Twombly and Nicola heard Ezra Pound, exiled poet, ancient and mostly silent, speak. "I did not enter into silence," Ezra Pound said of his self-imposed quiet, "silence captured me."[19]

From their private box at the opera house, Nicola and Cy could see Pound and his companion Olga Rudge. On the stage below, the concert of a Russian pianist was about to start. They watched the two like hawks, trying to overhear the conversation. What did Olga and Pound speak of? The weather. The music. The body in pain. The fresco on the ceiling. Rasp and possibility. Waiting and listening. "They both

described it as the whispering of a deeply wounded and suspicious man," writes Sally Mann, "but also of a man fading out of this life."[20]

"Cy said he would have loved to exchange just one word with this intransigent, mysterious, wrong-headed, brilliant man," she continues. "Instead he and Nicola somehow maintained a posture of intense interest in the music played before them, arching backwards in their seats hoping to hear the thoughts of a genius."[21]

The truth is that everyone had a story about meeting Pound at Spoleto. He attended the festival for the first time in 1965, reading poems translated by Robert Lowell and Marianne Moore. After that he was a regular. "I heard him read," Joe Brainard, an American poet, wrote in his diary of Pound, "I could not understand a single word he said. When you meet him he does not say a word: he rolls his eyeballs around and does not look real. He looks like he belongs on a coin."[22]

Poet Allen Ginsberg, who made a splash at Spoleto in 1967, briefly arrested for reading an obscene poem, wrote to Gary Snyder of meeting Pound one night at the opera house before the performance of *The Magic Flute*: "silent just like Julius—looked in my eye tiny blue friendly pupils for 5 minutes, held my hand wordless." Elsewhere Ginsberg wrote of Pound: "I kept thinking it was like being with Prospero, it was a pleasure. There was no weight in the silence—there was lots of room, there was no need for anxiety about it. It was like the silence of the Indian munifi holy men who have taken a vow of silence, like Meher Baba did—there was a Baba-esque quality to his silence."[23]

Nicola wrote to Sally Mann of seeing Pound as well. The old poet, according to Nicola, was "extremely shy like only a northern blond child could be. He hardly looked at us and in a side way." A different vision, less holy man and more spoiled kid.

In documentary footage from the festival, a white-bearded Pound incants a poem to a crowd gathered on a side street. I spent hours watching the black-and-white film for some glimpse of Cy or Nicola. I tried to find them in the passing shots of Piazza del Duomo and the Roman amphitheater and the opera house, crowds coming and going, but never did.[24]

Hours spent looking, just looking, trying to discern the story of each mark, the history of each word, Carol Mancusi-Ungaro describes restoring two early Twombly paintings damaged by the neglects of time, water stains and cracks, distinguishing between the mark of purpose and the mark of accident.

"I studied them daily," she wrote. "I came to know every aspect of the canvases and the idiosyncratic nature of each form. The space around and between them became as familiar and important as the images themselves."[25] Of her learned ability to read Twombly's marks, Mancusi-Ungaro offers a lesson in patience. What's hidden can be made clear. The eye can see.

In reading the accounts of their first meeting, I feel like the conservator, trying to see the differences in the pattern, the truth of things from an impossible angle of seeing. On the surface, and from this distance, the two men who seemed to have little in common—a difference of age and country, of experience and background—found in each other something that would sustain a lifetime together. Every relationship is a secret kept from within, some more than others.

When I started writing about Twombly, Nicola's very presence seemed closer to a fiction. A reality only in so much as his name kept appearing and reappearing—on the covers of catalogues he'd edited, in articles about the Cy Twombly Foundation's legal disputes, in the margins of posthumous profiles of Cy. I was reminded of one of the first of Twombly's blackboard paintings—*Untitled* 1966—white windows fly across the canvas, from a single rectangle on the left to a mass of them on the right, like a Xerox of white windows, layers over the layers.

For a time though, like Betty or Giorgio, their names diminished in the record of Twombly's works and days, Nicola's name was missing. So many places where it could have or should have appeared, but was absent. In the years after the artist's death that has changed, and is changing.

In the months before I arrived in Rome, I resigned myself to the

impossibility of meeting Nicola. I told myself that I could write this narrative without him. I could trace the contours of Twombly's life and art, the motions and direction, as something independent from this mysterious figure.

A lie I told myself, if only as a way to keep going.

The complicated truth was that I needed to talk to Nicola. I wanted to, when asked, *Have you talked to Nicola?*, say yes. I needed to meet him, at least once, to make him real, to give the passages in which he appeared a human voice.

16

NICOLA

ROME, THANKFULLY, IS A SMALL town. Everyone knows everyone else. But no one simply handed over a way to get in touch with Nicola. There's a way things are done. Introductions, right words, waiting. An obscure procedure that works, like much in Italy, on its own languorous, maddening time. I tried to remember the letter I'd read in the archives for the Castelli Gallery, a note from Thomas Brown Wilber to Leo Castelli: "To pin Cy down is absolutely impossible. So I willingly substitute patience."[1]

I met Max Renkel, a friend of Nicola's, in a café across from his *centro* apartment. Once a famous meeting place for Roman intellectuals, Antico Caffè della Pace has become an overpriced tourist spot. Fel-

lini once sat here watching as the well-heeled strolled the cobblestone streets on display. Everything changes, and nothing changes.

A German visual artist living in Rome, Max is a man of fickle affections: an easy confidant one day, a distant acquaintance the next. Tall and lanky, his owlish, world-weary eyes look over spaces with both confidence and boredom.

"What's your angle?" he asked. "Who have you talked to? Have you talked to Nicola?"[2]

He knew that I hadn't. This was the reason I was there, an ongoing game, from one friend to another, until hopefully, finally, someone would offer Nicola's email or phone number. I waited for a blessing of approval, and then, an introduction.

Max, in stereotypical teutonic manner, offered opinions about Twombly that were, the way he said them, not possibilities but facts: "Twombly really isn't American he's more European, but over here he's considered to be an American. On the one hand he's an abstract painter, on the other you can recognize the figure, say that's a flower." The binaries in Twombly's art, and life, always fall apart—American/European; abstract/figurative; high/low; straight/gay; secretive/public.

Max wasn't just a gateway to Nicola. He knew Cy a little, and more, he knew as much about Twombly as anyone I had ever met. His vast collection of Twombly materials rivaled the best libraries in the world— all the catalogues raisonnés, all the books Twombly illustrated, original posters and ephemera from Twombly's over fifty years of shows at galleries and museums around the world.

After coffee we walked across the street and upstairs to his flat. Max carefully slid open the small paper cartons, the kind found in archives to store insect samples or tiny buttons, to reveal postcards announcing each of Twombly's shows dating back to his first show at The Seven Stairs Gallery in Chicago in 1951. In a black binder, Max kept postage stamp–size photocopies of all the posters he owned, empty spaces for the ones he was missing. "And we Twombly cultists," writes John Waters, "can get quite obsessed."[3]

Years before, he started down a path, and now, he continued to fill in the gaps. This, I recognized, that confirmation or collection of facts, that gathering up of the scattered pieces. None of these posters were

on the walls. Max, I imagine, was the kind of child who collected toy figures but kept them safe in their plastic boxes.

"What makes us randy for relics?" writes Julian Barnes of our desire for all the "leavings of a life" that might "contain some ancillary truth."[4] For Max—and myself—there is, I think, truth and connection in these paper relics. For Cy too, who owned early editions of the books he loved and handwritten letters by artists—Turner and Monet. "You're absorbing," he said, "a kind of instinct or something."[5] "Ancillary truth" or "kind of instinct," we follow whatever route to the past we can find.

Max excused himself to make a phone call and I waited in the dark, high-ceiling room of his old palazzo. The cracked floor tiles shifted beneath my feet. His own work, framed and under glass, filled the walls. It was a space not unlike the one Twombly and Tatia called home in Rome.

"Nicola," I heard him say from the other room. The narrow street hummed with conversations from the café and the steady stream of people below.

"Yes, it's settled," he said when he returned. "He's coming to Rome on Tuesday and I'll call you if Nicola is available to meet."

"Increasingly the marriage evolved into a tale of two marriages," writes Stacy Schiff of Vera and Vladimir Nabokov, "a port for him, a career for her." "Her capability was matched only by his capacity for ignoring everything that did not concern his own work."[6] Beyond all of the typical activities of that generation for a wife, she was her husband's first reader, editor, secretary, and occasionally she taught his classes for him. He described her as "my assistant."

What Schiff writes of the Russian novelist and his wife could be true for Cy and Nicola. For despite the references in sympathetic profiles to his career of "selling antique picture frames" or restoring old apartments, there is little to suggest he had any other life, any other occupation but Cy.[7] His versions of things, are told, almost entirely, in the afterlife of the artist, the time when Twombly is gone and the story belongs to him. Almost.

"Del Roscio, who has lived and worked by Twombly's side for nearly 40 years, has mastered the complex art of understanding the artist's temperament and needs," writes Marella Caracciolo in her 2004 profile of Nicola at his Gaeta home, a conversation where Cy is alive, present, and interjecting wry asides.

"Even Cy's closest relatives, his wife, Tatia Franchetti, and their artist son, Alessandro, appreciate del Roscio's delicate role."[8] What exactly, you might ask, is that "delicate role," a coy phrase that hints beyond the meanings of tact or sensitivity? "I supposed it is a form of laziness on my part," Nicola told the writer of this lifelong role. "Time passes so quickly. On the other hand, if one has a great admiration for someone's work, if one understands what they do, that makes it worth it."[9]

A decade later, and after Twombly's death, a very different claim of their relationship emerges: "Despite their linked lives, Del Roscio never let the artist subsume him or define him," writes Stowe in her *Times* profile. "Even now, he worries that what is written about the two men will be too 'gossipy' or stray too far into intimate territory." The piece goes on to quote Nicholas Serota, at the time director of the Tate: "'It's important to note that Nicola had a life independent from Cy,' Serota says, 'pursuing his own passion for the palm garden, creating an environment and a house that is singularly Nicola, with his strong sense of color and textiles that he managed to combine in a very effective way.'"[10]

Serota is hardly a disinterested party; in 2014, the Cy Twombly Foundation, under Del Roscio's direction, donated three paintings and five sculptures to the Tate that the artist had placed there on long-term loan, "a dazzling gift, the most valuable in decades," worth millions.[11] "In particular," Serota writes in the acknowledgements to the catalogue for the *Cycles and Seasons* show, "we would like to thank Nicola Del Roscio, Cy's long-time collaborator and editor, who played an instrumental role in every aspect of this exhibition, and has been exceedingly generous with his unrivaled knowledge of the artist's work, in addition to his patience, humour and hospitality during our visits to Gaeta."[12] That expertise, no small thing and far from inevitable, was gained from decades at the artist's side.

"I remember the times that I accompanied him on his travels,"

Nicola writes, "trotting behind him . . . making things happen, since Cy was too lazy or shy, or too busy to take care of certain things and needed someone to drive a car or buy tickets or make calls for him."[13] Nicola, following behind, taking care of the day-to-day concerns of life—tickets, rides, laundry—all the domestic business that allowed Twombly to spend his time devoted to thinking or reading or making.

In a way, this is the rough reality of being an artist. "[T]here is an appalling amount of mechanical work in the artist's life," writes Anne Truitt in *Daybook: The Journal of an Artist,* "lists of works with dimensions, prices, owners, provenances; lists of exhibitions with dates and places; bibliographic material; lists of supplies bought, storage facilities used. Records pile on records. . . . It is all very well to be entranced by working in the studio, but that has to be backed up by the common sense and industry to run a small business."[14]

Lawford in his *Vogue* article described Tatia, "slight and self-effacing, almost imperceptible yet frankly indispensable," as the "painter's wife personified."[15] Evidence for such a statement is sparse at best. Instead, Lawford could have been describing Nicola, who is never mentioned in the *Vogue* article despite his presence in the artist's life and in the days leading up to the photo shoot, moving artwork about the apartment with Cy.

Twombly, lazy, shy, or busy, vast differences between these, but in the end the reasons matter less than the result. Like Vera, the "Saint Sebastian" of partners, Nicola's "common sense and industry" made Twombly's work possible.[16] "Nabokov didn't even fold his own umbrella," writes Jenny Offill in her novel *Dept. of Speculation.* "Vera licked his stamps for him."

█

From his collection, Max carefully pulled out a postcard announcement for a 1974 show at the Castelli Gallery. On the front, Twombly and Rauschenberg lie together on Captiva Island, beach grass behind them, the men stretched out like resting farmhands; it's hard not to see in the reclined pose of Rauschenberg an echo of the photograph of Twombly on that Staten Island beach.

Here's one critic's take on the card: "There they were, Tom Sawyer

Cy Twombly, Nicola Del Roscio, Micky (longtime collaborator of gallerist
Yvon Lambert), Paris, 1984 Photo: André Morain

and Huck Finn in middle age, taking a moment of well-earned rest—or,
more likely thinking up new ways to startle their admirers. Old friends,
they seemed at ease with each other and with the world."[17]

I described it to Max as pastoral, two shepherds throwing them-
selves down under a tree at noon to sing songs of loss.

"They seem like a married couple," Max corrected. It was the exact expression several writers have used to describe Cy and Nicola.[18]

Looking at the postcard, Twombly and Rauschenberg relaxing on the dunes, I asked Max, "What's your take on their relationship?" Relationship—that's the word I used, not friendship or affair, sex or love—a word that could be used for brothers or lovers, neutral and vague.

"It's all rather complicated," he said and led me out.

Max never called on Tuesday. I waited all day, continuously checking my phone. By the evening I gave up. The next day, Max called and told me to come quickly to Piazza Farnese, his voice annoyed when I told him it would take twenty minutes to get there.

I entered the piazza and saw Max near the small fountain in front of the palace, tourists and businessmen and students eating their lunch. Pigeons begged at their feet. We walked over the stone benches that surrounded the Renaissance palazzo where Nicola sat, waiting.

Nicola, lime green sweater and old-man running shoes, was older and smaller than I expected. Nothing about him was imposing except perhaps his eyes, which darted around, nervous and pensive and aware. Max sat next to me and listened without comment. For a couple of minutes Nicola and I made small talk about Baltimore, the city where I grew up, and filmmaker John Waters, great devotee of Twombly's art.

Small patches of hair framed a bald spot on the top of Nicola's head. I looked in his face for signs of the great beauty that others have claimed. "The look of a Caravaggio youth who took good care of himself," wrote Danto only five years before.[19]

I tried to imagine what it might be like to fall in love, if indeed that was the case, with one person at nineteen or twenty and forever be in their shadow. And make no mistake, it was a long shadow, Twombly's enormous physical and psychic presence continuing beyond death.

"Do you believe in accident?" Nicola said to me. "In chance?"[20]

Before I could answer, his cell phone rang. I glanced at the name,

Julie Sylvester, a board member of the Foundation. He missed the call and for the next couple of minutes he tried to call her back.

"Ask the hard questions," Max said as we had walked up to meet Nicola, but in the same breath he described how Nicola always felt "undervalued." Nicola's work as editor and archivist—roles that couldn't have been easy at the start, what with his lack of background in art—grew and evolved over time.

Until Twombly's death, Nicola was almost never mentioned beyond his work as an editor. Twombly survived his hard years of exclusion through a bit of luck and a stubborn certainty in his own work. "It's not for everybody," Twombly said of his own art. "I'm lucky to have people close to me—my wife, my son, my friends—who understand the work."[21] In this article, published in 1994, Nicola isn't named or acknowledged as he should have been.

To be bold and cautious at once is a hard balance. I was unsure how much to ask at that moment and how much to put off. I settled on a delicate, kid-glove approach at first. To listen and watch, with the hope that this would be the first and not the last meeting.

It didn't matter. This wasn't so much an interview of Nicola but an interview of me—where I'm from, what I'm doing here, who I've talked to so far. Am I someone worth talking to?—this the unasked question lingering behind all the others. "And what is it that you do?" Jackson Pollock supposedly asked Twombly when they met for the first, and last, time.[22]

Nicola wanted to know my favorite book. My favorite movie. He wanted to know what my parents did for a living. We danced around the subject of him. "I like to talk around things," Twombly once said, a truth for his work as much as his life.[23]

Twombly's name was all but unsaid.

∎

From Piazza Farnese we walked down a side street to lunch. A man I didn't know joined us. Cue-ball bald, gold jewelry jostled on his wrist and neck. I didn't catch his name or why he was there exactly, something about money.

The waiter dropped menus and bread and water. I caught Nicola studying me, his eyes narrow and intense.

Nicola, Max, the bald accountant, and I shuttled awkwardly between English and Italian. At a neighboring table a group of boisterous priests drank the house red. Two liters, then three. The three men at my table laughed all at once. *"Pesantone."* The fat men. Max explained the joke to me.

I tried to see before me the man who met Twombly when he was so young. There is a striking photograph by Twombly of Nicola in 1969 on a trip to the island of St. Martin, twenty-three or so, his head turned in profile and wrapped in a turban, his features at once delicate and sharp; "Like a hip Pisanello," to quote Vincent Katz's essay accompanying these images.[24] Selected and published in the artist's lifetime, the volume includes only photographs of five people—lovers, family, friends, teachers—Betty di Robilant, Alessandro Twombly, John Cage, Franz Kline, Robert Rauschenberg, and Nicola Del Roscio, who edited the catalogue.

The photo of Nicola bears a striking similarity to one of Twombly taken by Tatiana in Egypt in 1962, the artist in traditional garb, white cloth covering his body so only his face is exposed. How strange the symmetry, the conscious retaking of the same image. One love captures another.

"What is it you want from me?" Nicola asked as we finished our meal.

I don't remember now exactly how I answered. I probably said something about insight into Twombly's practice as an artist. But really, at that moment, I just wanted him to talk.

Mystery made into words. Tell me about windows in Twombly's work. Tell me about the "turmoil" you felt after you first met him, or how it felt to shake Twombly's hand. Tell me about your childhood. Tell me about the first time you talked when there was no one else there, how the rooms of Via Monserrato smelled. Tell me about grief. Tell me everything. Strike anywhere, I wanted to say.

Nicola deflected my questions. He wanted to know about the research I had already done, and more importantly, who I had talked to.

I told him that the year before I'd gone to Lexington, Virginia, and

met a couple of Twombly's friends there, including a retired philosophy professor, Harry Pemberton, and Twombly's helper/assistant in Lexington, Butch Bryant.

Nicola, without kind words for either man, wanted to read what I'd written about the trip. I told him it was just notes. That's okay, he said, I'll read those. It was a bind and one that I couldn't seem to get out of. He was not going to take no for an answer.

His face lined and aged, he seemed at once impervious and vulnerable. "The smartest man I know," said Max of his friend. An island. A keep. Perhaps this was one of the things Twombly recognized in him. One of the things that Twombly needed in a partner. "Cy came on as vulnerable," the American expat photographer Milton Gendel said to me of Twombly, "He gave the feeling that any word might injure."[25] Once, in response to a handwritten letter, Twombly received a typewritten reply from Jasper Johns. Hurt and bad feelings followed.

In a way too, Nicola gave this same impression. One wrong word, it seemed, might have ended the lunch. On the other hand, there was a toughness about him, an aloof confidence and self-assurance.

Lunch ended. Nicola and the accountant went their separate ways. I walked with Max for a bit and then turned down a side street towards home, unsure if I would see Nicola again.

EXILES

THE NIGHT OF NOVEMBER 9, 1965, a blackout along the Eastern Seaboard of the United States turns the clocks in New York City back a hundred and fifty years. The world ends and starts again. Twombly, in the city to work on pieces for a show, wanders in that dark, moonstruck city, a hum of anxiety. He walks out on the street, without a direction, the city noisier and quieter at once. Neighbors, who in the way of city life might have lived beside each other for decades never having passed a kind word between them, meet in the hallways to borrow candles. Thousands of commuters, stranded, sleep on the floors of Grand Central and the lobbies of office buildings, their jackets rolled up into pillows. And then, tired of walking, he returns home to draw.[1]

Picture the dark room. Picture the artist pacing, trying to figure out a way out of his own head. In the dark city, history repeats: a temporary space like that quiet motel in Georgia where a decade before Twombly made a myth of his making without sight, his hands retraining the lessons of their youth. What's repeated in that Midtown Manhattan studio apartment, rented from David Whitney for four months, wasn't just the absence of light but Twombly's need for these borrowed rooms, spaces without the distractions or familiar patterns.

"Habitualization devours works, clothes, furniture, one's wife, and the fear of war," writes Viktor Shklovsky in "Art as Technique." "Art exists that one may recover the sensation of life; it exists to make one feel things, to make the stone *stony*." He could be describing Twombly's process as an artist. To feel things—stone or word, arrow or window—Twombly continually undoes the binds and tethers of his self-made routines and comforts. It's why he's here, making work for his first opening in New York since the 1964 failure of the Commodus paintings.

In a 1965 New Year's Eve letter to Giorgio, a distraught Twombly expresses a feeling of being "undermined" during the previous two years.[2] A stranger in his own country, his upcoming show of drawings at the Castelli Gallery felt like another make-or-break moment, another comeback. The effects of Twombly's doubt and disappointment are physical and mental. Even small activities cause the artist to feel, as he writes to his brother-in-law, anxious and weighed down. An anchor of lead carried through his days. Days when harsh words, unkind reviews—"there's nothing there"—come back like skywriting.

Doubt, like fear of failure, like pain, never feels productive or fleeting or contained. This is it, you think. My last good poem. My last good painting. The sensation spreads across your life. Doubt your art. Doubt your marriage. Doubt your country. Doubt your lover. Doubt your life.

The blackout ends. Lights return and like that first real and bright day of spring, or the morning after a hurricane, a joyous recovery of vision and familiar motions. Even though it is cold, the sharp edges of winter gusts against exposed cheeks, people chat on the street for longer, catching up as if they'd be away from each other for months.

"If you really are interested in being in the art world," Twombly once said, "in getting ahead, you are in New York, not in Gaeta."[3]

If you didn't know the facts of Twombly's life, you might think that he stayed away from the art world. You might believe that Italy, Rome or Bassano or Gaeta, were his exile. And for a number of years, between 1957 and '65, Twombly did mostly stay away. From the end of 1965 to the start of 1970, however, New York City for all intents and purposes was his second home, his laboratory and refuge. From the apartment on 52nd Street to the loft on Canal to a studio on the Bowery, Twombly found places to create, spaces that offered a life apart from life. A way to get ahead.

Twombly's letters back to Giorgio in Italy offered scouting reports from the front: drawings by Robert Rauschenberg selling for several thousand dollars and Jasper Johns's work—sold before it was even on the walls—fetched an unbelievable $7,500. In one letter to Whitney, Cy writes of his sadness at selling a painting. "Money," he writes, "is certainly no consolation for something beautiful—but it is some help in other matters (I will save it for NY)."[4] More than money, Twombly was desperate for the same success of his peers, for recognition, in all the senses of the word: acceptance and approval and acclaim.

"The other painters, whatever they think about it, instinctively keep their distance from discussions on current trade," wrote Vincent van Gogh to his brother Theo. "Ah well, really we can only make our paintings speak."[5]

There's no distance between Twombly and "discussions on current trade." In one 1965 letter to Betty from New York, Twombly explains his attempt to build back his name after what he describes as "nine years of neglect."

Neglect is an odd choice, at least from this distance, and doesn't seem quite accurate. One thinks of Castelli's letters pleading to Twombly for work. From the artist's point of view though the other artists Castelli represented, Rauschenberg most of all, were doing well, selling work, becoming famous. Twombly didn't feel that he was fully appreciated or that Castelli had the right sensibility for his work.

To hear Ivan Karp—"a cigar-chomping, fast-talking New York gallery owner who helped find, popularize and market the Pop artists of the 1960s," as one obit puts it—describe the affection and loyalty that he and few others had for Cy, is to rethink the artist's sense of things. Karp said of Twombly in a 1969 interview:

> But he really had no audience here. In the United States, there were no more than a handful of us, about eight or ten people, who knew of Twombly at all or who ever spoke of him or who ever even thought that he was of any consequence. And we'd pull out the works and talk about them, just a little handful of people, you know. I always felt very warm about Castelli's feelings about Twombly. He was always tremendously loyal to Cy's art. And I felt the same way; that we should never lose him, somehow just keep clinging to him.[6]

Karp and Castelli, among others, continued to support Twombly and his work, even after "the very bad show." Which of course is not to say that the artist, looking around at the relative success and acclaim of his peers, didn't feel undervalued.

The failure of the Commodus show, bad reviews, unsold paintings, was as much about the direction of art at that moment towards Pop and Minimalism. Twombly's work, for better and worse, seemed out of step with trends in the art world. The black marks against him at the time—his distance from the scene, American toughness traded for European luxury—would later become his great claim of independence. Indifference, he'd later claim, rather than being a problem, allowed him to work without pressure.

Decades after, Twombly claimed the Commodus incident made him "the happiest painter around, for a couple of years: no one gave a damn what I did."[7]

And if you believe that, then you might believe anything.

In New York I imagine Twombly retracing the steps of his youth to a gallery or museum he first visited almost twenty years before, people on the sidewalks in a great and busy hurry, like schools of fish, circling around him. Every city is a little haunted.

In the drawings done on the floor of Whitney's 52nd Street studio apartment, Twombly rediscovered the quickness of ink and pencil. It is as if a gale wind has blown through the field of his earlier drawings leaving behind only one or two central shapes fixed to the surface by strong tethers—an upside-down triangle, a large arrow, two horns, circles of blue around a box with the word *Reflection*, five shaded circles, a crown or castle with gentle pink spikes, a crude hyacinth. The city, its graphic signs and bright neon, found its way into these pictures.

Twombly starts again, it seems, turning back to a different kind of simplicity, not the childlike (though never childish) scrawl of the years before, but something more open. They are not images under the sign of Pop art, but share that graphic directness.

In one drawing, *Untitled (Greetings from Gorgo)* 1965, Twombly has sketched two upside-down rhino horns or two angular breasts, dark marks like an aureole on each. The phrase *Greetings from Gorgo* signed in cursive above these mostly colored-in figures, red pencil with streaks of blue and green.

The Mary Barnard translation of Sappho Twombly owned and read describes Gorgo as "a woman who is said to have been wealthy and a rival of Sappho's." "Greetings to Gorgo," begins one of the several poems addressed to her rival. It's possible to see Gorgo as a figure for Tatia, descendant of the wealthy Franchetti line, just as it's possible to think of Twombly in another of Sappho's poems, a defense and claim: "Really Gorgo / / My disposition / is not at all / spiteful: I have / a childlike heart."[8]

Twombly created these pictures for a gallery show at Castelli's in February of 1966. Like giant postcards on oversized sheets of paper, almost three feet by two feet, full of personal notes and messages, many of these drawings have small passages handwritten by the artist, passages from poems Twombly was reading, neither commentary on,

nor explanation of, the images, but part of each picture's composition.

His great discovery of this time was Federico García Lorca, the Spanish poet of desire and war who spent a year in New York City, a time of sexual and artistic freedom. I know the weight of a battered paperback copy of *Poet in New York*, his poems of these days, surreal and sensual wanderings. A book of walking and looking, Lorca, hungry and alive, gathering up images and experiences. A book of sex and wanting, the world as strange offering and permission.

In the introduction to the copy Twombly might have owned, the 1940 bilingual edition published after Lorca's murder, the translator writes, "I can, of course, now and then be caught taking liberties; I do not much care whether critics call this presumptuous, provided they do not say I have been silly or stupid."[9] Sometimes I think that what I'm writing is a kind of translation, an attempt to bridge the distance from the unreadable text of a life to something one might carry in their pocket for solace.

Or maybe he was reading the New Directions edition of *The Selected Poems of Federico García Lorca* translated by William Logan, a work that includes Lorca's "Romance Sonámbulo," the poem that opens with the line, *Verde que te quiero verde.* Green, how I want you green. Green: the color of sex and flesh and desire. The "men with the green glance / who love men and burn their lips in silence," Lorca writes in his poem "Ode to Whitman."

The words in Twombly's drawings are like notes slipped inside a bottle and thrown into the ocean and carried across waves and time. Twombly, through Lorca, asks, "What angel do you carry / hidden in your cheeks?" For both men, the question is about the secret charges a place carries, and how to find it.

▮

In New York, Twombly, thinking of Nicola, writes his name, his full name, in drawings:

Nicola del Roscio sleeping under the Palms at Aqaba.
Or, *Nicola del Roscio Asleep by the Ionian Sea*
Or, *Nicola del Roscio asleep under the Sea*

Variations on a theme of dreaming, Twombly imagines what is not really there. Asleep by a foreign sea or in a foreign land. Asleep in the unreachable depths. *Verde que te quiero verde.* Green, how I want you green. The names of gods and goddesses, of heroes and emperors, of poets and philosophers, all the names that form the constellations of Twombly's making, and now, like a sudden bolt of lightning, Nicola.[10]

"If you will come," he writes on one drawing, a line from Sappho, "I shall put out / new pillows for / you to rest on."[11] Fragments of invitation and suggestion. Here, the passage from Sappho seems to say, this is a pillow for you to sleep under the palms or by the sea or under it. A letter to the absent beloved and a piece of a puzzle. Like Lorca chasing down the ghost of Whitman, beard full of butterflies, Nicola is made present in his absence.[12]

The image in the drawings that bear Nicola's name: three oblong tendrils emerge from, or enter into, an open jaw, half Venus flytrap and half singing clam. This figure appears in earlier pictures that don't include his name, but now, its weight and meaning changed by Nicola's presence. Life breaking in. I can't decide if it is a beautiful or sensual image, or one of violence and possession—not that those things can't exist all at once. A figure of longing. Consuming or letting go. Waiting in a state of suspension, those three elliptical strands, a trinity of uncertainty. *Verde que te quiero verde.* These words curve around that open jaw and beside Nicola's name. We want what we do not have. We want what's at a distance—fame or sex, a distant shore or city.

Green, how I want you green.

❚

In the winter of 1966, just before the drawing show opened, Nicola traveled to the United States to visit Cy.

According to Nicola's own account, he slept on a "dilapidated foam rubber mattress," a detail that protests too much.[13] What does seem true in his description is the sense of being part of a new, dynamic world, from Susan Sontag's smoky Greenwich Village apartment to uptown dinners with the well-connected curators, from late-night artist gatherings in Rauschenberg's kitchen to wild scenes at Warhol's

factory. What a thrill to be offered a place at these tables, a thrill I recognize—this fine life, these smart conversations, this sophisticated world of makers and buyers—in that Twombly has offered me, too, entrance into rooms that I might never have entered, meetings with people whose names are well known.

Nicola's truest sentence is this one, from a description of accompanying Cy to architect Philip Johnson's Glass House and a dinner party of "interesting people": "I was very intimidated by their fame."[14] An impossible situation for Twombly's young friend, the word I'm sure that was used to introduce him, a not-so-secret code, instantly recognizable: This is my friend. No nods or winks necessary.

Virginia Woolf wrote of Joseph Conrad and his "preference for living in the depths of the country, out of ear-shot of gossips, beyond the reach of hostesses, so that for news of him one had to depend upon the evidence of simple visitors."[15] I think of Twombly and Nicola in New York City, out of reach from their normal lives, far from the "ear-shot of gossips."

As with his essay on meeting Cy for the first time, Nicola's decades-later recollection of New York is notable for what it leaves out. Nicola describes Twombly's new friendship with Johnson and how honored he was to be invited to the Glass House. In a separate sentence he mentions David Whitney's aside that Twombly was a star of the "underground" art world and the fact that Whitney was the one who took him to see the bacchanalia of Warhol's factory. But the details matter. Philip Johnson and Whitney were partners, romantically involved since Whitney, then a student at the Rhode Island School of Design, approached the much older Johnson after a lecture with a question about Johns's famous flag painting. "I told the truth too soon, as usual. So then we got started," Johnson recalled about their first meeting.

"We were never secretive," Whitney said about their lifelong relationship. "It was always terrifically open." They were, in many ways, mirror images of Cy and Nicola. "I'll make decisions about our daily life," Whitney said in an interview. "It could look like I was pushing him around, but in fact he wants to be pushed around . . . I like everything about Philip. Einstein once said, 'My wife takes care of all the little things and I take care of all the big things.' I think I take care

of all the little things." Whitney, a respected collector and curator, is being modest.[16]

The parallels are striking. Nicola, like Whitney, took care of the little things. For many years, Nicola traveled with Cy, first to New York and in later years to Lexington to help the artist get settled in his studio. He'd return months later, help him pack up and return to Italy. For while Twombly was capable of seeing the world as no one else, he was, in Nicola's words "not so brilliant at putting things back in order again."[17]

▌

When Twombly went back to the United States in November of 1965, Alessandro, almost six, accompanied him. It's hard to see Twombly taking care of Alessandro by himself for such a trip, perhaps to visit his grandparents in Lexington; indeed it was Betty who flew with the young boy back to Rome, delivering him to Tatia, while Twombly stayed behind to keep working on the drawings for the show. An incident that wouldn't matter much except for that in the months after, Tatia refused to answer Cy's letters from New York. Silence.

In a letter from 1966 to Giorgio, Cy wrote that he wouldn't return to Italy, if that's what Tatia wanted. Despite the fact that he'd written three or four times, she never wrote back. Twombly asked Betty for information about Tatia; what, he wanted to know, was wrong. The details of this fight matter less than the small window it offers. Seven years after their marriage, Cy didn't want their relationship to simply slip away. One small fragment—distance and anger nested like cup and saucer—in the story of Cy and Tatiana's complex relationship: her stubbornness and independence, his dependance on her.

The source of Tatiana's anger with Cy isn't explicit. Maybe Tatia found out that Nicola was in New York with Cy. Maybe she was annoyed that Betty brought Alessandro home. Or maybe another reason, impossible to reconstruct from the thin traces of what's left in the present.

When I asked Alessandro about letters between Tatiana to Twombly, he said they were mostly postcards. Is that the truth? Or, were the letters destroyed, lost, or held back by whoever has them?

What's clear in this incomplete narrative is that Tatiana was not powerless, not the passive partner.

They reconciled, though I wonder if she ever saw the drawings from New York, the ones under the spell of Lorca, not just Nicola's name and the green admissions of want Cy inscribed, but drawings with lines from Lorca's poem "La casada infiel" ("The Faithless Wife") sometimes in English and sometimes in Spanish: *la mitad llenos de lumbre / la mitad llenos de frío. Half full of Fire and full of Cold.* Those lines are equally true of Twombly's own personality, his oscillations between passion and detachment, presence and absence.

Sometimes our words are incantations of desire, asking for what we want. Other times language is for curses, for palinodes and dispraise, for poems about those that disappoint us and enrage us. Twombly's words are never one thing, except maybe this: personal. Which is not to say that they're always, or even ever, autobiographical.

▌

Twombly's drawing show opened at Leo Castelli's gallery on February 12, 1966. Seven days earlier, a show of Donald Judd's opened and ran concurrently with Twombly's. Judd's rectangular metal blocks extended from the wall like little metal cliffs. It seems a cruel irony that Twombly would share the walls with Judd, though in a way there's a lovely contrast between Judd's ordered repetitions and Twombly's chaotic ones, between their divergent instances on kinds of making, machine or hand.

Twombly's show was either a great success or another flop. It depends on who you trust. Nicola writes that the Castelli drawing show "sold well and represented a good réentrée for Cy into the New York art world."[18] In this version, the show of drawings reversed some of the damage to Twombly's reputation from the 1964 Commodus show. The attempt to build back Twombly's name and profile after "neglect" worked. In her short, mostly positive review, Dore Ashton writes, "[Twombly] still wields his pencil lightly, with the assumed innocence of childhood. His wavering lines and scribbled messages sprawl ingenuously on the page, heightened now and then with a few crayoned tints.

Yet beneath the airy, agreeable lightness there is a sombre hint now and then of potential violence and eruption."[19]

Or, do we believe Twombly? Even with prices set low—$300 for a picture, which included the $70 frame—he didn't have enough to pay back Whitney for the use of his apartment. Twombly had to borrow money from his brother-in-law Giorgio, a few hundred dollars just to get the slow boat back to Rome.

The truth seems to be somewhere in the middle. It was neither the great triumphant return the artist hoped for—that was still years away—nor was it the dismissal he encountered two years before. What matters most perhaps, at least for this story, is Twombly's sense of things at the time, how this moment felt as he left New York for Rome.

"I would have sold easily a monkey turd on a plate than these things as absolutely no one gets them," he wrote back to Rome.[20] When Twombly writes that "no one" gets them, his doubt isn't his work or vision, but the taste of his age.

"I always thought that an artist's was the hardest life of all," said Lucian Freud, "Its rigour—not always apparent to an outside observer—is that an artist has to navigate forward into the unknown guided only by an internal sense of direction, keep up a set of standards which are imposed entirely from within, meanwhile maintaining faith that the task he has set himself to is worth struggling constantly to achieve. This is all contrary to the notion of bohemian disorder."[21] Twombly has that faith, a resilience, not against doubts, but despite them, a wounded sense that the problem was the viewer, the audience, the buyer who failed to recognize or understand what made these pictures worth living with. This too is what I admire about Twombly. Against all the uncertainties of making something, anything, in a fickle and capricious world, he continues to make his "difficult paintings." His doubts were not about his work but their reception. He's waiting for the world to catch up to what's he's done.

18

CHALK

TWOMBLY RETURNED TO ROME BY ocean liner in the spring of 1966. Against the metal rail of the SS *Raffaello* his body braced against the constant, forward motion of the ship, the Atlantic waves below doing their own chaotic, unorganized thing—a kind of possibility to be moving and never arriving, to be living and never quite done.

Salt-licked air, the absence of birds, the sky a parallel gray to the ocean. A small notebook of sketches in his shirt pocket. He plots the process of moving from mind to paper to wall. Go to Poggi's store. Buy paints. Tack the empty canvas to the wall. Wait for the right moment to turn these pictures, these diagrams, equations, or plans, into something more than ideas. White against gray, like the chop and glimmer of whitecaps.

In Rome, the first pleasures of return: dinners with friends to gossip over the New York scene, ochre light against the motorbikes outside the cafés, lost-hour walks through side streets. The vast open rooms of Via Monserrato. If Twombly loved the pleasures of disruption, of working in temporary spaces, then he also seemed to be flush in times of return. At least for a while.

The first works made in the months that followed his return to Rome—call them blackboard or chalkboard paintings, call them gray gouache or white loops—have become in the years since his death the most recognizable, and the most valuable, of his oeuvre. And like all Twombly paintings, they offer and refuse, they seem to say come close, and then they pull away.

In the arc of Twombly's art, they are a continuation and departure, an undeniable breakthrough. Even at the time of their making, he knew he was on to something; in one letter from November of 1966, Twombly wrote to Whitney that he was making his finest work in years.[1]

These paintings and drawings, white or blue lines swirling on a wash of black-gray or beige ground, offer no literary allusions, no images of sex or gods or battles. No words we can read. Instead these paintings offer an unending trace that speaks in an illegible tongue. But still, we try to read it. To see influences and habits in the making. To read our lives in the oracles of movement. To decipher the circling lines and continual erasures, as if, by looking, Twombly's voice might read back to us the open scripts: *I make the words I never have to say. I make the words I never have to say.*

I picture Twombly back in Rome watching Alessandro, six at the time of the first blackboard paintings, "write" in squiggles and loops. I've watched my daughter as she rehearses the lives she sees. "I'm making a shopping list," she'll say, and the lines unravel like fuzzy yarn, unreadable to me and translatable by her.

The blackboard paintings, like a negative of those baroque and historical sequences—minimal, ahistorical, singular—are a seismic shift away from the ornate, color-splashed, and literary works of the early

1960s. Gone are the impasto layers, thick globs of pink and brown, gone (mostly) are the highly literary and referential titles, gone are the pencil lines and smears of hand. Gone are the words of Keats and Sappho and Lorca.

At the same time, these paintings share the artist's commitment to an individual, particular voice. No loop is exactly the same or symmetrical. Imperfect rounds and ovals. The backgrounds differ, always. The principle is not that of Minimalism, as some have claimed of these pictures, not the party of Judd, but the afterlife of Pollock, the tradition which Twombly seems, even in this phase of his career, to be in conversation with. "Each exquisitely wrought drip is perfectly calibrated to give an effect of happenstance," writes critic Brooks Adams. In the same review he writes, less generously, "But these works don't really look like blackboards with random markings on them: they are, rather, carefully wrought field paintings that reenact the Abstract Sublime on a megalomaniacal scale commensurate with the most bombastic 19th-century Salon machines."[2]

There, without doubt, in the background of these works, is the failure of the Commodus show in 1964. Painful and dispiriting at the time, the "fiasco" allowed Twombly a period of cooling off, a chance to think and rethink his work.

"I sort of held off with Twombly," said Castelli about the period after the failure of the paintings, "because I knew that he would mend because of his personality and all that. One could sort of trust him." Castelli was right to trust that Twombly's own artistic gifts and ambition would allow him to discover a new way forward.

In these blackboard paintings, Twombly has found a way to both speak and stay silent at once. The paintings call out to the viewer with the illusion of legibility. They write our names in water. In the blackboards with their rows of "writing," Twombly discovered a pictorial language that would sustain his work for over a decade. Sometimes tight loops, sometimes looser gestures; three even rows, then four, then a scattering of the lines, then the white swirls like figure 8s of rain, a storm. Layered white, erased and written over again and again, or a single strand: thread, blood vein. These variable, distinct moods col-

lapse into one mass, one word—untitled, blackboard, loop: imprecise and incomplete.

The differences in the backgrounds of the gray paintings are sensed more than observed—some seem tinged with green, like a sea at night, while others are infused with a white light, others more black than gray, sometimes the blue of nostalgia or longing. Eventually, Twombly would experiment with a background that evokes the exterior wall of an old Roman church, a weathered shade, that once, centuries before, might have been a kind of white.

There is a primal energy in these works that's hard to articulate, the inevitability of those bone-white lines, full of purpose and carefree, as if they offer what we've been waiting our whole lives to see. And while the lasso loops speak to the patterns of boredom and predictability, they also seem to be the pulse of something greater than ourselves. Our very pulse made visible.

▮

"Handwriting has become for Twombly the means of beginning again of erasing the Baroque culmination of the painting of the early 1960s," writes Robert Pincus-Witten in his 1968 essay "Learning to Write," one of the most often quoted essays about these paintings, "beautiful writing has been submerged within a Jasper Johns–like gray field. Put bluntly, it has been drowned in a schoolmaster's blackboard."[3]

Pincus-Witten sees in the white circling of wax on canvas a kind of indecipherable handwriting. On the teacher's blackboard of instruction, or the student's slate for practicing his cursive, it is as if the artist is scrawling, "over and over again, 'I will not whisper in class anymore.'"

I disagree. Despite their room-filling size, they do not claim *not* to whisper. Instead they play by the rules. Or they try to. If this is the school blackboard, the exercise of the loops seems to be a kind of exercise in control, keeping it together. A test of will. Of patience. At any moment they say, it will all be undone. Their power comes from this tension between control and release, restraint and abandon.

To write about Twombly's loops is inevitably a frustrating task, not

simply because the paintings reproduced on the page fail to capture the scale and energy, not simply because with a few early exceptions— *Night Watch*; *Cold Stream*; *Hill*; *Problem I, II, and III*—they are all called *Untitled*, though that is suggestive of the problem. The paintings, with their subtle shifts of tone and scale, of color and line, blur together. To a casual viewer, the painting called *Untitled* done in Rome in 1966 and the one called *Untitled* 1970 only differ under careful scrutiny.

All of the individual works accumulate, and so to write about *loops* or *lines* never feels sufficiently precise: Sometimes the white line is tight, repeating over itself, in others the line seems more languid, the circles opening almost into cursive letters, l or i or c. In some of the blackboard paintings, there are no loops but squares or rectangular shapes; in some, little doors or windows flying off their hinges. In some, white hearts. In one, a rare use of "real" writing, the word "Duino" a shout-out to Rilke. In others, the *Orion* series for example, semicircles descend down the off-white canvas like Duchamp's *Nude Descending a Staircase, No. 2*.

White windows. White waves. White spaceships and sculptures. Wavelength, equation, graffiti, rain.

∎

Though Twombly completed the first gray paintings in Rome in 1966, they are works associated in my mind to his long love affair with New York City.

There's a resonance between these new paintings and *Panorama*— and the other early chalkboard paintings, now destroyed, done in Rauschenberg's Fulton Street loft in 1954—as if the idea of this monochromatic dance waited in a shadow corner of Twombly's mind for a decade. *Panorama*, more black than gray, more all-over marks, more anxious and worked over, lacks the feeling of these loops, the sense that they were imagined first in the mind and then on the paper. The pleasure of *Panorama* is akin to seeing a map of constellations, a depth and range beyond the eye's ability. The pleasure of the later gray paintings is more like staring at the ocean, the sense of vast indifference as the water cycles in and out.

In these new paintings there's a certain effect of weather and sky in

that diluted gray. A walk on gray sidewalks in the iron-and-glass shade of a building, the air full of steam and smoke, a gauze of fog, even the birds, slate wings. But still, within this chalkboard world, flecks of silver light or the flash of headlights down the current of an avenue or the glistening drip of spray paint on the face of brick buildings. This is the city in which these paintings live. Or, this is the city that lives in these paintings.

And so it seems in hindsight inevitable that Twombly would return to New York to keep working on these paintings.

In the winter and spring of 1967, the artist worked on the gray paintings in Whitney's Canal Street loft in the Lower East Side. Between stretches of time in New York, Twombly returned to Rome at Nicola's urging, a return he would describe to Whitney in December of 1967 as "paralyzing."[4] This "paralyzing situation"—obligations to family and others in Rome—made him anxious to find a more permanent studio space back in New York. As always, Twombly's personal relationships—with Nicola or Giorgio or Tatia—rising and falling like white loops.

With lots of help from Whitney, Twombly took a studio on the Bowery in 1968. It's a wonder to read the many letters of Twombly's studio preferences, little diagrams of ideal layouts and worries over price: "I just want the space to look as void of functional things as possible (but having them too)."[5] This would be his primary working studio through the early 1970s, just a couple of years, but in Twombly-time, an eternity to be making work in the same place. Twombly was just one of the many artists who made their studios in that under-loved stretch of New York City attracted by cheap rents for live-work space, what William Katz in his introduction to *On the Bowery* called "the anonymous wreckage."

That slim volume from 1971 features photos of ten artists, Twombly among them. Eight of the ten artists are pictured in their Bowery studios. Twombly is not one of them. In the photograph, taken by Eliot Elisofon, he stands outside the doorway of the building, centennial and distant from the space within, a vast, rundown open live-work studio.

It's unclear if what's behind him is a painting, or a mark of graffiti on the wall.

How different from the 1966 *Vogue* photographs that let us gaze inside those vast rooms, those images that seem to let us within. Twombly and Tatiana and Alessandro dressed in their costumes of wealth and leisure, the guise of a traditional family, surrounded by Louis XIV chairs and Egyptian marble busts of dead emperors. Of course, it's funny now to look at Twombly's own paintings on display, part of that narrative of grandeur and excess, and know how they were makers of an earlier, transforming style—baroque and colorful, literary and referential. They are an imprecise, calcified picture of Twombly's vision, a marker, like those busts, of already past history. Another partial truth. An already changed mind.

▮

Where did the chalkboard pictures come from? Or, maybe, the better question is, where do any pictures come from? As if we could unlace the rib bones or peer inside the magician's conical hat to find that single moment of realization. A source or start that explains.

Some critics have pointed to the Palmer Method of handwriting instruction, students copying down lessons of grammar or history or spelling, vast fields of white chalk in almost neat rows.[6] By other accounts, the paintings emerge from Twombly's lifelong interest in Leonardo da Vinci and his deluge drawings, images of waves swirling about and around. Twombly used a cutout of one of Leonardo's deluge drawings in a collage on paper in 1968, several years after the first of the blackboard paintings. In the lovely words of one writer, the deluge drawings "echo" through his paintings. What Twombly borrows (or learns) from these drawings is motion.

Very few writers on Twombly have noted the terror of Leonardo's deluge drawings, the swirls of wind and dust and water and fire, as they destroy cities and forests, men and animals slaughtered in half-visible edges below dark weather. Reckoning is uncontrollable. Twombly seems to be saying something different. The lines in his paintings, like the wobble of light or sound waves, stretch out in their separate rows,

physical and muscular, bounded by an invisible force field that keeps those loops in their own horizontal plane. They pulse. They vibrate.

When I look at Twombly's gray paintings, I can't help but think of baseball and the artist's father, for a time a professional player. In those cursive open loops of white on a gray ground, I've imagined the motions of a baseball game—the ball loping and winding through the air—or the swing of the bat, or the runners moving with force and speed around the horn in the repeated square chalk boxes. Baseball is a slow game punctuated by bursts of activity, a game of waiting. And Twombly's father didn't just play any position. He was a pitcher, a position that requires discipline and attention, a willingness to wait for the right moment and then a quick release.

A pitcher is, in a way, a reader. Reading the body language of the batter in the box. Reading the wind and air. There are a limited set of pitches—fast, curve, knuckle, slider, sinker—yet in each is an enormous range of motions and micro-adjustments, an action of fingers and wrist, arm and shoulder, head and heart and breath.

"A really good picture looks as if it's happened at once," the painter Helen Frankenthaler said in an interview. "It's an immediate image." She goes on to describe that when the work is "labored and overworked" one can tell. "And I usually throw these out," she said, "though I think very often it takes ten of those over-labored efforts to produce one really beautiful wrist motion that is synchronized with your head and heart, and you have it, and therefore it looks as if it were born in a minute."[7] This is the spell of the gray paintings.

❚

At the Menil Collection, where I taught for a time, the windowless room that holds three large chalkboard paintings is dark as an old cathedral. Or maybe the better analogy is the cabin on the SS *Raffaello*, traveling from New York City to Rome, where Twombly could hear but not see the ocean, could feel but not touch it. In the cool shade of the gallery, the pictures come alive. The white feels electric and haunted. A cadence not unlike music. Not the notes as they might be played, but the way those chords vibrate in our marrow.

For my students, the room was not a series of blackboards—a reference point that was almost gone in their whiteboard classrooms, dry erase markers replacing chalk, computer screens instead of paper and ink. They were not the kicked-up chalk of a baseball diamond. They never noticed Leonardo's influence. These were pictures without narrative or story, without immediate footholds for them. Instead, the students always loved the strange and inexplicable certainty of Magritte's *The Invisible World* or Cornell's boxes of bells and birds.

Of their writing I have almost nothing. At the end of the tour, before they would take their poems and stories home with them, I would copy a few of the best pieces, a record of that day and examples of the kind of work done, for schools and donors. Maybe the absence of pieces I have about Twombly means that they never wrote well about his work.

This is the one I still have, a poem by a student named Ajdin, a third-grader.

"Tornado, after Cy Twombly,"
He had to tell the people but it was too late and all the people
were screaming for their lives because the tornado was there
When the tornado went away all the people died. But the
man who knew the tornado was coming did not die.

I can't picture the boy who wrote the piece. I don't remember the writing prompt I gave them that day, though I'm sure it was about seeing and imagining the "real" world in the layers of lines and loops. Even though the moment of its making is lost, I can see in the student's narrative an allegory of voicelessness. The boy cries in fear of the wolf that's just outside the door. The prophet runs through the streets with a bell in hand. We understand the experience of living in a contingent world, the dangers of wind or rainstorms, of sickness or terrible loss. We recognize this feeling of being young: to speak and be unheard, of having something to say and no ear in which to whisper it.

I think of myself in those galleries, the years in Houston. A regular to the guards in their starched white shirts and black jackets, I was to Vera, one of the several older women from Eastern Europe who worked at the museum, Joshua. She'd say my name with a kind of joyous sur-

prise, and we'd chat about the weather or what exhibit was coming. Vera and I talked at least once a week for two years.

I knew nothing about her and she knew nothing about me.

▮

Erasure is a queer beast.

The chalkboard, with its written-over remains, like an absent voice calls back from beyond. This is the magic (and poison) of these pieces, the sense that there's a secret below, some nearly absent idea, a current or tide, language or lover, humming its mystery. Don't think you can read the curves of white. Instead, look to what's gone. When I stand before these paintings, enormous and gray-minded, I see what's been taken away.

"The way I read those paintings," said Richard Serra, "is that he deliberately set out to make a colored ground with washes that would then simulate what a blackboard would look like if you erased it. These paintings aren't constructed from making a poem or script and then wiping it off; they make the ground look not quite like a trompe l'oeil illusion but like the illusion of a surface that has been worked with white."[8] Serra, his artist's eye, knowingly sees beyond the effect and to the method, the "illusion of a surface." Many years after they were made, we now know that Twombly used diluted bleach to thin the thick surfaces of oil, sometimes letting the oil drip down the canvas, like water drops, and other times allowing the uneven surface to bleed through.[9] To add and erase. To make and melt away. A sponge against paint revealed the layers beneath, a taking away, a stripping down.

"Erase to make a mark," is how Tacita Dean puts it. "Twombly crosses out as a way of making the surface work: his rubbing out is a process of adding as well as subtracting: a build up of cancellation when the connection has broken, marking to say and then not to say: retraction that leaves a trace."[10] Twombly, in loop and square and tally, in the gray and black, offers the image and the erasure of it. These paintings recall too Twombly's attempts to erase from his own hand artistic expertise or knowing.

And so again we return to an idea so fundamental to Twombly's

practice as an artist. The desire isn't so much to de-skill his hand or eye, as to make that very skill and technique invisible. The effort to make art look effortless, though, is never simple. Every choice matters, the paintings seem to say. Every action has consequences. "Because what Twombly is working on and, working out," writes Dean, "is how to make a painting."

I think of that early series of blackboard paintings, the three canvases of *Problem I, II, III*—the first, a rectangle; the second, a rectangle with two horizontal dividing lines; the third, a rectangle with three dividing lines, two horizontal and one vertical. The mortal life, divided, by attentions and attachments. The first box is a coffin or a landscape. It is the rough figure of a man or a woman. And then in those divisions, the shapes, divided or added, depending on your point of view, are made smaller and greater at once.[11]

Perhaps the problem of these paintings is the fundamental act of making a mark. Any mark. The problem is how the simplest form (or life) may be changed, not by a tornado or earthquake, but a single white line.

For forty years Twombly bought his materials at Ditta G. Poggi in Rome, just one of the countless famous and not-so-famous artists, from de Chirico to Schifano, who found their paper and canvas, oils and pencils, at the shop. Open since 1825, Twombly's time as a regular patron, at least when he was in Rome, was just a brief blip in the store's history, which, in the scale of time and history in Rome is itself nothing.

I picture him in the narrow aisles eyeing the palate knives and running his fingers over the neat rows of wax crayons. It's not enough. I want to see him at work. I want to see his hands as they work across the surface. If the ground of the painting has been worked over, shaded and layered and dissolved, the artist's hand is quickness. Lightning strike. The snap of fingers. The arc of his arm as it moves, like ocean waves, forward and back, ceaseless.

In one account—by Nicola—Twombly worked on multiple chalkboard paintings at once, an ecstatic movement between them while the

paint was still wet. "I remember," Del Roscio writes, "helping Cy in the studio, first to nail canvas on the wall or paper to the floor, apply gray or black paint on them, which he would correct with a touch of his own, and execute the work."[12]

The wax crayon, a stick of compressed pigments, more wizard's wand than schoolmaster's scold, worked into wet paint, a technique that allowed the artist not only speed and a particular quality of translucent light, but that chalk effect. An effect so convincing, a catalogue for a major European retrospective listed chalk as one of the materials.[13]

When Twombly first started using the white wax crayon for the chalkboard paintings, I trust he knew the etymology of the word: *crayon* comes from the French word for chalk, *craie*. An inside joke. A wink to the bookish, the logophile, the lovers of the *OED* and origins. He makes one medium look like another. Wax becomes chalk. This trick of the eye. This trick of language.

Chalk—or the illusion of it—is an apt metaphor for Twombly's very life and work. To see the truth, or some version of it, we have to uncouple words from their first meanings, we have to stand close enough to the canvas to see the way paint moves like slow thunder and rain, we have to wait long enough for the silent surfaces to speak.

19

SHELLS

A SEASHELL, A PHOTOGRAPH, A set of drawings. What we have from those weeks on the Caribbean island of St. Martin in the winter of 1969. A collection of days and hours where Cy drew and Nicola sunned. Walks along the curves of white sand. Simple meals of fish and rice. These free and easy hours, a vacation from a life that, from a distance, seems like an endless holiday from the complications of everyday life.

From here until the end, Twombly slips in and out of view, like a buoy on rough waves. It's not that things stop happening in Twombly's life: the domestic triangle of wife and partner, his son growing older and apart, his father's death and then his mother's, his success in the international art market, his travels across the world, and on. Instead, our

windows into his life get narrower and narrower. A well-known biographer relates an anecdote that Mrs. Dostoyevsky said to Mrs. Tolstoy "that a person's character is never so much revealed as in his day-to-day life at home."[1] But Twombly's day-to-day life is nearly impossible to see—or totally absent, particularly in these middle years: Twombly cooking. Twombly on hold with customer service. Twombly folding towels from off the line. Twombly's work feels far from tasks of everyday life with perhaps the exceptions of reading, or later, gardening.

Paradoxically, with success Twombly retreated even further from public life, at least for a time. He could afford to travel. A winter trip with Nicola to St. Martin. A summer escape to Lake Bolsena. He no longer depended on the Franchetti family as before. More guarded of his space and time, more isolated from the rough weather of having to make money, he moves from temporary space to temporary space like a pilgrim. He disappears behind the ancient brick walls of palazzos. He sets up new houses and lets them fall.

Spring 1969. Three years after writing to Giorgio for help to pay his very modest fare back to Rome aboard the *Raffaello*, Twombly tells his brother-in-law that it had been a "big $100,000 season."[2] MoMA bought one of his Rome paintings from the early 1960s, *The Italians*. In Europe, younger gallery owners—Heiner Friedrich in Munich, Gian Enzo Sperone in Turin, and Yvon Lambert in Paris—pursued Twombly for shows.

More than just the hum of praise and shows and commercial success, though, there is the work: the gray-ground paintings Twombly started in 1966 would continue through 1972, though the repeated circling rows of the late '60s unravel into white lines that stream down into different kinds of repetitive marks—figure 8s, lines like stratified earth, circular echoes, and the all-over sickles like a flock of birds writing his name, Cy, into the sky.

And as much as I love the gray-ground or blackboard paintings, and feel in them the artist's physical body as it thinks and makes, I feel acutely the absence of biographical signs—the allusions to myth and the words of poets that, in their metaphors and layers of meaning, open the pictures outward towards the hours and days of Twombly's own life.

And so, I'm grateful for the biographical moments of exposure

where the man, or some version of him, appears in, or on, or beside these pictures, moments in which one can trace a line from the mark to the man.

▌

A truth in the form of a joke, Carla Lonzi's *Autoritratto*, first published in 1969, includes interviews with the famous Italian artists of the day: Kounellis, Nigro, Paolini, Pascali, Rotella, Scarpitta, Turcato. They all agreed to talk to Lonzi. Twombly refused and so Lonzi included him anyway, in the only way she could; dozens of times after one of her questions, his name appears, followed by one word: *Silenzio*. He is present only by his absence.

It's hard to see the man, his "character," not simply because of his silence—his refusal of a public life, of being interviewed, of answering questions about method or meaning, his distrust of most reporters or critics or writers—but because he let others speak for him. I shouldn't find it remarkable how similar the descriptions of Twombly are by those who knew him. But I do.

"Slow, careful phrases are followed by and sometimes interrupted by long pauses," writes Pamela Simpson, a friend of Twombly's who taught for thirty-eight years in the art history department at Washington and Lee. "Until you get used to it, you find yourself leaping in to fill the gaps. But that is a mistake. When he is ready to finish the sentence, he does, whether you are speaking or not. The embarrassing overlaps quickly teach you to simply wait him out."[3]

Simpson, who died in 2011, just months after Cy, continues, "The gaps are part of his thought process. He doesn't fill the space with dead words or markers ("ah," "well," "you know" . . .) the way most of us do. If you are patient, you realize his speech is like a sort of poetry with its own rhythms and cadence." Of the connection between Twombly's speech and his art Simpson concludes, "There is a similar openness, space, pause and then intense concentration."

Greatness and concentration. Impatience and guardedness. "Although Cy was delightfully good company and amusing," remem-

bered Nicholas Cullinan, "you were always aware you were in the presence of greatness."[4]

Cullinan, then a young curator at the Tate, traveled often to the artist's home in Gaeta to work with him on the *Cycles and Seasons* show. That "presence of greatness" can't be reduced to a clever quote or a revealing anecdote but is something more subtle, more intuitive that requires careful attention, what Alfred Kazin on a writer's prose described as, "the marginal suggestiveness which in a great writer always indicates those unspoken reserves, that silent assessment of life, that can be heard below and beyond the slow marshaling of thought."[5]

"Dry-witted and charmingly irreverent . . ." wrote Carol Mancusi-Ungaro. "He would speak freely of Don Juan, his mother, and Apollo. It did not seem to matter that they had lived hundreds of years ago or ten years ago, or never lived at all." The personal, the fictional, the mythic are all "equally available."[6] In spending time with Twombly, Mancusi-Ungaro also learned that in offhand comments about the size or color of a frame or the quality of a dirt that tinted a painting—the "orangish dust from Asia Minor" he wanted left on the canvas—Twombly was revealing his strong opinion about the conservation and display of his work.[7] Roundabout and indirect, one had to follow the small clue for his true intentions.

To try to see the man maybe isn't so different, an act of faith to trust the words of others. He is, in all these accounts of friends and critics, the hero of the story. "Knockout. Hero. Genius," as one headline claims shortly after his death.[8] One critic tells the story of how Twombly arranged a retrospective of his sculptures. With fifteen rooms to fill, he put all the sculptures in one room and then proceeded from room to room, never going back as he selected and oriented the pieces in the space. Only at the very end did he make minor adjustments. "A mind at once offhand and precise," the critic writes of the artist.[9] These are not oppositional forces in Twombly but the part of the same personality, part of the same secret.

In the summer of 1969, Twombly was the guest of Count Giovanni del Drago at his estate on Bolsena Lake, a sixteenth-century castle, "somewhere between a fortress and a place of leisure, surrounded by terraces and gardens."[10] Frescos of nymphs and dragons and lush battle paintings covered the grand walls. In the months before this, Twombly traveled to New York; Captiva Island; Los Angeles; Mexico; and Grand Case, St. Martin. The places and times turn into pattern: Another borrowed room. Another borrowed life.

The set of fourteen paintings, the so-called Bolsena Paintings are often thought of as a kind of break or departure for the artist, an oasis within the chalkboard desert. The random white loops has been replaced with random numbers—technical and repetitive.[11] By the artist's account to Kirk Varnedoe, the paintings came from "a long and lonely siege of work."[12] They are, like the works of the early 1960s, without shadow or gravity, full of numbers and boxes that seem to be sliding off the top right edge of the canvases. Beige and cream, brown and black, with sparks of blue and red, they return to the all-over markings of his earlier works. No trace of gray ground or the inscribed white that for so long before, and then again after, had been his primary visual language. And yet, one of the fundamental questions of these paintings, like so many Twombly works, is how do we make and mark time?

One critic described the rectangles in the Bolsena Paintings as "slanting mirrors." Another sees open windows.[13] Others have seen the July 1969 launch of Apollo 11 in the numerical figures and ascending forms, part of the artist's interest in "weightlessness" and space flight: "All the talk of vectors, orbits, rocket segments, and distances in space filled his thoughts as he painted."[14] (As a bright and humorous contrast to highbrow readings of the paintings, or the images of the palace's luxury is the note that Twombly wrote to Whitney that he had to go to Rome to buy locks for his door because the "Prince of Drag's dogs keep coming in and pissing on my pictures," turning them yellow.)[15]

But what I keep thinking about are the seashells, a souvenir of another place and time smuggled into the field of the picture. Picked up from the sandy shores of Grand Case, St. Martin, and carried across the

ocean perhaps in the front pocket of his shirt, where he could run his fingers along its rough back or smooth interior. A lover's ribs, a lover's thigh.

"Twombly has taken a seashell," writes critic Susan Larsen, "and traced its outline on the page . . . Twombly adds a darkened area to its neck and shades its rounded bottom to create a primitive jar. In another place it assumes the shape of a woman's lower torso, perhaps another allusion to Venus who arises from the sea."[16] I love how Larsen, in tracing the journey of the shell in the composition—shell to jar to body—shares an account of her own process of looking.

This shell, a placeholder for beauty, an image of displaced restlessness, a vessel waiting to be filled, anchors those abstract figures and forms, those numbers, with an object from the natural world. I think too of Tatiana, gathering specimens from around the world to fill the glass jars she kept in her studio in Via Monserrato, these apothecary containers teeming with pinecones from the trees in Monteverde, stones from the banks of the Tiber, and seashells from the coasts of other countries.

Just above and below the shell in one of the paintings, half of a scallop shell, like a circular fan, with crenellations scribbled in its center, the artist has written *Cy Twombly BOLSENA July 69*, another emblem of time and place, a claim to this life. This life and no other.

<center>▌</center>

January 25, 1969. Grand Case, St. Martin. Twombly made a drawing—or at least dated one—an image full of penciled figures: lemons and shells, straight-edged boxes and the phallic shapes, all swirling together like debris in space on the cream-colored paper. In another drawing, done a day or two before or after that one, undated except for the month and year, Twombly wrote, clearly, the words *NUDE* and *Suck Here*. These drawings, preliminary sketches for the Bolsena Paintings, suggest more than they name.

Seeing these drawings, like souvenirs of those island days, the heat, the crystal waters, the sun, the flesh, I think again of Twombly's photograph of Nicola, taken sometime during their time on St. Martin. Nicola, young, a checkered scarf wrapped around his head, and without a shirt,

the tan blade of his collarbone and fine skin, cut in profile, recalls a marble Antinous, the beautiful young lover of Emperor Hadrian.[17] (Think back for a moment to the *Vogue* photo shoot, Twombly "slouched on a divan, leg propped, wearing white linen and a pouting smile, as a bust of Hadrian, the emperor of sugar daddies, looks on."[18]) The photograph, like those drawings, mark this moment in time.

"What Twombly and these poets understood was that timelessness was a sham," writes poet and critic John Yau, "that one lived in time and could neither escape its clutches nor step outside of its pull. And yet, despite knowing this, in their best work all of them remained open and, in a deep sense, were simultaneously impulsive and concentrated."[19]

Yau writes against what is a common and often repeated claim about Twombly's work: that Twombly lived apart or outside of his own time. He was simultaneously ahead of his time and behind it, or so goes the claim. In reality, Twombly's relationship to time has always been more anxious and earthbound. And more interesting.

Desire in time, and the desire to hold time. "Twombly's works are markers of time," writes Nicholas Cullinan, "akin to crossing off days. They are a testament to the hours spent contemplating them, the days that went into their making."[20] Again and again, the subject, if that's the right word, of Twombly's art is not language or poetry, not the troubles of eros or the violence of war, not sign and signification, but time.

"It's like there's no beginning or end," Twombly said about his use of white in the blackboard paintings. "Then the painting doesn't have a centre—it comes in one side and goes out the other. And so white is that."[21] He might as well have been describing this foolish mortal life.

20

NINI'S PAINTINGS

ON NEW YEAR'S EVE, THE cusp of 1970 to 1971, Nini Pirandello, wife of Plinio De Martiis, hosted a party in Rome. After dancing with each of her guests she committed suicide.

The five paintings, each titled *Nini's Painting*, are Twombly's remembrance and elegy for her. Completed in Rome in the autumn of 1971, obsessive, layered, complex, Nini's Paintings are among my favorite Twombly paintings. When I see these works, I'm a true believer.

Twombly spent time with Nini, the wife of his gallerist, dinners at their house, trips to Sperlonga, and they were close "on an emotional level." But, she was not Betty. She was not Rauschenberg. She was not Nicola or Tatia. And yet, the news of her death is said to have caused

Twombly extraordinary grief; "I never saw Cy cry so much as he did over her death," writes Del Roscio.[1]

They have a source, claimed at least in their title, that returns us to the artist, to Rome, and perhaps Nini's life. "Almost nothing is known, therefore, of the emotional experiences or psychological impulses that lie behind this or that painting," claims Philip Larratt-Smith in his essay on Twombly. "For that reason, the bulk of the existing literature is reduced to speaking about the 'what' and the 'how' of his art, but not its 'why.'"[2] In the case of Nini's Paintings we do have the "why." Or at least one vision of it.

The biographical story of their making—elegy—isn't necessary to stand before one of the Nini's Paintings and feel the "music," as Twombly puts it, of their motion. In the layers of pencil and crayon and oil paint, dark browns and blacks, grays and blues, the lines swirl around and down, as if being pushed and pulled at once. It's as if her name (or maybe it's just his own name, swirling cyclones—endless versions of "Cy") is being written and written and written, all the ways to keep her, in the living present. The "obsession repetition," as one critic observes in the paintings, reveals "an inability to say something: madness, tragedy, deep melancholy."[3]

Another critic describes these works as fusing the different periods of Twombly's career—the loops of the blackboard paintings of the late 1960s and the detailed, calligraphic marks of the '50s. "In this way these paintings become 'works of mourning' from the cyclical patterns within Twombly's oeuvre."[4]

Twombly's reaction to Nini's death, at least in one letter to Giorgio, reads as unsympathetic. Even as Twombly claims to be sad, he instructs his brother-in-law not to include certain paintings, including *Olympia* or other important works from that period, in the event that "something is to be done." That "something" is unnamed in the letter, perhaps a memorial show or benefit in Nini's honor. Twombly pleads, "I don't want any of my tender open canvas ones to go. Please! Please!"[5] What matters most to Twombly is keeping the best works in his own possession.

As Gian Enzo Sperone remarked years after he first showed Twombly's paintings at his Turin gallery in 1972, "At the time, Twombly's exhibitions were met with almost total consensus from the critics, and

since his prices were very low [$15,000–$30,000], he was relatively easy to sell. But his paintings were a rarity because he kept most of them for himself, building up a sort of private collection, like Picasso, parsimoniously meting out what he exhibited and leaving his dealers very little leeway."[6] Twombly had, as expressed in the letter to Giorgio, a keen sense of what were the essential and important pictures from his early work. Grief and generosity are absent, at least in this letter.

What narratives become simpler over time?

An allegory. Shortly after Cy's mother died in December of 1988, Cy's sister called him in Gaeta to let him know the family home was being sold and he should collect anything he wanted. Though Cy had been in Lexington earlier that fall, he returned to Italy that winter.

"Apparently Cy didn't realize the urgency of the request," writes Sally Mann, "or maybe he just blew it off, but everything in the attic was eventually gathered up and handed over to a local auctioneer."[7]

Gathered up and handed over: the things from the attic, countless and uncatalogued and irreplaceable objects from his life dispersed for pennies—photographs from his days at Black Mountain and New York, the charms and trinkets and fetishes made by Rauschenberg while they traveled, early paintings and, in my ideal vision, letters from his younger days. For the rest of his life, according to Mann, Twombly searched local yard sales and junk shops for the lost fragments of his childhood and early career.

Of Mann's two options—either he "didn't realize the urgency of the request" or "he just blew it off"—I keep returning to the latter, a continuous thread in Twombly's life: the artist avoided difficult, emotional situations.

Scettico. The word used by another artist to describe Twombly. And when I asked her to explain, she said, "far away from what happens, trying to keep a distance." It's not quite the same as the English words the dictionary offers: disbeliever, skeptic, blasé, unconvinced.

In her 2013 essay "Cues from Cy," Carol Mancusi-Ungaro describes a series of failed attempts to stretch *Treatise on the Veil (Second Version)*

1970. One of the largest paintings Twombly ever completed, *Treatise on the Veil* is epic in scale at nearly thirty-five feet long, a distressed slate gray background, a relative of Nini's Paintings in the family tree of his blackboard works. Architectural lines, like plans for an endless highway or the foundation for a building that will never be built, stream across the bottom in white chalk.[8]

Witnessing the conservator's frustration, the artist warned her not to "strive for perfection," going on to share an anecdote about how, years ago, in Sicily, if a young girl was thought too beautiful, the older women from the community would scar her, a cut on the cheek, to "dispel the perfection."[9]

"He then let his mind wander," she writes, "and lost in associative reverie, he recalled the origin of the title of the painting. Once while visiting Sicily, he stood on the crest of a hill and saw a bridal procession below. The bride wore a long veil, and that sight later inspired the title of the painting. I was left spellbound by everything about this artist: his fragmented speech, his reserved intimacy, and his unparalleled power of observation."

As much as her story tries to show Twombly's humanness, his rapt attention to the world around him—what she calls "reserved intimacy," and what others have described as a "negligent grace"—it reveals too that distance.[10] Twombly watching from a hillside. Twombly telling the story from a culture that wasn't his. Twombly "lost in associative reverie." What's remarkable too is how similar in frame and angle it is to the story Twombly told Edmund White:

"In a village," Twombly said, describing traveling between Olympia to Epidaurus, "I saw a young woman weeping. She'd stop crying, then start again. Her knees would buckle; she'd have to be held up by the other villagers. She'd just lost her husband, who'd died a few days after their marriage in a car crash. She would never find another husband, since she was no longer a virgin. Her whole life had already become tragic."[11]

White writes too of the artist's revelries, digressions of place and refusals of contemporary time. The year 1959, or 1659. The violence of tra-

dition. The joy of the bride. The grief of the living. One could imagine this anecdote being told as an origin story for Nini's Paintings—or for *Treatise on the Veil*—or maybe any of his works. This is the beauty and risk of a myth, the way it can be read and reread, a narrative about grief or a narrative about attention.

I

When I look at Nini's Paintings, their crests of pencil and wax, this distance, this refusal to engage with the wildness of emotion, is far from my mind. The swirling and layered struggle of the paintings tap into some collective consciousness about mortality, a shared feeling of loss. The paintings, despite their named relationship to Twombly's own life, exceed that biographical connection.

The grief Twombly channels into the paintings is not his own personal despair at her loss but something larger. As one critic writes, "Twombly's art asks those deeply private, nearly unspoken questions that lie at the core of all human activity: whom shall I love, how will I die, how and by whom will I be remembered?"[12] And this is finally what matters, the ability to surrender to the activity of his own making and transcend the self.

The variations between paintings are like watching a sky at dusk, the fleeting transformation, blue to another blue, slate gray to half-black, that can't be held for long. According to the artist, the progression between Nini's Paintings goes from tightest to loosest, an opening perhaps from grief to a different kind of grief. The shifts of color and mark, the building up and letting go, which makes Nini's Paintings so luminous and strange and perfect, capture a feeling—not grief or loss exactly but a kind of wonder.

"You can ask me for my definition of art if you want," Agnes Martin ends one interview: "Art is the concrete representation of our most subtle feelings. That's the end."

THE EXCERPT

I MET NICOLA FOR THE second time by accident, just two weeks after our first meeting. In Rome today, as when Twombly lived there, the circles of art and writing and culture overlap and connect. In the doorway of a packed gallery, I stood with the other latecomers. Men and women read poems dedicated to the memory of the sister of Alberto Di Fabio. I was hoping to interview Di Fabio, a well-known painter in Rome and friend of Twombly's, and as I'd later learn, a cousin of Del Roscio.

Seated among the others, Nicola wore the same green sweater as the first time we met, his arms crossed against his slouched body, a look of boredom or contempt or exhaustion. If I hadn't already met him, I

would not have remembered him from the crowd. He moved in a way to be ordinary, forgettable, invisible among the other people at the reading. To see without being seen—like a painter. Strategy or disinterest, I didn't know.

From his seat, Nicola gave me a nod and turned back to the lectern and the woman reading aloud. A break of luck to run into him here, or so I thought. I hadn't heard from him since our meeting in Piazza Farnese. I leaned against the doorjamb and listened to the poems, catching occasional Italian words and bits of meaning, but mostly I allowed the sounds to crest and fall, then rise up around me. I wondered what to say to Nicola. Do I ask about the excerpt or wait for him to bring it up?

The excerpt. In the days after my lunch with Nicola and Max I asked advice from friends about what to do. To send or not to send. And if send, what part of the early draft? One writer friend, Mike, who I trust in all things and had been there when I first went to Lexington, insisted I should tell Nicola that I wasn't ready for anyone to read yet, still figuring it out, and that I could promise to show it to him after I was done. An act of good faith.

I had protested to Mike, or anyone who told me not to send at all, that Nicola was pretty clear: he wouldn't speak to me again unless I showed him what I was working on. Finally, after delay and delay, I emailed Nicola two short sections: one described visiting the Menil and seeing *Say Goodbye* for the first time while the other recounted a visit with the man who was Twombly's driver and assistant in Lexington, the man who "generally maintained him when in Lexington," Butch Bryant.[1] I thought these pages, early versions of a book still in flux, would show Nicola my deep love for Twombly's work and the kind of research I'd started in the United States.

I included a short note with the excerpt to Nicola, borrowing Mike's language for my own, "I normally would not share unfinished writing but I'm making an exception for you as a show of good faith." My attempts at flattery seem so obvious now, and so foolish. "I would ask that since these are in-progress," I wrote at the end of the email, "you do not share these pages with anyone else."

Nicola wrote back a couple of hours later. He promised not to share the pages and that after he read it, I could come to Gaeta, an hour and a half by train from Rome, to talk more.

A window seat on a fast train, or so I envisioned, as I traveled along the western coast to Gaeta, a dream of cliffs and villas, of the turquoise sea, and the hours with Nicola talking about Twombly in Twombly's house, drawers of letters and photographs, books on the shelf, and his paintings and drawings and sculptures around us. This world, hidden from public view, I might enter.

In 1997, on an all-white panel of Twombly's triptych *Phaedrus* 1977, the artist Rindy Sam made her mark: a kiss with red lipstick.

"I take responsibility for my act," she said, "This white canvas inspired me. I am told it is forbidden to do such things, but it was totally spontaneous . . . I just gave a kiss. It was a gesture of love; when I kissed it, I did not think it out carefully, I just thought the artist would understand."[2]

He didn't. Twombly's response to this mark was not so different from Nicola's response to my excerpt.

The reading over, Nicola and I sat together on a stone bench in the hallway. A low hum of people all around us, as they admired the row of sculptures in the hallway.

"I really didn't like what you wrote," Nicola told me.[3] Though he had had the excerpt for nearly two weeks, I'd heard nothing, except the note saying he'd received it. His voice, like his gestures, were soft and unrushed. Edmund White could've been describing Nicola when he wrote of Twombly: "[he] stammers slightly. He is by turns paranoid and innocent and open."

"Lies," he said. "You've written lies. Cy was very generous. He gave Butch's daughter three sculptures."

"I didn't know that," I said. "I want to get things right. I want to know these things." It sounded cliché the minute I said it. I wished I could've taken it back. But there was truth in it; Nicola knows things about Twombly's life and work that no one else does.

Nicola asked if I've read the novel *Auto-da-Fé*. I hadn't.

"There is a man who has a beautiful *biblioteca*," Nicola said as he recounted the story of Elias Canetti's novel—the man, a great genius, needed a maid to help him clean his enormous library. The man found a woman to help and after a time she starts to think she's as smart as him. The story ends when he burns the library down. Nicola's allegory is clear. Twombly is the great man and Butch, like the maid, is a simple laborer who forgets his place. The plot, as told by Nicola, shows too the differences of class and education between Cy and Butch. They do not have the same values. They are from different worlds.

After the opening I went home and looked up the book, its title a reference to the Spanish Inquisition ritual of public confession and execution of heretics, often by burning. An act of faith. I was struck at what Nicola left out: the woman isn't simply the maid of the library but becomes the professor's family, his wife. The professor, tranquil and chaste, lives alone with his many thousand books in a sanctuary of his making. "The reclusive scholar in the sky marries his housekeeper, a character as monstrous as any in the paintings of George Grosz or Otto Dix—and is pitched into the world," writes Susan Sontag in her review. The book ends with the professor, driven mad by the woman, burning the library from within.

Every story eludes us to some degree. And in this one, a narrative for Nicola about a thief in the palace, about the too-high place that some people take and shouldn't, about the difference between street smarts and book smarts, can be for others a narrative about "unworldly, easily duped intellectuals, and is animated by an exceptionally inventive hatred for women."[4] The slippages between Nicola's memory of the book and the book itself revealed, in part, his vision of each man. Twombly is the genius of the story who needs no one else. Who has no peer or equal. Butch is an employee. Forgettable. Insignificant.

If one follows Nicola's logic, the stories that Butch has, like the maid's influence, can mean destruction of the man and his art. What we leave out of a story is often as revealing as what we put in, or as Debussy put it, "Music is the space between the notes."

This is the excerpt I should have sent. Blank pages. My words with black censor lines as in Twombly's *Untitled (Thyrsis Lament for Daphnis)* 1976, where the far right panel resembles the dark erasures of redacted government documents.

Or, I should have sent a photocopy of the thirty-eight drawings in Twombly's *Letters of Resignation*, pages of illegible script that promise nothing and everything, a refusal. "*Letters of Resignation* is a rant, an agonized response to the lack of power this fictitious author feels," writes John Waters of the drawings. "His terrible impatience and obsessive frustration turn the very act of writing and revising into a tortuous revenge against authority."[5] Each sheet of the *Letters* tricks the eye, calligraphic stops and starts that aren't translatable back into words. A dummy list crossed out and painted over. An ersatz note left on the kitchen counter to say *I'm going out* or *I've met someone else* or *What you want is not what I can offer.*

"When," asks the critic Jon Bird, "does erasure—as painting over [with white] or reconfiguring an image record a correction to, or an amplification of, the overall composition."[6] Erasure as correction, erasure as amplification. To that we might add: erasure as method, erasure as process of discovery, as obscuration, as making or remaking or building up. Erasure as subversion. Erasure as performance and production. Erasure as closeting. Erasure as act of rebellion or refusal.

Unreadable missives—*Letters of Resignation, 8 Odi di Orazio, Roman Notes*, even *Treatise on the Veil* or *Poems to the Sea*—are their own category in Twombly's art, the "writing" that isn't just imagined by the viewer, but named by the artist, one that calls to poets and writers with the seduction of all that could be said, but isn't. That never will be. These signs without attachments. Is this a love letter or one of pleading for forgiveness? Is this a note about the weather in Rome or the hunger for flesh? Is this for us or for another?

The set of four drawings, *A Letter to Nicola* 1967, begins *Nicola* and ends with the artist's full name *Cy Twombly*, a signature of the lover as artist, artist as lover. The pages between are filled with cursive-like writing, expressive patterns of lines, that say something and nothing at the

same time. On each of the four drawings, just over 9 inches x 9 inches, the "essence" of writing without the burden or trouble of words. Our written words are trouble: so permanent, so fixed in time. Words haunt us. I write, *The surface of Lake Eden is black glass under the press of winter stars*, and daytime will never arrive. The lake will never vanish.

Perhaps, in these wordless writings, these erasures and over-writing, these loops and doodles, we have the "minutely varied record of passing feeling and thought," an attempt to capture the fleeting sensations of our daily lives.[7] This everyday inability to say what we want to say—our quiet rages and anxieties and desires. Our words come out wrong. Our letters are misread.

❚

Well-dressed people with plastic cups of white wine talked in loud voices. A sculpture knocked off its pedestal at the far end of the hall momentarily silenced the room with a crash.

Nicola told me of his upcoming trip to Germany to work with publishers. A vague promise that, when he returned, we would talk more. A woman walked over and kisses on each cheek were exchanged. He introduced me but in the noise of the space I couldn't hear her name, only that she was involved with Art Basel.

"I hope you're not writing a book of gossip," the Art Basel woman said. Only later did I realize how odd that this would be her first assumption. If one writes on Twombly, she suggested, it would be a book of gossip. The implication, too, was that there is enough gossip to fill a book.

A book of gossip, of whispers and asides, of the anecdote quickly followed by an admonition, *but don't include that*, would be perhaps easier to write. Instead, what I have is a book of silences. Of decades without comment. Of letters unanswered. Of locked archives. Of questions.

I thought of the profile of Nicola from 1998 by Marella Caracciolo, a photo shoot and essay about Nicola's Rome apartment, his first public interview as far as I could tell. The apartment, "like entering a secret shrine to pagan pleasures," is filled with murals of romantic and sexual love—Venus and Zeus, Zeus and Ganymede—as well as that seductive portrait of a young Twombly leaning against a wall. The

sixteenth-century apartment, according to Nicola, was bought as is. "'Everything you see,' he says with a smile, 'is the result of chance.'"[8]

Maybe that's what I was making too: not so much a book of silences or questions (though that's also true) but a book of chance. The scattered threads I had been able to gather by hard effort and looking, by years of my life intertwined with Twombly, came down to discovering a nearly two-decades-old article in an obscure magazine or running into someone at a reading. When we first met, Nicola asked if I believed in chance. I never answered, but clearly I would say yes.

I gave the woman my standard reply—"It's a book about Twombly's life and work"—but she was uninterested. She wanted Nicola's full attention. There was business to discuss.

∎

Later that week I visited Alberto Di Fabio's enormous basement studio in Pigneto, a neighborhood on the east side of Rome known for its immigrant population and hipster bars. The space was filled with his own bright paintings, their intricate patterns like microscope slides as seen by someone who had just dropped acid.

"Though much younger, I spent a lot of time with Cy and sometimes I filled in as his assistant," Di Fabio said in a remembrance of Twombly published in *Art in America*. "He was a true maestro: always concentrated on his work, he would get angry with me if he felt I didn't give my all to the work."[9]

In person, gregarious and warm, Alberto spoke about Twombly in vague platitudes, reluctant to say anything bad about the "great master." No surprise. Alberto is, I'd later learn, a close friend of Alessandro, a nephew by marriage to Del Roscio, and his wife, Yumiko Saito, helped research Twombly's catalogues raisonnés. He is also represented by Twombly's last gallery, the Gagosian Gallery.

"When everyone went away, he stayed in Rome and worked," he said, thinking of that sweltering August in 1961 when Twombly, in his Campo de' Fiori studio, painted the sexually charged *Ferragosto* series.[10]

"There are," I replied, thinking of Alessandro as a small child, "sac-

rifices for such focus." When I tried to point Alberto towards a specific memory of his time with Cy, he told me again and again about the "great artist looking down from his mountaintop with total focus and dedication."

I was reminded of a story Nicola recalls in the introduction to the fifth volume of the catalogue raisonné of drawings. Cy was at work on Nini's Paintings in Via Monserrato in Rome, when Tatia opened the door and a prominent gallery owner burst into their palazzo with grand offers to represent Cy, to make him a fortune, to take care of everything.

"He did not," Del Roscio writes of the gallery owner, "have the look or the language of an intellectual . . . Then as Cy remained silent, ruminating in his mind how to get rid of him, all of a sudden, as unexpectedly as a flasher in the park or on the beach, he clicked the mechanism of his bag and voilà, on opening it, packs of shiny, fresh, green dollars stuck their heads out . . . Cy exclaimed: *'You cannot do that! Take it away!'*" It fell to Nicola to show the man out, which he did in a "diplomatic way."[11]

Where does one start? With the rare mention of Tatia? With the fact that it was she who opened the door and then, her role as disrupter of his work complete, she disappeared from the story? Or does one notice first the reading of Cy's thoughts, that "rumination," a trick of perspective beyond what he could have known. I am not innocent of this, though the difference is perhaps one of qualification: I imagine, I want to see, I envision.

Or, is it the snobbishness that one sees, the sense of the man at the door as not being intellectual enough to either understand or appreciate the work? The role of Nicola in this story, like others from the same essay—"I became like a policeman trying to untangle a traffic jam"—is as the middleman between the artist and the different galleries from around the world.[12] Some of these galleries, to Nicola's horror, were only concerned with business. Money is not what we're after.

In another Del Roscio essay, an eighteen-year-old German in lederhosen appeared at the door of the palazzo to buy a drawing—"his pockets," as Nicola remembers, "full of money from tips he had made by delivering couture tailored clothes to clients of his mother."[13] He returned a year later to buy one of the Bolsena Paintings and drawings.

The young man, Lothar Schirmer, became a publisher of art books, including the catalogue of drawings in which that essay appears. The implication is that he was of sufficient intellectual and cultural pedigree to understand and buy the great artist's work, as if only some people truly appreciate Twombly's work.

Before the Art Basel woman interrupted our conversation, Nicola told me about visiting an apartment for sale next to the church in Piazza Navona. In the restored apartment, being sold for many millions of euros, a window looked down from a great and private height into the stone nave of the cathedral.

"Too much beauty," he said, his hands lifted to make the gesture for too much.

I liked Nicola in that moment. I saw the man Twombly must have loved and trusted—a man of fierce intelligence with a keen eye for the wonder of the world.

Too much beauty, I hummed towards home.

22

BASSANO

TWOMBLY FELL OUT OF LOVE with Rome. He changed. The country changed. The years of sweetness turned into the years of ash. *Anni di piombo.* Radical uprisings of the early 1960s against war and oppression, student demonstrations and worker protests, turned dark. These so-called years of lead in Italy, beginning in the late '60s, and lasting for over a decade, conflicts of the extreme Left and Right, Communists and neo-Fascists, turned the public spaces of the cities into sites of discord and violence. Bombings, assassinations, kidnapping—they filled the headlines, and created an atmosphere of fear and suspicion, rage and anger.

A Fire That Consumes All Before It, Twombly scrawled below a

bloodred and black cloudburst, a painting from 1977, part of a cycle of works about the wars of men and gods. The riotous cloud might as well be an explosion. Car bomb. Molotov cocktail. Firebombing. The violence of the past isn't so different from the violence of the present.

In truth, the domestic affairs of Italian life never much interested Twombly; indeed the politics of the modern world were held at arm's length. "He drew a total blank when our conversation turned to the intricacies of Italian politics," writes Edmund White, "but he warmed up considerably when we started discussing Peter the Great." Of Peter the Great's "barbaric cruelty," Twombly told White, "He cut off his wife's lover's head and put it by her bed for six weeks! But she never cracked or showed the least sign of emotion."[1]

Even if the everyday intricacies of politics didn't much interest the artist, he couldn't escape the trouble and tensions that filled the streets of the city. In one letter to Whitney in May of 1971 Twombly describes the crowded streets and terrible smells of Rome, the garbage strike, and several days without water. The city he'd once adored, a doorway opening to the past, opened now too much to the present.

It wasn't just the politics that was changing but the natural landscape. "At the beginning of the sixties," writes the filmmaker Pier Paolo Pasolini, "the fireflies began to disappear in our nation due to pollution of the air, and the blue rivers and canals, above all in the countryside. This was a stunning and searing phenomena. There were no fireflies left after a few years."[2]

When you open the 1982 issue of *Vogue* to Deborah Turbeville's photo essay, "Portrait of a house—as the artist," the first thing you see is Twombly, sitting alone in a darkened empty room staring at a white canvas nailed on the white wall. The image, a two-page spread, offers a man alone and thinking; the long fingers of his hand stretched over his thighs. No furniture except the chair he's sitting in, and another chair just off to the side. He is dressed—with the exception of his black suspenders and shoes—all in white. The melancholy monk. The lonely saint.

Two articles accompany the photos at Twombly's summerhouse in the Italian hill town of Bassano in Teverina, one about the art, the other about the man. They run like narrow streams that never meet, one in italics and the other in bold, flush left and flush right, on opposite sides of the pages: "The Artist: His Work by Carter Radcliff" and "The Artist: His House by Sandi Britton."

"'The house is so much like me it's like talking to myself,' says American expatriate, painter, sculptor, Cy Twombly of the summer retreat—both stark and luscious—he has created for living and working in the Italian countryside."[3] So reads the caption above the photo of the artist. The house and the artist are one, as if Twombly might eventually disappear into those white walls or become part of the canvas. White on white on white. But, there is a second half to the quote found in the article, a missing clause—"'and,' Twombly continues, 'my own company bores me.'" Twombly's contrary and sharp tongue undoes any easy metonymy of man and house. A disenchanted Narcissus: I am this place and this place is terrible.

And yet, this place represents a decades-old dream for Twombly. Twombly in 1966: "For weeks on end he broods and fidgets, lies flat in bed, hears himself described by his wondering son as *pigero* (lazy), disappears into the country and wishfully inspects tracts of farmland in the Abruzzi, with a view to buying a hut and living for a change close to earth."[4] Nick Lawford wrote that a little less than a decade before the artist would finally make the country house a reality. Twombly in the farmland of Abruzzi—Nicola's birthplace—surveying property, a future gentleman farmer, like Thoreau looking for his Walden. There is a wishful desire for the nearly solitary life apart, "living for a change close to earth."

▮

The fireflies in the dark. The quiet piazzas. The postcard-ready city and sites. The feeling of those lost days infuses Twombly's work, aphoristic, impersonally personal, fleeting gestures of language in works from the early 1970s—*Turn and coda. How long must you go. The secrets that fade*

will never be the same—speak to this sense of longing for what's ending, what's gone, what will never, ever, be the same. The memory of those past, early days set against the present-day corruption of the city by violence and industry might seem to be a nostalgia for a world that never existed, a recollection of an ideal and never-happened past.

In a way, the slow-motion departure from his life in Rome began the minute he arrived, first with New York and then with temporary spaces and travel—Tunisia, Captiva Island, Capri, Tangiers, Bolsena, Luxor, Jupiter Island, St. Martin, places that, like the untitled titles of the gray paintings, slip like quicksilver.

Of all his temporary rooms and cities, the site that lingers is the one Twombly made his summer studio for a number of years, one of the few places he worked in the mid- to late-1970s. From 1948 to 1971, Twombly completed more than five hundred paintings. In the years that followed, from 1972 to 1995 he finished just sixty-five.[5] Almost all were done at Bassano.

Making real this dream of a country house wasn't easy. Twombly, in a 1971 letter to Giorgio, wants to know what's happening with Tatia and the project for a house at Bolsena, a first attempt for a country project, one that would eventually fall through. Fearful of returning to Rome and the "dislocated gypsy atmosphere of Via Monserrato," Twombly aimed to "make very concrete my ideas of living and soon."[6]

I think too of the letter Twombly wrote to Whitney in February of 1971 from Rome, again using his nickname for Tatiana, "It certainly is nice here without Stella puffing + blowing around. It would be easier + cheaper to keep her flying to the four corners of the world for the rest of her 'natural' life."[7] (She could have, I imagine, written the same of Cy.)

Both letters of complaint, beyond pointing to the up and down nature of Cy and Tatia's relationship, reveal the artist's forever desire for freedom. Twombly wanted a place that was his own, and on his own terms, not unlike Rauschenberg's place on Captiva Island, a refuge from the cities of art and markets, noise and distraction. A refuge from others.

To read of the "dislocated gypsy atmosphere" of Via Monserrato

is to return to Nick Lawford's description five years before, a vision of unhurried leisure, "It is not a world in which one regularly gets up early, or arrives on time at a rendezvous, or even arrives at all."[8] In that same article Lawford describes a day when Tatiana took Alessandro to the beach at Ostia and Twombly stayed, "irate and incommunicado indoors, pacing the apartment and anxious for everyone else to go away and let him go back to work in peace."[9] Twombly once tolerated this chaotic way of living, even thrived in it, but eventually hated it.

Twombly's words to Giorgio, distressed and worried about the silence of Tatia and the plan he had been relying on her to make real, confirm too what we know about Cy and Tatia's life together. I think again of that description of Tatia as being "like air." Her wildness of spirit that translated to the atmosphere of the house, the spaces where people came and went, the knocks on the door or calls up from the window, the "unsure what comes next" feeling of days.

▌

The house at Bassano was discovered by Tatia in 1972 and restored over the next several years by Giorgio, who oversaw the construction of additional spaces, including a southern-style "sitting room."[10] Giorgio's name, and Tatia's name, are absent from the description of Bassano in the catalogue raisonné biographical notes: "The artist purchases a fifteenth-century house in Bassano in Teverina, north of Rome, near Bomarzo, and starts its restoration, making it his summer studio for the following years." Many years later he would say to Edmund White, "'The Franchettis don't like building. They like fixing things up . . . Giorgio is always restoring things. He restored my house in Bassano. But when he designs something from scratch, it's too . . .' He doesn't finish the sentence."[11]

We don't get Giorgio or Tatia's take, though house finding and recovery is a trait the Franchetti siblings come by honestly, inherited from their father. The myth goes that the patriarch Carlo, stumbling down a mountainside in Val Gardena, caught sight of a dilapidated castle, once a summer hunting lodge for Austrian princes, now abandoned

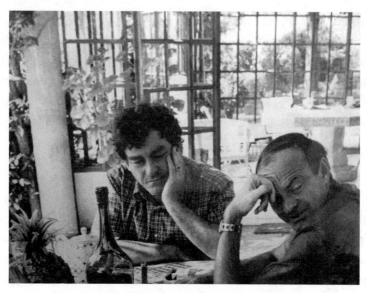

Giorgio and Cy, Porto Ercole, 1970s, Photo: Elizabeth Stokes

and ransacked. Restored from ruin, it became for the Franchetti family, as it once had been, an escape from the heat of a summer city, a refuge in the quiet and cool mountains.

"They like making houses and then moving on," said Soledad Twombly, Alessandro's wife, "playfully." "They place the last pillow and leave—it's the Franchetti way!"[12]

For a time, Twombly himself was a kind of project of restoration for the Franchettis—the brilliant American artist who they helped make connections to the Italian art world, the young man they supported and encouraged, rough edges and middle-class origins, fixed up. "All this high society collected once were landscapes and sheep grazing in olive groves," said Twombly to a friend, a position he happily took up with an estate of his own.[13]

"Much of the house," Twombly said to Britton as he led the writer through its four levels, "is empty and dry and hard; then you come up here and you see all that marvelous green."[14] We stand here with Twombly and the writer, in that upper part of the house, looking out to the volcanic hills rising and falling with thickets of green leaves, hazelnut and olive trees, holm oak and beech, fig, lime, and laurel. This rich

soil and the feverish hum of birds and insects and bells in the church towers. This borrowed Arcadia. Again and again, the inner world and the outer world are set in opposition, though now it's the stark, empty interior, and the rich, lush vistas and landscapes.

"When I used to spend time in Bassano," Twombly said, "you could still see shepherds tending flocks of goats. Once I actually saw one throw himself down under a tree and play a flute."[15] The world of a pastoral dream, the privileged, set-apart realm in which shepherds rest under laurel trees protected from the noonday sun. "The land around the house and the (then depopulated) village was thoroughly rustic," offers Kirk Varnedoe in his own reflection of visiting Twombly's country house, "and shepherds would come with tinkling bells on their flocks to play music on the hillside directly below the studio window."[16]

This vision of shepherds playing flutes just below the studio window, is, in the words of curator James Rondeau, "a description that strains credulity."[17] And yet as Rondeau notes "the immersion" in this village "stoked bucolic impulses" towards reflection on cycles of seasons, on the flora and fauna of this adapted place—mushrooms, trees—and on the poets who have stalked this same fertile ground, Virgil, Theocritus, Spenser. Twombly, as artist Francesco Clemente put it, "sailed away from history into geography," a lovely, if not quite accurate description of the shift from his earlier Rome paintings to these new works connected to land and nature and place.[18]

"Every now and then one gets excited by nature," Twombly said in an interview. But the excitement of nature doesn't translate, not exactly, to the canvases. To be excited by nature is not the same thing as being in love with it or interested in its reality. And so in the hills and copse around Bassano we don't see Twombly forging wild mushrooms like Cage or netting butterflies like Nabokov or bird watching under trees. No, he's inside the house, sheltered in the "fragments of space . . . of solitary daydreaming," he's at the window staring down into the pages of a book.[19]

In a photo taken by Plinio De Martiis in 1971, Twombly looks the shepherd's part, work boots and jeans, a flock of white sheep, like clouds, passes before him.[20] He rests under a tree, a lake behind him. "I like a view," wrote Gertrude Stein, "but I like to sit with my back turned to it."

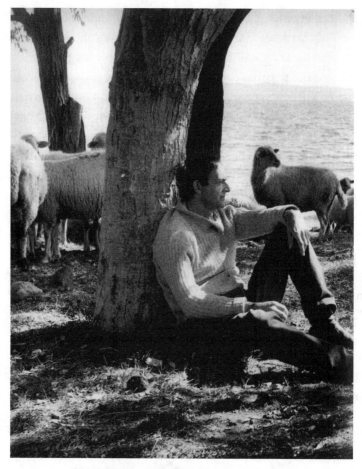

Cy, Lake Bolsena, May 1971, Photo: Plinio De Martiis

In the enormous triptych *Thyrsis* 1977, an early painting completed at Bassano, the names of speakers from Theocritus' *First Idyll* fill the far left canvas. In the center canvas, the largest of the three, Twombly scrawls in huge, mostly legible script, *I am Thyrsis of Etna, blessed with a tuneful voice.* Brag, boast, or reply. On the far right are the lines of Theocritus' poem, words spoken by the character Goatherd, a five-line song that begins, "Sweeten your sweet mouth with honey, / Thyr-

sis . . ." These words, barely legible in Twombly's hurried cursive and smudged erasure, offer to Thyrsis sweetness and possibility, a "mouthful of bucolic life: honeycomb, figs, goats' milk," as one critic describes the poem's sensory pleasures.[21] Life provides, your voice continues.

In this painting, Twombly claims an identity—I am Thyrsis. But he writes too the lines of the goatherder, giving us both sides of the singing, both sides of the dialogue. He is also Theocritus channeling these voices of Greek shepherd songs; Twombly wears the cloak of the shepherd and poet, singer and maker. In these "mirrors of masks," as one critic calls them, Twombly speaks or mutters, hides or shows off.

At the Hamburger Bahnhof Museum in Berlin I stood before this painting. I thought this: We make our lives in the shadow of the past. We sing in their voice. We owe debts—unspoken and spoken—to the artists and writers who come before. Our voice is always, already, a borrowed instrument.

These fragments, "little poems" of the idylls, are not Twombly's engagement with "real" nature, but literary nature, not the human voice singing but the pages of his book asking to be heard. "If Manet could be thought of as a 'museum' painter," writes one critic, "Twombly is perhaps a 'library' painter."[22] An artist of books—Twombly didn't just want to read his books but to have a conversation with them, to move through their pages as contemporary and scholar, as reader and editor. The lines of poems like paint or clay to be shaped and remade in his hands.

Twombly's mind and hand like a record player's needle stuck in a groove—I am Thyrsis, I am Thyrsis—or like the eye skimming back and back over the same line in a book. Other names—Virgil, Apollo, Pan, Orpheus—men and gods, poets of shepherds and storytellers of war, appear often in drawings from this time, a blur of letters smeared in the present. Like smoke. Like the way fog rolls in from the Pacific to submerge a city in its cloud, these single names both disappear and remain visible; the artist's hand smudging blue wax so that the letters seem to be escaping from the binds that hold them to the paper. Begin with the pastoral, the bucolic, the landscape, but arrive at the self.

"Most all of my work of the past five years was done here," Twombly tells Britton as they move from room to room of the Bassano house,

"and a lot of it is very connected to the landscape."[23] This is Twombly's constant refrain: "Landscape is one of my favorite things in the world. Any kind of landscape stimulates me," he said in an interview twenty-five years later, as he described driving through the Virginia hills or riding the train from Rome along the coast.[24]

Twombly's love of nature, at least in his work, is filtered through books and myths. A lens of words to see the shapes and shadows of his hills. There are no flowers, only the bodies of boys transformed, a purple hyacinth, trampled by shepherds, staining the ground. There are no winds, only lyre songs, dead-men laments, ghosts. There are no shepherds with flocks and bells, only their secondhand songs. A fiction of a fiction. To see trees or mushrooms, lakes or goats or bees, one must have first read about them. "Aristaeus Mourning the Loss of his Bees," he writes on a canvas of the same name in 1973, words borrowed from Virgil's *Georgics*. No bees in sight, just the green wash and fill, as if the artist covered the hive with his hand, or where the hive had once been. A missing swarm.

If ease and luxury and family life were offered in Horst's photographs from 1966, no matter how staged or untrue, the images taken six-teen years later at Bassano project solitude. The words accompanying Turbeville's photo essay claim a different story: "In the large sitting room, a gathering of richness drawn from antiquity: Ming pots, Flem-ish tapestry, ancient culture, fragments, a Corinthian helmet dating from fifth century B.C., Italian baroque chairs."[25] This description of "richness" and the photographs' washed out images, a dusty veil over things, conflict.

The tension between word and image, between what we see and what we read, between accounts and their truth, is a continual theme in the frustrating dance of these profiles. We have to take Britton's word about the bright, "marvelous" colors of the tapestries or the space as "spare, beautiful, with depths and richness not immediately apparent to the eye—this room, like this house, is another Twombly work of art."[26]

The agenda of the article—there's always one, somewhere—is to

see in these stark rooms the artist's individual genius. These rooms, the artist asserts, are not decorated. "They are *composed*."[27] The house as music and Twombly as the conductor. The maestro before the ancient world, gathering and collecting. Of those rare tapestries, Twombly claimed to have bought them in Paris years before "when no one else wanted them."[28] The interior of the house, composed of such fragments, anachronistic objects unmoored, aligns to neither a single place nor time: the rapacious gathering of beautiful, rare, fragile things. A "shy grave robber"—as one critic called the artist: "A real necrophiliac."[29]

Writing of Poussin, a contemporary, Bonaventure d'Argonne, observed: "I have come across him among the debris of ancient Rome and sometimes in the Campagna and on the banks of the Tiber, where he drew whatever most appealed to his taste. I saw also that he gathered pebbles, moss, flowers, and suchlike things in his handkerchief, which he wanted to paint exactly after nature . . ."[30] The debris gathering from nature—pebbles, moss, flowers, and so on—was more the work of Tatia.

What Twombly collected were the things already made, the "richnesses" of the world—vases, tapestries, broken sculptures, printed books; this is one part of his genius, the words and things of others, not arranged but composed. "Antiquity is a source of inspiration for Twombly," writes Philip Larratt-Smith, "because it is only accessible in fragments, and therefore can never lose its mystery and alienness."[31] A truth for the house. A truth for his work.

█

In his last library, Twombly owned four editions of C. P. Cavafy's poems by three different translators. In Cavafy's "The City," a poem I've always loved, and feared, too much truth in its refrains of departure and return, the poet writes, "You won't find a new country, won't find another shore. / This city will always pursue you."[32] It's not "a city" or "your city" but "the city" or "this city"—definite and definitive, a place like sleep, familiar and foreign, yours and not yours. The city is the place we carry around, not the old streets that haunt the present ones, but an impossible dream of a perfect, untroubled life. The pastoral impulse in

Twombly is finally about a kind of fiction. The fiction of a different life. The fiction of a different self.

"I went to the woods because I wished to live deliberately," Thoreau famously writes in *Walden*, "to front only the essential facts of life, and see if I could not learn what it had to teach, and not, when I came to die, discover that I had not lived."

Bassano is no Walden. Twombly is no Thoreau. And yet, the house in those Turbeville photographs, despite the fine antiquities, the marble and hand-woven tapestries, has a Spartan-like simplicity. Is it far enough from the "dislocated gypsy atmosphere"? Is it the dreamed-of hut in Abruzzo? Those first summers in Bassano, after the years of waiting for this physical space that was, finally, only his, a piece of *terra firma* against the troubles and waiting of everyday life, must have been lovely. No one at the door. Bright stars in the sky. Fireflies in the dark.

Bassano returned Twombly to his Lexington roots. In his Rome palazzo there were no attics, no basement walls, no vistas. This new place offered a return to the countryside, the southern pace of things, the kinds of secrets—corridors and passageways and levels—found in his childhood days.

I didn't think of Lexington when I stepped through the modest narrow door and into the empty, abandoned house at Bassano. Instead, I thought of the dank and dangerous natural world, half-present or missing, from Twombly's paintings: the wreckage of moss and mushrooms, of rain leaks and winter gusts, of mice burrowing and the bats that had taken up residence in the eves, rot and mold and decay. This was the state of Bassano when I arrived.

INTERIOR

I FOLLOWED ALESSANDRO THROUGH THE maze of the house at Bassano. Months after our lunch in Rome, I joined him, and his friend Miguel, on a long-delayed and haphazard tour of Cy's favorite places in Upper Lazio. Before we went inside, Alessandro asked us not to take photographs. "Out of respect to the wishes of Cy."[1]

He led us up and down stairs, passageway to passageway, from empty room to almost empty room. All the walls were bare. Dirty white and stone. A layer of dust coated every surface. It seems now like a dream, a site to which I can't return except in fragments: the notes I took, the memory I still feel—a damp rot at the tip of the tongue, the nearly chilled air inside the rooms, and a feeling of awe. Ruins inside

of ruin: the bust of an emperor, an unfinished driftwood sculpture, an empty bed, a broken chair, the torso of a Roman general with its carved pendant of Medusa's head on the stone armor.

"Look, you can see it was underwater," Alessandro said of one statue, a woman's robed body worn down and smooth. Her head and arms missing. Cy and Giorgio carried these heavy pieces together as they went from abandoned villa to abandoned villa searching for old Roman objects to fill this space. I touched the ridges of her robe, like small waves, an act forbidden in museums and yet longed for, this need we have not only to see but to feel and touch.

There were no tapestries, bright narratives of war, left on the walls to turn over. *Turn it over*—the first instruction and instinct of the artist or art historian when encountering a tapestry: to see against the damage of air and smoke, smog and ash, insects or water or light, the colors that might hold still their brilliance. The coral-red wings of a dragon, the foam-green hills rolling away, the soldier's black flag, the azure sky, radiant blue. Time is its own loom, pulling apart the weft, its own dyer's hand taking back color and shade.

▌

Twombly's photograph *Interior, Bassano in Teverina 1985*, opens a world and confirms a hunch about the wall hangings that once filled these rooms, a conversation between Twombly's work and those fifteenth- and sixteenth-century tapestries he bought for a song in Paris.

But let us go back. In the fall of 1952, Twombly wrote to Leslie Cheek at the VMFA of an upcoming show at a gallery near Via Veneto: "I've made 6 or 8 large tapestries out of bright material which the natives use for clothing."[2] Constructed in Tangier using traditional Moroccan and North Africa fabrics, "these works," writes one critic, "unique within Twombly's oeuvre and all apparently now lost, reveal a debt to both the ethnographic materials of North Africa and to his predecessors such as Matisse, who had also been fascinated by the vivid textiles he saw there."[3] The only proof of these "tapestries," shown in March of 1953 in Florence, are Rauschenberg's black-and-white photographs.

In another brush with tapestries, Twombly inscribes *Project for a*

Arazzi (Campo di Fiore) (For Tatia) 1960 on a drawing, *arazzi*, Italian for tapestries. A spare set of heart-shaped marks flit and fly in colored pencil on cream-hued paper. The drawing, one of two, was done shortly after Twombly returned to Rome in November 1960, a long journey home aboard the SS *Leonardo* from New York to Naples. I like to imagine these jewel-like marks along the bottom half of the page to be the artist's imagined design for a tapestry, a gift for Tatia, who loved textiles and gathered them in her travels, and a project for their new home on Via Monserrato.

Twombly's interest in tapestry returned at Bassano, where the large walls were filled not with his own work as in Rome but the handiwork of others. These wall hangings, proof of a maker's hands, with their threads and narratives of ancient wars and myths, perhaps offered Twombly a way back into the stories that had been erased, for a time, by the blackboard paintings. Similar in scale to his blackboard paintings, these "nomadic murals" as Le Corbusier described the tapestry, resonated with Twombly's peripatetic life, his continual motion and restlessness.

In the photograph, *Interior,* one of Twombly's later "pond" paintings, a deep and lush green, propped on a chair, sits in front of a tapestry. A white sculpture of Pan in the foreground of the photograph, and the wood beams above. The painting transforms into a pattern imposed into the tapestry, almost like a Persian rug, a blurring and blending of the layers.

There's something genius about the photograph, a dialogue between tapestry and painting. In the background tapestry one can make out two horses and a rider with his arm raised, and a man with an iron helmet. A war story. The photograph, taken with a Polaroid camera, replaces a field of depth with flatness. The colors so muted, one could easily mistake the vivid green of the painting for a dull black. One could forget how luminous—canary yellow, bloodred— these tapestries were.[4]

In another photograph at Bassano—some of his best photographs were taken here, little dramas of shadow and light, out of focus patterns and shapes, re-creations of art history, Vermeer's open window, Rembrandt's fading of corners—Twombly has replaced the green painting in

front of the tapestry with a thin tower-like plaster sculpture.[5] These wall hangings are turned into a theater stage for Twombly's own works, the angle of view through a doorway, casual like, as if walking from room to room, and then suddenly, one catches something from the corner of the eye and can't let it go.

"Extraordinary people, my mother and father," Alessandro said, as he described their isolated lives at Bassano. With the exception of a few people in town, Cy and Tatia were alone here. Nicola's name wasn't mentioned though I know he was here too, at least some of the time. If the house at Bassano was a family project, found by Tatia, restored by Giorgio, and part of Twombly's vision of a life away from Rome, Nicola's place in these discussions and restorations is harder to see.

That's what I thought at the time. In a long, rambling letter from the winter of 1971, Twombly writes to David Whitney that a house was under contract, perhaps the one mentioned to Giorgio in Bolsena. It was Nicola who helped navigate the tricky waters of Italian bureaucracy, forms and paperwork and complicated tax laws.

"It isn't anything special inside," writes Twombly in that same letter, "sort of *grand* outside—which I prefer the other way round. Tatia likes it for the good mt. air, Giorgio because he thinks of a garden on a rocky hill in back + Nicola because it is like nothing at all."[6] Here they all are, wife and brother-in-law and Nicola, each finding something in this almost-to-be country house. Their domestic lives, extraordinary and unremarkable, captured in a list of what they each might find in their country escape. The contract for this house fell through and the one at Bassano would not be ready for another four years.

This house, the one that came to be theirs was, in the words of Miguel, "like a sculpture." Square stone door frames, thick timbers that cut high above us, and the cool, expansive emptiness of the water cisterns: the place *did* feel like one of Twombly's own sculptures, simple and imperfect, those fragile plaster monuments and rough chariots. To think of sculpture here is apropos. After a silence of twenty years, at Bassano, the artist began making sculpture again. "I found myself,"

he said of this return to working in three dimensions, "in places that had more material. I found all kinds of materials to work with."[7] As always a sly reply, the double play of "finding himself," physically and metaphorically.

One summer, when Cy was ten or so, his uncle bought an island off the coast of Maine.[8] His uncle and his family lived in a converted barn on one side of the small strip of land while clearing the stands of pine trees to sell to the paper mill. The abandoned main house had long ago fallen to ruin, the roof opened to sky in patches and the windows cracked or missing. That island house was a miracle—rooms into rooms, yellowing sheets covering the furniture, the smell of sawdust and rotting leaves and the honeysuckle-air of summer—a perfect labyrinth for a boy who lived inside his own head, an odd, delicate creature, more at home in a book than on the baseball field. In the grand, spider-filled ballroom, garlands of pink and blue and silver paper danced around the room.

He spent his summer days there making sculptures and collages from the half-ruined toys: a rocking horse, broken trains and tracks, stuffed creatures losing their shape, a wind-up solider rusted into stillness. This first, found studio, this set-apart island of play and making: private and strange, archaic and claimed. Many years later, a poet, who couldn't have known this anecdote, told only once in an unpublished conversation, an unverifiable tale, would describe the artist's sculptures as "toys for broken adults."[9] In Twombly's work, the broken past returns, an archaeology of old things or stories, remade and reworked and reimagined by willful disobedience and a good eye.

In June of 1977, Twombly wrote to Whitney that he was looking forward to returning to Bassano to continue work on a ten-part painting, his first in four years. There in the cool and quiet dark, he started and finished *Fifty Days at Iliam*, one of his most important and ambitious works of the '70s. It couldn't have been made anywhere else.

Started that summer and finished the following year, the canvases, according to the artist, were loosely inspired by Alexander Pope's 1715

freewheeling translation of Homer's *Iliad*. Space too made this work possible; the canvases—like murals or tapestries—took over the walls of his studio and two adjoining rooms. The paintings reflect the "charge" of the house, its "dark *gravitas*."[10] The rooms at Bassano might look out to fields and trees but inside there was little light, a space "weighty and silent," filled with the "decor of fragmentary Roman sculptures and tapestries of military conquests, and the music of Wagner that played in the studio while he worked."[11] The paintings were as influenced by the interior spaces of Bassano as this epic poem of war and violence.

The subject matter of the *Iliad* wasn't new to Twombly; more than a decade earlier he'd completed *Ilium (One Morning Ten Years Later)* (painting in three parts) 1964, a triptych of chaotic energy, the names of the heroes scattered among the all-over scars of penciled figures, more battle than mediation, a warm-up to this later more ambitious, colorful, and narrative work.

Many of the paintings of *Fifty Days* are simply names and catalogs: *House of Priam, Heroes of the Ilians, Heroes of the Achaeans*. Simply, but never simple. Of a series of late paintings, Varnedoe writes, "I once said that it is precisely because Twombly loves antiquity that he is no antiquarian. Similarly, his great fascination for epic stories produces nothing of the standard storyteller, and even less the illustrator, in his spirit. Being literate about the motif entails nothing about being literal in its presentation, and 'accuracy' is hardly something he troubles with."[12] This is not Homer or Pope's Trojan War but Twombly's.

In the canvas *Heroes of the Achaeans*, a role call of Greek heroes and gods, names are handwritten in black: Thetis, Ajax, Hephaestus, Hermes, Poseidon, Hera, Athena, Diomedes, Menelaus, Telamonian, and Patroclus. All caps and a fiery red, Achilles' name, like the word Achaean, the name for the Greek side, dominates the field of view. The red is the red of fire and blood, of anger and rage. One can see Twombly's hand, not just in the heavy marks of red and black, but in the taking away: a list and the erasure of that list.

The paintings of *Fifty Days* live together permanently at the Philadelphia Museum of Art. Together they are a kind of suite, an "ensemble," an experience, a tapestry.[13] They are paintings to be seen all together, the drama of the whole, and to be observed one at a time.

The first painting, *Shield of Achilles*, "a powerful circular thunder-clap of dark reds and oranges that seems to presage the high drama to come," greets viewers before they enter the room.[14] Twombly's version of the shield isn't Homer's version with its vast fields, "yellow gold, vine-yards," and scenes of "noble" harmony forged into metal. No, Twombly's mandala of red and blue and black—layers made by oil stick wrapped loosely around a center of heat—is closer to Auden's dark poem about the shield, its scenes of violence and nightmare, "barbed wire" and "a sky like lead."[15] Twombly's shield is a warning.

Inside the room where the other nine paintings hang, the Greeks forever face the Trojans, *Achaeans In Battle* and *Ilians in Battle* apart on opposite walls but sharing a common language: triangles and names and phallic figures, orange and black and red swirls of script and era-sures, charging around the viewer in a frenzied rush. "The howling pain of war in Troy," one writer claims after seeing the works in person, "has never been communicated to me as potently as when I stood in the museum and saw the screaming red scrawl of the ACHAEANS and ACHILLES. Is this written in blood? in fury? in fear? or perhaps on what's left of the walls of Troy after the fact?"[16] The viewer who wrote that experiences the names not as a dead list from history but as figures brought back to life.

What strange interior lives they must have lived in this place. One senses the town's hilltop isolation, its apartness of height and defensive walls, its recollection of history and violence—both inside and outside of the house.[17] Time-worn Roman statues, empire beds, a few scattered chairs and tables, but mostly it was a house of empty rooms and beau-tiful vistas, rolling hills and stone buildings of town. In the rooms Cy used as a studio, one can see the holes where he nailed his canvases directly to the wall.

Alessandro opened the doors ahead of us, then closed them behind us, like an elaborate religious ceremony, a hovering silence and awed reckoning of things greater and mysterious. He led us upstairs to what was once the sitting room. A set of bedrooms situated off of this open

space. One room belonged to Cy. The other, though Alessandro doesn't say it, was probably where Nicola slept. Both are empty except for their single beds.

In what was Tatia's room, tattered books and yellow papers stacked indiscriminately on the bookshelf behind the bed. In my memory, the bed was half-made, as if she'd just gotten up to make coffee or open the blinds. Dust made its claim on everything. I wished I could have taken a photo, something to re-see, re-make that room again in the present. My notes as I walked through that space try to record a vague, imprecise feeling: *Intimacy*, I wrote; *warmth*, I wrote. My sense, wrong in fact, that Tatia had only just left. No one had slept there for quite some time.

"A twosome is a fragile structure that an intruder can slip into," writes Bianca Lamblin, the younger lover of Simone de Beauvoir and Jean-Paul Sartre, "but a triangle is a closed figure sufficient unto itself: nothing can break its geometric enclosure."[18] I thought of that strange triangle of Cy and Tatia and Nicola, sharing this house together. Traveling as they often did together—Tunisia, Iran, Egypt, and on. This triangle of affection and habit and secrecy. A closed figure.

Through the rooms of the dead we walked at Bassano, seeing their spaces, as if we might inhabit their past lives for a moment, as if they could whisper to us their bright secrets.

Afterlife—the subject too of *Fifty Days*; two of the canvases, *Shades of Achilles, Patroclus, Hector* and *Shades of Eternal Night*, offer a hushed stillness and calm grace amidst the terrible motion and rage. In *Shades of Achilles, Patroclus, Hector*, a row of three cloud-like figures, red, blue, and white, represent the dead heroes—these fuzzy ghosts, these spirits made flesh. "What we see," writes John Russell, "is not so much the ghost of Achilles but the ghost of history itself."[19] This panel is the center of the sequence, the climax and emotional heart; it's literally in the middle of the others, the one that you face when you walk through the door. Death, these cloudbursts say, is waiting.

I know the foolishness of wanting to find here anything more than

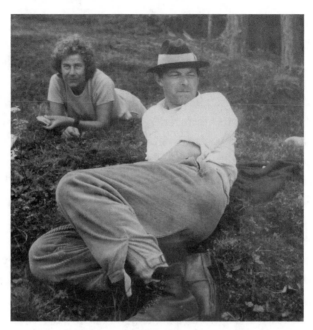

Cy and Tatiana, Val Gardena 1971, Photo: Elizabeth Stokes

dust and mold and broken, abandoned things. And yet, I touched the edge of the bed in the room where Cy slept. Touched the dust on the shelf of Tatia's bookshelf. Touched the holes in the wall, those spaces where nails tacked canvas. "The desire to touch," writes John Berger, "is, partially, the desire to lay hands on, to take."

Hours before we arrived at Bassano, we had all walked together through the gardens at Villa Lanta, a Renaissance estate of manicured hedgerows and cascading water. The babble of intricate fountains filled the air, not like song but speech, untranslatable words. Just ahead of me, Alessandro, his shoulders sloped, a body carried like a difficult weight, put his hands into the water. A gesture I imagined Cy doing, this small unexpected act as if there were no one else here and done simply for the pleasure of touch. I did the same, putting both my hands in the small river flowing from one fountain to the next, then down into the soft moss growing at the bottom, colder and deeper than I'd expected.

In the lush stillness of Bassano, I felt suddenly and inexplicably sad.

I imagined this house once filled with life, the slow and daily business of making art, of the days when Tatia toured the hills of the countryside in her Alfa Romeo, finding wildflowers to fill a small glass vase in her room.

We descended the stairs, retraced a route though the house and back outside. Below us, terraced fields and farmhouses and an old church of stone. The sky was an expansive blue. This eyrie. This crow's nest. This mountain villa in the days when letters arrived slowly, or not at all. What's hardest to see from this angle of history and time is the joy of this place. The other side of the tapestry. Alone and together. Cy, Tatia, and Nicola.

Once, when I asked Gaia Franchetti about the relationship of Cy and Tatia, she told me this story: One morning, perhaps ten years earlier, she'd been at Val Gardena, the Franchetti castle in the Dolomites, with Cy, Nicola, and Tatiana. "Cy was sitting at the kitchen table and Tatia came down and started to make her tea. 'How are you,' Cy said to her, 'little lady of the mountain?'"

"A lot of love," Gaia said, after a moment, "for the life they shared."

24

LOTUS

IN ROME I VISITED THE artist Isabella Ducrot again.

On the wall of her study, two Twombly drawings. One from 1959, what Isabella called "nothing," a penciled script of his name and date on a piece of faded paper, barely any mark to see, like a blinding white sky; the other, a drawing of a lotus flower. It was, she said, from "a time when he really loved me."[1] Words handwritten around the image of a single flower, turquoise green and light pink at the pointed leaf edges:

NELUMBIUM NELUMBO for ISABELLA from CY Dec 28 77
LOTOS

The lotus—rough drawn, three prongs, spiked edges—appears frequently in Twombly's drawings: *Some Lotus for Tatia* 1978, *Sesostris II* 1974, and, most familiar, shown and reproduced often, part of almost every big catalogue of Twombly's work, the large-scale drawing/collage *Apollo and the Artist* 1975. Below the word APOLLO, all caps in blue wax crayon, this flower.

Apollo is easy to see. But so too is Twombly, the artist, who becomes the image of a lotus flower, its W shape, calling us the sound of his last name. And in case this isn't clear, he has written the word *Artist* beside the ideogram. Indeed the word "artist" appears no fewer than three times in the drawing; *The Artist with Apollo* in tiny print at the top of the paper; and just above the huge blue, all caps APOLLO, *The Artist +*.

The title is *Apollo and the Artist*—the god first and then the man. The word that matters here is *and*. There's a mythmaking at work, a lining up of past and present, divine and human. "Unlike many of his contemporaries," writes Cullinan, "Twombly does not invent his own personal myths: he draws on the gods of classical antiquity and their posthumous existence."[2] This itself is but one of Twombly's myths. Even as his sources are sometimes traceable to a distant past, he makes himself part of those stories, a lineage, a birthright.

An act of mythmaking, too, in claiming the lotus as a sign for the self: the flower that sinks each night below the water and is reborn in morning, a symbol in Buddhism for purity, blooming from water and mud. Pink lotus, sacred lotus, Indian lotus, water lily—polyvalent and forever shifting—a symbol of sacredness or fertility or divinity. Continuation and struggle. Rebirth. It returns us, too, to places Twombly often drew from for inspiration, Egypt and India.[3] The critic Mary Jacobus points to the other meanings contained in the ideograph—"the drug that makes the expatriate Odysseus forget his homeland, the sacred flower of ancient Egypt, source of Nilotic fertility and symbol of natural cyclicity."[4] Each of these meanings—forgotten homelands, cycles, sexuality—combine and merge and repeat in Twombly's work, how they create, what she calls "genealogies and force fields of allusion."

In the large drawing *Apollo* 1975—completed the same year as *Apollo and the Artist*—there are no images, only words. Below the god's name, APOLLO in blue and black wax crayon, are two columns. In

one a list of nicknames, epithets, alternate ways of saying, god: Phoebus, Agyieus, Carneus; in the other column a list of animals and trees that represent Apollo: Laurel, Palmtre[e], Swan, Hawk, Raven, Mouse, Snake, Grasshopper. The names conjure. Apollo is written into being the way all gods are made, not with images, but with stories.[5]

The A of Apollo, like the A of Achilles, resembles a triangle. Or a pyramid. Or a temple. The A is an oracle: image and letter. Word and sign. There are no images of a hawk, its wings, like the sound of Apollo's lyre, must be found by the one looking at the words—or not at all. The world is made from words.

Again and again the blue wax is scribbled over Apollo's name, frantically rendered, obsessive, as if to remind us this isn't a name simply written, it's felt into being. There are so many ways to find a god. It is as if we can see the artist at work, figuring out the meaning and limits of the name.

"There is always a confusion, is there not when literary men meddle with art," writes the poet Richard Howard, thinking of famous pairs of writers/artists Rilke and Rodin and Ruskin and Turner.[6] But transpose his words, and it's equally true: there is, always, a confusion when artists meddle with literature. Not everyone is convinced; these "invocations," as one review claims, are "charged with rather fey, private meanings."[7] Another critic scolds, "Scribbling 'Apollo' on a canvas doesn't make a work lofty, though, and Mr. Twombly has not been well served over the years by those who have insisted that his art is."[8]

And yet, there is power in these names and beauty in these scribblings.

❙

Twombly left Leo Castelli's gallery in the summer of 1978. Cool, professional, and cutting—*Sincerely* instead of his usually affective *Love* or *As Ever*—Twombly's breakup letter to Castelli announces that there will be, sometime, in the distant future, a foundation for his work.

"I prefer to involve myself directly with this project," he writes, "as it will be the 1st serious attempt to do anything about my painting in America."[9]

Twombly had once called Castelli a "living doll." Now, fifty years

old, thinking about his fate and reputation, the course of his career, Twombly had clearly come to a decision to strike out in a different direction.

In the last sentence of his letter, Twombly instructs Castelli about where to send the funds still owed to him. I don't have Castelli's reply, though I imagine he might have written something warm and thoughtful, gently reminding Twombly that for two decades, even in the face of disappointment and failure, he had been a fierce advocate of Twombly's work. In the years between 1957 and 1979, Castelli had shown Twombly's work in seven solo exhibitions and a dozen group shows. The "serious attempt" to establish his reputation in the United States had been ongoing, slow and incremental, starts and stops since his first shows in the late 1950s at Eleanor Ward's Stable Gallery.

Even after the failure of the Commodus show, Castelli stayed with the artist, though for a time after that he kept his distance. "Twombly— well, there again, he disappeared for years and years," Castelli remembered, "remained in Europe and I didn't accumulate much there. Then he wasn't very successful here but he became so after a while. Now his paintings are very much in demand and as a result I don't get so many anymore."[10] He could've said this at almost any point in Twombly's artistic life, periods of feast and famine. At the same time, Castelli thought of Twombly as "an old friend."

About Castelli, Twombly was not as kind: "slightly dismissive of the maestro," as Castelli's biographer Annie Cohen-Solal notes. She understates, I think, the years of tensions between them. So too does Cy, who told Cohen-Solal in 2003, "[Ileana] had the eye." "Leo," he said, "had a silly side and a very honorable side." Twombly, Cohen-Solal suggests, "was not unformed enough to become the gallerist's creature, and he would always maintain a certain distance from Castelli."[11]

"When artists are not happy," said the dealer Arnie Glimcher, "they leave."[12] Rauschenberg would depart Castelli for Knoedler Gallery in 1984, soon to be followed by Judd and Schnabel—the "days of attrition" at Castelli's gallery. The relationship of an artist and dealer is unsteady by nature, the combination of "friendship, creative rapport, and business into one functional arrangement; it's practically inevitable that at least one of these components suffers in the long run."[13]

In November of 1978, the year Twombly left Castelli, the Lone Star Foundation showed *Fifty Days at Iliam* at the gallery of Heiner Friedrich in New York. The first monograph on Twombly's paintings, edited by Heiner Bastian, was published that same year. In 1979 the first volume of Twombly's works on paper, edited by Yvon Lambert, appeared. An early attempt was underway for the Dia Foundation to create a permanent space for Twombly's work in the former New York Cattlemen's Association building on West 23rd Street.[14] For financial reasons, this first Cy Twombly museum never came to be; for that, Twombly would have to wait several more decades. And the planning was underway for a retrospective at the Whitney Museum, curated by David Whitney (no relation to the museum founders). Books and special shows, important essays and retrospectives, a singular and permanent museum. Was this, finally, at long last, his "moment"? Commercial appeal. Name recognition. Was this what Twombly wanted, this kind of transformational success—glowing reviews, rising prices—or was he after something more abstract: Immortality. Fame. Love?

Prior to the Whitney retrospective in 1979, there had been two big museum shows in the United States, one in 1968 at the Milwaukee Art Museum and the other in 1975 at the Institute for Contemporary Art in Philadelphia, but none in New York. This, I think, was the dream. In one 1974 letter to Whitney, Twombly wrote that he prefers the MoMA, presumably for a show, and doesn't mind waiting to make that happen.

Their letters, beginning when Whitney worked at the Castelli Gallery in 1966, span twenty-five years, ending suddenly in 1982. A warm friendship and collaboration and then nothing. Cy's letters, shards of insight and humor, complaints about the obligations and logistics for shows and books, occasional bits of art world or family gossip also trace Whitney's evolving career, as the secretary for Jasper Johns for a time, as an artist, as collector and art world insider, and as a respected curator.

"There are not many artists," Twombly wrote to Whitney after he left his first job with Johns, "who have a secretary who can paint his pictures for him then buy them for $30,000."[15] Their exchange suggests that the effort for this first big New York show had been ongoing for a

number of years. As early as 1971, the artist asked about (or responded to) the possibility of a show. "Don't go to any trouble," wrote Twombly in a letter from that year, "— just call someone at the Whitney + leave it at that. My paintings always drew a blank wall in America . . . Maybe they are right—who knows."[16]

In the summer of 1980, Twombly wrote to Whitney from Bassano, that he needed to send "Big Daddy Rauschenberg" a note of apology for his behavior while visiting his friend at Captiva Island.[17] The events at Captiva, a place of immense importance and escape to Twombly, particularly in the mid-1970s, are impossible to know. David White, senior curator at the Rauschenberg Foundation, described a diferent "unfortunate incident" that ended the decades-long friendship of the two artists. In an oral history project White recalled:

> Cy used to come to Captiva and visit for a while too, and stay. There are multiple houses, so he could stay. He worked there as well, on his own artwork. Then at one point, there was some sort of suggestion where Bob invited Cy to come to a Thanksgiving dinner, and Cy said yes. But this was some time in advance, and I don't know what happened—if Cy forgot. In any case, Bob was making all these preparations and Cy never showed up. That really hurt Bob a lot, and he kind of backed off at that point.[18]

In a profile of Twombly from 1994, Rauschenberg "quips": "Cy says he'll be there in half an hour, but he doesn't say which month."[19] A joke that, after White's account, doesn't exactly seem like a joke. The interviewer in the oral history asks White if this was the "end of the friendship, or just cooling." More the end, said White, though the two remained in touch— Cy sent Bob photographs he'd taken years before—but they didn't see each other again. No year is given. No end point, just a vague fading away.

"Like all famous people," Edmund White wrote of Susan Sontag in

City Boy, "she constantly attracted new people, and she didn't have to cultivate old friendships, resolve disputes, soothe ruffled feathers. She could just move on."[20]

"I don't know what happened," David White said, and yet, we do, in a way.

This is the pattern in so many of Twombly's relationships—personal and professional—a period of great love and affection before the eventual falling out, the fading away, or cutting off.

As always, not knowing is only the start of the story.

▌

Only the start of the story. Robert Rauschenberg filled his houses and studios with the art of his friends and lovers. He owned more than fifty works by Twombly, the most by any artist he collected, from important early works, *MIN-OE* and *Panorama*, to a green-gray chalkboard of white hearts fleeting through the gravity-free space to postcard collages done at Captiva Island in the late 1960s and early '70s. Richard Howard, writing of the "private art" of Turner and Rodin, erotic drawings and watercolors, describes these as "an art without history, an articulation of a life that can be lived without repression, without sublimation, in eternal delight, in endless play, in the undifferentiated beatitude of bodies and earth and water and light whose realm is eternity, not history."[21]

In Rauschenberg's collection these are the flowers.

Flowers for Bob 1970, a pencil-drawn bouquet in a vase, is inscribed by Twombly "Happy birthday dear heart . . . a rose just budding." Another birthday drawing, more than two decades later, *Some Flowers for Bob* 1982, offers a fist of wine-dark reds and purple petals, oil pastels on paper.[22]

"It is tantamount to reading someone's love letters," writes Robert Storr of the drawings given to Rauschenberg by Twombly, gifts full of inside jokes and secret codes. "But the posthumous eavesdropping," Storr writes, "reveals a universally affecting tenderness that offsets any sense of being an unwelcome intruder in the private lives of others. And are not literature and life itself full of such triangulations between

intimates and strangers."[23] *Yes*, I said out loud when I read this for the first time, a recognition of what I knew but couldn't yet say about these complicated "triangulations between intimates and strangers."

A drawing from Valentine's Day 1972 addressed to "Dear Bob Rauschenberg," contains a list of those "inside jokes and secret codes": "friendship," "love," "warm house," "Captiva," "lime pie," "Peter," "Jungel [*sic*] Road," "many other reasons." The valentine, with its sentimental affections, is signed "xCy." Their youthful affair evolved into a decades-long adult friendship; this is Twombly at his most open, a period of closeness and collaboration and, why not, love.

If those flowers are for pleasure not posterity, the photograph of a young Rauschenberg, taken in the 1950s and printed more than four decades later, is something else. Like a Gerhard Richter painting, grainy and out of focus, and yet somehow precise, *Portrait of Robert Rauschenberg* circa 1950s, printed in 1999, was sent to Rauschenberg by Twombly years after their falling out. It is signed *Cy Twombly* at the bottom, and an edition number 2/6 marks this as not simply a private image but one that is shared, reproduced. A different kind of gift. A different kind of desire.

"Fame," wrote Rilke, "is no more than the sum of all the misunderstandings that gather around a new name." Those misunderstandings swirl and build: each review, each article that mentions Twombly's Roman life and his supposed distance from the art world, each profile in a glossy magazine with his family, each show, each gallery catalogue, each book.

"The Wisdom of Art" by Roland Barthes, the catalogue essay for Twombly's 1979 Whitney Museum show, side-by-side French and English, is more than just one of those misunderstandings. In hindsight, this second published essay by Barthes on Twombly is pivot and revelation.[24] No easy beast, it complicates and obscures. Just when you think you've got a handle on it, like Twombly's work itself, it slips away from you. The point is this—don't trust Twombly. Don't fall into the trap that's been set by the artist, the one I've tripped into again and again,

the reading of the literal or the figurative, when one should be reading the mark.

"Names," writes Barthes—Virgil, Apollo, Orpheus, etc.—"are like those jars we read about in I don't know which tale of the *Arabian Nights*: genii are caught in them. If you open or break the jar, the genie comes out, rises, expands like smoke and fills up the air: break the title, and the whole canvas escapes."[25] In a way Twombly always wants it both ways—to be figurative, calling forth the past, an invocation of a lost world *and* to have the gesture mean gesture. The line is the line.

To write or think about Twombly in any serious way, one inevitably encounters, admires, hates, confronts, avoids, and finally, quotes Barthes's essays. Here's another run by Barthes at the idea of the name in Twombly's work:

> When TW writes, and repeats this one word: Virgil, it is already a commentary on Virgil, for the name, inscribed by hand, not only calls up a whole idea (though an empty one) of ancient culture but also "operates" a kind of citation: that of an era of bygone, calm, leisurely, even decadent studies: English preparatory schools, Latin verses, desks, lamps, tiny pencil annotations. That is culture for TW: an ease, a memory, an irony, a posture, the gesture of a dandy.[26]

Ease and memory and irony and posture and dandy. Virgil is parody or nothing at all. As another critic cautions, Twombly's works are "evocations but not invocations."[27] Twombly might be, in Barthes's words, an artist of the "Mediterranean effect" but one should never take too seriously Twombly at his word. "Ever since Black Mountain," writes one critic, "Twombly seems to have looked on language as a game."[28] A game of looking, of playing, of multiple meanings. Don't see Apollo but the name Apollo.

"He wants to produce an effect," Barthes writes, "but at the same time he couldn't care less."

Twombly's Whitney retrospective opened on a late spring evening in New York City in 1979. Everyone who was anyone arrived dressed to the nines, black tie and black dresses, all of the gallery owners and money men and women, artists, journalists and writers, hangers-on, and all those that circle like sharks, there to see and be seen.

Just as the evening was getting going, glasses of champagne circulating on silver trays, the rising swell of chatter and whisper, Leo Castelli collapsed. He fell to the floor and for a moment the party stopped. Everyone looked. And then looked away. An ambulance, accompanied by the police, arrived at the museum and took Castelli to a nearby hospital, even as the conversation continued—perhaps he's sick, perhaps he died.[29]

Gian Enzo Sperone's recollection of that night isn't repeated in any of the reviews from the show. What the reviews do offer is a mix of admiration and condescension, an acknowledgment of Twombly's great strengths, but also his limits. Always with a qualification, a bit of doubt or a preference for this period over that one: "What is peculiar to Mr. Twombly is the richness and complexity of the echoes he can draw from this mode of expression," writes John Russell in his review of the Whitney show for *The New York Times*.[30] "Long residence in Rome has taught him, for instance, that a word niched in architecture or cut into a free-standing wall can sum up a whole society." The artist, he concludes, "contrives nonetheless to convey a notion of our universal inheritance that is genuinely august."

In another review of the show, "Cy Twombly: Major Changes in Space, Idea, Line" in *Artforum*, Margaret Sheffield describes the conflicts of a "cultivated, allusive mind and a personality at once lyrical and ironic, anxious and lazy, passionate and laconic."[31] She points to influence after influence: Italian art, Gastone Novelli in the present and Futurism in the past, citations of Virgil, Homer, Mallarmé, debts to Leonardo da Vinci and Surrealism, recollections of Gorky or Matta, references to Raphael and Poussin. And yet, she asks, "Are there any unifying principles, radical or major changes, or style in Twombly's work?" Yes and no. Good and not.

"A critical fiasco," in the words of one critic. "It seems to have cemented the prejudice that an artist's decision to leave American modernity for Italian antiquity could lead only to his decline (remember the fate of Ezra Pound)."[32] For Twombly, the show too was a failure, it "went over," he said, "about as well as a turd in a punch bowl."[33]

And yet, if many of the articles about Twombly published just before the next big U.S. retrospective, the MoMA in 1994, describe the Whitney retrospective as a "flop," as Brooks Adams notes, "this does not square with my memory."[34] The show "was seen and discussed by a whole generation of emerging artists and critics. It played a catalytic role at a moment between the end of Conceptual art and the coalescence of Neo-Expressionism." Adams points to how Twombly's Whitney show—along with a show of Joseph Beuys also in New York at the Guggenheim—"prepared the ground for the appearance of Julian Schnabel, Anselm Kiefer, Francesco Clemente and Sandro Chia in New York a year or two later."

Of all the artists moved by seeing Twombly's work in person at the Whitney, none were affected as much as nineteen-year-old Jean-Michel Basquiat. "In this genesis moment," writes critic Jerry Saltz, "he took Twombly's speed of history and amped it up to the speed of life."[35] In a 1983 interview, Basquiat said, "My favorite Twombly is *Apollo and The Artist*, with the big 'Apollo' written across it."[36] Twombly's barbed lotus echoes in Basquiat's iconic three-pointed crown. Simple lines to create dramatic effects. As Basquiat's lover Suzanne Mallouk remembers, "His favorite painters were Kline and Twombly, especially Twombly. Jean said that Twombly taught him he could scratch things out on the canvas."[37] Scratching the surface, words and numbers, a childlike simplicity without simplicity, graffiti, names, all of it transformed in the younger artist's imagination. Basquiat worked for a time with a book of Twombly's work opened beside him, an experience I know too well.

In a way, Twombly's influence on younger artists has become a kind of shorthand in reviews: scribbles, scrawls, doodles, graffiti. In a recent take on Julie Mehretu, perhaps my favorite living artist, Carol Vogel writes of her "combination of delicate markings reminiscent of Chinese calligraphy, scribbles that vaguely resemble Cy Twombly canvases and bolder architectural shapes." Twombly's presence in Mehretu's work,

work that doesn't just inhabit a room, but sometimes a whole building, is no small thing—layered surfaces, obsessions with history and landscapes, city walls and illegible languages, mark and scale and movement. Twombly's art offers more than simply influence, a set of forms or styles to be studied, but permission to trust one's own original style.[38] What else can we ask from our artistic models?

The point isn't simply that the Whitney show was a success, but that the definition of that success is up for debate. And here is the quicksilver question of what in the end that would look like for Twombly. His name in the pantheon of the greats. A seat at the table. Some old-fashioned respect.[39] Or maybe it's something else—a younger artist saying your name in awe.

We stood before the picture, a gift that might be called Isabella and the Lotus. Or Isabella and the Artist.

"Cy constructed his own story," Isabella said. Then added, "everyone does this, no? But he was like a bureaucrat. Methodical. Artist like employee."[40]

Isabella used a word I didn't know to describe Twombly. I made her write it down for me. Her artist's hand signed it on the page: *Sprezzature.*

That night I looked it up. *Sprezzature* is the "art which does not seem to be an art . . . a disdain or carelessness, so as to conceal art, and make whatever is done or said appear to be without effort and almost without any thought about it . . . obvious effort is the antithesis of grace."

A studied nonchalance that displays the absence of effort.

I was reminded of the photo of Twombly and Rauschenberg lying together in a grassy dune at Captiva, the one Max once showed me in his Rome apartment—Huck Finn and Tom Sawyer as one review has it. Twombly leans on his side propped up on his right arm, a brown-brimmed hat, he looks the part of a dandy to Rauschenberg's rake: pastoral shepherds, leisure-class artists, ex-lovers, lifelong friends.

It's a publicity photo. On the back of the postcard is printed: "Please come to the opening of an exhibition of works by Robert Rauschenberg

and Cy Twombly on Saturday May 4th 1974 at the Leo Castelli Gallery 420 West Broadway." They are not just selling paintings but an image of themselves. It's not far from the image they sold to a reporter the following year before Twombly's exhibition at the ICA.

"Mr. Rauschenberg and Cy Twombly drove from New York to Philadelphia for the ICA preview," reports one article about the show. "The weather was bad and they arrived 90 min late. 'We stopped twice for coffee,' said Robert Rauschenberg. 'Cy wanted to go to a drive-in movie, but I persuaded him to continue.'"[41]

I would love to know what they spoke of in the car, or didn't speak of, as they drove across the Hudson, down the New Jersey turnpike, stopping at the rest stops along the highway, this so very American anecdote: road and coffee and drive-ins.

But that's sort of the point. Not the events but the myth.

25

COLLABORATE

WITHOUT WARNING, NICOLA WANTED TO talk. An unremarkable Friday in early May, one in the endless string of lovely mornings in Rome when our daughter woke us up too early and we ate breakfast in the narrow white kitchen of our Trastevere apartment before walking together to the *asilo nido* up the hill in Monteverde.

Nicola wrote that he was in Rome and asked if I was free that afternoon. We hadn't seen each other in more than a month, not since a chance meeting at an art opening. A one sentence email. No explanation for why, after delay and silence, he was willing to meet.

I thought of what a friend had warned about Nicola's difficulty, his cautious and skeptical nature: "What do you expect. He's Abruzzo after

all. Hard mountain people." There is an Italian word I learned my first week in Rome. *Campanilismo.* Untranslatable exactly into English, it means something like loyalty to the bells of your own village. We all hear the bell towers of our birth, even after we leave those first places, a nature sealed in our blood.

▌

I sent Nicola a text and waited.

The month before, in April of 2014, I had again run into Nicola briefly at an event, this time an opening at the American Academy in Rome. That night, the yellow buildings of the Academy glowed in the half-light of longer spring days, dark not falling until later. From our apartment down the hill, we walked up, my daughter strapped to my chest like a koala, awake but tired. The stone fountain in front of the main building was surrounded by little candles for the opening of Prabhavathi Meppayil's show of white canvases inscribed with gold and copper wire, a Minimalist aesthetic that marries craftsmanship with negative space.

I wasn't surprised to see Nicola standing alone in the gallery. In fact, I had secretly hoped for his presence. Twombly had had a warm relationship with the Academy in his older age; a trustee, he designed a medal they give. In 1998 they hosted a small show of his sculptures and later a show of his photographs.

And yet, if one looks in the library of the Academy—a place I wrote some days when I wanted to be apart from the world, its hilltop sanctuary of wood and glass—there are very few books about Twombly.

Nicola wanted to know how the book was going. "Good," I said but offered no details.

"How old are you," he said to my wife as he shook her hand. He was, I think, trying to be kind, to say she couldn't be old enough to have a baby but the words arrived as awkward and impolite. To my daughter, he waved and smiled. She smiled back. "Lovely," he said.[1]

We drifted off together, my wife and daughter and I, to look around the show and find our friends somewhere in the crowd.

A few days later I sent him an email. The soft sell. I told him my

family and I were going to be in Gaeta and asked if he'd like to meet for coffee. I had imagined our chance encounter at the Academy, warm and casual, to be a fresh start.

He wrote back the next day that though it was nice to meet my family, he would not be in Gaeta. The last couple of years, he wrote, had been very stressful. He didn't use the word lawsuit or fraud or misuse of funds to describe the just-ended legal battle between the remaining four board members of the Cy Twombly Foundation. The email was friendly but promised nothing concrete. He would help with my book, he suggested, but only once it had what he thought of as a completed shape and structure.

And so, my days continued. I wrote about tapestries. I daydreamed in a library with open windows, the breeze from the garden casting everything in green shade.

Nicola, predictably, wanted to meet at a café in Piazza Farnese. In the cold metal chairs, bundled in our jackets, a surprisingly cool wind for the start of May, Nicola and I drank our espressos. From our table we could see the stone benches where we'd met the first time. A fleet of pigeons eating the bread tossed by German tourists, a cold breeze, and the threat of rain: none of it added up to an explanation of Nicola's sudden willingness to talk.

He told me he had just returned to Italy from seeing subtropical gardens designed by the daughter of a Russian czar. The name of the place I didn't hear. This wasn't uncommon. Nicola had a way of letting his words trail off, mumbling in his accented English. Sometimes I asked him to repeat himself, other times I let the words drift away, like a small cloud, grateful simply for this moment.

"Did Betty say he lived in an ivory tower?" Nicola asked for the second time, as if it was something we had been discussing already, enough that I'd know what he was talking about.[2] I had told him that I talked to Betty, but offered little about what we discussed. And so, we took turns, Nicola and I, with our vague answers to specific questions.

In Nicola's essay "1972–1979," a version of this story about the

"ivory tower" is repeated, though without Betty's name. One of Cy's best friends remarked in a "whispered aside," after seeing Bassano for the first time, "'He built an ivory tower for himself.'"

"She surprised me even more," Del Roscio writes, "when this concept was repeated in interviews . . ."[3] Perhaps Nicola heard the repetition of this "concept" in the quote of the friend who "mused" to critic Kirk Varnedoe that Twombly's "ideal abode might be 'in a palace . . . but in a bad neighborhood.'"[4]

In those days, the early 1960s, Nicola explained, many people in the neighborhood of Twombly's Piazza del Biscione studio didn't have indoor plumbing and you'd have to watch out for newspapers of shit falling from the sky. The neglected spaces filled with artists in search of cheap studio spaces; it's now, like one of the industrial warehouses in New York's meatpacking district, posh, full of expensive restaurants and boutiques. The comment to the critic, in light of Nicola's description of the neighborhood, doesn't seem so far from the truth of things, a seemingly harmless observation that captures the distance between the allusive, highbrow sources of some of his early paintings and the squalid physical space.[5] It was, Varnedoe writes, an attempt to "affectionally" and "metaphorically" describe the artist's unique "blending of cultural refinement and appreciation for the pithier vernacular life."

Nicola remembers a whispered aside from four decades before. An unattributed line in a twenty-year-old essay. He carries it, knows it, repeats it.

"By 1965, he had digested what there was to be seen in Italy," Nicola said to me with casual, but insistent authority. Much of what Nicola told me about Cy's life wasn't new: the New York City years, from Whitney's borrowed studio in New York City to the one on Canal Street—"#11" Nicola remembered—to several years that followed on the Bowery; a claim that Twombly spent so much time in warm winter places later in life because of "weak lungs from bronchitis in childhood"; the description of Twombly as the "first globalized artist" who pulled together in his art all the different places he lived and traveled, "Japan to India."[6]

A coy smile crossed his face as he described Cy: a "traveling salesman." Nicola, his quick mind of books and references, recalled Lucian's *Trips to the Moon*, and Augustine of the *Confessions*, to describe how one

could be called "Roman" yet come from a distant part of the empire, Syria or Tunisia. Nicola went so far as to compare Cy himself to the Roman Empire—a troubling comparison in that Cy becomes the colonizer, moving across Asia Minor and appropriating what is not his.

I told Nicola about an anecdote in H. V. Morton's *A Traveller in Rome*, that over two hundred different species of plants once filled the Colosseum in Rome, seeds carried in from all over the empire by animals once slaughtered for spectacle: giraffes, hippos, lions, flamingos, hyenas, all manner of wild creature. Now there are only a few species of plants. A story about unexpected consequences. A myth about gardens that bloom after death. An image, too, not just for the long arm of empire, but its ruin.

In 1979, shortly before the Soviet invasion, Twombly traveled to Afghanistan. A tour organized by Isabella's husband, a small group of travelers and among them, Cy, Nicola, and Alessandro. One afternoon, visiting a high mountain town, a sudden rainstorm forced them to evacuate. They rushed down the mountain as the storm closed in.

"An adventure trip," Alessandro said when he told me of their scrapes with danger as they trekked to the far eastern province of Nuristan, literally "land of light," just on the border with Pakistan. Alessandro smiled as he remembered their close calls with disaster, mud slides and flash floods, events turned comic in the distance of years.

I was surprised that morning in Rome by Nicola's story—the mountain town, the sudden evacuation. Nowhere in my conversation with Alessandro about this trip did he mention Nicola. Nicola too leaves out Alessandro from his essay, "Trip to Russia and Afghanistan with Cy Twombly, 1979," published in 2015. They are missing from their respective stories, omissions that point to their relationship, a relationship that Alessandro described to me once as "good," and then a beat later, "Well, not so good."

Nicola's essay, despite its occasional awkward prose or convoluted simile ("fruits sprinkled with water drops like diamonds trembling in the rays of the sun"; "walking burqa like paper puppets in a Mexican

fiesta") offers a more complete picture of the trip, from Kafkaesque air-ports and border crossing to the wonder of Kabul.[7] Especially reveal-ing are Nicola's claims about how the artist borrowed from landscapes, human and natural, in Afghanistan. From the fields of poppies to the "saddle shape" grave markers to the great tomb in Kabul of Babur, the Mogul emperor—they all find their way into sculptures.

Twombly's *Untitled (In Memory of Babur)* 2000 is at once memorial, memento, and inside joke. Constructed fifteen years after the trip, the all-white piece resembles a small bench flipped on top of a larger box. As if a miniature replica of his tomb, *Memory* in large cursive and *Babur* in block letters are written on the side. "In memory"—not just for the man but the moment of the trip. On his bedside, Twombly kept a photo-graph of the tomb of Babur. It stayed there until his death.

"We also went to visit Herat," Nicola writes, "I had the impression that Cy considered the trip to the remains of the ramparts of the castle of Alexander the Great as a pilgrimage, a homage to the entire story of Alexander. Many years after he dedicated a sculpture to that trip and titled it *Herat*, I suspect, among other things, to make up for the loss of the castle of Alexander, destroyed by Russian bombs."[8] To mark what is gone: again and again this is the impulse of Twombly's work.

In one of the small Afghan towns, the villagers offered Cy a live eagle as a present.

"A sign of respect," said Alessandro of this gift, when he told me about the eagle the afternoon we had met for lunch in Rome. I love the image, the enormous bird with clipped wings, an impossible offering, and its polite refusal. I thought too of Rauschenberg's combine with the stuffed bald eagle, *Canyon* 1955, a piece at once priceless and worthless, invaluable and, because of the endangered animal mounted to the can-vas, unsellable.

Nicola remembers it differently. The locals, high on opium, tried to sell them an eagle. Nicola fills out that moment, a story changed—less beautiful and romantic than the one Alessandro told—but stranger, wilder. "We stopped for drinks at villages where even the sheep were drugged out of their mind," he writes. "Villagers with swollen red eye-balls came to sell us an eagle. We were lounging sipping tea on beds (I should call them ottomans), lined up in the piazza, watching beautiful

ridges of blue mountains on the other side of the valley, like the convalescence of people at the beginning of the century at Davos, in Thomas Mann's *Magic Mountain*."[9] The group, among them a blond woman, immodestly lounging, attracted the attention of a gang of young men, drunk or high. Cy noticed the growing unrest in the crowd and his travelers made a quick escape.

The story changes. Nicola's scene making is comic. Davos. Mann's *Magic Mountain*. Old Europe in the days before the Soviet invasion. There's a surreal luxury in the image of the rich travelers lounging in the town square, and the anxious fear as the locals gathered to stare. There's the artist, too, ever watching, "eagle eyed." Del Roscio's version, though I'm not sure he intended it this way, captures the poverty of the people, their lives of war and drugs, their lives of desperation and the incredible privilege of Cy and Nicola and Alessandro to travel across the world and return home.

▌

The birds in the piazza flocked and scattered. A convocation of small garbage trucks offloaded their collected debris into a larger garbage vehicle. The noisy clatter overshadowed all the other sound from the square. I mentioned to Nicola, in passing, Arthur Danto's *Artforum* essay "Scenes from an Ideal Friendship," one of the few pieces in which Nicola and Cy's relationship is named directly: "partner, lover, critic, administrator, and helper."[10]

Of Tatiana, writes Danto, "I really know little about her, or the marriage, beyond what Nicola told us. He and she were not on cordial terms."[11] Danto, who died a couple of years ago, was in Nicola's words "an imposter." Nicola's objections to the essay seemed to be the timing, published just four months after the artist's death. Though now, Danto's statement that "[Nicola] became a friend immediately and remained a friend," seems far from true.[12]

We returned to the topic of my book. "I'm still afraid that you're writing a book of gossip," he said. He was, however, willing to work with me—"to collaborate" in his words—provided that I share what I wrote

so that he might offer "corrections." He brought up Butch again and the three sculptures that Cy gave him, worth a small fortune. "You have to change what you wrote," he said.

It was then that Nicola reminded me, his polite, quiet tone never changing, that the Cy Twombly Foundation, of which he is president, controls all of the images of Twombly's work. The warning seemed clear enough—a threat, I thought—then I immediately doubted myself.

As if anticipating my thoughts, he said, "I'm sure you're going to want pictures for your book. I'm not making a threat."

In a rare moment, as we said goodbye, Nicola talked about the man he knew, their bond and intimacy, sitting for hours together at a café near here and watching people go by. He told me of their "double talk," their inside jokes, the pleasure of each others' company.

There's a small note in the acknowledgments for *Writings on Cy Twombly*, published while the artist was still alive: "Many thanks to Cy Twombly who," writes Nicola, "by amusedly teasing me about my capabilities while I was working on this project, provided help through humor." The first time I read it, I thought about how even the artist questioned his competence at the start. Though now, it reads more as affection. A sort of joking "double talk."

"When young," Nicola said to me, a note of sadness in his voice, "you think everything is forever."

Who was this man? I didn't understand his motives for meeting— why today? Why now? It wasn't that Nicola had suddenly replaced silence with gushing openness, but something had shifted. He seemed less guarded. He was closer to the person classified by Sally Mann as Cy's "gentle erudite companion."[13]

Before my first meeting with Nicola, months earlier, an acquaintance told me of a little tree that Nicola and Twombly cared for in Piazza Navona. Together, they would clean away the accumulated plastic bags and trash then use water from one of the fountains to keep it alive. I looked for that tree but never found it.

A difficult man to know, a difficult man to please. I thought of a story told to me before I came to Rome by Harry Pemberton, Twombly's friend in Lexington. He met Nicola for the first time in Naples as they waited for Cy; he tried to make small talk, inquiring what he did for a living. Nicola replied, deadpan, "I read."

When I asked Nicola about his influence on Twombly he said, "More and more he asked my judgment." The council that Nicola provided—in particular responses to the art—resembles how Alessandro and others had described Tatia's influence on Cy, and how Betty described her own role, at least for a time.

"I did things," he told me that afternoon in Rome, "to make his life easier." But it's not that simple. Nicola and Cy's relationship, complex and mysterious, was one of interdependence. They needed each other.

"I wish," he said, "I had written down our conversations about art." Only later did Nicola start to take notes of Cy's observations, observations that Nicola claimed he wants to use for an as-of-yet unstarted book about Twombly.

Perhaps this book will include the story, part of the catalogue for the MoMA retrospective, that Twombly painted the upper sections of the untitled blackboard paintings "sitting on the shoulders of a friend, Nicola del Roscio, who shuttled back and forth across the canvas so that Twombly could work on the moving surface as if he were a typewriter striking its moving platen."[14] Beyond the humor of the image—Twombly's large, tall frame and Nicola's spry, shorter stature—it's a moment of physicality, bodies touching in a way no other public story allows. I once asked Harry if Twombly and Nicola were ever affectionate with each other, a question about how their relationship was displayed publicly—or not.[15]

"That's an odd way of putting it," he replied. "They were lovers."

I asked again, "I mean, to each other, were they publicly affectionate?"

"Never."

Del Roscio, once the guardian of Cy's time, protecting him from people who wanted things from him, gallery owners and the like, is now the guardian of his memory. In a way, he still carries Twombly on his shoulders, the weight of responsibility of the Foundation, the impossible task

of protecting his reputation from every slight or unapproved intervention.

As I watched him walk away, down the cobblestone alley of Via dei Baullari towards Campo de' Fiori, I imagined how hard it must be for him without Cy. To be without the man, and yet still responsible for him.

Suddenly, summer. Rome was hot and crowded. Everyone was in a hurry to be lost or wait on line. On the weekends, with my daughter, I went to playgrounds and museums. We walked in the neighborhood and shopped for fruit and vegetables in the stalls of Testaccio market and the little grocery down the street. She learned the words *dog* and *goodbye* in two languages.

In the days after meeting Nicola at Piazza Farnese, we exchanged emails. He sent me his latest essays, the short piece about his first meeting Cy in Rome and another about their travels to Afghanistan.

I was optimistic, again, that when he returned from traveling—an opening in Mexico City at the Museo Jumex, Twombly's first comprehensive exhibit in Latin America—I would go to Gaeta. We would collaborate.

I imagined a moment like the one he shared with Marella Caracciolo in her 2004 profile, an example of Nicola's sharp mind and deep knowledge of nature and literature and art. As they stood together on the terrace of his Gaeta house, an eighteenth-century hunting lodge constructed by a cardinal over the ruins of an eleventh-century tower, Nicola said to her, of the mist hovering over the sea, "The *quagliarola* must have started." *Quagliarola,* a word in no standard Italian dictionary, is the local term for the yearly migration of quail from North Africa to the Italian coast. This return after absence. This inevitable pattern.

I didn't know that would be the last time we met in person.

I didn't know the trouble to come.

PART THREE

THE WAVES

IN THE ITALIAN COASTAL TOWN of Gaeta, from Nicola's hillside house, Twombly studies the waves. It's the winter of 1984. Even when chilled, his teeth rattling and his hands shaking, he keeps his watch. A cold January darkness, just one night in a string of similar nights, Twombly watches the breakwater, a recurring pattern of force and randomness. He refuses to go inside.[1]

His mind "in the black," to borrow Olson's words from that winter night at Black Mountain. "Come inside, Come inside," Nicola might have said, the roles from that night on the lake more than thirty years before now reversed. Twombly, like Rauschenberg, moving out into the dark; Nicola, like Twombly, calling him back.

I like to think he knew the story of J.M.W. Turner, who like Odysseus, chained himself to a ship in a storm: "I wished to show what such a scene was like: I got sailors to lash me to the mast to observe it; I was lashed for four hours, and I did not expect to escape, but I felt bound to record it if I did."[2]

Not bound to his chair, Twombly remains anyway. A chill curled around his bones. A worthy stubbornness. In the hard wind off the water, he wraps a white knit sweater around his large frame. Can one memorize a wave? Can one hold a fleeting pattern in the storehouse of the body? The Tyrrhenian Sea cascading against the base of a cliff, a castle perched above, and the play of the green vegetation and the white waves and the black sky—or after time, the way those colors, white to green to black, merge together.

Memorized lines of poems circle about Twombly's mind in that darkness, wishful phrases for black days and cold nights. A little Keats. A little Seferis. A little Rilke: "I feel closer to what language can't reach / With my senses, as with birds, I climb / into the windy heaven." The motion of the waves, back and forth, as a refusal and a hope. This sense of proximate distance to something that escapes words. If I stare into the sea long enough, I will not memorize the waves but become them.

Twombly's Green Paintings, swirls of dark jade and white, with occasional flashes of blue, are lush, and yet, in their nearly monochrome palette, austere. A rich and fecund shade, Hooker's green—a color one critic described as "cooked spinach"—is washed over with white, like waves. They are yet another departure. Another mercurial turn in a career of so many turns. This is Twombly at his most painterly, meditative and gracious; the material of paint is, quite literally, on his hands. This is also Twombly at his most mimetic, the natural world made real.

The first set of these works—thirteen from 1985 to '86—the "pond" paintings as he called them, and the later nine that would be part of the 1988 Venice Biennale, fill their frames with streaks of dark green, layers of verdant mint and emerald, and washes of white, all on wood. Twombly wears his debts on his sleeve: to other artists—Monet and

Turner and Poussin; to places—Bassano and Gaeta; to nature—the shifting patterns of water and grasses, the fish nipping at the surface of the pond; and of course to poets—Ovid, Rilke. In one set, a triptych from 1988, Twombly's baroque frames, Renaissance-style lunettes, half-moons on four sides, bear an uncanny resemblance to mirrors. You might mistake yourself for Narcissus looking into the pond.[3]

"The biggest surprise in the Italian pavilion is Cy Twombly's installation," begins one review of the 1988 Biennale. "The new work confounds previous work and is not only exceedingly lyrical but it is also a refreshing liberation from Twombly's previous formulations."[4]

The critic is right to see the differences. And yet, they are, in their own way, a continuation—paintings that, like the chalkboard works, reduce the palate into an elemental duality; works that come as a set, a series to think through and around. "Maybe they're pages in a book," Twombly said of his groups and cycles, works that can't fit into one canvas but spread across multiple surfaces. The Green Paintings are, too, like so much of Twombly's work, a record of their making and a record of all the time before—the looking, the thinking, the waiting for the right moment to act.

While it's true Twombly watched the sea from the garden of the Gaeta houses where he stayed and from the train as it hugged the coast, the truth is that the majority of the paintings of this time were done at Bassano. The green is the green of those summer hills. The green is the green he'd had on mind (and canvas) since he first arrived and threw himself down under the olive trees, the green of basil and laurel and ryegrass.[5]

Before, Twombly's vision of nature was filtered through books, through the mythmaking of a self. But here, despite the bits of Rilke, Twombly's rendering of the natural world hews, by observation and attention, to the impressionistic reality of it. They feel un-ironic, homages to be taken straight, to the water lilies in Monet's Giverny garden, meditations on materiality and the activity of looking.

"The Green Paintings," writes Laura Cumming of the nine paintings that now live together in a single room at the Menil's Cy Twombly Gallery, "are Venetian seascapes almost kitsch in their tunefulness, deep green washes, tidal currents, water rippling with lagoon light. He

has been looking at Tiepolo, and the canvases have those fancy rococo shapes, but also at picturesque Monet." A vision of nature (seascapes, tidal currents, lagoon light) and a tradition of the made (Monet, Tiepolo) come together here. "Still," she continues, "you see the passage of the artist's fingers dragging and stroking the paint; no matter how charming, his pictures aspire to the primitive."[6]

The paintings were all made by hand, according to the artist. The method might be childlike, finger-painting, though the result is anything but childish. "Even in the most calculated major works," writes one critic, Twombly preserves "the look and feeling of the impromptu and a 'loose hand.'"[7] One can see, even from a distance, the marks of hands and finger, "dragging and stroking the paint." In this Twombly is the inheritor of the Abstract Expressionist tradition: intense physicality, immersion in the sensory process, speed.

▮

The paintings of this time return, at least for me, to that night decades before—what Olson called the "tale of the lake & the boy." "I've found when you get old you must return to certain things in the beginning," Twombly remarked, "or things you have a sentiment for or something. Because your life closes up in so many ways or doesn't become as flexible or exciting or whatever you want to call it. You tend to be nostalgic."[8]

The narrowing of options and choices, the life that can be counted in fewer years ahead than years past. Count the number of books you'll have time to read, or paintings you can make. It's not just the good days, but the bad ones too, that one misses. A desire to return burns through Twombly's work, a steady hum amplified in his later work.

"It seems that things are more like me now, / that I can see farther into paintings," writes Rilke in the poem "Moving Forward," translated by Robert Bly with beauty and a loose attention to fidelity.[9] Twombly borrowed this poem for the first part of the nine Green Paintings, its lines of mortality and vision. Those are not the words he selected to hand-write on the canvas. Instead he chose these lines, the cursive words sliding down the white center, lines broken in ways neither poet nor translator intended:

the ponds
broken off
from the sky
my feeling sinks
as if
standing
on
Fishes

Unlike some of Twombly's other handwritten passages, indecipherable
scrawls decoded only by scholars foolish enough to puzzle out almost
unreadable phrases, that word *Fishes* is enormous, and the others
stretch out from left to right. From this enormous fish, the word as sign,
it's almost as if the words are bubbling up from its mouth.

The Rilke poem ends with the line: "as if standing on fishes." What
better image for the paintings that would emerge from those nights, a
captured fleetingness, the slippery scales and quick darting energy of
those fish below the surface and impossible to see.

❚

In the 1980s Twombly developed "an aversion" to Rome. He preferred
to split his time between Bassano, Porto Ercole (where Betty lived), and
Gaeta, where Nicola had a house.

Here's how Twombly once described Gaeta: "Hadrian had a villa
here . . . Cicero is buried here, and so is the Roman general who founded
Lyon. Catullus had friends here. It was kind of a summer art colony,
like East Hampton, but not anymore—that was 2,000 years ago." By
one account, the city was named for Aeneas' wet nurse. "She was with
him on his return from Troy," Twombly said, "and she died here, so he
named the place after her. I believe that. Nobody could make that up."

At first he stayed in Formia, the next town over—his drawings
from there are dated 1981—and then later at a hotel in Gaeta, or with
friends.[10] He bought his Gaeta house in 1985 and restored it over the
next several years. Set in the hills of the medieval part of the city, a
promontory stretching out into the bay like an arm, his new, part-time

home offered a grand vista of Gaeta Bay. Nicola, according to the *Times* profile, first introduced Twombly to Gaeta, a place he knew from his own boyhood. In reality, of course, Twombly had been coming down to this part of Italy for years; Sperlonga, where he spent time in the late 1950s, is just the next town over.

Here's one writer's take on the house (many elements of which could be true for any one of his houses): "Palm trees, a trickling fountain, cement turbans crowning columns copied from the finials atop the church next door, tree trunks in the upper garden painted white to repel ants—these are the elements with which he pieces together his daydreams."[11] The interior of the house, seven or eight rooms on different levels, were filled with flea market finds, a jumble of fake and real antiques ("a genuine Louis XVI canopied bed," "curvaceous imitation Louis XVI chairs"), and floor tiles scavenged from the debris of the 1980 earthquake in nearby Naples.

On the hillside above Twombly's Gaeta house was Nicola's house, the closest the two would ever come to living together. "On our arrival," Danto recalled, "Nicola flapped a towel out the window to signify that we had arrived, and Cy flapped back a greeting. He lived at the bottom of the hill that Nicola lived on top of, and their windows were visible to each other. They were in constant communication by these peculiar means."[12] Guests, according to Nicola, never stayed with Cy but with him. Twombly, he said, was "anguished by the flood of people and his only desire was to paint before he could not anymore because he was getting old."[13]

(Caracciolo ends her 2004 profile of Nicola with this little gem from Twombly about the differences between their two houses: "'Nicola sees it from above,' [Cy] says with a touch of humorous competitiveness, 'but I have the sea in every window.'" Vistas or immersion—isn't that so often our choice in life and art?)

From the terraced garden of trees above his house or the small studio upstairs, Twombly had, writes Del Roscio, "unlimited opportunities for observing the ever-changing colors and movements of waves, presumably for pleasurable immersion."[14] That final clause—"presumably for pleasurable immersion"—like an undertow, insists too strongly on

the pleasure of going under and not the violent, tragic ends that obsessed Twombly his whole life.

It was during this time, the mid-1980s, writes Nicola, that "the heaviness of life's domestic and daily routine made his anguish come out in an unsafe way."[15] The nature of that "unsafe way" is unnamed. We're left to guess what he means. What recklessness, what risks, what harm Twombly attempted. We have only the paintings to go by. Read in that immersion—the drowned lovers, the green pools, the bits of the world "broken off from the sky"—not pleasure but loss. Not joy but terror. The view of these watery paintings is from within that fray of waves. "On balance, his art seems to me more of a fall than a rise," writes Richard Shiff, "it induces melancholy . . . The Green Paintings, especially, seem to fall—they sink."[16]

"During that period," Nicola writes, "Cy often felt trapped between a fear of death, concern over losing his creativity, worries about the possible physical destruction of his works (which were all stored in one place) in case of fire or water."[17] These recollections, from his essay "Crossing a State of Crisis (And Other Hidden Things)," are his most emotionally honest and personal writing about Cy, a picture of struggle and unhappiness. A portrait of the artist in distress. Transience and fleetingness, for so long one of his subjects, mattered now in a deeply personal way: the mortality of his body, the mortality of his art. No one said this life would be easy.

❚

A style changes because a life changes. We know this. Life and art lashed together like two boats.

In his despair he drew the colors from his own heart, Twombly writes as a pendant to the painting *Analysis of the Rose as Sentimental Despair* (set of five) 1985. In the double meaning of "drew"—the making and the pulling out—it is as if Twombly offers a guarded ars poetica, not only about his feelings, but also his style. The works of this time do indeed draw out new color—pinks and whites, greens and browns.

His intense anxiety about different kinds of deaths, a black cloud

over his days, is transformed into color. His canvases from this time brighten and burn. Twombly is no longer the "anti-colorist" that Barthes describes; "TW does not paint color; at most, one might say that he colors in; this coloring-in is rare, interrupted, and always instantaneous, as if one were trying out the crayon."[18] No longer is this true. What is true is the bliss.

The multiple versions of *Hero and Leandro*, the several *Wilder Shores of Love*, and of course the group of Green Paintings, all done in the mid-1980s, share a sensibility. The paintings evoke water, and drowning, a shifting perspective, sometimes above and sometimes below, from the shore and within the tumult of the water. These works fill the frame, a sweep of color that resembles the surface of water as a wind might blow across it. Ripples and swirls, a vortex of paint, a wonder.

One recognizes them as much by what's absent: the pencil lines like shrapnel, the anxious mark-making, the random numbers, the loops like chalk. Lines from poems stick around, as do the titles that draw from myths, but to stand in front of these paintings is to feel a different kind of free and easy hand. One senses the emotions—desire and longing and nostalgia—in the flow of paint, what one critic describes as "cascading brushwork."[19]

During this time, the mid-1980s, Twombly doesn't stop moving. Wintering by warm water, Key West, or in other years Jupiter Island or the Seychelles or St. Barts, he, like a well-heeled retiree, made work at uneven intervals, bursts of action and then nothing. As fellow artist Francesco Clemente imagines it, "Twombly wakes up in the morning and looks out the window, takes a nap . . . It is a work that only happens in extraordinary moments."[20]

"I work in waves, because I'm impatient," Twombly said.[21] Speed up and slow down. Hurry and wait. The rich and sensual works, hand-painted or quick strokes in acrylic paint arrive in bursts of energy. One wave. The sense of a period style, the working through of ideas or forms: another wave. The torment too, death worried and success worried, coming and going in waves. I think of Keats's grave epitaph, another kind of fleetingness and work that might, at any moment, vanish: *Here lies one whose name was writ in water.*

A storm of white sweeps over the surface of the canvas in the first painting of the sequence, *Hero and Leandro (A Painting in Four Parts)* 1984. The colors, as if pushed by something strong and willful to the edge, are more violent: blacks and greens swishing about in the bathwater. The name *leandro*, lowercase and cursive, like the smallness of a human body in this tumult.[22]

Parts II and III of *Hero and Leandro* are a kind of afterlife. White luminance. Like a blizzard of snow. White of shadows and depth. I think of Rauschenberg's white paintings, first done with Twombly's help on the stairs of Black Mountain's South Lodge, those "airports for the lights, shadows, and particles."[23] Twombly's Hero and Leander paintings, from that first smear and slip, to these ghosted negatives, seem to say that death is long and luscious and beautiful. The pain of the body can be swept up in the tides of wind and water, in streaks of whites and carmine, and turned into something transcendent.

To see Twombly's painterly effects, the "numerous washes" as Katharina Schmidt describes them, is to see just how carefully feeling is being managed. "[T]he paint," she writes, "gently flows from right to left contrary to the direction of reading, like water upon which the gaze rests. There is no horizon. Highlights shimmer, soft and white, on a sun-drenched surface, lending the paint, applied in broad washes, transparency and movement."[24] In Twombly's vision, the white of these works is all about the absence of a body.

Of *Hero and Leandro (To Christopher Marlowe)* 1985, a stand-alone work done the following year but part of the same conversation, Mary Jacobus writes, "The ambiguity of *Hero and Leandro* consists in the subject of its elegy, who or what is all washed up in the pallor of these washed out seas?"[25] Not just a beautiful painting of doomed lovers, but an elegy for something lost in this "fatal undertow." I can't answer that question any more than the critic can. Hero is lost. Leander is lost. Or maybe it's the wrong question. Rather than ask what is lost, perhaps the better question is what endures after this progression, away from life or shore. Bright cinnamon and a languorous blue. The deep green at the

place where the shore meets the break. Not the green of bright nature but something more feral, fecund.

In that fourth part of *Hero and Leandro (A Painting in Four Parts)*, a drawing on paper, the borrowed final lines of Keats's "On a Picture of Leander":

He's gone,
up bubbles
all his amorous breath

As the body sinks, breath breaks the surface, "amorous" and lingering. The breath that rises is momentary, the bubbles breaking the surface will disappear. The breath will stop. The lovers die again and again. What lasts is language. Not the image or the pale sweep of white, not a painting, but a poem. This is the afterlife. Handwriting, borrowed words, a disappearance. Not a shout for help but a bubble of breath.

▌

"I need to talk to her," Joan Didion's young daughter said after seeing Georgia O'Keeffe's *Sky Above Clouds* at the Art Institute of Chicago.

"My daughter was making, that day in Chicago, an entirely unconscious but quite basic assumption about people and the work they do. She was assuming that the glory she saw in the work reflected a glory in its maker, that the painting was the painter as the poem is the poet, that every choice one made alone—every word chosen or rejected, every brush stroke laid or not laid down—betrayed one's character. Style is character."[26]

I understand all too well this "quite basic assumption." Looking at the pictures from this time, their impasto layers, their gestures, I feel Twombly's presence in the emotional sweep and gestures. *A Wilder Shore of Love*, I read scrawled into the wet paint by the end of brush, and think of the friction of desires: Twombly's, mine, everybody's. And yet, to read Twombly's inner life, his personality or self or whatever you want to call that thing that made him who he was, in this or any painting is a forever tricky task.

"[H]e maintained a wonderful balance between the sublime and the ridiculous," Sally Mann said of her friend, "he always played those two things against each other, at least in his personal life. Maybe less in his art . . . He is such a revered figure with all these references in his art, but that's only part of the story. He was also funny and irreverent and a little bawdy, and he always had a sparkle in his eye. I wanted that to come through."[27]

I've stood before so many of his paintings, in admiration and wonder, but also waiting for that man, that glint in the eye or his coy, half-cocked smile or that gesture—hand lifted up to his mouth when he said something raucous or gossipy—to appear. To be visible, at last.

In the *Artists Documentation Program* video of Cy and Mancusi-Ungaro and Nicola, they pause in front of the Green Paintings. After some initial confusion—by Cy's account the paintings were done in one day, or a day and a half, or just the first one was done that quickly—he said, "And they're all done by hand."[28] If you look closely one can see the whitewash, the drips of which stream down over the layers like tributaries. It is both an observation and a correction, not just the hands but brush and rag.

He repeated that phrase, "Hand painted," to which Nicola responded "Hand cleaned."

"Hand painted," said Mancusi-Ungaro.

"Hand played," said Twombly.

"Hand played," said Mancusi-Ungaro.

It reads like a bit of Beckett, the back and forth dance of language, playful and ironic. It's almost, and never, enough.

I need to talk to her. But we can't. And so we keep looking. We invent. We remember. We look again.

EPITAPH

A YEAR AFTER ANDY WARHOL died everything stuffed into the late pack rat's New York City townhouse was sold. At Sotheby's, in the spring of 1988, a ten-day spectacle of 10,000 lots, the auction included everything from Warhol's 1974 Rolls-Royce Silver Shadow to his contemporary art collection to his almost two hundred ceramic cookie jars. On the night of May 2, 1988, a painting owned by Warhol, Twombly's *Untitled* 1967, loops of white in five uneven rows on gray ground, "wobbling hopelessly from margin to margin," came up for auction.[1]

Twombly's painting "got knocked down for just under $1 million that evening," remembers Arthur Danto; "it was the star of the auction and, as happens at those events, there was a round of applause when

the gavel fell."[2] No one in the art world, claims Danto, would've blinked at that almost million dollar price; while anyone outside of the art world would be incredulous that that amount was paid for what seemed meaningless white doodles over a dirty gray surface.

Untitled 1967, however, was not the only Twombly work sold that night at Sotheby's. Immediately following the auction for Warhol's collection, another set of paintings and drawings went up for auction to benefit the Supportive Care Program of St. Vincent's Hospital and Medical Center of New York.

"We are still helpless against AIDS," writes Thomas Ammann in the introduction to the catalogue, "but there are steps we can take to organize the fight against unnecessary pain and suffering. This auction is an example of such an organized step taken by artists, art dealers, and individuals."[3] The proceeds from that night benefited a program "to promote and achieve comfort—physical, spiritual, emotional." That was the limit of care then, not healing but comfort.

Twombly's drawing/collage, *Untitled (To Leopardi)* 1988, was among the dozen or so other works donated, alongside pieces by Julian Schnabel and Cindy Sherman and David Salle to benefit the patients, mostly gay men, dying of the virus, as everyone did in those days. Twombly's inclusion in that auction perhaps says more about his friendship (and business partnership) with Ammann than his commitment to the cause. Ammann, the Swiss dealer and collector, the "closest thing the art world has to a prince," an early supporter of the fight against AIDS, would himself die from complications from the virus.[4] Though Twombly offered his work, he was publicly silent.

As always, Twombly kept his distance.

<div style="text-align:center">▍</div>

Looking at *Untitled (To Leopardi)* 1988, the drawing/collage donated by Twombly to that AIDS benefit auction, I try to find some overlap, some coincidence between the event and the picture.

Over three feet by four feet, rows of circling rings six or seven across fill the bottom sheet of the drawing. A bright, blood red, the circles are not the open loops of the blackboard paintings, but more like

blood cells, free floating and isolated. A top sheet, taped in the center, hides the circles beneath. A familiar phrase in Twombly's work, written by hand: *In his despair he drew the colors from his own heart*—a line from Leopardi's *Zibaldone di pensieri*. There's a burst of red paint, a smear really, and below it, a black figure with four radiating arms, sort of like the blades of a windmill. My first thought is warning. It's not exactly the symbol for nuclear radiation, but there's something ominous and foreboding about that little wheel, like nothing else I've seen in Twombly's work. A sign of danger.

Unlike the skull and crossbones in Jasper Johns's watercolor and ink or Peter Halley's *Red Cell With Conduit*, both up for auction that night, there's nothing explicitly about AIDS in this drawing. Context, though, matters. It's there, among other works that name death in no uncertain terms. It's there among these first-generation responses to AIDS, works that say: "Here was a life, this life is missed; here are its mourners."[5]

In those cell-like circles, I can't help but think of the necessary and endless counting of white blood cells by those with HIV/AIDS—a counting made impossible by the fact that the top sheet is layered and taped over the bottom one. "One of the striking things about much AIDS art," writes Jonathan Katz, "is that it frequently appeals to our physicality, our own bodies."[6] There is a physicality in these repeating but contained circles, reminiscent of another work of loss—Nini's Paintings.

The body is often in danger in Twombly's art, at risk of disappearing. In the phrase Twombly has written on the collage up for auction—*In his despair he drew the colors from his own heart*—the heart, metaphorical to be sure, a phrase of loss and trouble, still names the body, a body in pain.

▌

In the early to mid 1980s, when there was no test—and even later when there was—sex was consequence. Desire was consequence. *Eros bringer of pain*, as he writes on another canvas, a line from Sappho. Twombly returns again and again to the gift and curse and consequence of desire: Hero and Leander drowning, Achilles mourning Patroclus, Narcissus rejecting Echo, Orpheus and Eurydice lost to each other.

"Each image," writes Wayne Koestenbaum of Andy Warhol, "while hoping to repel death, engineers its erotic arrival."[7] The same could be said of Twombly; in his work there's always a connection between sex and death, violence and desire, loss and repetition. The myths and stories Twombly loved are of individuals, pairs of lovers in which one or both dies.[8]

But Twombly's art from the early 1980s to the early '90s does more than think about his own mortality, or that of individuals. The sculpture *Thermopylae* 1992, a little plaster mountain, recalls in name and shape the narrow mountain pass where the Greek army of several thousand soldiers was slaughtered by Xerxes' Persian army. A mass grave, the deaths are statistics, numbers that exceed us, and our imagination. The sculpture's domed mound, an inverted wicker basket submerged in plaster, is a model of the place, a little white mountain. Five plastic flowers, painted white, rise up like soldiers or grave markers. From one point of view, the flowers are new life coming up from the heaped bodies of the buried dead. From another they are markers of mourning, the flowers left by the living. But these flowers too are dead things. Fake flowers that will never grow, never wilt.

The first lines of Cavafy's poem "Thermopylae," handwritten on the sculpture's side, seem to praise the heroic acts of the dead, those obedient nameless soldiers. *Honor to those who in their lives are committed and guard their Thermopylae.* The place, gravesite and landmark, is now "theirs." "Slowly but surely," writes one critic, "this ungainly blob of a sculpture becomes the most elegant and suggestive memorial to ephebes lost in noble battle."[9] Twombly's sculpture finds virtue in their deaths, praise for valor and courage in the face of death.

"Witty and funereal," is how Frank O'Hara characterized Twombly's early sculptures, and that grave humor continued. One critic describes *Epitaph* 1992, a white sculpture done at Jupiter Island, Florida, as a "reliquary gift box that cannot entirely contain its archaic dead."[10] In *Epitaph*, a white plaque, tilted at a 45-degree angle, is raised up by bulbous overflows of white plaster, like the dead rising from their graves.[11] On the surface of the plaque Twombly has inscribed that grim little Archilochus poem: "In the hospitality of war / We left them their dead / As a gift / to remember / us by." As with all of Twombly's "white originals," there's

something intentionally unpolished about the piece—slapdash edges, drip marks of white paint, uneven plaster, rough surfaces—that suggests an object corrupted and unfinished.[12]

This work is marker and memorial, though the dead are perhaps not as "archaic" as the critic suggests. The words of the poem are spoken by an opposing army, or perhaps, a plague. A plague, like war, takes the bodies of the young and healthy. A violence erases their names.

<p style="text-align:center">▌</p>

"No other artist," writes Harald Szeemann, "has such a gift for open-endedness. Numbers become dates, words becomes lines expressive of feeling, lines become tones, tones become tensions, white becomes resolution."[13] Images become other images, narratives become other narratives. Open-endedness makes possible a reading of his work as engaged in a conversation and community that he never claimed. At least not publicly. And so it feels like another moment when open-endedness, like coincidence, leads not to insight but trouble.

Edmund de Waal in a short essay on Twombly describes one of the artist's photos: "His photographs of bouquets of flowers left on a grave, Polaroid lilies and roses, are a particular moment of privacy staged in public. The flowers, which stretch from one plot to another, poignant in their extravagance, become a kind of testimony."[14] The grief in the photos is not his, a display of flowers left by strangers.

This is the tension, between the artist's own mortality—as Nicola claimed of this time, "Cy often felt trapped between a fear of death"—and that of those around him.[15] The tension between the losses that are "staged in public" and the personal ones, inward and hidden.

In an interview, Twombly digresses from a question about mark-making to describe his friend and dealer, a gallery owner in Naples, Lucio Amelio: "*Lepanto* is full of boats. It's all about boats. I always loved boats. That was done when Lucio Amelio was dying. I had all this gloomy text. I had no clue where it was from but it's beautiful."

There's some mixing up of dates and works—*Lepanto* was finished in 2001 and Lucio Amelio died from complications of AIDS in 1994—but in *Untitled* 1993, Twombly has written *To Lucio* on the bow of

a crude boat, a funeral ship, "an inconspicuous dedication."[16] It is a private marker of grief, a way of remembering—and years after, becomes by omission of the words HIV or AIDS in the interview, a forgetting and erasure.

Many of Twombly's "white originals," including *Thermopylae*, were cast in bronze. Primarily done by his close friend Gabrielle Stocchi at a foundry in Rome, the bronzing, besides creating durable multiples that could be sold, no small thing, made these sculptures even more monumental, more official, more public. The bronzes of *Thermopylae*, hard and unforgiving as armor, like a "fifth-century BC battle helmet" or that statue of Stonewall Jackson looking over the graveyard of Lexington.[17] Or think instead of that bronze bas-relief of Colonel Shaw and the Massachusetts 54th Regiment in Lowell's poem: "Their monument sticks like a fishbone / in the city's throat." We are asked to look at what we would prefer to forget.

Twombly is not a political artist, not by natural inclination.[18] The artist's instincts are more personal, more private. And yet, violence, and violence to the body, is everywhere in Twombly's work. From the sexual violence in the myth of *Leda and the Swan* to the violence of war in *The Vengeance of Achilles*; from *Rape of the Sabines* to those white monuments of loss: *Untitled (In Memory of Babur)*, *Thermopylae*, *Epitaph*, *Untitled ("In Memory of Alvaro de Campos")*.

Critics, with limited luck, have tried to argue for Twombly's political or social engagement, to see the Kennedy assassination in *Nine Discourses on Commodus* or the rage of Vietnam in *Fifty Days at Iliam*—or, later, the misadventures of war and empire in the Middle East by the United States in the bloody drips of his Bacchus Paintings. By one argument, for example, *Fifty Days*, is an indictment of war, specifically the Vietnam war raging when Twombly made the pantings: "Twombly has orchestrated an explosion and indictment of aggression, revealing war as the strange fruit of a visceral and nihilistic urge."[19] To see this is to read with irony those haunting clouds of blue and gray and those names of the dead heroes. This is the risk and possibility of Twombly's histor-

ical imagination: the past is always present, overlapping and repeating and continuous: "Did you know that the Alamo in San Antonio is sometimes known as the Thermopylae of America?" Twombly once wrote to Paul Winkler, "I imagine you never considered Leonidas and William Travis, James Bowie and Davy Crockett as comrades in arms."[20]

The French director François Truffaut allegedly said, "There's no such thing as an anti-war film."[21] Even though a film or painting might remind one of the brutality of war, violence and loss, it can't help but glorify victory or celebrate the camaraderie of soldiers. And this is the dilemma. Is Twombly's obsession with narratives of violence a caution? Is it ironic? Is it praise for the hero? Or, worse, is it only about himself? "In painting," he said, "you're always painting yourself."[22]

"From one angle war is a repetition of the past," the scholar Simon Goldhill said in a lecture on Twombly and Warhol, "and a terrible exercise of desire, a compulsion to live out inherited models and stereotypes. War's repetitions, war's violences reduce human beings to unnamed masses . . . But while the act of naming, of individualization, is a counteract to the namelessness of repetition or the silence of the mass victim, it is also an act of complicity. The hero's narrative also functions to keep cannon fodder as fodder."[23]

In so many of Twombly's works, the hero's narrative is inscribed and re-inscribed—Achilles' name, Babur's name, Apollo's name, Archilochus' name, Twombly's name. In *Epitaph*, the only two names that appear are the poet's name and Twombly's. The "hazard" of Twombly's art, explains Goldhill, "is scrawling a name across a canvas will work. The sick joke is that it's Achilles' name again."

▌

"Art since the mid-1980s might not always be about HIV," writes curator Rock Hushka, "but in its history and enormity it is rarely not about HIV either."[24]

I doubt Twombly would've thought of himself as a survivor. And yet, he lived in the shadow of AIDS, its dark possibility, not just for himself but for all those around him.

Twombly lived apart. His Gaeta house, "several small houses that

have grown together . . . like a castle," was guarded from the world by height and distance. Visiting Twombly there, a German reporter wrote, "[T]he house was not a house but a wall without windows, with a narrow gray metal door, rather an input slot. We rang, and nothing happened."[25] Very few were allowed past the "gray steel door embedded in a rough stone wall" to see the little Eden he tried to create: a terraced garden, what he called his *stanze segrete*, 'secret rooms,' each defined by a different tree—lindens, lemon trees, square-and-cone-shaped laurels, orange trees—with hedges of olive and laurel."[26] This is not metaphor. This is all metaphor.

Here, and in the other hilltop houses, Bassano or Porto Ercole, where he spent most of his days, Twombly lived outside the epicenters of the AIDS crisis, the distance of safety, and the distance of narrative: this is not my community, he could've said.

"I no longer think of AIDS as a solvent," writes Mark Doty in his memoir *Heaven's Coast*, a book about the loss of his beloved to the disease, "but perhaps rather as a kind of intensifier, something which makes things more firmly, deeply themselves. Is this true of all terminal illness, that it intensifies the degree of what already is?"[27]

In the case of Twombly it is distance, emotional and physical, that is intensified. Betty tells a story about Perry Bentley, a photographer and art collector from Dallas, Texas. Bentley, attractive and talented and rich, became friends with Cy in the 1980s, introduced to the artist by Betty and her son Tristano. A collector of Cy's work and an influence on his photography, Bentley spent time with Cy in Rome, corresponding often by letter and postcard.[28] One day in 1985, Cy was at Betty's house and Perry, very sick, dying from complications from AIDS, called her from the United States. When Twombly realized who was on the phone, he made the gestures of "I'm not here, I don't want to talk." Betty handed him the phone and made him speak.

At the same time, it was a death that deeply shook him. Bentley was one of the first people the artist knew to die from the virus. Even if he wanted to remain apart, he couldn't. Not really. To be a part of the art world, even at some distance, was to be personally and professionally affected. "[E]veryone with any sensitivity at all," writes David Salle, "was deeply, guiltily disturbed by the seeming inability to do anything

about AIDS."[29] So many in the art world—artists, curators, patrons—would die from complications from AIDS—or be left behind. So many of the men whose names fill this book, and Twombly's life.

I think of David Seidner, a well-known fashion photographer, capturing the studios of artists. Seidner, who lived with the virus for fifteen years before his death in 1999, went to Lexington to photograph Twombly, a now iconic image: the artist in his warehouse studio, a temporary space in which to finish what he thought would be his last great work. That painting, finally finished after more than twenty years, is installed permanently in the Cy Twombly Gallery at the Menil Collection in Houston.

THE MENIL

WHAT I FIRST LOVED ABOUT the Cy Twombly Gallery at the Menil Collection in Houston wasn't the art but the cold. I moved through the gallery rooms suspended in the blast of air-conditioning, its cool, chemical teeth, and the electric hush as thousands of watts powered small invisible fans.

Some days, I was there to lead tours of students through the galleries. Other days I went for the bone-white cold. I stopped by for no other reason than to be submerged in its ice bath, a break from humidity and sunlight. To walk in those white rooms, like the inside of a freezer or the vision of heaven as promised to children, offered escape. In summer, when the temperatures broke 100 degrees Fahrenheit, this

was the coldest free place in the city that wasn't a shopping mall. I went to be still. I went to be alone.

This was my starting point. The beginning I didn't know was a beginning. Before Rome. Before Porto Ercole. Before Bassano and Gaeta and Lexington. Before I knew Twombly's work and life forwards and backwards, an encyclopedia of one, there were these rooms in which I dreamed.

Twombly remarked that if it was too hot, he would paint to cool down.[1] As if his paints could reverse the temperature of the air. The best description of color I know.

▌

The story of the Cy Twombly Gallery begins with an unanswered letter: To Twombly in Rome, curator Paul Winkler sent an invitation for the artist to be part of the Menil Collection's 1987 inauguration. He received no reply.

Months later, without warning, Twombly called Winkler and asked if he was still interested in a show. Winkler, along with Walter Hopps, the director of the museum, traveled to Rome where they met with Twombly and worked with the artist to select pieces for an exhibition. Though Twombly didn't attend the opening, in September 1989, his friends who went brought back enthusiastic reviews of the installation and the new museum.

Shortly after that successful first Twombly show, Winkler sent the artist a letter about the possibility of a new permanent space with works by John Chamberlain and Dan Flavin in adjoining rooms. It was similar to the idea proposed by the Dia Foundation for a permanent space in New York City, a vision abandoned when the financial markets tumbled in the early 1980s.

Twombly wrote back the next week, the speed of his reply a stark contrast to the silence after Winkler's first request. "Naturally I would be terribly interested that the 'holdings' find a 'permanent' place," Twombly wrote to Winkler, "as they have been in storage for at least 10 years except for a few moments."[2]

It's hard not to think of Twombly's letter to Castelli a decade ear-

lier, lament and critique, the artist's claim of the first real attempt to do anything about his work in the United States. This new chance at the permanent collection that had eluded him years before.

▮

In the late summer of 2012, more than five years since I lived in Houston and taught at the Menil, I returned. The sky was washed-out peach and pink, ribbons of chemical light reflected on the cars lurching slowly forward on I-45. A clichéd entrance to the city. I wished it was raining or snowing, something less expected, less predictable than this familiar collision of glimmering cars and tinted sky. The nature of the city is the nature of the city. I felt the familiar rush of nostalgia and anxiety, a return to a city of ghosts and lost loves.

The fantasy of the archive is the secret hope that one might find the lost document that rewrites history: the unpublished novel in the bottom of a drawer, the reclusive poet's letters to her lover, the play never produced, the opera unsung. I wanted to find an answer to an unknown question. Or maybe, I was just there to see the shape of his handwriting.

The next morning, the head archivist, Geri, an older woman, her small face dominated by eyeglasses wide as ripe grapefruits, met me in the back atrium of the Menil. A Warhol portrait of the museum's founder, Dominique de Menil, florid and playful, hung behind her.

Geri led me down several flights of stairs into a lower basement, storage for rolled canvases, works leaving or returning, as well as the museum's archive. It was a section of the Menil I'd never seen before, not part of any tour. I felt like a conspirator, a secret knowledge of this underworld unknown to the visitors who strolled the galleries above.

"Everything you might need is here for you," she said when we arrived through the maze at a small metal desk with boxes of files, each neatly ordered and labeled. I hoped she was right.

I thought of the writers who would come after me. How they'd sit at this same metal desk with its small reading light opening boxes and files. We all want the same thing, some abstract intimacy and connection, some claim against forgetting, against error. I was there to find something: a starting point, a way in, some deeper sense of the

works and the person who made them—not just the how or the when, but the *why*, the impossible *who*. I'm reminded of what James Baldwin wrote, "The purpose of art is to lay bare the questions hidden by the answers."[3]

I

Twombly's fingerprints dance along the top of *The Age of Alexander*. Accidental impression or purposeful signature, their swirl and singularity marks his presence. In the same way, his fingerprints are all over his eponymous gallery. To read Twombly's letters to Winkler during the construction, or Winkler's later recollections, is to see the artist's active involvement, from the basic floor plan to the thickness of the walls to the source of the concrete.

"I swear if I had to do this over again," Twombly said in 1994, "I would just do the paintings and never show them."[4]

No proof of that, especially in his pleasure in making an ideal space for his work to be seen. For Twombly, the Menil Collection offered a home, and a legacy. It offered a chance to be in control of how the works might be viewed, not in a big traveling retrospective, but every day, and over time. Works that had been in storage for decades, unshown loves, a lifetime—the Lexington Paintings of 1959, *The Age of Alexander*, the Green Paintings, the still unfinished big picture with its shifting title, sometimes *Anatomy of Melancholy* or *Mists of Idleness*—would now live and breathe together in a single space.

"It will be as ideal & I would say as perfect in every way that one could wish for," Twombly wrote to Paul Winkler during the planning stages for the building.[5]

A fine mind for architecture and space—"a good building only needs a good engineer," he wrote, "and an understanding of simple space"— the building owes a debt to Italy, to Twombly's days of walking through sites and palaces of Rome.[6] Classical proportions and influences, from the double cube to the diffused quality of the light to the visible thickness of the walls, Twombly understood too the architecture of motion, the body as it walks again and again through the same rooms.

Inside and outside the structure, Twombly wanted to control the

details, or at least have some input. In one of my favorite letters, Twombly sketched the hedges he envisioned at the edge of the new gallery for his work, swirls of black ink for the green shrubbery. "I'm sure in Houston," he wrote to Winkler, "they have good thick kinds of plants for doing tall hedges which is softer for a division not that sense of barring off the back side etc."[7] Above his little loops of hedgerows, his command above: "kept clipped."

Over the course of the construction, Twombly came to Houston twice, working with Winkler on the design and construction and materials, but also the careful selection of what would fill the nine rooms of the building, and how it would be displayed. All these details, some visible and some invisible, add up to something that's hard to explain. This strange alchemical process to create a space of experience, the sum of choices more incandescent than its parts. In a book of fifty poems, as Robert Frost once supposedly said, the fifty-first poem is the book.

▌

I felt a surge of recognition at seeing Twombly's handwriting for the first time. Not like the writing in the paintings, not exactly: more hurried, less controlled, yet often more readable. In a letter from Twombly to Winkler, written on graph paper, the cursive letters were a tight, small script, tied anxiously to line. In other letters, on blank white paper, the script opened up, a widening spell. Sometimes only four or five words appear on a line, each stretched out like a cat in sunlight: wide loops of his cursive *l*s and the open eyes of his lowercase *a* and *d* and *o*.

In all the letters Twombly writes like a man who couldn't get the words down fast enough, they fumble out, slanting to the right. For passages I couldn't decipher, a mysterious word or phrase, a series of buttonholes and dashes, I put a piece of paper over the paper and traced his letters. His words and mine, collapsed and separate.

In a 1989 letter about his first show at the Menil Collection in Houston, Twombly wrote that despite keeping away from interviews, Winkler can still send a few interesting questions and, "if I have a flash of verbal intrigue I would put down a few words, just don't turn me off with When or Why types."[8]

His voice is cranky and resistant. In a magazine profile of the artist a little more than a decade before his death Twombly was asked about a work-in-progress: "It's not Four Seasons," he corrected the writer, "That sounds like the Four Seasons Hotel. I think of them as Quattro Stagioni. Summer isn't finished yet, as I told you, and that's all I'm going to say about that. It's absurd to talk about paintings that you haven't finished."[9] The impatience in his reply—"as I told you"—a scolding correction for the name of the work and refusal to discuss it reveals Twombly's difficulty as much as his certainty.

In that same letter to Winkler, Twombly wrote of being very happy with the show, drawings of *Poems to the Sea* stretched across the walls like waves, "It seems so natural and complete in its own way."[10]

There would be no interview.

"I spill my guts out on the paintings and then they want me to say something about them," he reportedly told Winkler.[11]

His fear is in a way understandable. He committed so little of himself to paper, in writing or interview, that each scrap is examined and twisted, measured and prodded like a panther in a cage. By critics and scholars. By those who want his work to be one thing or another. I am no exception.

Ironic for an artist so in love with words: this refusal to commit ideas to paper. In his vast knowledge and admiration of writers he understood, maybe all too well, the power of poetic phrases, that "flash of verbal intrigue." Seeing his own editing of poems, the way lines might be altered or erased, perhaps he knew how words can be borrowed and remade, first in memory, and then in the hands.[12]

"Dear Friend," writes Claude Monet to G. Geffory, "Alas No, I cannot accompany you. You cannot imagine how hard I am working, even though I have no more strength, I will need another ten or twelve days of work, after which I will pack it in."[13]

Twombly owned the handwritten original of this letter sent in March of 1893, words in a language he couldn't read, possessed for the pleasure of the object, ink on paper, a talisman of the artist. Illegible writing, even if unreadable, offers joy, and evidence of the life that made the work. Twombly trusted this, perhaps above all else. Monet's letter is a refusal of obligations, a rescheduling of dinner with the journalist

and art critic (and later biographer) Gustave Geffory. He needs to keep working; *Travail*, the clearest word in the letter. There is no end point to our work, we always want a few more days, and a few more after that.

∎

"Museums are magical spaces, transformative places," writes the art historian Annabel Wharton. "They all transform into art the objects put inside of them. But some museums are more magical than others. The most powerful museums are those that not only change objects into art but also change observers into participants in the making of art's meanings."[14]

No one understood that more than Renzo Piano, the Italian architect who designed the Menil Collection's main building. His design for the Cy Twombly Gallery (sometimes called the Cy Twombly Pavilion) transforms those who enter it. "A butterfly alighting on a firm surface," is how Piano described his work on the Twombly Gallery, a contrast between the almost weightless light within and the heaviness of the stone block building.[15] The creation of space is about control—the balance of different elements and sensations, the acute understanding of rooms and how people move together and alone—but also about mystery. There is no formula for the creation of wonder.

A building, unlike a painting or poem, is a collaborative venture. The vision for the Twombly Gallery wasn't Twombly's alone. Heiner Friedrich, one of the directors of Dia, the son-in-law of Dominique de Menil, and the gallery owner who first showed *Fifty Days at Iliam* at his New York City gallery, suggested adding three rooms to the back of the building, increasing the number of galleries.

The initial "conceptual ideas and preferences" of the artist for the space were brought to Piano, who was excited about the chance to respond to his earlier structure. In one "brilliant stroke" Piano reoriented the building so the entrance didn't face the street. Instead one has to follow a small path, off the main sidewalk past a small green space with an enormous oak. When you enter, it feels like a secret. When you leave, the first thing you see is a tree.

Piano also came up with one of the building's most remarkable

features: the lighting system. Just as in the rest of the Menil, all the light comes from natural illumination, mostly overhead. There are no windows in the Twombly Gallery, instead, light passes through a set of filtering planes on the ceiling so that only a tiny fraction of the bright Houston sun comes in.

Above the museum, and invisible from below, layers of metal and glass and cloth translate the sky into a new kind of light. First, there are a "canopy of louvres, shading the slopping, hipped glass roof." Below that glass, another set of mechanical louvres that change a few times each day, mirroring the movement of the sun. And then, finally, a canvas ceiling, a taut sail, stretched and visible within the building, shade like those handprint leaves on the tree just outside the big glass doors. The diffused light, which allows shadows from outside to enter, a shifting mood of shade and brightness, also keeps the space cool and protects the art. These rooms, white and bright and dreamlike.

Once my brother sent me an email after seeing *Say Goodbye* for the first time at the Menil. Standing in front of the painting, he heard a plane fly overhead, a shadow cast through the sailcloth skylights onto the wood floor and then, he wrote, "the jet disappeared into the painting."

More than Twombly or Winkler or even Piano, though, it is Dominique de Menil whose presence one feels in the rooms of the museum. For nothing happened in those years without her approval and consent, her vision. De Menil gave the Dia Foundation 5 million dollars in exchange for its donating six works in its holdings to the Twombly Gallery. Beyond her financial impact, it is her vision that informs the space. It was Dominque, after all, who approached Renzo Piano about designing and constructing the space.

Socially progressive and deeply religious, Dominique de Menil and her husband, John, French exiles who made Houston their home, collected the pieces of their vast art collection one by one, with attentive care and a wild, independent aesthetic. As the artist Roberto Matta noted, collecting for the de Menils was "a way to know oneself, like a

mirror, a way of seeing oneself."[16] With a fortune from the oil business, and a good eye, they bought what they loved, and it shows. An ethos of accessibility and openness informed their lives, first at the University of St. Thomas in Houston and later at the Menil Collection. In the forward to a 1968 catalogue, Dominique de Menil wrote:

> "When you love a painting you want to touch it," once wrote Marie-Alain Couturier . . . He believed a work of art needs intimacy to be understood and loved. It is precisely this intimacy that a teaching collection provides. The student can look at a painting day after day; he can observe a sculpture from all angles, feel its weight, smell it, caress it. A work of art has invaded its territory and demands a response.[17]

Again and again she insisted on this engagement, this direct confrontation with the art. One cannot be passive. One must react. That ideology is clear in the aesthetic of the Menil Collection. Her aim, the "mutual interrogation" of viewer and work, was part of every aspect of the museum's construction and design, from the absence of long explanations on the walls to the almost silent air-conditioning system. An "economy of care," as one scholar describes it.[18] That same vision is part of the Cy Twombly Gallery, a space where, "poetry would be allowed to prevail over pedagogy."[19]

"The most important thing Dominique de Menil wanted was to work with light," Piano observed about the construction of the Menil Collection. "She wanted to feel the clouds coming and going. She used that expression."[20] And you can. The light shifts and the space moves. In the Twombly, too, one senses, the sky and the sun and the clouds, the outside atmosphere changing by degrees and in motion.

To read anything about Dominique—her political activism, her dedication to the arts, her reserved willfulness, her attention to detail— is to be in admiration of her. "She was a stubborn lady," writes Piano, "Everybody knows that, but she was actually the most stubborn lady I ever met in my life! She was tiny, skinny, physically light. Beautiful, beautiful. And she was light in the sense that she used to love to talk,

Cy and Dominique de Menil at the opening of the Cy Twombly Gallery, Houston, 1995, Photo: Camilla McGrath

to understand, to listen. Stubbornness is a great quality only on one condition: that you know how to listen to people. You are as stubborn as she was, but at the same time, you are permeable. You grab hold, and then you're still, and you think."[21]

"Cy's art is so personal that all we can have of it is what we bring to it," Winkler wrote in one of his notes, what seems to be a good coda for his own keen eye and ear.[22] It's also an uncanny echo of what Rauschenberg said about Twombly: "Cy's direction was always so personal that you could only discuss it after the fact."

Hunger, desire, worry, faith. These are what we bring with us. And

hope. That we might be changed, or suspended from our life, or woken from sleep, or offered a dream. "Art makes a miracle," Piano said in an interview, "I'm not talking about artists; I'm talking about art. When you are in front of a piece of art, it's about the untold; it's about something almost mysterious. There is something coming out, something that causes you to dream or think in a different way."[23]

Historian and archivist, secretary and gatekeeper, Dictaphone and critic, witness and pundit, Winkler's handwritten notes about Twombly, filed away in banker boxes, offer a portrait of the artist. His visits to Italy and conversations with Twombly range from the personal to the esoteric to the profound, and in these snapshots one hears not only Twombly's frustration with his reception over the years, but also a sense of what matters to his work.

"It is a plastic thing," Twombly told Winkler. "If intellectual at all, it is fluid, emotional intellect, not analytical. Critics tend to pick things from artists' work to fit a theory. That's not how art is made. The artist works from something more direct. It is a visual medium. We don't need literal interpretation of visual things. Enjoy it for visual, sensual reasons, not literal, interpretive reasons."[24] In this, and indeed all of his observations, Twombly insists on the emotional over the intellectual, the intuitive over the learned.

Even as Winkler offers a vision of the artist, his notes, too, capture the dream of Rome, all the unending, enduring possibilities: pilgrimages to the shrines of art in the city, including Twombly's home and studio at Via Monserrato. Winkler clearly enjoyed spending time with Twombly, and Twombly, by his (sort of) openness seemed to indicate that the feeling was mutual.

"Incursions into Cy's realm were always on his own terms," Winkler wrote in a 2013 essay. "He could be reserved but once his trust was gained, he was generous and open."[25]

This constant refrain: A guardedness that might, in time, soften. Twombly let Winkler in. I wouldn't say friendship, not at first, but collaboration—artist and curator—a mutually beneficial relationship for both men.

"Like all projects it has been a long haul," Francois de Menil wrote

to Winkler after the Cy Twombly Gallery opened in February 1995. "But it has been worth it. I am sure the experience has taken its 'pound of flesh' from you, but you can be proud of it."[26]

I identify with Winkler, not just for a project that takes its toll, but for how his connection to the artist also started with admiration. The story of the Twombly Gallery is one of luck and persistence, good timing and cooperation, a long shot at the start—not unlike the artist himself. Nothing about its construction seems inevitable. This much is true: without Winkler it wouldn't have happened.

How strange it was to be back in the Menil, like entering a scene in the movie of my life, all the sets unchanged, the extras out of place. My day done at the archive, I walked over to the Twombly Gallery, down the walkway, past the oak tree, and through those heavy glass doors.

I stood before one of the blackboard paintings and thought of what Brice Marden said about them, "In terms of the writing when I see these big blackboard paintings, it is like the oracle. You have the feeling that you just could keep looking at it, and the answer will make itself apparent. But the answer will be a word, not an image."[27]

No words came. Instead I remembered all of the times I stood before this picture with my back towards it, looking out to the glass doors and the oak tree, as I talked to students.

On Friday mornings buses arrived at the Menil and elementary and middle school students, often in matching primary-colored shirts, lined-up single file outside before entering. My job was to lead creative writing exercises based on the artwork; the paintings and sculpture were the imaginative springboard to their own poems and stories. The museum was closed to other visitors. This space, I'd tell my students, is ours: a private kingdom in which we alone are welcome. The students snaked behind me, carrying their clipboards against their chests, each child a small X of arm crossed over arm.

I'd pick three or four pieces in the museum for the students to write about. For elementary school students, I'd start with the Pacific Island masks or the room of Surrealist curiosities. For the older students, we'd

write about Warhol's haunting electric chairs in *Lavender Disaster* or Magritte's uncanny dreamscapes. But no matter our route through the museum, I always took the students to the Twombly Gallery.

The other writers and I had nicknames for the rooms in the Twombly: the Green Room, the Pink Room, Food Fight, Chalkboards, Goodbye. There was no name for the room with the five off-white canvases scarred by small penciled scribbles, never popular with the kids. Each of the rooms offered a study in palate and obsession, like with like, a sensation of immersion that turned the gallery into a world with its own rules of grammar and syntax.

I liked to take my students to the watery green canvases with the heavy paint of emerald and white, paintings made by the artist's hands and fingers. We'd sit on the floor and I would ask them what they saw. We'd talk about water and movement, how the paint resembled a swamp or forest closing in around us, canvases teeming with birdcalls and dangerous rapids. We're lost, I'd say and then we'd pretend for a while we were lost in the woods.

"Has anyone ever been lost in a forest? On the beach? Has anyone ever been separated from your family?" Always at least one story of a misadventure in a supermarket, their name voiced over a loudspeaker and their mother or father gathering them back into safety.

"What did it feel like?" I asked as we descended deeper into the woods.

Alone and scared, they'd say. Afraid and nervous, they'd say. And then we'd get into our canoes or put on our hiking shoes and walk along the water and through the woods before finally—after thinking of all the sounds and smells and sensations at the edge of our fingertips— begin writing a story.

29

SAY GOODBYE

THE STORY OF TWOMBLY'S *UNTITLED* *(Say Goodbye, Catullus, to the Shores of Asia Minor)* 1994 is one of persistence and ambition.

Started in 1972 and finished "all sort of one winter," it was a work he struggled with for over two decades. Twenty-two years is, depending on your perspective, an eternity or the slow and necessary fire in the life of ideas. A flash or a forever. Maybe it takes a lifetime to make a single work of art. It is, to my mind, his masterpiece.

For years, the unfinished piece hung on the walls of his Rome studio covering the wood-shuttered windows. "Well the painting went on," said Twombly, "and finally it was painted and, because I had to pass by it every day, I took it down. And then on that wall the original windows

were reopened so that there was no place ever to hang it."[1] To see him seeing it every day, the work waiting to be completed or abandoned, is to witness his patience as an artist, and his stubbornness.

Twombly's final campaign to complete the painting occurred in the winter of 1994, in a warehouse in Lexington, Virginia. The three panels of the painting, the size of a small airplane, demanded space to be unrolled and seen all at once. A culmination and a breakthrough, it is a show-off of his skills and talents as a painter of form and color, a work that engages the past and present, a work of ambition and scale, but also intimacy—personal as a prayer.

"It's a passage through everything," Twombly claimed about the painting that now lives permanently in the Cy Twombly Gallery at the Menil Collection.[2] He's right; a passage in space and time, a passage of motion from one side of the canvas to the other, a passage through and of texts, a passage from the rich colors, bright explosions of pinks and yellows, blues and reds to the crosshatch marks, like little boats, in the white abyss at the painting's far left.

To attempt a description of the enormous three panels of *Say Goodbye* is to fail. For even the most precise or lyric attempts to make the work speak confront the limits of language. It's always a wonder that language should come so close to meaning, only to fall short. As another poet, Jack Gilbert, writes, *"Love, we say, / God, we say, Rome and Michiko, we write, and the words / Get it wrong."*[3]

▌

"It was impossible to view the work . . . from very far back," Dorothea Rockburne wrote of seeing *Say Goodbye* on her lunch hour at the Wooster Street gallery when it was first publicly displayed. "In fact, the gallery had moved a wall to separate the street entrance from the exhibition, making the viewing space narrower than it normally was. Therefore, the only possible way to view the work was to begin at one end and walk alongside it. 'Hmm!' I thought. 'Cy has been studying the Giotto corridor in the church of Saint Francis in Assisi.'"[4]

I, too, have walked along the painting, as if it were a river. Of Giotto's corridor, Rockburne writes, "In order to experience the work, the

viewer must walk along and by it. If one is visually sensitive, this viewing position mysteriously causes one's body to function as part of the painting." One walks along the painting, and in a way, through it. This doesn't just happen.

In the Cy Twombly Gallery, where *Say Goodbye* is now permanently installed, one is overwhelmed, by its size at first, but then by how much there is to see. One chooses either intimacy and detail or scale and sweep. One must, as Rockburne puts it, be "visually sensitive." Or, in my case, I simply returned again and again. I sat on the wooden bench opposite the painting, I paced along the painting's edge, a border, a river, a church; I waited. I wanted to be changed.

When the woman took off her clothes and danced before the painting, twirling her body in the sunlight, the wood floor steady and smooth beneath her feet, the guard stepped in and gently said in accented English, "I can admire your beauty, madam, but if you don't put on your clothes, you'll be more famous than Cy Twombly himself." She left a note in the guestbook: *The painting makes me want to run naked.*[5]

A timeline, as best as I can puzzle it out: In the winter of 1992, Paul Winkler and Carol Mancusi-Ungaro came to Rome to see what works Twombly had in mind for the proposed Cy Twombly Gallery. Packed up and shipped to Houston with all the other paintings that had been anxiously stored in his Rome apartment, fire- and water-prone, the panels of *Say Goodbye* arrived at the Menil in the late summer of 1992.

"They need some more work and I can decide what to do sometime when I'm there," Twombly wrote in September of 1992 to Carol Mancusi-Ungaro, "(maybe I was premature in sending them, but with a few good days it might have been worthwhile)."[6]

Only in January 1994, though, would the painting be delivered back to Twombly in Lexington by "two couriers . . . in an ice storm."[7] For months I read any account I could find of the painting, but the ice storm and these two workers were never mentioned. Some questions lodge their barbed spikes in our minds. It mattered to me to know the story about these two couriers and the unlikely ice storm. Who were they?

What was their reaction to seeing the painting for the first time? Was it surprise at its size, or maybe they were unimpressed—overworked and underpaid; the painting offered them nothing for their travels? Or maybe the painting was already rolled when they arrived and so they never saw it?

A few good days—or, to be more accurate, a good space in which to see it all. "He didn't know how to finish it," remembered Julian Schnabel. "And then he unrolled the painting in another space that was bigger."[8] That space, a warehouse in the industrial part of Lexington, once occupied by a carpenter, the smell of pine and turpentine, and everywhere wood shavings and sawdust, is where it was finally completed.

From there it went on to New York City, shown from September 24, 1994 to January 7, 1995, in the Wooster Street gallery of Larry Gagosian, a satellite show to coincide with the MoMA retrospective organized by Kirk Varnedoe. Installed permanently at the Cy Twombly Gallery for the opening in February of 1995, it seems like fate that a painting about passages would be itself in motion.

Missing, though, from this list of places and dates and methods of transport is the story that, in the early 1990s, Twombly was told by his doctor in Italy that he didn't have long to live. The doctor's prognosis proved wrong. And yet, the fear of death gave the artist an urgency to finish *Say Goodbye*. I can't prove this. Not exactly. I have only the unconfirmed words of Twombly's Lexington friends to support this claim, and the artist's own stated fears that this painting would be his last, an urgency one feels in its presence. He couldn't have known at the time there would be other paintings. Other periods. Twombly's death, still far away, almost two decades. But the intensity of this work betrays this feeling. It was as if this one painting had to contain it all. A last will and testament. A passage to be remembered by. All the quotes copied down from books and saved. All the figures and forms part of his imagination and his previous styles. And it does.

▍

At the time of its completion, the very title of the painting was still in flux, as it had been for many years. When it was first shown in New York

City, it was simply *An Untitled Painting*. A work in search of a title, and in that searching a whole history unravels.

For a while he called it *Anatomy of Melancholy* after Robert Burton's 1621 "scientific" treatise: encyclopedic, strange, and vast; it's not a book to read as much as to explore, to dip in and out of its vast gathering of quotes and texts, a never-ending knot of thought and investigation into the "black bile" of our hearts and humors.

Later, he said, it was called *On the Mists of Idleness*, after Keats. "But actually I suspect that it's your own conflation of two different lines," David Sylvester pointed out in his interview with Twombly, "'Seasons of mists and mellow fruitfulness' and 'The blissful cloud of summer-indolence.'"[9]

Two lines folded into one, a familiar story.

Of the painting's eventual title, Twombly said, "I had already read Catullus, and the image came that is one of the really beautiful lines. I very much like Catullus and you can just visualize his brother by reading that line. You know the line: 'Say goodbye, Catullus, to the shores of Asia Minor.' It's so beautiful. Just all that part of the world I love. The sound of 'Asia Minor' is really like a rush to me, like a fantastic ideal."[10] What matters to the artist, more than sense, is sound: an individual vision of a "fantastic ideal."

That exact line doesn't exist in the body of Catullus' work. Twombly is thinking of Catullus' Poem 46 in which the poet tells himself,

Say good-bye, Catullus, to the plains of Asia Minor,
leave these spawning farmlands
and heat-sick Nicaea.
We shall sail, shall fly
to our fair Aegean cities.[11]

Though every translation of the poem is slightly different, in each version the poet leaves for home with a jittery anticipation at the prospect of return. In turning "plains" to "shore," Twombly remakes the line so that it is *his* own homecoming. The shores of Italy, Rome, or Gaeta become the points of departure, the places he has left, physically and metaphorically again and again.

Then again, Twombly first used that line decades before, in an untitled drawing from 1965 in New York City. *Say Goodbye Catullus to the PLAINS of ASiA MINOR*, the artist scribbled onto the drawing. A lifetime of leavings. The note in the catalogue of drawings offers this incorrect gloss: "The line is from a poem by Catullus written upon leaving Asia Minor after visiting the tomb of his brother." It's the same conflation of two poems, 46 and 101, the artist made in describing *Say Goodbye*. The essential story in this other poem—Catullus' Poem 101—is simple, human, and mournful. A man travels to see his brother in a strange land only to arrive and find his brother turned to ash.

In another version of completing *Say Goodbye*, Twombly zeroed in on the boats: "Catullus went to Asia Minor to see his brother, and while he was there his brother died, and he came back in this little boat."[12] At the core of the painting, then, or at least in Twombly's description and titling of it, is loss.

Catullus doesn't begin Poem 101 with his own grief but with his journey home. So many others, he writes, have followed this same route, this same watery landscape, this same pattern of life and death. The poet describes both his brother's death and his own failures, his own mortal body with its tears and rituals, his own travels, his goodbye. There is an elegiac quality in *Say Goodbye*, as in many of Twombly's later paintings, a sadness and nostalgia at the margins. How do we call back the lost world? How do we live after loss?[13]

Who cares if he mixed up the two poems? They're both poems of travel and return, albeit of very different moods. The imagination isn't interested in limit. And yet, to question one story unravels the neatness of a single narrative, a simple truth. Or maybe the better question is how much of these poems can we find in Twombly's painting? All of it. None of it. If Catullus' name weren't part of the title, or you'd never read the interview with the artist, one could spend a lifetime looking at the painting and never think of a dead Roman poet.

∎

In the archives of the Menil, on a document tucked into a file unopened since it was labeled, I found this note: "Panels shipped to Lexington

Virginia on January 7–8 1994. Jesse Lopez and David Warren delivered panels to Twombly."

I felt a rush of pleasure. For a brief moment I solved a puzzle.

One critic, on finding a scrap of paper in Twombly's handwriting, paint splattered, an obscure and previously unknown poetic passage inscribed on *Say Goodbye* writes that it "solves a crux at the heart of the painting's whitened seascape."[14] I don't agree, not exactly, that it resolves a "crux," or really that anything could "solve" Twombly's work. But I recognize her thrill, that sense of possibility to see some physical proof, note or memo, stolen out of time.

I quickly learned that Jesse Lopez died years ago and David Warren moved to North Carolina.

"Yes, we were delayed on the road due to winter weather," Warren wrote back to my email. "We wondered about the art being subject to sub-freezing temps, but were assured they would be fine by Mr. Twombly and Carol Mancusi-Ungaro."[15] I sent back my thanks. He wrote that he would keep thinking of other memories of the journey but it had been a long time.

To know the origin of a work is to be in dialogue with it. On the one hand, I understand there's no one fact, no key or singular detail, that could define the painting, its history or meanings. On the other, I thought, if I could trace its transit across the country, I might claim a knowing insight, an understanding about this particular painting, and, by extension about Twombly. I was grateful for their names, a vision of the two men at work in T-shirts, eight inches of snow covering the ground and the sky bright as they unloaded the art into Twombly's house. A human story beneath the noise of history.

▌

"I mean, this painting down at Gagosian's," remembered Brice Marden, "I haven't seen a painting this big in this town ever. It is an amazing thing; it's an event just to walk into the room and see it."[16] When Twombly is critiqued as being overblown or attempting the too-big idea, I go back to those first days the painting was shown at Gagosian's

Wooster Street gallery. Ambition, restlessness, inclusion—this is what I love in Twombly's *Say Goodbye*.

An "event" just to see it, and an event, too, the sit-down dinner to mark the opening. Between courses of that dinner, the two sides of the table switched places so those with their backs to the art could now take bites of chocolate mousse in full view of Twombly's canvas. John Waters, who was there that night, wickedly asks, "Was I the only one who noticed the delicious detail that the waiters neglected to switch plates so you were forced to contemplate somebody else's leftovers? Did anybody but me put two and two together that night? . . . Were poetry, garbage, and genius ever such a holy mix as they were that rare night in artful Manhattan?" A strange admixture—poetry, garbage, and genius—and one that turns art into decoration for "the entitled and distressedly dressed-in-elegance crowd."[17]

In another account of seeing *Say Goodbye* in its first Wooster Street home, Brooks Adams described the painting as "an awesome palimpsest, a passage through time and space, from pure form to pure color. In order to read it, you literally have to start at the left with the grisaille boat forms, which mark a return to the brindly shapes of the early '50s."[18] Adams, in his precise and tactile words—"grisaille" and "brindly"—captures the primal, animal nature of the markings, like coats of strange beasts.

"It's an engaging composition—a sort of guide to Twombly's predilections," writes Jed Perl after seeing the painting in that same gallery. "Moving from left to right we pass through a landscape of choices. There's the land of no color; there's a broad plain crossed by thickets of lines and inscribed with the words 'The Anatomy of Melancholy'; and there's a grand burst of fireworks in orange and violet and yellow. This painting embraces several different moods, yet it's so large and spare a work that each mood is wrapped in its own aureole of skepticism."[19]

Right to left, left to right, pure form to pure color, life to death, boats leaving or arriving: it's cliché but true, so much of Twombly's work depends on how you approach it.

"The artist roughly thinks of *Untitled Painting [Say Goodbye]*," writes Robert Pincus-Witten in the catalogue essay for that Gagosian show,

"as having passed from an Expressive stage, at the left, through a Romantic stage in the middle, culminating in an Impressionistic phase at the right."[20] No small claim, and purportedly from the artist himself: the eye in motion traces Twombly's arc as an artist, and the history of art writ large.

Another critic, claiming *this* to be the way that the artist wanted it, writes "the painting is intended to be read from right to left, like a Chinese scroll, marking the direction of Twombly's return over the Atlantic as it does the movement of soul boats crossing the Nile, the primary pictorial theme."[21] This is the way one often sees it at the Menil, facing the far-right panel when entering that vast white room.

Who's right? Right to left or left to right?

"Of course, you can't trust everything Twombly says," writes Edmund White. "When I asked him what his parents did, he said that they were Sicilian ceramicists, and that he'd sold their pots in Ogunquit, Maine. When I asked him how many paintings would be in his MoMA show, he said, without a blink, 'Forty thousand.'"[22]

This obfuscation is an art, a refusal of facts, or at the very least, a desire to throw off the scent of the dogs at his heels.

"You know, Cy is a great trout fisherman," former Menil director Walter Hopps told Claire Daigle about his series of Green Paintings. "He told me that these paintings come from imagining what a trout would see looking up." A few days later, Daigle told this to curator Paul Winkler as they stood together in front of those works. His response: "Twombly had never held a fishing pole in his life."[23]

Daigle, an academic, asks two questions. First, who offered the "red herring," the artist or Hopps? And, "Does it matter?"

Yes and no. Maybe. Another allegory about trying to write about Twombly, the shifting ground of glimpsed truths, small shards of insight that disappear in the light of facts. "And if there's something I didn't say," Twombly jokes at the end of his Serota interview, "you could make it up."

Then again, maybe it's not a question of the right way to read the painting at all. I go back to Eleanor Clark writing of Rome: "[T]he thing now is to find a way into it. You could start anywhere, it doesn't really matter, you will see so little anyway." Begin anywhere in the work, any mark or line is its own passage, its own story, its own little poem.

A poet's painter. Critics, art historians, poets—they all say it. It's said often enough that one can begin to mistake repetition for truth: Twombly is a poet's painter because he incorporates lines of poems into his canvases. It's a reputation that goes back to Twombly's earliest days.

There's more to the claim, of course, than the simple fact of words or lines being borrowed from the great and dead, though at first, in those early days of my visits to the Twombly Gallery, it's what I admired and recognized. I wanted to be writing those lines myself, to be conjuring phrases so beautiful and memorable that an artist would want to immortalize them on canvas.

A special kinship between poets and Twombly, a shared faith in the power and wonder of the word. A skepticism, too. Twombly claimed he liked the compression that poems achieve, a state or emotion captured in very few words, a narrative submerged in lyric, a story hidden but implied. He is an artist, as one poet put it, of "inverse ekphrasis: literature turned to a painting."[24]

"I like something to jumpstart me—usually a place or a literary reference or an event that took place, to start me off," Twombly said of his poetic borrowings. "To give me clarity or energy."[25] Twombly doesn't simply make a mark to be seen or read. Instead, these poetic lines matter to the artist. They record a process, they capture a feeling.

About the phrases Twombly selected, there is something that's hard to quantify or explicate. They share a common DNA, a root in sentiment and drama and epiphany, an attempt to get at something essential to his own life, and life in general. Loss, desire, regret. These lines are, and are not, about the artist's life. They are, and are not, about our own lives. They bait and hook. They offer and refuse. They are (mostly) impossible to read in the paintings, but still there, waiting.

When I say Twombly is a poet's painter, what I mean is that he understood that one of the greatest tools of a poet is silence: the white page as a field of composition, a field of play, where what's missing is what matters. What I mean is that the sidetracks, the alleys, the digressions, are places of discovery and entry. When I say Twombly is a poet's painter, what I'm describing is a sensibility. The way strangers will

silently nod to each other as they pass on the switchbacks of a mountain trail, a gesture of shared recognition; what I recognize in Twombly's art is a process of association, where what's seen matters as much as what's unseen.

In *Say Goodbye*, as is true so often in Twombly's work, the beautiful phrase is smudged or erased. Paint is the eraser.

Or if they're not fully erased, only by intense looking can one decipher single words or phrases, fragments of poetry, lines relineated and edited. The painting, like the torn-out page of a commonplace book, is itself a literal passage, overfull with inscriptions, overlapping texts from an Archilochus fragment to lines from Rainer Maria Rilke's "Tenth Duino Elegy," George Seferis's "Three Secret Poems" and "Automobile," and Richard Howard's "1889: Alassio."

For almost none of these borrowed lines does Twombly write the name of the poet or poem on the canvas. In none of these does Twombly offer a gloss, a description, for example, of the line from Howard's persona poem, as being a homoerotic scene of Venetian boy bathers. Twombly doesn't say that the line from Seferis's poem "recall[s] a clandestine love affair as two lovers on the highway draw apart indifference or division."[26] Each word, each line, each poem or poet, each allusion or reference, is a little lost city.

It's easy to fall down the rabbit hole of passages, reading or overreading. Clever interpretations of these "literary networks," based on virtually unreadable passages handwritten on the canvas, abound. Once down that burrow it's easy to get lost. One might, as a critic has done, create a chart that counts every time Twombly quotes a writer or names an artist, an obsessive scorecard: Mallarmé (9), Sappho (20), or Rilke (30), or most revealing of all Twombly (112).[27] An absurd counting, that says as much about critics as it does the art or artist. There's a saying that splitting wood heats the cutter twice, once in the cutting and again in the burning. In one way, the texts that act as inspiration to the artist offer secondary sparks to the critics, who find in this "labyrinth of literature" a lifetime of puzzles.

To write of all these texts in *Say Goodbye* is to ask, who are these lines for? The answer is, as always, complicated. "The relationship between painting and source text," write Marjorie Perloff, "is almost always thematic rather than verbal."[28] Perloff is on the side of Barthes, who describes Twombly's words and phrases as "semi-parodic signs of displacement," pointing to nothing beyond themselves.

To read Twombly's passages as literal or even necessary isn't quite right. Often they remain nearly invisible to every viewer. A painting is not a palimpsest to decode. A crux to uncover. Which is not say that his texts are not instructive. An incomplete list of themes in the passages above: memory, time, vision, death, erotic life, the past, violence and departures, the sea, the shore, light, endings. As one critic notes, "With handwriting, Twombly could feel his way through a text, that is, a thought."[29]

"Lines have a great effect on paintings," said Twombly. "They give great emphasis. There's a line in Archilochos, who is my favourite poet, a general, a mercenary: 'Leaving Paphos rimmed with waves, rimmed' . . . It may not sound interesting to you but it's central to me."[30] That "central to me" defines Twombly's poetic borrowings: the line is always personal, a reminder of place or time, a feeling made present by writing it. Twombly's poetic borrowings offer both dialogue and silence, "a paradoxical form of concealment and self-outing."[31] This desire to both say it and hide it.

It's hard to miss the same-sex desire in the texts and writers Twombly borrows. Gay writers, some open and others closeted, but all writing of desire, its pleasures and complications, its consequences, its longings, its loves, its losses. The erotic life as it appears in these poems, lines that Twombly kept in mind or notebook, is decidedly queer.

❙

When Chekov's *Three Sisters* first played in St. Petersburg, the city's cosmopolitan theatergoers returned night after night to see how the sisters were doing. Sitting in the dark theater as the pantomime of life, more real than real, played out before them, they could be comforted by the scripted order of things. It wasn't that they expected the fates of Olga,

Masha, and Irina to change, yet they wanted to confirm that nothing, and everything, was different. It was never the same play. And they were never the same in that dark.

I heard this anecdote, maybe untrue, years before I understood it, and years before I first saw *Say Goodbye*, in the fall of 2003. Everything from those years, all my desires and fears, passes through this painting. I felt a kinship with the painting, though I was unable to say exactly why. In time, it became a marker, a line of before and after, a stand-in and nostalgic placeholder for what's gone.

"I slumped into an empty corner opposite *Say Goodbye, Catullus* and wept into my knees for a half hour," writes the novelist Catherine Lacey on her own encounter. "A guard paced nearby, nonplussed, and though I knew my behavior was ridiculous, it also felt like the only rational response. Perhaps it was taxing to take in an entire lifetime of work in a handful of minutes, or perhaps I was just lonely, or tired, or simply moved by all that broken beauty. But even now, just recalling this moment, my tear ducts flare and prickle."[32]

For all the smart, academic readings, all the ways of seeing this figure or that text, I love the painting too for that initial starburst of feeling, that collision of rage and hunger and desire and longing I felt before it. That first time, and so many times after. Even after it dulled, the blade of that painting still cut.

Said another way, by a very different kind of artist, David Salle writes of Jeff Koons's enormous public sculpture *Flower Puppy*, "I was so grateful for its being there; it was such a *gift*. I never tired of seeing it; I was just happy that it existed. What more can an artist do?"[33]

RETROSPECTIVE

FROM THE GLASS VIEWING BOX above the auction, men and women in black tie drink wine and watch it all. The camera cuts to the phone banks awaiting bidders. Then a close-up of a painting, bluish lines like veins riveted into dried paint. The auctioneer asks for a higher bid. The rich smiles of the rich crowd. A world-weary voice-over describes the scene: "This one, a canvas of scrawls done with the wrong end of a paint brush, bears the imaginative title of *Untitled*. It is by Cy Twombly and was sold for $2,145,000. And that's dollars, not Twomblys." And so, Morley Safer, faux-naïf reporter for *60 Minutes*, begins his tour of the art world, marveling at the absurd sums paid for childlike "scrawls."

On any given day in the Twombly Gallery, one can hear some vari-

ation of *I could do that* or *My kid could*, said in a whisper to a friend or partner, and sometimes said out loud, a knowing bravado, to no one in particular. It's a familiar reaction to Twombly's work—easy or repeatable, banal or simple. The effort to make art look effortless, though, is never simple. As Twombly noted, it is "very difficult to fake, to get that quality you need to project yourself into the child's line. It has to be felt."[1]

It is not just about work, this reaction. It is about money. And power. And fame. For as much as any artist creates work for themselves, some secret propulsion to make visible an idea, it is soon enough given over to the world and its markets. Art & Money, that old saw and fateful combination. Twombly, for better and worse, has been—and continues to be—a symbol of the out-of-control art market.

"At the height of the 80's boom," writes art critic Deborah Solomon, "the money that was thrown at art had the paradoxical effect of devaluing it morally: art became a vehicle for quick profit, nothing more, nothing less."[2]

"The public," she writes, "in turn, took one look at the slick art of the 80's and felt confirmed in its old suspicion that all of modern art, from the pricey doodles of Picasso on down, was really a ruse." Twombly's work, certainly part of that wave, was often held up as an example of that "ruse." The 1980s boom busted, only to return in full force a decade later, yet another phoenix-like rise from the crashes of value, a cycle of boom and bust and boom.

Safer's now infamous segment, "Yes . . . But Is It Art?" aired in September of 1993. That painting, *Untitled* 1956, one of Twombly's early graffiti-esque works, its surface dug into, would easily be worth five times as much today. In a way, the journalist's take on Twombly was a year early, for the artist's rise—fame, money, recognition—was only just beginning in earnest.

▌

"The Museum of Modern Art will excite the chattering class with its show of Cy Twombly, the painter who along with Robert Rauschenberg and Jasper Johns, helped recast art after Abstract Expressionism,"

goes one announcement for the opening of the September 1994 retrospective, which traveled on from New York City to Houston, Los Angeles, and Berlin. "Twombly remains very controversial outside the art world."[3]

This was the typical narrative, a mix of praise and condescension: the art world "chattering class" love him, while the public is confused by him. The bafflement about Twombly was usually described (and often still is) in two ways, one for the work (What does it mean? Is it any good?) and one for the money (How could it possibly be worth so much?).

Since the Whitney show in 1979, Twombly's reputation and prices had been on the rise, a wagon hitched to the bull market. A blackboard painting that sold for $250,000 in the early 1980s sold for $5.5 million in May of 1990. "For brash nouveau American and Japanese collectors eager to put the stamp of respectability on their recently acquired contemporary art, a Twombly must have seemed like the ne plus ultra of Old Masterish cachet," wrote Brooks Adams for *Art & Auction* in 1992.[4] At the same time, in a reminder that boom and bust is all a matter of perspective, Adams writes that compared to "the gilded age just past," a mere two years before, the market for Twombly's work had softened. An auction for *Nini's Painting* at Christie's, instead of reaching the $2.5 million low estimate, failed to sell: "'It would have been $4 million to $6 million two years ago,' says the head of Christie's contemporary department, Diane Upright. 'The question is, how much Twombly can this market absorb?'"[5]

It's hard not to be a little cynical. "Today's art market is publicity-fueled and driven by collectors who often invest for the sake of profit rather than art," wrote one reporter, a sentence that could've been written in 1987 or 2017. "It is described by dealers and curators as 'irresponsible,' and comparisons with Hollywood and Wall Street are frequent."[6] It's never just about the art.

Then again, Twombly, even at the height of this boom, was never as recognized or rewarded by collectors. "By comparison with his fellow artists," remembered Thomas Ammann, "Cy's work was much cheaper. I wanted to offer a group of paintings to a European museum. But even when museum directors saw the work, and realized its importance,

they always wanted to buy something else first. Then I thought 'why I am being so stupid? I have these great pieces; why don't I keep them?'"[7]

I

For some artists, high prices signal sinister commercial motives. For others, those same sky-high prices are overdue recognition, repayment for neglect. Which to assign to Twombly is an open question.

In the years after he left Castelli, Twombly's work was sold by a number of dealers and galleries in the United States and Europe: Yvon Lambert, Thomas Ammann, Lucio Amelio, Gian Enzo Sperone, Stephen Mazoh, Karsten Greve, and Heiner Friedrich. Of these, it was Larry Gagosian that perhaps most dramatically changed his life, and reputation. With his youthful good looks, Gagosian, a one-time business partner of Castelli and full-time capitalist, looks as if he just stepped off his yacht. His empire of galleries dot the capitals of the world, built with a good eye and an instinct for both restraint and glamour. When an artist signed with Gagosian, after all, the prices were known to jump immediately by 50 percent.[8]

Just look at the numbers: between the years 1959 and 1987, Twombly's work was featured in group or solo shows at Leo Castelli's gallery less than thirty times. In the next twenty years that followed Twombly's move to Gagosian's eponymous gallery, his first solo show in 1989, he had over twenty solo shows and nearly as many group exhibitions.

"Art is no lady," writes art critic Mark Stevens, "More often than not, she's the brilliant often coquettish mistress of power . . . And art often takes advantage of the banality of money, which seems naked, abstract, and cheap without art."[9] Money can't buy taste, but it can buy expensive things. It can turn art into a prop, take out its stinger, turn it into a three-chord pop song played in a gold elevator. At the same time, there's no pure gesture. No exhibition that doesn't privilege one set of works over another, one version of the life over another, one artist over another.

In these overlapping circles of publicity and power, an ecosystem of dealers and auction houses and museums and foundations, the patterns

of self-interest seem everywhere. As one writer puts it, "The Gagosian galleries do a lot of advertising in art magazines, not so much to attract customers as to reinforce the Gagosian brand, keep gallery artists in the public eye, and reassure previous buyers that 'their' artist is being promoted."[10]

Go back to the installation of *Say Goodbye* in Gagosian's gallery on Wooster Street, an event coinciding with, but apart from, the MoMA retrospective. To reproduce the painting in the special catalogue, a lush oversized book, it was necessary to photograph it in pieces and rejoin it digitally to create a foldout, no easy feat at the time. "The labor," wrote Stevens, "is deeply flattering to the artist: One imagines making such an effort for, say, the paintings in the caves at Lascaux. Where will Twombly, who now sells through a number of outlets, be likely to market his work in the future?"[11] What's being sold is future value. What's being sold is a brand.

"Artists don't make art," Sarah Thornton writes, riffing on Duchamp's claim that he doesn't believe in art but the artist, "They create and preserve the myths that give their work clout."[12] This is, in a way, the speciality of Twombly: The outsider. The dandy. The who-gives-a-fuck artist.

Gagosian and Twombly never signed a contract. Or so goes the legend. Rather, their relationship was forged by mutual respect and benefit. "He was unlike any artist I ever met," said Gagosian of Twombly. "He never drove a car, never owned a television. He didn't really care about money—he was no fool, but he certainly wasn't driven by money. He just lived his own life and was totally an artist—all in, all the time."[13] That purity, living in his own way, committed to his work, didn't mean that he was disconnected from the art world.

Neither saint nor clown, Twombly made more money as one of Gagosian's stars than could be spent in a lifetime. A long way from the winter of 1966 when he had to ask Giorgio for the boat fare back to Italy.

▮

Simply titled "Cy Twombly: A Retrospective," the 1994 show offered pleasure for both sides, the lovers and the haters, for those who value Twombly's work less than even the "puke" of realist painters of the

Gilded age, and others for whom "the genius of our time is for the displaced meaning and the image of a mind wandering at will."[14]

With works from his early period, paintings never before included in a retrospective, and a "substantial body of important new work," MoMA director Richard Oldenburg in his forward to the exhibition catalogue claimed this show would give "a younger generation of artists an opportunity to study afresh the full extent of Twombly's achievement."[15]

The show marked a turning point for the artist: a new public life, at least temporarily, and a solidification of his reputation in the United States as one of the great artists after Abstract Expressionism. As Oldenburg notes, "though his work is held in the highest regard by connoisseurs worldwide, he has perhaps been lauded more extensively in Europe than in his native land."[16] He was right. In Europe a big traveling retrospective organized by curator Harald Szeemann in 1987 debuted in Zurich before moving on to Paris and Madrid, London and Dusseldorf. The show "allowed many people their first glimpse of lots of Twombly: whole cycles of drawings and paintings, enormous blackboard paintings and first sightings of the fey little still-life sculptures he had been making since the '50s."[17] But that exhibition never left Europe. In the years that followed there was talk of a new American retrospective organized by Mark Rosenthal at the Philadelphia Museum of Art, but it never happened.

There is in the art world the idea of one's "moment." As in, this will be the moment of fame or financial success. As in the moment the clouds break open into light. Was this, the mid-1990s, Twombly's moment? The question is there in so many of the reviews from this time, an awareness of Twombly's reputation, the price of his work, and the vastness of the show. The MoMA show, curated by Kirk Varnedoe, a "relatively recent convert to Twombly," was the first big exposition of Twombly's works in the United States in over fifteen years.[18] Not just his moment, but his American moment.

"The goal of the show," writes Michael Kimmelman, ". . . is clearly to secure Mr. Twombly a place beside his old friends Jasper Johns and Robert Rauschenberg at the head of the post–Abstract Expressionist class."[19] The review goes on to describe Twombly as "neither sham nor shaman. He's a good artist whose work can be pure pleasure, exuberant

and rude at the same time. The best paintings and drawings, with their itchy, stammering, skittering forms that coalesce—precariously, and as if for an instant—are like no one else's." Another writer described the show as a "knighthood of a kind."[20]

Not everyone was impressed. "Your art critic, Mark Stevens, flails about in the slough of class consciousness in his sorry review of the Cy Twombly mess at the Museum of Modern Art," complains Morley Safer in a letter to the editor of *New York* magazine. Almost a year after his "Yes . . . But Is It Art?" segment aired, Safer complains about Stevens's glowing review (in which Stevens took a thwack at the *60 Minutes* piece). Safer continues:

> In barely five paragraphs [Stevens] spits out the phrase *middle class* six times . . . as if it were a recurring proletarian hair in his cultivated alphabet soup. Meanwhile he repeatedly savors the words aristocratic and *cultivated* to describe the few true cognizenti [*sic*] who relish Twombly's limp drawings . . .
> Was this a review or a compulsive act of social climbing.
> Mr. Stevens also engages in some shaky art history when he suggests that Cy Twombly is the James Abbot McNeill Whistler of his day. Whistler could puke and create more aesthetically pleasing canvases than Twombly can paint in his best year.

Stevens replied, his letter printed directly below the attack on his "social climbing" review: "Morley Safer and his fans take great pleasure in attacking Cy Twombly. Cy Twombly and his fans take equal delight, I would guess in attacking Morley Safer."[21]

❚

What is the purpose of a retrospective? Pleasure and profit, insight and vision and history. To see an artist's mind at work, ideas evolving over time. To make a story from the disorder of the day-to-day randomness of making. To name a tradition. To right a wrong of neglect or misinterpretation. To make a claim for greatness, or package a product for sale.

Retrospective, from Latin *retrospectare*, "look back." That activity of looking back can be seen most clearly in Varnedoe's catalogue essay "Inscriptions in Arcadia." Based on interviews with Twombly, archival research, and his own astute observations, the essay offered the most complete biographical portrait of Twombly assembled at the time, though it is far from intimate. Running over fifty pages with exhaustive notes, the essay, much like the show itself, at once dispels the aura around Twombly and adds to it. All the photographs of Twombly—with the exception of one facing the title page—are of the artist as a young man: this is the artist as genius. A recognition that as much as we want the art, we also want to imagine the man who made it.

Early in his essay Varnedoe quotes a letter from Conrad Marca-Relli from a 1955 fellowship application: "[Twombly's] originality is being himself. He seems to be born out of our time, rather than into it."[22] Time, then, appropriately enough, is the very subject of Varnedoe's essay—not Twombly's exception or escape, but his very real, lived life.

In the 1979 Whitney show, the essay by Barthes is brilliant but elliptical, describing the artist in insightful though hardly biographical terms, while in the 1987 Szeemann catalogue, the biographical note for the artist is a single paragraph. Varnedoe, by contrast, divides his essay chronologically, each period of the artist's life accounted for, artistically or biographically: *Early Life and Education, 1928–52*; *Army Service and Teaching in Virginia, 1953–56*; *From Epic to Pastoral: The Later 1970s and the 1980s.*[23]

The essay, and the collected works up for view, trace an arc of Twombly's artistic vision, his merging of an American "sense of now with the European sense of *then*." It makes a biography. It's no accident the essay ends with a map of the places in Italy where Twombly lived and worked, a visual aid for a distinctively American audience. You can, the maps say, see his body in place and motion.

For this is a story, too, of homecoming—"the adoptive home is no final substitute for native soil."[24] Varnedoe argues for Twombly's American lineage—Pollock, Whitman—a certain idea of genius: white, male, and, though he doesn't quite get there, queer. "Most recently," writes Varnedoe, "a fraught concern with sexuality has appeared among contemporary artists whose anti-formal expressivity and candor about the

body, opened still another avenue into Twombly's achievement."[25] That avenue, however, at least by Varnedoe, was left unwalked.

The retrospective was, in one way, not a "look back" but forward. The drawings of the *Gaeta Set* or the first version of *The Four Seasons*, new works, done at Bassano and Gaeta and Lexington, mark a late style for Twombly. These works, full of color and a renewed energy, waves and flowers and boats, transform not just the show, but one's vision of Twombly. This is the start of something, rather than the end.

▌

Twombly's *Summer Madness* 1990 fills the cover of the September 1994 issue of *Artforum*. From a center mass of blacks and browns emerge flower-like stalks with blossoms in bright yellows and reds. There's something anxious and brash about the image, a bouquet of messy fire, though like much of Twombly's work, it reproduces badly. Flat and glossy, the painting on the cover is but a pale shade of its real-life, live-wire tension.

To mark Twombly's retrospective, the magazine featured two articles that "size up the artist's contribution." The essays—run side by side, one in blue ink, the other in black, a parallel conversation about the virtues and limits of Twombly—couldn't be more different, and yet they speak to the intersections of money and pretension, elusiveness and appeal, that followed Twombly and the show. Neither total dismissal nor total praise, the two essays, even as they questioned Twombly, and his values, participated in the conversation, in this "knighthood."[26]

"The eminence granted Cy Twombly by our era's leading art critic, the auction market, bothers me," begins the review "Size Down" by Peter Schjeldahl.[27] And yet despite his "tic of alienation" over Twombly, "the Other Guy from Black Mountain," Schjeldahl finds plenty to praise. "Twombly as an artist is plenty soulful and incredibly seductive," he writes. "He projects a splendid irritability. His work is as much a form of behavior as a product of craft. It is restless, with the discontent of a dog that turns and turns, unable to feel just right about the place it has chosen to lie down." He finds seduction in Twombly's lyric sensibility—"a poet of belatedness"—while at the same time describing how the artist has

been "inflated by others, through no fault of his own, with the gas of an inauthentic, smarmy, self-hypnotized nostalgia."

The problem is money. The collectors and buyers, "checkbooks aloft, seem to be voting him the boss abstract painter after the New York School." The question for Schjeldahl, then, isn't just if Twombly is any good but what his elevation says about the larger world of art, buyers, sellers, critics, curators, artists. There are others, he claims, who deserve recognition, from Agnes Martin to Robert Ryman, and that it is Twombly who is lionized by the museum and the market points to a sickness; others, he writes, "count more than Twombly in diverse ways, if truth to our time is what interests us."

Rosalind Krauss's "Cy's Up," wrestles not with money but control and interpretation. Who, the essay asks, speaks for the artist? On the one side is the "chosen mouthpiece," Heiner Bastian, and all the other critics who find in Twombly a poetic imagination that works by analogy—"mimesis, representation, likeness."

"They believe," she writes of these critics, "that if it is written Sunset (as on *School of Fontainebleau*, 1960), then 'Here is a light-filled landscape.' They rush to fill in—in their imaginations, but also on the canvas onto which they project them—the places where they know Twombly has stayed: the Lake of Bolsena (although they always say the Lago di Bolsena, since that sounds so much sunnier, so much more Italian)."[28]

By contrast, Krauss claims Twombly's marks are performances. They are graffiti, his way of responding to Pollock and the mark of Action Painting. Twombly "suspend[s] representation in favor of action: I mark you, I cancel you, I dirty you." Graffiti, she claims, "is violent: always an invasion of a space that is not the marker's own, it takes illegitimate advantage of the surface of inscription, violating it, mauling it, scarring it."[29] In a way, Krauss's description of Twombly's work goes back to some of the earliest interpretations. "Who has not left a sign on a wall," writes Palma Bucarelli, after an early show of Twombly's in Rome, at La Tartaruga, "inspired by the unstoppable impulse to trace a sign, make a gesture, a pure gesture on a white wall?"[30]

Twombly himself rejected the idea that his work was related to graffiti. "Yeah, I don't think of graffiti and I don't think of toilets," Twombly told Serota in their interview.[31] How much, though, Krauss wonders,

should we ever really trust an artist to interpret their own work; "no more," she writes, "than the analysand is the best reader of his or her dreams, motives, associations? To the contrary—the analysand is often the worst."

Perhaps the artist would have preferred how James Lawrence put it: This is not graffiti, the "assertive . . . political or scatological" marking of another's surface. "A more appropriate comparison," writes Lawrence, "would be with a builder who runs a finger through wet cement not out of mischief or spite, but because the tactile urge is irresistible."[32]

Then again, so what? This might be the reply of a casual viewer of a Twombly painting. It might be the response of the artist himself. "At the mention of some piece of criticism or a highbrow article," writes Sally Mann, "Cy and I, both of us with sensitive bullshit meters when it comes to artspeak, would roll our eyes."[33] And in one way they would be right. Forget theory. Forget intention. The experience of looking is at last about letting go: to feel something, anything. "Part of the knack of looking at his paintings, as with swimming, is just to relax," writes Martin Gayford. At which point, "Twombly's art, far from being dauntingly avant-garde, is very easy to enjoy."[34]

▪

"Cy never went to the openings of his shows," Del Roscio writes—except when he did.[35]

"Of course he went," writes Dorothy Spears, in her review of the MoMA show, "and there were the obligatory photographs on newspaper pages the following Sunday . . . Still it's a pity to think that a sixty-six-year-old curmudgeon must act out a role scripted for an ingenue."[36] Just as he had attended the Whitney opening in 1979, he attended the MoMA opening. Skeptical of being a public figure, he nevertheless performed the role asked of him, however reluctantly.

The morning after the preview, a picture of Twombly, in a tuxedo, appeared in the Evening Hours column of *The New York Times* Style Section. "Seeing Expressionism in the Post-Abstract," is the headline accompanied by four pictures: Ann Twombly Leland, "the artist's sister with two of her three daughters"; Leo Castelli, backlit and standing

before one of the "Four Seasons" canvases; next, architect Philip Johnson kissing collector and philanthropist Agnes Gund; and fourth, Lily Auchincloss, "a benefactor of the exhibition," with Cy Twombly and his son "Cyrus Alessandro Twombly, who is also a painter." Everyone in that last photo is smiling, including Twombly, who seems to be laughing at an especially winning joke.

Art and Money rubbing shoulders, kissing each other, making nice for the camera. Just a couple of years before, Robert Hughes dramatically described the "Great Massacre of 1990" in *Time* magazine; the great art boom, he writes, started euphorically in 1982, "crested in 1989, is now over, vanished into the sand."[37] The collapse of the auction market, he cautions, merely sets the stage for different kinds of sales, more private dealers, and an eventual recovery: "But anyone who thinks the market decline will instantly produce saner relations between art and the public ought to think again."[38]

In those photos I don't just think about money and art, Gordian knot of connections, but how these images assign Twombly a family he was never particularly close to: a distant sister and her children; his own adult son; and absent from the record—Tatia, Nicola, Betty. The family man in full, at least for the night, and with just about everyone missing.

We shouldn't believe everything we see. "Artists like to live simply," Twombly warned one writer, "despite the glamorous images in the magazines . . . You know, all the vases [in these articles] have to be Ming, but, they probably came from Wal-Mart or something."[39]

▪

Six months after the *Artforum* essays, a letter to the editor from Heiner Bastian was published. Taking almost comic umbrage at being called Twombly's mouthpiece, his response scolds and corrects: "Ms. Krauss just creates misery! Culture lives a very fragile life at the end of the second half of the century."[40] Such a response is unusual for him, he claims, as he is normally interested in opposing ideas, but then again, it's not often that a critic would introduce his work, as Krauss does, as

an example of a view, "in its most sick-making, obsequious form, written by Twombly's assiduous art-historical amanuensis."

"She is not interested in criticism," Bastian writes, but "just denouncing." Rejecting her "stupid term" of "mouthpiece," he describes Krauss's "sad and poor" approach to Twombly's work. It is a strange reply, as she points out in her response, published alongside his letter, as her review was hardly the tougher of the two responses in that issue. "He surely must know," she writes,

> that if Twombly's work has often received a lukewarm
> reception when it has crossed the Atlantic—and the Peter
> Schjeldahl essay with which mine was paired was an instance
> of just this—this is because it has been misperceived (and
> thus, indeed, "stigmatized") as soft, "poetic," and European.
> I was trying to combat this perception by showing that the
> conditions of the work's beauty are also those of its resistance
> and toughness.[41]

Bastian's letter is itself an example for Krauss of the kind of writing about Twombly that does him no favors: "Mr Bastian's letter underscores the extraordinary gap between his world of reference and the one out of which my essay on Cy Twombly was written." Her letter goes on to restate how Twombly's work "reads" and "strongly misreads" Jackson Pollock, terms she borrows from Harold Bloom's theories of influence. "It would be beyond my comprehension that Mr. Bastian could see my comments as anything but praise of Twombly, except that—and this was indeed what I laid at his doorstep in that essay—his notion of praise moves in certain poetic channels and mine does not."

Krauss's essay ends with a question: "I have no idea which Twombly the Museum of Modern Art's upcoming retrospective will celebrate. Twombly's? Its own? A combination of the two? That it will be mine or Barthes' is the least likely. But one can always hope." The answer to Krauss's question, I think, is both. The crown prince of open-endedness, Twombly makes possible likeness and its ironic gesture, the mark of representation and the one of performance, the line of graffiti and high art.

These questions are far from settled. John Yau's essay in the catalogue for the 2016–2017 retrospective at the Centre Pompidou rejects Krauss's (and Barthes's) idea that Twombly's work was ironic or, worse, graffiti: "Starting with his early glyph paintings, Twombly was never interested in 'anti-form' or idealized form. The fact is that he could scratch 'Virgil' into a painting's surface and 'mean it straight.' Twombly was not looking backward when he inscribed his surfaces with words, pictographs, legible or illegible marks. He was looking forward."[42]

In an even more recent piece, a 2018 review of a drawing show at Gagosian's gallery, Yau again takes issue with Krauss and her readings of Twombly's work. In his defense of Twombly against her nearly twenty-five-year-old claims, Yau writes, "His passions and enthusiasms extended to paintings of all kinds, as well as to history, mythology, music, and much else, and he did not care if others did not share them. He was learned in a non-scholarly way. For him, culture was a living thing, not a box full of treasures to be plundered."[43] It's a good reminder of Twombly's curiosity and inventiveness, his model of humanist inquiry. But Yau overstates the case. Culture for Twombly was both a "living thing" *and* "a box of treasures to be plundered." These are not mutually exclusive, especially for Twombly. And this—I imagine the artist with a half-cocked smile at this debate—is what's so attractive about him.

❚

In a 1971 letter to Giorgio from New York, Twombly writes that in just two years, instead of the three he'd planned, he'd accomplished what he wanted. Twombly isn't explicit about exactly what he wanted to achieve but it's implied: solid prices for his art, perhaps, or the reputation he'd been hoping to establish since his first show in the late 1950s. Was 1994 his moment? Was this "it"?

Twombly seemed to believe so: "I think certain things are accepted at certain moments in time. For example, my 1979 Whitney show was totally ignored. Now about 75 percent of the paintings included in the exhibition at the Museum of Modern Art will be the same paintings that hung at the Whitney. I expect that the response will be different."[44]

He was right.

I often return to a conversation I once had, early in the life of this book. For several days one summer, the artist Mark Flood and I were regulars at a café in Marfa, Texas. Like fate, I thought, when I heard from a mutual friend that Flood, a visual artist, had worked for a time at the Menil Collection in Houston. He'd later tell me that he helped install *Say Goodbye* when it arrived in Houston for the second time. About the arc of Twombly's reputation he said this, a statement that could be true of seeing the work itself in person: "At first he looked out of touch, then he looked inevitable, and then he looked great."[45]

OLD DOG

IN A VAST, NEARLY EMPTY carpenter's warehouse turned temporary studio on the edge of Lexington, Twombly let himself be photographed. *Say Goodbye*, still in progress, a prop behind him. On his studio table, the objects like actors waiting for the curtain to rise: mostly full paint tubes, a few small brushes, a package addressed to his Lexington house on Barclay Lane, and a handwritten passage from Archilochus. This inventory of possibility offers a snapshot, not just of the process of making, but of the man.

"Cy is the king of painters and the Garbo of the art world," writes

FACING PAGE: **Studio Table, Lexington, 1994,** Photo: David Seidner

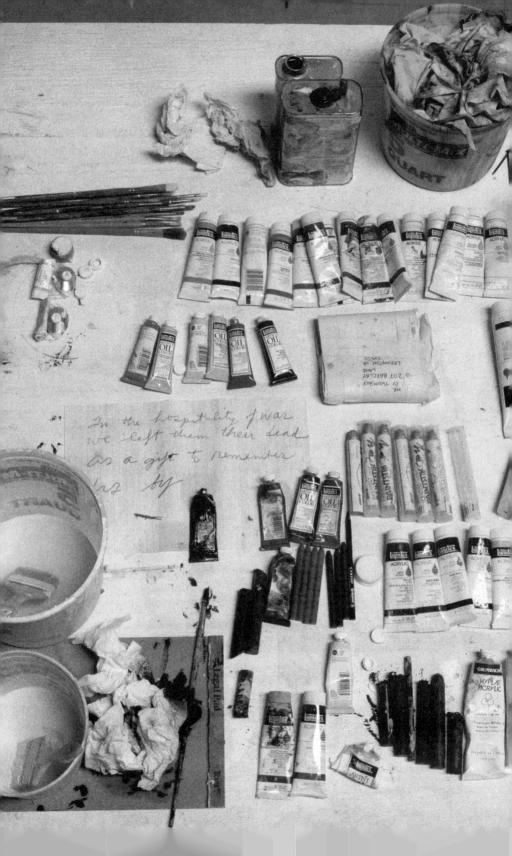

In the hospitality of war
we left them their dead
as a gift to remember
us by

David Seidner in his book of photographs *Artists at Work: Inside the Studios of Today's Most Celebrated Artists*, in which this photograph, in black and white, and others in color of the studio, first appeared.[1]

Twombly wasn't easy to convince to sit—almost twenty years of asking—and he wasn't easy in the moment; in his guarded posture, a refusal of vulnerability. "I'm asking them to empty themselves," the photographer said of his process of giving his subjects so many instructions for how to position their body that they "become unaware, almost, of being photographed."[2]

Unlike Seidner's other portraits of artists—Joan Mitchell, John Cage, Cindy Sherman, Jasper Johns—Twombly is at a distance. The other artists gaze directly into the camera, filling the frame with intensity and openness. Instead of the deep blacks and chiaroscuro of the close-up faces, Twombly's portrait is muted, a soft scale of grays and whites. His body and face almost dissolve into the painting. This is an image of proximity without intimacy. Or maybe, that very distance is what draws us closer, makes us want to know more. Alberto Giacometti said his sculpture *Four Figurines on a Base* was inspired by seeing four naked women in a Paris brothel. The artist recalled, "The distance which separated us, the polished floor, seemed insurmountable in spite of my desire to cross it and impressed me as much as the women." That very difficulty of crossing, what seems impossible, is itself a kind of lure.

Before their photo shoot on the stairs in Rome, or the double exposure in Venice, Rauschenberg took a series of posed photographs while they were students at Black Mountain, a portfolio of attention. These six photographs recall the progression of Twombly down the stairs in Rome later that year. In one, a close-up of his face, handsome, out of focus, a serious straight-ahead look. Unblinking. His hand draped over the arm of a chair in another picture. He is both artist and gentleman: tie and jacket in several of the photos and a painter's work-shirt and jeans in others. The emotion of these photographs, titled *Portfolio II* 1952, "conceived and printed in 1998," but taken four decades earlier, is hard to name. Inaccessible. Fleeting. Mutable. He keeps changing, shifting. Twombly the serious model, posed, hand over the chair. Twombly the indolent artist, straddling a chair. Is this the same man? The same body? The same hands? In these images, it's not his face but his body that seems to be the subject.

We've been here before, I know, these snapshots of desire moving towards or away. But these beginnings return at the end: Twombly let himself be seen, at least for a moment, then vanished again.

❚

"These photographs were taken on a glorious Spring day," writes Seidner, "a bit cool and foggy in the morning but clearing to reveal great expanses of green rolling hills. Lexington is horse country and the home of a famous military institute. Everywhere gorgeous cookie-cutter cadets in starched and pressed uniforms marched about with impeccable posture."

Why, after defining his life for so many years around the Mediterranean, would the artist choose "to spend spring and fall in his native Virginia?" This is the riddle as one 1994 profile has it: "His travels were usually to exotic places, like the Tangier of Paul Bowles in the 1950's or Asia Minor, and he still harbors an urge to visit the ancient sites of Iran. Against all that, Lexington, where he bought a two-story, 19th-century brick house last year, might seem prosaic, though he insists it is 'quite a sophisticated little town.'"[3]

The sophistication of Lexington—a college town where Twombly rubbed elbows with professors of Classics and literature and philosophy— is secondary to its refusal to change. There's a stubbornness to the place: the old stone architecture, the gravestones, the historic manors houses, the smell of burning leaves in fall and the-ice tea heat of July, the streets with the dress-white cadets. A conservative streak in Twombly too—he hated that the VMI admitted women into the cadet class—that fits with his return to Lexington, a town with a church named for Robert E. Lee.

"After over 35 years in Rome and Southern Italy," Twombly said, "I found Lexington to be the perfect kind of intermediate place. There is an order, a lack of hysteria or confusion here. I'm happy to have the rest period, the calm."[4] That sense of order comes in part from the place itself, but also from the familiar ease of return.

"I don't count interviews quite as artists' writings," the poet Stephen Spender wrote. "They belong really to a more or less respectable branch of advertising, or self-advertising."[5] Spender is right, of course. That doesn't mean Twombly's words, in their repetitions or evasions, in

their claims or silences, don't matter. There are truths worth noticing.

There's a similarity to his interviews done in the fall of 1994, lines and phrases that reoccur. In William Cocke's profile "Cy of Relief," Cy tells the young writer, "Lexington is not your typical Southern town." It was, the writer sharply notes, "a phrase used in myriad interviews in recent months."[6] As one critic said to me, Twombly, for all the openness he reluctantly offered, remained in fear of being "misunderstood."[7]

Writer Alec Wilkinson described Twombly in Lexington this way:

> He radiated an aura of lonesomeness and melancholy, but he also seemed to be entirely self-contained. He was quite tall, and his gaze was measuring. The instant you met him you could tell that he was a serious person with a prodigious interior life. His sense of time seemed languid. He never seemed to hurry, or move any more than was necessary. He took small steps, as if the deeper his thoughts, the less attention he had for his movements, and with his bald head and rangy form and his girth, he looked like a figure from the history of the church.[8]

I like the physicality of the description, Twombly's body, in its slow careful steps and his frame, no longer just tall, but broad. Even more than this well-wrought image, the "measuring" gaze and "prodigious interior life," I like the scene in the article of Twombly and the writer, sitting in a Lexington coffee shop watching the boys from the VMI, following the ones whose "appearances interested him" and making predictions about their movements and actions, "the way someone might follow hands in a card game and the exchanges among the players."

On my first visit to Lexington, I watched two VMI boys stand before the bulletin board menu at a coffee shop on Jefferson Street. They debated their endless choices before settling on drinks submerged in whipped cream. Attractive in a certain kind of bland communal way, their personal edges hewed back, an uninflected, unstudied handsomeness, each of them retrieved their stash of spending cash, kept safe inside of ziplock bags, from underneath their military caps. The little

soldiers in the coffee shop collected their drinks and walked back into the crisp fall air.

Twombly's Lexington pleasures: sitting outside the Wal-Mart with Sally Mann, being driven around the countryside, scouring yard sales and flea markets for odd treasures, strolling through town, or watching the cadets' Friday formation. These small joys, local and familiar and without pretense. He returned because he wanted quiet; because he could live a simple life. He returned to make art. He missed the hills, he missed the smell of pine, he missed the green fields and the mist. He missed grits and American diner coffee; he missed all the familiar things from his boyhood. It was inexplicable, an urge even he couldn't quite name—routine, custom, vistas. The question perhaps isn't why he returned but why any of us do. What is it about those places of first beginning that call us back? What is it that calls us from inside our bones to come home?

It seems predestined, in a way. For as much as Twombly traveled, he was, at heart, a man of steady habits. Each morning in Rome Twombly walked from the apartment on Via Monserrato to the café in the piazza—*his* café—to buy a coffee and a newspaper. Above the café, a sign read, in English: *The Best Coffee in Rome*. In Lexington, Twombly went for breakfast at the same diner, ordered the same meal, walked to the post office, drove (or really, was driven) around the countryside, took a nap, sometimes went into his studio to paint, and (when he was in the mood) had dinner with his friends in town.

He was often alone in Lexington. Del Roscio would come at the beginning and the end of his months in Lexington to help get him settled and then packed up to go back to Italy. Alessandro, an adult with a family of his own, was off in New York and Rome and elsewhere. Tatia never came. He lived an independent life, solitary when he wanted to be and with others when he was done being alone, friendships he carefully cultivated. He chose which people to share his company, inviting them into the fold. Loyal without being intrusive, acquiescent without being subservient, generous without asking the same in return, a circle of friends and acquaintances available whenever he wanted a home-cooked meal or a ride in the countryside. They didn't ask him to be

warm or talkative. They didn't ask him about his past or himself. Very famous in a very small place and yet that smallness protected him, kept him guarded.

▌

In the summer and fall of 1994, one might have opened *Vanity Fair* to Edmund White's profile or *Vogue* to Dodie Kazanjian's piece, surprised to see Twombly splashed out in glossy print and images. Both writers visited Twombly in his Gaeta home, as did Alan Cowell for his *Times* profile, "The Granddaddy of Disorder." All these interviews and articles appeared within months of each other, a publicity blitz to coincide with the 1994 MoMA show.

In a way it's telling that for the most part, the profiles and articles about Twombly happened in Italy. This was the place, the home and country, the life, he wanted to show reporters and writers, though Nicola doesn't appear in any of these profiles and Tatia is a passing fact. As with the palazzo in Rome or the house at Bassano, the spaces could be made into theaters.

By contrast, in Hayden Herrera's profile of Twombly in Lexington, "Cy Twombly: A Homecoming," in the August 1994 issue of *Harper's Bazaar*, the writer follows Twombly through town, but we never see inside his home. It's all outside—the narrow lane, the gardens, the unfinished studio in the back; she never describes the interior of that "soberly American" house.

"Last year he rediscovered Lexington, Virginia, where he grew up," writes Kazanjian in 1994. Of course that isn't quite true. Twombly had been returning to Lexington and the United States almost every year. As Sally Mann points out, "The phrase 'Twombly returns to Lexington' recurs, choruslike,'" throughout the biographical summary of Twombly's life in the Tate's *Cycles and Seasons* show.[9]

"I'm like an old dog," Twombly repeated to several different writers, "who's come home to die. I see people I grew up with, but I can't talk about old times with them. I can't remember any of that. It's not a nostalgic trip for me."[10]

Except that's exactly what this late-life return seems to be. Even if

he can't talk about "old times," or recollect about all the years he was absent, in Lexington, he spoke the common tongue. He knew the manners, written and unwritten. He could notice the changes that would be invisible to all but those who had been born and raised in this place.

Twombly, buying that brick house on Barclay Lane and moving from that big warehouse to a more permanent studio in town, a storefront that had once been the office for the gas company, made himself again a citizen of Lexington. Not just the famous artist returning for a passing visit, but the famous artist who could be claimed as a local. Local boy made good. Prodigal son.

▌

"Twombly was never a man for public appearances," writes Nela Pavlouskova in *Cy Twombly: Late Paintings.* "Devoted exclusively to his art, he regarded all media coverage as useless and had no desire for self-promotion or careerism of any kind."[11] Written after his death, an aura of hagiography, it is neither totally true nor totally false.

Twombly preferred to stay out of the public spotlight. He was camera shy. He hated to talk about himself to writers and it shows; there's a bristling edge in these interactions. Kazanjian describes the brief and passing "storm" of Twombly's anger; he "suddenly erupts" when she tried to steer the conversation towards his family history.

"I'm just not interested in myself that way. I was brought up to think you don't talk about yourself. I hate all this." Should we take Twombly at his word? Not just his refusal to talk about himself but his distant relationship to the art world and the purpose of these conversations. "I hate all of this"; *this,* any conversation about his life or art or subject that doesn't interest him.

"They use the word, but I'm not secretive," Twombly said in 1994. "It's not like I'm closed in here. It's not like I'm just with four or five people."

Twombly "insists" on his openness, while at the same time betraying his endless desire to be in control, a watchman of his daily hours: "I haven't answered my phone in years . . . If I want to talk to someone, I call them."[12] To hear people describe his years in Lexington, from that

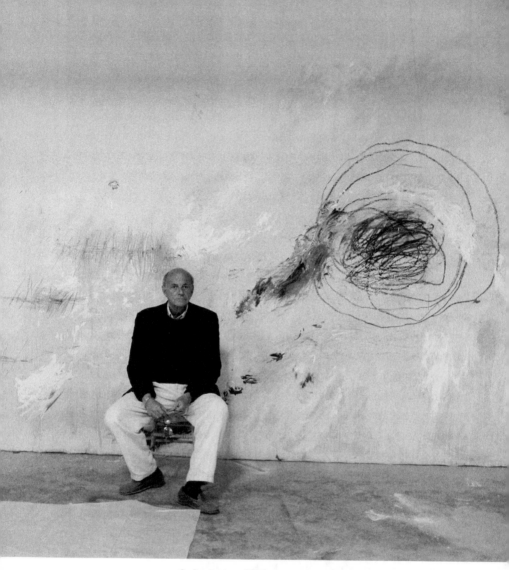

Cy, Lexington, 1994, Photo: David Seidner

finding of a first studio and house in 1993, to his yearly returns for several months, is to have a vision of a man you could always, and easily find. The opposite of that Gaeta residence, up a high hill and invisible from the street.

To hide in plain sight.

"Like his fellow townsmen, he is too much of a gentleman to appear hurried," observes one writer as she accompanied him through town. "When I take a walk," he told her, "my progress is slow because I stop and talk to everyone."[13] To walk the streets of Lexington with Twombly in town was to see the man as he wanted to be seen.

"Although he pretended to need solitude when working," Félibien writes of Poussin, "so as not to be obliged to let certain people into his quarters who would have interrupted him too frequently with their visits, nonetheless my dealings with him were such that I was always at liberty to see him paint." He continues, "And so it was that, combining practice with instruction, he pointed out to me as he worked, and by tangible demonstration, the truth of the things he taught me in our conversation."[14] Twombly's willingness to be photographed—or be the subject of profiles—seems not so different, a kind of instruction in how to be seen, a desire for control.

There's a folksy quality to Twombly in these little portraits, an insistence on his simple wants and needs. Not humble, exactly, or free from pretensions, but authentic—or at least the appearance of it. "I was surprised to discover how down home he could be," writes White, "when I asked him where he was from, he said in a good ol' boy drawl, 'Me? Hell, I'm just from Chitlin' Switch.'"[15] Twombly's pose, modest and mocking, was "his way of saying he's nobody from nowhere." Aristocratic baron and country bumpkin, art world player and distant spectator.

Not everyone bought it. "There was a simplicity all around him that didn't exist in his work," White wrote of Twombly, after his death, "I found him to be an elusive, cagey man who mumbled and took back every statement he made, just as he erased so many of the words on his canvases and constantly equivocated about his life and sexuality, standing perpetual guard over his biography."[16]

LEXINGTON

IN HER 2007 PROFILE OF Twombly, Pamela Simpson writes that after returning to Lexington Twombly "helped briefly with a class that philosophy professor Harry Pemberton was teaching on aesthetics, but didn't want to be pinned down to attending regularly."[1]

"Quite an exaggeration," Harry corrected in an email when I wrote to him in the fall of 2012. "Cy came only to the first class and sat in the back unfortunately beside a student who was nervously cracking his knuckles. Cy was offended and did not return. That is Cy. He made instant judgments that are then immovable."

Harry urged that I come to Lexington soon, as Twombly's house and studio were slated to be sold. "I will be pleased to show you about

if you come." I went down a couple weeks later, for what would be the first of several trips.

When I arrived in Lexington in October of 2012, Harry, quickly approaching ninety, met me with a boyish grin. Retired from Washington and Lee, he still taught ancient philosophy, though now at VMI. Wisps of white hair danced at the top of his head. When he had a juicy bit of gossip, he would rub his hands together, then put all ten fingers up, small eye roll and little puckers of his lips accompanying this gesture, as if to say, "I'm just a bit player and I don't know. But I'd like to."

Harry met Twombly for the first time in Key West in the early 1980s where both men were on vacation. They met again in Naples. The first meeting was accidental, the second arranged, and a friendship followed. Harry visited Twombly in Rome, and remembered that Twombly and Tatia, each with a separate wing of the vast apartment, spoke by telephone from their opposite ends. They talked almost every day when Twombly was in Lexington, too, though she almost never came to visit. When visitors came to see the artist in Lexington, it was Harry who would often accompany them to lunches or dinners. He had, for a time, a front-row seat to Cy's Lexington life.[2]

∎

Harry's slow, old-bones walk belied the speed at which he drove his vintage gold Mercedes, taking sharp, fast turns through town and then later on country roads. The first stop of Harry's tour of Twombly's Lexington was the house on Barclay Lane. We walked around the perimeter of the older two-story brick colonial, with English-style boxwood hedges and stone cupid statues. The interior of the house had been cleaned out of everything valuable. What remained were scores of books and the odds and ends Twombly picked up at local flea markets, yard sales, antique shops, and discount malls; the word "hoarder" might describe the way in which rooms, hallways, and closets overflowed with junk: rugs bought and never unrolled, blue tea sets that collected dust on high shelves.

There was no magic in this empty house, though I tried to find it, to call back the ghosts of a place, lifting myself up to peer into its dirty

windows. "The more I think about him, the closer he gets," writes Carol Mavor of Gauguin. That wasn't enough for me, not ever. I didn't want to just think about Twombly, his life or studio; I wanted physicality, the tactile sensation of being there.

Around the side of the house, a gray concrete and glass studio added by Twombly. "It looks like the sort of place you'd take piano lessons," Twombly joked to a writer while the little space was being built.[3] "The whole studio is built around the (18th century restored Jeffersonian) windows," Twombly said of his little home studio, constructed from an existing garage behind the Barclay Lane house to replace the warehouse studio he'd used to finish *Say Goodbye*. "There's no heat, no water, no problem. I'm not an engineer or mathematician but I like to deal with the placement of windows."[4]

I pressed my nose to the glass to take account of the studio's leftover contents: A thirty-year-old exercise bike. A can of colored pencils. A stack of yellowing *Times*. The mantle of a fireplace. Not much to see. He almost never used this space. Twombly preferred instead the building he rented in the center of town, a "humdrum little storefront" on Nelson St. with a bank of windows on the street.

Cy worked in that third, and final, Lexington studio for over a decade. He took over the space in 1999 and quickly filled it, like a junk shop, disordered order of paint and plaster containers, white sculptures rising like layer cakes for unhappy weddings. With its low drop ceilings and humming florescent light, it was a world away from Italian palazzos and country estates. By one account it was a dentist office. In another account, it used to be the Columbia Gas Offices for Rockbridge County. Either way, this "funny old building," captured in Sally Mann's photographs and Tacita Dean's film, is by now iconic in its own humble way.

"You would never, ever think of Cy Twombly working there," Mann said in an interview of this storefront studio. "You'd think of him as being in some poetic, lyrical place filled with ossified Greek heads and this kind of stuff. No, no, no—not at all. It was a storefront and it had these shabby little Venetian blinds. I had no idea why he chose them. I never asked . . ."[5]

Twombly, despite his independence, depended on others. In Gaeta, Nicola lived up the hill, and Cy's assistant, Viorel "Tiger" Grasu, a large Hungarian man who expertly drove the two black SUVs Twombly owned in Gaeta, was also always available. In Lexington Twombly relied on Butch Bryant, "Cy's right-hand man in Lexington," as one obituary put it.[6]

Studio helper, chauffeur, checkbook keeper, social secretary, canvas cutter, and roadside narrator, Butch worked for Cy Twombly for almost a decade. That may not mean he knew the artist best, or can speak as thoughtfully as others in town, but proximity can create closeness.

"He was just a down to earth Southern Gentleman," Butch told a local reporter about Twombly. "He just took it as it came. He never really bragged and boasted on himself."[7] In another interview, shortly after Cy's death, Butch said, "Not only did I lose a boss. I lost a friend. I lost somebody who cared about people and expressed it in his own way."[8]

Sometimes, as he drove Twombly aimlessly through the country-side around Lexington, Cy would have Butch stop the car and get out to photograph the trees and creeks, the fields and the hills. Butch's own description of himself as a "typical Rockbridge redneck" doesn't say anything about those other kinds of knowing, hardship wisdom, old-country truths, plainspoken virtue, that Butch possesses.[9] He was, as one reporter put it to me, the "Sancho Panza to Twombly's Don Quixote."

Another writer speculated about Twombly's penchant for listening, for wanting to be in the presence of others—whether it was Butch or Harry or any of the other friends and acquaintances with whom he'd visit—their voices a kind of radio in the background of his dreaming: "Twombly enjoyed hearing them talk, as if it were soothing somehow, as if it reassured him, as if their talk and ordinary lives were standpoints outside the capacious and demanding territory of his imagination."[10]

Or maybe, Twombly needed Butch, not simply as a driver or helper, but for something more abstract. Butch connected Twombly to

the place and the people. He wanted nothing from Twombly and didn't ask of him to be a famous or brilliant artist. Butch made home home.

▌

By convergence and coincidence, I arrived in Lexington for the second time on the same weekend as Twombly's Nelson St. studio was being cleaned out. When Twombly died, the doors had been locked. It was as he had left it in the fall of 2011 when he had returned to Rome for the last time. Butch too was getting ready to leave. It was as if all of Twombly's Lexington ties were being cut at once and I was trying to gather the threads before they dispersed like confetti thrown into the wind: at once the wrong time to be here and the perfect time.

The first time I met Butch, introduced by Harry, we sat inside in his living room, the TV on mute, as the weatherman pointed to images of a hurricane barreling up the Eastern Seaboard. Cigarette smoke held tight to the fabric of the couch, and just outside on Butch's front lawn, an auctioneer with a headset microphone called out numbers as the bidding started. I thought that Twombly would've liked this, all the priceless knickknacks and tchotchkes, and the anticipatory hum of people in their hungry-eyed search for a bargain and treasure. This selling-off was part of his own preparation for leaving town. He said it wasn't the right time to talk. I should come back when things were settled down.

Two months later, I returned to Lexington for the sole purpose of seeing him. Butch suggested we meet at the Lexington Motel Restaurant, at the east end of town, the greasy spoon where Twombly ate the same breakfast each morning he lived here. The sign on the front, in big red lettering: LEXINGTON RESTAURANT.

That morning, amid the buzz of the breakfast crowd, as the waitresses—neither rude nor friendly, "Honey" and "Sugar," everyone gets called—efficiently poured coffee and served plates of eggs and biscuits, Butch and I talked about Cy.[11]

In the fall and spring months when Twombly was in Lexington, each day was almost the same. Butch picked up Twombly for breakfast at the diner before driving the county roads. Then he'd drop Cy off at home to nap or they'd go to the studio.

"I cut canvases, I hung canvases on the wall, I done all the backdrop painting," Butch said about his work for Cy. "And basically, when he walked into the studio, he was ready to do his loops, curls, marks, or whatever he wanted to do. The same thing with sculptures. Sometimes we'd come in here and work on paintings. Sometimes we'd work on sculptures. Sometimes we'd do absolutely nothing."[12] Some days they wouldn't even go inside the studio, just sit in the car.

Working for Cy gave Butch status in Lexington. A figure of authority, a gatekeeper to Twombly, he knew where to find the great man when he was in town. He worked in the studio; he met the famous art world people; he knew Twombly's days, his house, his hours. Before that, Butch had been on the facilities staff of Washington and Lee, where he had met Harry, who in turn set him up with the job working for Cy. He was, in his own way, essential to Twombly. "He often told me," Butch said, "that his paintings and everything would not have excelled if it hadn't been for me."[13]

Butch is not a man one goes to for information. At night, when Twombly had dinner at the houses of his friends, Butch waited in the car. Part of Twombly's daily world, he was excluded from it too, not that it bothered him. But to be with him, in a roundabout way, is to be with Cy.

As we said goodbye, Butch talked about his own retirement: a condo in Florida and the artificial lake where they fed the ducks and turtles each day, and the shopping center right there, and the layout of the rooms in the apartment. I found myself watching the blue jays circling around the leafless trees across Main Street. Butch can speak about little for a long time, and if one misses what he says the first time, he'll repeat it once again. I imagine this was the dynamic of Twombly and Butch for those years: Butch talking and Twombly looking out of the window as the landscape of hills around them rushed by.

"Most stories about artists and their assistants," writes Roger White, "wrap a protective layer of humor around a nub of anxiety; if you unwrap them you find the question of authenticity at their tiny, fragile core. When are artists delegating nonessential aspects of their work to capable assistants, and when are they phoning it in? The Solitary Genius dies hard."[14]

I doubt Twombly ever "phoned it in"; his vision is too singular. The

kind of work that Butch did for the artist still preserves that idea of the "solitary genius." Yet Butch's very presence runs counter to a mythology in which Twombly worked only alone—or alongside Nicola. As Arthur Danto in his essay "Scenes From an Ideal Friendship," writes, "I know a number of artists whose studio assistants have had that sort of privilege—Motherwell, Mapplethorpe, and several others. They did not have teams of studio works but counted on a single assistant to help. Apart from Nicola, I think Cy was on his own."[15]

In the biographical notes at the end of the seventh volume of the catalogue raisonné of drawings, the entry for 2011 reads "Works on eight paintings *Untitled (Camino Real)* during the month of March, assisted by Viorel Grau and Nicola Del Roscio." That last clause, added between the second and third volume of the catalogue, turns those paintings into collaborative efforts. A similar phrase appears further up the page of the biographical notes; Twombly in 2008, "works in Via Monserrato in Rome on dividing his complete oeuvre into finished and unfinished works, assisted by Nicola Del Roscio."

"I never had a professional assistant," said Twombly in 2004.[16]

I

This is not the excerpt I sent to Nicola. What's different now is not only how much I can reveal about Butch but how much I'm willing to disclose.

Dear reader, fear not. You're missing nothing except this: The sense of loss that's not mine to claim. It belongs to others.

One journalist relates a conversation with Butch days after Cy's death: "Bryant recalled an emotional phone conversation with his employer on Father's Day, in which Twombly sounded 'kind of choked up.' It turned out to be the last time they talked."[17] It's hard not to miss that Twombly, in Butch's account, called on Father's Day.

Grief is a strange animal. There are no scales for loss, no weights or measures. I mourn the silence, not the man. The word *miss* appears four times on one page of Mann's memoir. She writes:

I miss him now each spring and fall, the seasons when he would alight in our valley, and I miss him for lots of reasons, but especially for his irreverence, his confidence in his (and my) art, and how comfortable he was working outside the urban art world. I miss our afternoons at the kitchen table over his favorite meal: tart apples, fried on the wood-stove in the cast-iron skillet with bacon fat, salt, cinnamon and brown sugar.[18]

She misses those things that made him particular, that can't be known except in their intimacy, what C. S. Lewis writes of in his elegiac book for his late wife: "all her resistances, all her faults, all her unexpectedness . . . her foursquare and independent reality."[19] What we love in another is not simply our understanding of them, but the ways in which we don't, and can't, know them, not completely.

STUDIO

BY LUCK, FOR A BRIGHT, brief moment, I was let inside the Nelson St. studio.

My first time in Lexington, a month earlier, I pressed my face against the glass of the studio, angling my head to see through the cracks of the white blinds. I could, just slightly, make out a white sculpture, a narrow pillar of bulbous plaster. Now, allowed in for a proper look, I tried to take it all in: the dripped paint on the baseboards, the line where a canvas had been tacked to the wall, the gray model of a battleship, undoubtedly something found at a thrift store or junk sale, stacks of art books and catalogues, cans of house paint, and tubs of glue and plaster scattered haphazardly. Palette knives and brushes bloomed from their

containers like a vase of metal irises. Bit by bit we attempt to possess the stories of others. Possess their rooms. Their cities. Until we are, finally, ourselves possessed.

I thought, just then, of the moving truck, packed with the artist's work, rounding the Washington Beltway or jetting up the New Jersey Turnpike towards the city, one truck among many: indistinguishable, private. A locked room. I had no way of knowing what imperfect treasures had been packed up and taken away.

Still, this room felt like an arrival.

At the back of Twombly's studio, inside a large wooden armoire, I found an unstretched canvas. I unrolled it across the floor of the studio. I was stunned to see a smear of red and green paint, the lines and gesture of the paint unmistakable: Twombly. But the colors weren't quite right. A swirl of yellows and reds massed at the center felt off-kilter in relation to arcs of color all around it. Unfinished, abandoned, forgotten: it was as if someone had done a bad impression of a Twombly painting.

I thought back to Bassano, a studio space tucked below a stone staircase: a wooden rudder of a small boat, perhaps from a rowboat salvaged from one of the lakes nearby, turned up and mounted vertically on tree stump, driftwood white, with a few nails bent on the surface. I imagined Twombly had just left for the afternoon in the middle of his work—and never returned. A broken, incomplete, and striking reminder of Cy's presence and all that goes undone.

To see an artist's early drafts—Elizabeth Bishop's first drafts of her poem "One Art," for example—or their scrapped efforts is to know how much work goes into the pieces that are finished. The image on the unrolled canvas looked like a Twombly but didn't feel like one—a subjective distinction to be sure, but one that gets to what's so hard about writing about art, or change, or time, or any of the hundred thousand abstractions that depend on being there, on looking at the thing and not the idea of it. Twombly knew this. In his Bassano studio, tacked to the wall, this from John Crowe Ransom: "The Image cannot / be dis possessed of a / PRIMORdial / freshness / which IDEAS / CAN NEVER CLAIM."[1]

The night before, I had walked down Nelson Street, my breath visible in the cool fall air. The plain gray moving truck with New York plates

parked in front of the studio blocked the view of the artwork, wrapped and rolled and crated, and taken to a warehouse. All the secrets of the studio, the last unfinished works, the small scraps of paper with hand-written notes, the empty vodka bottle on the shelf—the last time he drank, a story half-told by those that knew him—boxed and taken away.

It's remarkable the number of times Twombly, who made his work alone, is imagined in his studio, attempts by friends and scholars, by fellow artists and writers, to see the man at work, a way to collapse the distance between the artist and the man.

❚

"What do you use?" David Seidner asked Twombly about his methods of working, the lack of brushes on his worktable.

"Oh, rags, sticks," said Twombly, "whatever I can get my hands on."[2]

It all returns. Fielding Dawson, at Black Mountain College with Twombly and Rauschenberg in the summer of 1951, describes a scene of painter Robert Motherwell instructing his young pupils, the spirit of experimentation:

> Rauschenberg and Twombly on the gravel patio beneath the
> Studies Building, gazing down at a large canvas, covered
> in most part by tar. They tossed handfuls of pebbles on it.
> Motherwell, between them, gestured. Said to throw more, and
> they did.

> "More."
> They did.
> "More."
> They did.[3]

These are works of sensation and chance, "hands on" actions that are maximalist ("More") and, at the same time, very loose. Traits— "irrational, involuntary, accidental, free, random," to quote Deleuze on Bacon—that remove the painter's expert hand, the feeling of

deskilling that Twombly had spent a lifetime seeking and perfecting.[4]

In one of the photographs in Mann's *Remembered Light*, taken in 1999, we see a folding table lined with oil tubes and a collection of paint-dipped paper towels. Crumpled and crenellated in bright pinks and yellows like picked flowers. This beautiful debris. Not one to waste, Twombly transformed these rags or paper towels into the bright top of a white box sculpture. This piece, *Untitled* 2001, like a child's birthday cake. Like a gravestone of electric flowers. Like grafts from his own work.[5] Behind that sculpture, in Mann's photograph, we see the beginning of a painting; a canvas tacked to the wall, a bright yellow circle, the beginning of his ten-part *Coronation of Sesostris*.

I

Coronation of Sesostris 2000, like *Say Goodbye*, is a kind of journey. This cycle of ten paintings moves from childlike suns, discs with sharp rays— the words *Solar Barge of Sesostris* written above the little chariot on the second canvas—to passages of brilliant primary colors and crude boat-like forms, black oars dipping into the white. The chariot that brings the sun, the myth of the solar barge, becomes the boat that takes the dead to the underworld. "They are characteristically Twombly exercises in sophisticated infantilism of deception," writes one critic, "coupled with a kind Alzheimer's calligraphy, which is uncertain—taking a line for a few hesitant childish steps, trembly, wobbly, twombly steps."[6]

Half-legible lines—the unnamed source is Sappho—fill one canvas and are erased with paint in another: *Eros weaver of myth, Eros sweet and bitter, Eros bringer of pain*. It's a refrain. A curse. A song to dance and live by. Other poetic fragments too, a little Archilochus, *Leaving Paphos Ringed by Waves*, and the poem "Why Drink," by a little-known contemporary American poet, Patricia Waters. Don't try to read all the words: some are clear and others slip away.

By now you know all of this—the title and words in the painting are a clue to intentions, or a dead end—Sesostris, a twelfth-dynasty Egyptian pharaoh; the solar barge; the lines of Sappho. This isn't new material. Like a dog with a bone, Twombly has other drawings with

the same or similar titles from 1974 on Jupiter Island, Florida, though the spellings (Sesterois, Sesotris) sometimes change, an act of carelessness as "freedom or indifference," or just error.[7] As a former professor of Classics at Washington and Lee observed, a man who often answered questions about Roman emperors and Greek epics for the artist: "Twombly usually got the names wrong."

"The series depicts the myth of love," writes Craig Raine, "its intoxicating power, those *ravishing* reds and yellows, those luscious lavenders, and its end in darkness, the blacks in the final canvas. Everything depends on the pigment. It does not fail us."[8]

Coronation reminds me of what David Salle writes about these painterly effects. "But more to the heart of the work," writes Salle, "the thing that reveals its nature and quality, is the *how*, the specific inflection and touch that go into its making. To take a work's psychic temperature, look at its surface energy. Like syntax and rhythm in poetry, it's the mechanics that reveal an artist's character. They determine the way that art will get under our skin, or fail to."[9]

One could write a short dissertation about the textual layers or allusions claimed here, both by Twombly and his critics. And yet, these paintings, in their journey and progression, in their texts, whispered like a "lover whose pillow talk can barely be heard," work because of Twombly's bright effects and dark marks. "Twombly," critic Jed Perl writes, "knows how to express dispassion with a little painterly passion."[10]

In his review of the paintings, first shown at Gagosian Gallery in New York in 2001 (and again in 2018), Jerry Saltz describes the progression of the paintings as a kind of "vision." Saltz, at least in this review, is hardly a critic ready to love these paintings: "Since the mid 1970s, Twombly's art has felt either apathetic, out-of-sync, overly refined, or overwrought."[11] Writing, not quite accurately, that it had been thirty years since an exhibition of new Twombly paintings in a New York gallery, he traces *Coronation*, from part to part, its "mournful minor keys of yearning and homesickness."

On the fifth and sixth paintings, his favorites of the cycle, as the "fabulous barge comes into view," Saltz writes, "Part chrysanthemum, part thistle—a descendant of his early vaginas and phalluses—this

nebulous vessel is drenched in blush-rose reds, violets, and yellow. The sight of oars being lifted from or dipped into the white ground is blissful . . . Overwrought or not, it's pretty poignant."

I

"One of the things about Cy that always fascinated me," said Mann, "and even made me a bit jealous, is that he seemed to work with such extravagant joy, with an energy that almost burst out of him and onto the canvas."[12] Twombly's method of working was at once breathless, energetic, a dervish of activity but also a slow process, one of waiting for the right moment. It's to see, as Edmund de Waal notes in looking at Mann's photographs of Twombly's studio in Lexington, the transformation of everything brought into the space, from the gathered treasures from yard sales to the stacks of books, into art: "This strange way in Cy's work that junk becomes sculpture, that reading becomes painting, that mark-making becomes drawing, that graffiti becomes words."[13]

Simon Schama, looking at those same photographs, describes the "improbable discipline: tubes of paint laid out in rows; cleaned brushes reporting for duty in their pots." This "improbable discipline" gives way to what he calls "Twombly's Rabelaisian appetite for raw color."[14] Mann's photographs of Twombly's studio or home never show the artist at work. David Seidner's photographs too give us only the studio, the paints in their careful order. The stacks of books and tools and assorted objects that might one day become sculptures.

Among the few photographs of Twombly in his studio, I've found only two photographs of him actually at work. One, an intimate image taken by Camilla McGrath in 1959 of Cy drawing on paper. In the second, from 1962, taken by Mario Dondero in Twombly's Rome studio, the artist appears to be making a pencil mark on a canvas. This, though, is far from a casual snap, a staged encounter; Twombly's posture stiff, joyless as, by standing close enough to whisper to the canvas leaning against the wall, a mark is made.

Two other photographs—one by Ugo Mulas taken in 1969 in Bolsena and one from Horst's shoot at Via Monserrato in 1966—show the artist attaching canvases to the wall, but in neither is he actually at

work. In another of Mulas's photographs, Twombly—barefoot and in shorts, a look of ease and summer—peers down at a series of drawings on the floor, a painting in progress tacked to the wall behind him.

"This is how I imagine Twombly working," writes Tacita Dean: "trance-like concentration with his pencils and crayons lined up and ready, and with his tubes of paint, advancing to make preliminaries, retreating, advancing again to make progress by undoing, and then retreating."[15] Order and chaos balancing against each other in Dean's vision of the man, military-like in his campaigns and returns, the tension between the order and the chaos.

By contrast, there's Brice Marden's attempt to picture the artist: "Yesterday, I was trying to imagine him at work. I can see Richter, all these other people, but it's hard to see [Twombly] physically applying the paint. There was the relaxed demeanor he had, but such an intensity to the paintings. Was the relaxed demeanor because he had to be that way to work up that kind of intensity? I don't know."[16]

Here's yet another take by Carol Mancusi-Ungaro of watching the artist at work, the first time she'd seen him hold a brush: "He had written the added phrases on notebook paper beforehand, but his decision regarding their inclusion continued up until the last moment. He also proceeded to correct a few misspellings that reportedly had been pointed out to him by one of his old friends from Lexington."[17] Twombly in this moment wasn't making as much as revising, shaping the lines he'd written on the canvas.

"You would think you could get away with placing a mark on such a big painting that wasn't quite right," Twombly said to Paul Winkler, "but it is not possible; it affects everything."[18] There is an invisible structure that holds it all together, a balance between chaos and order, between the work that is unfinished and that is finally done. Twombly, for all his claims of disinterest or casualness, reveals his intense concentration and focus. A secret perfectionist. He worked "up until the last moment," and then continued.[19]

But to see firsthand Twombly actually creating, we have to return to, and trust, Nicola's description of making the gray-gouache drawings of the early 1970s. Nicola, essential in his own retelling, describes how they laid out newspaper across the floor, the drawing paper carefully

positioned above, the acrylics opened or mixed by Nicola "to create the impression of multi-layered colours that Cy was looking for." Nicola describes the scene:

> I still have the vision of Cy's hands holding the white wax sticks like a conductor's wand, moving as if by magic . . . Now and then the white wax crayon would break under the pressure of his fingers on the paper . . . I can still hear the noise of the wax sticks breaking under the pressure and the noise of restarting while Cy's heavy breathing made one notice even more the silence of the room.[20]

And yet, even as we hear the sticks breaking or the breath of the artist, he is out of reach in these moments as well. He moved, as Nicola writes, "as if he was dreaming in a place where memories of experience live under the shade of melancholia."

The lesson is this: we want to step inside. To study. To see.

THREE SCULPTURES

A COUPLE OF MONTHS AFTER his surprise invitation to meet, I wrote to Nicola.

"Dear Nicola," I began, "I hope this finds you well. I am not sure if you're still traveling or back in Gaeta, but I wanted to be in touch." I told him that I would only be in Italy for another month, spending part of that time in Germany conducting research. "I would very much like to talk to you again. Perhaps we might set a tentative date to get together, either in Rome or, if possible Gaeta? My thanks as always for your time and your insights."

He wrote back two weeks later: From Joshua to Mr. Rivkin; from Nicola to Nicola Del Roscio, the tone of the email changed, even if the

substance—the three sculptures that Cy may or may not have given Butch—remained. He described the writing that I had sent as inaccurate, a distortion of the facts and a repetition of a fantasy by Butch, a close relationship that never existed.

Nicola's previous messages had been full of common idiom and spelling mistakes, some because of his English, some because he had replied via an iPhone. This email, though, was flawless.

Nor, he said, did he think much of my writing. Almost five months after I first sent the excerpt, Nicola had decided that my writing failed to do justice to an artist as extraordinary as Twombly.

I was disappointed, of course, though by then accustomed to the repetitive dance—court and reject, court and reject. I thought of the letters controlled by Twombly's estate that I'd never read, I thought of the images I would be unable to include, all the stories that Nicola might have offered, a filling out of the years they spent together.

I wrote back right away, a carefully worded email of surprise, both at the tone and content, especially considering that he had initiated our previous meeting and then followed up with a nice email and two of his essays. At the same time, I tried to be as direct as possible:

> To be clear, I met Butch on two occasions in Lexington. My reporting of his comments is accurate. His point of view and memories are important, even if they are partial and even if he leaves some things out. What he leaves out is, in a way, just as important as what he includes, and any careful reader will see this.

I ended with a mix of bravado—"My work on the book continues"—and sentences that now seem naïve: "If you change your mind, I'd still be happy to talk to you more. I do hope you'll reconsider as you offer a valuable perspective."

I had thought my email would be the end of it. A disagreement over what is a decidedly minor point—a gift that was extended or not—in a much larger story of Twombly's life and work. But *this* is the story: what narratives may be told and which must be kept silent. And, beyond that: who decides.

I was unprepared for what followed. Nicola wrote back, this time cc'ing Julie Sylvester and David Baum, the Cy Twombly Foundation's counsel and a partner at a large New York City law firm. Nicola claimed to have contacted Butch, who said he had never spoke to or met me.

Why would Butch suddenly not remember? And why would Nicola get in touch with him now? Though I didn't record the interviews, I had my notes and cell phone records—not to mention the word of others, who were there when I first met Butch.

I didn't respond. I didn't see the point. "It is useless," Jonathan Swift supposedly said, "to attempt to reason a man out of anything he was never reasoned into." I was done trying to convince him or anyone else on that email of my good intentions or the accuracy of Butch's statements. It felt like relief. The subtle plays of power and promise had arrived at nothing, though in a way we'd each gotten what we wanted: the confirmation of our basic narratives of each other.

I could say that Nicola was every bit as difficult as people had warned me. He could claim that I was simply interested in gossip. These are not the full stories of either of us, of course, inaccurate and incomplete like an unfinished painting, or the view of a battle from a great distance.

Several days after the email from Nicola in which he claimed to have spoken to Butch, I received an email from the Foundation's lawyer with a scanned statement by Butch. The signed statement claimed that I never met him, but if I did, which he now can't recall, he never said the things he said. It reads like the work of an attorney: *I didn't meet, but if I did*. The language of having it both ways.

It was hard not to notice Butch's simple signature, a sharp contrast to the polished tone and lawyerly content of the letter. The letter that Butch signed quotes specific passages from the excerpt I sent to Nicola: a brief of quotes taken out of context. Butch's letter was careful to say

that he hadn't read the excerpt I had only shared with Nicola, though its substance had been relayed to him.

There was, the letter states, no father/son relationship between himself and Twombly; their relationship had been strictly professional. I thought not only of our conversation but also what Butch said to a reporter shortly after Twombly's death: "Not only did I lose a boss, I lost a friend."[1]

I wanted to write back to ask why the lawyer for the Cy Twombly Foundation was working on behalf of Butch. He is not listed as an employee in any of their public tax filings, and by his own account, was done working for Twombly and the Foundation. I wanted to write to Butch to ask why he would sign the letter.

In all of these letters, from the lawyer, from Nicola, and even in the one from Butch, the refrain is the same: This is gossip. And, as such, trivial. What Butch revealed about Twombly, however, is far from gossip. He offered an example of Twombly's influence on the lives of people in Lexington. He offered a small window into Twombly's life and artistic practice.

▌

The letter from the lawyer claimed to have my interests in mind. Cy Twombly, he noted, is a public figure, while Butch is not. Thus, the legal standards of what can be written about each are different, a distinction I learned on the sharp curve of threat and worry.

He was right, to a point. The standards *are* different; the famous and the dead have little control over what's written about them, while the unknown and living have more rights. I started researching the right of privacy and the right of publicity, fair use and fair dealing, a rabbit hole, dark and deep, full of sketchy information and "what ifs." About the truth, I had, and have, no doubts: I interviewed Butch on two occasions, my notes of our meeting are accurate, and the information is relevant. Yet, here I was put in the position of having to defend those facts, or at the very least anticipate the same at some point down the road.

I got in touch with friends, lawyers in the Bay Area, for advice. Their

response was clear and immediate: Don't write back without counsel. The couple, both attorneys, started asking around, trying to find someone who is an expert on these matter to help further.

The couple's neighbor, a former lawyer for the *San Francisco Chronicle*, stopped them halfway through their account of the situation and said, "Let me tell you what's happening." He knew it—from the sample pages to the lawyer's request for confirmation of receipt. "This is a professional job," he said. "They're laying the groundwork for a suit. Your friend needs a lawyer."

�

The experience turned surreal.

The attorney for the Foundation emailed again; if he didn't hear from me, he would start contacting places I've published poems and essays to find my mailing address. Beyond my concern, it struck me, too, as funny; at that moment, I was more or less without a fixed address. I imagined letters being forwarded from previous address to previous address, unable ever to catch up to me.

"Don't write back," my lawyer friends warned again. Even to acknowledge the email could be seen as an acceptance of the veracity of the claims. And so, a black cloud descended on my last days in Rome.

Accuracy, I wanted to write back to the Foundation's lawyer, is my goal, too. About the genre of the biography, Janet Malcolm, who was once sued for libel in a case that went all the way to the Supreme Court, wrote, "the pose of fair-mindedness, the charade of evenhandedness, the striking of an attitude of detachment can never be more than rhetorical ruses."[2] At the same time, as another biographer put it, "There is no one truth, but there are a lot of objective facts."[3]

The subjectivity of looking back on an event—whether hundreds of years before we were born or just months or years gone by—means that there is never a single truth. Or, as Nicola admitted in his introduction to the seventh volume of the catalogue raisonné of drawings, a warning about the limits of his own perspective, "Although what one remembers is never exactly a faithful copy and becomes filtered by one's mind."[4]

I wanted to write back this: a sentence from William Maxwell's novel *So Long, See You Tomorrow*, "In any case, in talking about the past we lie with every breath we draw." Memory is contingent. A country not without facts but always shifting and imperfect. As I wrote in my email to Nicola, omissions can be just as revealing as what's actually said. As for our recollections of the past—the color of a bruise, the smell of an afternoon thunderstorm, or green shade filtering down from the Live Oaks—they transform over time. To refuse that is to refuse a fundamental truth about human experience. It is a claim made in Twombly's art, again and again and again.

PART FOUR

35

LATE WORK

VINEYARDS AND OLIVE TREES AND embankments of bright green rose into hills only to fall open again into fields, as the train, *his* train, the one he'd take from Rome to Formia, the closest station to Gaeta, shuffled down the coast. I waited for the water. I waited for Twombly's promise of "white, white, white," and the lines, inscribed on *Say Goodbye*, to be made flesh: "Shining white air trembling in white light reflected in the white flat sea."[1]

Rome disappeared, and with it, all the anxiety about Butch's letter, the lawyer's email, the complications of biography. I was alone, the whole day ahead—no obligations or wants, nothing to get right on paper—just the heat of summer, the blaze of light and permission, the

pleasures of a new place. "Leaving Rome," wrote Cheever in his journal, "the sense of leaving an immense physical and intellectual explosion; the ruins of. South, all the fruit trees are in bloom and all the gardens green."

The train arrived in Formia and I took a bus down the hill to Gaeta. I didn't know where I was going. I had no map, no guide, and only one real destination. In a stroke of good timing, there was an exhibit of Twombly's photography at a local museum in Gaeta, sponsored by Del Roscio's foundation. Before arriving, I had pictured Gaeta as a seaside village where waves of the Tyrrhenian Sea crashed against the seawall of the Sanctuary Grotta del Turco in dazzling effects of light. The reality was different. The new part of the city bustled with activity. At the same time, there was an ease here, a calm away from Rome, all this light and sea air, all these teenagers with tanned shoulders and women holding pink or yellow umbrellas under their arms. At the beach, rows of colored umbrellas stretched into a far distance.

I took a second bus across the causeway to the older, historic part of Gaeta where Twombly had lived, enormous houses set on the hillside, a grand and garish orange-pink church with gold crosses, and small streets just off the water with cafés and seafood restaurants. From the bus's window, the water gleamed. On the street side, fixed on windows and walls advertisements for the photography show at the Museo Diocesano, *CY TWOMBLY: Fotografie di Gaeta*.

His name everywhere.

■

Gaeta, like Bassano or Lexington, offered sanctuary. A world apart from Rome and all the distractions and crowds. This place, where he'd make some of his last great works from his hillside perch, where he could see out to sheltered harbor, the boats like small black sparrows, protected him and his work. Of the effect of Gaeta on Twombly's work, Varnedoe writes, "Since the early 1990s, this misted radiance, and a greater maritime liquidity, have found their way into his art, along with a new palette of ultramarines and blazing yellows."[2]

Twombly's Gaeta house and studio looked out to boats, from U.S. Navy warships circling the nearby base to tourist ferries to yachts to simple fishing boats. These crafts, transformed into a black ideogram, rough hull and quick oars, found their way into his paintings and sculpture, sailing from canvas to canvas. When asked if boats have a particular meaning for him, Twombly evaded the question. "Yes, boats," he said, "I like the idea of scratching and biting into the canvas. Certain things appeal to me more. Also pre-historic things, they do the scratching. But I don't know why it started."[3]

Of these boats, their "infantile" marks, critics have tried to answer that question of meaning, describing these forms as "symbols for the passage of time, for the journey of our life," or as a "ship of the dead," an idea borrowed from Egyptian mythology.[4] For some scholars, these are the barges where the dead burned. For some, they are the royal ships of Luxor. Or maybe the boats are all the same, just one boat, the canoe of Charon ferrying the dead across the river.

Simon Schama writes of Twombly's boats as being part of a tradition of depiction, a contemporary answer to ancient and medieval catalogs. "[Twombly's] renderings of warships are childlike," he writes, "but no more so than where they first appear in the inscriptions of the warrior imagination: in the fleet of William the Conqueror making cartoonishly for the white cliffs across the unfurled film strip space of the Bayeux Tapestry Channel; in friezes of Roman triremes paddling to hubris, officered by captains who ought to have known their Thucydides."[5] Twombly knew his art history and his ancient history, at least enough to recognize that the boats of the past become the boats of the present, continuous metaphors for passage and departure, empire and its fall, commerce and progress, escape, return, exile, or war.

A boyhood "passion" and one that courses through the whole body of work, Twombly's painted and sculpted ships preceded Gaeta. And yet, this late proximity to the vistas of water, the harbor and the Tyrrhenian Sea, with all those passages and passengers, inspired him anew. "Everyone has a labyrinth, mine is history," writes Jill Lepore of her lifelong obsession. Twombly's labyrinth, even more than history or poetry, is place.

Inside his Gaeta house, Twombly displayed two photographs of an elderly Matisse taken by Henri Cartier-Bresson, a knowing nod to this good and possible model for his own late-life exuberance. In one of those photographs Matisse is at work, his back to the camera, and his hand drawing the outline of his model on the canvas.[6] "Matisse and Titian," Twombly said, "both took motifs from their earlier work and rethought them in a freer fashion."[7]

There is an ecstasy in his own late works, an openness, a "freer fashion." Twombly's colors grew wilder, florescent green and electric pink, bloody red and cadmium yellow. Moving by pain and pleasure, these paintings create simple forms in complex sets, reminders, as the poet Larry Levis wrote, "that ecstasy remains as much a birthright in this world as misery remains a condition of it."

The truth is this: the MoMA show could've been the end. A valedictory homecoming. A place in the pantheon in which he'd always seen himself. The miracle is this: Twombly continued. For nearly two decades more he kept working, fits and starts, waves and ebbs. He lived, as always, at his own pace and in his fiercely particular way, a life of the mind on its own terms. In two places—one adopted, Gaeta; and the other rediscovered, Lexington—Twombly had that rarest of things in American life: a final act.

Coronation of Sesostris; *Lepanto*; *Bacchus*; *Untitled (Gathering of Time)*; *Peony Blossom Paintings*; *Quattro Stagioni (2nd version)*; *III Notes from Salalah*; *Camino Real*. Of these late works, some are great. Others less so. What they share, though, these paintings, and the hundreds of sculptures and drawings and photographs done between 1994 and his death in 2011, is a testament to his commitment to beauty, a last romantic phase, full of boats and flowers, fire and words, a brightness of paint and mind. Twombly's work in the seventeen or so years between his return to Lexington and his death, rather than growing smaller, expanded up and out as it continued on the themes of his life: desire and time; loss and language.

Perspective is everything in Twombly's *Lepanto* 2001. A series of twelve paintings, each the size of a garage door, this late-career masterwork offers his take on the famous naval battle, a decisive moment in the history of Western Europe. Twombly's childlike boats, oval hulls and spiky oars, burn in iridescent water: saffron yellow and pacific blue and incandescent ruby-orange. In some, we're at eye level to the oars and the colorful bursts seem to be coming from within the boats, little explosions, red and golden streams (like blood or piss) blossoming from the hulls. In others we're above it all, a God's-eye view, looking down at the chaos.[8]

In the *Lepanto* paintings, like *Bay of Naples* or *Triumph of Galatea*, reds and pinks and browns applied directly from tubes, Twombly's whole body is involved in the act of making. The intellectual distance of the "god's-eye narration," writes Kirk Varnedoe, is "counterweighted by an intense physicality—juicy, finger-smeared, gushing and drooling surfaces, where all the elements of air and water and fire are brought back to pungent earthiness by the unmistakable bodily engagement of the artist."[9] A remarkable feat, this physicality, this hunger, given Twombly's advancing age, seventy-three at the time of their completion.

Commissioned by Harald Szeemann for the 2001 Venice Biennale and completed in Lexington, the series drew on eyewitness accounts of the battle: the sea turning red from blood, smoke darkening the day into night and by the end of the battle "gold and crimson in the night sky."[10] From "hand copied verbal passages" from history books to descriptions in literature and poetry, the artist "surround[ed] himself with thickets of such stimuli . . . that spur his imagination."[11] We see, centuries later, not the facts—a 1571 naval battle between a collation of Catholic maritime states, the Holy League, and the Ottomans, a decisive battle between East and West—but rather the feeling of those facts. "What he aims to give us is not the look of great events," writes critic John Russell of Twombly's work, ". . . but the fragmented memory of them."[12]

From G. K. Chesterton's poem "Lepanto" to eyewitness accounts to the four tapestries hanging at the Doria-Pamphilj Palace in Rome (and seen by Twombly in photographs) to paintings by Luca Cambiaso, Giorgio Vasari, Ferrando Bertelli, Juan Luna, Andrea Vicentino, and countless others, Twombly participates in a very long conversation, literary and artistic, about the battle.[13]

Of all of these, it's Veronese's *Allegory of the Battle of Lepanto* c. 1572/3, hanging in Venice's Palazzo Ducale that I return to. I like to imagine Twombly saw the painting at least once, either with Rauschenberg on their first visit to Venice or in the decades after. The bottom half of Veronese's painting depicts the chaotic collision of ships, their masts and little pendant flags. The thousands of men with their thousands of oars. Some of the ships are sinking and others are on fire. Above the human scene of death and struggle, Venice is personified as a young woman kneeling in the clouds. At the far right of the painting, an angel in a pink robe hurls down arrows into the battle. It was, according to the victorious writers of history, an act of divine will that prevented the Ottomans from advancing into Italy and through the Mediterranean.

Twombly's *Lepanto*, in which there are no men, takes no sides. Rather, the boats of each army are broken down, and then apart, in their most primal elements. Missing from Twombly's work are the tens of thousands who died, the small faceless men in Veronese's painting. What stands in for the cannon fire and mayhem, violent shipwrecks chumming the waters with wood and blood and shit and fire, is scale: One isn't simply a viewer in the battle, but surrounded by it, taken up into those galleys and engaged in the shattering of those ships. We're at sea. We're at war. We are in the middle of it—the "it" being history and time, war and death.

Bullshit—my usual reaction, mostly unvoiced, when someone, usually a well-meaning student, describes the lack of description in a short story or some vague abstraction in a poem as a good thing because "it lets us use our imagination." But not here. The filling in of absent detail—the men in the water, the chaos on the decks of ships, the terrible thunder of cannon fire—is our task in Twombly's *Lepanto*. A task

asked of us by size and color, by the motion of the lines, by those electric hues and fiery implosions. If we stand close enough, we can almost hear the cries of the men.

"This then, I thought, as I looked round about me, is the representation of history," writes W. G. Sebald in *The Rings of Saturn*, on visiting the battlefield of Waterloo. "It requires a falsification of perspective. We, the survivors, see everything from above, see everything at once, and still we do not know how it was."[14] A wrong way of seeing, he suggests, comes perhaps not from the failure of attention to what's there but from thinking one can see the past in the present, and vice versa.

It is both a warning about the limits of knowing, to "not know how it was," and a command to imagine. Not the end of our ability to see or know, but the place we start from and return to.

▌

To see the Lepanto paintings in person, permanently installed at the Brandhorst in Munich, a crescent-shaped room designed specifically for these works, is to feel their incandescent gravity. I felt myself pulled closer, trying to see not just the works at distance but how each stroke of the brush or hand burned until the guard called out, "Sir," so that I'd back up.

The canvases demand to be seen individually, phosphorescent ships burning in water, but also collectively, an experience. They make their claim as a group. Through Twombly's stage direction, we move from one canvas to the next, a time lapse, a cinema, a panorama, as if each painting is an hour of the day, or some other diagram of time and movement that coordinates our relation to the scene. The feeling in these works of "lush beauty and grotesque calamity" is of motion.[15]

Or perhaps, as Butch said in an interview, thinking back to their making, it is as if we're looking up from beneath the water.[16] I love his sense that we're not watching the battle unfold from hill or sky or crow's nest, but from under the water itself, in the quiet grave of the sea while above everything is won and lost.

It's easy to forget that these paintings were done in Lexington. It's easy too, to see in their watery forms and engagement with Mediterra-

nean history, echoes of Rome and Gaeta. The curator Reinhold Baum-stark on visiting the studio on Nelson St. observed the miracle of these enormous paintings having been completed in that cramped two-room studio:

> Due to a lack of space, the artist could only work on four pictures at a time and hung a new canvas in front of a barely dried canvas as soon as one was finished . . . This cell-like workplace is all the more remarkable when the visitor considers that Cy Twombly had to conceive of the monumental compositions, had to calculate the dimensions of the room-filling series and had to anticipate the effect on spectators that is now governed by distance and a panorama view.[17]

Even more astonishing, Baumstark claims, is that Twombly in that "cell like workplace," with the blinds to the street closed, captures "Mediter-ranean light into this work, how his gaze seems to have been branded by the view of Gaeta Bay and the Tyrrhenian Sea." From his first paintings in Rome—*Blue Room* or *Olympia*—to these most recent ones, Twombly conjures a luminous and particular sense of light and sky, water and motion.

In *Lepanto*, this drama of light and water, force and time, is what matters: "This is not about objectifiable facts," Carla Schulz-Hoffmann writes of Twombly's work, "but about an overall context that comprises all the inconsistencies and contradictions of memory and perception."[18] She could be writing about this painting—or, indeed, any work of art. She could be writing about the very work of describing the life or mind of another person.

CUTTINGS

THE YOUNG MAN WHO MET me to open the Gaeta museum was unhappy. Normally, the museum didn't open until the evening but I'd made a special appointment with his boss. He led me up the staircase to the second-floor gallery, two windowless rooms where the thirty photographs hung in cheap frames on the wall.

Twombly's Polaroid photographs document what is easily missed: a foundry in Naples, rooms of his Gaeta house, gnarly lemons, small and bulbous. And then there is the photo titled *Miramare By the Sea, Gaeta*: a string of blue beach umbrellas at the bottom of a washed-out sky bleeding into a washed-out sea. Twombly's harbors and interiors, antiqui-

ties and details of his own sculptures, blurred: ethereal postcards from Twombly's life.[1]

Over the course of their friendship Perry Bentley sent Twombly several of his photographs. "Your 'snap' is a 19th cent. Masterpiece," Twombly wrote to Bentley. "You shouldn't give it away. (now I have II)."[2] Twombly praises the colors of his friend's "snaps" while also lamenting his own less vivid attempts. The influence of Bentley's photographs is hard to measure, but as always, Cy's eye, ever aware and open to influence, gathered from multiple sources and Bentley was surely one of them.

With their washed-out hues, soft or out-of-focus subjects, Twombly's photographs catalogue his obsessions with texture and light and place, with the life of domestic objects. At their best, they serve as grace notes to his paintings. "Twombly as patron of the Instagram generation," wrote one reviewer of the show Last Paintings/A Survey of Photographs to describe the nostalgic infusion and modern sensibility in these images. Take the slightly out-of-focus photograph of the large military ship passing in black shadow through the bay; it could have been taken five or fifty or a hundred years ago.

Often, his photographs seem as if they were taken by accident: shot, printed, then discarded. They recall relics found at estate sales, cast-off pictures of private moments: a photo of a bedroom with no bed, only a sculpture and books, a jacket over the chair. "This photograph," writes Edmund de Waal, "takes that moment and gives it a pause."[3] There, in that aporia between this moment and the memory that's being made of it, Twombly's photographs linger and surprise. There's something unnerving about them too, as if in the corridors of the house or on the beach, we're supposed to be seeing a person at the center, a child waving for the camera of his father or the couple on their Italian beach honeymoon, and they're nowhere to be found. The subjects are absent.

The display of photographs at the Gaeta museum was at once incomplete and incompetent. A photo of one of the Bacchus Paintings, for instance, was misspelled as "Beacchus paint." The show was not without its pleasures though; in one small glass display case, along with several of his cameras, different Polaroid models, was a binder of the

white border snapshots in plastic slots. A window into his process: take many, print few. This record of his days, as always, blurred and incomplete: a water glass, a water glass with a biscuit on top, a fleet of boats, a gray-pink cloud, a sunset over a balcony, lemons, doors of a café. Like cuttings from his own life.

∎

To be in Gaeta is to see Twombly's inspirations everywhere. The warships in the harbor. The light. The Mausoleum of Lucius Munatius Plancus, set on top of Monte Orlando like the bottom of a stone cake or one of Twombly's sculptures, his "white originals." And, of course, the flowers: irises, lilies, bellflowers, peonies, chrysanthemums, tulips, tea roses, dried roses, black roses, palm leaves, calla lilies, hibiscus, dried garlic, plastic and paper and fabric.[4] From his set of untitled "garden-inspired works" done on paper in the spring and summer of 2001, "a riot of floral forms, patterns, and impressions" to the large-scale, wall-filling series *Peony Blossom Paintings* 2007, to the even grander set *The Roses 2008*, Twombly's floral imagination filled his later canvases.[5]

Peony Blossom Paintings, six eighteen-foot canvases with swirls of red and pink, overpainted drips, big brushstrokes, and simple forms, is lush and violent. Twombly, as one critic notes, "has an apparent affinity for the beauty of the peony, having photographed the flower as early as 1980 in Bassano in Teverina."[6] In the photograph *Tree-peony* the white flower resembles a light bulb; the stem is black, while the flower is suffused with illumination, its petals like a single burning mass. And yet, even as *Peony Blossom Paintings* announce a particular flower, the peony in their title, and the fragments of Japanese haiku poems handwritten by the artist, there's nothing that identifies these blooms as one kind of flower or another. Instead, as with another set of flower-like forms, *A Gathering of Time* 2003, white blooms splotched on a turquoise ground, the shapes evoke without specifying. "[T]hey weren't about peonies; they're just about blooming," he said, describing that the "haiku were added as a kind of nuance or touching piece to the paintings."[7]

In real flowers Twombly had little interest. "Although Twombly's

imagination may be filled with flowers," writes Nela Pavlouskova, "they were absent from his garden in Gaeta."[8] A garden of trees. It had always been those around him, Tatia and Alessandro and Nicola, who made gardens of flowers and palms.

His Gaeta studio was a different story, filled with flowers, or at least the images of them, tacked to the wall: "Loosely painted late Renoir flower prints jostle with eighteenth-century still lifes ripe with abundance; a postcard of a simple photograph of a rose in full bloom opposite a late Pierre Bonnard painting, *Nature morte au melon* 1941, of a yellow melon and bowl of peaches rendered in swirling, interlocking greens and reds."[9] Are these images for inspiration or warnings about the road already taken? Or, are these a reminder of the flowers of his early years, little pictures of bouquets and blossoms drawn as personal gifts: *Some Flowers for Suzanne* 1982; *Tulips* 1980; *Some Flowers for Bob* 1982; *Some Flowers for Debbie* 1982; *Some Lotus for Tatiana* 1978; *Untitled (BETTY WITH 3 SONS)* 1978; *Nicola's Irises* 1990?

Of these late flowers—and especially *The Roses* series—I'm unconvinced, a reliance on grand gestures to prop up empty ideas. His faults, as Randall Jarrell wrote of Whitman, are easy to see and obvious. Like Warhol's flowers or Matisse's paper cutouts in subject and bold palette, Twombly's roses, with their fragments of Rilke's poems, electric streaks of red and yellow dripping over circular forms, overwhelm the viewer with their size and sweep. Scale, though, is not enough. Compared to the flower works of these other artists—or, indeed, compared to the bright burn in Twombly's late-life Bacchus Paintings, for example— they lack something. All perfume and no thorns.

In praise of Titian's paintings, Lucian Freud said, "They have what every good picture has to have, which is a little bit of poison."

▌

Is Cy Twombly what's wrong with modern art? goes the attention-getting headline for an article published in the *Houston Chronicle* shortly after a set of shows at the Menil and MFAH in 2005.

"The faults in Cy Twombly's paintings," writes the critic, "are right

on the surface: grandiose scale, pretentious classical allusions and gushing sentimentality. Hating Twombly for his self-indulgence is like hating the ocean because it's wet."[10] In generous moods, I disagree, but the big flowers done at Gaeta test my love of Twombly.

The catalogue essay for the 2007 show at the Collection Lambert in which those Peony Blossom Paintings were shown, "Blooming: A Scattering of Blossoms and Other Things," claims that, "These new paintings daringly conflate French decorative art and architecture, Japanese history and poetry, German Romanticism, the élan vital of Twombly's own original Abstract Expressionism and the human implications that these flowers hold for the artist as he punches eighty."[11] It sounds good, but it doesn't line up with the work. Daring devolves into mannerism. Though I doubt he means to, Robert Pincus-Witten, a fine critic of Twombly's early work, conjures a critique of Twombly's so-called decorative streak, the sense of his paintings as beautiful, expensive wallpaper.

The charge that Twombly was an empty and pretentious decorator, a criticism tied up in homophobia and ideas about what a masculine "straight" artist should look and live like, goes all the way back to the first reactions of that 1966 *Vogue* shoot, those decadent rooms of antiques and his own art. "Simply put," writes Pierre Alexandre de Looz of this initial response to Horst's photographs, "Twombly had taken on a role deemed acceptable for a gay but distasteful for a serious artist; he had come out as a decorator."[12] One can, as de Looz effectively does, dismiss the critique of Twombly as decorator (or embrace it without those pejorative connotations, a praise of camp and decadence and performance) and still question these "not so complex" paintings, as Twombly described them.[13]

In *Blooming* 2001–2008, dozens of overripe forms, like rounded carnations or bright roses, burst and drip in cadmium red. A print for easy enjoyment, vivid and immediate and graphic, the scrawls of acrylic and crayon on wood panels. It's no wonder that at the 2016–2017 Centre Pompidou retrospective, that painting's pattern was reprinted on a tote bag.

Not every work can or should be as ambitious (or serious) as *Say*

Goodbye. Joy and happiness and ecstasy, even if temporary pleasures, have a place in Twombly's work and in contemporary art. And sometimes those decorator effects, those shimmering surfaces, are enough. Of seeing the Jackson Pollock room at the Met's *New York Painting and Sculpture: 1940–1970*—a show that included both Johns and Rauschenberg but not himself—Twombly said, "I felt uplifted. This is what art should do—make people feel more alive."[14]

TO HOLD THE TENSION

I TRADED THE COOL AND quiet of the Gaeta museum for the blinding sun and the heat of midday. Twombly's house called to me. I wanted to collapse the distance between our lives. Without a guide, I soon found myself lost and hot. As I wandered up staircases and down narrow streets, the sidewalks vanished. Cars hurled past. On the far side of the peninsula, I looked down as the turquoise sea crashed against the rocks.

Their houses—Nicola's, a converted nunnery, and by one account full of oil paintings and a stuffed lion; and Twombly's, "like a castle," with its gray front door and "endless corridors, crammed with books

and art and found objects"—were here somewhere.[1] I had once hoped that I'd be welcomed in Gaeta by Nicola. Inside Twombly's house and studio I would study the notes he left tacked to the wall, the white bookcases and the books with their paint-stained pages; I would walk through Nicola's vast garden, the little eden, "he created from scratch . . . over 15 terraces with thousands of shrubs and trees, as well as palms, many endangered, from every corner of the earth and a raft of orchids and irises."

Navigating those narrow roads, the vista of the sea widening, I imagined knocking on doors and trying to find Twombly's house, or at least the gate. I practiced the words in Italian, *Scusi, Cerco de la casa del artist Cy Twombly*. I was done with closed doors, with spaces I couldn't enter. At least for today. I knew myself well enough that any claim of being done was only temporary. I'm called to graves. I'm called to the lives and stories of others. I meandered down the hill towards the bus that would take me to the beach, and then home.

▌

This is Twombly at the end: He kept working. He kept making, kept returning, kept trying to create something beautiful and imperfect.

"Painting is one of the few things in life for which youth holds no advantages," writes David Salle. "The diminutions wrought by aging—of muscle mass, stamina, hearing, mental agility (the list goes on)—are offset among painters by fearlessness, finely honed technique, and heightened resolve."

Of his *Untitled (Bacchus)* paintings, sets from 2004 and 2006–2008, enormous loops of orange-red on a beige ground, a late-life engagement with the actions of his younger days, he said, "It was just very physical, it's a process. I tried to do one since then but it didn't work. It was the sensation of the moment, you can't warm it over, unless you want mannerism."[2] Twombly, using brushes attached to long poles, the same technique Matisse used for the chapel at Vence, found new freedom—to work at a scale greater than his body, to allow the loops of paint to drip.[3]

For the whole of his life, Twombly was drawn to the figure of Bacchus or Dionysus, a totem for the creative act itself, an undoing of inhibitions.[4] Abandon! Abandon! In these late works, done when the artist was in his seventies, there is a boldness, a vibrant, expressive attention; like blood or wine or fire, the lines overlap and overwrite and bleed. Drips of paint course down the canvas.

"It's instinctive in a certain kind of painting," Twombly said, "not as if you were painting an object or special things, but it's like coming through the nervous system. It's not described, it's happening."[5]

Of the process of creation, Nicholas Cullinan writes that some of these later paintings, executed in the Gaeta studio, "were folded over on the floor, so paint, still in its liquid state, poured down and accumulated in the fold between wall and floor, or the axis between horizontal and vertical."[6] The effects are wild, a technique that favors chance. The red paint and beige ground, Cullinan writes, is "suggestive of flesh and wine, while the dancing movements of a series of seizures, splashes, deletions and erasures orchestrate the unruly choreography of the brushwork, which is no longer hesitant, as with much of Twombly's previous work, but bold, performative, even theatrical."[7] To achieve this, Twombly sometimes drank while he worked, trying to "stimulate a free passage of thought."[8]

I once stood before two of the Bacchus Paintings at the Brandhorst in Munich, noting the differences, in their arcs and swirls, the play between circle and line. These works, in conversation with the earlier blackboard loops and yet so different, seem to halt and reverse, to change their course while the white loops keep going. These are, and are not, the loops of those early years. These loops are mortal, the course of blood under skin. The flow of wine in the veins.[9]

Behind me, as I took in the painting, two boys in their twenties in tight black jeans, their patter in German beyond my understanding. I wished I could have eavesdropped on their conversation to know what they thought of these works, what secrets the open circles might have spoken to them. In my notebook, right below *One sees places where the drips seem to be added later* and *The work in this scale feels museum ready*, I tried to draw the loops in my notebook, tracing first the top row, the

larger circles, the wilder vortex, and then the lines going under and over until my eye finally got lost and I could no longer distinguish the start or continuation or end of the lines. As the artist said of his own work, "I show things in flux."[10]

Looking at this wild bacchanal of motion, I was reminded of the incident between Twombly and the curator Achim Hochdörfer.

Hochdörfer said something offhand to the artist about the decline of Rauschenberg's work in old age. Cy became furious. "Do you have any idea how difficult it is to hold the tension over several decades?" screamed Twombly.[11] Twombly's already short temper grew shorter with age.

"Twombly brought me up short," the curator later wrote. "He stood up and started pacing back and forth (which he always did when he was pensive), looked out the window at the open sea, then finally returned to our table. It was clear that that discussion was ended, and the rest of our conversation dealt with more innocent matters."

These works have that tension, and surprise, a management of feeling and a freedom. To hold the tension—it must have required not just stamina but thirst.

I

An enormous wooden cabinet in the offices of Nicola's foundation holds fifty years of Twombly's things: "private letters, original Polaroids, correspondences with dealers, workaday notes requesting paint colors, Twombly's eyeglasses, paintbrushes."

"But he doesn't open the cabinet for a visitor," writes Stacey Stowe in her *Times* profile, as if channeling Nicola, "Some things belong under lock and key."

The fact of the matter, though, is that these things are not kept under lock and key. Nicola doles out bits and pieces, a studio note here, a binder of Polaroids there, a private letter between lovers. In the catalogue for the Centre Pompidou retrospective, Edmund de Waal's essay on Twombly and whiteness ends with a sort of postscript. Just before the essay was printed, he got an email from Del

Roscio, with a letter "found in the archives of his Foundation," sent by Rauschenberg to Twombly on April 15, 1954, a time when Rauschenberg was in New York and Twombly stationed in Washington, DC, an army cryptographer.

A note of nostalgia, written in all capital letters; "IF ONLY," it begins, "TIME WERE OURS TO SPEND, AGAIN. TO HAVE OUR LIVES." Rauschenberg says that he's just finished a set of fours panel white paintings and it's now drying. "I WANTED YOU TO BE WITH ME SO MUCH WHILE I WAS DOING THE PAINTING AND THOUGHT OF BLK. MT. IN THAT FUNNY LITTLE ROOM WHEN WE PAINTED THEM THE FIRST TIME."[12]

The letter reveals that Rauschenberg's first white paintings were a collaborative act, a fact that others have noted elsewhere.[13] The real revelations here are more personal, more intimate. The paintings, in the letter, become markers of distance, of longing, of moving apart, of impossible desire. *If only. I wanted.* Does this, too, a moment between ex-lovers, belong under lock and key?

Or maybe that's the wrong question. Because it's not just a matter of what belongs under lock and key, but rather what will be revealed despite that. Of this, I have hope. Not in my lifetime, perhaps, but eventually much more of the truth will come out; letters will surface; stories will be told.

In the *Times* profile, after describing Nicola's lifetime of cultivating his garden, Stowe writes that, "his most dedicated cultivation is Twombly's legacy." The writer's metaphor of "cultivation"—Twombly as garden, Nicola as gardener—isn't quite right. Instead I think of Nicola's description of his house: "I spent all my life to restore this place and when I finish, it will collapse." Nicola's quixotic image of restoration, an act of individual care and attention, ends in "collapse." A possibility for what lives beyond the control of human hands and wishes.

There's a story I love about that auction of Warhol's possessions, an account about discovery and affection and death: In one of the dressers in Warhol's bedroom, a Sotheby's staff member sorting through the late artist's things found a manila envelope with Twombly's return

address in Rome. "It had been opened, so I took it out," remembers Leslie Prouty, "It was a Twombly drawing addressed to Andy, and it was around the time that he had been shot and was recovering . . . It was a beautiful, beautiful Twombly drawing."[14]

A composition in pencil and ballpoint pen, this drawing from 1968 showing an arc of windows above a small mountain of messy red and graphite forms—doodles, stray flowers, oblong clouds, scribbles, little rockets—is inscribed "to Andy with Admiration, Cy."

In the auction of all of Warhol's things, it, too, was sold.

I

In one of the photographs displayed in that Gaeta exhibition, you can see Twombly's reflection in the glass entrance of Bar Bazzanti, a café just outside the museum, where several signed posters of his shows hang above the café's tables. Twombly's face is obscured in the reflection, but you can see the large frame of his body if you look closely: shorts and white athletic socks, the camera held at chest level to take the picture. The artist doesn't hide behind his work but is blurred inside of it. This to me is where we find him.[15]

This self-portrait, taken on the streets of Gaeta, like the glass display case beside the photographs, an old Polaroid camera with the yellow sticker—WALMART HAVE A NICE DAY—offers evidence: There was a man. He lived a life. As much as some might protest any writing about Twombly that isn't strictly about the art, there he was, reflected in the window, a mirage, imperfect and incomplete.

A man's life is a continual allegory, or so claimed Keats. We try to understand the lives that have come before us. Model and warning. We create a topographical map of where they went and what they did. We create a vision of who they were. Promise and possibility. I never found or entered Twombly's house in Gaeta or the old monastery where Nicola lives still, and for this, in a way, I am grateful. In the end, it's not Twombly's house—empty rooms, empty answers—I was after, but his questions.

I got off the Gaeta bus at a stretch of beach. My toes in the sand,

I took off my shirt and stretched out near the water. I closed my eyes. Waves. Kids laughing. Quick conversations all around me. The staccato whistle of the man selling granita. When it got too hot I asked the family next to me to watch my bag—*"una bomba?"* the father joked in Italian, and we both laughed. I waded into the surf. Behind me, rows of orange umbrellas. I turned back to the water, perpetually shifting, silver and blue, nearly perfect, and dove below.

LAST WORDS

IN 1820, KEATS TRAVELED TO Rome to be cured of tuberculosis. The dry heat of a Roman winter, his doctors hoped, would heal him. From the window of his second-story apartment he could see the Piazza di Spagna, its famous steps, and hear the Barcaccia fountain bubbling like breath. All day, then as now, water courses through ships carved in travertine marble, the fountain built as either the commemoration of an unloved emperor's naumachia, a staged navel battle in a fake lake, or as a marker for the very real flood of 1598, which impossibly carried a barge from the Tiber into the city streets.[1] All day, people gather on those steps to gossip. Just down the street is the pension where Twombly and Rauschenberg first stayed in Rome. Maps over maps.

Today, you can visit that room where Keats died. The Keats-Shelley House, opened to the public as a museum and library in 1909, overflows with real relics—a lock of Milton's hair under glass, for instance—and good reproductions, period pieces that stand in for his sickbed or the chair where Joseph Severn, Keats's friend, read to him "incessantly"— *Don Quixote*, English newspapers, anything he could find. Keats, dying, wanted to hear stories that would take him out of the city, to the golden age of another time, Greece or Spain, words to erase his body, erase that room.

When Keats died on February 23, 1821, the landlady burned all of the furniture. The ceiling in the bedroom, untouched, looks exactly as it did, a flower-esque pattern on periwinkle blue, a sequence to count and count again as Keats might have done from his sickbed, Severn reading in the chair and a fire burning in the little fireplace. Keats's last hours, last words, were recorded for posterity by his friend in a letter back to England. "He is gone," wrote Severn, "he died with the most perfect ease. He seemed to go to sleep. On the 23rd Friday, at half-past four, the approach of death came on. 'Severn—S—lift me up for I am dying—I shall die easy—don't be frightened—thank God it has come.'"[2] That letter, Severn's charcoal deathbed sketch of Keats, and the white plaster death mask, live in that room, forever now, under glass.

∎

Like Keats, Twombly thought often about death. Mortality, there in the green waves, in chariots and boats to the underworlds, in the murders of war, in the unmarked graves and tombs of his white monuments. *Untitled ("In Memory of Alvaro de Campos")* 2002, a white gravestone of wood and plaster, marks the "passing" of Alvaro de Campos. It's a mourning for someone who existed only in the mind of a poet, one of Fernando Pessoa's "hetronyms," or fully formed identities that "wrote" the poems. Not a pseudonym but a persona, a whole other self imagined, Alvaro de Campos was "a bisexual dandy who studied in Glasgow, traveled to the Orient, and lived it up in London . . . acting out many things Pessoa dreamed of but never dared to do. Or never cared to."[3] On the front of the sculpture, as if a headstone carving, Twombly has written:

IN
MeMORY
OF
ALVARO
DE
CAMPOS

On one of two bases that raise up the "headstone" a line from one of Campos's poems: *to feel all things in all ways*. What a lovely and terrible idea, a life totally consumed by feeling—an idea that even the poet came to abandon. In "Time's Passage," a poem that begins with that phrase, Campos writes, "I'm held by nothing, I hold on to nothing, I belong to nothing. / All sensations seize me, and none endure."[4] And so ends a romantic, free-spirited life, a life of traveling and fucking, in disillusionment.

Seeing that grave little sculpture, a single life memorialized, it's hard not to think, too, of Poussin's *Et in Arcadia ego*, or *The Arcadian Shepherds*, the painting of cloaked herders gathered around the tomb, that Latin phrase cut into stone, as if spoken by Death or the grave itself: Even in this place of pastoral ease, death exists.[5] Death waits. Twombly's grave for Campos is the marker for the end of a self, abandoned or changed, a mask being put down. This is no ersatz gravemarker at the feet of the living. In a museum, a viewer encounters the sculpture, raised up on a pedestal, like a mirror.[6]

The draw of Pessoa, and Campos, for the artist, seems obvious. Twombly had no shortage of other selves—Apollo, Thyrsis, Narcissus, Achilles, Venus, Bacchus, Orpheus, Sappho, Adonis—mirrors, alteregos, windows, doorways, doubles.[7] If one has a thousand masks, a thousand versions of the self, one can die again and again. Bury one self, inhabit a new one.

"No one was as many men as this man:" Jorge Luis Borges writes of Shakespeare, "like the Egyptian Proteus, he used up the forms of all creatures. Every now and then he would tuck a confession into some hidden corner of his work, certain that no one would spot it. Richard states that he plays many roles in one, and Iago makes the odd claim: 'I am not what I am.'" Confessions in Twombly's work are often hidden

in plain sight, too, submerged in myth and history and poetry, they are marked on the gravestones of imaginary poets, their last words as command and hope and desire: *to feel all things in all ways.*

❚

Twombly, too, returned to Rome to die. Visiting the graves of Shelley and Keats in the Protestant Cemetery in Rome, "Cy decided he wanted to be buried by their side," his friend and dealer Yvon Lambert remembered.[8]

To believe that, in any event, completes a narrative in which the simplest version is that Twombly fell in love with Rome, married a rich Italian aristocrat, sired a son, and never looked back. Rome, always and eternal, welcomed him, changed him, made him, and then waited for him to come home.

"We are all pilgrims who seek Italy," wrote Goethe, though what we seek, even at the end, isn't the place but our dream of it, its fickle shadows and uncertain signs.

In 2010, after an improbably productive fall in Lexington, five finished paintings each called *Camino Real*, violent red and orange swirls over a field of florescent green, Twombly flew back to Italy. His trip wasn't easy, despite the fact he flew on Larry Gagosian's private jet, one of the perks of their business relationship and personal friendship.

"The only two things I like are painting and flying on Larry's plane," Cy supposedly said to Gagosian.[9] Towards the end of his life, the jet took him between Virginia and Italy. When he was first diagnosed with cancer, around 2008, treatments in Boston were successful for a time, but they took a toll. Twombly's medical history, like his lost army records or the locked cabinet of letters in Gaeta, is impossible to reconstruct. We have only the knowledge of his cancer, remarked upon in obituaries after he died, without the fine details of its course or treatment. Do we see blooms in his late work not as flowers but cells? Or, do we see in the loose, wild streams of paint down the canvases of *Camino Real* and *Untitled (Camino Real)* 2011, the rapid spread of illness through his body?

One thing is certain: Those paintings, his very last, were done by a man suffering. "He was in agony; but he did not want to give up," Nicola told one curator. "It really was his last effort."[10] He'd long ago given up

cigarettes while he worked, and his lungs, damaged from a boyhood bout of bronchitis, were weak.

Working through the pain, Twombly struggled for breath, an act of physical endurance to keep going, to hold that tension. I think of that inner compulsion which, even more than that ticking clock, sharpens the mind and moves the hand. "Will I ever reach the aim that I've so long pursued and searched for?" Paul Cezanne wrote in a letter in September 1906, a month before his death.[11] "I am still working from nature and feel I am making a little progress."

Cy Twombly died on July 5, 2011, in a Rome hospital. He was eighty-three years old.

The year before, in November of 2010, Tatiana Franchetti died in Rome. She was seventy-six. Twombly wasn't there. They were still married, though they hadn't lived under the same roof—or even in the same city—for quite some time. In her last years, some of her happiest, she lived with Alessandro in his house outside of Rome—a house filled with the objects gathered from a lifetime of travel: Indian straw carpets and textiles, Turkish rugs and kilims, wild roses.

"Tatiana Franchetti continues to play a lively role," observed one writer visiting Alessandro there, "animating the house with her spirited and cultivated conversation and embellishing its gardens with the exquisite wild roses that are her passion."[12]

Tatia restored this house, along with Giorgio, a wedding present for Alessandro and his wife Soledad. In the process, she discovered the original carved and hand-painted ceiling, two hundred years old, beneath the previous one. The ceiling is "signed 'Nazareno from Capranica' identifying the artist to be from a village two miles away."[13] Tatia's life was like that I think, a signed secret.

"But it is growing damp and I must go in. Memory's fog is rising," Emily Dickinson writes in one of her last letters. It is as if, Mary Ruefle points out, "a woman who everyone thought of as a shut-in, home-bound, cloistered, spoke as if she had been *out*, exploring the earth, her whole life, and finally it was time to go in. And it was."[14]

Cy and Tatiana, 1986, Photo: Camilla McGrath

I don't know what Tatia said or wrote at the end, though she lived her life in precisely this way—*out*—exploring the earth, wandering. And yet, she never left Twombly. The "why" of that choice remains an enduring enigma. Perhaps in a conservative Italian society they felt it necessary to stay together or perhaps it was simpler, after a time, just to live their own lives, to go their own way without any ruptures, any drama. Perhaps they truly loved and needed each other. *For TATIA love Cy Dec 25 1977*, he wrote on the wheel of a little chariot-like sculpture, a small dedication, like those early works dedicated to Lola. "A bouquet of flowers on wheels," he called it.[15] But their relationship was not always easy or ideal. They were an unlikely match from the start, not just in light of Twombly's sexuality, but given their radically different personalities.

Only let this, her death or life, framed by Twombly's, not be the final word. There's too much to admire. She mattered too much to the people who loved her: Isabella, Gaia, Alessandro.

A last story I love, of her freedom and strangeness: Once, she arrived to Isabella's country house with two parrots in their golden cages. As they sat outside and watched the sunset, Tatia opened the cage doors so that her birds might better see the sun go down. Of course, one of them escaped and flew into the branches of a tree. The people below searched for a ladder so that they might put the bird back in the cage. Picture this: Tatia, high above the gardens of the estate, climbing in the trees to coax her bird back down, her voice calling in the dark.

Twombly's final eight paintings—*Untitled (Camino Real)* works of florescent green, a surreal lawn, like nothing natural or wild, a man-made green, while loops of reds and yellows and oranges tornado above—make a last statement, then set it ablaze. Done in February of 2011 in his "factory-like atelier near Gaeta," these "graphically and chromatically harsh" paintings stretch up vertically even as the loops dance horizontally, right off the frames.[16] The circular gestures, layered and unique like the singular whorl of fingerprints, each painting has its own identity, its own DNA, pull and stretch apart, like a lowercase *e* or *l*, or cursive *O*.

As he worked, stick-brushes in hand, long staffs with a brush at the end, the wood panels leaned against the wall. Drips of paint pooled at the bottom, an edge of red like an imperfect timeline of where the stream of paint came to a halt. Hochdörfer describes these drips as "elegiac," a contrast to the crazy vitality of more Pollock-esque marks: "The flowing pigment does not try to record an ever-immediate present (as the dripped paint might), but rather proves to be that of a gesture from the past."[17] They record a letting go.

On his studio worktable, an edited line from an Anne Sexton poem about the fall of Icarus: "Think of that first flawless moment over the lawn. Think of the difference it made."[18] The poem, "To a Friend Whose Work Has Come to Triumph," ends with Icarus' "sensible daddy" arriving in town and Icarus falling into the sea. Icarus' fall in the poem is a

paradoxical act of freedom, not a giving up on life, but an embracing of its temporary heat and pleasure.

"Who cares," the poet asks, "that he fell back to the sea?"

▌

The strength of memory that is left behind. "Those, I was told by a witness, were Cy Twombly's last words," begins Richard Kalina's review of the Centre Pompidou retrospective. Twombly's absence hovers just above the words and spaces.[19] Kalina's opening sentences are also an announcement of access, the insider trading of the unnamed witness who is revealed at the conclusion of the essay, in a footnote, unsurprisingly, as Nicola Del Roscio.

"At the very end," claims Kalina, "Twombly was hallucinating, due to his deteriorating condition and the lack of oxygen in his brain." He wanted to see, for the last time, a small Picasso he owned, perhaps the drawing *Head of a Woman* 1946, a small inked head, visible in one of Horst's photos, that once hung at Via Monserrato. It was brought to his bedside. Surround me with beautiful things at my death. Surround me with the ones I love.

Here are his final words, as reported by Kalina, via Del Roscio:

I let it inside to create, to regenerate, to make it stronger rather than let it go out all at once like a flash in the eye. I made art that regenerates itself. I enjoyed making it so much. Oh! I loved it so much. The strength of memory that is left behind.

They are not words of pleading or intimacy. These are not words of regret. They are words of praise, deep feeling, and ecstasy. They are, to my ear, words that seem so different from the Twombly I've gotten to know in the letters and interviews and accounts of friends.

The story of the last words is first described by Nicola in the short, untitled opening essay of *Cy Twombly Drawings: Catalogue Raisonné Vol. 2*, a piece so slight it's easy to miss. He, too, begins with the end: "Almost one year has passed since Cy Twombly's death last July 5th, and I still

vividly recall his last days." The emphasis here is on the "discreet way," without complaint or mention of his pain, like Severn's description of Keats, that Twombly "relinquished life." In those last hours, Twombly, a lack of oxygen to his brain, thought the curtains were empty canvases and was agitated that he couldn't find his brushes. The reported last words—"the last rational description of his artistic mental process"— are the same, with a notable exception. Missing in Nicola's first account is that last phrase, "The strength of memory that is left behind."

They are also deeply unlike Keats's stuttering and fragmented last words, a direct address to the person beside him, which in itself may not make them implausible. Only that the texture of the language feels different, more written than spoken. The word "regenerate," for instance, twice repeated, or the odd simile "like a flash in the eye," rather than, as is usually said, "like a blink of the eye." It feels miles, too, from the anxiety that always seems to circle just above. In a conversation with Tacita Dean in 2011, Twombly recalled how his mother worried because painting filled him with such anxiety as a child.

"Does painting make you happy now?" Dean asked. To which Twombly replied, "More or less."[20] A far cry from, "Oh! I loved it so much."

These locked-room moments are unverifiable. So many false or multiple versions of final words; Oscar Wilde, for example, who didn't say on his deathbed, "Either those curtains go, or I do." We want those last words, not simply out of morbid curiosity, but because they offer the possibility of radical honesty. At that threshold moment, final and true, we confess: Speak the name of our beloved. The name of a god. A prayer for a mislived life, or offer a blessing for a good one. This last try for truth.

Trust for a moment this last phrase, *The strength of memory that is left behind.* What I know of memory isn't so much its strength or weakness but its volatility, how much it shifts and vibrates, a cycle of transformations and, sometimes, dissolution; memory is, as William Maxwell writes, "really a form of storytelling that goes on continually in the mind and often changes with the telling."

As if watching a stranger's dream, Tacita Dean's 2011 film, *Edwin Parker*, at once totally banal and oddly moving, nearly surreal in its humming plainness.

Dean follows Twombly through his Lexington day. Nicola and Butch hover in the background in and out of the frame while Twombly lumbers, walrus-like, aged and a little lost, his hands unsteady and his words spoken as with a mouthful of sand. "The old men I film," Dean said in an interview, "seem to die just afterwards."[21]

About Alberto Giacometti, John Berger wrote, "The act of looking was like a form of prayer for him—it became a way of approaching but never being able to grasp an absolute. It was the act of looking which kept him aware of being constantly suspended between being and truth." This is the true work of Dean's film.

For a moment, in that elegiac hum of film (Dean shot on 16mm celluloid), Twombly lives. A day unfolds. Butch brings him the mail. Cy asks Nicola to take care of something. A phone call. A catalogue unwrapped. They move around Twombly like birds, though they are never named in the film, never announced. If a person walked into a dark room where the film was playing, they would hardly be able to parse the relationships between them.

All three go to lunch. "Gloria, come," Nicola commands to the waitress at the diner. The only women onscreen in the film, in fact, are the ones serving the men. The camera lingers on the waitresses circling the coffee station in their uniforms of black pants and white shirts; these lives, we see, great artist and small-town waitress, are not so different. Art, after all, happens elsewhere. Or, is *this* the art?

In that strange Lexington studio, Twombly reads an article in the *Financial Times* about Larry Gagosian. We as the viewer are often positioned at a distance, looking over a cord of brushes at Twombly and Nicola, or through the window of the diner as they slowly leave. Blinds become narrow slats of witness. "Dean is a mystic," writes Emily Eakin, "and her recent films are best understood in this light, as awed testaments to the ineffable process by which obsession, solitude, boredom, and repetition are transfigured in the studio."[22]

The film is a rather persuasive argument against the greatness of the artist; the hero's art is not about imagination, we see here, but perseverance in the face of endless tedium. An artist doesn't make but waits, putters around his crowded rooms. And as much as the subject of *Edwin Parker* is time, it's also a film about bodies. Working and waiting. So often we don't see Twombly's face but his hands. To watch the film is to find your own breath slowing down.

"This is a wonderful book on Keats," Twombly says out loud, one of the only times in the film he speaks directly to Dean, mumbles really, the camera focusing the whole time on the book in his lap, poet Stanley Plumly's *Posthumous Keats*, Keats's death mask on its cover. He holds it, barely steady, in one hand, his glasses in the other, as he tells the story of how Keats, on the way from Naples to Rome, was too weak and rode in the carriage while Severn walked beside it: "He gathered a lot of flowers and stuffed the flowers all into the carriage of this dying creature."

In Plumly's book that scene of the carriage and flowers begins on the very first page of the preface. After their six-week journey over tremulous waters, and a two-week confinement in Naples, Severn, wanting to make room for his friend and exhausted of rough travels, decided to walk:

> His painter's eye cannot help but be attracted to the color in the day—mountains, the sea, the Italian sky, the fencerows of the vineyards, and almost at their feet, blue and white and yellow flowers . . . Keats and Severn are tourists, but broke . . . Severn can't keep his hands off the flowers. Nor does he know what to do with them once he's picked them. So he puts them, by the handful, in the small carriage with Keats, like company. This goes on, off and on, for days. By the time they reach the outskirts of Rome, Keats is witness to his own funeral.[23]

Twombly's retelling sharply picks up on the way in which Keats, this "dying creature," by the time they reached the city, was riding in his own coffin, "a witness to his own funeral."[24]

And, as if proof of the strength of memory left behind, I can't help thinking, too, about Twombly's first arrival in Italy, and the way he and Rauschenberg, broke and eager, wild-eyed and young and in love, worked their way north. They, too, "will see" those steps, those days of museums and flea markets, the hours of just being there, making and living together.

"An artist is a necromancer," claims the artist Takashi Murakami, the past conjured back, a dark and dangerous art.[25] Dean's film, like that hunger for last words, brings out the dead. At the film's end, a long, still shot of the leafless trees like veins against the sky, night coming on, wind blowing, and then a cut back to the dark, empty studio, sleeping sculptures, unfinished, and no one there.

39

FOUNDATION

A DARK CLOUD OVER MY final days in Rome sent me looking for something that would keep me going in the face of uncertainty. "When you are in the middle of a story it isn't a story at all," writes Margaret Atwood, "but only a confusion; a dark roaring, a blindness, a wreckage of shattered glass and splintered wood; like a house in a whirlwind, or else a boat crushed by the icebergs or swept over the rapids, and all aboard powerless to stop it. It's only afterwards that it becomes anything like a story at all." I was still in the middle of it, even as the days leading to our departure from Rome dwindled into single digits—days of goodbyes, final errands, and last pleasure trips: the wine store, the Saturday market in Tescaccio, parks and museums and playgrounds. At the same time,

I was writing desperate emails to anyone who might be able to offer advice about what to do about the lawyer's letters.

The artist Max Renkel first told me of the plaque months before, though he demurred when I asked where it was located. Refusal, by manner or custom, seemed to be how things were done in Rome—or at least in the circle of people who knew Twombly. So while the location of the plaque was an open secret everyone knew, no one talked. "Rome," Eleanor Clark wrote decades earlier, "beneath all its obvious racket, of whispers and secrets, so various and insidious that to be open to them can be the beginning of madness."[1]

In the end, the plaque wasn't so hard to find. Deep black with gold lettering and mounted to a marble pillar just off the entrance of Chiesa Nuova, a beautiful, baroque church not far from his Rome palazzo: Twombly's name, followed by a dedication in Latin, a paean from the "Roman fathers" for the "artist who made his Vallecian temple." A pretentious marker written in a language Twombly didn't know and almost never used in his paintings, a conversion of the man into one of the classical figures he loved. *Is this all there is?* I thought, as I stood before the plaque. The silence of stone.

Writing of Twombly's sculpture *Epitaph*, curator Kate Nesin describes the purpose of an epitaph—"to fix a passerby at the site in question."[2] I looked down from Twombly's plaque. At my feet, another grave marker— skull and crossbones carved into the marble, the bones of a long-gone body somewhere deep underfoot. To see these markers is to be reminded of our own bodies, "mobile but momentarily arrested," our own quick and mortal days. They can also be a warning, a reminder of risk: "Hasten Wayfarer," reads the inscription on Archilochus' tomb, "lest you stir up the hornets."[3]

Twombly's funeral was held here, Santa Maria in Vallicella, also known as Chiesa Nuova, just one church among thousands of others in this city, its tall green doors open to a small piazza and the thoroughfare of Corso Vittorio. Organized religion was never part of his life or identity. If Twombly stepped inside churches while he was alive, it would have been to see the art or architecture. It's hard to believe, though, having read the letters about the planning of the Menil gallery, the meticulous specifications about stones and hedges, that Twombly was not involved

in any decision-making about either the plaque or his own funeral. Then again, funerals and monuments are for the living.

In the CBS video feed from the ceremony, a raft of purple and yellow flowers, roses and lilies and hyacinths, bloom atop the wood casket. A string quartet plays somberly and smoke from the censer circles above. The priest sprinkles holy water over the casket, reciting words in Latin. The camera, as it pans across the assembled mourners, lingers on a woman in the first row, the black attire of mourning and bee-like sunglasses. An innocent mistake by a cameraman who, seeing a woman in black at the front, assumed *widow*. It is, in fact, Soledad Twombly, Alessandro's wife. Nicola stood on the other side of the aisle, in the front row of pews, as if he were just another mourner in the gathered crowd.

❚

The plaque is but one physical marker in Rome of Twombly's life. Fittingly, Larry Gagosian's Rome gallery was once a bank graced by neoclassical columns, though the rest is now white and glass; the sheen of money remains apparent.

Twombly's *III Notes from Salalah*, a massive triptych of dripping white calligraphic loops, tight and electric, inaugurated the space in December 2007.[4] "Hooker Green has never ventured so far," writes Julie Sylvester of the washes of green layered below the milky, Arabic-like loops and gestures. Sylvester's lyric essay points to the painting's title as an allusion to a desert oasis, a view of the sea, the smell of incense: "It feels ancient, this very new painting."[5]

"Would it be mad of Gagosian," asks one reporter after the Rome opening, "to open a gallery just to keep him happy? No. It wouldn't be mad to build him a palace, or commission him to fresco a church. Great art comes through the rare marriage of genius and power. That is the tough lesson Rome teaches. It's the old Roman story, being told all over again by Gagosian and Twombly."[6] Power and art. Money and art. These marriages of convenience and necessity.

Another society column about that night—a photo of Twombly with the fashion designer Valentino, an aside about Morrissey dropping by for the show—asks and answers the question of, "[W]hy Gagosian would

open a gallery in Rome, where there are relatively few collectors; most speculate that it is a way to secure Twombly's estate. In 2005, the dealer established an archive dedicated to the artist at the elegant Palazzo Borghese in Rome."[7] Questions about Twombly's estate didn't start when he died. There was far too much at stake, enough to build a gallery, to start an archive, to make an early claim for what happens after.

In the early years after Twombly's death in 2011, gossip about the fate of his estate filled the ears of those who knew him with unconfirmed whispers. In Lexington, his generosity to local causes and friends—a new roof for the church of his childhood nanny, Lula Bell Mills, $10,000 tips at Christmas to the waitresses at the diner, donations to this cause or that—was mentioned as some kind of counterweight to the whispers about the billion-dollar value of his estate or the legal troubles of the Foundation.

Twombly's late-life generosity—a donation, for example, of $40,000 for repairs to the First Baptist Church of Lexington—is confirmed by the public tax records for the Cy Twombly Foundation. Set up in 2005, the Cy Twombly Foundation initially had five board members: Twombly listed as chairman; Nicola Del Roscio, president; Alessandro, vice president; Thomas Salbia, vice president/treasurer; Ralph Lerner, vice president/ secretary. In 2007 Julie Sylvester was added to the board. Seven years later only Nicola and Julie would continue to be involved. By July 2015, of the original members, only Nicola remained.

During the early years of the Foundation, when Twombly was alive, none of the board members received compensation. It was a time primarily of generosity to the local community. Between 2006 and 2010, the Foundation gave away $35,000 to $200,000 a year to a number of charities and organizations, the majority of them serving the people of Lexington or the surrounding area: Rockbridge Area Free Clinic, Habitat for Humanity, Rockbridge Area Hospice, and Project Horizon, a nonprofit fighting against domestic abuse. It gave, too, to arts and educational organizations such as Virginia Center for Creative Arts (VCCA), the Armonia International Foundation of Arts, and Washington and Lee University. Initial donations of $5,000 to Habitat for Humanity and Project Horizon in 2006, for example, were increased fivefold by 2010.

By 2012, the year after his death, there were only two charitable organizations listed. The first was for a church in Rome, a stipulated gift of

$9,804—presumably for the plaque—and second for the MoMA in New York for $5,000. Money donated to the Lexington community, at least through the Foundation, stopped with Twombly's death. The following year, one million dollars was donated to the Whitney Museum in New York. The year after, 2014, $85,000,000 was donated, in the form of three of the Bacchus Paintings and five bronze sculptures to the Tate.

"[Twombly] chose to place them here on loan," Nicholas Serota said of the gift, "and he did speak about them coming here permanently, but of course one never knows what will happen after an artist's death. It has taken until now to sort out the estate, and with the foundation which controls the estate which has given them to us."[8]

That uncertainty about "what will happen" when an artist dies is well founded. There's so much at stake; "In the current climate," Serota said, "they must be worth well over $50m [£30m]."

"Often, at the death of an artist," writes critic Robert Storr, "you may have one or two critics, a curator or two, or maybe three in some strange triangulated relationship, fighting for, in a sense, the right to be the priest of the cult, or the right to supervise the work and therefore guarantee the career of the person involved."[9] He could be describing the afterlife struggles over any number of artists' estates: Mark Rothko, Robert Motherwell, or, most recently, Cy Twombly. "This," the critic writes, "is almost always a recipe for unhappiness and sometimes a recipe for less reputable things."

In 2005, Twombly set up both a living trust and a private foundation. Six years later, at his death, assets from the trust that didn't go to Twombly's family, mostly artwork, were to be distributed to the Foundation. Things did not go smoothly. Alessandro threatened a lawsuit over which works were to go to the trust or foundation. At the time, Alessandro was on the board of both the trust and the Foundation, while Nicola was part of the Foundation only. By the time Alessandro reached a private settlement with the trust, holding on to an undisclosed number of works, he was no longer on the Foundation's board.[10]

Four people were left on the board—Nicola Del Roscio; curator

Julie Sylvester; Thomas Saliba, a financial advisor; and Ralph Lerner, a well-connected art world lawyer. In his introduction to the second volume of the catalogue raisonné of drawings, written a year after Twombly's death, Nicola thanks these other three members of the board by name for their "conscientious and honest work in taking care of Cy's legacy."[11]

A year later, *The New York Times* would publish an article with the headline, "Turmoil at Cy Twombly Foundation," a conflict—depending on your view—over money or power, or both.[12]

Here's one version of the lawsuit, a tale of greed.

Nicola Del Roscio and Julie Sylvester claim to have discovered $300,000 in unauthorized fees by Thomas Saliba. They gave him the chance to resign. He wouldn't. The fourth member of the board, Ralph Lerner, refused to be part of any board meeting, knowing the vote would be 2–1 to remove Saliba. His absence resulted in the lack of a quorum and a deadlocked board.

In March of 2013, Del Roscio and Sylvester, on behalf of the Cy Twombly Foundation, filed a lawsuit against Thomas Saliba. Ralph Lerner was added to the amended complaint in October 2013. The charges against Saliba and Lerner now extended past that first claim of unauthorized fees to include violating regulatory laws by Saliba for failing to register as an investment adviser, covering up the wrongdoing, and overstating the value of Twombly's estate. Money, they allege, is at the core of the trouble.

Here is the other version, this one, a narrative of control.

The actions of Del Roscio and Sylvester, according to the counter-suit, were an attempt to "take control of the Foundation" by their "refusal to fill the vacant Board seat or otherwise increase the size of the Board."[13] In January of 2013, months before their lawsuit, Lerner filed a petition with the court describing a deadlock on the board, 2–2, and asking the courts that Alessandro return to the board to break the tie, a fifth, "neutral and qualified person."

"In retaliation," writes Saliba's lawyer for Lerner's motion of a dead-lock:

Plaintiffs retained counsel and began making unsupported accusations of wrongdoing against Defendants on matters that Plaintiffs had long known about, all in an attempt to oust at least one of the Defendants from, and thereby obtain control of, the Board. Essentially, Plaintiffs attempted to manufacture a conflict on the part of Mr. Saliba to disqualify him from serving as a director so that they, Mr. Del Roscio and Ms. Sylvester, could gain a two–one advantage on the Board.[14]

Who was right? Who had the best interests of the Foundation and Twombly's legacy in mind?

In his last year, Twombly, with Nicola's help, sorted his art into four categories: "finished works, unfinished work, unsatisfactory work to be destroyed, and fragments to be used in the future for collages."

The lawsuit describes Del Roscio's "great frustration" with the archivist hired by Saliba and Lerner: "Del Roscio attempted to correct the errors (and note the discrepancies between the archivist's list and the catalogues raisonnés that Del Roscio had published based upon his expertise), but the archivist refused to make many corrections, stating that she was organizing the list pursuant to the instructions from Lerner and Saliba." The appraiser, according to the Foundation's suit, never inspected the works herself and instead relied on an inventory provided by an independent archivist.

Within the lawsuit a beautifully absurd little parable: A friend came to Twombly with a drawing, squiggly lines and spiky forms, an uncanny resemblance to the artist's own loose, anxious graffiti. I imagine Cy pursing his lips in concentration as he rotates it like a wheel, looking at an angle for a familiar mark or erasure. The artist takes the paper and turns it over. He smiles. *This is a fake drawing*, he writes on the back. He signed his name. A moment of sorcery. The drawing becomes, in that instant, an original. A coy play on Magritte's *The Treachery of Images*, a pipe with the phrase *Ceci n'est pas une pipe* (This is not a pipe) below an image of a pipe. Notice, the artist didn't write *This is a fake Twombly* but

that the very drawing isn't real. (Twombly once joked to David Whitney in 1977 that he was collecting "CT: fakes" and that's all he would ever show again.)

This is a fake drawing, Cy Twombly. When he died, that drawing was appraised for $350,000. The story of the signed "fake" drawing is alleged in the lawsuit as proof of the appraiser's incompetence, at best, if not greed or malfeasance.

Though implying wrongdoing, the questions about valuation don't go beyond that: "There exists no rational reason for inflating the values—other than that Lerner and Saliba might have deliberately overvalued the artwork in order to pay themselves inflated trustee commissions from the Trust."[15] Notice that "might have" in the lawsuit. The lawyer for Saliba counters that, "despite knowing that Messrs. Lerner and Saliba did not claim or receive commissions, instead of omitting references to commissions supposedly received by Mr. Lerner and Mr. Saliba from the Amended Complaint, Plaintiffs asserted ambiguous and equivocal allegations regarding purported commissions in an effort to disparage Mr. Lerner and Mr. Saliba." The reply points to a slight change, from "commissions that *were* claimed" to "commissions *that can* be claimed." Innuendo and allegations on both sides make it hard to know the truth, if there is one.

"What is pleaded as misconduct by Lerner and Saliba," writes Lerner's lawyer, "has now been expanded to a vast supposed conspiracy including not just the Defendants, but also Alessandro (purportedly in collusion with Lerner and Saliba), a world-renowned art appraiser and her archivist (who had the temerity to disagree with Del Roscio on how to appraise Twombly's artwork), 20 Withers timekeepers (who supposedly misbilled their time for some unspecified but nefarious reason), and the law firm itself (which supposedly hid the invoices from Plaintiffs even though it followed the same billing protocol that existed while Twombly was alive)."[16]

▍

Even if they didn't benefit individually from the valuation, as a *New York Times* article points out, "Such overvaluation could leave the foundation

in a precarious position by creating unrealistic expectations of its financial power, and it could destabilize the market for Twombly work by sowing confusion about its true value." Yet, even as the suit complains about the inaccuracy of the appraisal—"The true market value, however, is less"—and asserts that it will seek a second appraisal, that billion-dollar figure continues to be used by the Foundation in their public tax filings.[17]

One billion dollars is, of course, an astronomical figure. A number even more shocking given that a 2010 study by the Aspen Foundation put the combined holdings of three hundred artist-endowed foundations, about half of those assets in the form of artwork, at just over 2.5 billion dollars.

The vast resources of the Twombly Foundation, in part, come from the ongoing possession of Twombly's work, some pieces stored away and others on long-term loan. Unlike artists who die broke, or with few of their own works still in their possession, Twombly's "parsimonious" relationship to dealers created "a sort of private collection."[18] If, in his lifetime, he worried about the works stored in the apartment in Rome, after his death, these works have become the way in which the Foundation exerts tremendous power and influence. Of the paintings "stacked and stacked, leaning face to the wall, jammed," at Via Monserrato, Edith Schloss writes, "Cy had a dirty secret like the rest of us: a surfeit of unsold work."

"All that stuff here," Twombly said to Schloss, "it's like the Collier brothers, isn't it?"

This remark about the Collier brothers, the famous hoarders who died in their own house, is prescient in a way. Mythically, among the worthless junk that eventually killed them, were shoe boxes full of cash.

∎

The judge, Hon. Donald F. Parsons, Jr., described the conflict this way:

As far as I'm concerned, I'm looking out at the parties, the individuals who are involved, and I've got four gray hats—no white hats, no black hats—four individuals who are incredibly fortunate that they've ended up at this place in their lives to be

tied in some way to this Twombly Foundation trust. It almost looks to me like they're all off the raft and they're in a great high place and they're all trying to push each other off because they can't share the riches that are falling to all of them . . .[19]

After more than a year of bitter, public dispute, the suits between members of the Cy Twombly Foundation were settled in March of 2014. In the confidential terms of the settlement, it is as if a military censor's blackout has ravaged the document.

"In the unanimous judgment of all four Directors of the Board," goes one unredacted portion, "the Foundation is best served by resolving both Actions so that the Foundation can move forward with its charitable mission and operations without the distraction, expense and reputational harm arising from the continued airing of its internal disputes in a public forum."

As part of the undisclosed terms, each of the sides dropped their suits, Lerner and Saliba resigned their positions on the board, with Del Roscio and Sylvester retaining control. Since the settlement, three board members have been added: Paul Winkler, formerly of the Menil; Udo Brandhorst, the collector and husband of the heiress to the Henkel fortune; and Jonas Storsve, the curator who organized the Cy Twombly retrospective at the Centre Pompidou. In June of 2015, Julie Sylvester stepped down and the Foundation's lawyer David Baum took her place.

Looking at the composition of a board without anyone from outside Del Roscio's inner circle—each one having collaborated with him in the past on catalogues or shows or sales—one returns to the claims made by Saliba's lawyer when he alleges the purpose of the lawsuit was to "take control of the Foundation."[20]

Then again, as curator and friend of Twombly, Bill Jordan, put it to me, Nicola is "the ideal person to be the steward of this legacy."[21] And the same might be said of the others on the board such as Winkler or Storsve or Brandhorst. These are the people with a lifetime of thought and knowledge about Twombly and his work.

"How did the artistic legacies of Motherwell, Rauschenberg and Twombly," one journalist asks, "turn into the gunfight at the O.K. Corral? The philanthropic mood at some artist-endowed foundations, a fast-growing niche among charities, has given way to rancor rife with accusations of salaries too high and fees unaccounted for or unjustified."[22] The answer to that question isn't simply money—though that's certainly part of it—or even poor planning, but rather the tricky conflicts of power and control, that question of who gets "the right to be the priest of the cult."

Private foundations are expected to do everything from sponsor exhibitions to donate work to publish the catalogue raisonnés, all in the name of the artist. Power, money, and control make complicated bedfellows. To sponsor the retrospective at the Centre Pompidou, for example, as well as the publication of the catalogue, "made possible by the generous support of the Cy Twombly Foundation," is clearly a public benefit. All above board. Yet, the result of any effort to promote an artist and the artist's work—whether an unintended consequence or purposeful aim—can be an increased value for the art.

In the fall of 2014, one of Twombly's blackboard paintings, *Untitled 1968*, sold for 69.5 million dollars, an auction record for the artist at the time. The private seller: Nicola Del Roscio.[23]

An Aspen Institute report on artist-endowed foundations warns, "For foundations endowed with artworks, placing the foundation's art dealer or other individuals who privately own and sell the artist's works on the foundation's board can create a heightened risk for conflict of interest."[24] Heightened risk, of course, is far from actual wrongdoing.

By law, a private foundation doesn't have to open an archive or even make charitable donations. "Despite their considerable influence," writes James Panero, "artist foundations follow no industry standards, are allowed to operate in complete secrecy, and are accountable to no outside individual or entity beyond the attorney general and the Internal Revenue Service, with only the courts offering glimpses of their operations."[25] Panero, however, overstates their freedom from all obligations. As tax-exempt organizations, they must work towards public benefit and

are required to distribute a small percentage of their assets each year. That said, unlike museums, which have standardized ethical guidelines for conduct, artist foundations are free to act as they wish, in particular when it comes to the access to images or archives, and more in their very definitions of "educational purpose" or "public benefit."

"Given that most artist-endowed foundations will be organized for educational purposes," writes lawyer Francis Hill,

> either in combination with a charitable purpose or as the exclusive purpose, the critical question is whether management and enhancement of the artist's reputation and therefore of the value of the art is a sufficient public benefit. If so, what constitutes the public benefit? If not, what activities should an artist-endowed foundation consider to ensure that it is operating for a public benefit?[26]

It is worth noting how the stated purpose of the Cy Twombly Foundation has evolved after the artist's death from "charitable, literary and educational purposes" to the "preservation of Twombly's artwork and legacy."[27] In May 2012, the Foundation bought a beaux arts townhouse on the Upper East Side of New York City with the intention of creating an exhibition space and education center for Twombly's work.[28] Six years later, the doors of that mansion remain closed to the public.

"We are also committed," claims the description of the Foundation's mission on the website, "to supporting other scholarship on the artist and exhibitions of his work around the world." A multiyear project "to process, preserve and digitize the archives" is, according to the website, underway. There's a small caveat that "for qualified scholars, curators, and researchers, however, we may respond to questions or make selected materials available." No gloss on "qualified" or "may" is really needed.

I'm on the side of Joseph Sax, who writes in *Playing Darts with a Rembrandt*, "A simple rule seems best: Material is either closed (for a reasonable period, to everyone) or it is open to all adults, with whatever qualifications are necessary to protect fragile materials from risk or excessive handling."[29]

"The Cy Twombly Foundation is committed to preserving the legacy of Cy Twombly and his work, and it is wonderful to see academic and other interest growing," Nicola said in 2016 when asked about the Foundation's plans. "We will continue to favour exhibitions and publications through which people will see and learn more. Twombly is a painter about whom there are always new things to discover, because as an artist, he kept renewing himself."[30]

Some artist foundations have a clear charitable mission to support individuals or nonprofits, everything from travel grants for younger artists to funding community art classes to public works projects. In the aftermath of Hurricane Katrina, the Joan Mitchell Foundation responded with over 3 million dollars to individuals and organizations in New Orleans.[31] The Rauschenberg Foundation offers residencies at Captiva Island and seed grants to arts organizations. In his will, Andy Warhol "specified that his unsold art and earnings from his copyrighted images should go toward furthering the cause of visual art."[32] In 2012, the Warhol Foundation announced its intent to sell or donate all of the work they owned. In doing so, they would focus only on grants to non-profits and art writers. Every situation is different. Twombly, unlike Warhol, didn't leave behind thousands of works, and his reputation wasn't nearly as public, and yet, the question remains: Is stewardship of an artist's legacy enough?

Twombly's resistance to public life, his private, self-focused, independent way of living, is a kind of bloodline, a dark inheritance for his foundation. In April of 2017, the Cy Twombly Foundation launched a new website. The words "public" or "education center"—once the claimed purpose of the New York City townhouse—appear nowhere in the description of the Foundation; nor is there any information about grants or programs to support artists or arts-based organizations.

Comparisons are everywhere in the world of artist's foundations, but the one that I keep thinking about is the Rauschenberg Foundation, which announced in February of 2016 that it would ease the copyright restrictions on reproduction of its images for scholars and museums. The kinds of works and grants and decisions his foundation has made,

in the years before and after his death, reflect the artist's lifetime of progressive politics and activism in social causes.

An artist's foundation becomes, in the artist's absence, the official storyteller. The guards who either throw open the gates or lock down the barracks. In their donations or refusals, their sponsorships to this exhibit or permission to that scholar, they create a version of the artist, and their final wishes and hopes. Each action of the Foundation creates Twombly's voice as a man and artist: his desires and intentions, before and after his life.

Twombly's life was more than a set of drawbridges or guard towers. Ambition and risk, travel and generosity, strangeness and vision, a spirit of moving against the grain of the world like a fish upstream; these, too, defined him—and for the first years of the Foundation, when he was alive, these traits were mirrored in the donations to local charities, Habitat for Humanity, Project Horizon, VCAA. Perhaps one day, those traits will again be synonymous with the foundation that bears his name.

And indeed there is some hope of this.

In January of 2018, the Foundation for Contemporary Arts (FCA), supported with money from the Cy Twombly Foundation, awarded the first Cy Twombly Award for Poetry. Del Roscio is quoted in the press release: "Cy often recalled the experience of hearing poetry at recitals in New York when he was very young. He loved how poetry can express all kinds of nuances in life in a condensed lyrical line; passion, color, philosophy, mortality, irony, and other states of mind." It's promising, I think, that the award of $40,000 went to Anne Boyer, a poet without connection to Twombly or his foundation, a process of selection managed by the FCA. It is, if it continues, a fine way to remember the artist. A legacy, ongoing, new lines in new books.

40

THE WAY IT ENDS

AFTER WEEKS OF EMAILS AND favors called-in, my wife's friends found a lawyer in San Francisco who specializes in these kinds of cases—and not just any lawyer but one who has a name, a reputation, and a history of big cases. He has weight to throw around. "The older generation helps the younger," they said when I called to thank them.

The San Francisco lawyer and I talked on the phone about the situation: emails from the Foundation and their demands for reply. When I told him about Butch's letter, he wasn't surprised; it's not uncommon, he said, for people to talk and then get cold feet.

He asked what I wanted. Cooperation, control, access—these now seemed impossible and so I would, I said, happily settle on a little peace

of mind that my family and I are not at risk of being sued. I wanted to defend my reputation as a writer. I wanted to keep writing the book. Most of all I wanted to be done with it all.

He agreed to help. He drafted a letter to the Foundation's lawyer and sent it to me to look over.

> *I am writing on behalf of my client Joshua Rivkin in response to your July 24, 2014 e-mail to him. Your letter asserts that Butch Bryant does not recall meeting my client and "does not wish to be the source of any story that you have written."*
>
> *My client met with and interviewed Mr. Bryant twice: on October 27, 2012 at Mr. Bryant's house, and on November 21, 2012 at the Lexington Motel Restaurant. My client has contemporaneous notes which verify the accuracy of anything Mr. Bryant is quoted as saying. Mr. Rivkin, of course, has a right under the First Amendment to use any material gathered from Mr. Bryant. Nothing in his manuscript is actionable as to Mr. Bryant and, even if it reflected adversely on Cy Twombly (which it doesn't), any claims of Mr. Twombly were extinguished with his death. Your letter urges Mr. Rivkin to "exercise caution" and to "avoid stories without proper and reliable sources." Mr. Rivkin is a responsible journalist and has no desire to publish a manuscript which is inaccurate. He is entitled, however, to go forward with his work and he intends to do so.*

"Dead people belong to the live people who claim them most obsessively," wrote James Ellroy; this sentence the epigraph in a friend's memoir, a book about violence and its aftermath. I copied it down on the first page of my notebook, though I didn't understand it at the time, not really.

By this measure, Twombly surely belongs to Nicola. To the Foundation. But also to those who carry his name, every day of their lives— Alessandro and his children. To his most ardent lovers and critics. To the deepest pockets. He belongs, at least for a time, to living memory.

So what if Twombly relied on Butch? So what if Twombly's sexual

orientation wasn't entirely straight? So what if he lived an unconventional life? The reputation of Twombly as an artist is secure, as are the ever-climbing prices for his paintings and drawings.

"Describing another's mind is an act of interpretation," Nicola warns in one of his introductions. "No one really knows someone else's mind or intentions; even if a particular behavior is recurrent, it remains complex and subject to continuous change like a metamorphosis."[1] He's right, to a point. Our inner lives are too wild to be summed up like a problem, let alone the solution to one. That doesn't mean we can't witness the patterns of living and making. Flashes, perhaps, and blinding at times, but there is truth there, waiting to be captured and recorded and related. Better that, I think, than silence.

Novelist Bruce Duffy describes his early encounter with his own obsessive subject, the philosopher Wittgenstein, a passage in which Twombly's name could be effortlessly substituted:

I suspect the widespread discomfort over Wittgenstein's sexuality—this difficulty in squaring the priestly image with that of the homosexual—partly explains why, in a world where almost every minor personality is mythologized, there was, until several months ago, no biography of the man who is arguably this century's greatest philosopher. This squeamishness in discussing his life, this continuing tendency to gloss over certain obvious questions or else treat them as unworthy of consideration—these were among the first qualities I detected in the literature, and I found them most evident in the various memoirs. In their effort to put forth a plain, unvarnished record of what Wittgenstein did and said, some of these memoirs have almost the feeling of gospels— hushed, reverential, proprietary . . .[2]

It's all there—the glossing over of "obvious questions" or describing them as "unworthy of consideration," and the "feeling of gospels" in the accounts of friends.

"And then after I'm dead," Twombly said of his works, "they could

talk about them all they want."[3] The dead don't care about their reputation; the dead can't be embarrassed or ashamed. That's a problem for the living, for those that come after. And yet notice how Twombly doesn't say *they can talk about me* or *my life all they want*. I'm with Donald Judd who said, "Basically, after you die it's not yours anymore"; the "it" is unnamed, extending, I think, well past the stuff made to include the life itself, in all its wonder and contradictions.

The irony, of course, is that Twombly agreed to have that writer, among at least a dozen others, interview him in the first place. Consider the anecdote Janna Malamud Smith tells in the introduction to *Private Matters*, a book-length defense of anonymity. *Look* magazine wanted to come to spend several days with her by-then-famous father Bernard Malamud and his family for an article. Though tempting, he refused. "My father," she writes, "sought privacy because without it he could not create fiction."[4]

Twombly too needed privacy to create. And yet, in the numerous profiles of Twombly—and later Nicola—that desire is hardly absolute. Twombly never had to allow a single journalist or curator or photographer through the thresholds of his houses. He never had to conduct an interview; just as Nicola never had to write or publish those personal introductions and essays. The windows were opened long before I arrived.

▌

What's private? It is a concern suspended just above these pages, like a sword—a question at once essential and impossible. Dangerous, too. Legal questions, rules and guidelines, rapids to navigate, quickly become calls of judgment and disposition. When does a fact—open or closed, guarded or revealed—show us something meaningful, not just about the life of the subject, but our own?

"The concept of privacy," writes Janet Malcolm, "is a sort of screen to hide the fact that almost none is possible in a social universe."[5] We write our letters and email. We live among friends and family and strangers who think of us in deeply complicated ways. It's not just that

our lives are public, but we make them that way. A "social universe" of lovers and friends, wives and husbands and children, and for some of us, strangers. We invite others inside. We have no choice.

Every relationship is both private and public, some more than others. "I'm not frightened of the affection that Jasper and I had," Rauschenberg said in an interview, one of his most open statements about his relationship with Jasper Johns, "both personally and as working artists. I don't see any sin or conflict in those days when each of us was the most important person in the other's life." And yet, he claims, what had been "tender and sensitive became gossip," part of the reason for their split. But it's a claim he only makes after being encouraged by the interviewer: "How much will you go on the record about this? I think that there are lots of reasons to talk, especially in the current climate of suppression of gay arts and artists."[6] In the twenty-five years since this interview much has changed. Just as much, it seems, has stayed the same.

To be a public or semi-public figure does not mean that everything is open and available. Nor does it mean that every known fact can be repeated. Respect and limitations matter as do intimacy and dignity. But so do truth and transparency. Intent does too. I think of what Sally Mann said about photographing Twombly's house after he died, the unavoidable entering and capturing of his home: "It's in the nature, I'm afraid, of the process," she said, "But again, I wanted it to be more of a caress than a violation."[7]

Tenderness, claimed Chekhov, is made possible by art. And art is made possible by knowing. Sometimes that means casting light in places where someone might prefer darkness, might prefer silence. A defense of privacy can't be a way to deny or distort, a means to manage meaning or inconvenient facts contrary to simple narratives. The complexity of Twombly's relationships matter. The pleasures and difficulties of desire matter.

▌

Within minutes of the San Francisco lawyer sending that letter on my behalf, the Foundation's lawyer called his office. The Foundation's law-

yer asked where I lived and said that if I wanted the Foundation to cooperate with me, I should tell them my motives for writing the book. The San Francisco lawyer told him that having been a media lawyer for thirty years, he found it odd that they would engage a lawyer before the piece had ever been written, let alone published. Any suit, he said, would just result in publicity adverse to the Foundation.

"I see no point in calling him back or educating him about your motivations," said the San Francisco lawyer. "It seems apparent to me they are not going to cooperate."

A whimper not a bang. A neon sign, *To be Continued.*

I tried—and try—to remember what Janet Malcolm said of the libel lawsuit brought against her, a sort of invocation against harm: "It took me out of a sheltered place and threw me into bracingly icy water. What more could a writer want?"[8]

And so, I was given a final act, a gift I didn't choose and one I would happily give back, a narrative that I curse and hate, but still an essential one—about the afterlife of an artist, his or her legacy, and how it's guarded, protected, claimed. To have continued to write and research and publish after the initial pushback was, and is, perhaps an act of foolishness, tilting at windmills in a hurricane. But what else, in the aftermath of confrontation, was there to do?

"I prefer to tack the unstretched canvas to the hard wall or floor," wrote Jackson Pollock in 1947, "I need the resistance of the hard surface."[9] This is how Twombly worked too, this play of different kinds of tensions, the loose canvas against the hard ground or wall. Maybe that is what every artist needs, that sense of coming up against force, that sense of struggle. Resistance that makes the risks feel real.

AFTERLIFE

I WANT TO BELIEVE I saw Cy Twombly once, at the 2005 opening for his *Lepanto* paintings at the Museum of Fine Arts in Houston. Or, to be more precise, that we were in the same room. Though, a decade later, I can't find any photos or articles from the opening to confirm he was there that May evening. That night, searching for him by the cucumber canapés, I thought I would recognize the artist from his photograph: Twombly, tall and gangly, an old man, standing in suspenders and Brooks Brothers chinos before the floor-to-ceiling panels of *Say Goodbye*, his well-fed body imposing; as if more aristocratic gentleman than rebel artist, he laughs, leaning away from the lens.

I hadn't yet seen any of the images from Rome, the young man, gaunt and melancholy, never smiling, his head turned away from the camera or missing. I hadn't seen the double image of Rauschenberg and Twombly in Venice, or the one of Betty and Cy and Alvise, or the contact sheets in a drawer of Alessandro's house, pictures taken by Tatiana of their happiest times together.

Women in yellow summer dresses and men in starched Oxford shirts drank cold white wine. It was late spring, the temperature outside hovering near 90 degrees Fahrenheit. Inside it was winter. Inside a museum there are no seasons. I walked over to the paintings. Enormous wall-sized canvases, florescent yellows and pinks, the blazing images of the boats transformed into flowers, sweetness and decay and overripe saturation.

That night, though, I didn't care about the art. I wanted to see him, as if proximity were enough. The man, his work. My life, his life. A mistake to make again and again.

"The love affair, however exhilarating," biographer Leon Edel said in an interview, "has to be terminated if a useful biography is to emerge. Sometimes there is disenchantment and even hate; the biographer feels deceived. Isn't that the way all love affairs run—from dream and cloud-journey to earth-firmness?"[1]

I'm not the same man as I was that night. Now, I know too much.

▌

At the 2016–2017 retrospective *Cy Twombly* at the Centre Pompidou, fifty years of making and unmaking, of movement and scattering, gathered together on the top floor of the Paris museum, a fleeting, impossible collection, I tried to see the works twice: once as a stranger, wandering through, knowing nothing of the artist, and then again as myself, years of my life wrapped up in Twombly's art and biography.

Even knowing as much as I do now, I found surprise in detail after detail—the words Leda + Swan, handwritten and tucked into a corner of *School of Fontainebleau*; the places in *Untitled* 1959 where the gesso stops to let raw canvas breathe; the visible staples binding the enor-

mous sheets of paper together in those mid-1970s drawings, *Apollo and the Artist* and *Mars and the Artist*; the edges of deep black paint where the canvas wraps over the stretcher bars in *Treatise on the Veil* 1968.

At night, in the window-filled room of his white sculptures, the city lights like a sea below. "They transmit an unreal, elusive radiance," writes one critic of those sculptures. "They are transmitters of light, transmitters of silence, transmitters of poetry."[2] In the next gallery I saw, for the first time in person, his "illustrations" of Spenser's *The Shepherd's Calendar*. A woman beside me smiled as she studied the twelve drawings arranged together on the wall, one for each month. In the green silhouette of July, I thought I saw the outline of Twombly's Bassano house.

I looked at all these pieces and saw, too, several continents, dozens of studios, Rome and Bassano and Gaeta and Lexington; I saw all the biographical events and omissions, all of the writing, so many words, some readable and others just gestures, pseudo-lines, drips, loops. But most of all what I noticed, as if for the first time, was just how often Twombly used his hands: so many instances where one can see his hands at work, intimate and present, especially the hand that erases, exacting a strikeout, the visible lines of the fingers. After seeing one handprint, in *Dutch Interior*, a painting from the 1960s, those lush, paint-heavy works of text and texture, luminous and overwhelming, I couldn't stop seeing them, everywhere, from the fingers smearing paint to the full print of the palm to the drawing of a hand, each of the five fingers numbered, these hands marking and remarking, all of the surfaces of a lifetime.

❚

The wall markers at the Paris show hide as much as they reveal. Take the signage for the relationship of Rauschenberg and Twombly:

The 1950s saw Twombly evidence a precocious maturity. After leaving Black Mountain College—the experimental liberal arts college in North Carolina where he encountered the crème de la crème *of the US avant-garde—the 24-year-old painter from*

Lexington, Virginia set off on a trip to Europe and North Africa in the company of Robert Rauschenberg.

There are miles between "in the company of" and the truth of that time. A decade earlier, at the 2008 show *Cycles and Seasons* curated by Serota, another chance for the public to see Twombly's work in a new light, another case for Twombly's ambition and greatness, a celebration of late-life productivity, the same distorted signage about Twombly's relationship with Rauschenberg and their first voyage to Italy. As artist and critic Michael Petry notes in his essay "Hidden Histories: Curating a Male Same-Sex Exhibition," the *Cycles and Seasons* catalogue, even as the chronology of Twombly's life included two "intimate photographs" of Twombly taken by Rauschenberg, "at no time did the text allude to the sexual nature of the friendship or the romantic status of the trip."[3] Instead, the chronology reads: "Rauschenberg, who at the time is separating from his wife Susan Weil, decides to join him."[4] By contrast, Petry notes, the catalogue emphasized the "honeymoon trip" of Twombly and Tatiana to Cuba after their 1959 marriage. The effect is a kind of "biographical distortion"—not simply eliding the nature of the relationship but insisting on the fact of the heterosexual marriage to the exclusion of everything else.

"You cannot fully understand Twombly's art," writes critic Lee Siegel, "unless you know that he is gay. It's often fatuous to reduce an artist to his or her sexuality, but Twombly is working in a tradition that associates homosexuality with an ideal human freedom."[5] Siegel's piece, first published in *Slate*, but no longer online, is plain wrong. Understanding Twombly's art in no way depends on knowing his sexuality; the fact of Twombly's complicated sexuality hardly leads to any easy explanations. And yet, it matters. "Living, looking, making:" writes David Sylvester, "Twombly seems to be someone for whom there is no break between these."[6]

The implications of the inseparability of the life and the work extend far beyond Twombly or even the art world. "Little was so zealously hidden half a century ago as was evidence of homosexuality by prominent persons," writes Joseph Sax, "helping to reinforce the familiar assumption that only *freaks* were homosexuals." He offers several

examples, including the conflicts over access to the papers of Ludwig Wittgenstein, again in fear of what they would reveal about his sexual orientation. "Only in retrospect," Sax writes, "can we understand just how broadly damaging such secrecy has been to public understanding of sexuality and sexual orientation."[7]

Robert Rauschenberg's painting/collage *Should Love Come First?* 1951 includes a piece of paper, torn from a magazine article, that asks, "my problem: Should love come first?" An elliptical phrase that wouldn't be out of place in one of Twombly's own canvases. Below that clipped question, Rauschenberg pasted an Arthur Murray–style diagram of two waltzing dancers. Instead of the outlines for male/female footprints, two sets of male feet move in coordinated steps: at once playful revision and coded queer tribute.

Art historian Jonathan Katz connects this painting to the beginning of Twombly and Rauschenberg's romantic relationship in New York. *Should Love Come First?* was made and shown three months after the two artists met in February of 1951 at the Art Students League in New York.[8] New lovers, the painting names in symbols and signs what couldn't be said. Code was necessary. "The 50s," as Rauschenberg later recalled, "were a particularly hostile and prudish time."[9]

About the queer codes and signals in this and other works by Rauschenberg and Johns, Katz writes, "The new homophobia no longer flatly denies, as it once did, the same-sex relationships among Johns, Rauschenberg, Twombly, Cage, Cunningham and so many others in their circle. Instead, it denies that biographical fact any critical purchase . . ." And yet, this web of personal relationships between us inevitably defines our art.

"[I]t was precisely Johns' and Rauschenberg's sexuality that informed their development of a critique of traditional forms of meaning making," Katz continues. "In short, the postmodern turn in American art had authors; these authors had relationships with one another; these relationships not only informed their thinking about audience and meaning-making in a context of grave constraint, but moreover is writ-

ten on the surfaces of their work—not only as iconography but as a far less codified, but no less intentional, pressure on the process of signification as well." There is, in other words, no escaping the personal, its effect on the work and its meanings.

Rauschenberg painted over the original work. *Untitled* 1953 (*Übermalung* of *Should Love Come First?* 1951) erases by covering up. Overpainted, the first of Rauschenberg's black paintings, a textured layer of an inky monochrome, the earlier work is obliterated as if in a volcanic landslide, a thick skin of ash, rough and forbidding. And yet, the questions of the original canvas remain, invisible and below the surface. The piece, as it was first made, survives only in a photograph, a photograph that is available on the website for Rauschenberg's foundation. Not all erasures are the same.

❙

"We should know them very well in every aspect," claimed the critic Dore Ashton. "If you're interested in writing about someone, ask yourself, 'What did he eat for breakfast?' Know everything you can about them. Firstly out of primary curiosity, but also out of a desire to see the person as an individual vis-à-vis his society and the environment he lives in."[10]

That desire to see the individual as part of a larger story, the society or culture the person was born into, means imagining a tenuous, marginal, and dangerous position. To be an openly gay artist was to be "branded unnatural by the dominant culture, hounded and persecuted," as Katz writes.[11] As another artist put it, "Sexuality was kind of a dangerous subject in the art world. Sex was never touched upon. And, to call yourself a gay artist would be, of course, the death knell of your career."[12]

One need only look at the reaction to the Horst photos and the Commodus show, both of which were described in less than coded language by those around Twombly: "It was really a flamboyant French kind of show," remembered one dealer. [13]

"It paid to stay in the closet, obviously," Edmund White writes of the "blue-chip" artists, who were gay but not as publicly out. Cy Twombly

is listed by White, as is Johns, Elizabeth Bishop, Susan Sontag, Robert Wilson, and John Ashbery. In contrast to the "condescending judgments all around us" for openly gay writers and artists, these "Blue Chips sailed serenely on, universal and eternal."[14]

"Of course," White continues, "they'd all eventually be outed after their death, but that would only add to their posthumous reputations and generate another shelf of theses by suggesting a whole new set of affiliations. During their lives they were secure and would never be marginalized. Well, more power to them, I thought. They definitely knew how to shape their careers."[15]

White is right about Twombly, certainly, who was never publicly explicit about his sexuality. That's not to say that everyone didn't know. In Rome, his relationships were an open secret, a fact perfectly well-known in his circles. But a circle encloses, limits.

I'm implicated by White's words. Twombly's posthumous "outing," by the simple fact of its truth, is part of this story. To ignore it would not be simply an omission; it would be a lie. My book will one day be found on that "shelf," another of the works that say, look what's been missed, look at how Twombly's sexuality has been part of the story from the start. Look how we can see the work and the man anew. Twombly's sexuality, in and of itself, isn't interesting. What's remarkable is how, even after his death, it is still ignored or resisted or denied. Choose your euphemism. Choose your implication.

Take these side-by-side sentences in the *Times* profile of Nicola, a coy juxtaposition: "Although the two men never lived together, their lives were perpetually intertwined. Twombly and Tatiana, who died in 2010, never divorced and remained friends."[16] In those careful clauses of suggestion—that qualified "although," the coded "intertwined" or that clarified "never divorced"—so much, even still, is left unsaid.

I'm not alone in seeing this. Notice the writer's aside, "we are assured," in a review of the 2016–2017 Centre Pompidou retrospective: "Eventually, Twombly settled down in Italy, and, in 1959, married Tatiana Franchetti, a painter herself and art patron; the two had a son, and, we are assured, remained lifelong friends, even after Twombly took up with Nicola Del Roscio."[17]

Tatiana's name appears twice on the walls of the Paris retrospec-

tive: once in a timeline of Twombly's life, and then again in the exhibit: *After Twombly's marriage to Luisa Tatiana Franchetti, celebrated in New York on 20 April 1959, the couple settled in Rome, living in an apartment on the Via Monserrato, in a quarter known for its intellectual life.* Nicola's name, absent from the biographical wall tags at the exhibition, fills the catalogue.

"On July 5, 2011, I received a short e-mail from Nicola Del Roscio that betrayed his panic," Jonas Storsve, the curator of the show and editor of the catalogue, begins his introductory essay. "He ended it with a kind word to me from Cy Twombly, who was hospitalized in Rome. The following day we learned of his death."[18]

Source and intermediary and collaborator, Nicola is, as the museum director writes, "our friend." On the back cover of the catalogue's dust jacket, Nicola's name appears twice, Twombly's only once. In the pages of the catalogue, there are five pictures of Nicola, and only two of Tatia. In many of the personal snapshots of Twombly with various friends and dealers, Nicola is the out-of-sight photographer. In the show's catalogue, spliced into the chronology, are excepts from Nicola's introductions to the catalogues he edited, those brief and personal windows: days together in New York and trips to Afghanistan. Richard Leeman's essay is dedicated to Nicola. And on. And on.

This is not a trivial accounting, but the visible emergence of Nicola as a public presence, not just an expert on the work, but an integral part of Twombly's personal and artistic life. For so many years, Nicola was there without being there, a figure unnamed in a photograph, a behind-the-scenes assistant, but now he is the source of so much, facts and images, rights and permissions, anecdotes and intimacies.

This story, by now, dear reader, you know.

‖

"Will you still love Twombly when you're finished?" my brother once asked me.

Though I'm not sure I can ever finish. Not really. The truth is this: It's never enough. Never enough knowing. Never enough remembering. Never enough stories. Never enough certainty. "But we, with our insa-

tiable eye always in heat, savor endless pleasures," Gauguin writes in a letter. "This evening, when I have my dinner, the animal in me will be sated but my thirst for art will never be quenched."[19]

This is no surprise. Though maybe this is what Twombly's art teaches (as if any art ever has at its heart instruction, least of all Twombly's)—to live with uncertainty—with the blurry line between randomness and intention, between control and abandon, between remembering and forgetting.

"I stayed nine months in Rome where I never had enough time to do all I wanted," wrote Alberto Giacometti of his days in Rome, walking around, reading Sophocles and Aeschylus, imagining the sky a new shade of red. Maybe this, too, is what Twombly teaches. To embrace failure. To love absence.

Shortly after Twombly's death Claire Daigle wrote of being shaken by his loss, an odd, complicated breed of mourning for a man she'd only met several times. There is, she describes, a "curious form of intimacy [that] dwells in this rarely acknowledged space, the scholar's sharing of love with a stranger."[20]

I wasn't shaken when he died. And what I feel now isn't grief, exactly, but something stranger, more luminous, more razor-edged in its absence, but duller in its pain.

I have followed Twombly for so long that it's strange to imagine a time when his days will not be my days. Across countries and oceans, cities and houses, through archives and museums and the narrow hallways of memory, so long that he feels about as familiar as anyone I know. I can say more about his life than my own parents' or grandparents'.

How strange to know someone so well and not at all. The last chapters of Nicholson Baker's U and I, a book about Baker's obsession with John Updike, describes the author's second meeting of Updike. Despite the unconventional nature of the work, a "closed book exam" about the (then) living writer by a younger novelist, the ending feels conventional, an expected arrival. Baker, at the end of his book, reading a passage in an Updike novel about the calluses on the hands of musicians, sees the influence of his own work on the master. The influence goes the other way, a source flowing back to a river.

That end is of course unavailable to me. Instead I'm left with all the sites of absent presence, places made famous by his touch and breath: his houses and studios, his cities and oceans, his books and museums, his works themselves. Works I'll never own. Works I live with in catalogues or imprinted in my memory. His words, too, all the fragmented phrases I've gathered from articles and interviews, stay with me. This life, or some approximation of it, and all the disappointments of arriving too late. This life, and all its possibilities.

"You'll never get past the surface," warned Achim Hochdörfer, director of the Brandhorst and an expert on Twombly's sculptures, as we walked through the galleries admiring the pieces we liked best.[21] Twombly's life was too protected, he suggested. A life hidden beneath the layers of time and distortion and erasure. Perhaps he was right.

Then again, to imagine Twombly drawing into the wet surfaces of his canvases or painting over words, corrections made at the very last minute, is to know, too, that the surfaces matter. Marks of time and effort. The hand at work. It is the mystery we can see, the surface as evidence of a life below.

❚

The light is gold. The sun has started to slip away. The shoreline glimmers. A photograph: Twombly laughs and Nicola, beside him, holds one hand up, as if he's about to blow a kiss, or show Cy a shell he's found. In his other hand, his sandals. Nicola is smiling an easy smile. It is late 1979, shortly after their trip to Afghanistan, when the artist came to this small Caribbean island, part of Guadeloupe, to work on watercolors and drawings. In the catalogue where the photo is published, only Twombly is named in the caption, but they are both there, equally the focus, as the waves crash behind them.[22]

Green hills in the distance catch that same glow of dusk. At their bare feet a curved shell. Here they live in full color, unposed, unguarded. There is a lightness, intimate and lovely, to this photograph, published a little less than two years after Twombly's death, a full page at the back of a catalogue. On that island, Twombly filled the pages of a notebook with acrylic and ballpoint, a little artist book blurring the bound-

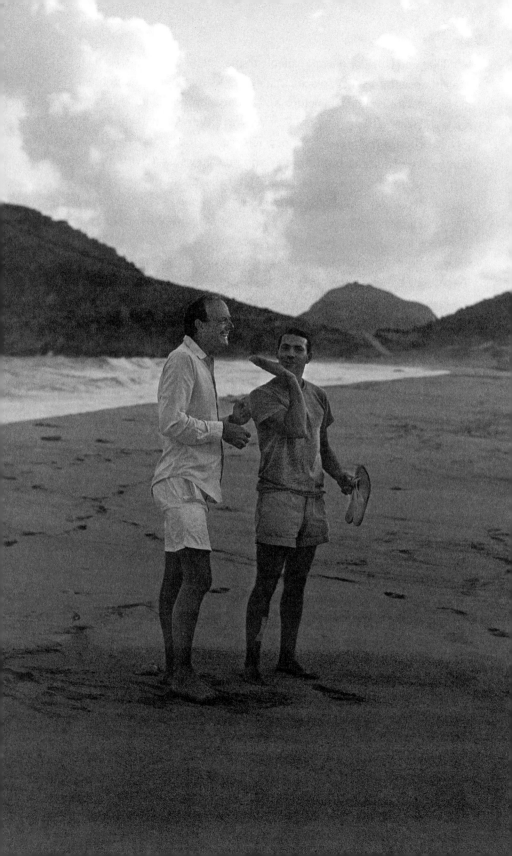

aries between sketch and story. *Souvenir De L'Île Des Saints, December 17, 1979–January 14, 1980.* Fragments of text shored like sea glass: *Jan. LES SAINTes. 1980. SOUVENIR de L'ILE Des SAINTS. Dec. 17–JAN 14, 1980. Grand Anse. Nicola by the Sea. off to Antigua Jan 14 80.* These drawings become souvenirs of this time, the beaches and dates of the present, looking forward, too—to a new year, a new decade—but also, always, returning to the past.

I think back to what Twombly wrote on those untitled drawings from the mid-1960s (and repeated again in the mid-1980s): *Nicola del Roscio sleeping under the Palms at Aqaba; Nicola del Roscio Asleep by the Ionian Sea; Nicola del Roscio asleep under the Sea.*Here, we have simply Nicola's first name. Here, he's not asleep but by the sea. Here, he stands in the photo, right beside the artist.

"Whisper to me some beautiful secret that you remember from life," the speaker asks of his dead friend at the end of Donald Justice's elegy "Invitation to a Ghost." For this is what we want, always. Not the words or images of what we already know, the ending preordained, but a photo tucked at the end of an obscure catalogue, and the drawings that overlap with those days, a vision of a self, intimate and true: the life that went into the work, the work that went into the life.

FACING PAGE: **Cy Twombly and Nicola del Roscio, Îles des Saintes, 1979,** Photo: Karsten Greve

ILLUSTRATION CREDITS

1 Fielding Dawson, *Cy Twombly at Black Mountain*, 1951, Casein on butcher paper, 50 × 24 in (127 × 61 cm). © Estate of Fielding Dawson. Fielding Dawson Papers at the University of Connecticut, Archives and Special Collections. Used with permission of the rights holder.

2 Robert Rauschenberg / *Cy + Relics, Rome*, 1952 / Gelatin silver print / 15 x 15 inches; image; sheet 20 x 16 inches (38.1 x 38.1 cm). Photo © Robert Rauschenberg Foundation/Licensed by VAGA at Artists Rights Society (ARS), New York, NY.

3 Robert Rauschenberg / *Cy + Roman Steps (I, II, III, IV, V)*, 1952 /Suite of five gelatin silver prints / 14 3/4 x 14 3/4 inches; image; sheet size 20 x 16 inches (50.8 cm x 40.6 cm) each (37.5 x 37.5 cm). Photo © Robert Rauschenberg Foundation/Licensed by VAGA at Artists Rights Society (ARS), New York, NY.

4 Robert Rauschenberg / *Staten Island Beach (II)*, ca 1951 / Gelatin silver print. Photo © Robert Rauschenberg Foundation/Licensed by VAGA at Artists Rights Society (ARS), New York, NY.

5 Robert Rauschenberg / *Bob + Cy, Venice*, 1952 / Gelatin silver print / 15 x 15 inches (38.1 x 38.1 cm). Photo © Robert Rauschenberg Foundation/Licensed by VAGA at Artists Rights Society (ARS), New York, NY.

6 Cy Twombly, Grottaferrata, 1957, Photo: Elizabeth Stokes. © Elizabeth Stokes.

7 Alvise di Robilant, Betty di Robilant, Cy Twombly, and Graziella Pecci-Blunt, Villa Marlia, 1957. Courtesy of Camilla and Earl McGrath Foundation, Inc and Elizabeth Stokes.

8 Tatiana Franchetti, Rome, 1959, Photo: Camilla McGrath. © 2018 Camilla and Earl McGrath Foundation, Inc.

9 Cy Twombly, Tatiana Franchetti, and Stefano Franchetti, Rome, 1959, Photo: Camilla McGrath. © 2018 Camilla and Earl McGrath Foundation, Inc.

10 Cy Twombly, 1959, Photo: Camilla McGrath. © 2018 Camilla and Earl McGrath Foundation, Inc.

11 Alessandro Twombly, Via di Monserrato, Rome, 1966, Photo: Horst P. Horst. Horst P. Horst/*Vogue* © Condé Nast.

12 Cy Twombly and Tatiana Franchetti, Via di Monserrato, Rome, 1966, Photo: Horst P. Horst. Horst P. Horst/*Vogue* © Condé Nast.

13 Cy Twombly, Via di Monserrato, Rome 1966, Photo: Horst P. Horst. Horst P. Horst/*Vogue* © Condé Nast.

14 Cy Twombly, Nicola del Roscio, Micky (longtime collaborator of gallerist Yvon Lambert), Paris, 1984, Photo: André Morain. © André Morain, Paris.

15 Giorgio Franchetti and Cy Twombly, Porto Ercole, 1970s, Photo: Elizabeth Stokes. © Elizabeth Stokes.

16 Cy Twombly at the edge of Lake Bolsena, May 1971. Photo: Plinio De Martiis, Galleria La Tartaruga, Concessione del Ministero per i Beni e le Attività Culturali - Archivio di Stato di Latina.

17 Cy Twombly and Tatiana Franchetti, Val Gardena, 1971, Photo: Elizabeth Stokes. © Elizabeth Stokes.

18 Cy Twombly and Dominique de Menil at the opening of the Cy Twombly Gallery, Houston, 1995, Photo: Camilla McGrath. © 2018 Camilla and Earl McGrath Foundation, Inc.

19 Cy Twombly's Studio Table, Lexington, 1994, Photo: David Seidner. © International Center for Photography, David Seidner Archive.

20 Cy Twombly, Lexington, 1994, Photo: David Seidner. © International Center for Photography, David Seidner Archive.

21 Cy Twombly and Tatiana Franchetti, 1986, Photo: Camilla McGrath. © 2018 Camilla and Earl McGrath Foundation, Inc.

22 Cy Twombly and Nicola Del Roscio, Îles des Saintes, 1979. Courtesy Galerie Karsten Greve St. Moritz Paris Köln.

NOTES

PREFACE

1. Charles Olson to Robert Creeley, January 31, 1952, in Olson, "Letter," 22. For a fine rendering of this incident, see also Sebastian Smee's review of the exhibition "Leap Before You Look: Black Mountain College, 1933–1957," "Recalling Black Mountain's Incident on the Lake," *Boston Globe*, January 9, 2016, https://www.boston globe.com/arts/2016/01/09/recalling-black-mountain-incident-lake/Q9Vc J6SZ44WplFStkyggON/story.html.
2. Charles Olson to Robert Creeley, January 31, 1952, in Olson, "Letter," 22.
3. Charles Olson to Robert Creeley, January 31, 1952, in Olson, "Letter," 22.
4. Charles Olson to Robert Creeley, January 29, 1952, in Olson, "Letter," 20.
5. Charles Olson to Robert Creeley, January 29, 1952, in Olson, "Letter," 20.
6. The terms for their relationship vary widely, from friend to companion to collaborator. Most directly, Nicola Del Roscio was described by art critic Arthur Danto as "Cy's partner, lover, critic, administrator, and helper" (Danto, "Ideal Friendship," 213). According to the "About the Author" for the most recent catalogues raisonné of

drawings on Amazon.com, "Nicola Del Roscio, born in Rome in 1944, was Twombly's long-time assistant. The editor of the *Catalogue Raisonné of Drawings* and *Writings on Cy Twombly*, he is president of the Cy Twombly Foundation (New York/Rome) and the Fondazione Nicola Del Roscio (Gaeta)." "About the Author," accessed March 14, 2018, https://www.amazon.com/Cy-Twombly-Drawings-Catalogue-1990-2011 /dp/3829607628/ref=sr_1_1?s=books&ie=UTF8&qid=1521043516&sr=1-1&key words=Nicola+Del+Roscio+raisonne.

7. In addition to numerous catalogues for individual exhibitions and accompanying essays quoted throughout, I have relied primarily on the catalogues raisonnés of painting, drawing, sculpture, and printed graphic work for information and images of Twombly's works. Though imperfect, these catalogues offer the most complete accounting of Twombly's work. These texts include:

Cy Twombly: Catalogue Raisonné of the Paintings. 6 vols. Edited by Heiner Bastian. Munich: Schirmer/Mosel, 1992–2014.

Cy Twombly Drawings: Catalogue Raisonné. Vol. 1, 1951–1955; vol. 2, 1956–1960; vol. 3, 1961–1963; vol. 4, 1964–1969; vol. 5, 1970–1971; vol. 6, 1972–1979; vol. 7, 1980–1989; vol. 8, 1990–2001. 8 vols. Edited by Nicola Del Roscio. Munich: Schirmer/Mosel and Gagosian Gallery, 2011–2017.

Cy Twombly: Catalogue Raisonné des Oeuvres sur Papier. Vol. 6, 1973–1976; vol. 7: 1977–1982. Edited by Yvon Lambert. Milan: Multhipla Edizioni, 1991.

Cy Twombly: Catalogue Raisonné of Sculptures. Vol. 1, 1946–1997. Edited by Nicola Del Roscio. Munich: Schirmer/Mosel, 1997.

Cy Twombly: Das Graphische Werk, 1953–1984: A Catalogue Raisonné of the Printed Graphic Work. Edited by Heiner Bastian. New York: New York University Press, 1985.

8. Stevens, "Classical Musings," 122.

9. Schjeldahl, "Drawing Lines."

10. For personal remembrances of Black Mountain College, see *Black Mountain College: Sprouted Seed*, edited by Mervin Lane, and *Black Mountain Book* by Fielding Dawson; for a more in-depth history of the ethos, freedom, and collaborative spirit of the college, see *Black Mountain College: Experiment in Art*, edited by Vincent Katz, which contains terrific photographs of Twombly taken by Rauschenberg, and the catalogue for the show *Leap Before You Look: Black Mountain College, 1933–1957*, edited by Helen Molesworth.

11. Serota, "History Behind the Thought," 44. This listing of artists and teachers is reminiscent of what Kate Nesin describes as "a property of self-mythology." Twombly often oriented his aesthetic "in relation to place rather than scene." However, as she notes, "In response to less specific queries Twombly would name freely the fellow artists of the 1940s and early '50s who had influenced his formation but thereafter designated landscapes and historical figures as his guides" (Nesin, *Twombly's Things*, 161).

12. Dawson, *Black Mountain Book*, 113.

13. Edmund White, review of *Cy Twombly: Late Paintings 2003–2011*, by Nela Pav-louskova, *The New York Times*, June 25, 2015.

14. Krauss, "Cy's Up," 118.

15. Daigle, *Reading Barthes/Writing Twombly*, 161n193.

CHAPTER 1

1. Mann, *Hold Still*, 71.

2. Mann, *Hold Still*, 71.

3. Kirk Varnedoe offers this very brief description in a note in his catalogue essay for the MoMA retrospective, "The artists' father, Edwin Parker Twombly, Sr., was born in Groveland, Mass., June 15, 1897 and died December 3, 1974. His mother, née Mary Velma Richardson was born in Bar Harbor, Maine, May 11, 1897 and

died December 28, 1988. They were married September 13, 1921. The artist has one sibling, a sister Ann Leland, four years older" (Varnedoe, "Inscriptions," 53n5). Cy's older sister, Ann Leland Cross died in 2015; she was, as one obituary put it, "renowned for her gracious Southern charm, generosity and kindness, classic style and colorful expressions" ("Ann Leland Cross," *Orlando Sentinel*, September 11, 2015, http://www.legacy.com/obituaries/orlandosentinel/obituary .aspx?pid=175801260#sthash.XpsLqBvu.dpuf).

4. Sylvester, *Interviews*, 173. The interview between Twombly and Sylvester was conducted in 2000 and first published in *Art in America* in July of that year. It was reprinted in Sylvester's 2001 *Interviews with American Artists*. It was the first of two published interviews with Twombly. Twombly's interview with Nicholas Serota was published in 2007 in the *Cycles and Seasons* catalogue. James Finch in his dissertation notes that, "Sylvester often edited together several different replies from Twombly into one response (one of which is 873 words long), in the interview with Serota the longest of Twombly's responses is 294 words, and the interview reads much more like a conversation" (Finch, *Art Criticism of David Sylvester*, 168). What the hand-corrected transcript of the interview reveals is that Nicola, attributed as NDR, was there as well, at a few moments offering corrections or additions. He is, as always, present. In the printed interview he is not mentioned.

5. Serota, "History Behind the Thought," 53.
6. Simpson, "Cy Twombly, the Lexington Connection," 11.
7. Kazanjian, "Cy Twombly: A Painted Word," 555.
8. Varnedoe, "Inscriptions," 11.
9. Sylvester, *Interviews*, 174–175.
10. Serota, "History Behind the Thought," 53.
11. Kazanjian, "Painted Word," 555.
12. Varnedoe, "Inscriptions," 53n4.
13. Simpson, "Cy Twombly, the Lexington Connection," 9.
14. Kazanjian, "Painted Word," 555.
15. Claudia Schwab, "Returning to His Lexington Roots," *Lexington (VA) News-Gazette*, October 12, 1994, 2.
16. This isn't quite fair. According to the article written on the occasion of his retirement from Washington and Lee, Cy Twombly, Sr., pitched for nineteen years starting when he was fourteen, including a number of no-hitters in the minors and semi-pro leagues. Twombly continued to pitch even after a brief stint with the White Sox, up until 1939. His decision to play only one season was, according to the article, his own. "There was much more of a future in school work," he said about the decision to not attend a second season of spring training with the White Sox. "Twombly Has No Regrets Giving up Big-Time Baseball for College Work," *Lexington (VA) News-Gazette*, March 26, 1969. See also http://www.baseball-reference.com/players/t/twomb cy01.shtml; http://www.baseball-almanac.com/players/player.php?p=twombcy01.
17. Mann, "Podcast NYPL."
18. Spawls, "At the Pompidou." The story is related to Spawls by the photographer Sally Mann.
19. Students of Lexington High School, *Crystal*, 12.
20. Varnedoe, "Inscriptions," 53n5.
21. Claudia Schwab, "Returning to His Lexington Roots," *Lexington* (VA) *News-Gazette*, October 12, 1994, 2. "I still have my Eagle Scout badge," Twombly told the reporter. "We did some camping and I learned to smoke." The lesson of these stories is just how hard it is to recover not the facts of these early years but the emotions, the life as it was lived.
22. Dwight Garner, "The Dramas and Intrigues of Louis Kahn, Monumental Architect," *The New York Times*, March 7, 2017.
23. Dean, *Five Americans*, 40.

24. Nesin, *Twombly's Things*, 155.
25. Herrera, "Cy Twombly," 146. This episode stands in contrast to Kirk Varnedoe's claim that Lexington was artistically "barren." To be fair, Varnedoe is writing specifically about "artistic instruction" in Lexington ("Inscriptions," 11).
26. Herrera, "Cy Twombly," 147.
27. "There was no such thing in Port Arthur, Texas," said Robert Rauschenberg, "as thinking you were an artist." Later in that same interview Rauschenberg said, "Always 'elegant,' [Twombly] knew all the right schools to go to" (Rose, Rauschenberg, 9, 36). One might substitute "books" for "schools."
28. Cheney, *Primer of Modern Art*, 6.
29. Caracciolo, "Walls Are Heard," 280–81. See also "Channing Hare 1899–1976." http://www.lirosgallery.com/harehome.html.
30. Varnedoe, "Inscriptions," 54n12.
31. Cy Twombly to Pierre Daura, February 15, 1948, box 138, folder 5, Pierre Daura Archive, Georgia Museum of Art, University of Georgia.
32. Varnedoe, "Inscriptions," 12n20.
33. Charles Olson to Robert Creeley, November 29, 1951, in Olson, *Complete Correspondence*, 199.
34. Serota, "History Behind the Thought," 44.
35. Cherubini, "White Talent."

CHAPTER 2

1. Tompkins, *Off the Wall*, 70.
2. Tompkins, *Off the Wall*, 69.
3. Cullinan, "Cy + Roman Steps (I–V)."
4. Cullinan's "Double Exposure" offers the best account of Twombly's travels in Italy and North Africa. Cullinan draws on the letters also quoted by Varnedoe in the archive of the Virginia Museum of Fine Art in order to "illuminate the famously taciturn artist's intellectual and artistic formation" (460–461). See also Dupêcher, "'Like Clocks'"; Crow, "Southern Boys Go to Europe"; as well as Cullinan, "To Exist in Passing Time," 32–33, for a discussion of *Cy + Relics* and Henry Fuseli's *The Artist in Despair Over the Magnitude of Fragments*, ca 1778–1780.
5. Clark, *Rome and a Villa*, 20.
6. Clark, *Rome and a Villa*, 23–24.
7. Cullinan, "Double Exposure," 462. Cy Twombly to Leslie Cheek, September 6, 1952, box 66, Leslie Cheek Papers, Virginia Museum of Fine Arts, Richmond (hereafter cited as Cheek Papers, VMFA).
8. Varnedoe, "Inscriptions," 57n52. Cy Twombly to Leslie Cheek, September 6, 1952, box 66, Cheek Papers, VMFA.
9. This photograph appears in Rauschenberg, *Photos In + Out City Limits*. The uncaptioned photo, No. 9, is clearly Twombly. It appears to be taken on the same day as the photo of Twombly's chest and lower body. That photo, *Staten Island Beach (I)*, ca 1951, is printed in Rauschenberg and Davidson, *Robert Rauschenberg*. Twombly is unnamed in both. In *Photos In + Out City Limits*, the photo on the next page is of a fully dressed Jasper Johns, the two ex-lovers back to back. It's a kind of inside joke: Twombly, all vulnerable sexuality and then Johns looking unhappy, fully dressed, a cold fish. The book as a conversation between the artist and the world. A plaiting of biography and art.
10. Chiasson, *Where's the Moon*, 46.
11. See Rauschenberg and Davidson, *Robert Rauschenberg, Rome Flea Market (I–IV, VII)*, 127–31. Rauschenberg's best pictures from their trip to my mind are not the ones from Rome or Venice or Spain but the ones taken in Tangiers. As with the Rome photographs, Rauschenberg's attention is to small moments of street life, but in these Morocco photographs, the light is crisp and clear and the pictures, looking

up to a balcony or down to the street, a man passing below, have an openness. Of course, this says more about my preferences as a viewer than Rauschenberg's skill as a photographer. Rauschenberg in an interview with Alain Sayag said, "I don't crop. Photography is like diamond cutting. If you miss you miss. There is no difference with painting. If you don't cut you have to accept the whole image. You wait until life is in the frame, then you have permission to click. I like the adventure of waiting until the whole frame is full" (Rauschenberg and Davidson, *Robert Rauschenberg*, 6).

12. Rose, *Robert Rauschenberg*, 38. See also Crow, "Southern Boys Go to Europe," 53–55.

13. Adams, "Sizing Up Cy Twombly," 77–78.

14. This account of early collecting is described by Twombly in an unpublished conversation with Paola Igliori.

15. True, Twombly is unclothed in one of these pictures—a kind of counter example to my earlier skepticism of the account of Twombly posing nude for the drawing class. But even here, Twombly posed in a way and at a distance that is far from naked; he is as hidden as he is revealed.

16. Ralph Blumenthal, "A Celebratory Splash for an Enigmatic Figure," *The New York Times*, June 4, 2005.

17. Rauschenberg describes in an interview that he could only buy a ticket back to Italy for the show *Scatole e Contemplavo Feicci Personali* at the Obelisco Gallery from Morocco because of the job he found there. "Cy had already spent absolutely the last of our 'joint' investment on a Roman emperor" (Rose, *Robert Rauschenberg*, 40).

18. Ralph Blumenthal, "A Celebratory Splash for an Enigmatic Figure," *The New York Times*, June 4, 2005.

19. Cheever, *Journals of John Cheever*, 75–76.

20. Erickson, "1950s," 280. In addition to Rauschenberg and Twombly, Erickson writes of the artists Ray Johnson and Richard Lippold, the later who arrived with his wife, and took up with Johnson.

21. Rumker, *Black Mountain Days*, 13, 23.

22. Barnes, *Flaubert's Parrot*, 12.

CHAPTER 3

1. The note in the catalogue raisonné for one set of these drawings: "This work was made in Rome after the artist's trip to North Africa . . . This sketchbook consists of 12 sheets stapled together. It is a study for sculptures" (68). Together these drawings are known as the "North African Sketchbooks," though the name is a little misleading as the drawings were done in Rome after the North African trip. Each of the "books" contains multiple sheets of paper stapled together.

2. Dunbabin, *Mosaics of the Greek and Roman World*, 26. Pliny the Elder wrote in A.D. 77 that Sosos "laid at Pergamon what is called the *asarotos oikos* or unswept room, because on the pavement were represented the debris of a meal and those things which are normally swept away, as if they had been left there, made of a small tesserae of many colors."

3. Cy Twombly, *L'Esperienza moderna*, August–September 1957, reprinted in Varnedoe, "Inscriptions," 27.

4. Schjeldahl, "Size Down," 73.

5. De Looz, "Cy Twombly 1966."

6. Varnedoe, "Inscriptions," 57n56. Cy Twombly to Leslie Cheek, undated, Cheek Papers, VMFA. The same letter is quoted by Nicholas Cullinan with a date of October 15, 1952.

7. The mosaic was originally part of the Gregoriano Profano Museum, housed in the Lateran Apostolic Palace, before being moved to the Vatican in the 1960s. The Lateran Apostolic Palace also once housed the Museo Missionario Etnografico, a museum

that, like the Pigorini, contained relics and objects from non-Western countries, something that was of particular interest to the artist. See Dunbabin, *Mosaics of the Greek and Roman World*, 26–27, and http://www.museivaticani.va/content/musei vaticani/en/collezioni/musei/museo-gregoriano-profano/Museo-Gregoriano -Prófano.html.

8. Tompkins writes that "Rauschenberg had to be dragged to the museums; it struck Twombly as odd that someone as active as his friend should be so difficult to move" (*Off the Wall*, 70).

9. Paz, "Cy Twombly Gallery," 182.

10. In his short piece on Twombly, Charles Olson wrote of the young artist, "These artifacts he finds surround himself in the same digging out of which he is digging himself" ("Cy Twombly," 10). Kate Nesin notes the similarity of this to something Twombly would say later about his return to sculpture: "I found myself in places that had more material." The play of discovery—digging himself or finding himself—is true in both passages.

11. Dupêcher, "'Like Clocks,'" 22.

12. Berger, *Portraits*, 427. From Dore Ashton's 1953 review: "Giant figures suggest archaic votive sculptures; parallel lines indicate a landscape sprawling in tiresome sunlight" (Ashton, "Cy Twombly," 24).

13. Sebastian Smee, "Recalling Black Mountain's Incident on the Lake," *Boston Globe*, January 9, 2016, https://www.bostonglobe.com/arts/2016/01/09/recalling -black-mountain-incident-lake/Q9VcJ6SZ44WplFStkyggON/story.html.

14. Dupêcher, "'Like Clocks,'" 27. Writing in part of the North African notebooks, Dupêcher claims, "Rome in Tangier, pockets of Africa in Italy: this permeability is emblematic of Twombly's conception of history. Rather than being 'classical' on the one hand, balanced by the 'primitive' on the other, his work turns on the inter-penetration of different levels of history—a mixing both temporal and spatial." As Kate Nesin notes in her book *Twombly's Things*, "'Primitive' and 'classical' were not so much aligned for Twombly in his sojourn abroad as confronted through one another. This is the 'history', at once broader and more specific, that the Morocco paintings reveal: broader in burrowing into the archaic past, more specific in spring-ing from a set of lived experiences" (Nesin, *Twombly's Things*, 111).

15. Cy Twombly, "Application Statement," 1955 and 1956, Leslie Cheek Papers, VMFA. Reprinted in Dupêcher, "'Like Clocks,'" 32–33, as well as Varnedoe, "Inscriptions," 33n45.

16. I'm indebted here to Dupêcher's consideration of the paintings as souvenirs and Susan Stewart's discussion of them in *On Longing*. There are other direct namings of the drawings as souvenirs—*Souvenir D'Arros*, 1990, part of *50 Years of Works on Paper* or the artist book of eighteen pages, done from December 17, 1979 to January 14, 1980, titled *Souvenir de Île des Saintes*.

17. Varnedoe, "Inscriptions," 59n72.

18. Fitzsimmons, "Art, 1953," 27.

19. Stuart Preston, "Diverse Openings," *The New York Times*, September 20, 1953.

20. Tomkins, *Off the Wall*, 77.

CHAPTER 4

1. Varnedoe, "Inscriptions," 57–58n61. Cy Twombly to Leslie Cheek, undated. May 1953?, Cheek Papers, VMFA.

2. Pincus-Witten, "Learning to Write," 58.

3. Leeman, *Cy Twombly*, 29. Richard Leeman's 2006 *Cy Twombly: A Monograph*, translated from the French and based on his doctoral dissertation, alongside Kirk Varnedoe's catalogue essay "Inscriptions in Arcadia," is the closest thing to a biog-raphy about Twombly in so much as it considers, even in the most basic way, that a life went into the making of the work. For a critical review of the book, see Ben-

jamin H. D. Buchloh's "Ego in Arcadia." The critic's primary issue with Leeman's approach is that it "effaces" Twombly's relationship to New York School painting and his response to Pollock. "And, equally urgent," Buchloh writes, "by transforming painting into an allegorical incantation, Twombly mourned both the loss of a disappearing classical world of mythical experience, and ultimately, the loss of painting itself" (26).

4. There's no second source for this except what Twombly told Leeman. Twombly's records of that time are missing, burned in a fire along with 80 percent of all the army's official military personnel files from those discharged between 1912 and 1960.

5. Biographical notes, *Catalogue Raisonné of Drawings*, 2:267.

6. Kazanjian, "Painted Word," 555.

7. Tomkins, *Off the Wall*, 108.

8. And, if this wasn't complicated enough, the tapestries Twombly completed in Rome, and discussed here in chapter 23, "Interior," "not only bear a resemblance to some of Rauschenberg's later works with fabric collage elements, such as *Yoicks* (1954) . . . but also more generally prefigure Rauschenberg's adoption of textiles and craft dimensions, including the quilted bedspread which famously figures in his *Bed*" ("Double Exposure," 465n41).

9. For the 1957 photograph *Bed*, see *Cy Twombly: Photographs*, edited by Mark Francis (Beverly Hills: Gagosian Gallery, 2012). The earlier photograph also titled *Bed* appears in *Cy Twombly, Vol. IV, Unpublished Photographs, 1951–2011* (Munich: Schirmer/Mosel, 2012). Unlike Twombly's paintings, drawings, and graphic works, all of which have been carefully and close to completely catalogued, the photographs are scattered across various catalogues: *Cy Twombly: Photographs 1951–2007* (Munich: Schirmer/Mosel, 2008); *Cy Twombly Photographs: 1951–1999* (Munich: Schirmer/Mosel, 2002); *Cy Twombly: Photographs III, 1951–2010* (Munich: Schirmer/Mosel, 2011); and *Le Temps Retrouvé: Cy Twombly photographe & artistes invites* (Avignon: Actes Sud/Collection Lambert en Avignon, 2011). This is also true of Twombly's sculptures. Currently, the single volume of the *Catalogue Raisonné of Sculpture*, edited by Del Roscio with a catalogue essay by Arthur Danto, covers the period from 1946 to 1997. However, there are several excellent catalogues that focus on the artist's sculptural practice: *Cy Twombly: Sculptures 1992–2005*; *Cy Twombly: Die Skulptur / The Sculpture* (2007).

10. Schjeldahl, "Drawing Lines."

11. Karp, "Oral History."

12. Frankfurter, "Voyages of Dr. Caligari through Time and Space," 65.

13. See *Cy Twombly Catalogue Raisonné of the Paintings*, 1:97. In the introduction to this catalogue, Bastian writes, "Twombly uses a thin layer of paint as a dispersion that seeps deeply into the coarse canvas. He draws with white chalk upon a near uniform sooty black. The black matter preserves the sharp contours of the lines as something near-physical, a presence that the colourless darkness of the painting's depth resist absorbing" (23). Bastian writes in more depth on *Panorama* in *Audible Silence*, a work he describes as "poesie pure . . . a work without Isms, invented by a young artist as a language in evolution, as a form of self-discovery and thus—for a fleeting instant—halting modernism and the idea of any kind of aestheticism" (41). Images of the destroyed paintings also appear in *Cy Twombly Photographs: 1951–1999* under the title *Fulton St. Studio, NYC, 1954*. It's noteworthy that it is this place, and not the works, that are named. Other photographs from Fulton Street show the combine material used by Rauschenberg, a scattered debris of materials. The timing for the completion of the painting, 1954 and not 1955 as the artist remembered, is described in Varnedoe, "Inscriptions," 22. *Panorama* was owned for a time by Rauschenberg.

14. Serota, "History Behind the Thought," 52.

15. In six of the drawings the artist has drawn a little frame around the image, cutting off a few of the strands of the pencil marking. It is a way of working—selection and editing—reminiscent of his method of painting described by Manfred de la Motte, "Twombly's large canvases also forgo what was previously so important for paintings: a specific format and frame. The canvases are irregular, even torn, and attached by nails to the wall without a stretcher or skirting. In his studio in Rome an entire large room is covered with canvas, even the corners. Then he starts work, close to the floor or up under the ceiling. After many days everything has been covered in scribbles, sullies, smears, or left empty. He cuts out large pieces from the raw material thus produced and then works on them" (de la Motte, "Cy Twombly," 49).

16. *East Hampton* (NY) *Star*, October 6, 1983.

17. Years after first reading and writing about those 1955 pencil drawings completed in New York City, the "album" that never was, a suite of wild and generous early pieces, I discover Bedenkapp's name in a series of letters Twombly wrote to David Whitney. Clearly he and Cy were friends for a time, Bedenkapp occasionally visiting the artist in Rome. In January of 1974 Twombly mentions the burning of a painting in an incinerator, presumably *Desert of Love*, by Bedenkapp's partner. One puzzle replaces another.

18. Charters, *Olson/Melville*, 84.

19. Alec Wilkinson, "Remembering Cy Twombly."

20. Kazanjian, "Painted Word," 555. A conflicting account of Twombly's teaching of this class is offered in the chapter "Lexington."

21. Serota, "History Behind the Thought," 43.

22. O'Hara, "Cy Twombly, 1955," 34. O'Hara is writing specifically of the drawings shown at the Stable Gallery in 1955, but the effect seems true for these works as well.

23. Cy Twombly to Pierre Daura, February 15, 1948, box 138, folder 5, Pierre Daura Archive, Georgia Museum of Art, University of Georgia. There's an anecdote in Nicola's essay "1972–1979" about a curator from a museum in the United States who came to Twombly's studio looking for "the perfect drawing" and the artist "like a carpet seller in an Istanbul bazaar" offering endless, unsatisfactory options. She didn't end up buying a drawing from the artist, but instead bought "the perfect drawing" from "a friend of Cy's, a drawing that Cy had cleared away while cleaning up one of his previous studios." Nicola reports that this American friend took the drawing from the trashcan, ironed and framed it, and then sold it to the curator. This idea of the "perfect drawing" became an inside joke between them. Interestingly, this story was edited out when this short essay was reprinted in the recent *Cy Twombly* catalogue for the Centre Pompidou show. Nicola doesn't name the curator, the drawing, or the American friend (6–7).

24. Sylvester, *Interviews*, 176–177.

25. Temkin, "Out of School," 345.

26. Temkin, "Out of School," 345. "This wasn't a conventional canvas. It was a cheap piece of cloth, like what you would use as a drop cloth. And it wasn't paint, it was pencil" (Ann Temkin, Audio Tour, https://www.moma.org/m/tours/7/tour_stops/137?locale=en).

27. Mancusi-Ungaro, "Cues from Cy Twombly," 69. Mancusi-Ungaro dates this conversation as from December 16, 1993.

28. Stevens and Swan, *De Kooning*, 360. "Later, de Kooning became angry when the younger artist publicly exhibited *Erased de Kooning*. De Kooning believed that the murder should have remained private, a personal affair between artists, rather than splashed before the public. He was from an older generation" (360).

CHAPTER 5

1. Dupêcher, "'Like Clocks,'" 32–33; and Varnedoe, "Inscriptions," 33n45. Cy Twombly, "Application Statement," 1955, Cheek Papers, VFMA.
2. Cy Twombly to Betty Stokes, November 6, 1955.
3. Stokes, "Lot Notes."
4. Sylvester, *Interviews*, 173.
5. Serota, "History Behind the Thought," 44. Nicholas Cullinan in his chronology in *Cycles and Seasons* writes of Twombly's return to Italy in Feburary of 1957: "Betty Stokes, his long-time friend from Lexington, who had married a Venetian, Count Alvise di Robilant, the previous year, has her first baby. With financial support from [Eleanor] Ward, Twombly leaves New York to spend some months in Italy with her and stays at the di Robilant's house in Grottaferrata, south of Rome" ("Chronology," 237).
6. Stokes, "Lot Notes."
7. Varnedoe, "Inscriptions," 62n127. Varnedoe quotes from several unpublished letters from Twombly to Eleanor Ward from the spring of 1957 and March of 1958.
8. Varnedoe, "Inscriptions," 62n127.
9. Twombly occasionally dedicates his paintings to the living or the recent dead. A few early drawings—and several from the 1970s—are dedicated to Tatiana or his son, Alessandro. "For TATIA love Cy Dec 25 1977," Twombly writes on the wheels of *Untitled* 1977, the sculpture, a "rough but sweetly flower-topped car" (Nesin, *Twombly's Things*, 143). Nini's Paintings are named in the memory of Nini Pirandello, late wife of Plinio De Martiis, and of course *Nicola's Iris*, a series of flower drawings for Del Roscio. Most of the time the "*To*" marks Twombly's artistic debts—impersonal love letters from one artist to another: *To Valery, To Tatlin, etc.* Barthes describes the dedications in Twombly's work as performative gestures; he writes, "Again, nothing here but the graphic action of dedicating. For 'to dedicate' is one of those verbs linguists, following Austin, have called 'performatives,' because their meaning is identified with the very action of uttering them: 'I dedicate' has no meaning other than the actual gesture by which I present what I have made (my work) to someone I love or admire" (Barthes, "Wisdom of Art," trans. Howard, 181).
10. Waters, *Role Models*, 246.
11. James Panero, "Behind the Veil: Questions About Art Authentication," *Wall Street Journal*, March 23, 2011. Issues of authentication have not publicly come up for the Twombly Foundation, unlike, say, the public legal brinksmanship of Motherwell's Daedalus Foundation, but these conflicts are inherent in the very business of the artist-endowed foundation.
12. Adams, "Expatriate Dreams," 63.
13. Temkin, "Out of School," 345.
14. Quoted in Cullinan, "Catalogue," 72.
15. Cy Twombly to Giorgio Franchetti, undated, 1971.
16. Stokes, "Lot Notes."

CHAPTER 6

1. DeLillo, "That Day in Rome—Movies and Memory," 76–78.
2. Betty Stokes, conversation with the author, April 16–17, 2014.
3. Plumly, *Posthumous Keats*, 332.
4. Let me clarify a bit of confusion which might arise if one looks at the date Betty sold her sculpture. The year 2013 is, of course, two years after the artist's death. The bronze sculpture up for sale in 2013—*Untitled* 1990—was, in fact, part of a set of five, four of which were owned by Betty and her sons. It was one of those pieces, owned by one of the boys, that was sold earlier and the possible source of Twombly's anger over the sale.
5. Serota, "History Behind the Thought," 47.
6. Weiss, "Private Practice," 216.
7. In 1954, Twombly made "plaster sculptures in the sand at Staten Island; all these are

now lost" (Cullinan, "Chronology," 236). Schmidt in "Looking at Cy Twombly's Sculpture" describes the practice in 1992 in the making of *Thicket* 1992, and includes a photo of the process of pouring the plaster into sand.

8. Newton, *Encyclopedia of Unsolved Crimes*, 180. See also Bruce Johnson, "Murder of Opera Fan Blamed on Gay Serial Killer," *Telegraph* (UK), September 11, 2002, http://www.telegraph.co.uk/news/worldnews/europe/italy/1406907/Murder-of-opera-fan-blamed-on-gay-serial-killer.html.

CHAPTER 7

1. Giosetta Fioroni, conversation with the author, June 20, 2014.
2. Reginato, "Alpine Way," 188.
3. Schjeldahl, "Drawing Lines."
4. Schloss, "Cy Twombly."
5. Cy Twombly to Giorgio Franchetti, November 30, 1958. Of his meeting of Tatiana and Giorgio Franchetti in 1957, Varnedoe writes, "Giorgio's support had enabled him to work more or less as he wished without worry over the costs of studios or materials and without undue concern for the sales of his painting" ("Inscriptions," 31).
6. Gaia Franchetti, conversation with the author, July 17, 2014.
7. Giorgio Franchetti, interview by Francesca Romana Morelli, *Mecenatismo*, August 15, 2006, http://www.mecenate.info/giorgio-franchetti-aveva-nel-dna-la-passione-per-larte-collezionista-militante-introdusse-in-italia-larte-americana/.
8 . Celant and Fioroni, *Giosetta Fioroni*, 106.
9. Varnedoe, "Artist's Artist," 167.
10. Cy Twombly to Giorgio Franchetti, 1959d. There are five extant letters from Cy to Giorgio from 1959, all undated. They are marked here as *a–e*. Excerpts of letters between Giorgio and Cy also appear in *Da Giorgio Franchetti a Giorgio Franchetti: Collezionismi alla Ca' d'Oro*.
11. Cy Twombly to Giorgio Franchetti, 1959b.
12. Malcolm, *Silent Woman*, 110.
13. Serota, "History Behind the Thought," 44.
14. Charles Olson to Robert Creeley, November 29, 1951, in Olson, *Complete Correspondence*, 199.
15. Lawford, "Roman Classic Surprise," 194.
16. Cy Twombly to Giorgio Franchetti, 1959c.
17. Cy Twombly to Giorgio Franchetti, 1959e.
18. Alan Cowell, "The Granddaddy of Disorder," *The New York Times*, September 18, 1994.
19. This letter, 265, from Dickinson to Thomas Higginson is dated June 7, 1862. "If Fame belonged to me, I could not escape her—if she did not, the longest day would pass me on the chase—and the approbation of my dog, would forsake me—then— My Barefoot-Rank is better" (Dickinson, *Letters*, 174).
20. Gayford, *Man with a Blue Scarf*, 72. It's worth noting how, while there are frequent references to Tatia's portrait painting, very few appear in books or catalogues about Twombly. As Adams notes in his review of the MoMA show, "I do wish Varnedoe had included at least one documentary photo of Tatiana Franchetti's work" ("Expatriate Dreams," 63).
21. Mézil, "Memories of Cy Twombly," 247.
22. Blistene, "Cy Twombly," 31.
23. Barthes, "Wisdom of Art," trans. Howard, 180. The problem of titles is one that has vexed critics of Twombly since the start of his painting career and continues to be a source of both possibility and pleasure, but also potential for misreadings or overreadings. "Twombly," writes Richard Leeman, "is not systematic," perhaps the truest statement in his book.
24. Gayford, *Man with a Blue Scarf*, 108.

CHAPTER 8

1. Lawford, "Roman Classic Surprise,"194.
2. Lawford, "Roman Classic Surprise," 195.
3. Lawford, "Roman Classic Surprise," 195.
4. Cy Twombly to Giorgio Franchetti, April?, 1959a.
5. White, "Rebel Vision," 210.
6. Isabella Ducrot, conversation with the author, May 8, 2014.
7. Milton Gendel, conversation with the author, June 1, 2014.
8. Schloss, "Cy Twombly."
9. Kazanjian, "Painted Word," 555.
10. Twombly, *Artists Documentation Program*, 18.
11. Gaia Franchetti, conversation with the author, July 17, 2014.
12. Bowles, "Italian Lessons," 193.
13. Lawford, "Roman Classic Surprise," 195. These accounts of the interior style by Bowles and Lawford parallel another description of the Franchetti castle in Val Gardena and its dozens and dozens of nearly empty rooms: "A typical bedroom offers a rare, 16th-century Gothic bed (and a mattress seemingly dating from the same period), with a stern iron lamp and one elegant cabinet. Nearly every room, however, features a brightly colored antique tiled stove, a traditional Alpine feature. Just don't look for many comfortable chairs" (Reginato, "Alpine Way," 190).
14. Kazanjian, "Painted Word," 617.
15. Barthes, "Wisdom of Art," trans. Howard, 192.
16. Del Roscio, "Crossing a State of Crisis," 6.
17. Boland, *Against Love Poetry*, 9.

CHAPTER 9

1. Serota, "History Behind the Thought," 52.
2. Giosetta Fioroni, conversation with the author, June 20, 2014.
3. Varnedoe, "Inscriptions," 27. The essay by Twombly was originally published in *L'Esperienza moderna* in August–September 1957.
4. Glück, *Proofs & Theories*, 74. One critic wrote of *Poems to the Sea*: "Just as sexuality is an analogue for artistic creation, the timeless sea, a theme which would reoccur in grandeur in Twombly's later work, is here an emblem of elemental drive" (Delehanty, "Alchemy of Mind and Hand," 14). Dry prose hides the power of this statement, for what is an "elemental drive" if not the very heart of Twombly's work: the violence of battles, the empire of oceans that course through his images, the struggle of desire: lost beloveds, lost homes, time and memory, exile and longing and sex and shame and fear and joy.
5. Varnedoe, "Inscriptions," 27.
6. Isabella Ducrot, conversation with the author, May 8, 2014.
7. Schmidt, "Looking at Cy Twombly's Sculpture," 49.
8. Serota, "History Behind the Thought," 52.
9. Varnedoe, "Inscriptions," 63n138. Cy Twombly to Leo Castelli, undated, August 1959, Leo Castelli Gallery records, Archives of American Art, Smithsonian Institution (hereafter cited as AAA, SI).
10. Sylvester, *Interviews*, 175.
11. Sylvester, *About Modern Art*, 499.
12. Leo Castelli to Cy Twombly, August 31, 1959, Leo Castelli Gallery records, AAA, SI.
13. Varnedoe, "Inscriptions," 63n138. Cy Twombly to Leo Castelli, September 17, 1959, Leo Castelli Gallery records, AAA, SI.
14. Cy Twombly to Leo Castelli, undated [1961?], Leo Castelli Gallery records, AAA, SI.

15. Ileana Sonnabend to Leo Castelli, May 15, 1962, Leo Castelli Gallery records, AAA, SI.
16. Writing of water as a metaphor, poet Cole Swensen claims, "It is also the perfect metaphor for painting. Of the four elements, only land can be painted, while water, fire, and wind are among the hardest things to capture because paint is a solid object, albeit one always trying to refute that. And yet all paint is liquid when alive, and thus all painting is the property of water, with which it must make its peace before it can go on to anything else. Twombly addresses this by addressing the sea, over and over, because it is that which must be crossed" (Swensen, "Drowning in a Sea of Love").

CHAPTER 10

1. Cullinan, "Catalogue," 88n2. Cy Twombly to Leo Castelli, Leo Castelli Gallery records, AAA, SI.
2. Roberta Smith, "An Artist of Selective Abandon," *The New York Times*, July 6, 2011, http://www.nytimes.com/2011/07/07/arts/design/cy-twombly-an-art-who-emphasized-mark-making.html.
3. Adams, "Expatriate Dreams," 66.
4. Dean, "Panegyric," 37.
5. Bastian, "Comments," 37.
6. See Leeman, *Cy Twombly*, 114–115, for a discussion, and over-reading, of "wings" in Twombly's work from poetic inspiration to Platonic metaphor; "So the wing comes to embody more precisely the flux to which the artist gives a shape, from his scribbles to his pictograms: a 'flood of longing'" (115). There's a larger problem and question at work here. "Writers on Twombly's sculptures have been prone to source-hunt," writes Kate Nesin, "cataloguing absent whites rather than present ones in their bids to account for the advent and perseverance of white in them" (35). That "source-hunt" can sometimes illuminate Twombly's method and thinking, but it also leads to assumptions and quagmires and overreaching. I implicate myself. Nesin goes on to astutely describe one of the problems of writing about Twombly: "The Twombly literature has long shown a propensity for the belle-literalistic and more specifically for a lyricism in response to what is judged to be the artist's own—no matter the fastidious, even pointedly causal physicality of many of his works. Twombly's de-skilled handling incites romantic effusion rather than fore-shortens it and, consequently, these critics who most value the artist's avant-garde credentials are often those who have written about him most gingerly, as if afraid to be seduced" (23–24).
7. Bowles, "Italian Lessons," 193.
8. Alessandro Twombly, conversation with the author, April 23, 2014.
9. Kazanjian, "Painted Word," 617.
10. Auden, *Collected Poems*, 594.
11. Varnedoe, "Artist's Artist," 176.
12. Didion, *White Album*, 75.
13. White, "Rebel Vision," 211.
14. Biographical notes, *Catalogue Raisonné of Drawings*, vol 7.
15. Cy Twombly to Betty di Robilant, November 12, 1968.
16. White, "Rebel Vision," 211.

CHAPTER 11

1. The story is recounted in a letter from Cy Twombly to David Whitney from May 24, 1971. Today, at Joyce's Rome house, 52 Via Frattina, a small plaque marks the door.
2. Kushner, "A Rock, A Deceptive Manor," 44.
3. This passage does not appear in Richard Howard's translation of Barthes. This is

from Barthes, "Wisdom of Art," trans. Lavers, 16.

4. Christopher Knight, "Art Review: Twombly's End Game: Moca Retrospective Shows His Achievements While Clarifying His Place in 20th-Century Art," *Los Angeles Times*, April 10, 1995, http://articles.latimes.com/1995-04-10/entertainment /ca-52955_1_modern-art.

5. Lawford, "Roman Classic Surprise," 196.

6. Varnedoe, "Artist's Artist," 166. Though Clemente attributes the quote to Italo Calvino, I have yet to find it.

7. Serota, "History Behind the Thought," 45.

8. White, "Rebel Vision," 210.

9. Trapp, "Cy Twombly's Ferragosto Series," 71.

10. Cullinan, "Catalogue," 101; Sylvester, *Interviews*, 178. Cullinan's essay "Abject Expressionism" in the *Cycles and Seasons* catalogue describes Twombly's schema of color—red for "flesh + Blood" and brown for earth and excrement—and the scatological signification of the paintings. Cullinan also notes that brown can represent, as it did for Twombly at a later point in his career, "the pinnacle of artistic achievement, like the brown paintings by Rembrandt, J.M.W. Turner, Frans Hals, Anthony van Dyck and others whom Twombly especially admires, analyzed in The Frick Collection in New York as a student, and later sought to emulate" (101). Though I appreciate the ambition, these late works are some of my least favorite Twombly paintings.

11. Barthes, "Wisdom of Art," trans. Lavers, 10. See Varnedoe "Inscriptions" for more about the smearing of the paint. "Clutching gobs of oil pigment let him work more continuously, uninterrupted by the need to 'reload' a brush, and it put him, literally, in closer touch with the picture." Twombly traded the sharp point of the pencil for touch: "his impulses would meet the surface sensuously, in the broad, flat engagement of the palm, or by fingertip daubs, or through varieties of clawing and caressing" (35).

12. Berger, "Defending Picasso."

13. Rose, *Robert Rauschenberg*, 37.

14. Sylvester, *Interviews*, 179.

CHAPTER 12

1. Davis, "Rome Revisited," 6.

2. Davis, "Rome Revisited," 6.

3. See Cullinan, *Twombly and Poussin*, 20. Cullinan writes in his catalogue essay, "In these remarkable and coincidentally similar compositions both Twombly and Poussin seem fascinated by fictive landscapes with quoted architectural element, and the play between nature and artifice, real and imaginary, civilization and the uncultivated and untamed" (20).

4. White, "Rebel Vision," 210.

5. Serota, "History Behind the Thought," 46.

6. "Cy Twombly 1966," *Nest*, 24.

7. Clark, "At Dulwich."

8. Patton, "Cy Twombly," 71.

9. Of *Coronation*, Twombly said to Serota, "They were started in Bassano and hung upstairs for years. I like the sun disc because I managed to do very childlike painting, very immediate. Then I took them to Virginia and finished them—wound up at the end with a detail of Degas's *The Cotton Exchange in New Orleans*. How it got in there, I don't know, but it's one of my favourite sets." Social and personal at once, Degas's 1873 painting, done in New Orleans after observing his family's business, has, "a popular, if rather inflated, reputation, as 'the single greatest masterwork produced on these shores,'" writes Marilyn Brown (*Degas and the Business of Art*, 1). Degas might seem like an unlikely source. Degas's painting is an outsider's take on

an American scene, a not unfamiliar feeling for Twombly: "I've lived in Italy for so long, that Lexington seems foreign" (Herrera, "Cy Twombly: A Homecoming," 144).

10. Said another way, "There is a wonderful tension between vatic reference and vernacular mark" (Schjeldahl, "Size Down," 73).

11. Nabokov, *Lectures on Literature*, 64.

12. Varnedoe, "Inscriptions," 36.

13. See Delehanty, "Alchemy of Mind and Hand," 61–73, on Twombly's sources for this work. See also Cullinan's *Twombly and Poussin*. As Leeman notes, "the flesh colour of *Triumph of Galatea* evokes not so much the Villa Farnesina but as Twombly himself says, Flemish Baroque, and Rubens in particular" (*Cy Twombly*, 91).

14. Ovid, *Metamorphoses*, 335.

15. Christopher Knight, "Art Review: Twombly's End Game: Moca Retrospective Shows His Achievements While Clarifying His Place in 20th-Century Art," *Los Angeles Times*, April 10, 1995.

16. Goethe, *Italian Journey*, 129. Twombly would create his own homage and response to this text in a series of works from 1978 titled *Goethe in Italy*. The artist also made several drawings titled *See Naples + Die* 1960, where he inscribes that phrase made famous by Goethe, "*Vedi Napoli e poi muori!*—See Naples and die!"

17. Rockburne, "Moveable Feast," 219. Rockburne perhaps downplays the experimental nature of this rebellion. Olson describes to Creeley the radical nature of Twombly's "conservative" and "archaist" art: "(By the way, am to do a note on T for a show of his at Washington & Lee; & look forward to it, for the lad is a conservative, as i begin to think any archaist is (eh? DHL? RC?)—that is, "radicalism" in art (I mean, of course solely positional) looks as thin as avant guard *[sic]*, as bourgeois, as realism" (Charles Olson to Robert Creeley, November 29, 1951, in Olson, *Complete Correspondence*, 199). See also Yau, "Cy Twombly and Charles Olson and the Archaic Postmodern," which argues for the influence of Olson on the younger artist.

18. Albee, "Cy Twombly," 11.

CHAPTER 13

1. Cy Twombly to David Whitney, November 11, 1966, box 4, folder 30, David Grainger Whitney Trust, Menil Collection, Menil Archives, Houston, TX (Hereafter as Whitney Papers, Menil Archives).

2. Lawford, "Roman Classic Surprise," 196.

3. De Looz, "Cy Twombly 1966."

4. Rockburne, "Departures," 33.

5. Lawford, "Roman Classic Surprise," 194.

6. This is a story not about Twombly, but what I imagine his own reaction would be to being filmed at work. On seeing Merleau-Ponty's film of him painting *Young Woman in White, Red Background* 1946, Matisse said, "I suddenly felt as if I were shown naked—that everyone could see this—and it made me feel deeply embarrassed" (Bois, "Certain Infantile Thing," 71).

7. De Looz, "Cy Twombly 1966." The critic invoked though not quoted directly in the article is Nicholas Cullinan.

8. Smith, "Great Mediator," 15.

9. Olson, *Collected Prose*, 112.

10. Varnedoe, "Arist's Artist," 169. This idea of "analogy as creation" appears throughout criticism of Twombly. Take for example, Richard Howard's account of Twombly's *Lepanto* paintings, "As we move along the swarming gamut of Twombly's sea-battle," writes Richard Howard, "there is a sense that we have encountered an anthology of creative invention—the vivid compression of painterly possibility, all-out and all-over" (Howard, "On Lepanto," 36).

11. Wijnbeek, "Twombly, Cy," 86.

12. Stevens, "After the Heroes," 100.

13. Sylvester, *Interviews*, 178.
14. Varnedoe, "Inscriptions," 63n138. Cy Twombly to Leo Castelli, undated, August 1959, Leo Castelli Gallery records, AAA, SI. Varnedoe writes that this letter was probably written the week of August 20, 1959.
15. Bastian, introduction to *Cy Twombly Vol. 2*, 29.
16. Kushner, "A Rock, A Deceptive Manor," 45.

CHAPTER 14

1. Savig, "Handwritten Letters From Legendary American Artists." Cy Twombly to Leo Castelli, 1963?, Leo Castelli Gallery records, AAA, SI. The digitized letter is also reproduced on the website for the Archives of American Art, https://www.aaa .si.edu/collections/items/detail/cy-twombly-letter-to-leo-castelli-11824.
2. Cullinan, "Cy Twombly."
3. *Historia Augusta I*, 291.
4. Cullinan, *"Nine Discourses on Commodus,"* 78. Cullinan writes of Twombly's historical imagination as it is informed by the present. See also Suzanne Delehanty, from a conversation with the artist, who describes these pictures as "portraits . . . who, like ancient alter-egos join the artist on canvas. Twombly was attracted to the contradictory personalities of these men of myth and history; he found them perfect examples of action and sensibility" ("Alchemy of Mind and Hand," 18).
5. Cullinan, "Cy Twombly."
6. Jonathan Jones, "The last American hurrah," *The Guardian*, April 10, 2004, https://www.theguardian.com/culture/2004/apr/10/1.
7. Chia, "Sandro Chia."
8. Bolaño, *Between Parentheses*, 51.
9. Cullinan, "Cy Twombly."
10. Judd, "In the Galleries," 128–29.
11. Fisher, *Wonder, the Rainbow, and the Aesthetics of Rare Experiences*, 160. Fisher's chapter on Twombly "Thinking through the Work of Art," traces the journey through two very different kinds of Twombly works, a blackboard painting, *Untitled* 1970, and *Il Parnasso* 1964. Unlike the chalkboard painting, in which "we feel the relation of the everyday to the infinite," of the later, he writes, "one paradox of this work is based on the power of the minute. Intense, local scribbles or patches of color with only a nearby field of action (much like a small face in a large canvas) are linked in pairs, often with partner areas far away in the field of the work" (155, 178).
12. Perl, *Eyewitness*, 41.
13. As Carol Vogel in *The New York Times* put it in 2007: "When the dealer Leo Castelli couldn't sell the work, he returned it to Mr. Twombly, who sold it to a private collector in Rome. A few months ago the collector sold it to Larry Gagosian, the Manhattan dealer, who sold it to the Guggenheim Bilbao. The price paid by Guggenheim, around $25 million, is a fraction of what those works would sell for now on the open market" (Carol Vogel, "Independence at the Hammer," *The New York Times*, January 19, 2007, http://www.nytimes.com/2007/01/19/arts/design/19voge.html).

CHAPTER 15

1. Del Roscio, introduction to *Cy Twombly Drawings*, vol. 3, n.p. We know the year Twombly and Del Roscio first met but not the month. I never got the chance to ask him. My guess, based on the fact that Twombly worked in Munich in the fall, was that they met in the spring. But according to the biography in the catalogue raisonné, the artist "spent the spring in Greece" and worked at Castel Gardena in Dolomites for July and August." The same confusion exists about Nicola's age at their meeting, either nineteen or twenty, depending on if you look at his account in the introduction or the 2015 *Times* profile by Stowe.
2. See the recent catalogue for 2017 retrospective at the Centre Pompidou, *Cy*

Twombly, edited by Jonas Storsve.
3. Mancusi-Ungaro, "Conversation about the Cy Twombly Gallery."
4. Quoted in Tytell, *Ezra Pound*, 347; Hall, "Ezra Pound."
5. Del Roscio, introduction to *Cy Twombly Drawings*, vol. 3, n.p.
6. Fisher, *Wonder, the Rainbow, and the Aesthetics of Rare Experiences*, 160.
7. Stacey Stowe, "Cultivating Genius," *The New York Times*, March 26, 2015.
8. Stacey Stowe, "Cultivating Genius," *The New York Times*, March 26, 2015.
9. Del Roscio, introduction to *Cy Twombly Drawings*, vol. 3, n.p.
10. "Cy Twombly 1966," *Nest*, 19.
11. The myth of Leda and the Swan, Zeus transformed into a swan to rape Leda, the distant origin of the Trojan War as Helen was the daughter of Leda, is another story with a vast tradition of artists, from Michelangelo to Titian to Boucher, and no shortage of literary forebears from Ovid to Rilke to Yeats to H.D. The title is the hook, a barb in the eye, that gives this image the weight of story.
12. One could write a book on the window in Twombly's work. A brief sketch: "Towards the middle of the canvas," Laura Cherubini writes of *Untitled* 1958, "we can trace the vague outline of a window. The same window appears in other cases, such as in *Leda and the Swan* (1962), in which the window seems to take flight from a tangle of signs." A "wide window," as she notes, is how Bastian described Twombly's paintings, and for the Surrealists, "the window looks upon an interior reality." By contrast, in some Renaissance paintings, the open window is a marker of death. The soul fleeing this mortal coil through an open sky passageway (Cherubini, "White Talent"). See also Hochdörfer's essay, "Blue Goes Out, B Comes In," for more about the window as sign and motif, a form that appears in many drawings of '61 and '63 as well as the Munich paintings of '64. In his book Leeman describes the window, along with the mirror and the pool, as "yet another symbolist image," while Claire Daigle connects the window to Renaissance painting (Leeman, *Cy Twombly*, 119). "The window's escape," Daigle writes, "suggests that Twombly is leaving behind his Renaissance compatriots with their classical subjects and perspectival window views" (*Reading Barthes / Writing Twombly*, 36, also 82–83). Twombly's windows, by her reading, rebel against tradition. Likewise, Delehanty in "The Alchemy of Mind and Hand" writes about the emergence and transformation of the rectangle as it connects to "movement, time, and pictorial space" (20). Of *Untitled* 1965, a drawing done in New York City, she writes, "The window questions the nature of art and the artist's activity" (22).
13. Leeman, *Cy Twombly*, 119. Leeman writes of this moment, "The window and the cloud are recurrent poetic images in Twombly's work, from the black Homeric cloud of the grief of Achilles to the 'crushing cloud'—the eminently symbolic white cloud also captioned 'diluting dreams' in *Untitled* (1962)."
14. Del Roscio, "Crossing a State of Crisis," 8.
15. In an earlier drawing, from 1961, Twombly used the same phrase, "Notes From a Tower," though in that drawing he also wrote "Wolkenstein Castle, Tyrol, 1961," a reference to an ancient, ruined castle built high on a hillside near Castel Gardena. See also Delehanty, "Alchemy of Mind and Hand."
16. Woolf, *The Diary of Virginia Woolf*, 234.
17. Rondeau, *Natural World*, 16–18. The addition of the phrase, *How Long Must You Go?* feels even more pressing in the light of Twombly's restless movement from place to place, working on drawings occasionally and paintings less and less.
18. Kirk Silsbee, "The Arc of a Modern Maverick: Cy Twombly at MOCA," *Los Angeles Downtown News*, August 15, 2011, http://www.ladowntownnews.com/arts _and_entertainment/the-arc-of-a-modern-maverick-cy-twombly-at-moca/article _46e4dce2-c766-11e0-9b15-001cc4c03286.html.
19. Nadel, *Ezra Pound*, 180.
20. Mann, *Hold Still*, 79.

21. Mann, *Hold Still*, 79.
22. Quoted in Bill Berkson, "Spoleto '65."
23. Quoted in Wilhelm, *Ezra Pound*, 271.
24. This documentary footage is from 1967. Mann in her account of this incident gives a date of late 1960s. Only later, from an undated letter to Whitney of this incident—Twombly writes that Pound resembles Robert E. Lee—is it clear that it is in fact 1969. Twombly at the time was working in Bolsena.
25. Mancusi-Ungaro, "From a Conservator's Journal," 59.

CHAPTER 16

1. Thomas Brown Wilber to Leo Castelli, November 1959, Leo Castelli Gallery records, AAA, SI. According to the lot notes for *Portrait of Thomas Brown Wilbur* 1950, a Picasso-esque portrait of Wilber by Twombly, the two were friends in Lexington, both students in Marion Junkin's painting class. https://catalogue.swanngalleries .com/asp/fullCatalogue.asp?salelot=1915++++++10+&refno=++499755&sale type=.
2. Max Renkel, conversation with the author, February 13, 2014.
3. Waters, *Role Models*, 246.
4. Barnes, *Flaubert's Parrot*, 12.
5. Sylvester, *Interviews*, 175.
6. Schiff, *Vera*, 155.
7. Danto, "Ideal Friendship," 213.
8. Caracciolo, "Cy Freedom," 130.
9. Caracciolo, "Cy Freedom," 130.
10. Stacey Stowe, "Cultivating Genius," *The New York Times*, March 26, 2015. From the original print article to the one on the *Times* website, the title of the article has changed, "Cultivating Genius" to "The Centuries-Old Italian House Where Cy Twombly Thrived"; Nicola's role is diminished. It's a strange new title considering that Twombly in fact had his own house in Gaeta. The house photographed in the article belongs to Nicola.
11. Maev Kennedy, "Cy Twombly Paintings and Sculptures Donated to Tate," *The Guardian*, June 12, 2014, https://www.theguardian.com/artanddesign/2014/jun /12/cy-twombly-paintings-sculptures-donated-tate.
12. Serota, acknowledgements, 8.
13. Del Roscio, "Some Notes on Cy Twombly," 5.
14. Truitt, *Daybook*, 117.
15. Lawford, "Roman Classic Surprise," 194.
16. Schiff, *Vera*, xii.
17. Goldstein, "Forum," 33.
18. "The dinner was amusing and good," Edith Schloss wrote about a night she met Cy and Nicola for dinner, "but for once Cy was not amusing and he and Nicola quibbled over everything like an old married couple" (Schloss, "Cy Twombly"). As another writer put it after going to Twombly's house in Gaeta, "More often than Tatia, Nicola del Roscio comes, who Cy Twombly has known for decades. They, too, are, in their own way, an old married couple" (Niklas Maak, "Verschwunden in Italien," *Frankfurter Allgemeine*, January 22, 2005).
19. Danto, "Ideal Friendship," 213.
20. Nicola Del Roscio, conversation with the author, February 19, 2014.
21. Herrera, "Cy Twombly," 146.
22. Cullinan, "Catalogue," 55n1. Cullinan reports this based on a conversation with the artist in Gaeta, June 29, 2005. Robert Rauschenberg in an interview reports a similar interaction with Pollock. Heiner Bastian writes that when he asked Twombly in November of 1972 if his work had been influenced by Pollock, the artist responded, "No, rather not, my works aren't hermeneutic images of expressive sub-

jectivity but rather 'landscapes' that narrate and create symbols" (Bastian, "Day with Cy Twombly," 16). It's hard to imagine Twombly using the word "hermeneutic" or being that descriptive of his own work, though by the mid-1970s, his work seemed less in response/conversation with Pollock and the earlier generation of Abstract Expressionists. In his short essay about the first meeting with Twombly, Bastian doesn't mention Nicola. By contrast, Nicola writes of meeting Bastian at the Cologne art fair while he was helping with Gian Enzo Sperone's booth: "After our long discussion, I suggested that he come to Rome to visit Cy . . . Once they met in Rome, he began a series of books on Cy's work, paintings, drawings, and prints, and for a time, he became a kind of counselor, mentor, and dealer/collector of Cy's work" (Del Roscio, "Crossing a State of Crisis," 7).

23. Caracciolo, "Cy Freedom," 130.

24. Katz, "Cy Twombly's Photographs," 11. In this selection of photographs, edited by Nicola Del Roscio, *Cy Twombly Photographs: 1951–1999*, there are two photographs of John Cage, Betty di Robilant, and of Del Roscio himself, both titled *Nicola Del Roscio*. St. Martin, 1969.

25. Milton Gendel, conversation with the author, June 1, 2014.

CHAPTER 17

1. I can't confirm that Twombly was in New York City during the blackout. However, we do know that he was in New York beginning in November of 1965.

2. Cy Twombly to Giorgio Franchetti, December 31, 1965.

3. Alan Cowell, "The Granddaddy of Disorder," *The New York Times*, September 18, 1994.

4. Cy Twombly to David Whitney, October 28, 1966 (postmark), box 4, folder 30, Whitney Papers, Menil Archives.

5. Vincent van Gogh to Theo van Gogh, Wednesday, July 23, 1890, Auvers-sur-Oise, http://vangoghletters.org/vg/letters/RM25/letter.html.

6. Karp, "Oral History." In the same interview Karp described Twombly's changed relationship to the Commodus paintings: "He's a little ashamed of it himself now he says."

7. Varnedoe, "Inscriptions," 39.

8. Barnard, *Sappho*, n.p. The poems quoted are nos. 81 and 79 in her translation, respectively.

9. Charles Poore, "Books of the Times," *The New York Times*, May 25, 1940, http://www.nytimes.com/books/99/09/12/specials/lorca-newyork.html.

10. The drawings are dated November 1965–1966 in Vol. 4 of the catalogue raisonné of drawings. In 1983, Twombly made similar works, writing in one drawing "NICOLA de ROSCIO asleep by the Ionian Sea." In another drawing, done the same day, December 15, 1983, in Rome, he wrote, "NICOLA DEL ROSCIO asleep by the Ionian Sea." That drawing, all in red, is similar to the ones done in the 1960s, half sexual innuendo and half Venus flytrap. What explains the alternative spelling of Nicola's name, de instead of DEL? A play of language? A gesture of intimacy and knowing? A sign of control, as in "I can make and unmake you"? Maybe this is one of the "perfect mistakes" John Waters writes of, a way of fucking with the viewer. Of the spelling "error" in *Fifty Days at Iliam*, the substitution of the A for the I in Ilium, David Sylvester said to the artist, "They may have noticed it but been too polite to say because they thought you were making a mistake." Twombly responded, "Or no one cares . . ." (*Interviews*, 177–178). Johanna Burton writes of this in her brilliant essay "Cy Twombly's Transformations," "Of course, Twombly may also be correct: no one notices or no one cares, but this seems unlikely given the institutions and individuals involved. And, in any case, not caring is implicitly not an option in considering the work in the present context: there is always the chance that Twombly himself sought to cast doubt on any single meaning for his work, in which case his

suggestion that audience might 'not care' is, in fact, an utterance whose significance turns on the hope that they do" (Burton, "Cy Twombly's Transformations," 231).

11. In the Barnard translation of Sappho 45 and the drawing, it is *pillows*, not *pillow* as the catalogue raisonné transcribes. The plural shifts the meaning of the line from an act of accommodation to one of luxurious invitation (*Untitled, 1965, Catalogue Raisonné of Drawings*, 4:85).

12. In another, drawing, a blue and yellow triangle, like a reinvented traffic signal, this fragment, also from Sappho:

Cyprian in my Dreams
the folds of a purple
kerchief shadowed
your cheeks—the one

Timas one time sent,
a timid gift all
the way from Phocaea

Aphrodite, or Cyprian, comes to the poet in sleep. The poem moves from the night-time visitation of the goddess of love to this kerchief that has crossed the sea as a gift.

13. Del Roscio "Some Notes on Cy Twombly," 6.

14. Del Roscio "Some Notes on Cy Twombly," 7.

15. Woolf, *Common Reader*, 309.

16. Allen, "David Grainger Whitney."

17. Del Roscio, "Some Notes on Cy Twombly," 11.

18. Del Roscio, "Some Notes on Cy Twombly," 7.

19. Ashton, "Artist as Dissenter," 165. Her review focuses on the political impli-cations of the Lorca passages, "a poet who cannot be dissociated from war and outrage." "The Lorca pages," she writes, "for instance, are carefully designed, eco-nomically phrased so there is no mistaking the specificity of Twombly's choice . . . Even Cy Twombly seems unable to work in peace of late."

20. Cy Twombly to Giorgio Franchetti, February 24, 1966.

21. Gayford, *The Man with a Blue Scarf*, 130.

CHAPTER 18

1. Cy Twombly to David Whitney, November 9, 1966, box 4, folder 30, Whitney Papers, Menil Archives.

2. Adams, "Expatriate Dreams," 66–67.

3. Pincus-Witten, "Learning to Write," 56.

4. Cy Twombly to David Whitney, December 18, 1967, box 4, folder 30, Whitney Papers, Menil Archives.

5. Cy Twombly to David Whitney, March 2, 1968 (postmark), box 4, folder 30, Whitney Papers, Menil Archives

6. Alston and Taylor, *Handwriting Theory, Research, and Practice*, 163. See Leeman, *Cy Twombly*, 171–185. The Palmer Method was a strict way of teaching handwriting in the United States, though by the time Twombly was in school, this method of instruction was declining in popularity. Leeman draws a loose connection between the "rediscovered Americanness" of these paintings, "simple, rudimentary, elemen-tary, masculine," and this strict method of instruction (Leeman, *Cy Twombly*, 174).

7. Rose, *Frankenthaler*, 85.

8. Varnedoe, "Artist's Artist," 168.

9. Del Roscio, "Some Notes on Cy Twombly," 11.

10. Dean, "Panegyric," 35.

11. Of the rectangles in *Problems*, Delehanty writes, "As opposed to the Renaissance notion of the canvas as reality's window, Twombly's rectangle is a twentieth cen-tury window, a construct to delineate near and far, interior and exterior pictorial

space. It is, perhaps, an unconscious memory of Delaunay's window painting. It is Magritte's eye" ("Alchemy of Mind and Hand," 22). It's also worth noting Twombly's observation to Delehanty that the artist "lightens black to grey, not to suggest a schoolroom blackboard, but to 'make a black and white painting without making a black and white painting'" (22).

12. Del Roscio, "Some Notes on Cy Twombly," 11.

13. The materials for *Untitled* 1968, part of the 1987 Szeemann curated retrospective, are listed as "oil, chalk, and tempera on cloth." The catalogue raisonné lists the materials for this same painting as "oil based house paint, wax crayon on canvas."

CHAPTER 19

1. Joyce Wadler, "Public Lives: A Biographer Peers, Briefly, at Her Own Life," *The New York Times*, May 11, 2000, http://www.nytimes.com/2000/05/11/nyregion/public-lives-a-biographer-peers-briefly-at-her-own-life.html.

2. Cy Twombly to Giorgio and Anne Franchetti, 1969.

3. Simpson, "Cy Twombly, the Lexington Connection," 11–12.

4. Nicholas Cullinan, "In Awe of Cy Twombly," *Art Newspaper*, July 13, 2011, https://www.artlistings.com/Magazine/In-awe-of-Twombly-71733.

5. Kazin, *On Native Grounds*, 145.

6. Mancusi-Ungaro, "Cues from Cy Twombly," 63. Unlike profiles by other writers who spent only a short amount of time with Twombly, Mancusi-Ungaro's reflections on Twombly come from many years of being in his presence. She's careful in her essay to write that some of her observations were "noted at the time."

7. Mancusi-Ungaro, "Cues from Cy Twombly," 68.

8. "In these days of so much dry, clever, soulless trivia, completely lacking in worthwhile subject matter, Twombly stood a towering hero," Maggi Hambling writes in her remembrance of the artist. "His mixture of intimacy and grandeur, force and delicacy, creates a sexy dynamism. He advanced the language of paint—from late Titian, through Rembrandt, Van Gogh, Rothko and Pollock—and so takes his place among the elite. He is dead, but the courage of his work lives on." ("Knockout. Hero. Genius: Cy Twombly," July 6, 2011, https://www.theguardian.com/artanddesign/2011/jul/06/cy-twombly-remembered.)

9. Sylvester, "White Originals," 69.

10. "The Farnese Family's Historical Homes Open To The Public," *Italian Ways*, October 16, 2015, http://www.italianways.com/the-farnese-familys-historical-homes-open-to-the-public/.

11. Barthes, "Cy Twombly," 157. As Roland Barthes sharply observes in one of his essays on Twombly, an essay that begins, "Who is Cy Twombly?," there are in fact two kinds of writing in Twombly's art, the illegible handwriting in white across the blackboard and the numbers. In a conversation with Richard Leeman, Twombly describes numbers as "a kind of reality: a "real effect . . . a 1 is a 1 and a 4 is a 4" (Leeman, *Cy Twombly*, 149).

12. Varnedoe, "Inscriptions," 43.

13. Adams, "Expatriate Dreams," 67.

14. Varnedoe, "Inscriptions," 43.

15. Cy Twombly to David Whitney, undated, Summer 1969?, box 4, folder 30, Whitney Papers, Menil Archives.

16. Larsen, "Works On Paper," 38–40. I think of Sappho's fragmented poem, a command for song: "Come now, my heavenly / tortoise shell: become / a speaking instrument." I don't know if Twombly thought of this poem—or Venus rising on Botticelli's scalloped shell—just as I don't know for certain if the shell made the journey back home, or if it was lost and remembered months later in another country as he drew with pencil onto canvas this totem of another place and time.

17. One scholar describes the limited information we have about Antinous, "tainted

always by distance, sometimes by prejudice and by the alarming and bizarre ways in which the principal sources have been transmitted to us" (Lambert, *Beloved and God*, 48). The writer continues, "Sometimes, however, as with Hadrian, private and sexual preoccupations clearly impinged on public, political actions. In spite of this, and in spite of an unusually varied and consistent amount of contemporary information, studies of Hadrian either ignore altogether or skate gingerly round the issue of his putative homosexuality or bisexuality" (76). The connection between Cy and Hadrian is tenuous to be sure, and yet as Nicola notes, Twombly for a time stayed at the Hotel Serapo in Gaeta "the same hotel where Marguerite Yourcenar would stay while writing the book *Memoirs of Hadrian*" (Del Roscio, "Crossing a State of Crisis," 10). One of Twombly's drawings, *Animula Vagula Blandula* 1980, borrows lines from a poem dictated by Hadrian on his deathbed.

18. De Looz, "Cy Twombly 1966."
19. Yau, "Cy Twombly's Remarkable Treatise."
20. Cullinan, *Twombly and Poussin*, 57.
21. Serota, "History Behind the Thought," 52.

CHAPTER 20

1. Del Roscio, "Atmosphere and People Around Cy, 1970–1971," 7.
2. Larratt-Smith, "Psychedelic Antiquity," 15.
3. Leeman, *Cy Twombly*, 184. This insight is shared with Leeman by one of Twombly's dealers, Gian Enzo Sperone.
4. Cullinan, "Catalogue," 137.
5. Cy Twombly to Giorgio Franchetti, undated, 1971.
6. Cohen-Solal, "Multiple Territories of Cy Twombly," 8.
7. Mann, "Hold Still," 73.
8. "The beholder becomes," writes Jeffery Weiss of the second version of *Treatise*, "in a manner of speaking, a surrogate for Muybridge's walking figure. The painting's affect is one of anticipation, which corresponds to what might be described as the present-tense nature of Twombly's work overall" (Weiss, "Cy Twombly," 369). We "inhabit" the painting, moving through it, the white contrail unspooling along the bottom that marks our journey. Weiss repeats, what seems to me, an apocryphal source for the painting: a nineteenth-century photograph by Eadweard Muybridge of a veiled bride walking in front of a train given to the artist by Rauschenberg. In another account of the origin of *Treatise on the Veil (Second Version)*, Twombly credited composer Pierre Henri's piece "Le Voile d'Orphee," an avant-garde musical work, that repeated sound of fabric being torn. The piece, a 1951–53 cantata for the ballet *Orphee 53*, recalls the myth of Eurydice at the moment she's torn away from Orpheus (as well as Orpheus' own fate of being torn apart by the maenads).
9. Mancusi-Ungaro, "Cues from Cy Twombly," 73.
10. Mann, *Hold Still*, 82.
11. White, "Rebel Vision," 211.
12. Smith, "Great Mediator," 21.

CHAPTER 21

1. Young, "Way I Live Now."
2. "One is art, one is vandalism—but which is which?," *Scotsman*, October 10, 2007, http://www.scotsman.com/lifestyle/culture/one-is-art-one-is-vandalism-but -which-is-which-1-694734.
3. Nicola Del Roscio, conversation with the author, March 6, 2014.
4. Sontag, "Mind as Passion," 27.
5. Waters, *Role Models*, 247.
6. Bird, "Indeterminacy and (Dis)order," 501.
7. Jacobus, *Reading Cy Twombly*, 101.

8. Caracciolo, "Walls Are Heard," 281.
9 . Di Fabio, "Departures," 33.
10. Alberto Di Fabio, conversation with the author, March 7, 2014.
11. Del Roscio, "Atmosphere and People Around Cy, 1970–1971," 9.
12. Del Roscio, "Atmosphere and People Around Cy, 1970–1971," 9.
13. Del Roscio, "Some Notes on Cy Twombly," 12.

CHAPTER 22

1. White, "Rebel Vision," 176.
2. Pasolini, "Il vuoto del potere in Italia."
3. Turbeville, "Portrait of a House," 263.
4. Lawford, "Roman Classic Surprise," 195.
5. Rondeau, *Natural World*, 16.
6. Cy Twombly to Giorgio Franchetti, undated, 1971.
7. Cy Twombly to David Whitney, February 17, 1971, box 4, folder 31, Whitney Papers, Menil Archives.
8. Lawford, "Roman Classic Surprise," 195.
9. Lawford, "Roman Classic Surprise," 195.
10. The dates are based on letters between Twombly and David Whitney. The date in the chronology of the catalogue raisonné for the purchase and restoration of his country house is 1975.
11. White, "Rebel Vision," 210.
12. Bowles, "Italian Lessons," 193.
13. Schloss, "Cy Twombly."
14. Britton, "Artist," 337.
15. Kazanjian, "Painted Word," 617.
16. Varnedoe, "Inscriptions," 46.
17. Rondeau, *Cy Twombly*, 18.
18. Varnedoe, "Artist's Artist," 170. Landscape has been at the heart of Twombly's painting since the start. Just as many of the early works were named for North African villages, two of the first works he made at Black Mountain in 1951 were called *Landscape No. 1* and *Landscape No. 2*.
19. Bachelard, *Poetics of Space*, 9. Gaston Bachelard in *The Poetics of Space* asks: "Was the room a large one? Was the garret cluttered up? Was the nook warm? How was it lighted? How, too, in these fragments of space, did the human being achieve silence? How did he relish, the very special silence of the various retreats of solitary daydreaming?" These questions are mine too. What I want to ask or discover. To know these "spaces of our intimacy" as Bachelard calls them, the rooms and alcoves, corridors and window seats where Twombly worked or read, slept or fucked, hungered or fretted, tells us more than a catalog of dates.
20. The photograph was taken by Plinio De Martiis in 1971. In the photo Twombly is "looking out over the Lake of Bolseana, surrounded by a flock of sheep" (Schmidt, "Looking at Cy Twombly's Sculpture," 69). In her fine writing about the relationship between Twombly and the figure of the shepherd, Schmidt notes the year of the photo as 1968.
21. Jacobus, *Reading Cy Twombly*, 168. These are the lines spoken by Goatherd in *Idyll* rewritten by Twombly on the far right panel: "Sweeten your sweet mouth with honey, / Thyrsis, and with honeycomb. Eat your fill / of Aegilus's finest figs, for your voice / outsings the cricket's. Here is the cup: / smell, friend, its sharp freshness—" In another Theocritus-inspired triptych on paper from the year before *Untitled (Thyrsis' Lament for Daphnis)* 1976, Jacobus poetically describes that above the handwritten phrase THYRIS' LAMENT FOR DAPHNIS is marked by "a rough scrawl of paint and crayon whose dark sepia evokes cuttlefish ink— anciently used for writing, but equally associated with mourning." And though

I'm deeply skeptical Twombly had this mind, I love the image of this animal's gift, the cuttlefish's interior transformed into paint. Just as with that cuttlefish, I want to imagine that when Twombly used Hooker's green in the "pond" paintings, he knew that the shade, developed by the artist William Hooker, combines two colors, Prussian blue and gamboge, and that the latter, a dark saffron, was used to dye the robes of Buddhist monks. In some ways this is the very problem of writing about Twombly. In "Cy Twombly: Writing after Writing," Abigail Susik describes the dilemma of Twombly's "labyrinth of literature," the way that texts, both the ones he read and used, and what's written about him, lead us off the trail and into the wilderness. Gift and limit at once, she writes: "Perhaps it is appropriate that when I set out thinking about the paintings of Cy Twombly some time ago, I was quickly routed into a labyrinth of literature that kept me busy reading as opposed to actually looking at the paintings. The fundamentally intertextual and poetic nature of Twombly's works resulted in a domino-effect of prose-heavy reception from the start of his career in the postwar period. So it was nothing new that I was caught up in this series of distractions—arrested at first, like nearly everyone else in the past few decades, by the illuminating commentary of Roland Barthes in particular. Yet, the more I followed the trail of texts to their various detours and destinations, the farther I travelled away from the point where I had started: Twombly's enigmatic paintings—to the extent that nothing quite conclusive had been gained in my analysis of Twombly, it seemed" (Susik, "Writing after Writing," 1). To read of this being led away from the starting point, these "detours and destinations," I'm reminded of a line from Frost's "Directive," about the guide "Who only has at heart your getting lost." Distraction, misdirection, digression: what more could we want from our guides, or our art.

22. Daigle, *Reading Barthes/Writing Twombly*, 60.
23. Britton, "Artist," 337.
24. Serota, "History Behind the Thought," 46.
25. Turbeville, "Portrait of a House," 267.
26. Britton, "Artist," 337.
27. Britton, "Artist," 337.
28. Britton, "Artist," 337.
29. Morris, "Arcadian Ways," 217.
30. Clark, *Sight of Death*, 66.
31. Larratt-Smith, "Psychedelic Antiquity," 21.
32. Cavafy, *Poems*, 28.

CHAPTER 23

1. Alessandro Twombly, conversation with the author, July 20, 2014.
2. Cullinan, "Double Exposure," 464n40. Cy Twombly to Leslie Cheek, October 15, 1952, box 66, Cheek Papers, VMFA.
3. Cullinan, "Double Exposure," 465.
4. For a clearer photograph of this tapestry than the one offered in Twombly's Polaroid snaps, see Igliori and Thain, *Entrails, Heads & Tails*.
5. See Nesin on Twombly's practice of photographing his own sculpture and paintings, *Twombly's Things*, 195–208. "[T]hey are," she writes of these photographic documentations of his work, "only partial, only details, only incomplete and imperfect registrations of the sculptures, a fact that could be thought through in the interest of the photographs's limits or of the sculpture's" (203).
6. Cy Twombly to David Whitney, undated, January? 1971, box 4, folder 30, Whitney Papers, Menil Archives.
7. Whether or not that's true, I'm not sure. As Kate Nesin notes, his return to sculpture coincided with a mid-career retrospective at the ICA in Philadelphia in 1975.
8. The location of the island is impossible to know. Twombly offers no detail in

his memory of that abandoned house that can help identify its exact location. Two possibilities—Maine or Massachusetts. His father's family came from Groveland, Massachusetts, not far from the Atlantic and a series of islands offshore. However, in a conversation with Paul Winkler he describes being isolated and lonely as a boy in Maine, and more importantly, there are over three thousand islands off Maine, many of which were used for logging. The details of the rooms and the toys come from his account to Paola Igliori in an unpublished interview from 1989.

9. Jacobus, "Time-Lines." Jacobus writes, "The poet David Shapiro calls Twombly's sculptures 'toys for broken adults', saluting their simplicity and pathos."

10. Varnedoe, "Inscriptions," 45.

11. Varnedoe, "Inscriptions," 45.

12. Varnedoe, "Cy Twombly's Lepanto," 57.

13. I have no proof that Twombly saw or knew of the many tapestries that depict the Trojan War, many of which are strikingly similar. At the time of their making, the workshops in the Netherlands and France would repeat designs, with variations, from the same modelo or cartoon, the preparatory drawings on which the tapestries were based. Did he see the tapestry of *The Sack of Troy* at the Victoria and Albert Museum or the modelo on which they were based at the Louvre? Would he have seen the tapestry *The Battle with the Sagittary and the Conference at Achilles' Tent (from Scenes from the Story of the Trojan War)* at the Metropolitan Museum of Art in New York City, a tapestry that's beautifully described by one curator as "an orphan of the storm of neglect and mistreatment to which most medieval tapestries have been subjected?" And yet, what Twombly's painting and the Trojan War tapestries share, aside from the fact that at the start the paintings were tacked directly to the walls, filling the room with their bright drama, is the name. "Unless he happened to read the names of the heroes," writes William Forsyth, "someone looking at these tapestries for the first time would hardly suspect that Greek and Trojan warriors are represented." Narratives in French and Latin ticker-tape above the battle scenes and the names of the figures, contests of individuals in "the confusion of a medieval melee," are woven into helmets and swords and belts, their names on the bridles of their horses and at the edges of their robes, all the names marked on their bodies. This is what lasts. (Forsyth, "Trojan War in Medieval Tapestries," 82, 80).

14. Stevens, "Classical Musings," 130.

15. Auden, *Collected Poems*, 594.

16. Strabone, "Cy Twombly."

17. Robert Coates doesn't mention Bassano in his 1961 *Beyond the Alps: A Summer in the Italian Hill Towns*, but his depiction of these places feels true to this place; he writes that a hill town "is an eyrie, a crow's nest for humans. Walled for defense, and protected if possible by a series of cliffs as well, with its houses huddled around a church, a square and a castle, it sits on top of its own craggy little hill, remote and self-contained, more or less impregnable except by siege standing now, for all the charm of its tortuous, cobblestoned alleys and crumbling battlements, as a monument to the violence of the days which gave it its form" (Coates, *Beyond the Alps*, 44–45).

18. Lamblin, *Disgraceful Affair*, 171.

19. John Russell, "Three Striking Current Shows," *The New York Times*, January 7, 1979.

CHAPTER 24

1. Isabella Ducrot, conversation with the author, June 5, 2014.

2. Cullinan, *Twombly and Poussin*, 82.

3. The water flower, opening in the morning and retreating at night, "a feature," according to the *Oxford Dictionary of Art*, "that came to symbolize a resurgence of life and the sun itself and became associated with the sun god Horus. The morning

sun was pictured as rising from the lotus flower and settling back into the flower at night. When associated with Isis, the lotus became a fertility symbol" (Wilson, "Lotus"). Kate Nesin's *Twombly Things* offers a good discussion of these collages, 168–172. See Leeman, *Cy Twombly*, 217–218, as well as Jacobus, "Time-Lines," for other readings of the lotus flower in Twombly's work and Katarina Schmidt's essay "Looking at Cy Twombly's Sculpture."

4. Jacobus, "Time-Lines."

5. In the same year, 1975, Twombly worked at the Hotel Excelsior in Naples on a series of similar drawings for Orpheus, Narcissus, and Dionysus. In each of these it is the name that matters.

6. Howard, "Fragments of a 'Rodin,'" 335.

7. Schjeldahl, "Drawing Lines."

8. Michael Kimmelman, "The Changing Seasons of Cy Twombly," *The New York Times*, September 23, 1994.

9. Cy Twombly to Leo Castelli, July 24, 1978, Leo Castelli Gallery records, AAA, SI.

10. Castelli, "Oral History."

11. Cohen-Solal, *Leo and His Circle*, 263.

12. Cohen-Solal, *Leo and His Circle*, 419.

13. White, *Contemporaries*, 151.

14. See Bob Colacello, "Remains of the Dia." *Vanity Fair*, September 1996, https://www.vanityfair.com/magazine/1996/09/colacello199609.

15. Cy Twombly to David Whitney, January 25, 1968, box 4, folder 30, Whitney Papers, Menil Archives.

16. Cy Twombly to David Whitney, February 25, 1971, box 4, folder 31, Whitney Papers, Menil Archives.

17. Cy Twombly to David Whitney, August 28, 1980, box 4, folder 31, Whitney Papers, Menil Archives.

18. White, "Oral History."

19. Kazanjian, "Painted Word," 555.

20. White, *City Boy*, 278.

21. Howard, "Fragments of a 'Rodin,'" 333.

22. *Some Flowers for Bob* 1982, a drawing given to Rauschenberg on his birthday and signed Love, Cy is not included in *Catalogue Raisonné of Drawings, Vol. 7.*

23. Storr, "First and Final Glimpses of a Gyroscopic Archive," 22.

24. The first essay by Barthes, "Non Multa Sed Multum," appeared in the first catalogue of drawings edited by Yvon Lambert and published in 1976 and was later reprinted in the catalogue for *Fifty Years of Works on Paper.*

25. Barthes, "Wisdom of Art," trans. Howard, 180–181. In her essay, "Drowning in a Sea of Love," Cole Swensen weighs in on this question of sign and signifier; she writes, "Twombly is dedicated to the crisis of the line, which is the crisis of signification. Is he writing or drawing or painting these words? And what would be the difference? The written word remains symbolic; the word 'ocean,' for instance, remains a road sign pointing to enormous water until the word is drawn, at which point it becomes the blueprint for reality, but only when it is painted does a word actually become, a real thing in a real world, the more barely legible, the more indelible." A good discussion of this question over signs and signifiers appears in Daigle, *Reading Barthes/Writing Twombly*, 71–81.

26. Barthes, "Works on Paper," 162. In a series of four drawings from 1973, Twombly would write VIRGIL on each. In some the word is traced over again and again, in others one can see the word and the earlier versions below or behind, off center and in one small and large. There's an obsessiveness in these drawings, a writing down and over, erased and rewritten.

27. Blistene, "Cy Twombly," 31.

28. Leeman, *Cy Twombly*, 289.

29. See Cohen-Solal, *Leo and His Circle*, 411.

30. John Russell, "Art: Twombly Writ On Whitney Walls," *The New York Times*, April 13, 1979.

31. Sheffield, "Cy Twombly," 40.

32. Buchloh, "Ego in Arcadia," 25. One hears the echo—fiasco—of Judd's 1964 review of the Commodus paintings.

33. White, "Rebel Vision," 177.

34. Adams, "Expatriate Dreams," 60.

35. Saltz, "Cy Twombly and the Transporting, Transforming Power of Art That Barely Uses the Tools of Art."

36. Basquiat, "From the Subways to Soho."

37. Clement, *The Widow Basquiat*, 38–39.

38. See Fretz, *Jean-Michel Basquiat*, 82. "It was not just influence. Basquiat had evolved his style from his own childhood drawings, but Twombly's work gave him permission to take it seriously."

39. If you wanted an example of Twombly's neglect or the lack of respect, look in the catalogue, *Art of the Fifties, Sixties, and Seventies: The Panza Collection* (1999), a snapshot of Giuseppe Panza's significant postwar art collections. There is a single painting, and the artist's name is misspelled in the catalogue.

40. Isabella Ducrot, conversation with the author, June 5, 2014.

41. Ruth Seltzer, "Cy Twombly, Art Admirers Fly in for His Retrospective Exhibit," *The Philadelphia Inquirer*, March 17, 1975.

CHAPTER 25

1. Nicola Del Roscio, conversation with the author, April 2, 2014.

2. Nicola Del Roscio, conversation with the author, May 2, 2014.

3. Del Roscio, "1972–1979," 9.

4. Varnedoe, "Inscriptions," 36.

5. In the essay, this story is told in the context of Twombly's "engagement in the art scene" and a desire to avoid it. "Success," Nicola writes, "also brings envy, jealousy or entreaties to share the spiritual experience that people presume or believe that a creative artist carries within himself while searching for spiritual relief from ordinary life" (Del Roscio, "1972–1979," 9).

6. Del Roscio, "Some Notes on Cy Twombly," 10.

7. Del Roscio, "Trip to Russia and Afghanistan with Cy Twombly, 1979," 453.

8. Del Roscio, "Trip to Russia and Afghanistan with Cy Twombly, 1979," 457. The title of the sculpture also evokes *Memoirs of Babur*, the emperor's autobiography of military campaigns and landscape.

9. Del Roscio, "Trip to Russia and Afghanistan with Cy Twombly, 1979," 460–61.

10. Danto, "Scenes of an Ideal Friendship," 213.

11. Danto, "Scenes of an Ideal Friendship," 214.

12. Nicola in the essay "The Last Twenty Years" describes the interaction of Twombly and an unnamed famous New York art critic and his wife in Rome. The wife "often interrupted" the conversation between artist and critic with "irritating, banal questions." The artist's comic response to a question about thoughts of shepherds in a set of drawings—something to the effect that they were thinking about fucking—"did not go over well." The critic "remained vindictive even after Cy's death" (Del Roscio, "Last Twenty Years," 11).

13. Mann, *Hold Still*, 79. An almost exact description of Nicola appears in David Seidner's profile and portrait in his book *Artists at Work*: "Cy often travelled with a beautiful and gentle Italian friend, Nicola del Roscio" (Seidner, *Artists at Work*, 136).

14. Varnedoe, "Inscriptions," 63n168.

15. Harry Pemberton, conversation with the author, November 12, 2012.

CHAPTER 26

1. The details of this night are reported in Del Roscio, "Crossing A State of Crisis," 10.
2. Berger, *Portraits*, 207.
3. See Cullinan, *Twombly and Poussin*, for a discussion of the Narcissus works from 1960 and 1975 and their theme of reflection. Additionally, Leeman writes about the relationship of Narcissus myth to narrative in Twombly's work (Leeman, *Cy Twombly*, 152–56).
4 Caley, "Venice Biennial," 106.
5. Jeremy Lewison in the catalogue essay for *Turner, Monet, Twombly* writes of the relationship between these artists as "one of affinity in terms of themes and preoccupations. Mortality, memory, memorializing, loss, history and time are among the issues that I suggest preoccupy Monet and Twombly on a conscious or unconscious level." The argument for their connection is partially thematic, what Lewison describes as late-life "preoccupations," as well as a confrontation with "similar issues: the coming of modernity and its consequences for culture; the process of aging; the relevance or otherwise of myth and history to visual art; the means by which to make painting into an art of allusion; the changing nature of vision; and how paint can embody feeling and sentiment of the most personal kind." The attempts of museums to line up Twombly with earlier (Poussin) or later (Franz West) artists says more about our desire for connection than any artistic affinity (Lewison, *Turner, Monet, Twombly*, 13, 74).
6. Laura Cumming, "Top Marks for Handwriting," *The Guardian*, June 21, 2008.
7. Riley, *Color Codes*, 62. Critics go out of their way, often with good reason, to show skeptical viewers the sophistication of Twombly's techniques and methods and ideas. As Brooks Adams writes, "Yet Twombly's process of over- and under-painting, as we have seen from the outset of the exhibition, is mandarin and complex, especially in the way drawing is suspended within the liquid mediums" ("Expatriate Dreams," 65). In his essay "Your Kid Could Not Do This, and Other Reflections on Cy Twombly," Kirk Varnedoe writes, "One could say that any child could make a drawing like Twombly only in the same sense that any fool with a hammer could fragment sculptures as Rodin did, or any house painter could spatter paint as well as Pollock. In none of these cases would it be true. In each case the art lies not so much in the finesse of the individual mark, but in the orchestration of a previously uncodified set of personal 'rules' about where to act and where not, how far to go and when to stop, in such a way that the cumulative courtship of seeming chaos defines an original, hybrid kind of order, which in turn illuminates a complex sense of human experience not voiced or left marginal in previous art" (22).
8. Sylvester, *Interviews*, 174.
9. Rilke, *Book of Images*, 101.
10. Twombly's first set of drawings done in Gaeta were finished in 1986, the completion of the Gaeta Set III and IV he had started in 1981 in Formia. These sets of drawings, done mostly in acrylic, are vivid and expressionistic. He would complete more drawings there in 1988. These are imperfect diaries, rough indications of where he was and when. Twombly would often spend time in a place without working.
11. White, "Rebel Vision," 210.
12. Danto, "Scenes from an Ideal Friendship," 213.
13. Stacey Stowe, "Cultivating Genius," *The New York Times*, March 26, 2015.
14. Jacobus, *Reading Cy Twombly*, 144. Twombly describes the "small studio upstairs in the house in Gaeta" in his interview with Serota.
15. Del Roscio, "Crossing a State of Crisis," 8.
16. Shiff, "Charm," 27. In his essay, "Next/Next," Philip Fisher writes, "Twombly's real story is the slow process of defeat and not the possibility of survival, much less that of some chance of victory. Troy always falls, Leander always drowns" (94).

17. Del Roscio, "Crossing a State of Crisis," 8–9.
18. Barthes, "Works on Paper," 166.
19. Cullinan, "Catalogue," 166. At the same time, one can see this technique in its nascent form much earlier. I think of the painting *Untitled* 1972, vertical streaks and swirls, in whites and blues, and below it the phrase *The secrets that fade will never be the same.*
20. Varnedoe, "Artist's Artist," 167.
21. Serota, "History Behind the Thought," 45.
22. According to the catalogue notes for *Hero and Leandro* 1984, the painting was started in 1981 and completed in 1984 in Bassano in Teverina. The version of *Hero and Leandro* completed in 1984 was the first of multiple engagements with this myth. For a short essay on the poetics of the different versions of Hero and Leander, from 1961 to the two done in the 1980s, see poet Cole Swensen's essay "Drowning in a Sea of Love." In *Hero and Leandro (To Christopher Marlowe)* 1985, a stand-alone work, a rage of colors foams at the bottom in pinks and reds. There are no words. The painting feels warm and ethereal; its colors do not say *drowning* but *disappearance.*
23. Cage, *Silence*, 102. I'm also partial to Cage's description of those paintings as a "clock of the room."
24. Schmidt, "Hero and Leander," 107.
25. Jacobus, *Reading Cy Twombly*, 147.
26. Didion, *White Album*, 126.
27. Mann, "Conversation with Edmund de Waal," 14.
28. Twombly, *Artists Documentation Program*, 22. In conversation with Ralph Blumenthal, Twombly describes his process of making the nine Green Paintings: "'I don't work 9 to 5,' he said, acknowledging that he spent long periods in contemplation before putting mark to paper or canvas and then creating in a frenzy. Those nine pondlike green paintings with Rilke verses in the next room—'Those were done in Venice in one day with my hands'" (Ralph Blumenthal, "A Celebratory Splash for an Enigmatic Figure," *The New York Times*, June 4, 2005). Carol Mancusi-Ungaro, reporting what Nicola told her, describes the process of painting: "[Nicola] confirmed that Twombly had painted the nine parts as a set in Rome, going from one to the other, and except for the use of a brush in the application of the isolating layers, Cy painted them with his fingers using acrylic paint" ("Cues from Cy Twombly," 74). Different methods, different places—the truth might matter less than just how hard it is to find it.

CHAPTER 27

1. Danto, "Cy Twombly," 504.
2. Danto, "Cy Twombly," 504.
3. Ammann, introduction, 5.
4. Gimelson, "Ammann for All Seasons," 192. See also Edmund White's *Inside a Pearl*, 49–69.
5. Deitcher, "What Does Silence Equal Now," 97. Deitcher quotes critic Jan Zita Grover who divides the generational responses to AIDS into two groups, the first was "fundamentally declarative or descriptive" while the second-generation responses "consisted of the 'activist, largely collectivist work' that moved beyond expressions of loss to 'make social connections, touch the anger and harness it to a social purpose'" (97–98).
6. Katz, "How AIDS Changed American Art," 41.
7. Koestenbaum, *Andy Warhol*, 55.
8. Leeman notes that "despair linked to the loss of a loved one, a subject fundamental to Twombly's work" (Leeman, *Cy Twombly*, 80).
9. Adams, "Expatriate Dreams," 67.

10. Stewart, *Cy Twombly*.

11. See also *Thicket* 1992, done during that same time at Jupiter Island, a plastered wooden box with a set of plastic leaves, also painted white, blooming from the top of the plaster mound. While it's possible to describe the work in terms of "fertility," "a verdant grove of artificial flowers that spring from a kind of primeval plaster," I would suggest that it connects more directly to a grave site and ideas of mourning as in *Epitaph* (Stewart, *Cy Twombly*).

12. The year 1975 at the ICA was the first time since 1955 that Twombly's sculptures were exhibited in the United States, a retrospective of "paintings, drawings, constructions." The sense of these objects as "constructions," especially the early pieces, comes from Twombly's use of found materials jerry-rigged together by string and cloth and wire (Nesin, *Twombly's Things*, 173). For in-depth discussions of Twombly's sculptural practice, see Nesin's *Twombly's Things*, David Sylvester's "White Originals," and Danto's introduction to the *Catalogue Raisonné of Sculpture Vol. 1*.

13. Szeemann, "Cy Twombly," 12.

14. de Waal, "Cy Twombly," 2.

15. Del Roscio, "Crossing a State of Crisis," 8.

16. See Achim Hochdörfer, "I voyaged quite alone," 289. Hochdörfer connects this dedication to another series of sculptures done at Jupiter Island in 1992, works of baked clay that resemble, at once, a boat's hull and a set of oars; it is "an assembly of bones." In her book, Mary Jacobus notes how lines from Seferis's *Three Secret Poems* have been threaded into this work dedicated to Lucio, a painting that resembles in palate and mood the *Quatro Stagione* 1993–94 paintings (*Reading Cy Twombly*, 43–44). Del Roscio's memories of Lucio, as described in his essay "1972–1979" are less memorializing: "Cy was amused by Lucio's Neapolitan character, enjoying his accent and his chaotic intelligence, but at times found him irritating. So in a combination of hostility and humor, he prepared a show for Naples that was full of anarchic energy" (11).

17. Stewart, *Cy Twombly*.

18. Though Del Roscio tells a story that after their trip to Afghanistan in 1979–1980, "to refresh our memory . . . and in honor of that country" they demonstrated against the Soviet occupation, when we met in Rome he said that Twombly thought, "If artists are too deeply political they become dated" (Del Roscio, "Trip to Russia and Afghanistan with Cy Twombly, 1979," 463; Nicola Del Roscio, conversation with the author, May 2, 2014).

19. Resikini, "Conversing with Homer and Twombly," 315.

20. Cy Twombly to Paul Winkler, July 1993, Menil Collection, Menil Archives.

21. Others have asked a similar question of Twombly's work, notably Simon Goldhill in his lecture on Twombly, but also Simon Schama who writes, "Twombly's maximalist-historicist instincts have been engaged by a profound problem of translation; and one, moreover, which shows no sign of going away: how do we visually euphemize war?" ("Cy Twombly," 22).

22. Claudia Schwab, "Returning to His Lexington Roots," *Lexington* (VA) *News-Gazette*, October 12, 1994, 2.

23. Goldhill, "Respondent."

24. Hushka, "Undetectable," 132.

25. Niklas Maak, "Verschwunden in Italien," *Frankfurter Allgemeine Zeitung*, January 22, 2005, http://www.faz.net/aktuell/feuilleton/kunst/zu-besuch-bei-cy-twombly-verschwunden-in-italien-1214222.html.

26. Kazanjian, "Painted Word," 617.

27. Doty, *Heaven's Coast*, 3.

28. For the 1980 show at Southern Methodist University, Bentley lent several of the Twombly drawings he owned including *Picture in 24 Colors to Sergio Tossi* 1970 and

Untitled 1973. The drawing *Picture in 24 Colors to Sergio Tossi* 1970 does not appear in the *Catalogue Raisonné of Drawings Vol. 5, 1970–71* (Twombly and Jordan, *Cy Twombly*, np).

29. Salle, *How to See*, 46.

CHAPTER 28

1. "If it's too hot I do some cool paintings" (Serota, "History Behind the Thought," 45).
2. Winkler, "Just About Perfect," 17–18; Cy Twombly to Paul Winkler, May 30, 1990, Menil Archives.
3. Cited in Rankine, *Citizen*, 115. This often-repeated Baldwin quote appears to be a paraphrase of the following: "The artist cannot and must not take anything for granted, but must drive to the heart of every answer and expose the question the answer hides" (Baldwin, *The Price of the Ticket*, 316).
4. Kazanjian, "Painted Word," 617.
5. Winkler, "Just About Perfect," 22; Cy Twombly to Paul Winkler, April 21,1992, Menil Archives.
6. Winkler, "Just About Perfect," 18. Winkler notes, "Although the galleries are equal in size with the exception of the one double-cube room, they are in no way static. The openings to each room are at different positions in the walls, resulting in varying configurations. As one progresses through the building, the spacial experience changes in each gallery" (Winkler, "Just About Perfect," 22). For more on Twombly's relationship to architecture, see Schmidt's *Sculpture*, 103–09.
7. Winkler, "Just About Perfect," 19; Cy Twombly to Paul Winkler, April 21,1992, Menil Archives.
8. Cy Twombly to Paul Winkler, August 24, 1989, Menil Archives.
9. Kazanjian, "Painted Word," 548.
10. Cy Twombly to Paul Winkler, August 24, 1989, Menil Archives.
11. Winkler, "Just About Perfect," 26.
12. See Jacobus, *Reading Cy Twombly*. Jacobus's well-researched monograph, with access to Twombly's library, offers a vision of Twombly as a reader and editor, not simply taking lines from poems as is, but cutting, rewriting, and reinitiating the poems he admired.
13. Lewison, *Turner, Monet, Twombly*, 75. Autograph letter from Claude Monet to Gustave Geffory, postmarked 31 March 1893, in the Collection of Cy Twombly. Translation and note by Jeremy Lewison. In addition to Monet, "among his archive of letters he counted one written by Turner. When asked why he bought it, he answered that he liked to collect letters written by artists in whom he had a marked interest" (Lewison, *Turner*, 14). As Twombly said to Sylvester about owning a second edition of Burton's *Anatomy of Melancholy*, "I like to have the material that's as close as possible to when it was done" (Sylvester, *Interviews*, 175). The Monet letter in its entirety and several letters of Turner's are reproduced and transcribed in the catalogue for this show.
14. Wharton, "Rafael Viñoly's Nasher Museum of Art at Duke University," 17.
15. Winkler, "Just About Perfect," 21.
16. Van Dyke, "Losing One's Head: John and Dominique de Menil as Collectors," 119.
17. Smart, *Sacred Modern*, 62–63.
18. Smart, *Sacred Modern*, 124.
19. Smart, *Sacred Modern*, 13.
20. Piano, "Working with Light," 219.
21. Piano, "Working with Light," 219.
22. Paul Winkler, undated note, Menil Archives.
23. Di Suvero, "Renzo Piano."
24. Winkler, "Just About Perfect," 14.
25. Winkler, "Just About Perfect," 14.
26. Mr. and Mrs. Francois de Menil to Paul Winkler, February 2, 1995, Menil Archives.

27. Varnedoe, "Artist's Artist," 173.

CHAPTER 29

1. Sylvester, *Interviews*, 176.
2. Sylvester, *Interviews*, 174. This idea of passage is described in Schmidt's "Looking at Cy Twombly's Sculpture" in connection to the color white, its customary role as a "symbol of purity, cleansing, and 'passage'" (95).
3. Gilbert, *The Great Fires*, 5.
4. Rockburne, "Moveable Feast," 219. Rockburne's reading of the painting is prescient. In 1952, Twombly wrote to Leslie Cheek at the VMFA, "It was wonderful to return to Rome not as a stranger. I was able to make short stops at Assisi and try and see the beautiful Giottos" (Cullinan, "Double Exposure," 463; Cy Twombly to Leslie Cheek, October 15, 1952, box 66, Cheek Papers, VMFA).
5. Ralph Blumenthal, "A Celebratory Splash for an Enigmatic Figure," *The New York Times*, June 4, 2005.
6. Mancusi-Ungaro, "Cues from Cy Twombly," 62.
7. Daigle, "Lingering at the Threshold between Word and Image."
8. Varnedoe, "Artist's Artist," 179.
9. It's worth noting that this correction by Sylvester was added to the printed transcript. Neither he, nor Twombly, nor Nicola, knew the origin of the Keats line in real time.
10. Sylvester, *Interviews*, 176. I also can't help but think of the fragment of Archilochus of Paros, quoted in Lattimore's *Greek Lyrics*, a book Twombly knew and used in other works: "Say goodbye to Paros, and the figs, and the seafaring life" (4).
11. Catullus, *Poems*, 61. According to Jacobus, this was the translation on the bookshelf in Twombly's Gaeta house.
12. Serota, "History Behind the Thought," 50.
13. This poem of grief, Catullus' Poem 101, has been described as "untranslatable." Not that this stops many from attempting. Of these, the one I love most is Anne Carson's book-length translation in *Nox*; she captures the repetitions, the frustration of grief, the way loss holds us and repeats itself: "many the people / many the oceans," "last gift / sad gift," "burials," "wrongly," "farewell and farewell." And of course, "brother," four times in fourteen lines, the most repeated word in the poem. Loss isn't about the dead but the living. The human voice that speaks in place of the mute ash. Its demands and complaints, its commands and goodbyes. It's a poem that questions the purpose of its making and the purpose of these rituals and griefs, which are, by their nature, incomplete and lacking.
14. Jacobus, *Reading Cy Twombly*, 49. The edited line is from Richard Howard's dramatic monologue "1889: Alassio": "Shining white air / of afternoon / trembling in white / light reflected / in the white flat sea / La Bella noia!"
15. Email from David Warren, September 18, 2012.
16. Varnedoe, "Artist's Artist," 179.
17. Waters, *Role Models*, 254.
18. Adams, "Expatriate Dreams," 68.
19. Perl, *Eyewitness*, 46.
20. Pincus-Witten, "Twombly's Quarantine," 17.
21. Daigle, "Lingering at the Threshold Between Word and Image."
22. White, "Rebel Vision," 176.
23. Daigle, *Reading Barthes/Writing Twombly*, 121.
24. Swensen, "Drowning in a Sea of Love." The influence—poets on Twombly, Twombly on poets—goes both ways. In a note about his Twombly-inspired poems, "Cy Twombly, 'Beyond (A System for Passing),'" H. L. Hix, said, "I don't mean these poems to demand prior knowledge of Cy Twombly's art . . . I do suspect that they will hold relatively more appeal for readers who do (and less appeal for those who do not)

share my sense that emotional conflicts internalize, and existential dramas localize, metaphysical and epistemological problems inherent in the human condition" (Share, "Twombly Poetry"). For other Twombly-inspired poems, see also Cole Swensen's poem "The Future of White," in *Goest*, Jake Adam York's "Letter Hidden in a Letter to Cy Twombly," or Javier O. Huerta's "Cy Twombly's *Untitled (Say Goodbye Catullus, to the Shores of Asia Minor)."* Consider also Charles Olson's piece on Twombly or Twombly's collaboration with Robert Duncan, "The Song of the Border Guard" (1952). "But here is a painter who has a poetic sensibility," claimed Octavio Paz, "an intuitive grasp of the instant. In a similar way the moment is very important in my own poetry. One of the functions of art, poetry, and painting is to capture and to express moments of our human experience" (Paz, "Cy Twombly Gallery," 181).

25. Serota, "History Behind the Thought," 50.

26. Jacobus, *Reading Cy Twombly*, 44. With a debt to Jacobus for tracking down these previously unknown sources and lines.

27. Greub, "To Revalorise Poetry Now," 366.

28. Perloff, "Cy Twombly, the Postmodern Painter."

29. Shiff, "Charm," 27.

30. Serota, "History Behind the Thought," 50. In addition to the phrase "Leaving Paphos rimmed with waves," which became in later paintings "Leaving Paphos ringed with waves," as well as the lines in the sculpture *Epitaph* and *Say Goodbye*, "In the hospitality of war / We left them their dead / As a gift / to remember / us by," Twombly's borrowed lines from Archilochus (spelled Archilochos in the interview) in a series of untitled drawings done in 1988, lines and fragments of dark humor: "and may the dogdays / Blister the lot"; "Hang iambics / this is no time / for poetry"; "As one fig tree in a rocky place / Feeds a lot of Crows / Easy going Pasiphilé / Receives a lot of Strangers."

31. Jacobus, *Reading Cy Twombly*, 12. In a way, her very text enacts this as well. About the scrap of paper discovered with lines from Richard Howard's "1889: Alassio," she writes, "In a 2004 interview in the *Paris Review*, Howard said that, among the poems in *Untitled Subjects* that he most cherished, this one 'concentrates (if any poem of six pages can be said to be concentrated) all the attitudes and awfulness of homosexual life that I most deplored and feared in my future.' Twombly may have been struck simply by Howard's reference to the white light of the Mediterranean. But did he notice more?" Even as the critic points out all of these references to homosexual scenes or writers, that qualification—"But did he notice more?"—makes it possible to see these as just beautiful lines from beautiful poems and not as any window into the artist's own life. The desires and problems of his work are the desires and problems of his life. That said, here is where I agree with Jacobus; at the end of the chapter she writes, "Whatever meaning (or pleasure) *Say Goodbye* holds for the viewer is certainly not restricted to its poetry, let alone to uncovering Twombly's sources" (50).

32. Lacey, "Say Goodbye, Catullus."

33. Salle, *How to See*, 83.

CHAPTER 30

1. Herrera, "Cy Twombly," 147.

2. Deborah Solomon, "The Art World Bust," *The New York Times*, February 28, 1993.

3. *New York*, September 12, 1994, 54.

4. Adams, *Art & Auction*, 1992, 78.

5. Adams, *Art & Auction*, 1992, 115.

6. Reed, "To Be Rich, Famous, and an Artist," 56–57.

7. Gimelson, "Ammann for All Seasons," 196.

8. Thornton, *Seven Days*, 18.

9. Stevens, "Look of Power Now," 41.

10. Thompson, *$12 Million Stuffed Shark*, 35.
11. Stevens, "Look of Power Now," 40–41.
12. Thornton, *33 Artists in 3 Acts*, xiii.
13. Gagosian, "Larry Gagosian."
14. Stevens, "After the Heroes," 102.
15. Oldenburg, "Forward," 7.
16. Oldenburg, "Forward," 7.
17. Brooks, *Art & Auction*, 78.
18. Brooks, *Art & Auction*, 116.
19. Michael Kimmelman, "The Changing Seasons of Cy Twombly," *The New York Times*, September 23, 1994.
20. Wilkinson, "Remembering Cy Twombly."
21. Safer, "Letter," 10.
22. Varnedoe, "Inscriptions," 9.
23. Johanna Burton's essay "Cy Twombly's Transformations" offers a thoughtful reading of Varnedoe's scope and methodology—and its ongoing influence—as part of a larger reading of Twombly's reception: "That is, perhaps it is less Twombly's work that ought to be wholly categorized (impossible, since it functions always in relation to the context it has help [*sic*] enable and yet nonetheless reflects upon) and more the desire to write around it that should be named, if provisionally. If Twombly, as Varnedoe says, always brings a sense of context to bear on the writer addressing his work, he also, in so doing, creates a slightly dissociative state in the writer" (236).
24. Alan Cowell, "The Granddaddy of Disorder," *The New York Times*, September 18, 1994.
25. Varnedoe, "Inscriptions," 9–10.
26. Wilkinson, "Remembering Cy Twombly."
27. Schjeldahl, "Size Down," 71.
28. Krauss, "Cy's Up," 73.
29. See also Krauss's chapter 6 in *The Optical Unconscious* for a description of Twombly's work, in terms of Bloom, as a "strong misreading" of Pollock. Krauss points to the violence of graffiti, "a violation, the trespass onto a space" that is inherent in its action, an action that by its nature, is a canceling that comes after; "entering the scene as a criminal, he understands that the mark he makes can only take the form of a clue." "The graffitist makes a mark," Krauss writes, "Like all marks it has the character of a sign, structured thereby onto the double level of content and expression" (Krauss, *Optical Unconscious*, 259, 260).
30. Bucarelli, "Galleria del Cavallino," 44.
31. Serota, "History Behind the Thought," 53. In the same interview Twombly goes on to offer a fuller definition of graffiti: "Well graffiti is linear and it's done with a pencil, and it's like writing on walls. But [in my paintings] it's more lyrical. And you know, in those beautiful early paintings like *Academy*, it's graffiti but it's something else, too . . . Graffiti is usually a protest, or has a reason for being naughty or aggressive."
32. Lawrence, "Cy Twombly's Cryptic Nature," 13–14.
33. Mann, *Hold Still*, 85.
34. Martin Gayford, "Twombly Swirls Create One of Tate's Best Shows," Bloomberg .com, June 19, 2008, https://www.gagosian.com/artists/cy-twombly/artist-press? __v%3Afile=a73508b66f7b743580b3cf9cc811da18.
35. Del Roscio, "Some Notes on Cy Twombly," 10.
36. Spears, "Moment to Moment," 87.
37. Hughes, "Great Massacre of 1990," 124.
38. Hughes, "Great Massacre of 1990," 125.
39. Cocke, "Cy of Relief," 29.
40. Bastian, "Letter to the Editor," 7.

41. Krauss, "Letter to the Editor," 7.
42. Yau, "Cy Twombly and Charles Olson," 29.
43. Yau, "Cy Twombly's Extravagant Synesthesia."
44. Herrera, "Cy Twombly: A Homecoming," 146.
45. Mark Flood, conversation with the author, June 4, 2012.

CHAPTER 31

1. Seidner, *Artists at Work*, 34. Seidner's photo shoot in that studio is exceptional, too, for the temporariness of the space. Unlike his shots of Louise Bourgeois's loft in Brooklyn, a carnivalesque space of latex and broken limbs, "like a giant version of one of her installations . . . bursting with decades of work," or the dirty worktable of Joan Mitchell, splattered brushes and half-rolled tubes of paint, Twombly had just returned to Lexington, this transitional studio unlayered yet with the debris of making.
2. Neri, "David Seidner," http://bombmagazine.org/article/1846/david-seidner.
3. Alan Cowell, "The Granddaddy of Disorder," *The New York Times*, September 18, 1994.
4. Cocke, "Cy of Relief," 28.
5. Spender, "Painters as Writers," 148.
6. Cocke, "Cy of Relief," 30.
7. As another critic observes, "When his poetic, at times neurotic, scrawls move in and out of focus, one wonders if the artist doesn't live in mortal fear of being understood. But this is exactly what draws us in: the suggestion of meaning, the evocative markings and things not quite spelled out, the difficulty we all have in confronting ourselves and expressing truth as we feel it" (Spears, "Moment to Moment," 87).
8. Wilkinson, "Remembering Cy Twombly."
9. Mann, *Hold Still*, 64.
10. Kazanjian, "Painted Word," 555. See also Edmund White's "Rebel Vision" for this same phrase.
11. Pavlouskova, *Late Paintings*, 17.
12. Alan Cowell, "The Granddaddy of Disorder," *The New York Times*, September 18, 1994.
13. Herrera, "Cy Twombly," 146.
14. Quoted in Clark, *Sight of Death*, 54.
15. White, "Rebel Vision," 171.
16. Edmund White, review of *Cy Twombly: Late Paintings 2003–2011*, by Nela Pavlouskova, *The New York Times*, June 25, 2015.

CHAPTER 32

1. Simpson, "Cy Twombly, the Lexington Connection," 12.
2. Harry Pemberton, conversation with the author, October 26–27, 2012.
3. Cocke, "Cy of Relief," 29.
4. Claudia Schwab, "Returning to His Lexington Roots," *Lexington* (VA) *News-Gazette*, October 12, 1994, 2.
5. Mann, "Podcast NYPL."
6. "Cy Twombly Remembered in Lexington," July 25, 2011, *From the Corner of Washington & Lee: What's News Blog*, https://wlunews.wordpress.com/category/alumni/page/5/.
7. Bruce Young, "Web Extra: Butch Bryant Remembers Cy Twombly," WDBJ7 (Roanoke), July 22, 2011.
8. Mike Allen, "World-Class Lexington Artist Cy Twombly Dies in Rome," *Roanoke Times*, July 06, 2011.
9. Young, "Way I Live Now."
10. Wilkinson, "Remembering Cy Twombly."
11. Butch Bryant, conversation with the author, November 21, 2012.

12. Bruce Young, "World Famous Painter Remembered in Lexington," WDBJ7 (Roanoke), July 22, 2011. Unfortunately, this footage—along with the conversation with Butch Bryant that appeared as a "web extra"—is no longer available online.

13. Bruce Young, "Web Extra: Butch Bryant Remembers Cy Twombly," WDBJ7 (Roanoke), July 22, 2011.

14. White, *Contemporaries*, 74. There is a change between the transcript of the interview between Twombly and David Sylvester and the printed version. In their conversation, Twombly said the final title for *Say Goodbye* was selected with Paul Winkler. The edited final version replaces "we" with "I" and erases Winkler's name: "I didn't have an idea of which one of the three titles it would be until at Houston I decided on Catullus" (Sylvester, *Interviews*, 177). An acknowledged collaboration becomes an individual choice.

15. Danto, "Scenes From an Ideal Friendship," 214.

16. Serota, "History Behind the Thought," 47. In the same interview, Twombly claims that he is "not a professional painter, since I don't go to the studio and work nine to five like a lot of artists." Maybe the issue is that word "professional." Just as Twombly didn't see himself as a "professional painter," perhaps he didn't think of his own assistants as "professionals" in the same sense.

17. Mike Allen, "World-Class Lexington Artist Cy Twombly Dies in Rome," *Roanoke Times*, July 6, 2011.

18. Mann, *Hold Still*, 85.

19. Lewis, *Grief Observed*, 78.

CHAPTER 33

1. Varnedoe, "Inscriptions," 52.

2. Seidner, *Artists at Work*, 136.

3. Dawson, *Black Mountain Book*, 113. The paintings, by Nicholas Cullinan's account, and confirmed by Susan Davidson, are Rauschenberg's *Night Blooming* series. See *Double Exposure*, 461n12.

4. Deleuze, *Francis Bacon*, 82.

5. I like one catalogue description for *Untitled* 2001, the specificity of the colors: "Wood, plastic, pulp and printed paper, plaster, synthetic resin paint in white and light ochre tones, green, tones of yellow, purple and red, neon pink and neon yellow acrylic, 39 x 40 x 29.8" (*Cycles and Seasons*, 216). I like to imagine how this method of making—crumpling and balling, dipping and smearing—might have left his hands bright and marked.

6. Craig Raine, *More Dynamite*, 215.

7. Cf. Leeman, *Cy Twombly*, 293. A series of three drawings from August of 1981, done at Bassano, are also called *Coronation of Sesostris* or *Car of Sesostris*. In each, a bright red tempera triangle sits above two round blue wheels, the titles of each in wax crayon. The question of Twombly and spelling and misspellings is an ongoing conundrum—accident or intent, choice or carelessness.

8. Raine, *More Dynamite*, 216.

9. Salle, *How to See*, 15.

10. Perl, *Eyewitness*, 45.

11. Saltz, "Solar Power."

12. Mann, "Conversation with Edmund de Waal," 11.

13. Mann, "Conversation with Edmund de Waal," 13.

14. Schama, "Absence Turns into a Presence," 9.

15. Dean, "Panegyric," 35.

16. "Knockout. Hero. Genius: Cy Twombly," July 6, 2011, https://www.theguardian.com/artanddesign/2011/jul/06/cy-twombly-remembered.

17. Mancusi-Ungaro, "Cues from Cy Twombly," 69. One is reminded as well of the process depicted in Manfred de la Motte's 1963 essay on Cy Twombly.

18. Winkler, "Just About Perfect," 25.
19. Mancusi-Ungaro, "Cues from Cy Twombly," 69.
20. Del Roscio, "Atmosphere and People Around Cy, 1970–1971," 6. Del Roscio's account is confirmed by a letter from Twombly to Whitney: "Was working at 8 o'clock this morning Nick filling the back ground + I came right along with the image" (Cy Twombly to David Whitney, postmark November 16, 1971, box 4, folder 31, Whitney Papers, Menil Archives).

CHAPTER 34

1. Mike Allen, "World-Class Lexington Artist Cy Twombly Dies in Rome," *Roanoke Times*, July 06, 2011.
2. Malcolm, *Silent Woman*, 176.
3. Caro, "Art of Biography."
4. Del Roscio, "Crossing a State of Crisis," 5.

CHAPTER 35

1. These lines are from Richard Howard's poem, "Alassio 1889." See Jacobus, *Reading Cy Twombly*, 49.
2. Varnedoe, "Inscriptions," 53–54.
3. Serota, "History Behind the Thought," 48.
4. Hochdörfer, "'I voyaged quite alone,'" 289.
5. Schama, "Cy Twombly," 22.
6. White, "Rebel Vision," 211. See Bruce Weber's *A House Is Not a Home* for an image of this photograph in the Gaeta house of Matisse with model Micaela Avogadro taken in 1944 in Nice, France.
7. White, "Rebel Vision," 211.
8. How should we see these paintings? In what order? All at once or in a sequence? In one accounting of their narrative sequence, the paintings alternate between the galleys—the rustic boats with spindly oars set on a turquoise-blue sea—and the petal shapes, like oval pea pods overlaid with blotches of sunflower yellows and reds. As Varnedoe writes, "Twombly's galley scenes also seem to follow, quasi-cinematically, the general unfolding of the battle's day" ("Cy Twombly's Lepanto," 58). We move, left to right, a calm starting out, a cool and ordered distance, to a collision of form as the boats become more and more obscured, disappearing in the heavy paint. In the dramatic apex of the series, long contrails of scarlet and blue, black and yellow drip down, descending almost the length of the canvas with the boats, shapeless masses of purple and black and yellow, sinking into the depths. By another account there are three movements: the first of these show "occasional hits and just as occasional misses of cannon-fire"; the second, "the clearest progression of the galleys"; the third is "breathless . . . [with] no figuration of ships at all, merely versions of crimson, of madder, of scarlet, and the terrible gold edges to the flames" (Howard, "On Lepanto," 39).
9. Varnedoe, "Cy Twombly's *Lepanto*," 58.
10. Patricia C. Johnson, "Is Cy Twombly What's Wrong with Modern Art?," *Houston Chronicle*, May 29, 2005, https://www.chron.com/entertainment/article/Is-Cy-Twombly-what-s-wrong-with-modern-art-1920782.php.
11. Varnedoe, "Cy Twombly's *Lepanto*," 550.
12. John Russell, "Art: Twombly Writ on Whitney Walls," *The New York Times*, April 13, 1979. The phrase "hinge of history" comes from Varnedoe's essay on *Lepanto*, a good source for the significance of the battle, "as a tale told by the victors" (Varnedoe, "Cy Twombly's *Lepanto*," 45).
13. In his interview with Serota, Twombly describes that the *Lepanto* paintings were "done in groups because they come from this group of tapestries in the Doria Pamphilj family. Jonathan Doria Pamphilj gave me some photographs of the tapestries,

and those divisions are the borders of the tapestry and it builds up a sort of drama" (Serota, "History Behind the Thought," 49). The tapestries (and paintings) become cinematic, and modern, in their movement, one frame to the next. As always, we should take Twombly's words with a grain of salt, or at least an openness to the possibility that it's only part of a larger truth.

14. Sebald, *Rings of Saturn*, 125.
15. Varnedoe, "Cy Twombly's *Lepanto*," 58.
16. Bruce Young, "Web Extra: Butch Bryant Remembers Cy Twombly," WDBJ7 (Roanoke), July 22, 2011.
17. Baumstark "Journey to Lexington," 134–135.
18. Schulz-Hoffmann, "To Feel Things," 102.

CHAPTER 36

1. There has been much—perhaps too much—written about Twombly's photography, the least successful of his mediums. For several good references, see essays by Laszlo Glozer in *Cy Twombly: Photographs 1951–2007* and Vincent Katz in *Cy Twombly Photographs: 1951–1999*. See also Kovacs, "A Painter's Focus" and Edmund de Waal's short essay, "Cy Twombly: A Kind of Aura," which observes that "memory is at the heart of these photographs." Kovacs notes the "personal exercise" of his photographs and the "spontaneity" the Polaroid offered, and the thematic obsessions: "For Twombly, the act of photography resembled a reflex action to certain forms of visual stimulation; he used a camera, rather than a pencil or brush, to record his reaction to scenes ranging from the banal to the dramatic" (Kovacs, "Painter's Focus," 78).
2. Cy Twombly to Perry Bentley, November 28, 1983.
3. de Waal, "Kind of Aura," 3.
4. Pavlouskova, *Late Paintings*, 60.
5. Rondeau, *Natural World*, 22. One might also add to this list *Carnations* 1989, a series of seven drawing done in Porto Ercole.
6. Rondeau, *Natural World*, 29.
7. Serota, "History Behind the Thought," 50.
8. Pavlouskova, *Late Paintings*, 62
9. Cullinan, "Catalogue," 229.
10. Bill Davenport, "Ambitious. But Vile," in "Is Cy Twombly What's Wrong with Modern Art?," *Houston Chronicle*, May 29, 2005, http://www.chron.com/entert ainment/article/Is-Cy-Twombly-what-s-wrong-with-modern-art-1920782.php.
11. Pincus-Witten, "Peonies / Kusunoki," 1.
12. de Looz, "Cy Twombly 1966." De Looz offers a couple of responses to this idea of the decorative. One is to think about "Twombly's practice" as being "spatial, proto-installation. His paintings claim the rooms they inhabit. They draw a cognitive frame around the ambient space." The other response is to see Twombly as part of the now critically recognized sphere of "gay, decorative, and camp" art. Finally, de Looz suggests how these photos that see "the man in full" return in Twombly's own photographic practice: "[S]ome strongly echo those by Horst, as if Twombly has picked up the camera, pondering what the photographer had seen, mimicking his gestures, replaying the shoot, composing the pictures all over again."
13. Serota, "History Behind the Thought," 50.
14. Herrera, "Homecoming," 147. Twombly is listed among the "many artists of quality [that] have not been included in the exhibition" (Geldzahler, *New York Painting and Sculpture*, 24). "All of these artists will be remembered and collected and, like the art in the exhibition, will be reevaluated by each successive generation of artists, critics, museum men, collectors, and the general public in that process in which the history of taste merges indistinctly with the history of art" (24).

CHAPTER 37

1. Niklas Maak, "Verschwunden in Italien," *Frankfurter Allgemeine Zeitung*, January 22, 2005.
2. The first set of six, done in 2004, as well as the last set of seven from 2006–2008 were completed in Gaeta. There is also a group of very similar paintings done in 2005 in Lexington.
3. Cullinan and Serota, "'Ecstatic impulses,'" 613. The essay also discusses the relationship between these paintings and Twombly's lifelong engagement with Pollock. "This combination of liquidity and gravity also connects the works to Twombly's earlier efforts to respond to the poured paintings of Jackson Pollock" (615).
4. See Cullinan, "Catalogue," 219. In 1975, Twombly worked at the Hotel Excelsior in Naples on a series of drawings for Orpheus, Narcissus, and Dionysus. Dionysus is represented by a profile view of a phallus with the name written above. For more about the figure of Dionysus/Bacchus, see Leeman, *Cy Twombly*, 73–74, as well as Nela Pavlouskova's second chapter "Dionysian Paintings," where she discusses the ritualistic dance the Bacchus Paintings embody, the "almost performance art, by a body that has been possessed by the spirit of Dionysus, its arms flailing in ecstasy." She writes, "Observers standing in front of these works may not recognize the dance of Dionysus, but may understand how it felt by projecting their own experience. Twombly offers no key and makes no demands: he simply invites viewers to feel the impulses engendered by the impact of his gestures" (*Late Paintings*, 51).
5. Sylvester, *Interviews*, 179.
6. Cullinan, "Catalogue," 220.
7. Cullinan, *Twombly and Poussin*, 60–61.
8. Sylvester, *Interviews*, 177.
9. I'm not alone. Even the most theoretical critics of Twombly often reflect on what it's like to stand before one of his paintings. Jon Bird in "Indeterminacy and (Dis)order in the Work of Cy Twombly," writes, "[I]n New York (Autumn, 2005), I saw Twombly's recent paintings at the uptown Gagosian gallery, a series of eight large works with the generic title 'Bacchus.' It was impossible to view these wall-sized canvases without pondering their method of execution—how the brush was wielded (possibly attached to a stick or other extension in order to cover the total area), the degree of control exercised over the gravity-induced paint runs, the rhythmic movement of the whole body creating circles and arabesques as if a giant hand had been dipped in wine and then wandered purposively over the surface, lingering at moments in order to allow the colour to pool and coalesce" (502). Movement, method, body—it's never enough just to describe or see a picture but one must stand before the painting. Catherine Lacey's short but beautiful essay, "Say Goodbye, Cattullus," also describes the oceanic difference between seeing a Twombly in a book and seeing one in person.
10. Leeman, *Cy Twombly*, 35.
11. Hochdörfer, "How to Hold the Tension," 6. A similar story, without mention of Hochdörfer or Rauschenberg, is told in a slightly different fashion in Del Roscio's essay "Crossing a State of Crisis (and Writing of Hidden Things)." When asked about the end of one of "Cy's artist colleagues" creative productivity, "Cy Twombly went into a rage and with altered voice screamed: "'You do not know what a struggle it is for an artist to be continuously creative, the physical and psychological journey in the life of an artist, the intuition of something in one's abstract thought, the visible and the invisible'" ("Crossing a State of Crisis," 5). Nicola's anecdote ends with a reference to this "tension."
12. de Waal, "'White, white, white,'" 237.
13. In his remembrance of Black Mountain College, William McGee writes, "I met Cy just a few days after our arrival at the College. At the time he was sitting on the steps of South Lodge helping Rauschenberg brush flat white paint onto a series of stretched

canvases. As it turned out these were some of the 'white paintings' that were later shown at the Betty Parson's Gallery in New York City" (McGee, "Some Memorable Personalities," 316).

14. Kamholz, "Andy Warhol's Estate Sale."

15. I'm reminded of Claire Daigle's reading of the photograph used as the frontispiece in the MoMA catalogue: Twombly in Gaeta standing before the window, a figure caught in light. The labor, if there is any, is "intellectual labor." With his hands in his pockets, out of sight, "his body is cloaked in carefully pleated trousers and a dark sweater. The complete view of Twombly and out onto the vista is blocked by his work table with all the paint tubes, brushes, boxes, and source photographs painstakingly ordered. (This blocking of the figure by the tools of work seems right for Twombly's biography, Twombly the man, has always stood, nearly hidden behind his work)" (Daigle, *Reading Barthes/Writing Twombly*, 84).

CHAPTER 38

1. Clark, *Rome and a Villa*, 59.

2. Plumly, *Posthumous Keats*, 33.

3. Zenith, "Drama and the Dream of Fernando Pessoa," 2.

4. Pessoa, *Fernando Pessoa and Co.*, 162.

5. Varnedoe claims that Twombly's idea of Arcadia, beginning with works like *Arcadia* 1958, can be traced to Poussin's *Et in Arcadia ego* ("Inscriptions," 62n126).

6. One might compare this sculpture to another work that engages time and morality: *In Time the Wind Will Come and Destroy My Lemons* Rome 1987. The rough white crate bears that inscription in pencil, "a handwritten legend," as Schmidt notes. Like a grave marker to be looked down on from above, the piece is personal—that possessive "my"—and is based, in part, on a storm that destroyed part of Twombly's Gaeta garden. It's a title, or a version of one, that Twombly used on the sculpture he gave to Betty in 1967 (Schmidt, "Looking at Cy Twombly's Sculpture," 125).

7. Cf. Leeman, "It has been said before: like Montaigne, Twombly is the subject of his own oeuvre. In this respect, according to Yvon Lambert, *Idilli* (I am Thyrsis of Eta blessed with a tuneful voice) is an 'allusion all the clearer on Twombly's part, because, for the first time, the literary borrowing signifies the personal wish to be identified: I am.' Pursuing this interpretation, Achilles, Hero, Thyrsis, Venus, Apollo, Shelley can call be considered Twombly's doubles, ceaselessly mourning the loss of a loved one in the red stain of blood that is reborn as a flower" (Leeman, *Cy Twombly*, 239, quoting Lambert, *Catalogue Raisonné Paper VI*, 174).

8. Mézil, "Yvon Lambert," 249.

9. Elisa Lipsky-Karasz, "Art of Larry Gagosian's Empire," *Wall Street Journal*, April 26, 2016. https://www.wsj.com/articles/the-art-of-larry-gagosians-empire -1461677075.

10. Hochdörfer, *Last Paintings*, 9.

11. Yang, "*Birds, Beasts, and Seas*," v. The lines from this Semptember 21, 1906, letter from Cezanne to Emile Bernard are translated slightly differently elsewhere.

12. Bowles, "Italian Lessons," 196.

13. Lowry, "Country Culture," 152.

14. Ruefle, *Madness, Rack, and Honey*, 9. In this same essay, "On Beginnings," Ruefle describes Twombly's studio note with the passage from John Crow Ransom, "The image cannot be dispossessed of a primordial freshness which ideas can never claim." "Many men and women," Ruefle notes, with irony, "have written long essays and lectures on the ideas they see expressed in Twombly's work" (9).

15. Schmidt, "Looking at Cy Twombly's Sculpture," 63. Kate Nesin in *Twombly's Things* writes that Tatia was ill at the time of the gift, though I have yet to find the source of this (143). Schmidt describes this piece as one of the first of what would become an important theme for Twombly's sculptures: the chariot. Here's how she describes

one of these long narrow pieces, an axle with two wheels, done in 1978: "Archaic relic, model, toy—almost touching in its elegant simplicity, this vehicle at rest has the galvanizing effect of an inspired, astonishingly efficient invention" (65). Schmidt goes on to discuss other iterations of the chariot as theme in works such as *Anabasis* 1980, as well as other motifs and obsessions in Twombly's sculptural practice including the shepherd, rising and falling, ships and boats, landscape and flowers, myth, ritual sites such as monuments, and archaeological sites and "archaic architectural forms." The overlap between his painting and sculpture is evident, but these sculptures, with their rough, pulling together of found objects, unified by white paint, feel like an entirely separate practice. Her essay is a fine introduction to Twombly's sculptures throughout his career. "From the outset," she writes, "he found that assemblage suited his three-dimensional work, and he has, with few exceptions, pursued the principle ever since" (137). In the same catalogue as Schmidt's essay, Christina Klemm's "Material—Model—Sculpture" describes the sculptural materials Twombly employs, particularly his use of wood, as well as other "materials of *bricolage*" including cardboard, wire, rope, and nails (155).

16. Cullinan, *Twombly and Poussin*, 61–62. Given how similar they are in palate and form to the 2010 *Camino Real* paintings, these last pictures form a kind of final set.

17. Hochdörfer, "How to Hold the Tension," 7.

18. Sylvester, "Yes, yes, / As Sure as a poppy's," 41–42. Missing from Twombly's line is the phrase that follows the word "lawn" in Sexton's poem, "of the labyrinth," a phrase that turns the lawn into a prison.

19. Kalina, "Here and There," 72.

20. Dean, *Five Americans*, 51.

21. Simon Schama, "Tacita Dean Talks to Simon Schama," *Financial Times*, September 30, 2011, https://www.ft.com/content/b94bfcb4-e973-11e0-af7b-00144feab49a.

22. Eakin, "Tacita Dean: The Will to Create."

23. Plumly, *Posthumous Keats*, 15–16.

24. Plumly, *Posthumous Keats*, 15–16.

25. Thornton, *Seven Days in the Art World*, 198.

CHAPTER 39

1. Clark, *Rome and a Villa*, 18.

2. Nesin, *Twombly's Things*, 133.

3. Davenport offers this inscription in his introduction to *Archilochus, Sappho, Alkman: Three Lyric Poets of the Late Greek Bronze Age.*

4. That night in Rome was not the first time Twombly's work inaugurated a Gagosian gallery. In May of 2004, Twombly's works were the first to be shown at Gagosian's London gallery, a show that was pre-sold before any pictures went up on the walls (Don Thompson, *$12 Million Stuffed Shark*, 36).

5. Sylvester, "SA LA LAH," 8.

6. Jonathan Jones, "The Eternal City," *The Guardian*, January 8, 2008, https://www.theguardian.com/artanddesign/2008/jan/08/art. And because it's a Gagosian gallery, the wall of the large oval gallery space pushes open to a back room, a private space for show and sale, and beyond that the offices. The night of the opening, in that back room, hung an earlier work selected by Gagosian—*Untitled* 1973, a collage of stapled, diagonal "transparent film adhesive" on a gray-black ground, and a bronze sculpture, *Untitled* 2003, a series of blocks stacked like dinosaur vertebrae—"because I saw it and liked it and thought, Why not?" Asked why she thought those pieces where placed alongside the large-scale paintings, when the connection between the pieces is far from clear, Yumiko Saito, an archivist for the Twombly Foundation, said, "Well, he probably wants to sell it; it is a commercial gallery, after all" (Drake, "When in Rome"). What is sold in these spaces, of course, isn't just art but brands—the artist and the man selling the artist.

7. Drake, "When in Rome." In the acknowledgments for vol. 1 of the catalogue raisonné of drawings, published in 2010 while Twombly was still alive, Nicola writes, "I must thank Larry Gagosian for his financial help in creating an archive of the works of Cy Twombly." Unlike the later catalogues, in which Nicola writes a longer, personal reflection on the artist and their relationship, there is just a single page of thanks. He ends, a cool impersonal acknowledgment, with the artist: "All my gratitude goes to Cy Twombly for providing me with all necessary information." In the more recent catalogue raisonné of drawings, Gagosian is no longer mentioned: "During spring (2005), an archive of drawings with material collected over many years is established by Nicola Del Roscio."

8. Maeve Kennedy, "Cy Twombly Paintings and Sculptures Donated to Tate," *The Guardian*, June 12, 2014, https://www.theguardian.com/artanddesign/2014/jun/12/cy-twombly-paintings-sculptures-donated-tate.

9. Storr, "Toward a Public Library of American Culture," 420.

10. The exact terms are not public but according to the lawsuit, "included an agreement by Lerner and Saliba to distribute several important works of art by Twombly from the Trust to Alessandro."

11. Del Roscio, introduction to *Cy Twombly Drawings*, vol. 2, n.p.

12. Randy Kennedy and Carol Vogel, "Turmoil at Cy Twombly Foundation," *The New York Times*, March 13, 2013, http://www.nytimes.com/2013/03/14/arts/design/cy-twombly-foundation-embroiled-in-lawsuits.html.

13. Defendant Thomas Saliba's Opening Brief In Support of His Motion to Dismiss Plantiffs' Amended And Supplemental Complaint at 1, Cy Twombly Foundation v. Saliba, C.A. No. 8407-VCP (Del. Ch. Ct. Oct 31, 2013).

14. Defendant Thomas Saliba's Opening Brief In Support of His Motion to Dismiss Plantiffs' Amended And Supplemental Complaint at 1, Cy Twombly Foundation v. Saliba, C.A. No. 8407-VCP (Del. Ch. Ct. Oct 31, 2013). According to Saliba's motion, as president of the Foundation, Nicola Del Roscio had the authority to "generally manage and supervise the affairs of the" Foundation, but he needed the approval of the entire board for contracts. To remove one member of a four-person board would set up a situation in which they would be a single voting bloc on the board.

15. Verified Amended And Supplemental Complaint at 16, Cy Twombly Foundation v. Saliba, C.A. No. 8407-VCP (Del. Ch. Ct. Oct 11, 2013).

16. Defendant Ralph E. Lerner's Reply Brief In Further Support Of His Motion To Dismiss Plantiffs' Complaint at 3, Cy Twombly Foundation v. Saliba, C.A. No. 8407-VCP (Del. Ch. Ct. Dec 20, 2013).

17. At the time of publication, the most recent publicly available 990 tax filing for 2016 lists the total "net assets or fund balances at the end of the year" as 1,516,510,273 dollars. The "end of year—fair market value" for the artwork in that filing makes up over 1.3 billion of that number.

18. Cohen-Solal, "Multiple Territories of Cy Twombly," 8.

19. Oral Argument On Defendant's Motion to Dismiss at 4, Cy Twombly Foundation v. Saliba, C.A. No. 8407-VCP (Del. Ch. Ct. Oct 31, 2013).

20. Defendent Thomas Saliba's Opening Brief In Support of His Motion to Dismiss Plantiffs' Amended And Supplemental Complaint at 7, Cy Twombly Foundation v. Saliba, C.A. No. 8407-VCP (Del. Ch. Ct. Oct 31, 2013).

21. William Jordan, conversation with the author, May 16, 2017. In that conversation, Jordan also described Nicola as Twombly's "real signifiant other."

22. Katya Kazakina and Philip Boroff, "A $40,000-an-Hour Fee, Lawsuits Rock Artist Foundations," *Bloomberg*, September 8, 2013, https://www.bloomberg.com/news/articles/2013-09-09/a-40-000-an-hour-fee-lawsuits-rock-artist-foundations.

23. Carol Vogel, "A Warhol Leads a Night of Soaring Prices at Christie's," *The New York Times*, November 13, 2014, https://www.nytimes.com/2014/11/13/arts/design/a-warhol-leads-a-night-of-big-bids-at-christies-.html?_r=0.

24. *Artist as Philanthropist*, 19.
25. James Panero, "Behind the Veil: Questions About Art Authentication," *Wall Street Journal*, March 23, 2011.
26. Hill, "Public Benefit and Exemption," 358.
27. Verified Amended And Supplemental Complaint at 2, Cy Twombly Foundation v. Saliba, C.A. No. 8407-VCP (Del. Ch. Ct. Oct 11, 2013).
28. "The plan is to turn the five-story building into an education center and small museum to celebrate the artist's work. Nicola del Roscio, a longtime companion of Twombly's and president of his foundation, said in a statement that the artist was 'a towering figure of American art. It is only fitting that there should be a permanent space in New York dedicated to his achievements.'" (Carol Vogel, "Cy Twombly Foundation to Open Museum and Education Center in New York," *The New York Times*, May 31, 2012).
29. Sax, *Playing Darts with a Rembrandt*, 200.
30. Del Roscio, "Cy Twombly the Francophile."
31. Kinsella, "Artist as Philanthropist."
32. Mike Boehm, "Andy Warhol Foundation Finishes Spree of Art Giveaways," *Los Angeles Times*, March 19, 2017.

CHAPTER 40

1. Del Roscio, "1972–1979," 5.
2. Bruce Duffy, "The Do-It-Yourself Life of Ludwig Wittgenstein," *The New York Times*, November 13, 1985.
3. Kazanjian, "Painted Word," 617.
4. Malamud Smith, *Private Matters*, 4.
5. Malcolm, *Silent Woman*, 8.
6. Taylor, "Robert Rauschenberg," 147.
7. Mann, "Podcast NYPL."
8. Malcolm, "Art of Nonfiction."
9. O'Hara, "Jackson Pollock," 216.

CHAPTER 41

1. Edel, "Art of Biography."
2. Szeemann, "Cy Twombly," 11.
3. Petry, "Hidden Histories," 161.
4. Cullinan, "Chronology," 238.
5. Siegel, "Cy Twombly."
6. Sylvester, *About Modern Art*, 508. I'm reminded too of what Adam Kirsch writes about what one can learn from a literary biography: "Rather, it is to use the life to clarify the factors that shape the work—to show how life and work were both shaped by the same set of problems and drives" (Adam Kirsch, "When We Read Fiction, How Relevant Is the Author's Biography?," *The New York Times*, June 24, 2014, https://www.nytimes.com/2014/06/29/books/review/when-we-read-fiction-how-relevant-is-the-authors-biography.html).
7. Sax, "Public Benefit Obligations," 380. These questions are far from new. See Ian Hamilton's *Keepers of the Flame: Literary Estates and the Rise of Biography*, or Sax's own *Playing Darts with a Rembrandt*, in particular his chapter "Heirs, Biographers and Scholars." Sax profiles different conflicts between these parties, the ones who want to control or protect or profit and those who want to expose or examine, from the legacy of Dr. Martin Luther King, the letters of Warren Harding to James Joyce, Sylvia Plath, Matthew Arnold, and Henry James. "Why," he writes, "do we feel comfortable with [Leon] Edel's biography [of Henry James], why does he not appear as a biographical snoop? Because one earns a right to intimacy only by making a commitment to the human being, even a human being

who is no longer alive. When you know that much about a person, it is better if it comes with love and with some sense of obligation" (Sax, *Playing Darts*, 142). In a way the argument here becomes about time and distance. How long should one wait to write about the dead? Five years? Fifty? "To be sure," Sax writes of those who see no end to the subject's right to privacy, "some of the feeling grows out of a commitment to keep their forebear's reputation intact, even when it means disposing of inconvenient facts" (134). At the end, he writes, "the goal throughout and the core intuition of this book, is to let history make its own judgements, and not permit mere proprietors to preselect what sort of artistic, scientific, or documentary material is germane to that judgment" (200).

8. Katz, "Committing the Perfect Crime," 39. "In February of 1951," Katz writes, "[Rauschenberg] met yet another fellow student, Cy Twombly, at the Art Students League in New York and they became lovers. About three months later, beginning May 14th and ending June 2, 1951, *Should Love Come First?* was exhibited for the first time in Rauschenberg's first one-person show at the Betty Parsons Gallery."

9. Taylor, "Robert Rauschenberg," 147.

10. Ashton, "Dore Ashton Talks Art Criticism."

11. Katz, "Art of Code," 195.

12. Bronson, "AA Bronson Reflects."

13. Karp, "Oral History."

14. White, *City Boy*, 215.

15. White, *City Boy*, 215.

16. Stacey Stowe, "Cultivating Genius," *The New York Times*, March 26, 2015.

17. Swanson, "Learning to Love Cy Twombly."

18. Storsve, "Some Thoughts on the Person and the Work of Cy Twombly," 19.

19. Gaugaun, *Writings of a Savage*, 23. Paul Gaugaun to Emile Schuffenecker, September 1888, Pont-Aven.

20. Daigle, "In Memoriam."

21. Achim Hochdörfer, conversation with the author, July 8, 2014.

22. The photograph appears in *Cy Twombly, Work on Paper* (St. Moritz: Galerie Karsten Greve, 2013).

BIBLIOGRAPHY

Adams, Brooks. "Expatriate Dreams—Cy Twombly, Museum of Modern Art, New York." *Art in America* 83, no. 2 (February 1995): 60–69, 109.

Adams, Brooks. "Sizing Up Cy Twombly." *Art & Auction* 14, no. 6(January 1992): 77–78, 115, 116.

Agamben, Giorgio. "Falling Beauty." In *Cy Twombly: Sculptures, 1992–2005*, 13–16. Munich: Pinakothek, 2006.

Albee, Edward. "Cy Twombly." In *Cy Twombly: Sculptures, 1992–2005*, 9–12. Munich: Pinakothek, 2006.

Allen, Irene Shum. "David Grainger Whitney: A Curated Life and an Extraordinary Eye." The Glass House. http://theglasshouse.org/learn/david-whitney/.

Alston, Jean and Jane Taylor. *Handwriting Theory, Research and Practice*. New York: Nichols, 1988.

Ammann, Thomas. *Introduction to Contemporary Art: A Benefit Auction for the Supportive Care Program of St. Vincent's Hospital and Medical Center of New York: Auction*. New York: Sotheby's, 1988.

The Artist as Philanthropist: Strengthening the Next Generation of Artist-Endowed Foundations. Washington, DC: Aspen Institute, 2010.

Ashton, Dore. "Cy Twombly." In *Writings on Cy Twombly,* edited by Nicola Del Roscio, 24. Munich: Schirmer/Mosel, 2002.

Ashton, Dore, and James Panero. "Renowned Art Historian Dore Ashton Talks Art Criticism, the Art Bubble, and the Dedalus Foundation." *Hyperallergic,* February 12, 2013. https://hyperallergic.com/65051/renowned-art-historian-dore-ashton -talks-art-criticism-the-art-bubble-and-the-dedalus-foundation/.

Ashton, Dore. "The Artist as Dissenter." *Studio International* 171 (April 1966): 164–67.

Auden, W. H. *Collected Poems.* Edited by Edward Mendelson. London: Faber, 2007.

Bachelard, Gaston. *The Poetics of Space.* Translated by M. Jolas, and John R. Stilgoe. Boston: Beacon Press, 1994.

Baldwin, James. *The Price of the Ticket: Collected Nonfiction, 1948–1985.* New York: St. Martin's Press, 1985.

Barnard, Mary, trans. *Sappho: A New Translation.* Berkeley: University of California Press, 2012.

Barnes, Julian. *Flaubert's Parrot; A History Of The World In 10 ½ Chapters.* New York: Everyman's Library, 2012.

Barthes, Roland. "Cy Twombly: Works on Paper." *The Responsibility of Forms: Critical Essays on Music, Art, and Representation.* Translated by Richard Howard, 157–76. New York: Hill and Wang, 1985.

Barthes, Roland. "Non Multa Sed Multum." In *Cy Twombly: Fifty Years of Works on Paper.* Curated by Julie Sylvester, 23–40. Munich: Schirmer/Mosel, 2004.

Barthes, Roland. "The Wisdom of Art." In *Cy Twombly: Paintings and Drawings 1954–1977.* Translated by Annette Lavers, 9–22. New York: Whitney Museum of American Art, 1979.

Barthes, Roland. "The Wisdom of Art." In *The Responsibility of Forms: Critical Essays on Music, Art, and Representation.* Translated by Richard Howard, 177–194. New York: Hill and Wang, 1985.

Basquiat, Jean-Michel and Henry Geldzahler. "From the Subways to Soho." *Interview,* January 1983. https://www.interviewmagazine.com/art/jean-michel -basquiat-henry-geldzahler.

Bastian, Heiner. "A Day with Cy Twombly." In *Cy Twombly—A Mediterranean World,* 12–18. Berlin: Galerie Bastian, 2012.

Bastian, Heiner, ed. *Cy Twombly: Catalogue Raisonné of the Paintings.* 6 vols. Munich: Schirmer/Mosel, 1992–2014.

Bastian, Heiner. "Letter to the Editor." *Artforum International* 33, no. 7 (March 1995): 7.

Bastian, Heiner. "Introduction." *Cy Twombly Catalogue Raisonné of the Paintings, Volume II: 1961–1965,* ed. Heiner Bastian, 21–31. Munich: Schirmer/Mosel Verlag, 1993.

Bastian, Heiner. "Introduction." *Cy Twombly Catalogue Raisonné of the Paintings, Volume III: 1966–1971,* ed. Heiner Bastian, 22–35. Munich: Schirmer/Mosel Verlag, 1994.

Bastian, Heiner. "Panorama." In *Audible Silence: Cy Twombly at Daros,* edited by Eva Keller and Regula Malin, 41. Zürich: Daros/Scalo, 2002.

Baumstark, Reinhold. "Journey to Lexington." In *Cy Twombly: Sculptures 1992–2005,* 131–39. Munich: Pinakothek, 2006.

Berger, John. "Defending Picasso's Late Work." *International Socialism* 2, no. 40 (Autumn 1988): 111–17. https://www.marxists.org/history/etol/newspape/isj2 /1988/isj2-040/berger.html.

Berger, John. *Portraits: John Berger on Artists.* London: Verso, 2015.

Berkson, Bill. "Spoleto '65" *BOMB* 137 (Fall 2016), available at http://bombmagazine.org/article/2121927/spoleto-65.

Bird, Jon. "Indeterminacy and (Dis)order in the Work of Cy Twombly." *Oxford Art Journal* 30, no. 3 (2007): 486–504.

Blistene, Bernard. "Cy Twombly: Fifty Days." *Flash Art* 88–89 (March 1979): 31–32.

Bois, Yve-Alain. "A certain infantile thing." In *Audible Silence: Cy Twombly at Daros*. Edited by Eva Keller and Regula Malin, 71–72. Zürich: Daros/Scalo, 2002.

Bois, Yve-Alain. "Cy Twombly: Gagosian Gallery." *Artforum International* 44, no. 6 (February 2006): 206.

Boland, Eavan. *Against Love Poetry*. New York: W.W. Norton, 2003.

Bolaño, Roberto. *Between Parentheses: Essays, Articles and Speeches, 1998–2003*. New York: New Directions, 2004.

Borges, Jorge Luis. *Collected Fictions*. Translated by Andrew Hurley. New York: Penguin Books, 2009.

Bowles, Hamish. "Italian Lessons." *Vogue*, January 2000, 190–97.

Britton, Sandi. "The Artist: His House." *Vogue*, December 1982, 226–71.

Bronson, AA. "AA Bronson Reflects on Sexual Themes in the Work of General Idea." San Francisco Museum of Modern Art, available at http://www.artbabble.org/video/sfmoma/aa-bronson-reflects- sexual-themes-work-general-idea. Quoted in https://www.aci-iac.ca/content/art-books/7/Art-Canada-Institute_General-Idea.pdf.

Brown, Marilyn R. *Degas and the Business of Art: A Cotton Office in New Orleans*. University Park: Pennsylvania State University Press, 1999.

Bryce, Kristy, ed. *Cy Twombly: Works From The Sonnabend Collection*. New York: Eykyn Maclean, 2012.

Bucarelli, Palma. "Galleria del Cavallino." In *Writings on Cy Twombly*, edited by Nicola Del Roscio, 44. Munich: Schirmer/Mosel, 2002.

Buchloh, Benjamin H. D. "Ego in Arcadia." *Artforum International* 44 no. 5 (January 2006): 25–26.

Burnett, Craig. "Bits of Myth and Body." *TLS, The Times Literary Supplement* 31 (October 10, 2003): 31.

Burton, Johanna. "Cy Twombly's Transformations." In *Cy Twombly: States of Mind: Painting, Sculpture, Photography, Drawing*, edited by Achim Hochdörfer, 226–39. Munich: Schirmer/Mosel Verlag, 2009.

Cage, John. *Silence: Lectures and Writings*. Middletown: Wesleyan University Press, 1961.

Caley, Shaun. "Venice Biennial: A Report on the Major Pavilions—From Venice." *Flash Art* 142 (October 1988): 104–09.

Campbell, Thomas P. *Tapestry in the Renaissance: Art and Magnificence*. New York: Metropolitan Museum of Art, 2002.

Caracciolo, Marella. "Cy Freedom." *The World of Interiors*, June 2004, 120–31.

Caracciolo, Marella. "The Walls are Heard." *House & Garden*, September 1998, 278–81.

Caro, Robert. Interviewed by James Santel. "The Art of Biography No. 5." *The Paris Review* 216 (Spring 2016), available at https://www.theparisreview.org/interviews/6442/robert-caro-the-art-of-biography-no-5-robert-caro.

Castelli, Leo. "Oral history interview with Leo Castelli." May 14, 1969–June 8, 1973. Archives of American Art, Smithsonian Institution.

Catullus, Gaius Valerius. *Poems*. Translated by Horace Gregory. New York: Grove Press, 1956.

Cavafy, C. P. *C.P. Cavafy: Collected Poems*. Translated by Edmund Keeley and Philip Sherrard. Princeton, NJ: Princeton University Press, 1992.

Celant, Germano and Giosetta Fioroni. *Giosetta Fioroni*. Milano: Skira, 2009.

Charters, Ann. *Olson/Melville: A Study in Affinity*. Berkeley, CA: Oyez, 1968.

Cheever, John. *The Journals of John Cheever*. New York: Vintage International, 2008.

Cheney, Sheldon. *A Primer of Modern Art*. New York: Liveright Publishing Corp, 1966.

Cherubini, Laura. "White Talent." Translated by Beatrice Barbaresch. *Flash Art* 262 (October 2008). http://www.flashartonline.com/article/cy-twombly/.

Chia, Sandro and Alain Elkann. "Sandro Chia." *Alain Elkann Interviews*, August 26, 2015. http://alainelkanninterviews.com/sandro-chia/.

Chiasson, Dan. *Where's the Moon, There's the Moon, Poems*. New York: Knopf, 2011.

Clark, Eleanor. *Rome and a Villa*. Garden City: Doubleday, 1952.

Clark, T. J. "At Dulwich." *London Review of Books* 33, no. 16 (August 25, 2011): 24–25. https://www.lrb.co.uk/v33/n16/tj-clark/at-dulwich.

Clark, T. J. *The Sight of Death: An Experiment in Art Writing*. New Haven: Yale University Press, 2006.

Clement, Jennifer. *Widow Basquiat: A Love Story*. New York: Broadway Books, 2014.

Coates, Robert. *Beyond the Alps: A Summer in the Italian Hill Towns*. London: Victor Gollancz, 1962.

Cocke, William. "Cy of Relief." *W & L: The Alumni Magazine of Washington and Lee University* (Fall 1994): 28–29.

Cohen-Solal, Annie. "The Multiple Territories of Cy Twombly." In *Cy Twombly: Works From the Sonnabend Collection*, edited by Kristy Bryce, 5–11. New York: Eykyn Maclean, 2012.

Cremonini, Claudia and Flavio Fergonzi, ed. *Da Giorgio Franchetti a Giorgio Franchetti: Collezionismi alla Ca' d'Oro*. Roma: MondoMostre, 2013.

Crow, Thomas. "Southern Boys Go to Europe: Rauschenberg, Twombly, and Johns in the 1950s." In *Jasper Johns to Jeff Koons: Four Decades of Art from the Broad Collections*, edited by Stephanie Barron and Lynn Zelevansky, 45–61. Los Angeles: Los Angeles County Museum of Art, 2001.

The Crystal. Lexington: Students of Lexington High School, 1946.

Cullinan, Nicholas. "Catalogue," In *Cy Twombly: Cycles and Seasons*, edited by Nicholas Serota, 54–231. London: Tate Publishing, 2008.

Cullinan, Nicholas. "Cy + Roman Steps (I–V)." July 2013, https://www.sfmoma.org/artwork/98.297.A-E/essay/cy-roman-steps-i-v/.

Cullinan, Nicholas. "Double Exposure: Robert Rauschenberg's and Cy Twombly's Roman Holiday." *The Burlington Magazine* 150 (July 2008): 460–470.

Cullinan, Nicholas. *"Nine Discourses on Commodus*, or Cy Twombly's Beautiful 'Fiasco.'" In *Cy Twombly*, edited by Jonas Storsve, 77–88. Munich: Sieveking Verlag, 2017. https://www.guggenheim-bilbao.eus/en/works/nine-discourses-on-commodus/

Cullinan, Nicholas. "To Exist in Passing Time." In *Robert Rauschenberg, Photographs, 1949–1962*, edited by David White and Susan Davidson. New York: D.A.P., 2011.

Cullinan, Nicholas. *Twombly and Poussin: Arcadian Painters*. London: Dulwich Picture Gallery, 2011.

Cullinan, Nicholas and Nicholas Serota. "'Ecstatic impulses': Cy Twombly's 'Untitled (Bacchus).'" *The Burlington Magazine* 152 (September 2010): 613–16.

"Cy Twombly 1966." *Nest: A Magazine of Interiors* 21 (Summer 2003): 18–39.

Daigle, Claire. "In Memoriam: Cy Twombly (1928–2011)." *The Brooklyn Rail*, July 11, 2011. https://brooklynrail.org/2011/07/art/in-memoriam-cy-twombly-19282011/.

Daigle, Claire. "Lingering at the Threshold Between Word and Image." *Tate Etc.* 13 (Summer 2008). http://www.tate.org.uk/context-comment/articles/lingering-threshold-between-word-and-image.

Daigle, Claire. *Reading Barthes/Writing Twombly*. PhD diss., City University of New York, 2004.

Danto, Arthur C. "Cy Twombly." *The Nation*, October 31, 1994, 504–07.

Danto, Arthur C. "Scenes of an Ideal Friendship." *Artforum International* 50, no. 3 (November 2011): 212–15.

Davenport, Guy, trans. *Archilochus, Sappho, Alkman: Three Lyric Poets of the Late Greek Bronze Age.* Berkeley: University of California Press, 1980.

Davis, Melton S. "Rome Revisited." *Gentleman's Quarterly (GQ),* June 1962, 6–12, 37, 98.

Dawson, Fielding. *The Black Mountain Book: with Illustrations.* Rocky Mount: North Carolina Wesleyan College Press, 1990.

Dean, Tacita. "A Panegyric," In *Cy Twombly: Cycles and Seasons.* London: Tate Publishing, 2008.

Dean, Tacita. "Edwin Parker." 2011. 16mm color film, optical sound, 29 min.

Dean, Tacita, Massimiliano Gioni, and Margot Norton. *Five Americans.* New York: New Museum, 2012.

Deitcher, David. "What Does Silence Equal Now." In *Art Matters: How the Culture Wars Changed America,* edited by Brian Wallis, Marianne Weems, and Philip Yenawine, 91–125. New York: New York University Press, 1999.

de la Motte, Manford. "Cy Twombly." In *Writings on Cy Twombly,* edited by Nicola Del Roscio, 48–55. Munich: Schirmer/Mosel, 2002.

de Looz, Pierre Alexandre. "Cy Twombly 1966," *O32c* 19 (Summer 2010): 101–19. https://032c.com/2011/from-vogue-to-nest-032c-activates-the-secret-history -of-cy-twombly-by-horst-p-horst/.

Del Roscio, Nicola. "1972–1979." *Cy Twombly Drawings, Catalogue Raisonné of Drawings Vol. 6 1972–1979,* edited by Nicola Del Roscio, 5–11. Munich: Schirmer/Mosel, 2016.

Del Roscio, Nicola. "Crossing a State of Crisis (and Writing of Hidden Things)." *Cy Twombly Drawings, Catalogue Raisonné of Drawings Vol. 7 1980–1989,* edited by Nicola Del Roscio, 5–11. Munich: Schirmer/Mosel, 2016.

Del Roscio, Nicola, ed. *Cy Twombly: Catalogue Raisonné of Sculptures.* Vol. 1, 1946–1997. Munchen: Schirmer/Mosel, 1997.

Del Roscio, Nicola, ed. *Cy Twombly Drawings: Catalogue Raisonné.* [*1: 1951–55; 2: 1956–1960; 3: 1961–1963; 4: 1964–1969; 5: 1970–1971; 6:1972–1979; 7: 1980–1989; 8:1990–2001*]. 8 vols. Munich: Schirmer/Mosel & Gagosian Gallery, 2011–2017.

Del Roscio, Nicola. "Cy Twombly the Francophile (Interview with Nicola Del Roscio)." *Apollo,* (November 21, 2016), https://www.apollo-magazine.com/cy-twombly -francophile/.

Del Roscio, Nicola. "Some Notes on Cy Twombly." In *Cy Twombly Drawings, Catalogue Raisonné of Drawings Vol. 4 1964–1969,* edited by Nicola Del Roscio, 5–15. Munich: Schirmer/Mosel & Gagosian Gallery, 2014.

Del Roscio, Nicola. "The Atmosphere and People Around Cy, 1970–1971." In *Cy Twombly Drawings, Catalogue Raisonné of Drawings Vol. 5 1970–1971,* edited by Nicola Del Roscio, 5–11. Munich: Schirmer/Mosel Verlag, 2015.

Del Roscio, Nicola. "The Last Twenty Years." In *Cy Twombly Drawings, Catalogue Raisonné of Drawings Vol. 8. 1990–2011,* edited by Nicola Del Roscio, 5–13. Munich: Schirmer/Mosel, 2017.

Del Roscio, Nicola. "Trip to Russia and Afghanistan with Cy Twombly, 1979." In *Cy Twombly: Bild, Text, Paratext. (Morphomata 13),* edited by Thierry Greub, 459–470. Paderborn: Wilhelm Fink Verlag, 2014.

Del Roscio, Nicola. "Untitled Introduction Vol 2." ("Almost one year has passed . . .") In *Cy Twombly Drawings, Catalogue Raisonné of Drawings Vol. 2 1956–1960,* edited by Nicola Del Roscio. Munich: Schirmer/Mosel & Gagosian Gallery, 2012.

Del Roscio, Nicola. "Untitled Introduction Vol 3." ("In 1964 I lived in Rome . . .")" In *Cy Twombly Drawings, Catalogue Raisonné of Drawings Vol. 3 1956–1960,* edited by Nicola Del Roscio. Munich: Schirmer/Mosel & Gagosian Gallery, 2013.

Del Roscio, Nicola, ed. *Writings on Cy Twombly.* Munich: Schirmer/Mosel, 2002.

Delehanty, Suzanne. "The Alchemy of Mind and Hand," In *Cy Twombly: Paintings, Drawings, Constructions, 1951–1974*, edited by Suzanne Delehanty and Heiner Bastian, 10–32. Philadelphia: Institute of Contemporary Art, University of Pennsylvania, 1975.

Delillo, Don. "That Day in Rome—Movies and Memory." *New Yorker*, October 20, 2003, 76–78.

Deleuze, Giles. *Francis Bacon: The Logic of Sensation*. Minneapolis: University of Minnesota Press, 2005.

de Waal, Edmund. "Cy Twombly: A Kind of Aura." In *Cy Twombly: Photographs*, edited by Mark Francis, 1–4. Beverly Hills: Gagosian Gallery, 2012.

de Waal, Edmund. "'White, white, white': Cy Twombly's Sea." In *Cy Twombly*, edited by Jonas Storsve, 233–44. Munich: Sieveking Verlag, 2017.

Dickinson, Emily and Thomas Herbert Johnson, *Emily Dickinson Selected Letters*. Cambridge, MA: The Belknap Press of Harvard University Press, 1998.

Didion, Joan. *The White Album*. New York: Farrar, Straus and Giroux, 2009.

Di Fabio, Alberto. "Departures: Cy Twombly 1928–2011." *Art in America* 99, no. 8 (September 2011): 33.

Di Suvero, Mark. "Renzo Piano." *Interview*, May 12, 2015. https://www.interview magazine.com/art/renzo-piano#_.

Doty, Mark. *Heaven's Coast: A Memoir*. New York: HarperCollins, 1996.

Drake, Cathryn. "When in Rome." *Artforum* diary, December 27, 2007. https://www .artforum.com/diary/id=19134.

Dunbabin, Katherine M. D. *Mosaics of the Greek and Roman World*. Cambridge, UK: Cambridge University Press, 2012.

Dupêcher, Natalie. "'Like Clocks': Keeping Time and Tracing Space in Cy Twombly's Morocco Paintings." *Oxford Art Journal* 39, no. 1 (2016): 19–33.

Eakin, Emily. "Tacita Dean: The Will to Create." *New Yorker*, May 21, 2012. https: //www.newyorker.com/culture/culture-desk/tacita-dean-the- will-to-create.

Edel, Leon. "The Art of Biography No. 1," *The Paris Review* 98 (Winter 1985). https: //www.theparisreview.org/interviews/2844/leon-edel-the-art-of-biography -no-1-leon-edel.

Erickson, Ruth. "The 1950s: Ways of Life." In *Leap Before You Look: Black Mountain College, 1933–1957*, edited by Helen Anne Molesworth and Ruth Erickson. Boston: Institute of Contemporary Art/Boston, 2015.

Finch, James. *The Art Criticism of David Sylvester*. PhD thesis, University of Kent, 2016. http://kar.kent.ac.uk/60419/.

Fisher, Philip. "Next/Next." In *Audible Silence: Cy Twombly at Daros*, edited by Eva Keller and Regula Malin, 93–4. Zürich: Daros/Scalo, 2002.

Fisher, Philip. *Wonder, the Rainbow, and the Aesthetics of Rare Experiences*. Cambridge: Harvard University Press, 1998.

Fitzsimmons, James. "Art." In *Writings on Cy Twombly*, edited by Nicola Del Roscio, 26–31. Munich: Schirmer/Mosel, 2002.

Forsyth, William H. "The Trojan War In Medieval Tapestries." *The Metropolitan Museum Of Art Bulletin* 14, no. 3 (Nov 1955): 76–84.

Francis, Mark. *Cy Twombly: Photographs. Vol. 2*. London: Gagosian Gallery, 2016.

Frankfurter, Alfred. "The Voyages of Dr. Caligari Through Time and Space." *ARTnews* 55, no. 9 (January 1957): 28–31, 64–65.

Fretz, Eric. *Jean-Michel Basquiat: A Biography*. Santa Barbara, CA: Greenwood, 2010.

Gagosian, Larry and Brant, Peter M. "Larry Gagosian." *Interview*, November 22, 2012. https://www.interviewmagazine.com/art/larry-gagosian.

Gauguin, Paul and Daniel Guérin. *The Writings of a Savage: Paul Gaugin.* Da Capo Press, 1996.

Gayford, Martin. *Man with a Blue Scarf: On Sitting for a Portrait by Lucian Freud.* London: Thames and Hudson, 2014.

Geldzahler, Henry. *New York Painting and Sculpture: 1940–1970.* New York: Dutton, 1969.

Gilbert, Jack. *The Great Fires: Poems, 1982–1992.* New York: Alfred A. Knopf, 1994.

Gimelson, Deborah. "Ammann for All Seasons." *Art & Auction* 10, no. 4 (November 1987): 190–96.

Glozer, Laszlo. *Cy Twombly: Photographs 1951–2007.* Munich: Schirmer/Mosel, 2008.

Glück, Louise. *Proofs & Theories: Essays on Poetry.* Hopewell, NJ: Ecco Press, 1994.

Goethe, Johann Wolfgang von. *Italian Journey, 1786–1788.* Translated by W. H. Auden, and Elizabeth Mayer. New York: Penguin Classics, 1970.

Goethe, Johann Wolfgang von. *Letters from Italy.* Translated by W. H. Auden and Elizabeth Mayer. London: Penguin Books, 1995.

Goldhill, Simon. "Respondent: Achilles' Horses, Twombly's War: Monuments, Mourning, and Mars, lecture by Mary Jacobus." University of Cambridge, Centre for Research in the Arts, Social Sciences and Humanities, May 19, 2011. https://www.youtube.com/watch?v=NLk_ceIZEhM.

Goldstein, Malcolm. "Forum: An Untitled Drawing by Cy Twombly." *Drawing: The Drawing Society* 8, no. 2 (July/Aug. 1986): 33.

Greub, Thierry, ed. *Cy Twombly: Bild, Text, Paratext. (Morphomata 13).* Paderborn: Wilhelm Fink Verlag, 2014.

Greub, Thierry. "'To Revalorise Poetry Now': Zu Cy Twomblys literarischen Einschreibungen." In *Cy Twombly: Bild, Text, Paratext. (Morphomata 13),* edited by Thierry Greub, 359–80. Paderborn: Wilhelm Fink Verlag, 2014.

Hall, Donald. "Ezra Pound, The Art of Poetry No. 5." *The Paris Review* 28 (Summer–Fall 1962). https://www.theparisreview.org/interviews/4598/ezra-pound-the-art-of-poetry-no-5-ezra-pound.

Hamilton, Ian. *Keepers of the Flame: Literary Estates and the Rise of Biography.* London: Faber Finds, 2011.

Herrera, Hayden. "Cy Twombly: A Homecoming." *Harper's Bazaar,* August 1994, 142–47.

Hill, Frances R. "Public Benefit and Exemption: The Public Benefit Requirement as a Practical Aid in Designing, Organizing, and Operating Artist-Endowed Foundations." In *The Artist as Philanthropist: Strengthening the Next Generation of Artist-Endowed Foundations.* Washington, DC: Aspen Institute, 2010.

Hochdörfer, Achim. "Blue Goes Out, B Comes In." In *Cy Twombly: States Of Mind: Painting, Sculpture, Photography, Drawing,* edited by Achim Hochdörfer, 12–36. Munich: Schirmer/Mosel Verlag, 2009.

Hochdörfer, Achim. "How to Hold the Tension." In *Cy Twombly. The Last Paintings Catalogue,* 6–12. New York: Gagosian Gallery, 2013.

Hochdörfer, Achim. "'I voyaged quite alone in the silence of this magic sea'—Some Remarks on the Ship Motif in Cy Twombly's Oeuvre." In *Writings on Cy Twombly,* edited by Nicola Del Roscio, 288–296. Munich: Schirmer/Mosel, 2002.

Holden, Anthony, trans. *Greek Pastoral Poetry; Theocritus, Bion, Moschus, The Pattern Poems.* Harmondsworth, UK: Penguin, 1974.

Howard, Richard. "Fragments of a 'Rodin'" in *Poets on Painters: Essays on the Art of Painting by Twentieth-Century Poets,* edited by J. D. McClatchy, 323–38. Berkeley: University of California Press, 1988.

Howard, Richard. "On Lepanto." In *Lepanto: A Painting in Twelve Parts,* 35–40. New York: Gagosian Gallery, 2002.

Hughes, Robert. "The Great Massacre of 1990." *Time,* December 3, 1990, 124–25.

Hushka, Rock. "Undetectable: The Presence of HIV in Contemporary American Art." In *Art AIDS America*, edited by Jonathan D. Katz and Rock Hushka, 128–41. Seattle: Tacoma Art Museum in association with University of Washington Press, 2015.

Igliori, Paolo and Alastair Thain. *Entrails, Heads & Tails: Photographic Essays and Conversations on the Everyday with Ten Contemporary Artists*. New York: Rizzoli, 1992.

Jacobus, Mary. *Reading Cy Twombly: Poetry in Paint*. Princeton, NJ: Princeton University Press, 2016.

Jacobus, Mary. "Time-Lines: Rilke and Twombly on the Nile." *Tate Papers* 10 (2008). http://www.tate.org.uk/research/publications/tate-papers/10/time-lines-rilke-and-twombly-on-the-nile.

Judd, Donald. "In the Galleries." In *Complete Writings 1959–1975*, Halifax: The Press of the Nova Scotia College of Art and Design, 1975.

Kalina, Richard. "The Here and Then." *Art in America* 105, no. 4 (April 2017): 72–81.

Kamholz, Roger. "Andy Warhol's Estate Sale." *21 Days of Andy Warhol* (blog). November 2, 2013, available at http://www.sothebys.com/en/news-video/blogs/all-blogs/21-days-of-andy-warhol/2013/11/andy-warhol-estate-sale.html.

Karp, Ivan and Steven Lavine, eds. *Exhibiting Cultures: The Poetics and Politics of Museum Display*. Washington: Smithsonian Institution Press, 1991.

Karp, Ivan C. "Oral history interview with Ivan C. Karp." March 12, 1969 by Paul Cummings, for the Archives of American Art at the Leo Castelli Gallery. https://www.aaa.si.edu/collections/interviews/oral-history-interview-ivan-c-karp-11717.

Katz, Jonathan D. "The Art of Code." In *Significant Others: Creativity and Intimate Partnership*, edited by Whitney Chadwick and Isabelle de Courtivron, 189–207. London: Thames & Hudson, 1993.

Katz, Jonathan D. "'Committing the Perfect Crime': Sexuality, Assemblage, and the Postmodern Turn in American Art." *Art Journal* 67, no. 1 (Spring 2008): 38–53.

Katz, Jonathan D. "How AIDS Changed American Art." In *Art AIDS America*, edited by Jonathan D. Katz and Rock Hushka, 24–45. Seattle: Tacoma Art Museum in association with University of Washington Press, 2015.

Katz, Jonathan D. "The Outness of Rauschenberg's Art." *The Gay & Lesbian Review Worldwide* 15, no. 5 (September–October 2008): 10–12.

Katz, Vincent, ed. *Black Mountain College: Experiment in Art*. Cambridge, MA: MIT Press, 2003.

Katz, Vincent. "Cy Twombly Photographs." In *Cy Twombly Photographs: 1951–1999*, edited by Nicola Del Roscio. Munich: Schirmer/Mosel, 2002.

Katz, William. *On the Bowery*. Bonlanden: Domberger, 1971.

Kazanjian, Dodie. "Cy Twombly: A Painted Word." *Vogue*, September 1994, 546–57, 617.

Kazin, Alfred. *On Native Grounds: An Interpretation of Modern American Prose Literature*. San Diego: Harcourt, Brace and Company, 1995.

Kinsella, Eileen. "The Artist as Philanthropist." *ARTNews*, January 9, 2012. http://www.artnews.com/2012/01/09/the-artist-as-philanthropist/.

Klemm, Christina. "Material—Model—Sculpture." In *Cy Twombly: Die Skulptur/The Sculpture*, edited by Katharina Schmidt, 153–179. Basel and Houston: Hatje Cantz Verlag/Menil Collection, 2007.

Koestenbaum, Wayne. *Andy Warhol*. London: Phoenix, 2003.

Kovacs, Arpad. "A Painter's Focus." *Apollo* 176, no. 604 (December 2012): 74–79.

Krauss, Rosalind E. "Cy was Here; Cy's Up." *Artforum International* 33, no. 1 (September 1994): 70–75.

Krauss, Rosalind E. "Letter to the Editor." *Artforum International* 33, no. 7 (March 1995): 7.

Krauss, Rosalind E. "Olympian Deaths." *Artforum International* 50, no. 3 (November 2011): 210–211.

Krauss, Rosalind E. *The Optical Unconscious*. Cambridge, MA: MIT Press, 1993.

Kushner, Rachel. "A Rock, A Deceptive Manor." In *Cy Twombly at Casa Malaparte, Capri*, 42–45. London: Gagosian Gallery, 2015.

Lacey, Catherine. "Say Goodbye, Catullus." *The Paris Review* (Revisited Blog), July 17, 2017. https://www.theparisreview.org/blog/2017/07/17/say-good-bye-catullus/.

Lambert, Royston. *Beloved and God: The Story of Hadrian and Antonius*. London: George Weidenfeld & Nicolson, 1984.

Lambert, Yvon, ed. *Cy Twombly: Catalogue Raisonné des Oeuvres sur Papier Vol. VI: 1973–1976; Vol. VII: 1977–1982*. Milan: Multhipla Edizioni, 1979, 1991.

Lamblin, Bianca. *A Disgraceful Affair: Simone de Beauvoir, Jean-Paul Sartre, & Bianca Lamblin*. Translated by Julie Plovnick. Boston: Northeastern University Press, 1996.

Lane, Mervin, ed. *Black Mountain College: Sprouted Seeds: An Anthology of Personal Accounts*. Knoxville: University of Tennessee Press, 1990.

Larratt-Smith, Philip. "Psychedelic Antiquity." In *Cy Twombly: Paradise*, edited by Julie Sylvester. Ecatepec, Mexico: Fundación Jumex Arte Contemporáneo, 2014.

Larsen, Susan C. "Cy Twombly: Works On Paper 1954–1976." In *Cy Twombly Works On Paper 1954–1976*, 16–50. Newport Beach: Newport Harbor Art Museum, 1981.

Lattimore, Richmond. *Greek Lyrics*. Chicago: University of Chicago Press, 1960.

Lawford, Valentine. "Roman Classic Surprise." *Vogue*, November 15, 1966, 182–96.

Lawrence, James. "Cy Twombly's Cryptic Nature." In *Cy Twombly: Works From The Sonnabend Collection*, edited by Kristy Bryce, 13–19. New York: Eykyn Maclean, 2012.

Leclerc, Anita. "Cy Was Here." *Esquire*, September 1994, 56.

Leeman, Richard. *Cy Twombly: A Monograph*. Translated by Mary Whittall. Paris: Flammarion, 2005.

Lewison, Jeremy. *Turner, Monet, Twombly: Later Paintings*. London: Tate Publishing, 2011.

Lonzi, Carla. *Autoritratto: Accardi, Alviani, Castallani, Consagra, Fabro, Fontana, Kounellis, Nigro, Paolini, Pascali, Rotella, Scarpitta, Turcato, Twombly*. Milano: Et al, 2010.

Lowry, Vicky. "Country Culture." *Elle Decor*, April 2009, 152–59.

Magie, David, trans. *The Scriptores Historiae Augustae*. 3 vols. Loeb Classical Library. London: W. Heinemann, 1922.

Malamud Smith, Janna. *Private Matters: In Defense of the Personal Life*. Reading: Addison-Wesley Pub., 1997.

Malcolm, Janet. "The Art of Nonfiction No 4." Interviewed by Katie Roiphe, *The Paris Review* 196 (Spring 2011). https://www.theparisreview.org/interviews/6073/janet-malcolm-the-art-of-nonfiction-no-4-janet-malcolm.

Malcolm, Janet. *The Silent Woman: Sylvia Plath and Ted Hughes*. New York: Alfred A. Knopf, 1994.

Mancusi-Ungaro, Carol. "Cues from Cy Twombly." In *Cy Twombly Gallery: the Menil Collection, Houston*, edited by Julie Sylvester and Nicola Del Roscio, 61–77. New York: Cy Twombly Foundation/Menil Foundation, 2013.

Mancusi-Ungaro, Carol. "From a Conservator's Journal." In *Audible Silence: Cy Twombly at Daros*, edited by Eva Keller and Regula Malin. Zürich: Daros/Scalo, 2002.

Mancusi-Ungaro, Carol and Paul Winkler. "Conversation about the Cy Twombly

Gallery: Paul Winkler and Carol Mancusi-Ungaro." Public Program of the Menil Collection, Houston, Texas. October 13, 2013. https://www.youtube.com/watch?v=CwUVT6qgcUw.

Mann, Sally. "A Conversation with Edmund de Waal." *Remembered Light: Cy Twombly in Lexington*, 11–18. New York: Abrams: Gagosian Gallery, 2016.

Mann, Sally. *Hold Still: A Memoir with Photographs*. New York: Little, Brown and Company, 2015.

Mann, Sally. "Podcast #132: Sally Mann on Cy Twombly and the Babushkas Who Saved Russian Art." *The NYPL Podcast*, October 2, 2016. https://www.nypl.org/blog/2016/10/02/podcast-132-sally-mann-cy-twombly-and-babushkas-who-saved-russian-art.

McGee, William. "Some Memorable Personalities." In *Black Mountain College: Sprouted Seeds—An Anthology of Personal Accounts*, edited by Mervin Lane, 311–15. Knoxville: University of Tennessee Press, 1990.

Merleau-Ponty, Maurice. *The Primacy of Perception*. Evanston: Northwestern University Press, 1964.

Mézil, Eric and Yvon Lambert. "Yvon Lambert: Memories of Cy Twombly (As told to Eric Mézil)." In *Cy Twombly*, edited by Jonas Storsve, 245–252. Munich: Sieveking Verlag, 2017.

Morris, Robert. "Arcadian Ways." *Artforum International* 50, no. 3 (November 2011): 217.

Nabokov, Vladimir V. and Fredson Bowers. *Lectures on Literature*. New York: Harcourt Brace Jovanovich, 1980.

Nadel, Ira B. *Ezra Pound: A Literary Life*. New York: Palgrave Macmillan, 2004.

Neely, Evan. *Cy Twombly and the Ethics of Painting*, PhD diss., Columbia University, 2010.

Neri, Louise."David Seidner by Louise Neri." *BOMB* 51 (April 1, 1995). http://bombmagazine.org/article/1846/david-seidner.

Nesin, Kate. *Cy Twombly's Things*. New Haven: Yale University Press, 2014.

Newton, Michael. *The Encyclopedia of Unsolved Crimes*. New York: Checkmark Books, 2010.

O'Hara, Frank. "Cy Twombly, 1955." In *Writings on Cy Twombly*, edited by Nicola Del Roscio, 34. Munich: Schirmer/Mosel, 2002.

O'Hara, Frank. "Jackson Pollock." In *Poets on Painters: Essays on the Art of Painting by Twentieth-Century Poets*, edited by J. D. McClatchy, 195–218. Berkeley: University of California Press, 1988.

Oldenburg, Richard. "Forward." In *Cy Twombly: A Retrospective*. New York: Museum of Modern Art, 1994.

Olson, Charles. *Collected Prose*. Edited by Donald M. Allen and Benjamin Friedlander. Berkeley: University of California Press, 2007.

Olson, Charles. "Cy Twombly." In *Writings on Cy Twombly*, edited by Nicola Del Roscio, 9–12. Munich: Schirmer/Mosel, 2002.

Olson, Charles. "Letters to Robert Creeley." In *Writings on Cy Twombly*, edited by Nicola Del Roscio, 19–23. Munich: Schirmer/Mosel, 2002.

Olson, Charles, Robert Creeley, George F. Butterick and Richard Blevins. *Charles Olson & Robert Creeley: The Complete Correspondence Vol. 8*. Santa Barbara: Black Sparrow Press, 1980.

Ovid. *Metamorphoses*. Translated by Rolfe Humphries. Bloomington: Indiana University Press, 1958.

Pasolini, Pier Paolo. "Il vuoto del potere in Italia" (The Power Void in Italy), *Corriere della Sera*, February 1, 1975. Translated by Christopher Mott. http://www.diagonalthoughts.com/?p=2107

Patton, Phil. "Cy Twombly." *Artforum* 15, no. 4 (December 1976): 70–72.

Pavlouskova, Nela. *Cy Twombly: Late Paintings 2003–2011*. New York: Thames & Hudson, 2015.

Paz, Octavio. "The Cy Twombly Gallery at the Menil Collection: A Conversation." *Res: Anthropology and Aesthetics* 28 (Autumn 1995): 180–83.

Perl, Jed. *Eyewitness: Reports From an Art World in Crisis*. New York: Basic Books, 2000.

Perloff, Marjorie. "Cy Twombly, the postmodern painter." *Times Literary Supplement*, February 8, 2017. http://www.the-tls.co.uk/articles/public/cy-twombly-art-poetry/.

Pessoa, Fernando. *Fernando Pessoa and Co.: Selected Poems*. New York: Grove Press, 1998.

Petry, Michael. "Hidden Histories: Curating a Male Same-Sex Exhibition." In *Gender, Sexuality, and Museums: A Routledge Reader*, edited by Amy K. Levin, 151–62. London: Routledge, 2010.

Piano, Renzo. "Working with Light: A Portrait of Dominique de Menil." In *Art and Activism: Projects of John and Dominique de Menil*, edited by Josef Helfenstein and Laureen Schipsi. Menil Collection Series. Houston: Menil Collection, 2010.

Pincus-Witten, Robert. "Cy Twombly." *Artforum* 12 (April 1974): 60–64.

Pincus-Witten, Robert. "Learning to Write." In *Writings on Cy Twombly*, edited by Nicola Del Roscio, 56–60. Munich: Schirmer/Mosel, 2002.

Pincus-Witten, Robert. "Peonies/Kusunoki: Thoughts on Cy Twomby's 'A Scattering of Blossoms and Other Things.'" *Cy Twombly: Blooming: A scattering of blossoms and other things*, 1–9. New York: Gagosian Gallery, 2007.

Pincus-Witten, Robert. "Twombly's Quarantine." In *Cy Twombly: An Untitled Painting*, 14–17. New York: Gagosian Gallery, 1994.

Plumly, Stanley. *Posthumous Keats: A Personal Biography*. New York: W.W. Norton, 2008.

Raine, Craig. *More Dynamite: Essays 1990–2012*. Chicago: Atlantic Books, 2014.

Rankin, Claudia. *Citizen: An American Lyric*. Minneapolis: Graywolf, 2014.

Raizis, M. Byron. *Greek Poetry Translations: Views, Texts, Reviews*. Athens: Efstathiadis Group, 1981.

Rauschenberg, Robert. *Photos In + Out City Limits New York C*. West Islip, NY: ULAE, 1982.

Rauschenberg, Robert and Susan Davidson. *Robert Rauschenberg: Photographs 1949–1962*. New York: D.A.P./Distributed Art Publishers, 2011.

Reed, Julia. "To be Rich, Famous, and an Artist." *U.S. News & World Report*, March 9, 1987, 56–57.

Reginato, James. "Alpine way." *W*, June 2005, 188–95.

Resinski, Rebecca. "Conversing with Homer and Twombly: A Collaborative Project on the *Iliad* and *Fifty Days at Iliam*." *The Classical Journal* 101, no. 3 (2006): 311–317.

Riley, Charles A. *Color Codes: Modern Theories of Color in Philosophy, Painting and Architecture, Literature, Music, and Psychology*. Hanover: University Press of New England, 1995.

Rilke, Rainer Maria. *The Book of Images*. Translated by Robert Bly. New York: Harper and Row, 1981.

Rockburne, Dorothea. "Departures: Cy Twombly 1928–2011." *Art in America* 99, no. 8 (September 2011): 33.

Rockburne, Dorothea. "Moveable Feast." *Artforum International* 50, no. 3 (November 2011): 218–219.

Rondeau, James. *Cy Twombly: The Natural World, Selected Works, 2000–2007*. Chicago: Art Institute of Chicago, 2009.

Rose, Barbara. *Frankenthaler*. New York: Harry N. Abrams, Inc. 1975.

Rose, Barbara. *Rauschenberg: An Interview with Robert Rauschenberg.* Edited by Elizabeth Avedon. Vintage Contemporary Artists. New York: Vintage Books, 1987.

Ruefle, Mary. *Madness, Rack, and Honey: Collected Lectures.* Seattle: Wave Books, 2012.

Rumaker, Michael. *Black Mountain Days: A Memoir.* Asheville, NC: Black Mountain Press, 2003.

Salle, David. *How to See: Looking, Talking, and Thinking about Art.* New York: W.W. Norton & Company, 2016.

Saltz, Jerry. "Cy Twombly and the Transporting, Transforming Power of Art That Barely Uses the Tools of Art." *Vulture,* April 5, 2018. http://www.vulture.com/2018/04/cy-twombly-powerful-art-that-barely-uses-the-tools-of-art.html.

Saltz, Jerry. "Solar Power." *The Village Voice,* January 16, 2001. https://www.villagevoice.com/2001/01/16/solar-power/.

Safer, Morley. "Letter to the Editor." *New York,* October 10, 1994, 10.

Savig, Mary. "Handwritten Letters From Legendary American Artists." *Lit Hub,* June 23, 2016. https://lithub.com/handwritten-letters-from-from-legendary-american-artists/.

Sax, Joseph L. *Playing Darts with a Rembrandt: Public and Private Rights in Cultural Treasures.* Ann Arbor: The University of Michigan Press, 2004.

Sax, Jospeh L. "Public Benefit Obligations and Legacy Stewardship Activities of Artist-Endowed Foundations: Are They in Conflict?" In *Artist as Philanthropist: Strengthening the Next Generation of Artist-Endowed Foundations Vol 2.* Washington, DC: Aspen Institute, 2010.

Schama, Simon. "An Absence Turns into a Presence." In *Remembered Light: Cy Twombly in Lexington,* 7–9. New York: Abrams: Gagosian Gallery, 2016.

Schama, Simon. "Cy Twombly." *Cy Twombly: Fifty Years of Works on Paper,* curated by Julie Sylvester, 11–22. Munich: Schirmer/Mosel, 2004.

Schiff, Stacy. *Vera: (Mrs. Vladimir Nabokov).* New York: Random House, 1999.

Schjeldahl, Peter. "Drawing Lines." *New Yorker,* March 7, 2005. https://www.newyorker.com/magazine/2005/03/07/drawing-lines.

Schjeldahl, Peter. "Cy was Here; Size Down." *Artforum International* 33, no. 1 (September 1994): 71–75.

Schloss, Edith. "Cy Twombly." *Wanted in Rome* (blog), March 27, 2012. http://www.wantedinrome.com/news/cy-twombly-by-edith-schloss/.

Schmidt, Katharina. "Looking at Cy Twombly's Sculpture." In *Cy Twombly: Die Skulptur/The Sculpture.* Basel and Houston: Hatje Cantz Verlag/Menil Collection, 2007.

Schulz-Hoffmann, Carla. "To Feel Things in All Ways: New Sculptures by Cy Twombly." In *Cy Twombly: Sculptures 1992–2005,* 99–109. Munich: Pinakothek, 2006.

Sebald, W. G. *Rings of Saturn.* New York: New Directions, 2016.

Seidner, David. *Artists at Work: Inside the Studios of Today's Most Celebrated Artists.* New York: Rizzoli, 1999.

Serota, Nicholas. "Acknowledgements." In *Cy Twombly: Cycles and Seasons,* edited by Nicholas Serota, 8–9. London: Tate Publishing, 2008.

Serota, Nicholas. "History Behind the Thought." In *Cy Twombly: Cycles and Seasons,* edited by Nicholas Serota, 43–55. London: Tate Publishing, 2008.

Share, Don. "Twombly. Poetry. The Crisis of the Line." *Poetry Magazine. Harriet Blog,* July 6, 2011. https://www.poetryfoundation.org/harriet/2011/07/twombly-poetry-the-crisis-of-the-line.

Sheffield, Margret. "Cy Twombly: Major Changes." *Artforum* 17, no. 9 (May 1979): 40–45.

Shiff, Richard. "Charm." In *Cy Twombly: Cycles and Seasons,* edited by Nicholas Serota, 11–28. London: Tate Publishing, 2008.

Siegel, Lee. "Cy Twombly," *Slate*, April 6, 2005. http://www.slate.com/articles/arts /art/2005/04/cy_twombly.html; https://web.archive.org/web/20050413020353 /; http://www.slate.com/id/2116180/slideshow/2116232/.

Simpson, Pamela. "Cy Twombly, The Lexington Connection." *Shenandoah* (2007): 9–20.

Smart, Pamela G. *Sacred Modern: Faith, Activism, and Aesthetics in The Menil Collection*. Austin: University of Texas Press, 2010.

Smith, Roberta. "The Great Mediator." In *Cy Twombly: Paintings, Works on Paper, Sculpture*, edited by Harald Szeemann, 13–21. Munich: Prestel-Verlag, 1987.

Sontag, Susan. "Mind as Passion." *The New York Review of Books* 27, no.14 (September 25, 1980): 47–52.

Spawls, Alice. "At the Pompidou: Twombly's Literariness." *London Review of Books* 39 no. 6 (March 16, 2017). https://www.lrb.co.uk/v39/n06/alice-spawls/at-the -pompidou.

Spears, Dorothy. "Moment to Moment." *Art & Antique* (December 1994): 87.

Spender, Stephen. "Painters as Writers." In *Poets on Painters: Essays on the Art of Painting by Twentieth-Century Poets*, edited by J. D. McClatchy, 139–149. Berkeley: University of California Press, 1988.

Staff, Craig G. "A Poetics of Becoming: The Mythography of Cy Twombly." In *Contemporary Art and Classical Myth*, edited by Isabelle Loring Wallace and Jennie Hirsh, 43–55. Farnham: Ashgate, 2011.

Stein, Gertrude. *The Autobiography of Alice B. Toklas*. New York: Vintage Books, 1990.

Stevens, Mark. "After the Heroes." *New York*, October 3,1994, 100–02.

Stevens, Mark. "Classical Musings." *Vanity Fair*, March 1990, 122, 125, 130.

Stevens, Mark. "The Look of Power Now." *New York*, January 22, 1996, 36–41.

Stevens, Mark and Annalyn Swan. *De Kooning: An American Master*. New York: Alfred A. Knopf, 2013.

Stewart, Jessica. *Cy Twombly: The Sculpture*. Washington, DC: National Gallery of Art, 2001, available at https://www.nga.gov/exhibitions/2001/twombly/twombly11 .shtm.

Stokes, Betty and Robert Brown. "Lot Notes: Betty Stokes and Robert Brown in Conversation, May 2013." *Christie's*, May 2013, available at http://www.christies.com /lotfinder/sculptures-statues-figures/cy-twombly-untitled-5698856-details.aspx.

Storr, Robert. "First and Final Glimpses of a Gyroscopic Archive." In *Selections from the Private Collection of Robert Rauschenberg*. New York: Gagosian Gallery, 2012.

Storr, Robert. "Toward a Public Library of American Culture: Reflections on the Centrality of Art and Importance of Access in Artist-Endowed Foundations." In *The Artist as Philanthropist: Strengthening the Next Generation of Artist-Endowed Foundations*. Washington, DC: Aspen Institute, 2010.

Storsve, Jonas. "Some Thoughts on the Person and the Work of Cy Twombly." In *Cy Twombly*, edited by Jonas Storsve, 19–23. Munich: Sieveking Verlag, 2017.

Strabone, Jeff. "Cy Twombly: The Last Classicist?" *3 Quarks Daily*, Monday, July 11, 2011. http://Www.3quarksdaily.Com/3quarksdaily/2011/07/Cy-Twombly-The -Last-Classicist.html.

Susik, Abigail. "Cy Twombly: Writing after Writing." *Rebus: A Journal of Theory and Art History* 4 (Autumn/Winter 2009): 1–28.

Swanson, Carl. "Learning to Love Cy Twombly." *Vulture* (January 3, 2017). http: //www.vulture.com/2016/12/learning-to-love-cy-twombly.html.

Swensen, Cole. "Drowning in a Sea of Love." *Poetry Magazine* (October 15, 2008), available at https://www.poetryfoundation.org/features/articles/detail/69138.

Sylvester, David. *About Modern Art: Critical Essays, 1948–1997*. New York: Henry Holt, 1997.

Sylvester, David. *Interviews with American Artists*. New Haven: Yale University Press, 2001.

Sylvester, David. "The White Originals." *Art in America* 88 (July 2000): 66–75.

Sylvester, David. "The World is Light." In *Writings on Cy Twombly*, edited by Nicola Del Roscio, 275–282. Munich: Schirmer/Mosel, 2002.

Sylvester, Julie. "SA LA LAH." In *Cy Twombly: III notes from Salalah*, 7–10. Rome: Gagosian Gallery, 2008.

Sylvester, Julie. "Yes, yes, / As Sure as poppy's / Green." In *Cy Twombly—The Last Paintings Catalogue*, 41–43. New York: Gagosian Gallery, 2013.

Szeemann, Harald. "Cy Twombly: An Appreciation." In *Cy Twombly: Paintings, Works on Paper, Sculpture*, edited by Harald Szeemann, 9–12. Munich: Prestel-Verlag, 1987.

Taylor, Paul. "Robert Rauschenberg." *Interview* (December 1990): 146–151.

Temkin, Ann. "Cy Twombly's Fifty Days at Iliam." In *Handbook of the Collections*, 340–341. Philadelphia: Philadelphia Museum of Art, 1995.

Temkin, Ann. "Out of School: Ann Temkin on Cy Twombly's Academy, 1955." *Artforum International* 49, no. 10 (Summer 2011): 344–345.

Thompson, Donald N. *The $12 Million Stuffed Shark: The Curious Economics of Contemporary Art*. New York: Palgrave Macmillan, 2008.

Thornton, Sarah. *33 Artists in 3 Acts*. New York: W.W. Norton, 2015.

Tomkins, Calvin. *Off The Wall: A Portrait Of Robert Rauschenberg*. New York: Picador, 2005.

Trapp, Elizabeth. *Cy Twombly's Ferragosto Series*. Master's thesis, Ohio University, 2010.

Truitt, Anne. *Daybook: The Journal of an Artist*. New York: Scribner, 2013.

Turbeville, Deborah. "Portrait of a house—as the artist." *Vogue*, December 1982, 226–71.

Twombly, Cy. *Cy Twombly*, edited by Jonas Storsve. Munich: Sieveking Verlag, 2017.

Twombly, Cy. *Cy Twombly: Cycles and Seasons*, edited by Nicholas Serota. London: Tate Publishing, 2008.

Twombly, Cy. Nicola del Roscio and Carol Mancusi-Ungaro. Cy Twombly interview Transcript, *Artists Documentation Program*, The Menil Collection, September 17, 2000. https://www.menil.org/research/adp.

Twombly, Cy and William B. Jordan. *Cy Twombly: Paintings and Drawings*. Dallas: Meadows School of the Arts, 1980.

Tytell, John. *Ezra Pound: The Solitary Volcano*. New York: Anchor Press, 1988.

Van Dyke, Kristina. "Losing One's Head: John and Dominique de Menil as Collectors." In *Art and Activism: Projects of John and Dominique de Menil*, edited by Josef Helfenstein and Laureen Schipsi. Menil Collection Series. Houston: Menil Collection, 2010.

Varnedoe, Kirk, Francesco Clemente, Brice Marden, and Richard Serra. "Cy Twombly: An Artist's Artist." *Res: Anthropology and Aesthetics* 28 (Autumn 1995): 163–79.

Varnedoe, Kirk."Cy Twombly's Lepanto." In *Lepanto: A Painting in Twelve Parts*, 45–62. New York: Gagosian Gallery, 2008.

Varnedoe, Kirk. "The Ideology of Time: Degas and Photography." *Art in America* 68 (1980): 96–110.

Varnedoe, Kirk. "Inscriptions in Arcadia." In *Cy Twombly: A Retrospective*, 9–52. New York: Museum of Modern Art, 1994.

Varnedoe, Kirk. "Your Kid Could Not Do This, and Other Reflections on Cy Twombly," *MoMA* No. 18 (Autumn–Winter, 1994): 18–23.

Walls, Alissa. "Cy Twombly and the Art of Hunting Mushrooms." *American Art* 28, no. 2 (Summer 2014): 50–69.

Waters, John. *Role Models*. New York: Farrar, Straus and Giroux, 2010.

Waters, Patricia. *The Ordinary Sublime: Poems*. Tallahassee: Anhinga Press, 2006.

Weber, Bruce. *A House is Not a Home*. Boston: Bulfinch Press, 1996.

Weiss, Jeffrey. "Cy Twombly: Tate Modern, London." *Artforum International* 47, no. 2 (October 2008): 368–370.

Weiss, Jeffrey. "Private Practice." *Artforum International* 50, no. 3 (November 2011): 216.

Welsh, Marjorie. "A Discourse on Twombly." *Art in America* 67, no. 5 (September 1979): 80–83.

Wharton, Annabel. "Rafael Viñoly's Nasher Museum of Art at Duke University: Building Magic." In *The Nasher Museum of Art at Duke University: Rafael Viñoly Architects*, edited by Kimberly Rorschach. Durham: Duke UP, 2005.

White, David. "Oral history interview with David White, July 23–August 14, 2013." Columbia Center for Oral History, Columbia University. https://www.rauschenberg foundation.org/artist/oral-history/david-white.

White, Edmund. *City Boy*. New York: Bloomsbury, 2009.

White, Edmund. "Cy Twombly's Rebel Vision." *Vanity Fair*, September 1994, 168–77.

White, Edmund. *Inside A Pearl: My Years in Paris*. New York: Bloomsbury, 2014.

White, Roger. *The Contemporaries: Travels in the 21st-Century Art World*. New York: Bloomsbury, 2015.

Wijnbeek, Anneke E. "Twombly, Cy." In *The Grove Encyclopedia of American Art* Volume 1, edited by Joan Marter, 86. Oxford: Oxford University Press, 2011.

Wilhelm, James J. *Ezra Pound: The Tragic Years, 1925–1972*. University Park: Pennsylvania State University Press, 1994.

Wilkinson, Alec. "Remembering Cy Twombly." *New Yorker*, July 7, 2011. https://www.newyorker.com/news/news-desk/remembering-cy-twombly.

Wilson, Eva. "Lotus." *Oxford Art Online*, http://www.oxfordartonline.com:80/subscriber/article/grove/art/T052080.

Winkler, Paul. "Just About Perfect." In *Cy Twombly Gallery: The Menil Collection, Houston*, edited by Julie Sylvester and Nicola Del Roscio, 13–30. New York: Cy Twombly Foundation/Menil Foundation, 2013.

Woolf, Virginia. *The Common Reader*. New York: Harcourt, Brace and Co, 1925.

Woolf, Virginia. *The Diary of Virginia Woolf, Volume Two: 1920–1924*, ed. Anne Olivier Bell. New York: Harcourt Brace Jovanovich, 1978.

Yau, John. "Cy Twombly and Charles Olson and the 'Archaic Postmodern.'" In *Cy Twombly*, edited by Jonas Storsve, 25–29. Munich: Sieveking Verlag, 2017.

Yau, John. "Cy Twombly's Extravagant Synesthesia." *Hyperallergic*, March 24, 2018. https://hyperallergic.com/434178/cy-twombly-in-beauty-it-is-finished-drawings-1951-2008-gagosian-gallery/.

Yau, John. "Cy Twombly's Remarkable Treatise." *Hyperallergic*, December 21, 2014. https://hyperallergic.com/170270/cy-twomblys-remarkable-treatise/.

Young, Bruce. "The Way I Live Now." *Cat Typing* (blog), July 12, 2011. http://cattyping.blogspot.com/2011/07/way-i-live-now.html.

Zenith, Richard. "Introduction: The Drama and the Dream of Fernando Pessoa." In *Fernando Pessoa And Co.: Selected Poems*. New York: Grove Press, 1998.

ACKNOWLEDGMENTS

The fact of this book in the world feels miraculous. It would have been impossible without the help of so many people. I've tried to remember everyone, though I'm sure, like this very book, it is an imperfect catalogue.

The research and writing of the book was made possible by the generosity and community offered by the Fine Arts Work Center in Provincetown, U.S.–Italy Fulbright Commission, Ucross Foundation, National Humanities Center, Sustainable Arts Foundation, University of Southern California, Bread Loaf Bakeless Camargo Residency Fellowship, Camargo Foundation, and Bread Loaf Writers' Conference. With special thanks to Caroline Grant and Tony Grant at the Sustainable Arts Foundation, Michael Collier, Jennifer Grotz, and Noreen Cargill at Bread Loaf, and Janalynn Bliss and David St. John at USC. I'm eternally grateful for your vision, kindness, and support.

Thank you to my brilliant agent Rob McQuilkin for his guidance, insights, and being a fierce champion of my work. Thanks to my editor Ryan Harrington for his keen eye, endless patience, and unwavering belief in this book. My thanks to everyone at Melville House, in particular the sage counsel of Alan Kaufman.

This book would not have been possible without Erin Beeghly, Jacob Rivkin, Lacy Johnson, and Mike Scalise. My first (and toughest) readers, companions for adventure, and guides through rough waters and doubts—thank you.

For reading drafts and listening to me talk about Cy Twombly for too long, for their wisdom and mentorship, for allowing me to interview them, for opening doors and archives, for ping pong and friendship and community, for resistance and refusal, I'm grateful to the following people: Gerald Maa, Jessica Piazza, Brandon Som, Gabrielle Calvocoressi, Giuseppe Taurino, Paola Tello, Anna Ziegler, Darin Ciccotelli, Harriet Clark, Stephanie Soileau, Justin St. Germain, Jim Gavin, Peter Streckfus, Heather Green, Leslie Elwell, Matthew Culler, Margie Gelb, Marc Aaronson, Alexandria Marzano-Lesnevich, Holly Masturzo, Casey Fleming, Rachel Applegate, Marc McKee, Kate Marshall, Ian Newman, Ásta Kristjana Sveinsdottir, Dore Bowen, Chris Grasso, Annabel Wharton, Tamara Sears, Jim Parsons, Charlie Frazier, Lisa Iglesias, Paul Gerlitz, Aja Gabel, Katie Bellas, Janelle Iglesias, Elizabeth Bradfield, Chris Santiago, Joseph

Barnes, Athena Kirk, Andrew Moisey, Paisley Rekdal, Alen Hamza, Cori Winrock, Marcel Paret, Jessie Mandle, Moira Egan, Carlos Dews, John Rowe, Jane Brox, Eavan Boland, Sasha Dvorzova, Claudio Zambianchi, Lynn Boland, Valerie Grace Ricordi, Robert-Paul Sagner, Karl Olson, Will Cross, Tripp Evans, Bruce Young, Diane Henry, Kate Nesin, Nicholas Cullinan, Heiner Bastian, Isabella Ducrot, Peter Benson Miller, Harry Pemberton, Butch Bryant, Betty Stokes, Gaia Franchetti, Flaminia Allvin, Paola Igliori, Giosetta Fioroni, Mary Jacobus, Bill Jordan, Barbara Crawford, Mario Pellicciaro, Alberto Di Fabio, Andrea Di Robilant, Tristano Di Robilant, Alessandro Twombly, Milton Gendel, Max Renkel, Achim Hochdörfer, and Nicola Del Roscio.

Thank you to all the people who shared their stories and knowledge and lives with me. In November of 2017, several years after my visits to Lexington, Harry Pemberton passed away at the age of ninety-two. A man of wisdom and good humor, meeting him was one of the great gifts of writing this book.

My endless thanks to Brooke Andrade, Sarah Harris, and Joe Milillo at the National Humanities Center for their invaluable research assistance. Thank you too to all of the librarians, administrators, and archivists at the University of Southern California, University of Utah, American Academy in Rome, Biblioteca Hertziana in Rome, Menil Collection, Georgia Museum of Art, Rauschenberg Foundation, Earl and Camilla McGrath Foundation, and Archives of American Art. I am especially grateful for the help of Elizabeth Botten at the Archives of American Art and Geri Aramanda and Lisa Barkley at the Menil Collection.

Thank you Marsha and Skeets Harris for passing on your love of art, and Charles Fuller, who in tenth grade, knowingly assigned me a report on Henri Matisse. Thank you to all of the guards and staff at the Menil Collection. Thank you to everyone at Writers in the Schools in Houston: Robin Reagler, Jack McBride, Long Chu, and all my WITS students for helping me see the artwork of the Menil through their poems and stories.

I am forever grateful to my families—Rivkin, Horwitz, Plotkin, and Beeghly—for their love and encouragement, in particular my parents: Harriet Horwitz, Marc Horwitz, Richard Rivkin, Robin Anderson. It is a true gift to have a family that has always supported my path as a writer and artist in so many ways. Thank you.

And most of all, thank you Erin and Esme. In the book I quote from a poem by Jack Gilbert: "*Love*, we say, / *God*, we say, *Rome* and *Michiko*, we write, and the words / get it all wrong." Here now, in these acknowledgments, words can't quite get to how deeply grateful I am for you both. This book is an atlas and a clock of our lives together. It's also proof of your love and trust and patience. This book is for you.

INDEX

B TWOMBLY
Rivkin, Joshua.
Chalk.
10/08/2018